[New HOTELS]

[New HOTELS]

Edited by Alejandro Bahamón

HDi

**HARPER
DESIGN
international**

An Imprint of HarperCollins*Publishers*

Publisher: **Paco Asensio**

Editor in Chief: **Haike Falkenberg**

Editorial Coordination and text: **Alejandro Bahamón**

Translation: **Madeline Carey**

Art Director: **Mireia Casanovas Soley**

Layout: **Ignasi Gracia Blanco**

Copy-editing: **Lesley Bruynesteyn and Gyda Arber**

Research: **Marta Casado**

First published in 2003 by:
Harper Design International,
an imprint of HarperCollins Publishers
10 East 53rd Street
New York, NY 10022

Distributed throughout the world by:
HarperCollins International
10 East 53rd Street
New York, NY 10022
Tel: (212) 207-7000
Fax: (212) 207-7654
HarperDesign@harpercollins.com
www.harpercollins.com

HarperCollins books may be purchased for educational, business, or sales promotional use.
For information, please write:
Special Markets Department
HarperCollins Publishers Inc.
10 East 53rd Street
New York, NY 10022

Editorial project:
2003 © **LOFT** Publications
Via Laietana 32, 4ª Of. 92.
08003 Barcelona. Spain
Tel.: +34 932 688 088
Fax: +34 932 687 073
loft@loftpublications.com
www.loftpublications.com

Library of Congress Control Number: 2003103505

ISBN: 0-06-054469-4
D.L.: B-17.554-03

Printed by:
Anman Gràfiques del Vallès, Spain

First Printing, 2003

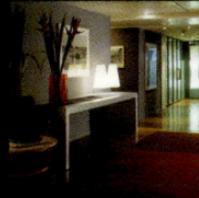

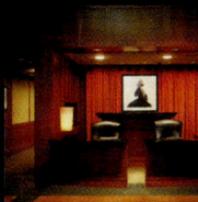

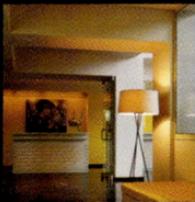

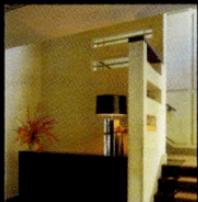

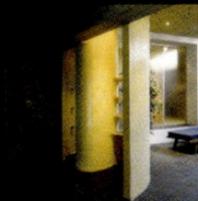

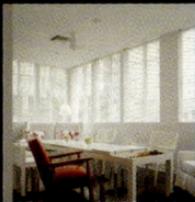

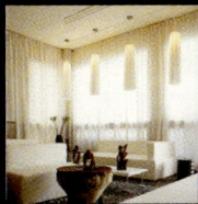

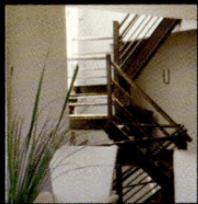

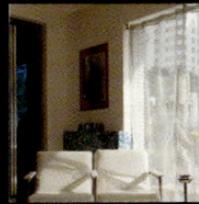

 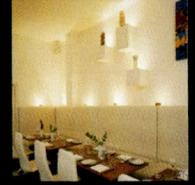

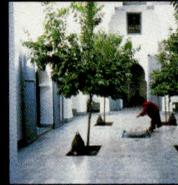 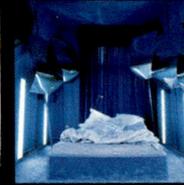

[208] REMODELING

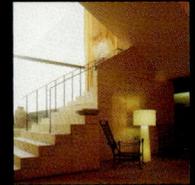

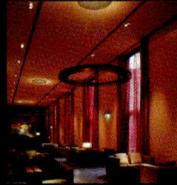 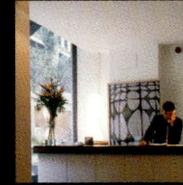

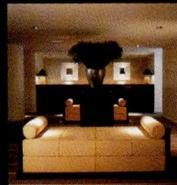 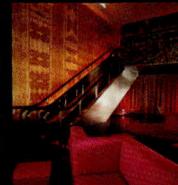 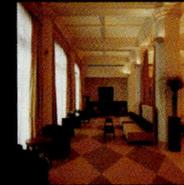

[272] ARCHITECTURE

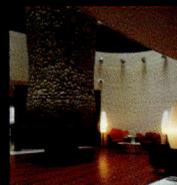 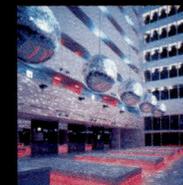 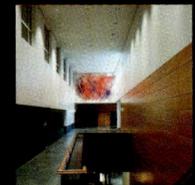

 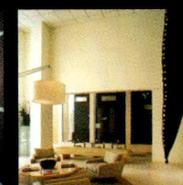

Introduction

Over the past two decades a growing demand for hotels with their own individual character has sparked the interest of both architects and designers alike. Where luxury hotels once meant expensive materials, exaggeration, and formality, they are now signaled by customized comfort and individual personality. Ample spaces, sensual atmospheres, the latest technology, and above all, a stylish sense of character are showcased in these spaces by some of the world's most prestigious architects and designers.

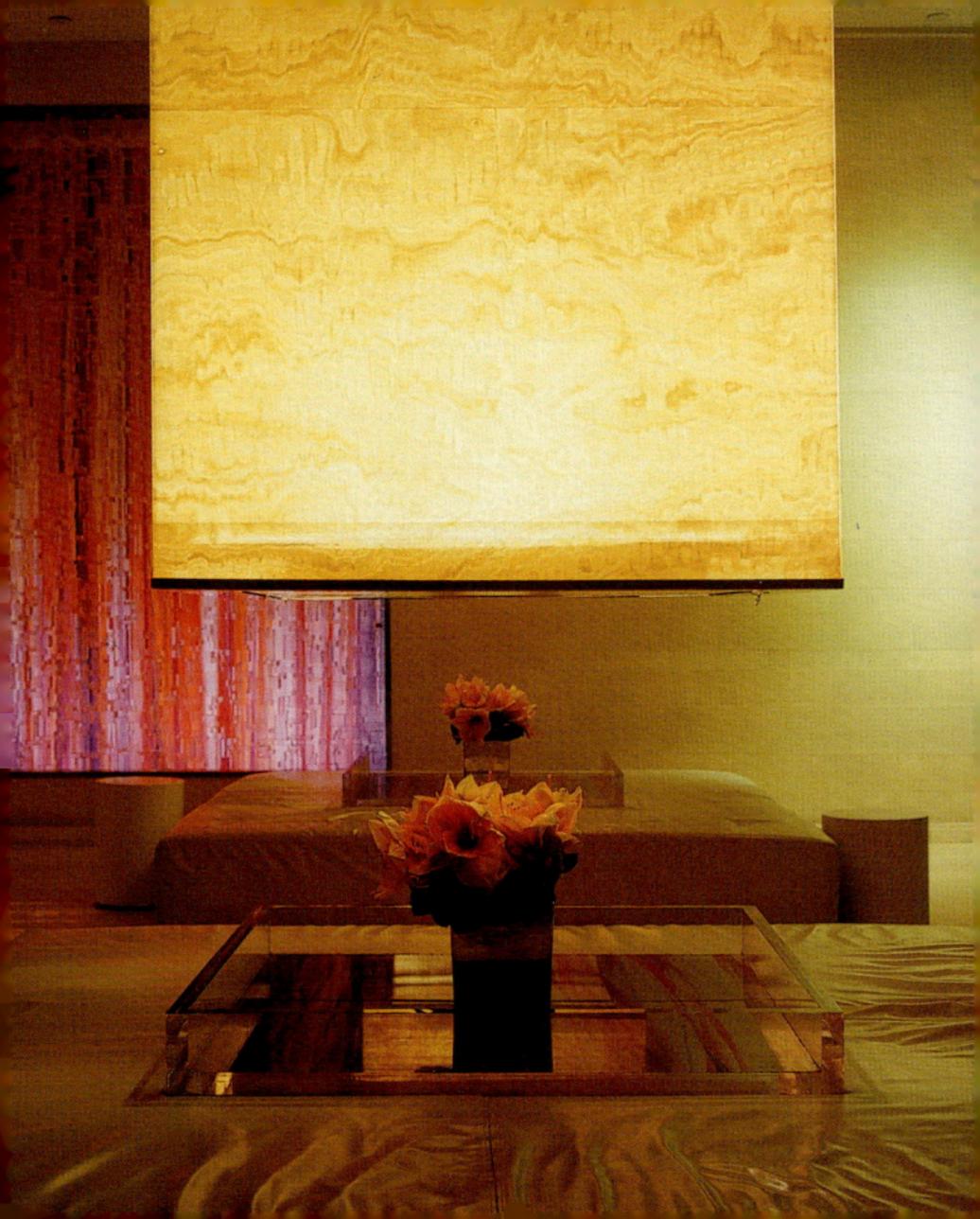

This new generation of hotels—fueled by the exponential growth of the travel industry—is notable for its attention to individuals and to detail. Globalization need not mean standardization. With more leisure time and more money available to spend on it, the more popular travel has become, and the more crucial vitality and variety have become in competing for the affections and pocketbooks of today's travelers. The new designer hotels can afford to be more detailed and exotic in their varying motifs. This attention to personality coupled with an organic integration of the building with its history and surroundings, are the hallmarks of each project presented in this collection.

The environments that they so uniquely interpret are organized as follows:

Urban
OASIS

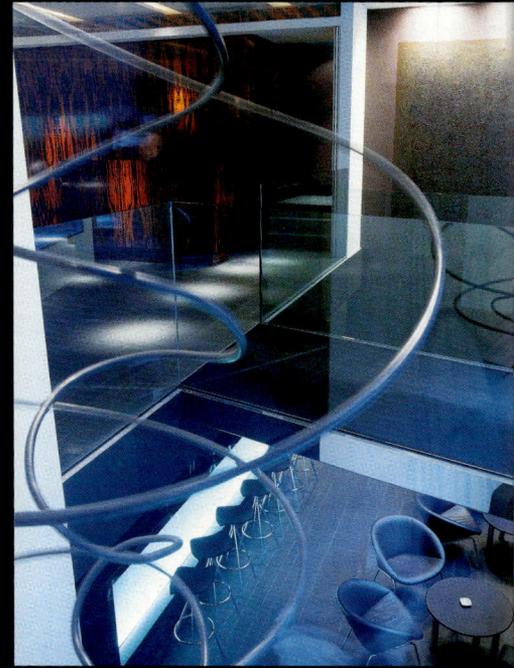

The large capital cities of the world are a common, often obligatory, destination for tourists and business travelers alike. The main attraction of these hotels is their proximity to the commercial, financial, or downtown districts. The hotels presented here, in cities such as New York, Mexico City, London, or Madrid, are true refuges from the hectic urban life that pulses outside their walls, isolating the building from the city's bustle but still capitalizing on its panoramic views, incorporating the best of without with the best within through the use of bold elements, such as double facades, hotels that start on an upper floor, and very restrained decorations that create their own world.

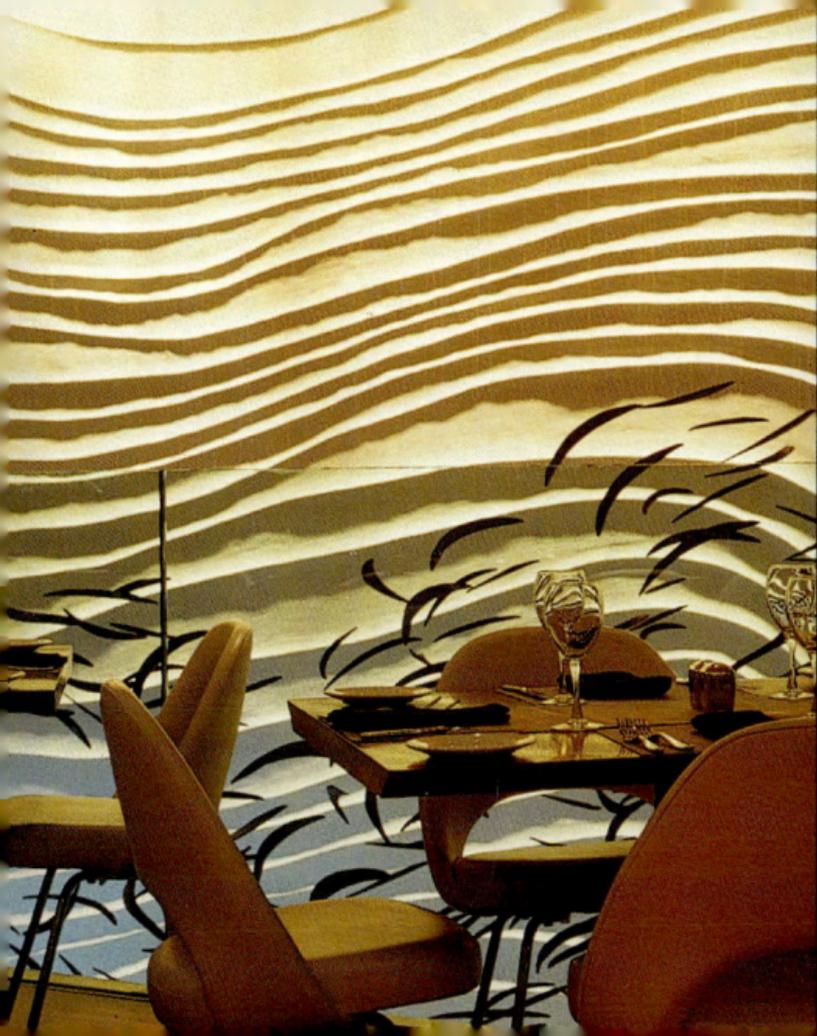

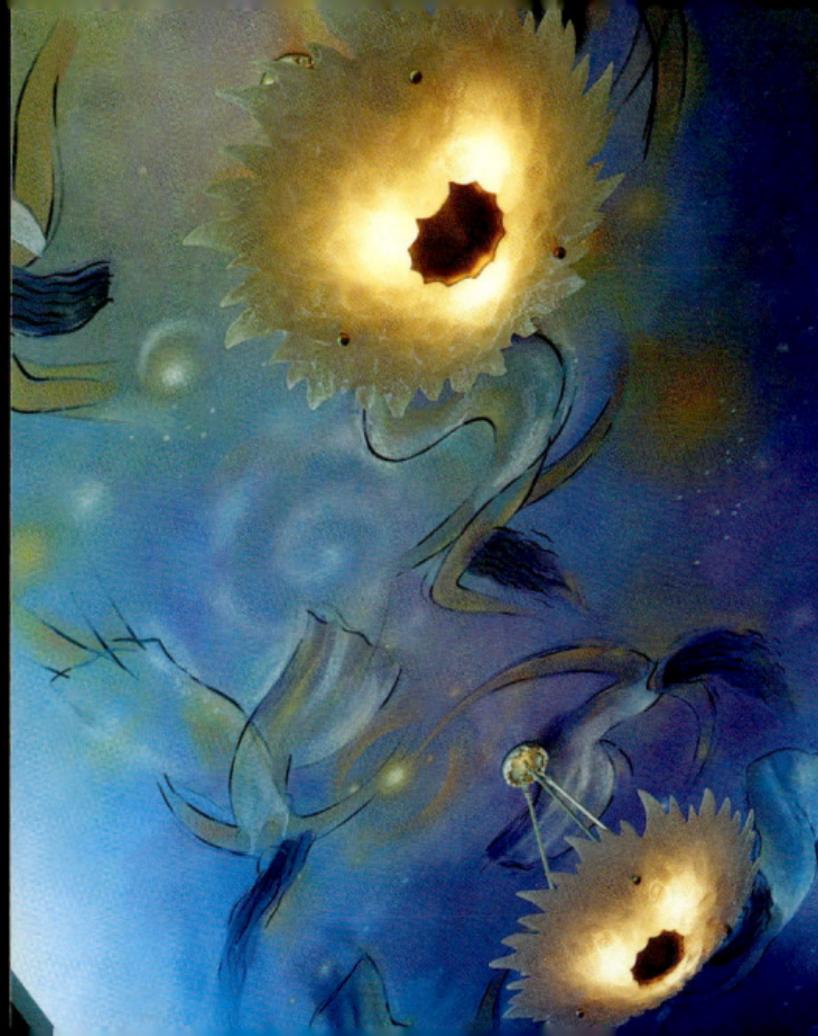

W Hotel
Times Square

1567 Broadway, New York, NY 10036, USA Tel: +1 212 930 7400 Fax: +1 212 930 7500 www.whotels.com

Creating an oasis of stillness and tranquility amid the frantic pace of a city like New York was the fundamental goal for the design of this hotel, located in Times Square, one of the most dynamic spots in the city. In this area, all the commercial and leisure activities of the Big Apple collide: shops, theaters, movie theaters, and popular shows. The first designer hotels opened their doors in this neighborhood and over time they have become urban icons and must-see attractions for tourists and residents alike. The W, although it is a part of the constant activity in the area, is also a refuge from it by providing a space filled with Zen references.

The moment the elevator doors open on the seventh floor, where the lobby is located, a delicate and tranquil atmosphere is apparent. A seemingly floating glass entrance hall with light geometric lines creates the effect of weightlessness. In the rest of the interior areas the same formal style continues, embodied in the large lamps hanging from the ceiling of the lobby, furnishings in pure shapes, and various pieces of decoration that complement the space. The mix of materials used, such as wood, vinyl, parchment, and glass, and the intense colors, which cover large surfaces, makes for a multifaceted ambience, intense but at the same time relaxing.

Designer: **Yabu Pushelberg** Photographer: **Pep Escoda** Location: **New York City, USA** Opening date: 2002

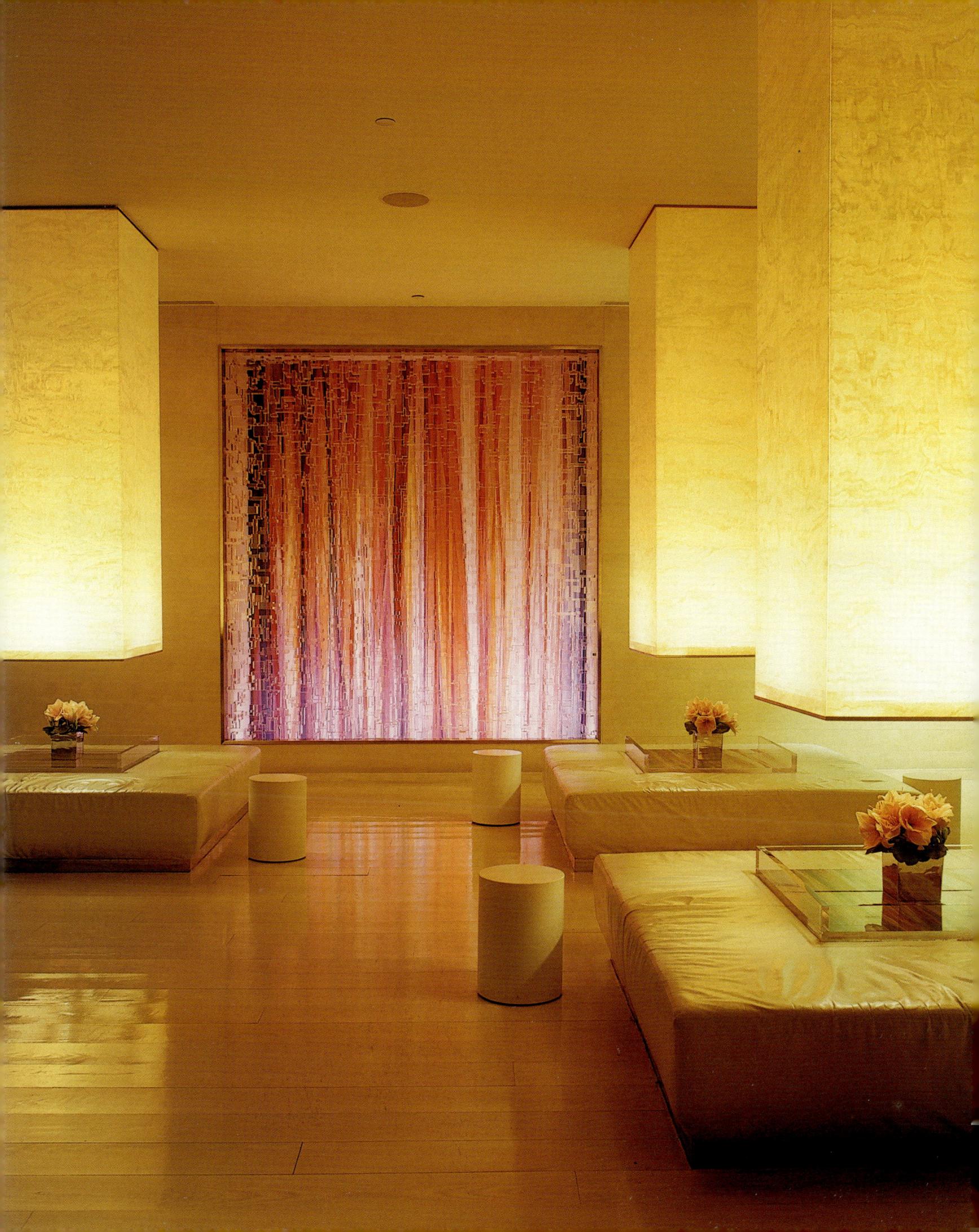

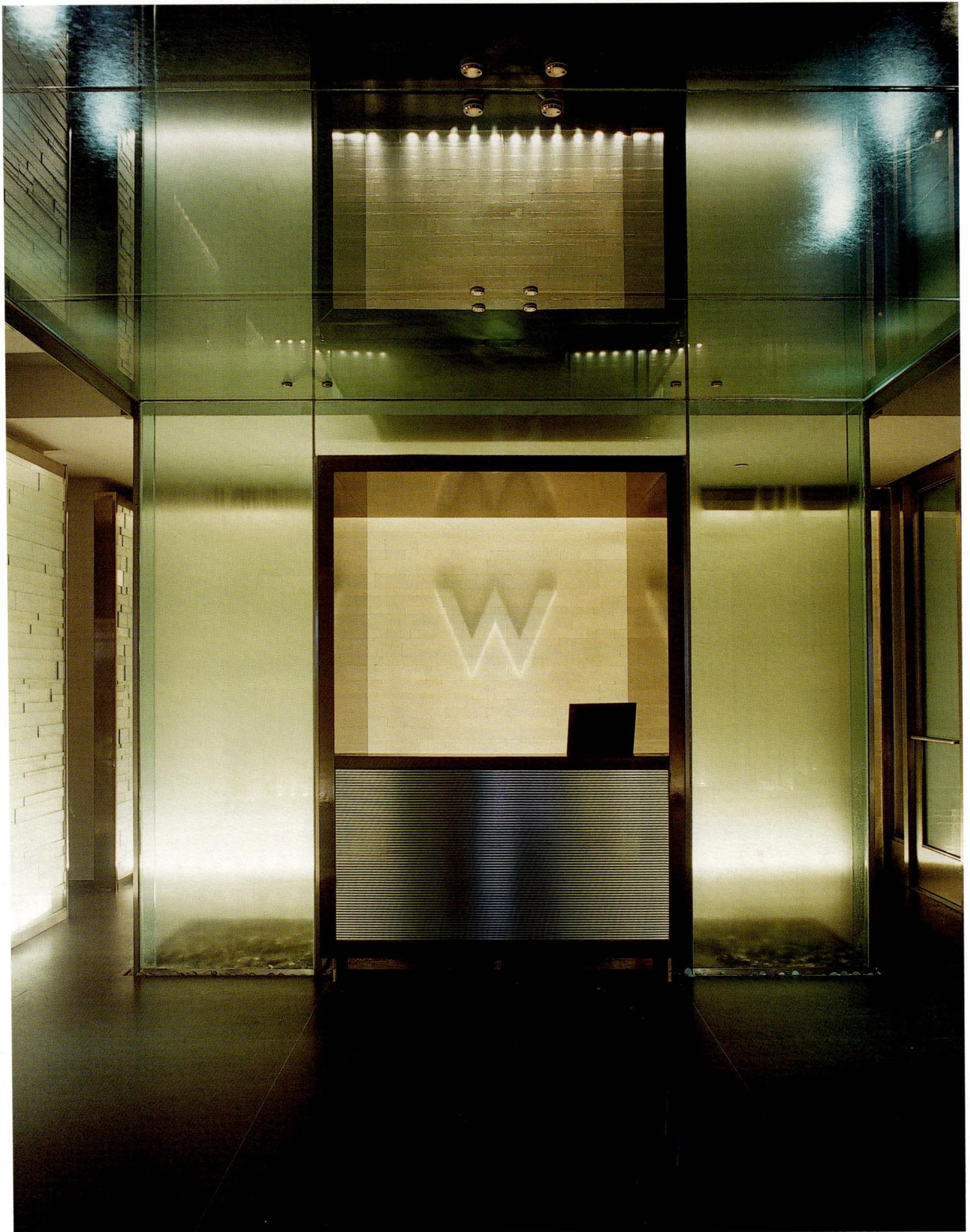

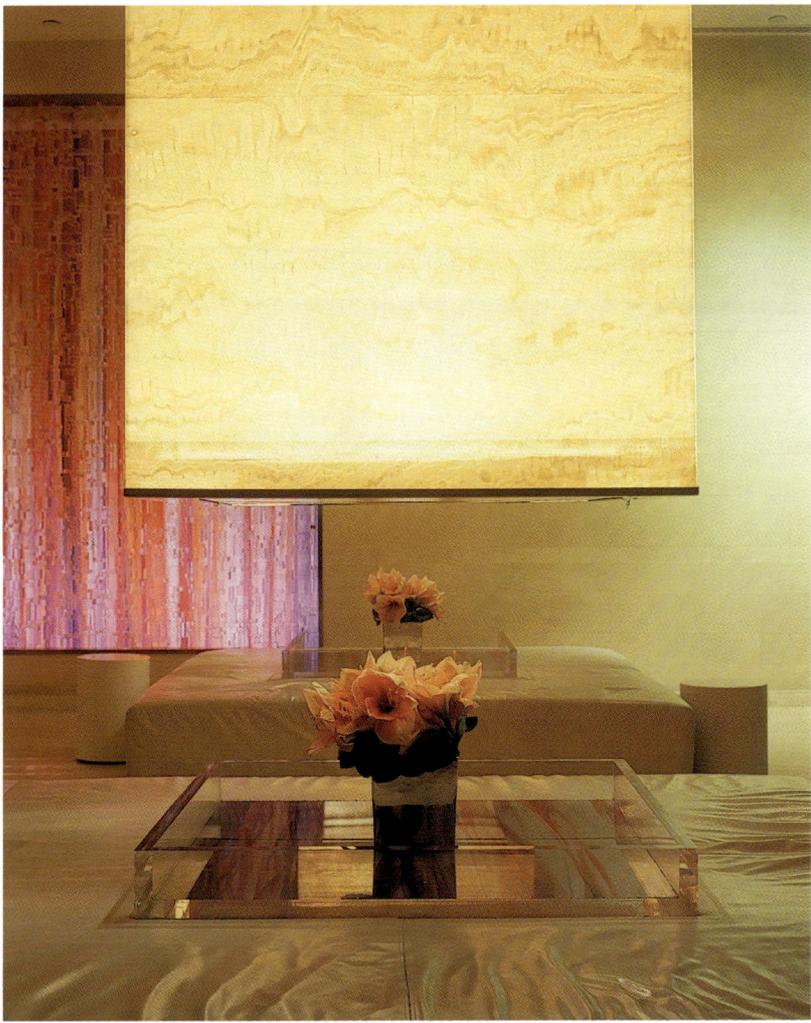
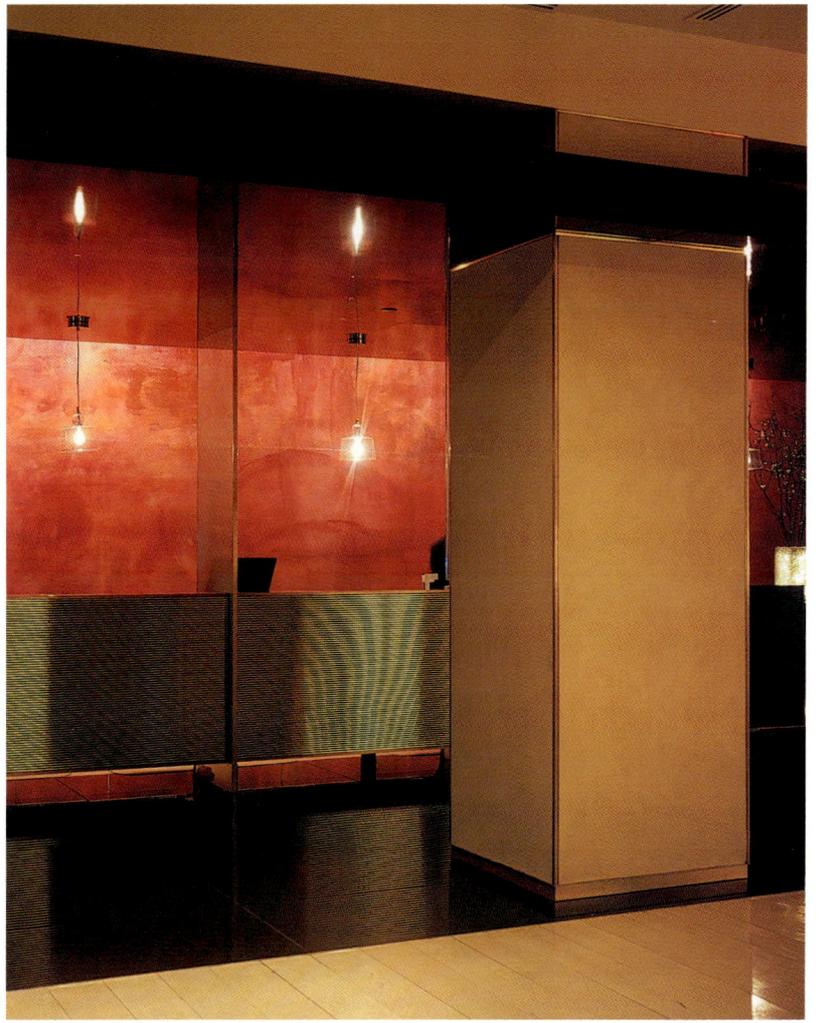
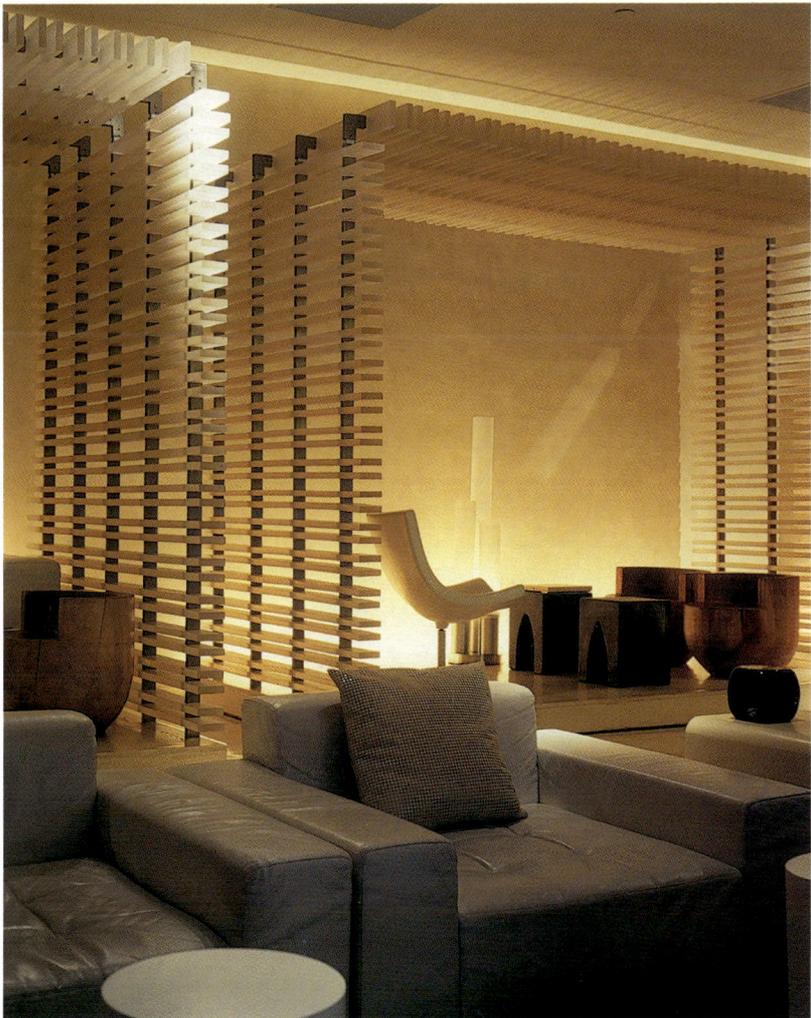
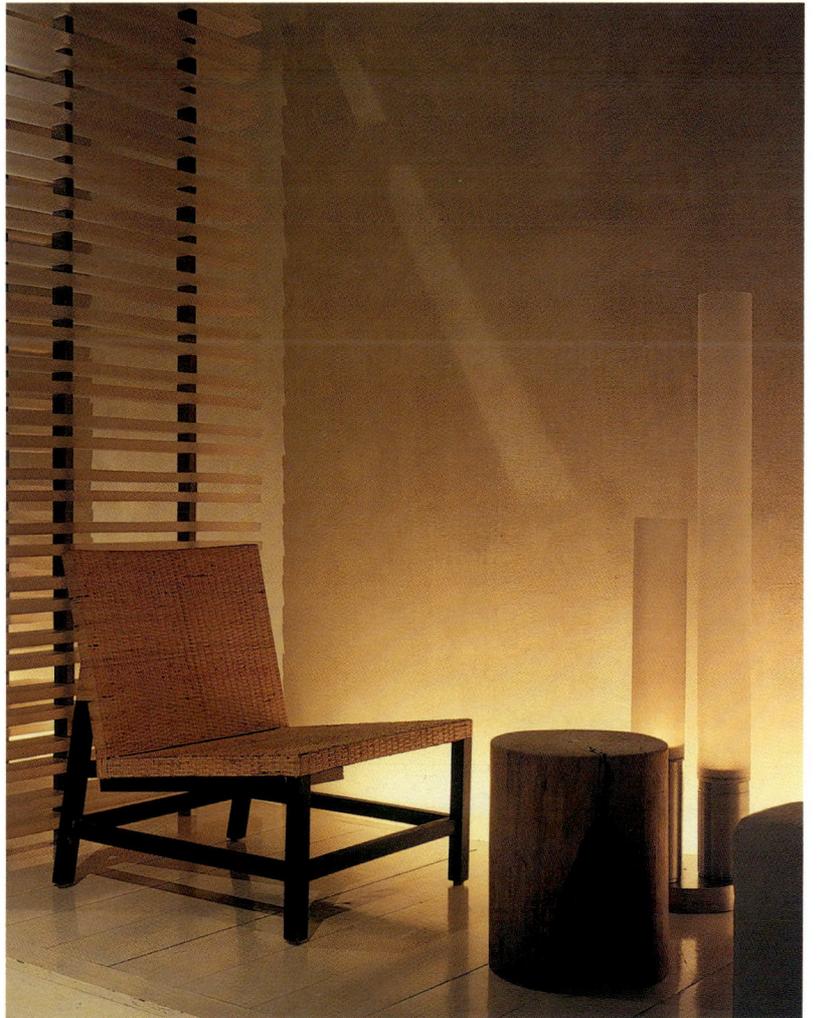

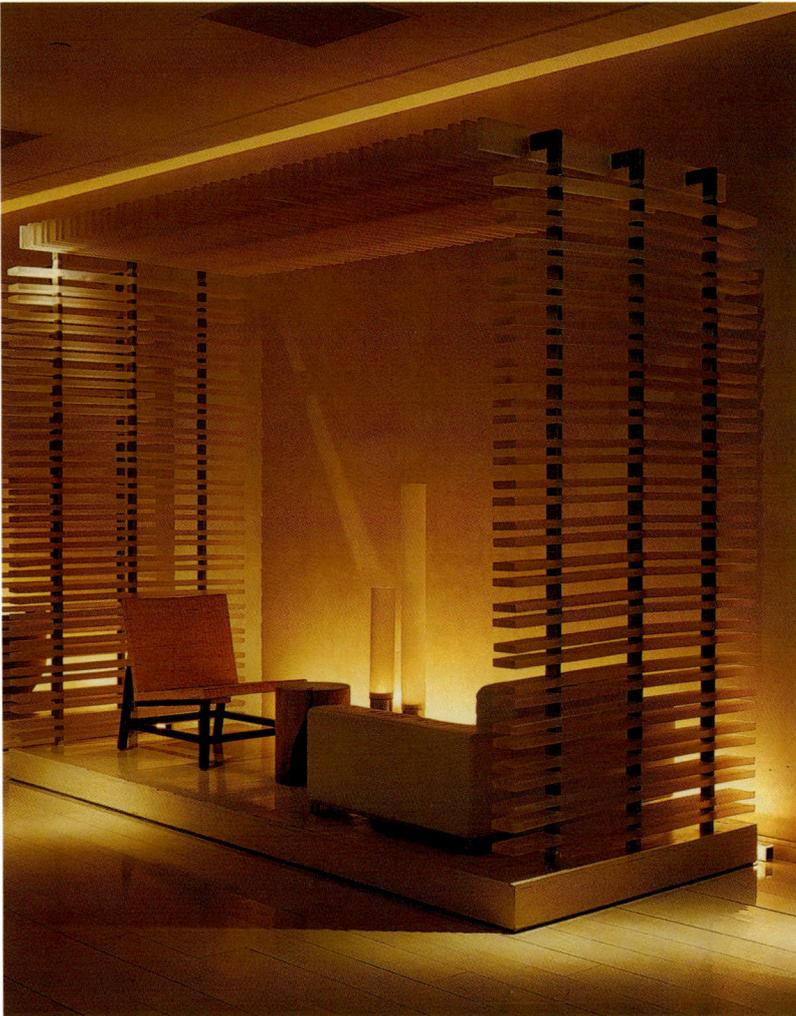

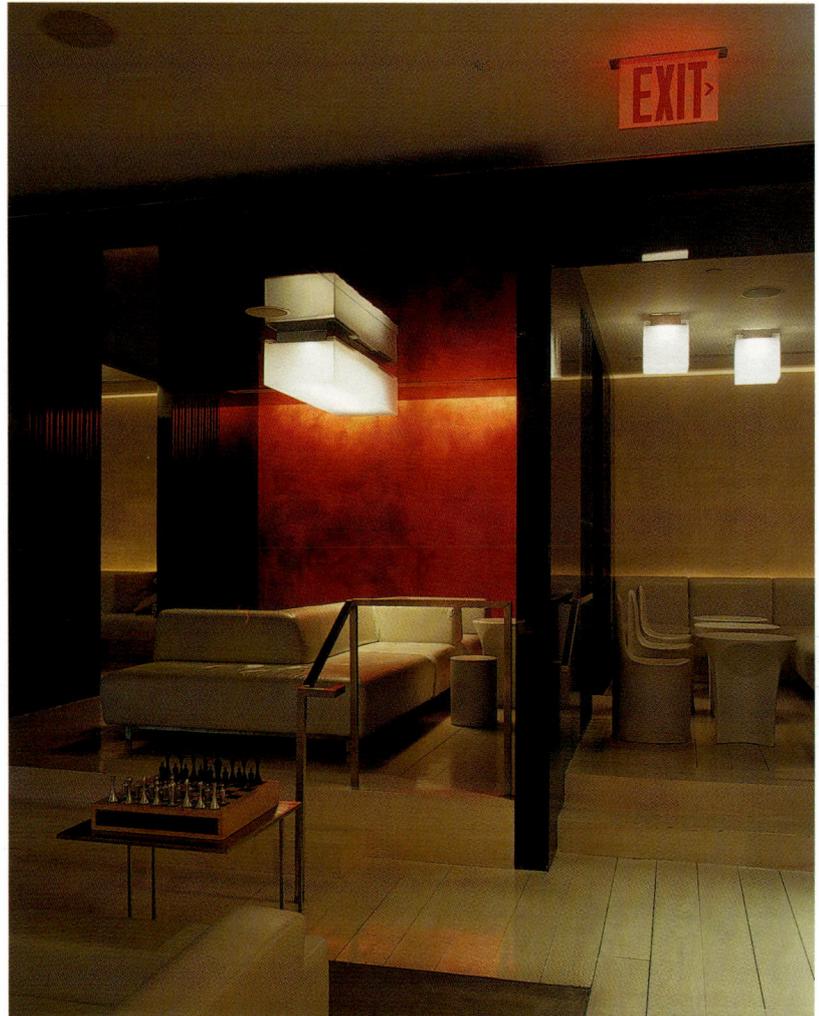

The concept of privacy and seclusion prevails in many of the public areas of the hotel. Subtle wooden divisions and the variation in floor levels—achieved with platforms—create small living room-like spaces.

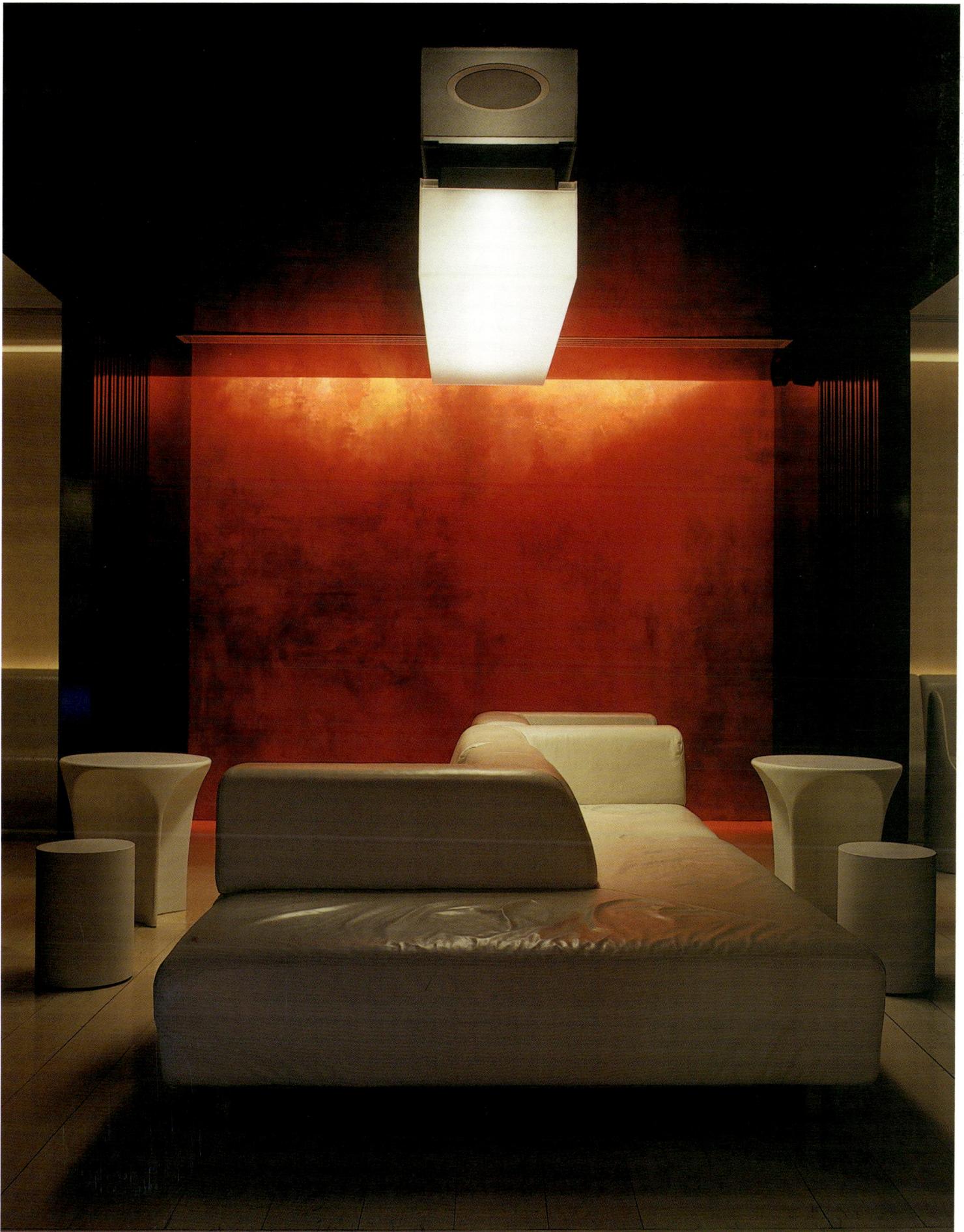

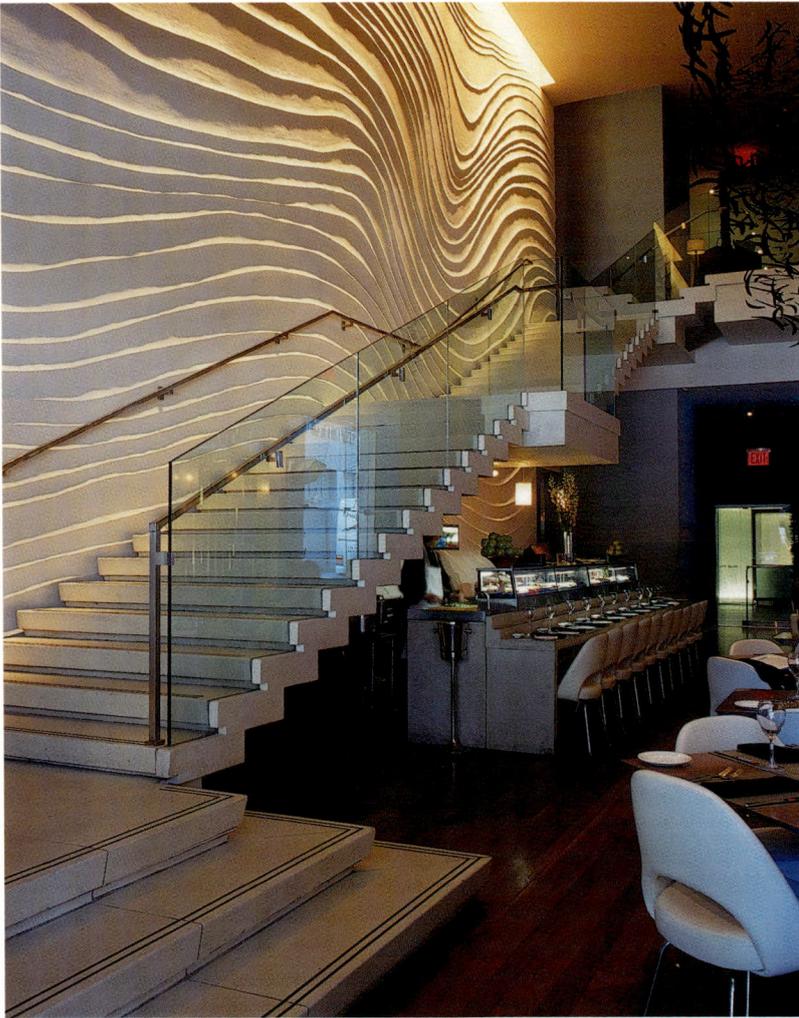

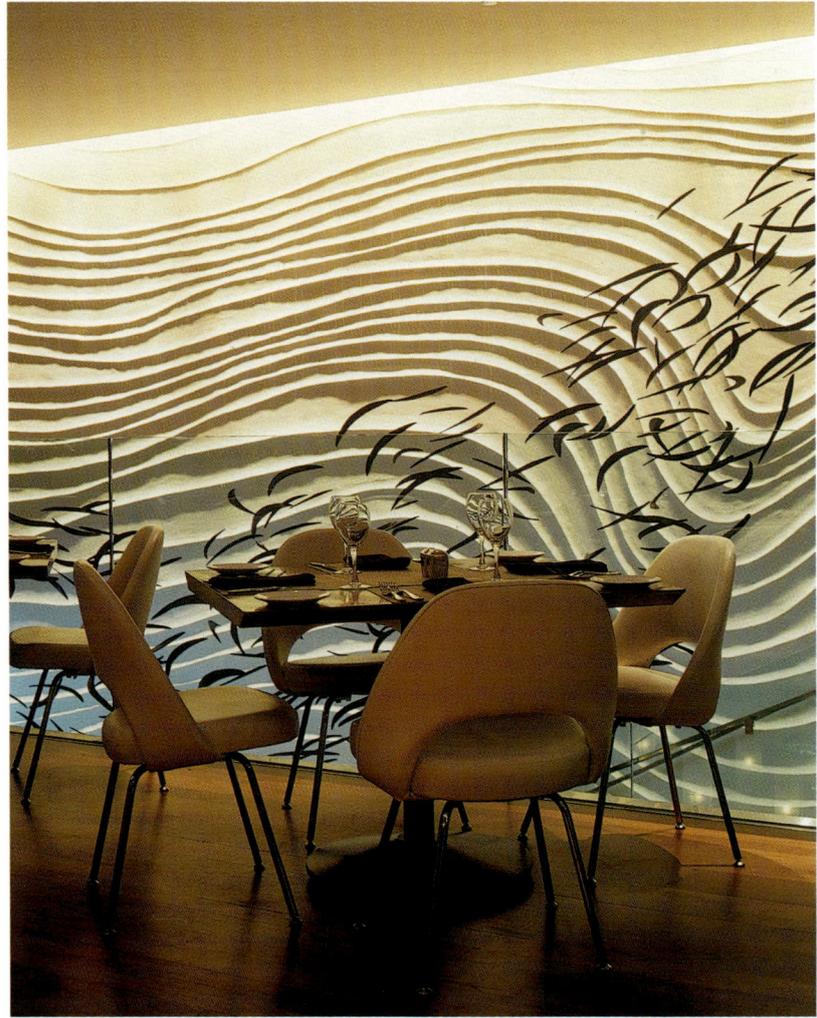

In the large, high-ceilinged space of the restaurant/bar, the soft texture of the wall along the staircase alludes to drawings of Japanese stone gardens. A kinetic sculpture, shaped like tiny leaves, hangs near the staircase, creating an effect of depth that is especially noticeable from the top floor.

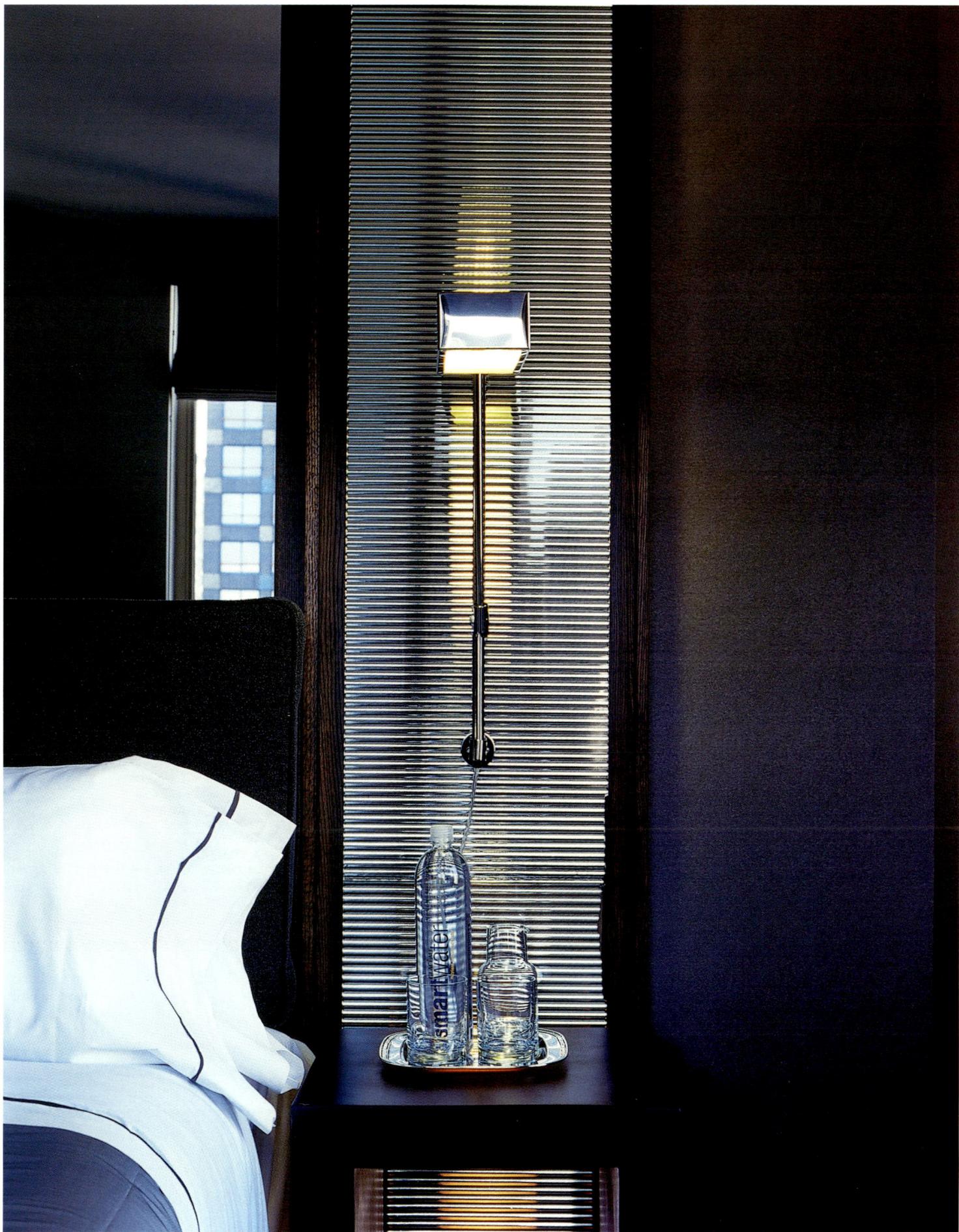

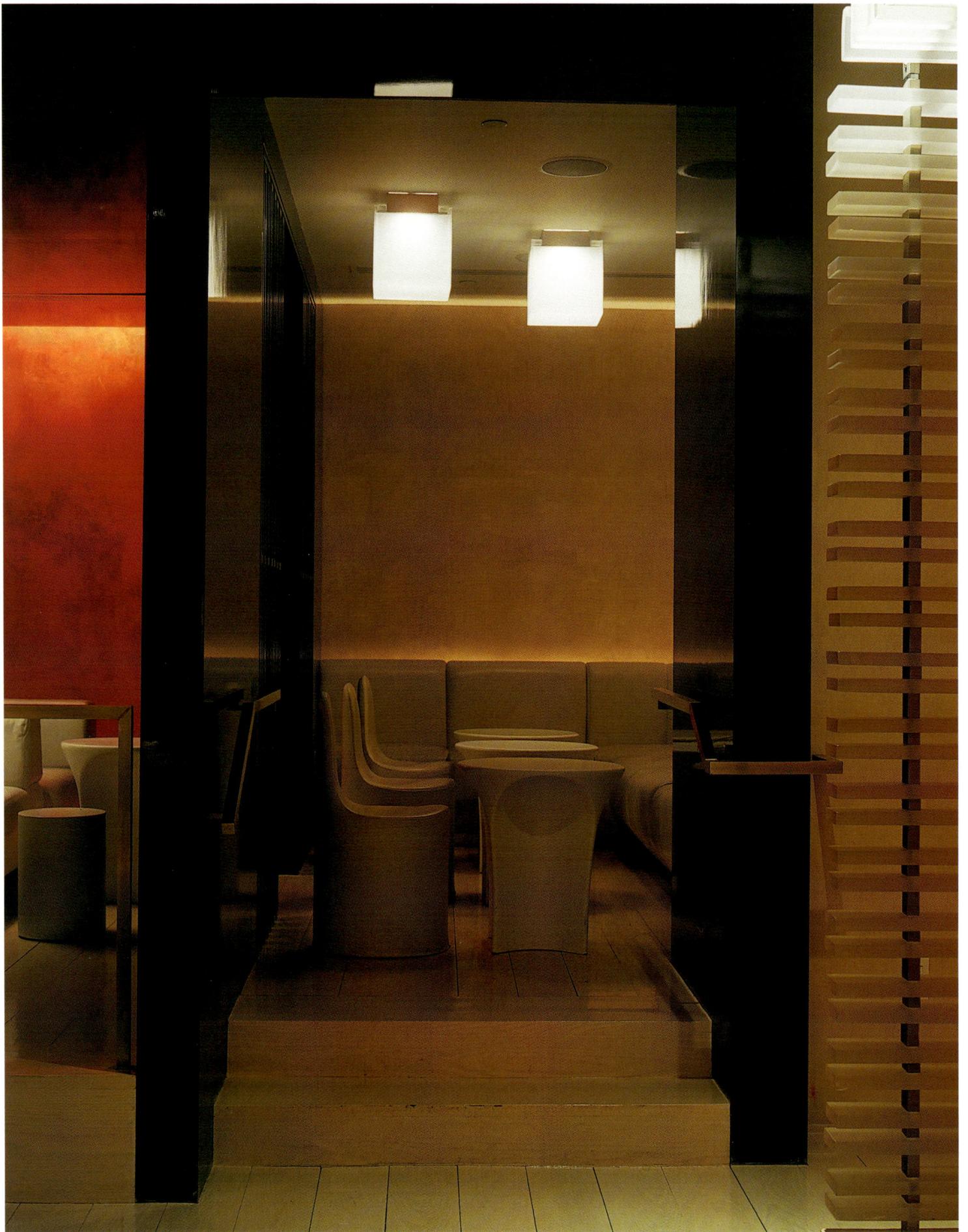

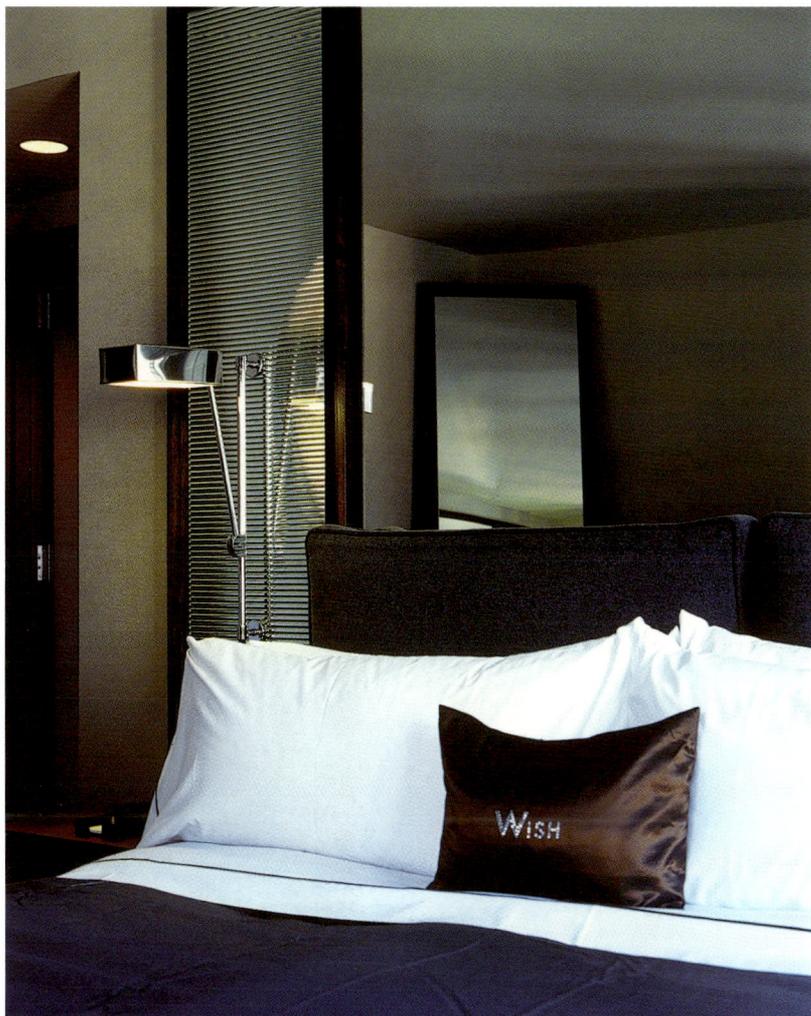

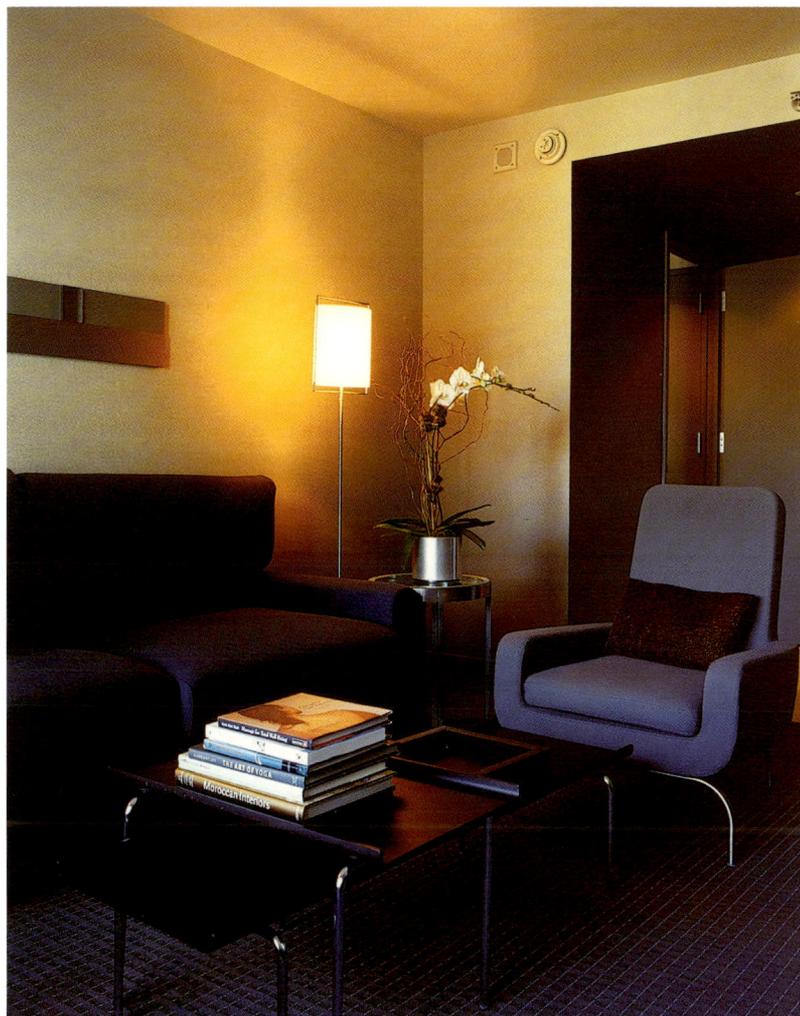

The warm colors of the public spaces were replaced by cooler tones in the rooms where white, black, and blue prevail.

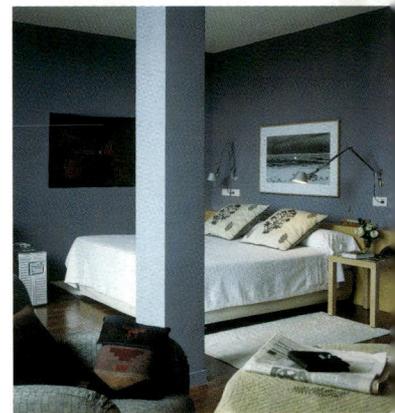

Hotel
Bauzá

Calle Goya 79, 28001 Madrid, Spain Tel: +34 91 4357545 Fax: +34 91 4310943 info@hotelbauza.com www.hotelbauza.com

Located in one of Madrid's busiest neighborhoods, this project consisted of the total renovation of a building that was originally also a hotel. The intention of the renovation was to create a space based on the comforts of a home, with its warmth, intimacy, and personality, far from the anonymous atmosphere of a hotel. Open spaces and rooms featuring materials that were chosen with great care give the sensation of exclusivity coupled with privacy. The hotel has ten levels. The entrance, lobby, and reception areas are located on the ground floor, while the second floor is set aside for the conference rooms, a restaurant, bar, library, and private dining room. The guest rooms are located on the remaining floors of the building.

The idea of creating a domestic environment is reflected in the design of the furnishings as well as the choice of materials and decorative objects. Natural materials have been chosen for the details and finishes among which linen, cotton, and wool prevail. As a decorative accent the designers brought together a prestigious collection of work by Spanish photographers that shows varied glimpses of other countries. An exceptional feature of the renovation was the opportunity to design everything from the overall look and feel of the spaces down to the smallest details, and this exercise in design has resulted in a timeless international hotel of great coherence.

Architect: Virginia Figueras Collaborators: Franco Corada, Ramón Pujol, Josep Bagá, Loles Durán Photographer: Jordi Sarrà Location: Madrid, Spain
Opening date: 1999

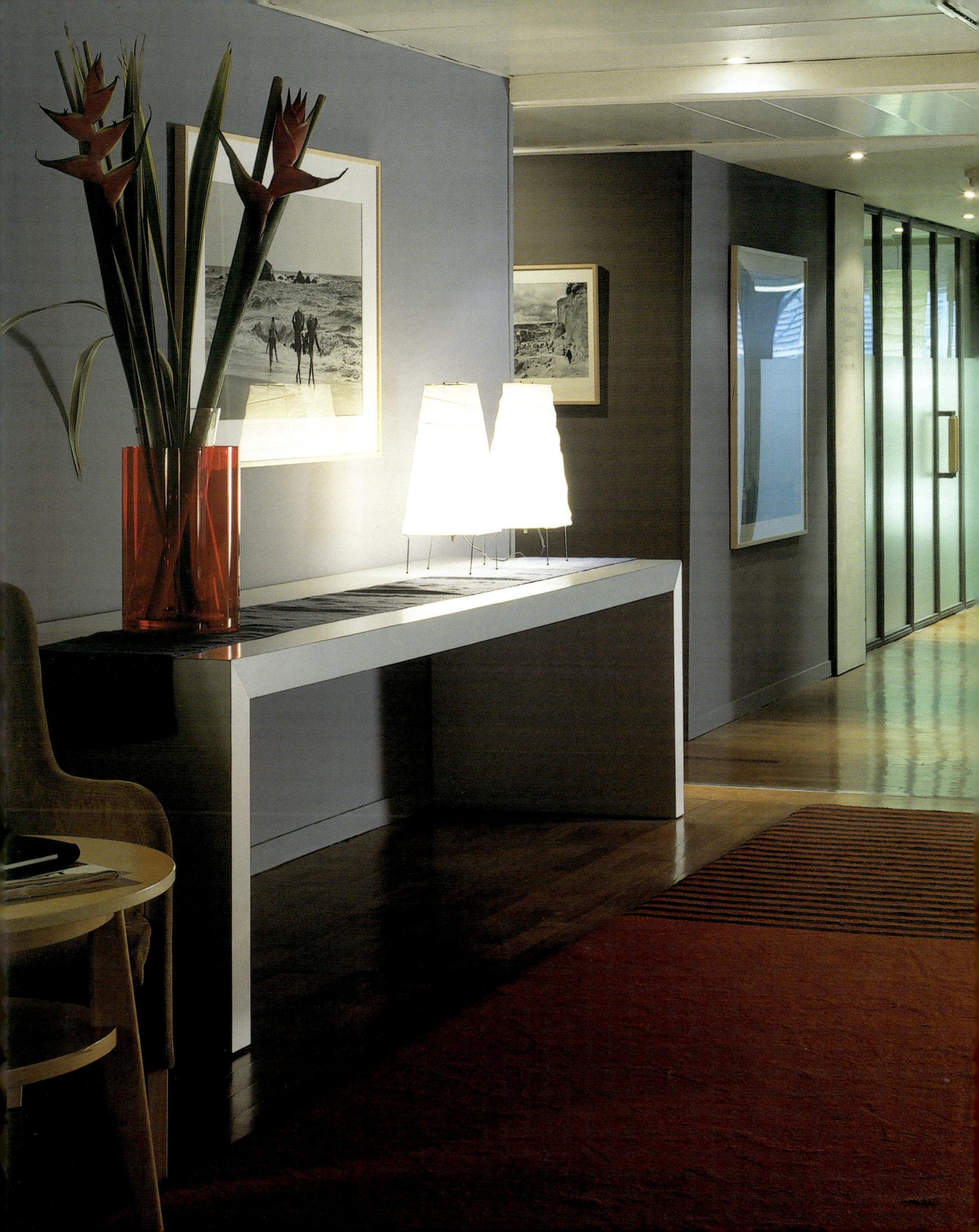

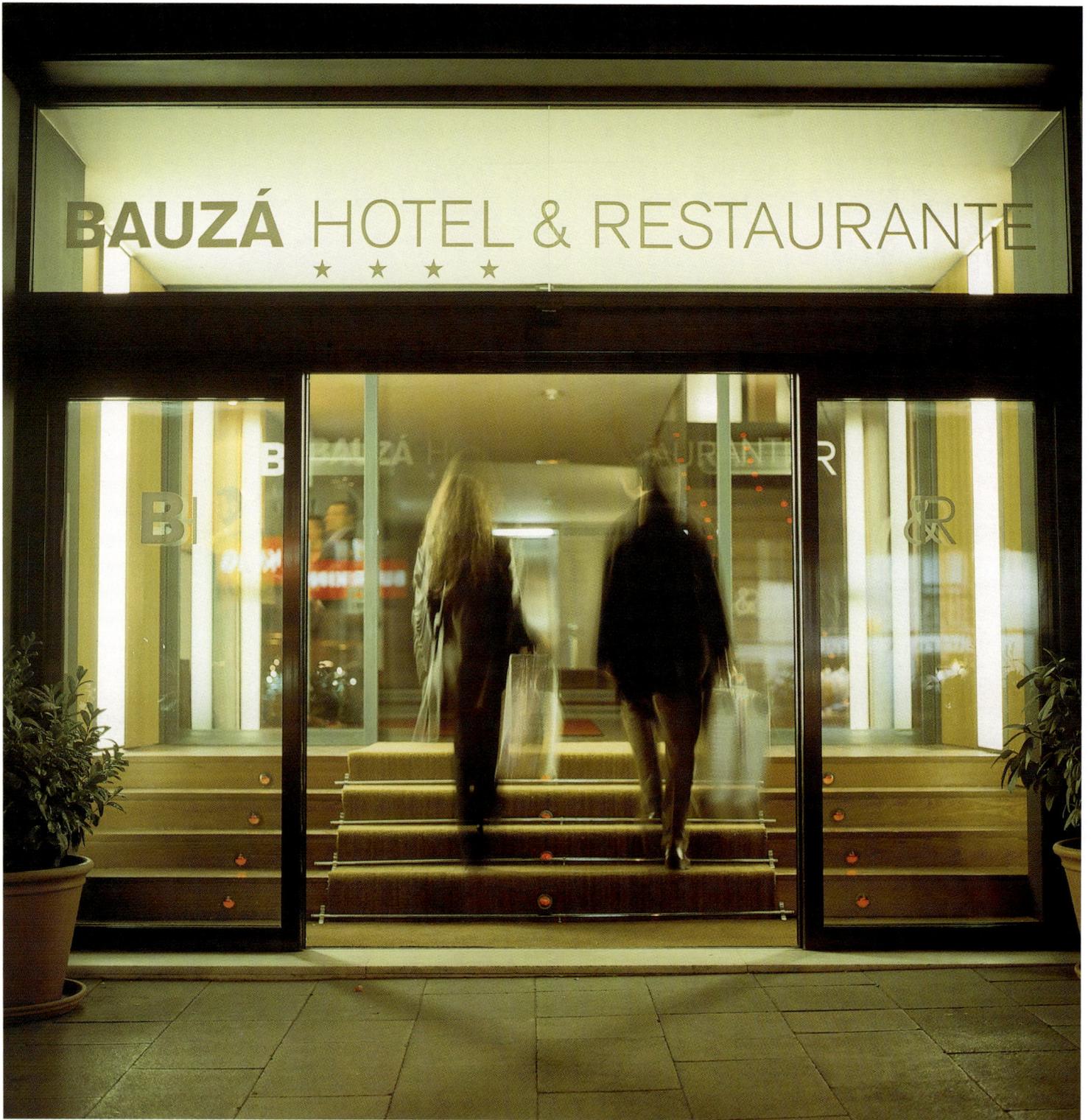

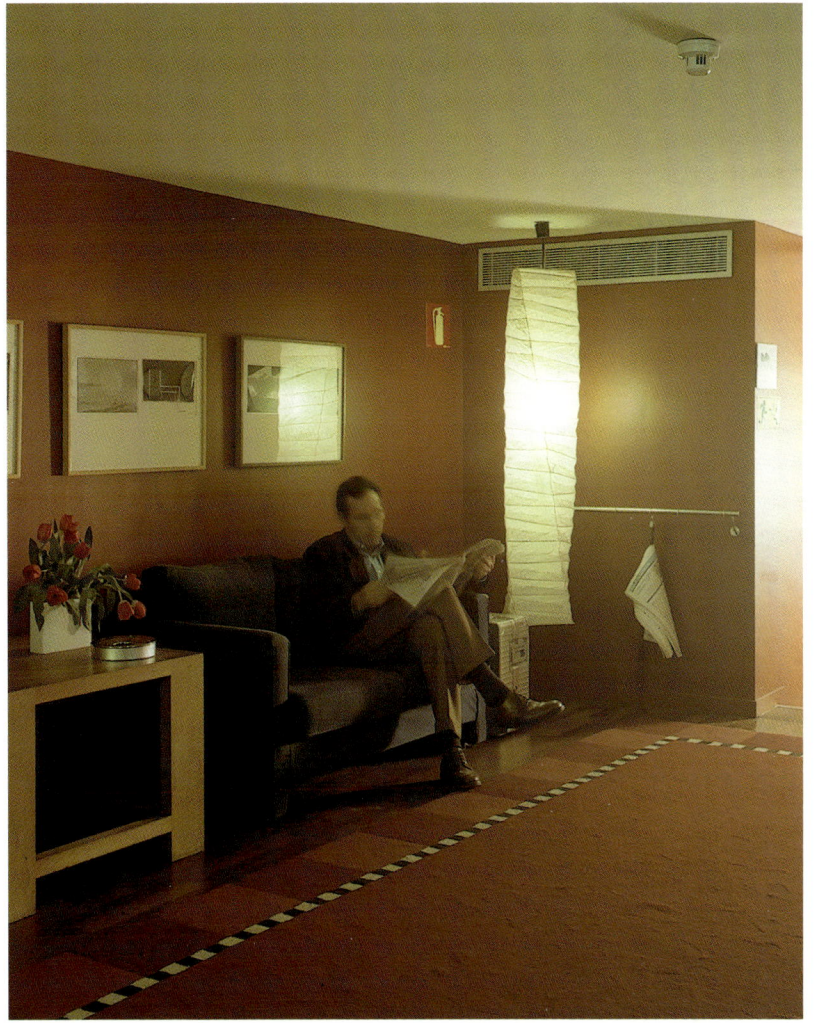

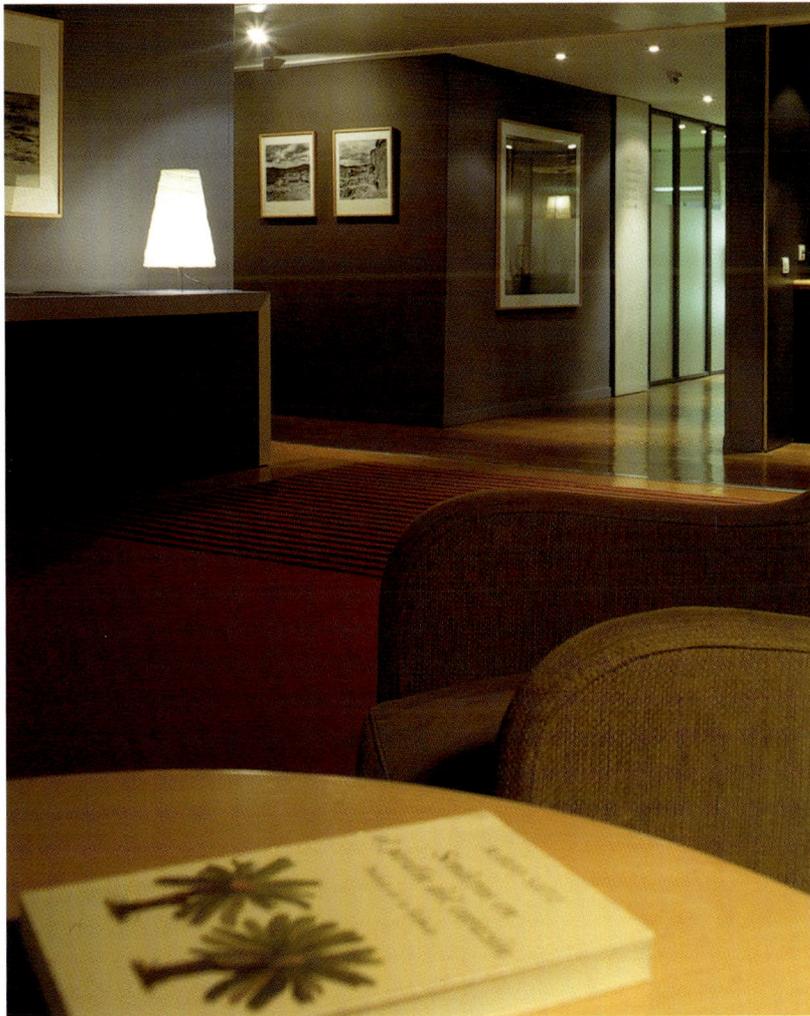

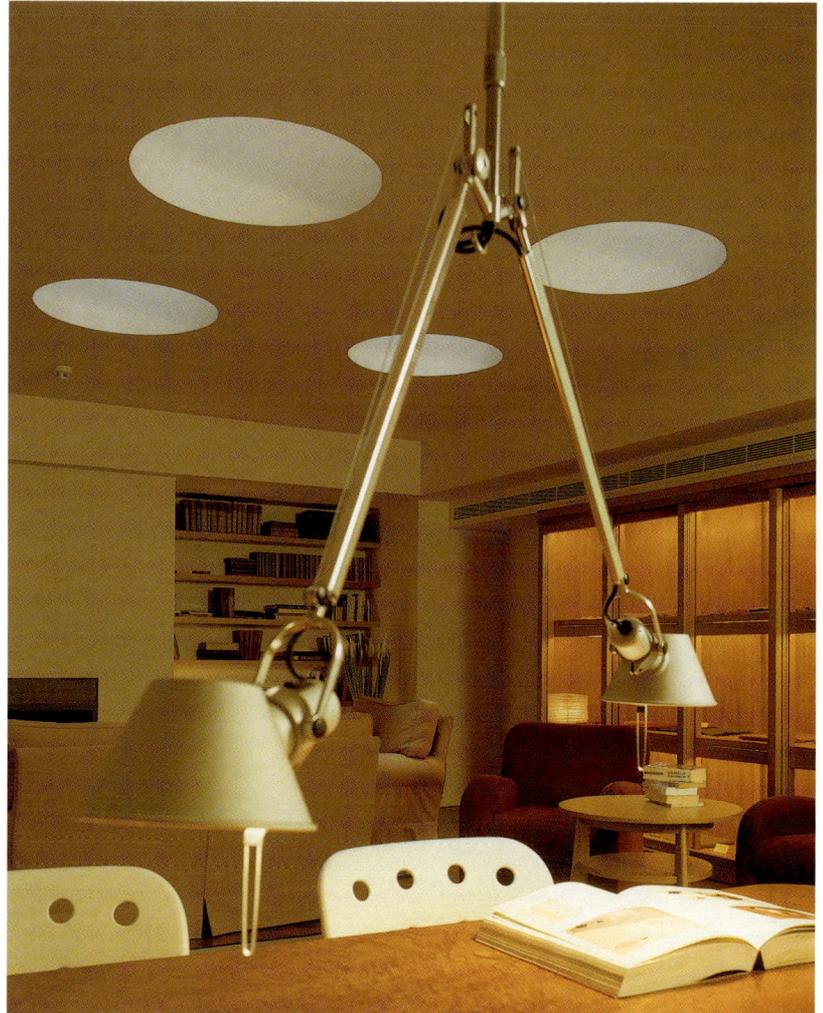

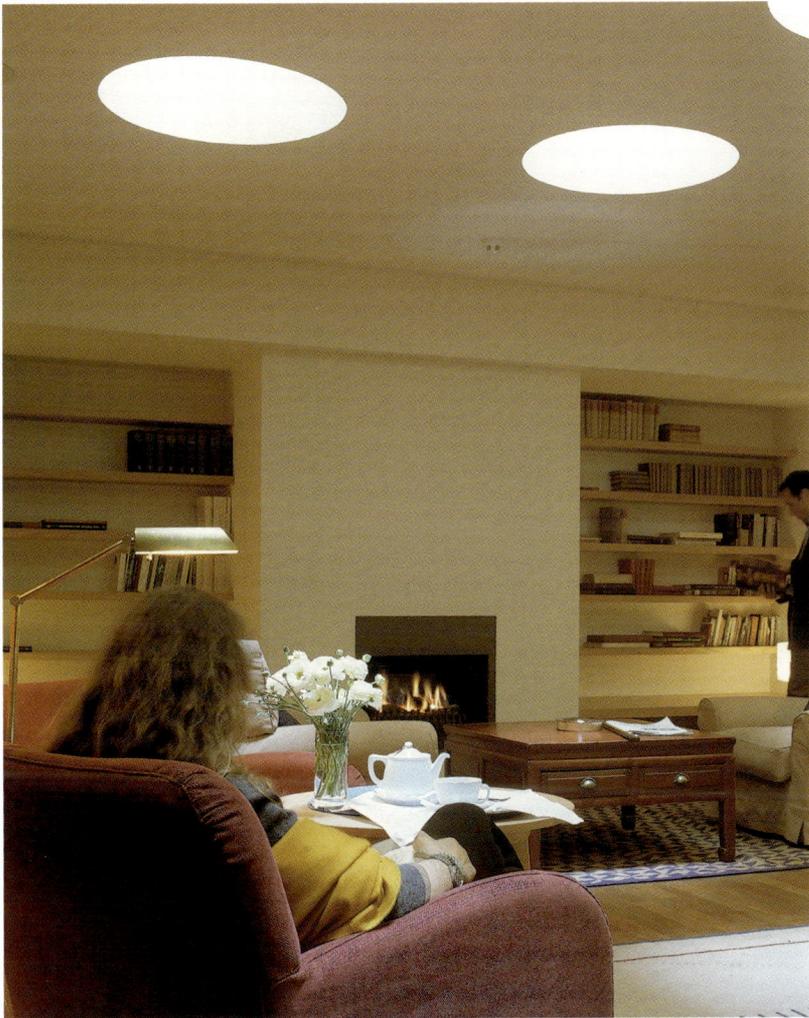

One of the spaces where the intention of design is most clearly evident is the quiet, cozy library with its fireplace and skylights. Here the hotel guests can enjoy some quiet time in an environment filled with character and personality.

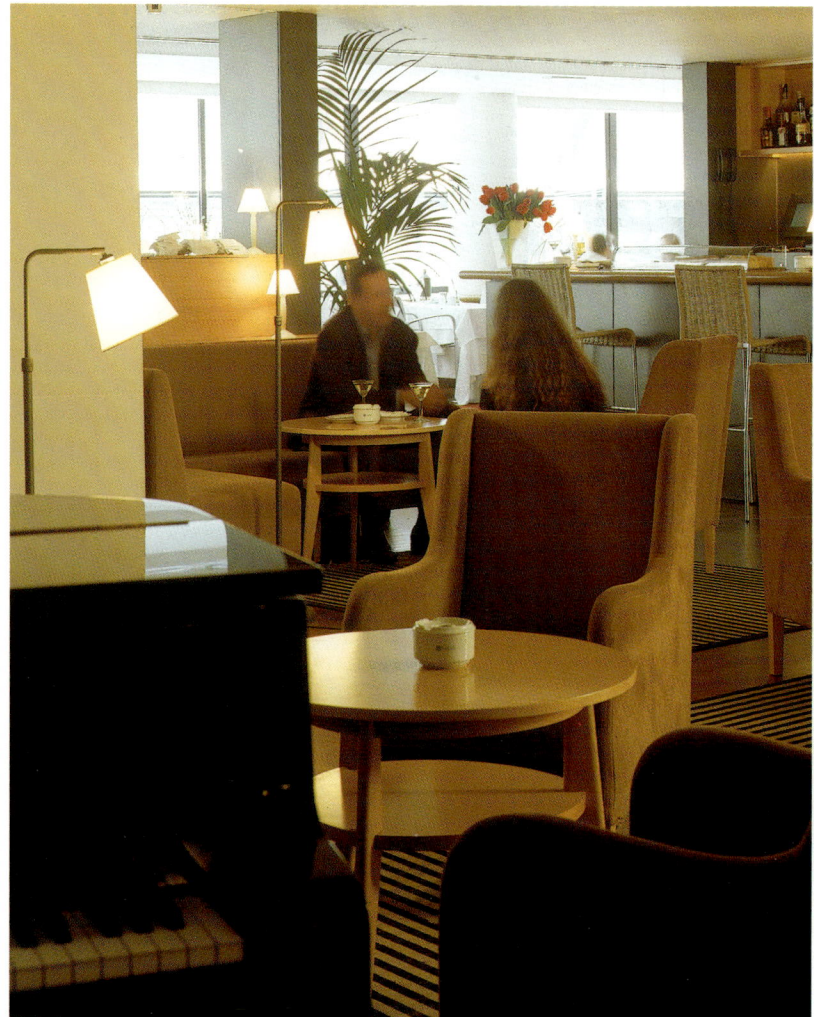

The proportions of the room and the density of the pieces of furniture create an inviting and intimate environment in the restaurant and bar, located on the second floor of the building. The grayish color of the walls and dark tones of the natural wood contrast with the natural light that illuminates the space.

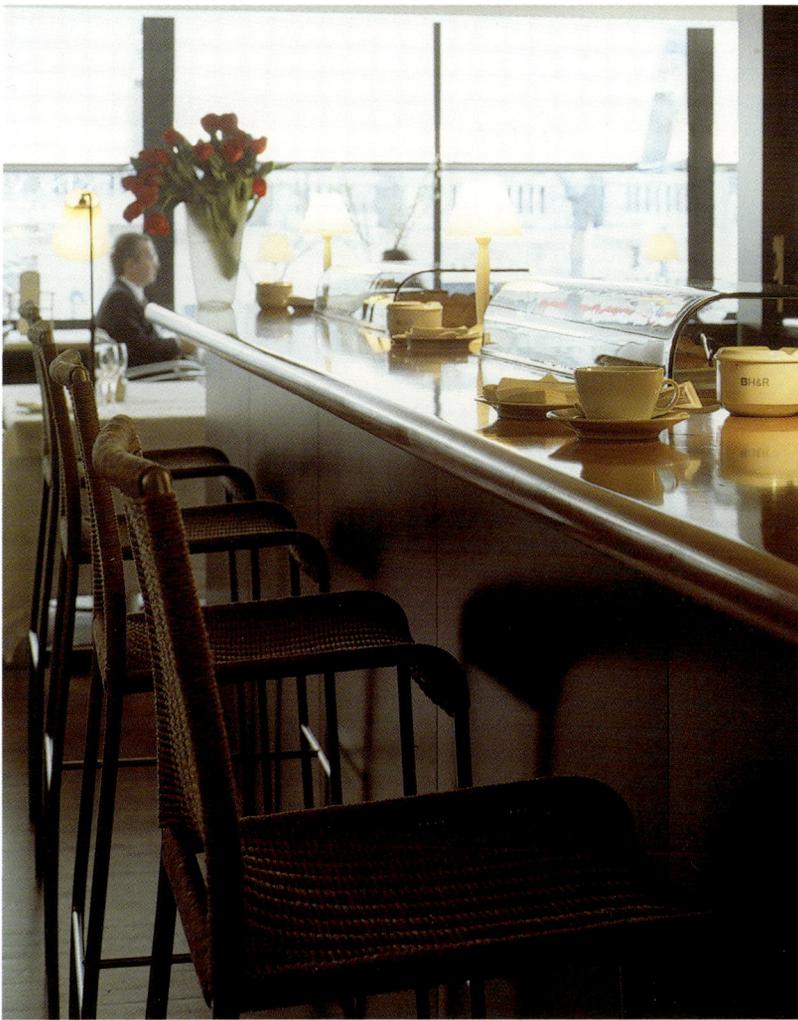

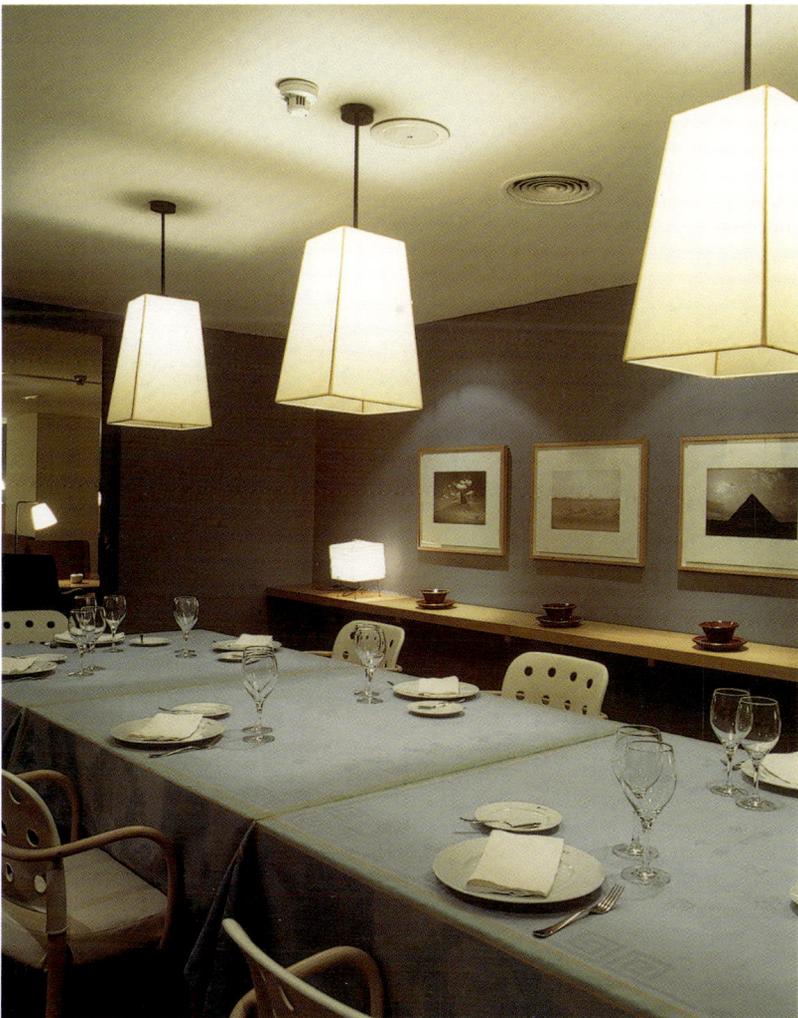
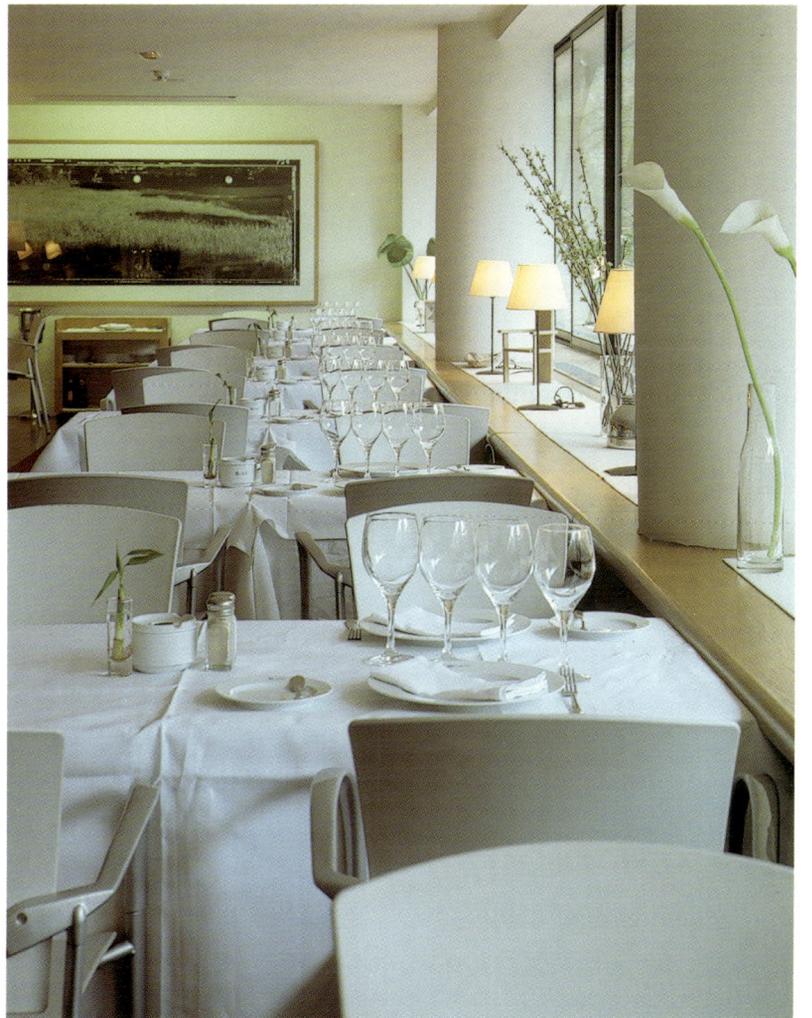

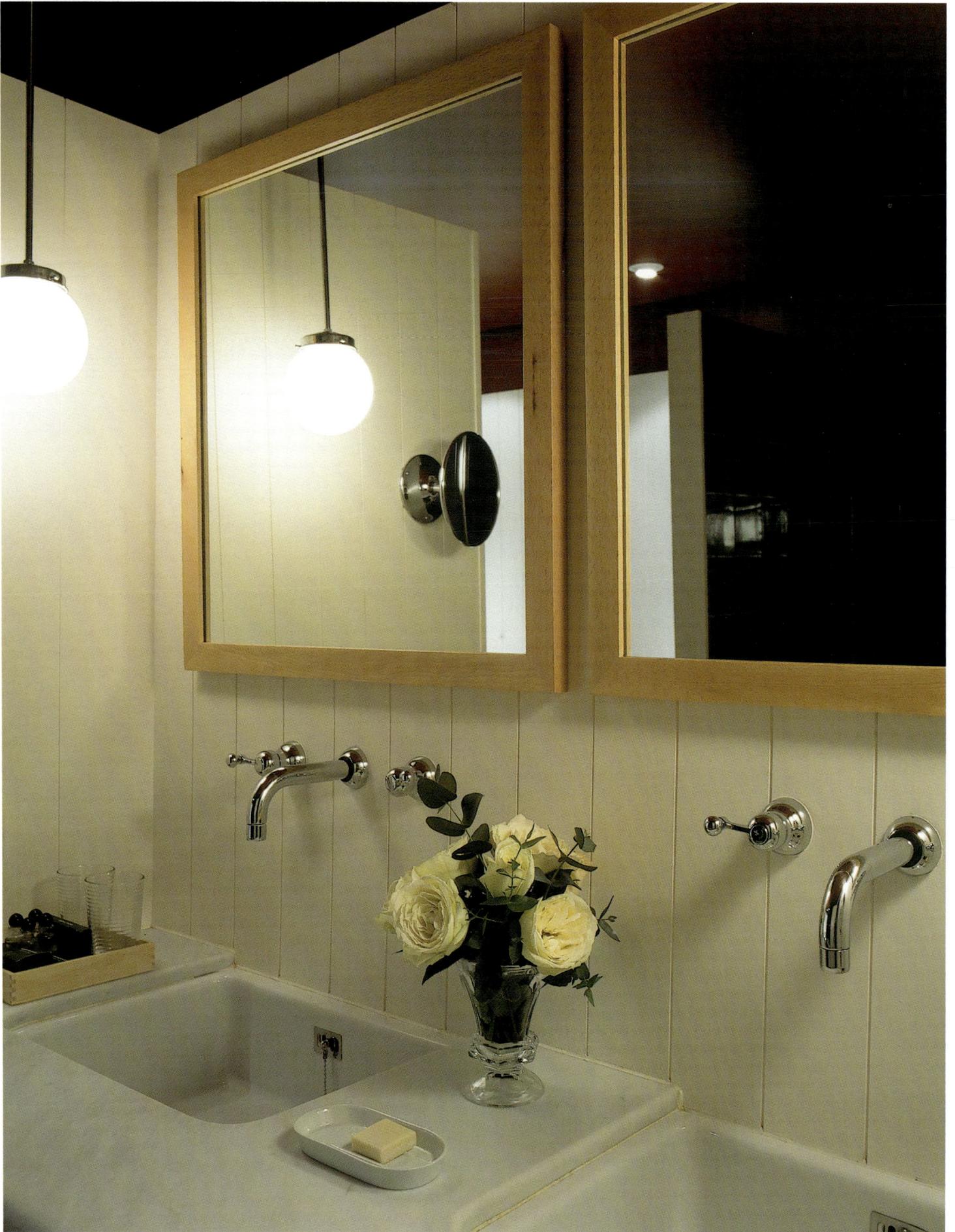

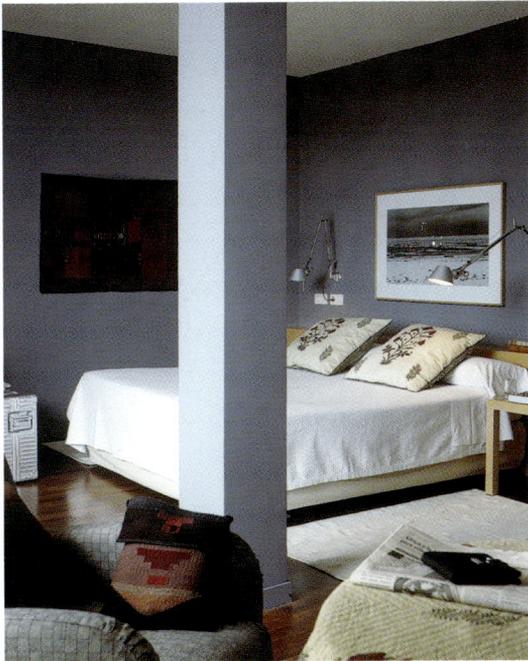

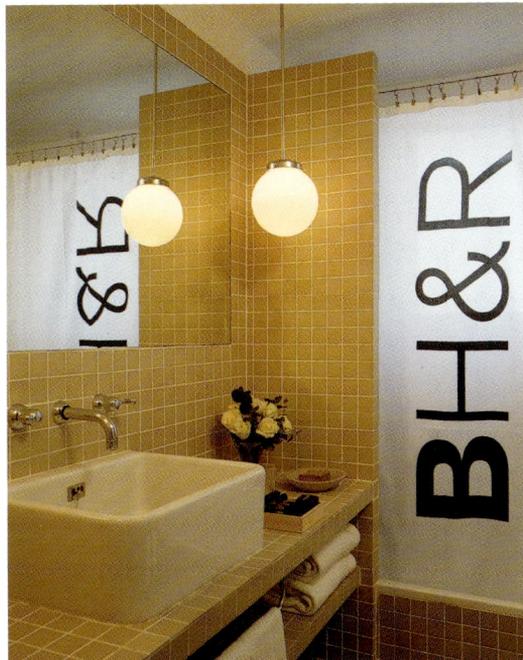

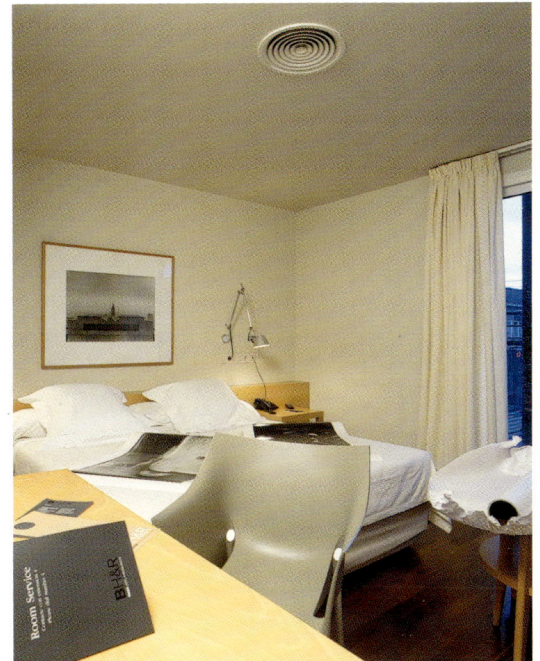

In the guest rooms a personal and domestic style has been achieved by using a palette of varied, bright tones. In the bathrooms the designers turned to wall coverings rich in color and texture that go well with the contemporary design of the faucets and fixtures.

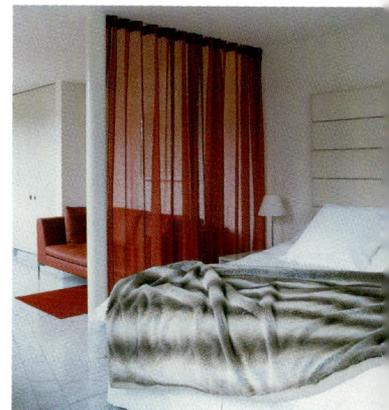

West Street

13-15 West Street, London WC2H 9NE, United Kingdom Tel: +44 20 7010 8600 Fax: +44 20 7010 8601 weststreet@egami.co.uk www.weststreet.org

The street this hotel is named after is typical of central London, with a mix of theaters, offices, homes, and exclusive stores. The hotel's design brings a real feeling of drama and modernity to this peaceful corner of Covent Garden, where it occupies two row houses from the early twentieth century. The subtle but forceful renovation encompasses the various areas of the hotel and achieves the dramatic effects that were sought after. A large window, which runs the entire height of the first floor, makes the place seem like just another store in the area while the rest of the construction is austere and more conservative. Theatricality is the recurring theme of the project. The extreme height of the front of the hotel makes it seem like a theater; in fact, from the first and second floors guests can see the orchestra pit where the bar is located.

The interior continues along the same line, and dramatic effects are achieved not just through the spatial configuration but with details, finishes, and decorative objects as well. Guests enter the hotel after passing through the huge exterior window via a bridge that extends over the bar. In this space with extremely high ceilings there is a large, almost twenty-foot-tall, kinetic sculpture made out of painted steel by Alex MacGregor and Richard Clark. The shadows it casts on the wall change as the sculpture moves.

Architect: **Wells Mackereth Architects** Photographer: **Henry Bourne** Location: **London, United Kingdom** Opening date: **2001**

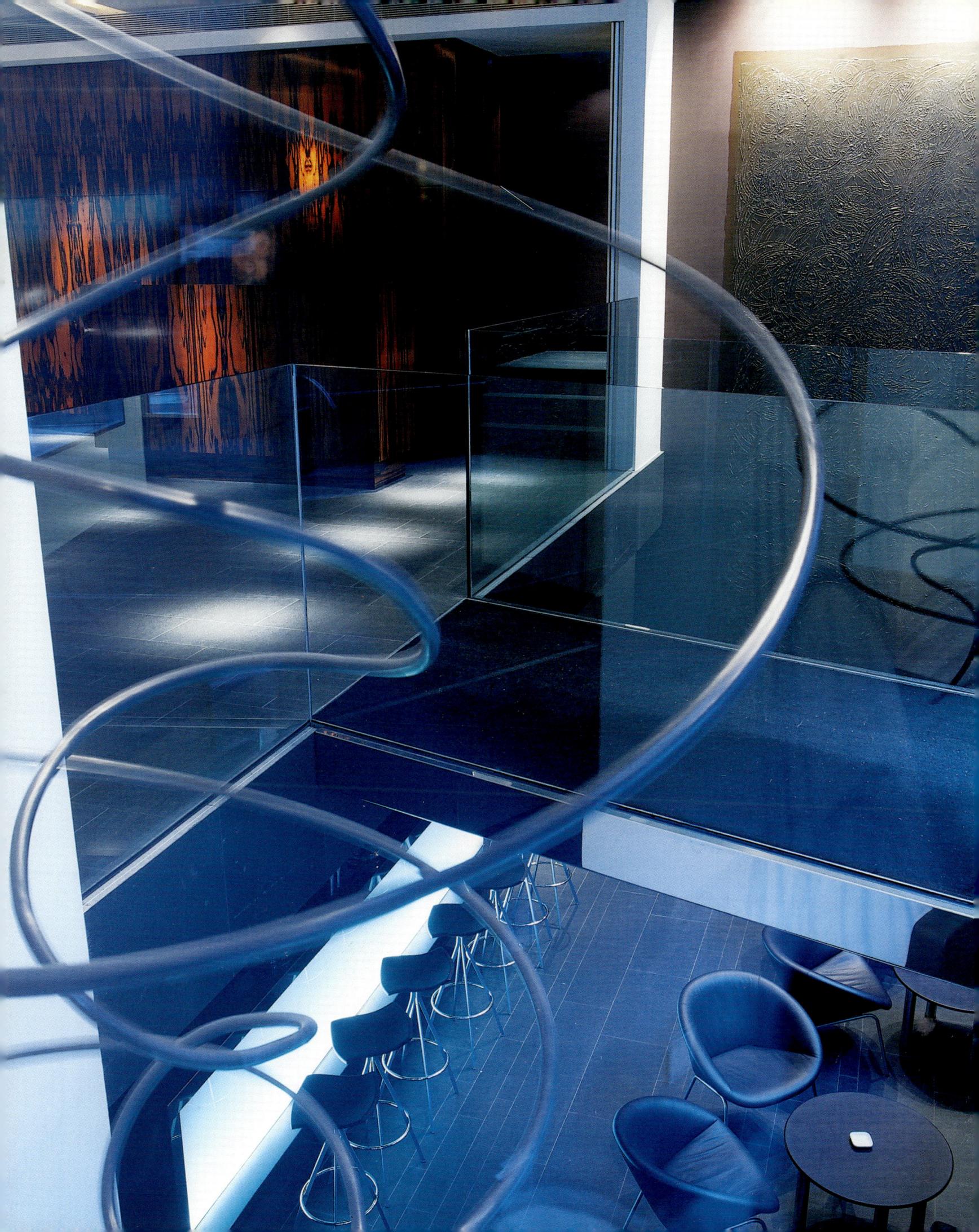

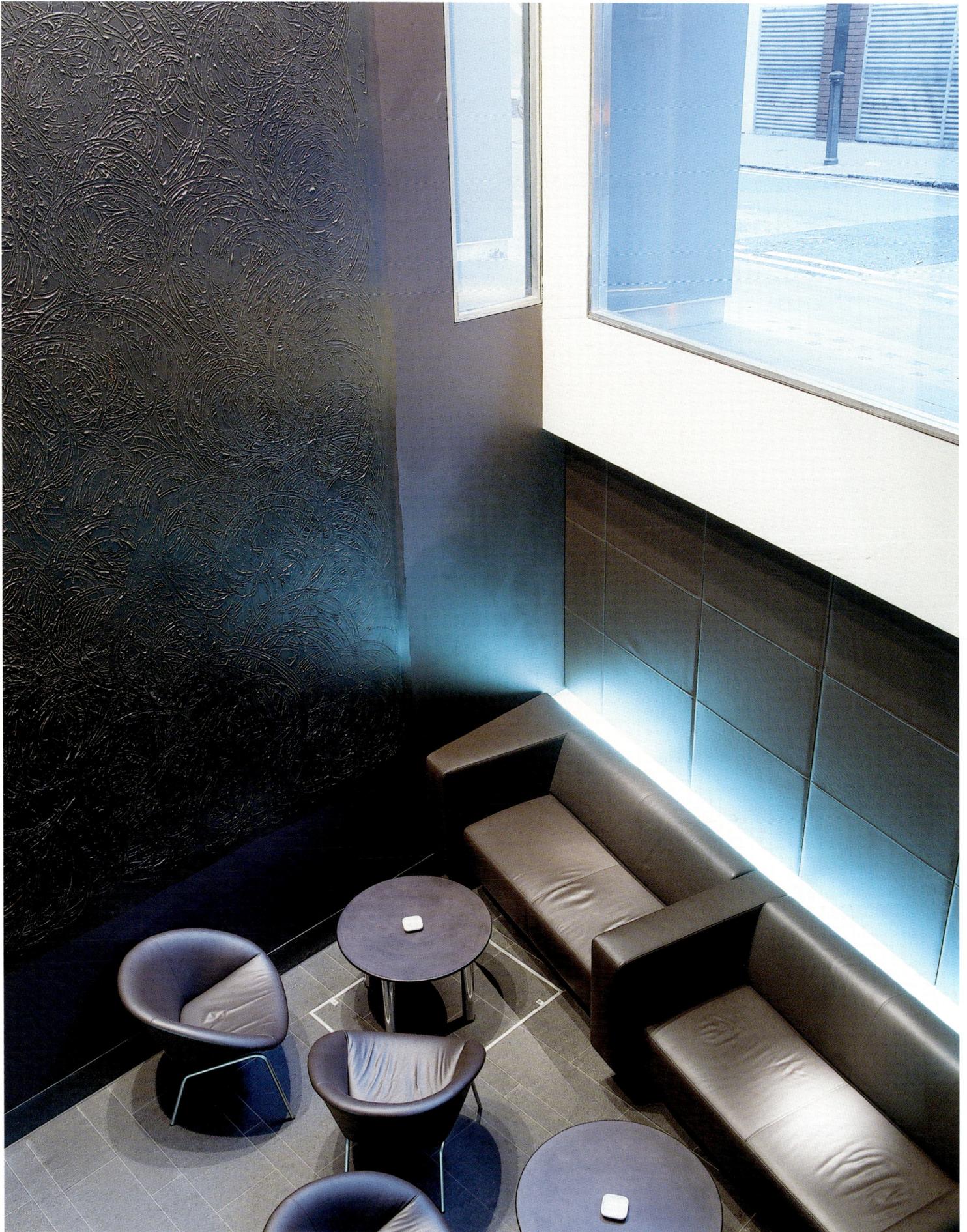

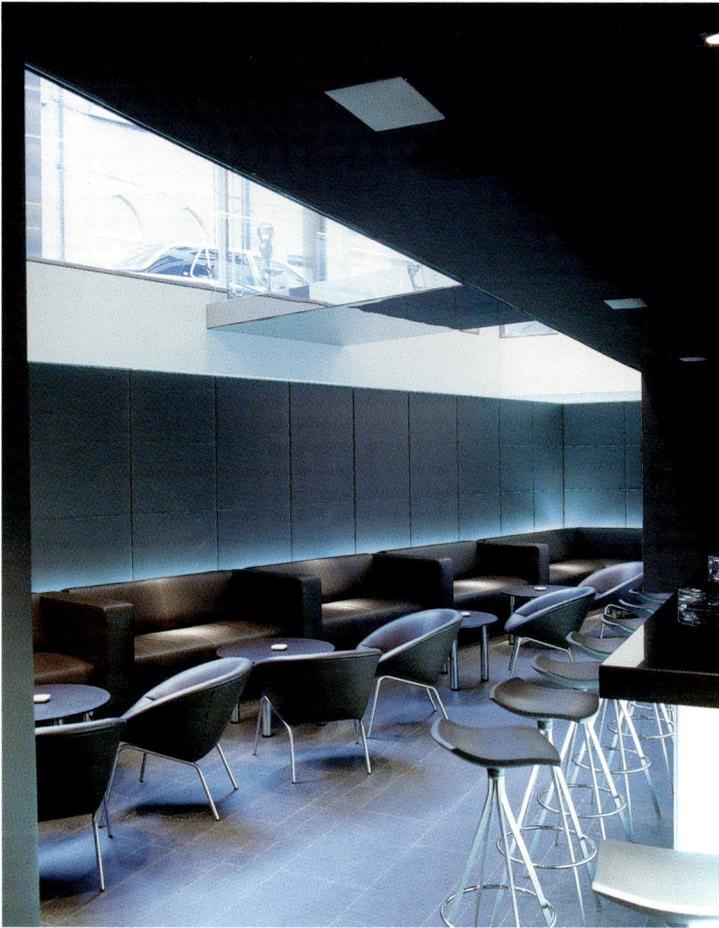
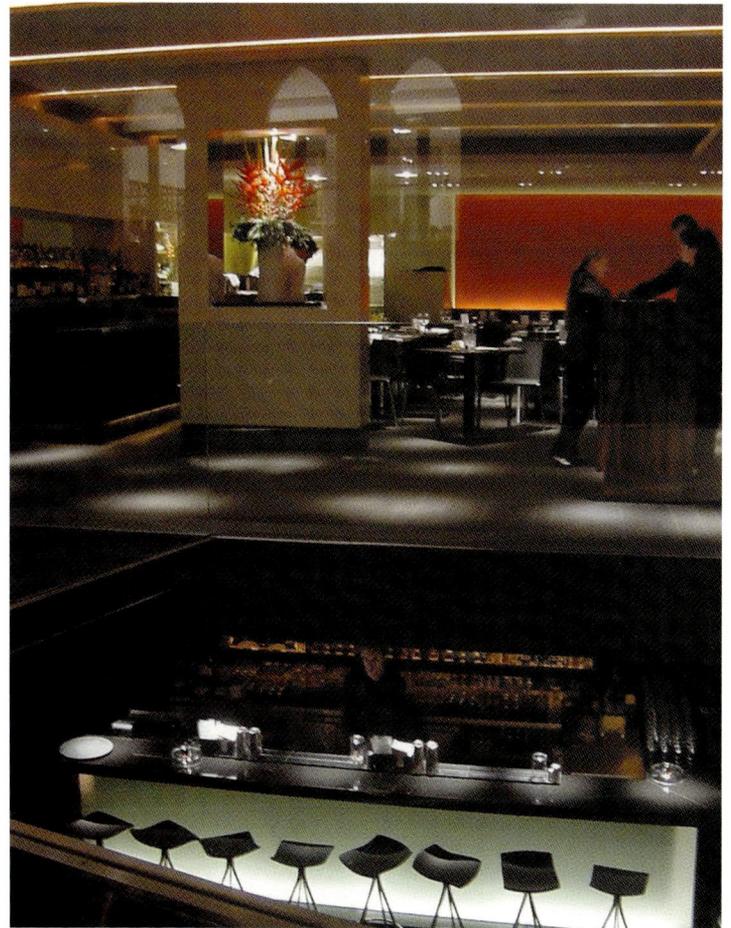

The bridge that balances the three stories of the entrance area is framed by a glass banister that accentuates its lightness and allows for better visibility.

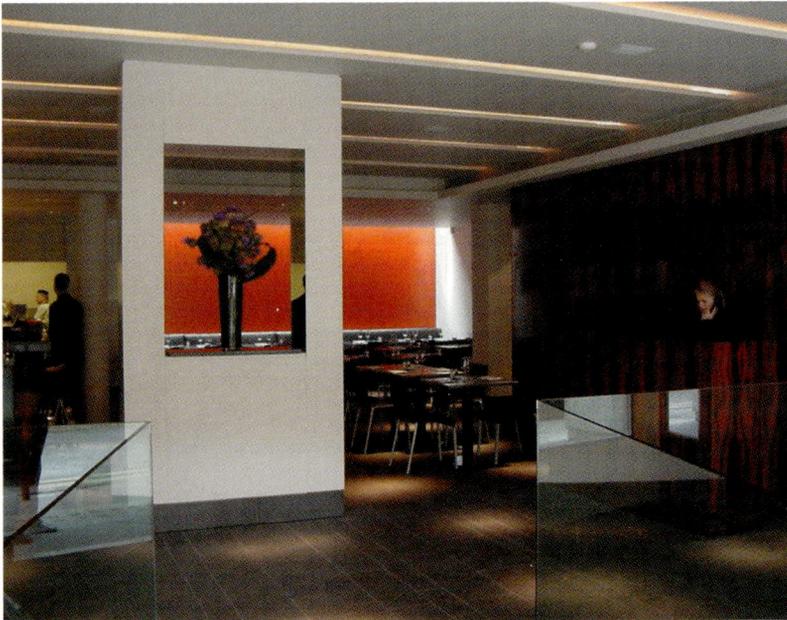

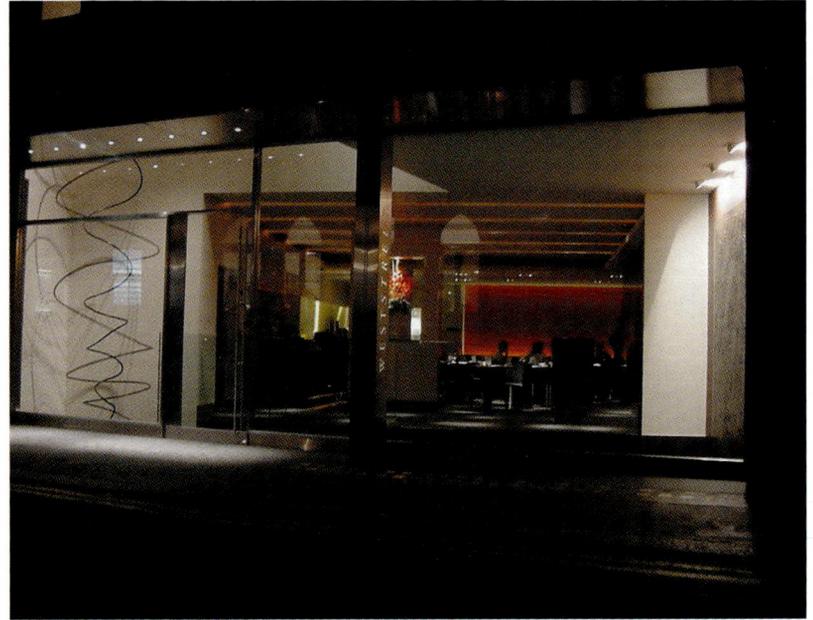

The restaurant, on the second floor of the hotel, is an intimate space where guests can enjoy a view of the lobby, entrance, and bar. Here, the windows are smaller and the decoration is similar to that of a traditional wine cellar.

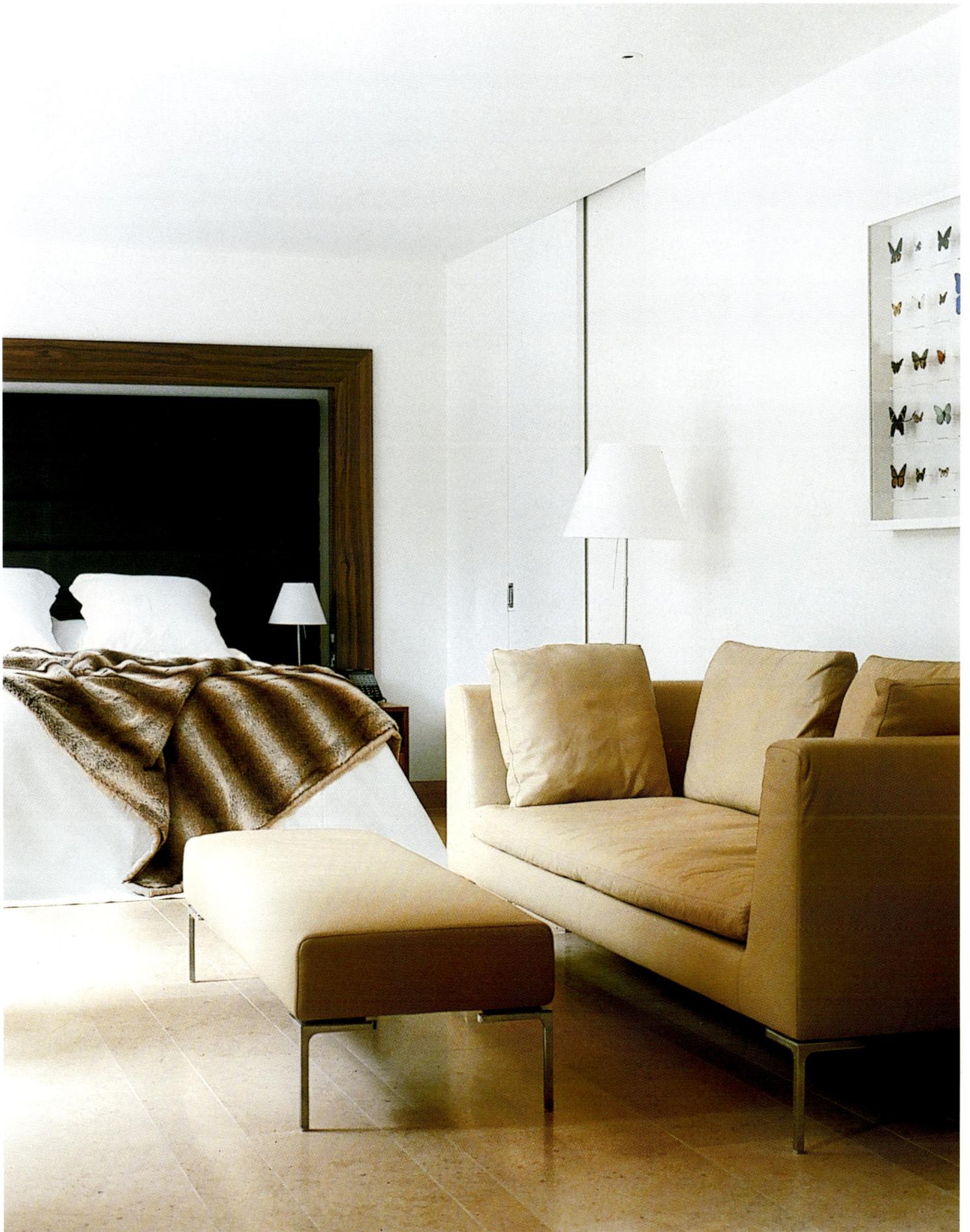

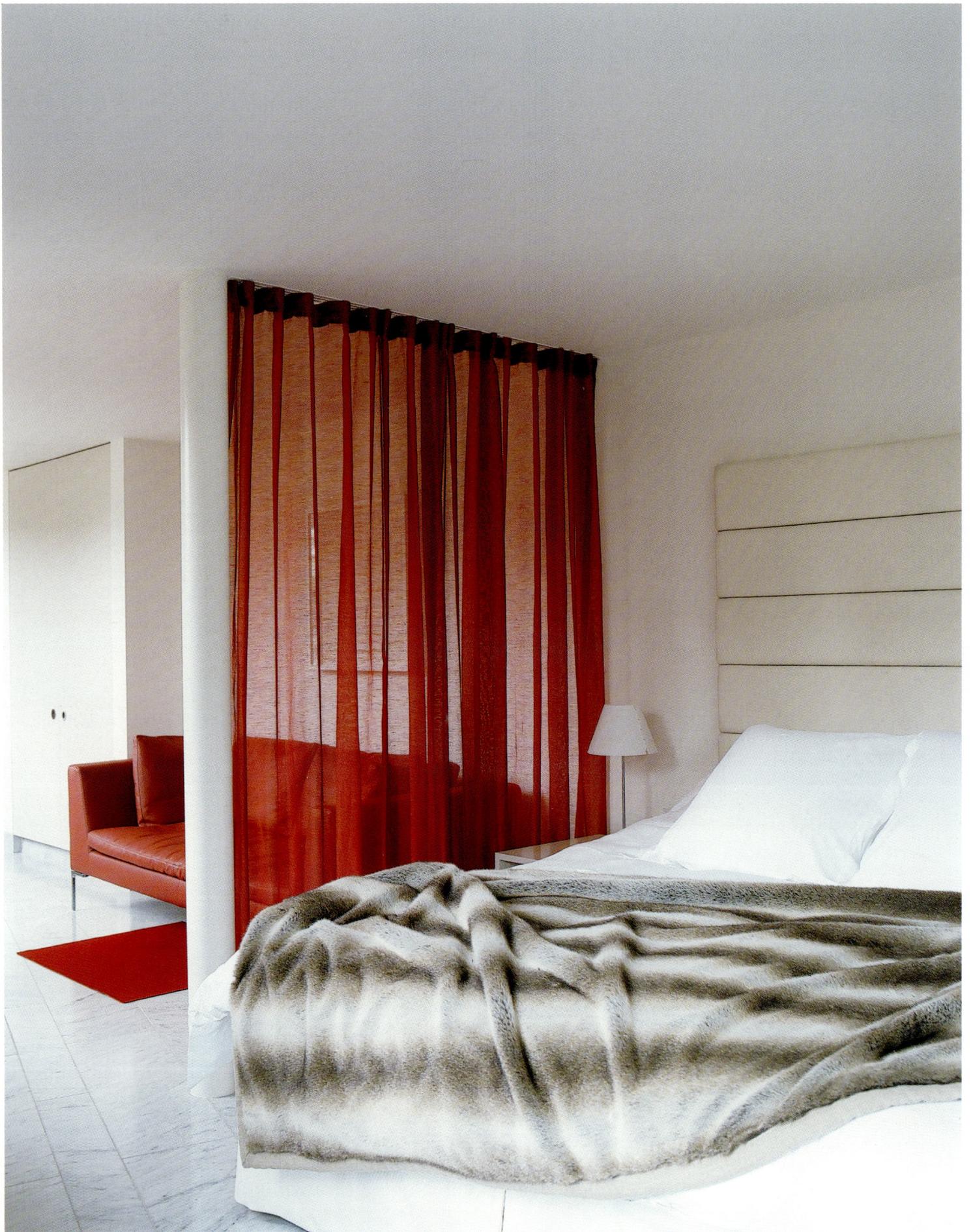

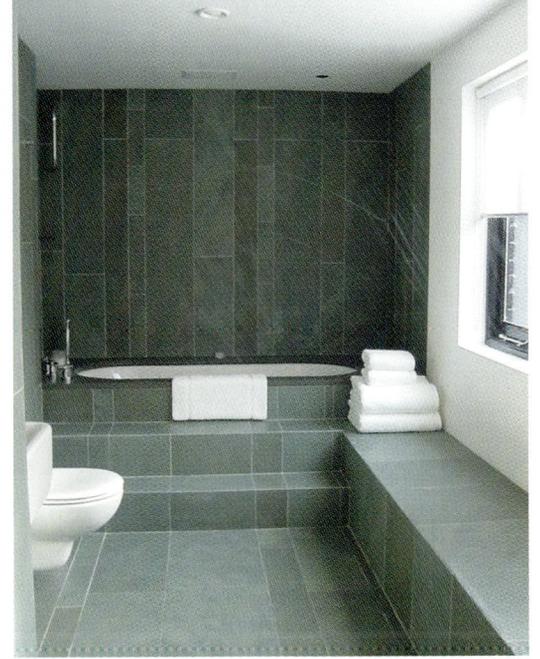

The apartment in the front of the building is designed and decorated with very sophisticated materials and furnishings. The floor, made of marble from Carrara, contrasts with the brightly colored pieces of designer furniture. In the standard rooms, dark limestone prevails.

St. Paul
Hotel

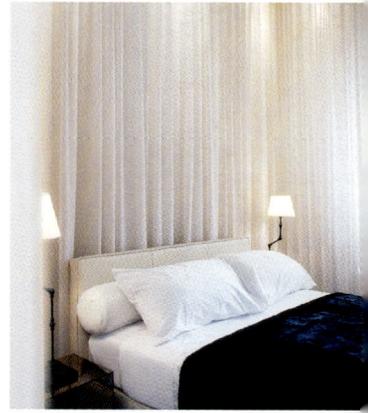

355 Rue McGill, Montreal, QC H2Y 2E8, Canada Tel: +1 514 380 2222 Fax: +1 514 380 2200 www.hotelstpaul.com

The heavy, solid external image of this building, a 1908 example of the Beaux Arts style of the city, contrasts dramatically with the interior where clean forms, airiness, and light stand out. The project is rooted in contrasts, which are found repeatedly from the public areas to the interiors of the guest rooms. The interior designer works from the premise that is the foundation of every hotel: it's a place where a lot of visitors, from different countries, come and go in short time spans. So a rather mute, neutral atmosphere is presented but each room has its own identifiable character.

Essential elements like earth, water, fire, and ice were sources of inspiration and are used as recurring motifs throughout the project, creating very dramatic effects, especially in the public areas. The restraint of the vestibule results in a very theatrical ambience where two large pieces stand out. On one side there is a large fireplace in Spanish alabaster that is over twelve-feet-tall, while across the room a dark mass of solid bronze shapes the bar and serves as an anteroom to the restaurant. Within this space, in a relaxed atmosphere, light colors—white and pink—and mirrors that reflect the dining room prevail. The furnishings, created by the same designer especially for this hotel, combine with some classic pieces of modern design, such as an Eames table, Mies van der Rohe chairs, and two authentic Thonets.

Interior Designer: **Ana Borrallo** Photographer: **Jean Blais** Location: **Montreal, Canada** Opening date: **2001**

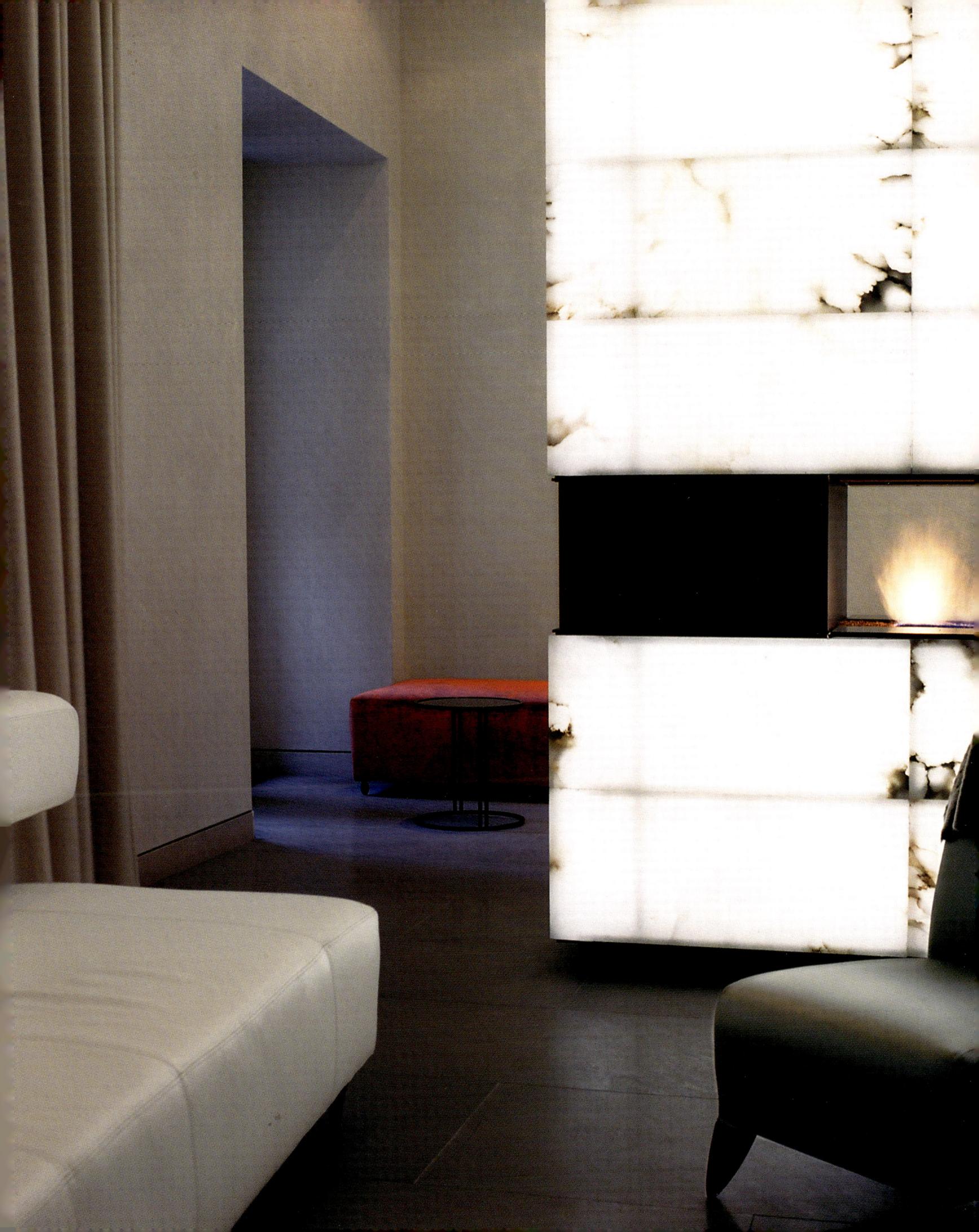

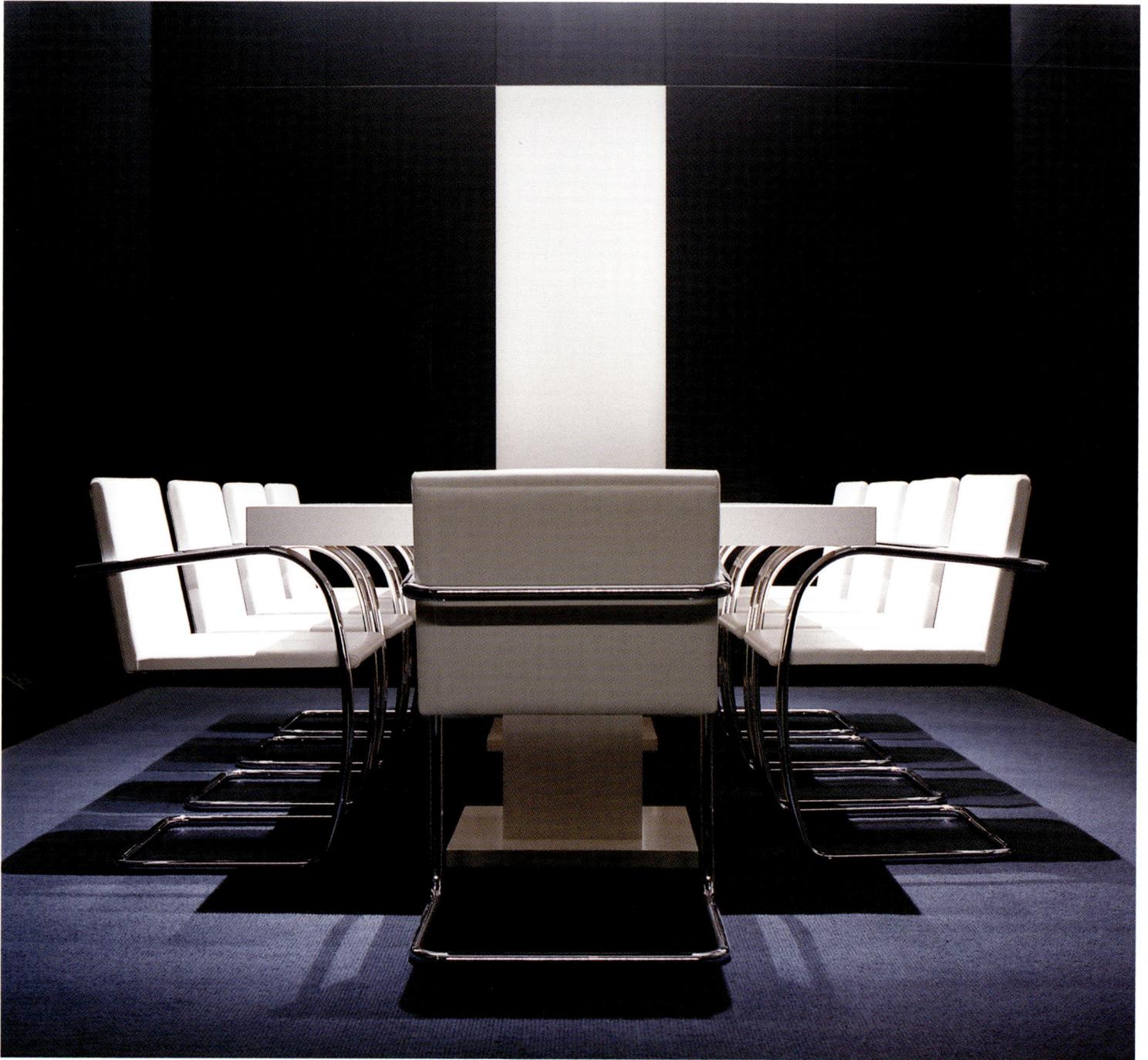

Contrast is a recurring theme in this hotel. It is reflected in the difference in style between the classic exterior and the contemporary interior as well as in the design of each space, where light and dark create dramatic effects.

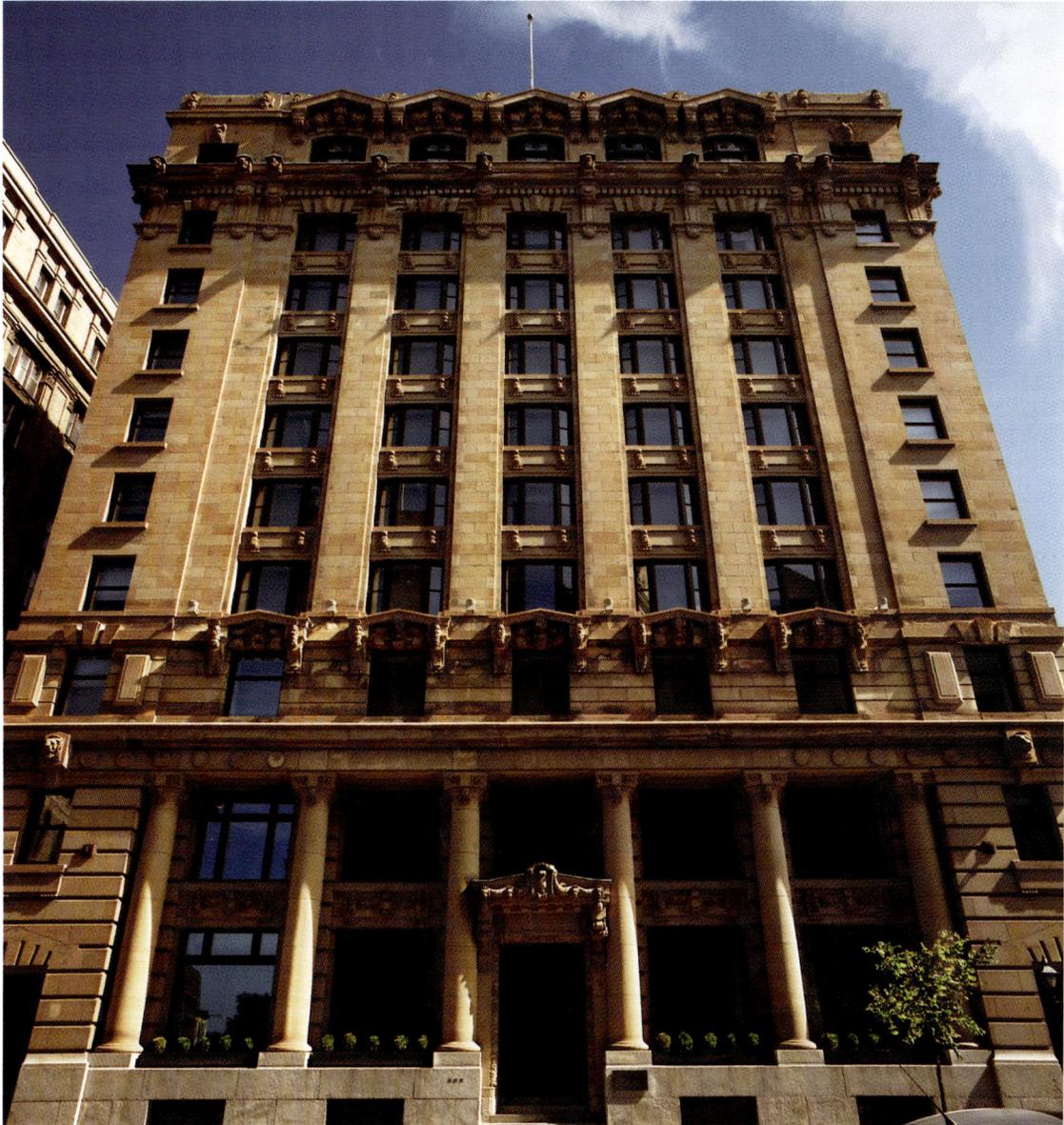

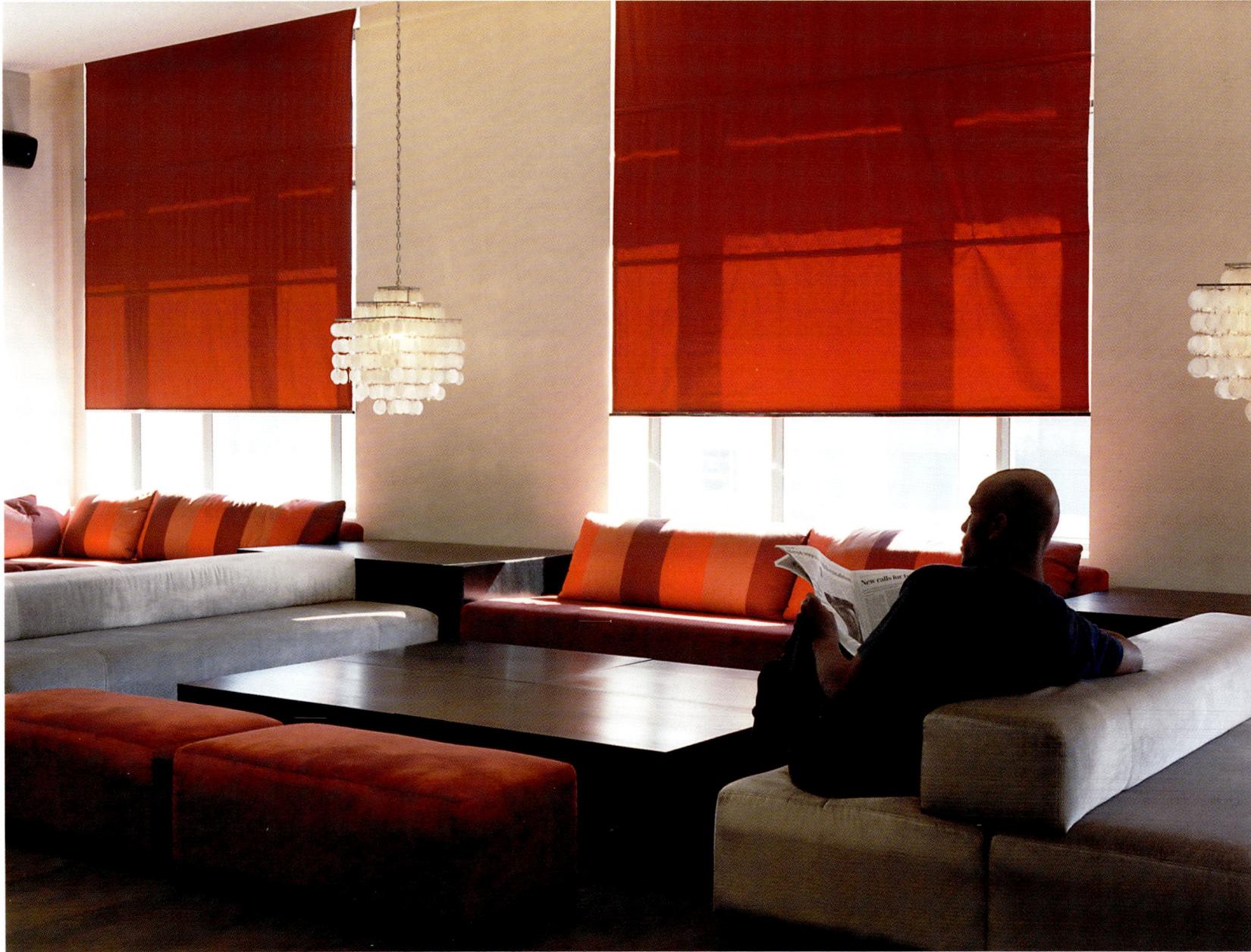

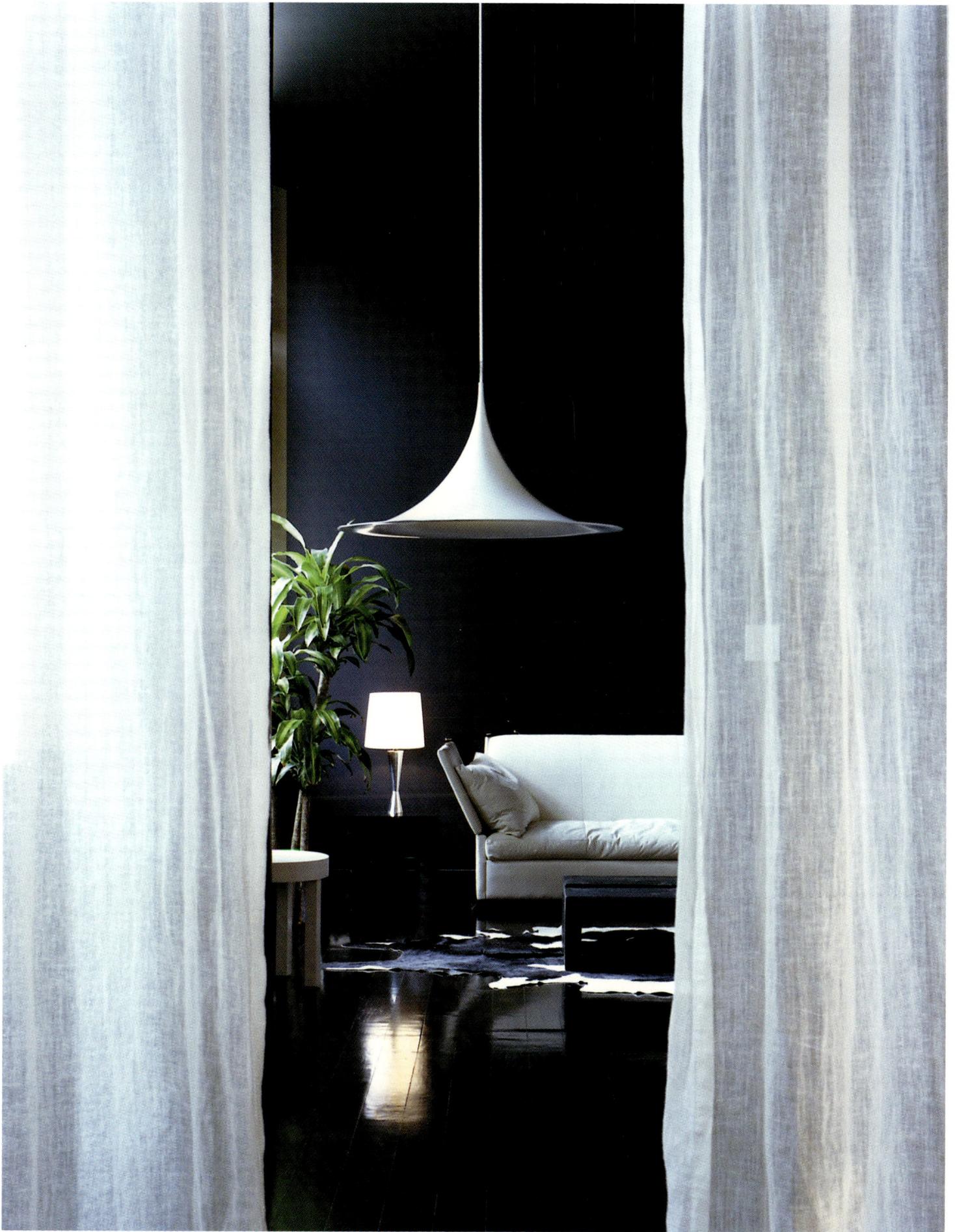

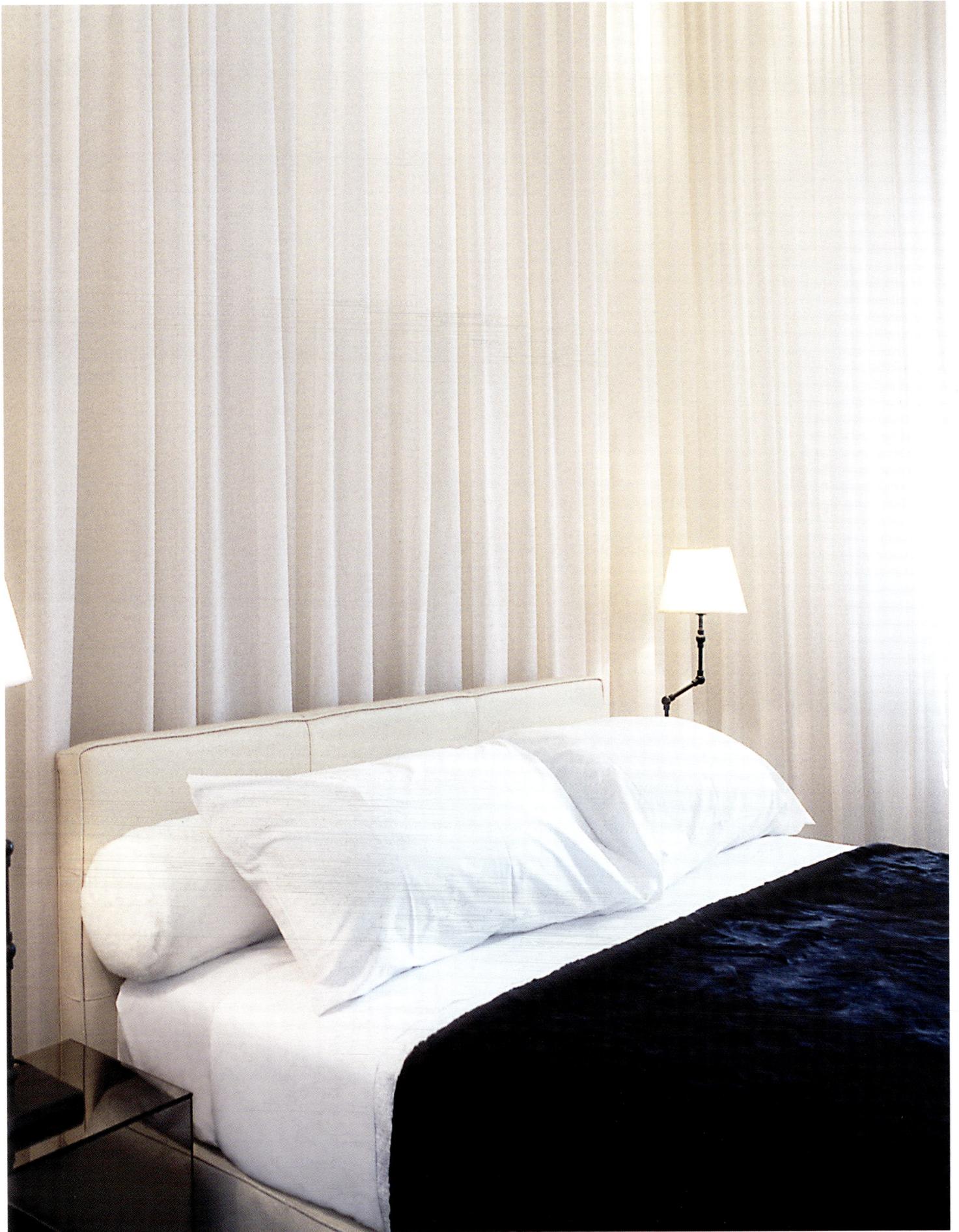

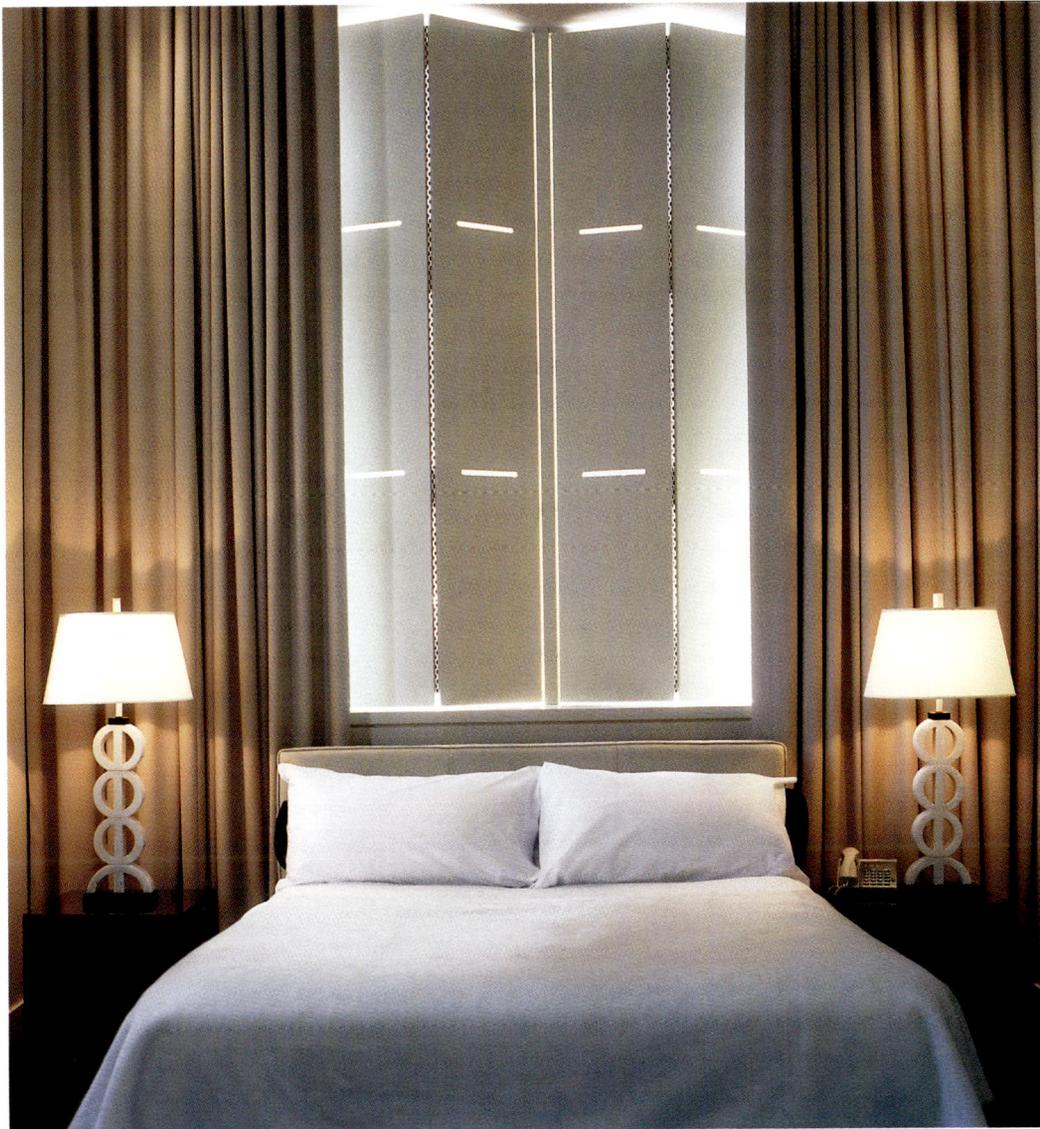

The textures, colors, and lighting become soft with subtle transparencies, due to the full-length curtains that surround the space, and in some cases the bed.

The Muse

130 West 46th Street, New York, NY 10036, USA Tel: +1 212 485 2400 Fax: +1 212 485 2900 sales@theMUSEhotel.com www.themusehotel.com

The location of this hotel, in the heart of Times Square, New York's theater district, is an open invitation to create a fantastic interior space. The objective was to immerse the visitor in a glamorous journey through the history of New York show business in the twentieth century. In order to achieve this, the designers drew upon the interior design styles of the Broadway theaters. On the exterior, a metal and glass pergola frames the entrance and is distinguishable from a distance due to the band of neon lights surrounding it—just like the entrance to other theaters in the area.

In the interior of the hotel, elements such as large curtains, dark furnishings, and special lighting were used to create the dramatic effect that was sought after. The whole is complemented by a collection of photographs of famous stars and shows throughout history. The reception area and the main lobby are treated like the foyer of a theater, with intimate areas and special furnishings. All of this is a preamble to the restaurant, which is filled with a great spatial and decorative richness designed from two perspectives so that the visitor feels like a star or a spectator depending on his position in the room.

Designer: **David Rockwell** Photographer: **Pep Escoda** Location: **New York City, USA** Opening date: **2000**

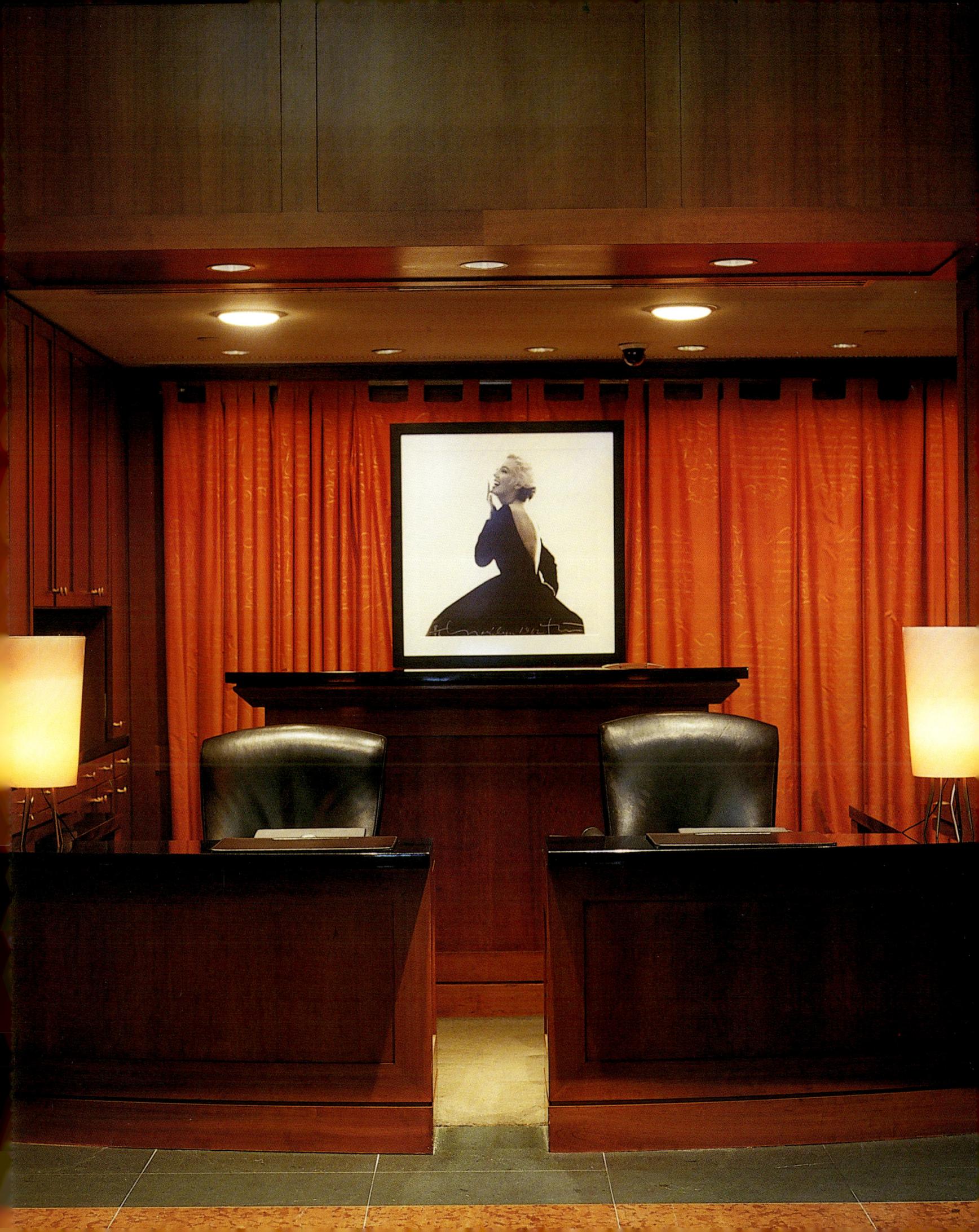

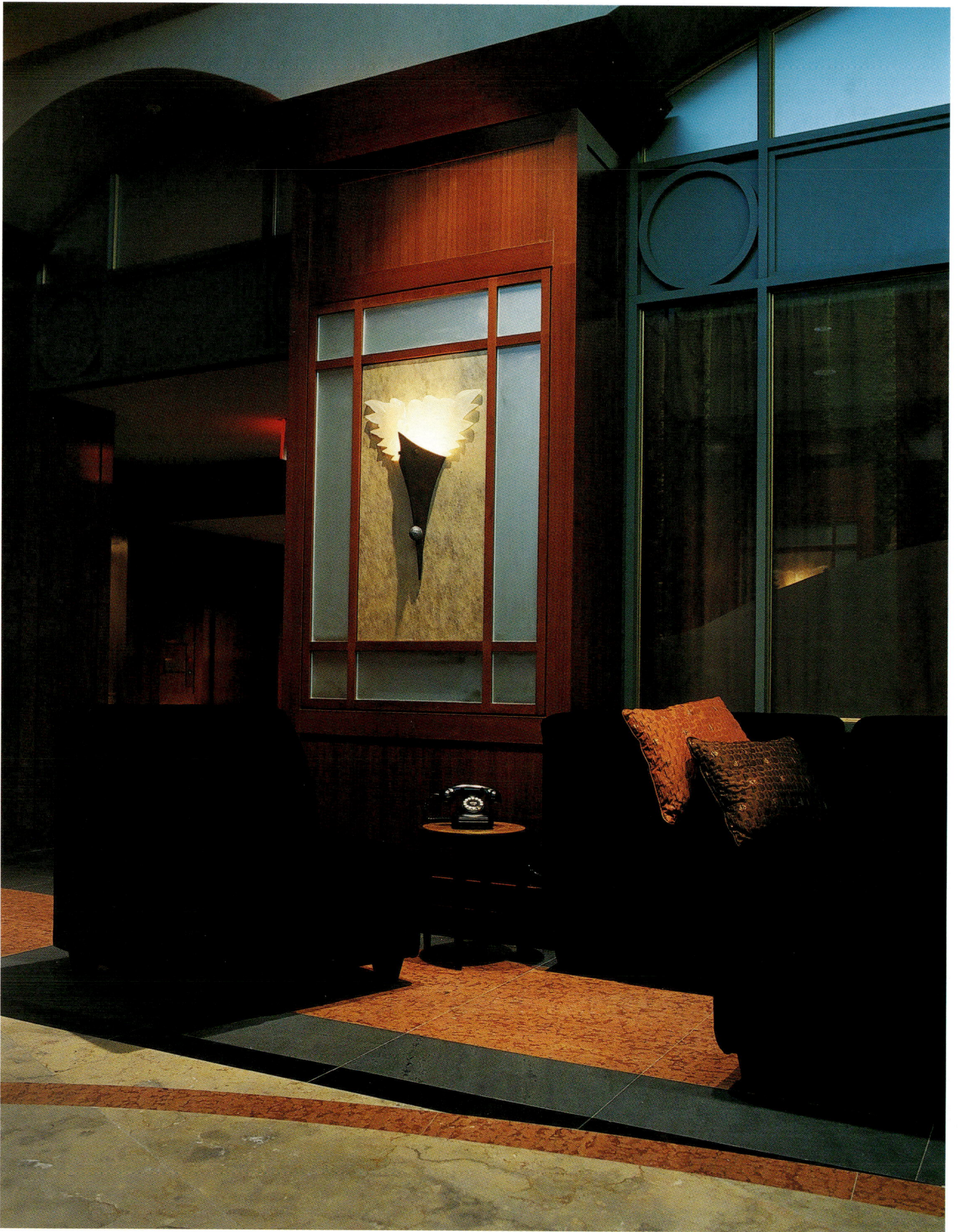

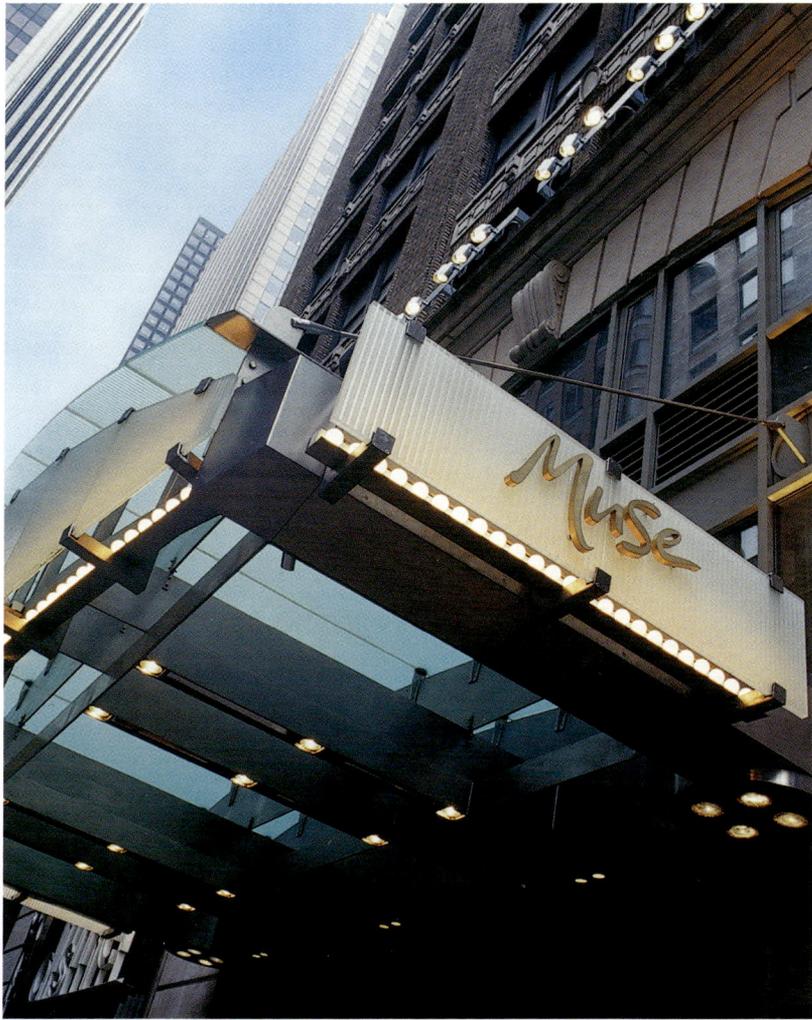
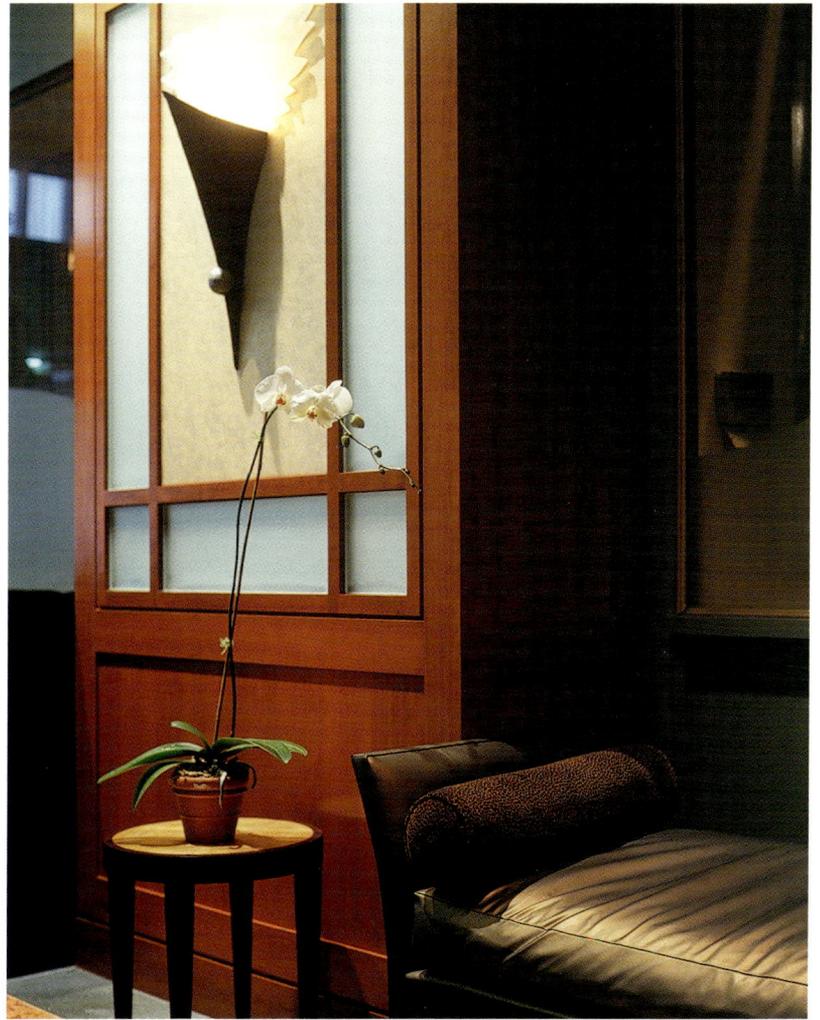

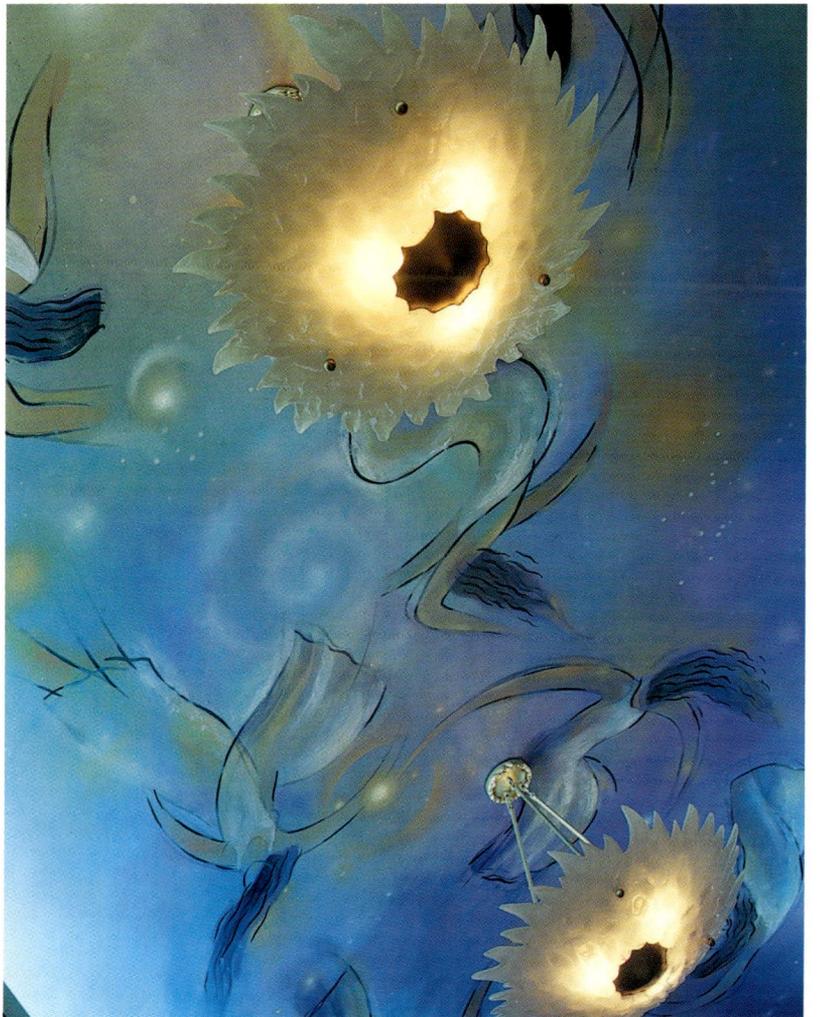

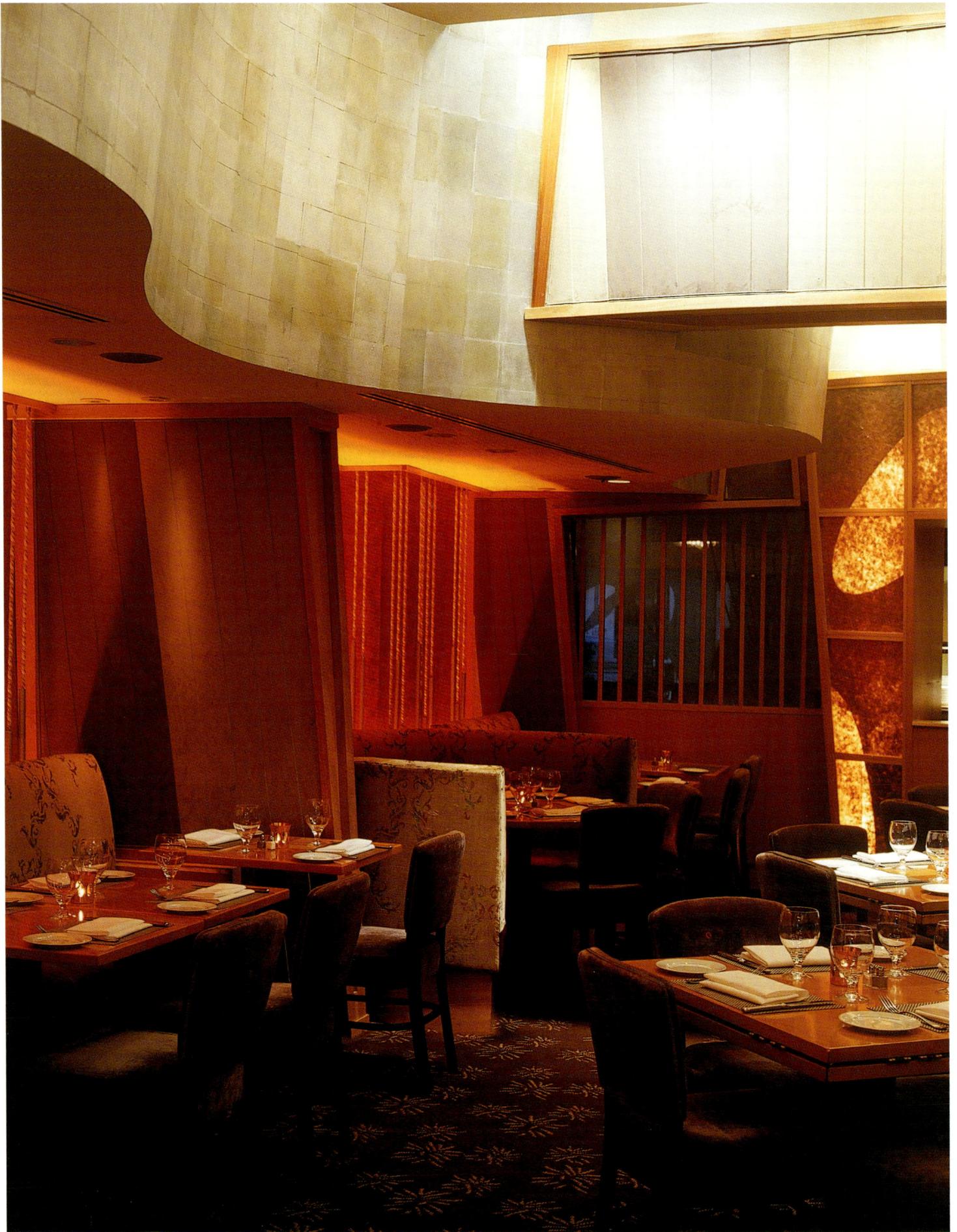

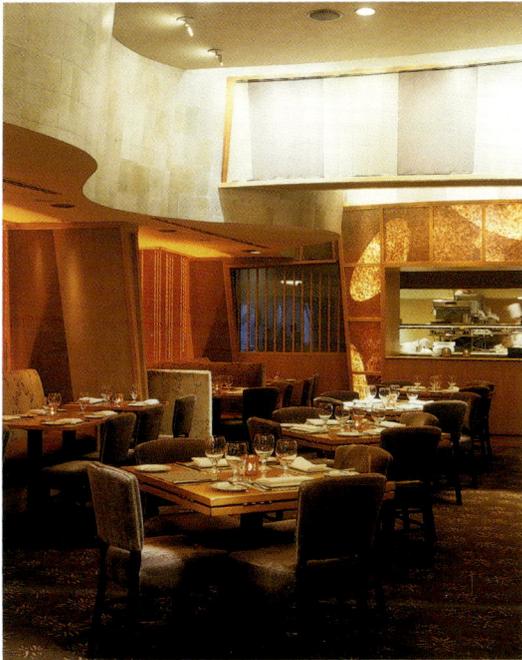

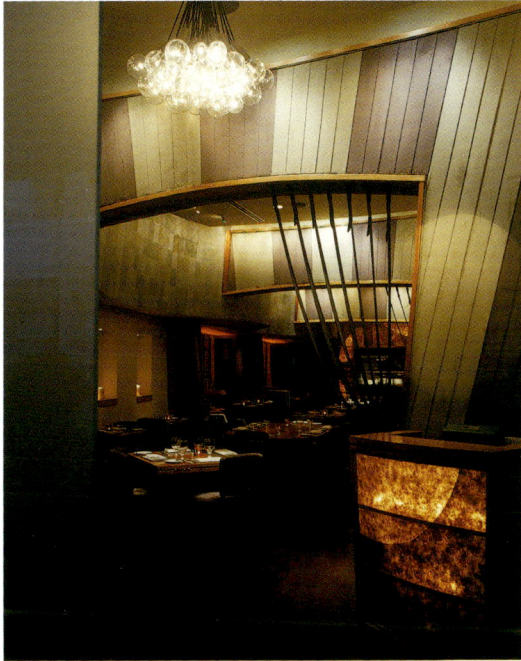

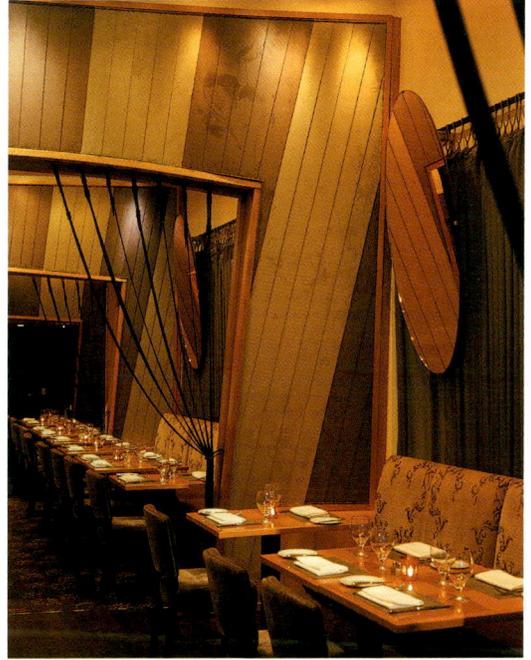

The rectangular shape of the restaurant space has been altered by a series of proscenium arches, much like a stage, which enrich the 85-seat dining room by offering various scenes up until the last arch, at the back of the space, which frames the kitchen.

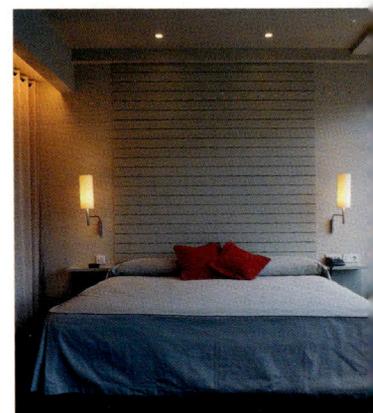

Miróhotel

Alameda de Mazarredo 77, 48009 Bilbao, Spain Tel: +34 946 61 1880 Fax: +34 944 91 4320 www.mirohotelbilbao.com

In the heart of Bilbao, halfway between the Guggenheim Museum and the Museum of Fine Arts, a six-story building houses one of the first designer hotels in this up-and-coming city. The Miróhotel has its own character due to the work of a team—an architect, an interior decorator, and a designer—who collaborated in order to create a hotel, which, despite its small size, could offer all the advantages of a large hotel. Designer Antoni Miró steered the project's design in the same spirit of conceptual rigor for which his work in the world of fashion is renowned. The hotel's minimalism is a guiding principle of the project.

Miróhotel is a decidedly cutting-edge and modern space where practicality and discretion stand out in every detail. In order to achieve this, an almost monochromatic palette was chosen, against which certain areas, such as the lobby or certain pieces of furniture, occasionally contrast in brighter colors and eye-catching shapes. The entrance, a space with high ceilings and geometric lines, is a few steps above the lobby and bar. This arrangement makes these spaces more intimate and cozy than the traditional international hotel lobby. The rooms, where the same chromatic contrasts continue, including the blue hue of the rug, are quiet, pleasant, warm spaces.

Architect: **Carmen Abad** Interior designer: **Pilar Líbano** Designer: **Antonio Miró** Photographer: **Pep Escoda** Location: **Bilbao, Spain** Opening date: **2002**

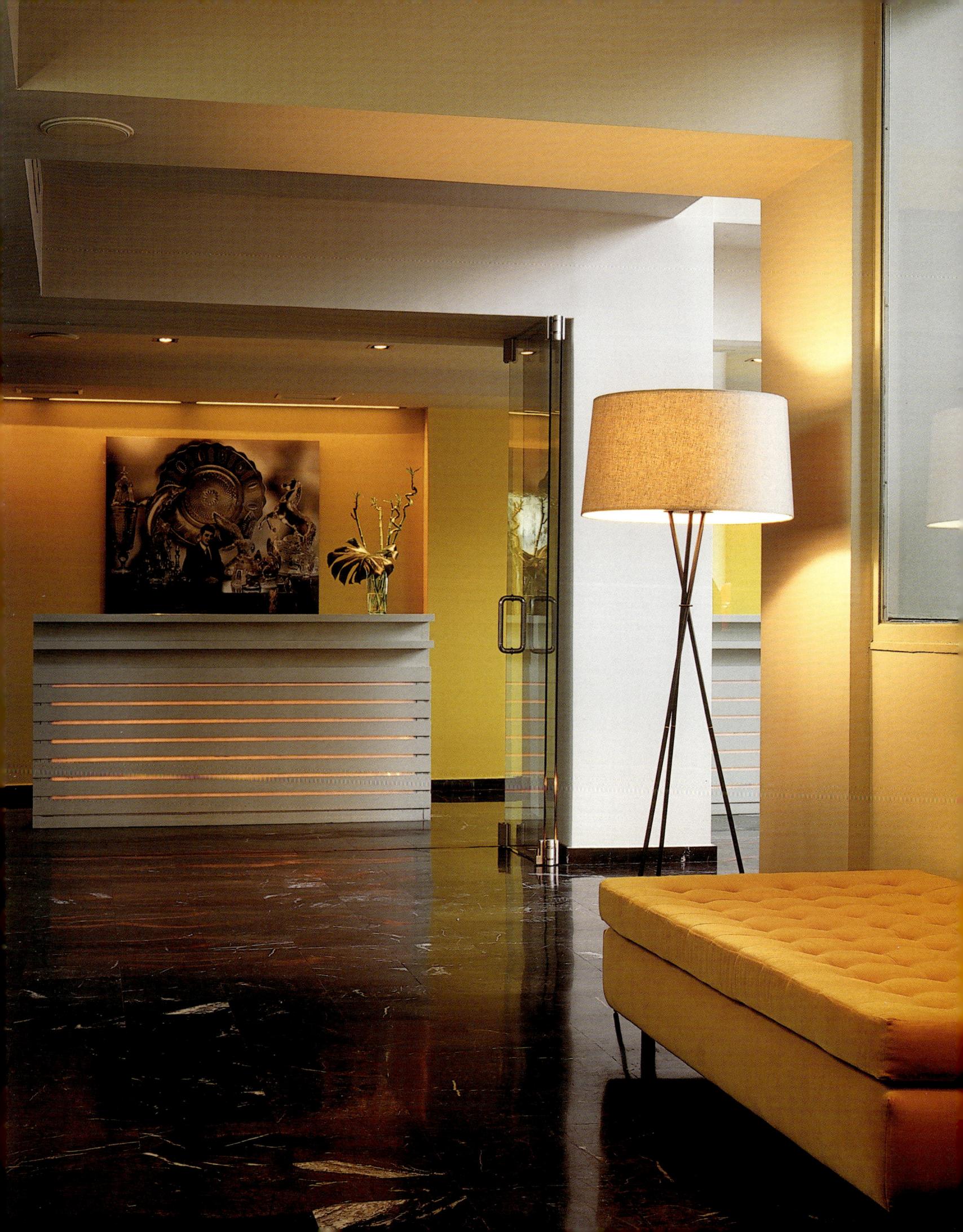

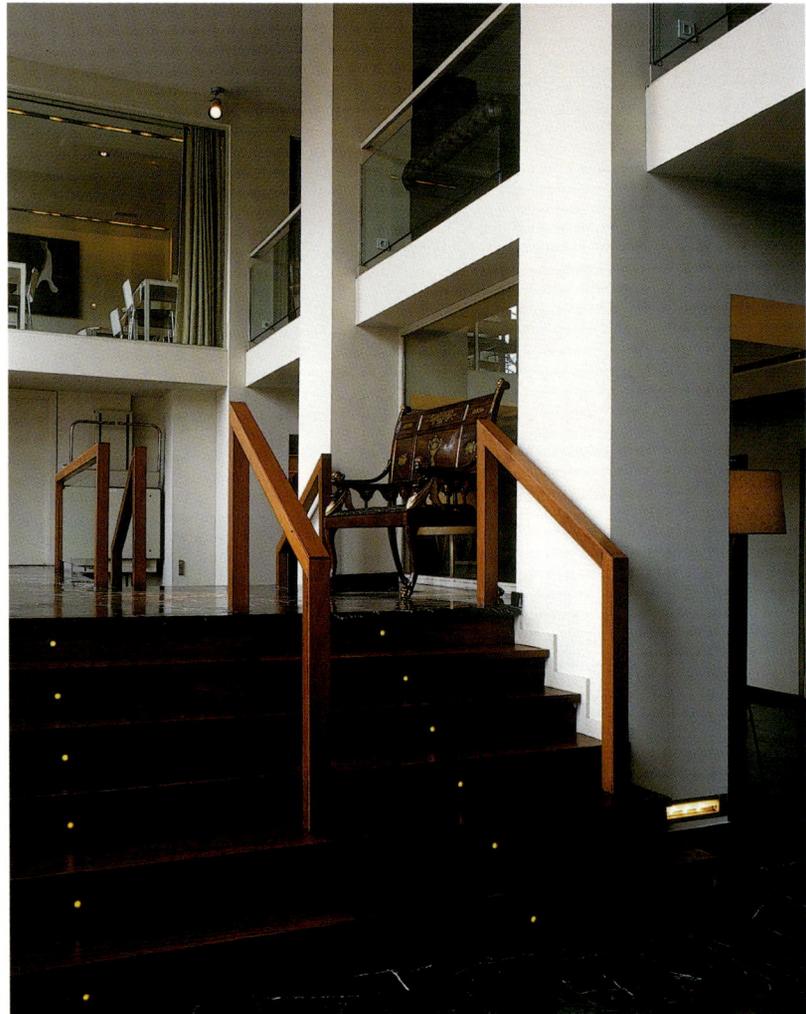

The hotel has a diverse collection of contemporary photography by established artists as well as newcomers, which can be enjoyed while passing through the hallways or other public areas. In this way, the hotel becomes part of the city's vibrant art scene.

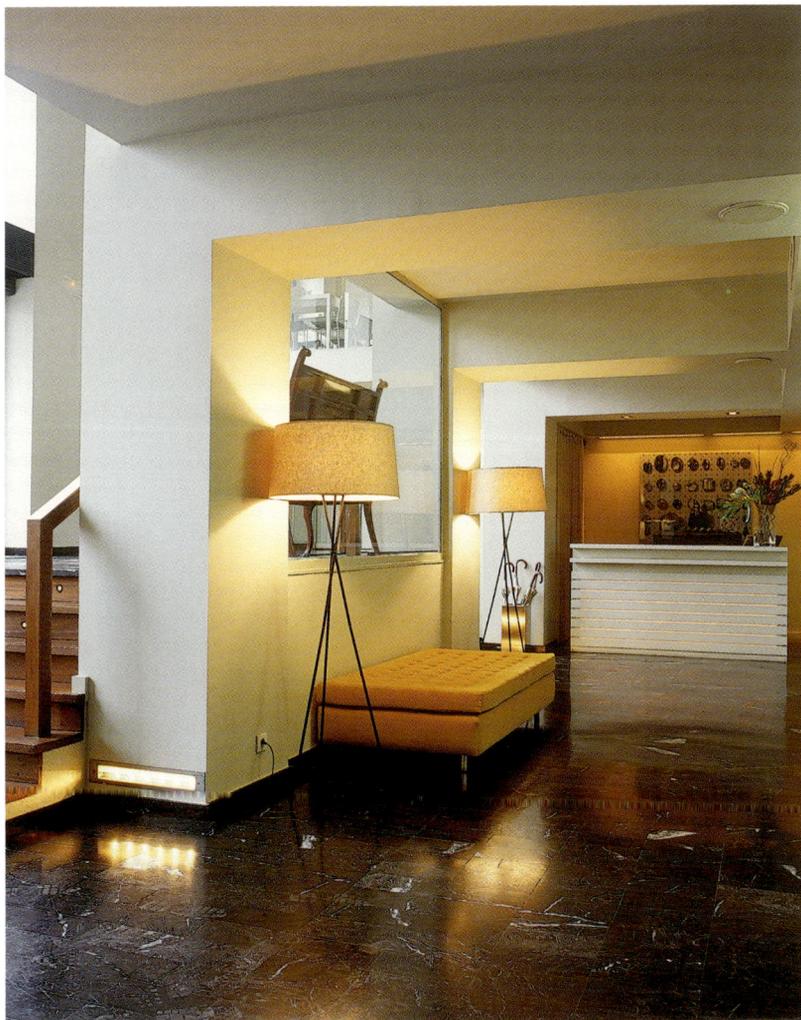
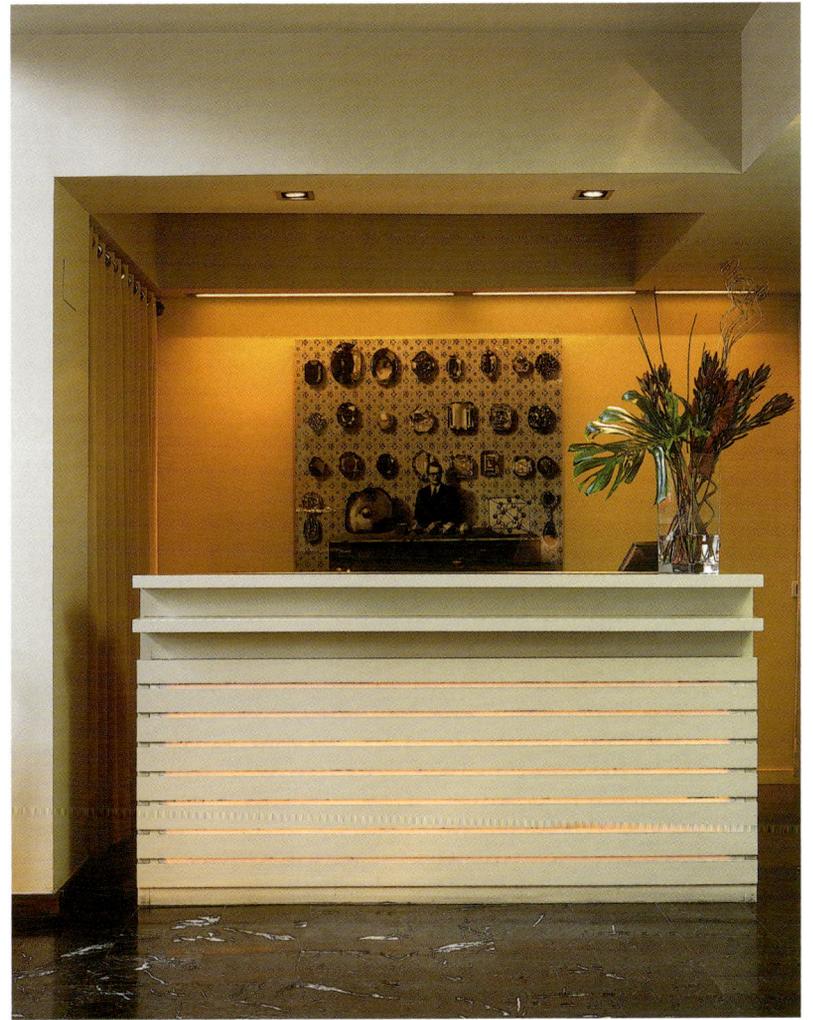

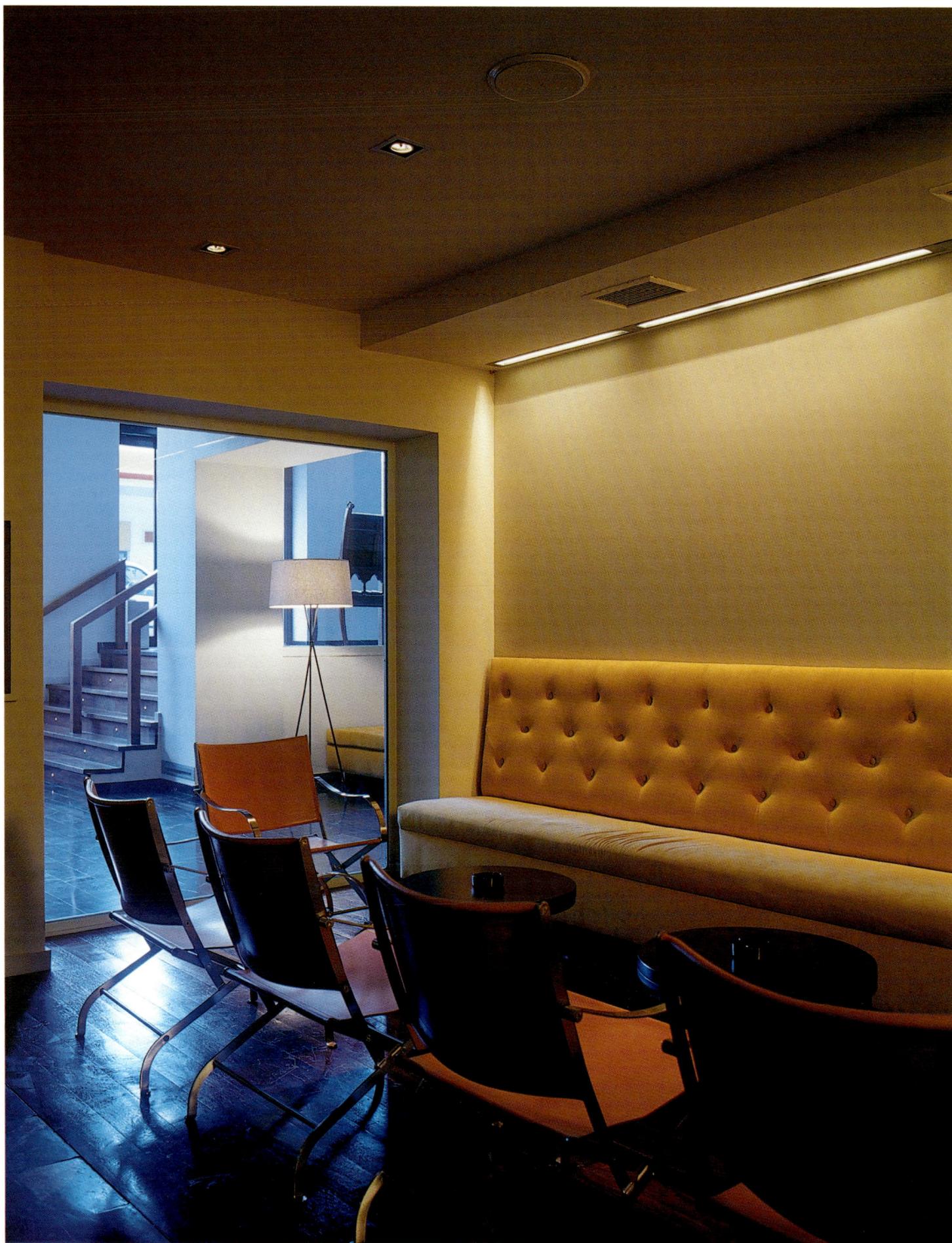

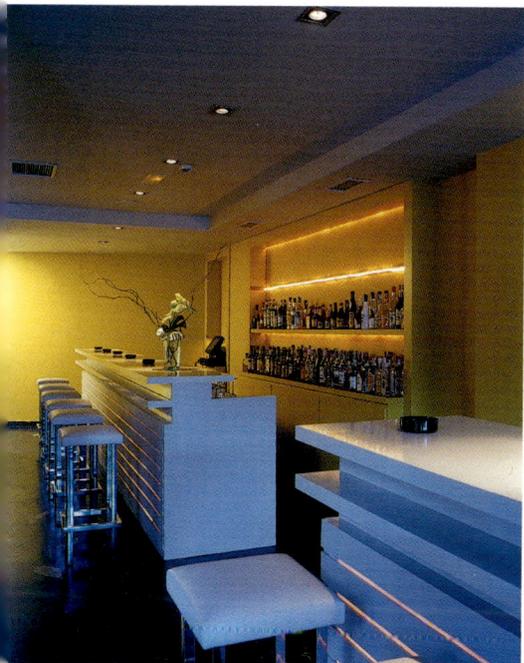

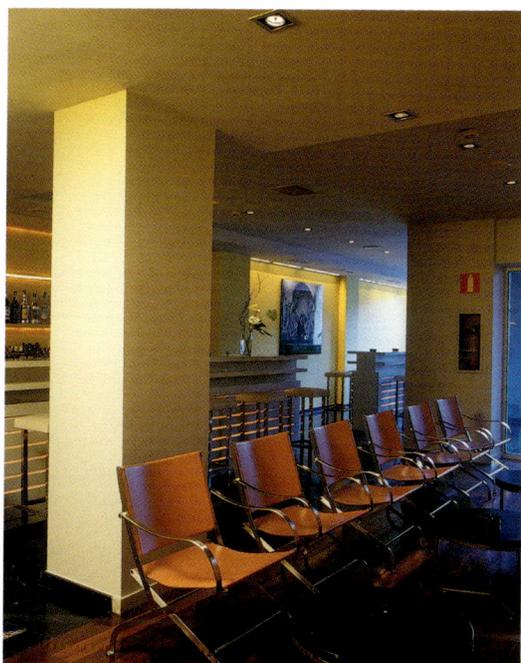

Clear geometric lines characterize the interior architecture, as well as the décor and the design of every detail. As a counterpoint, a play of symmetries, levels, and special relationships enriches the space.

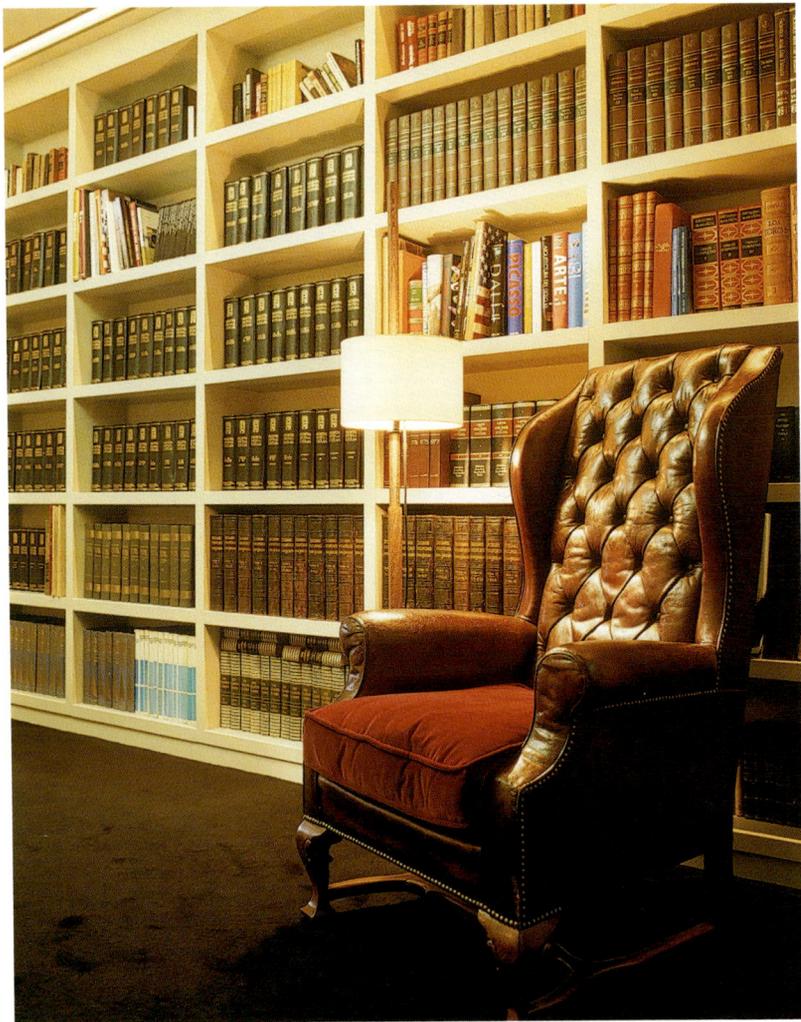
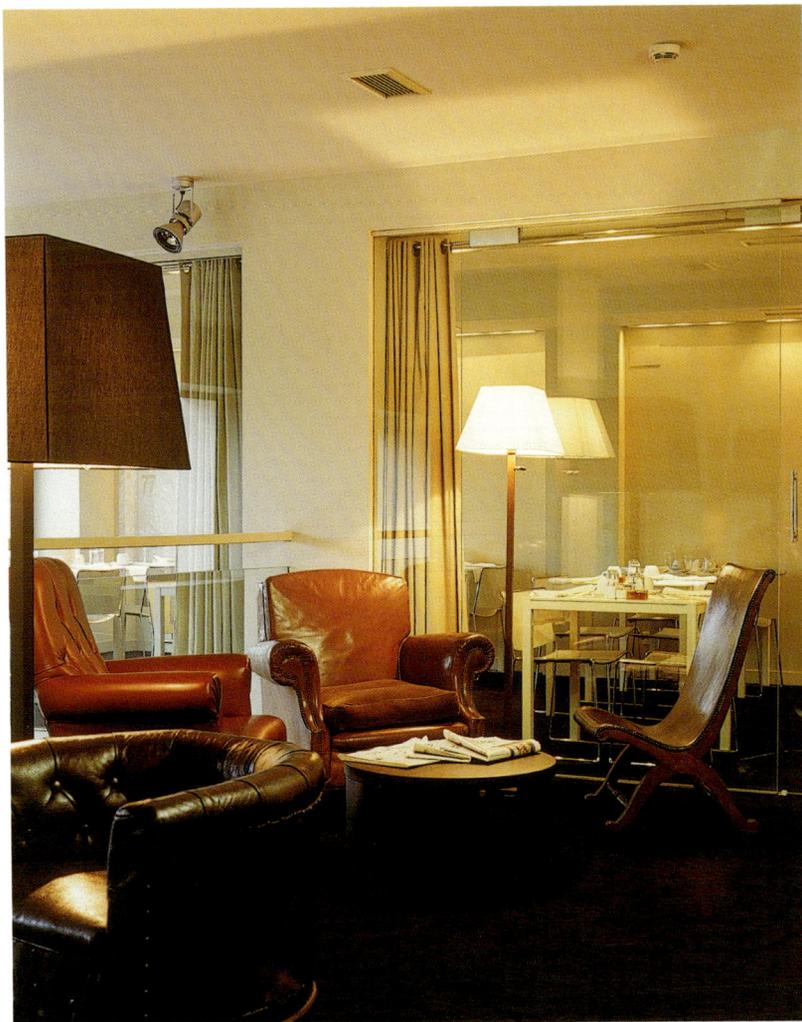
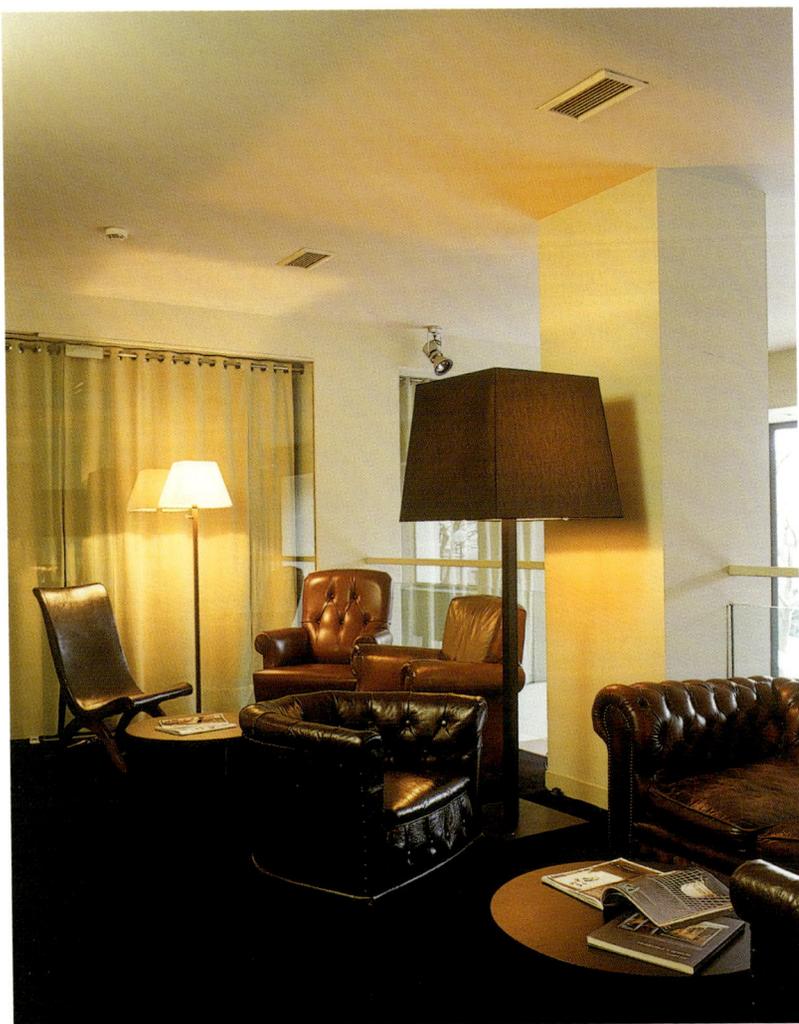

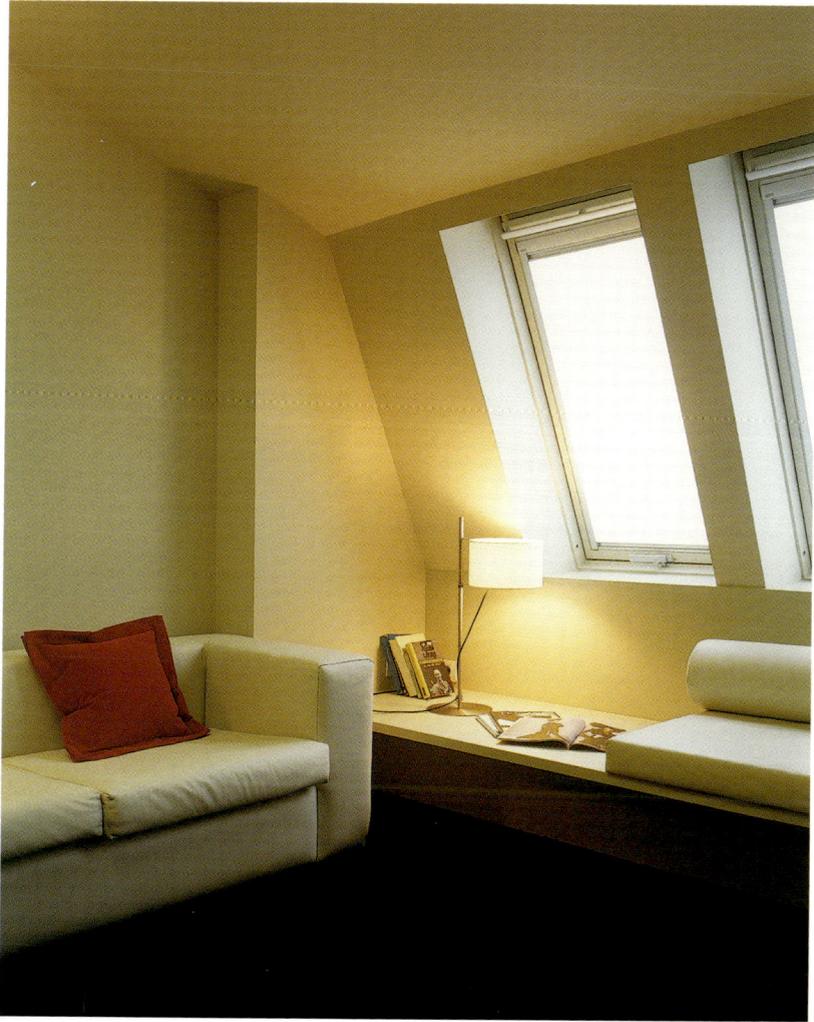
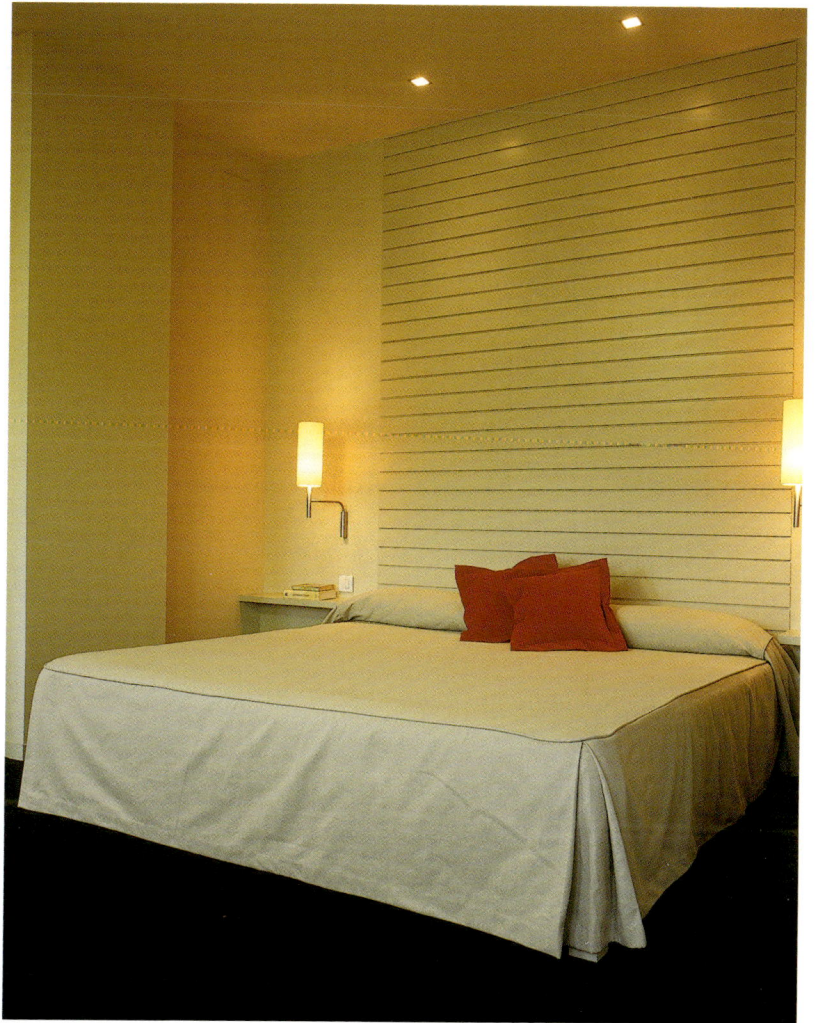

60

Thompson

60 Thompson Street, New York, NY 10012, USA Tel: +1 212 431 0400 Fax: +1 212 431 0200 www.60thompson.com

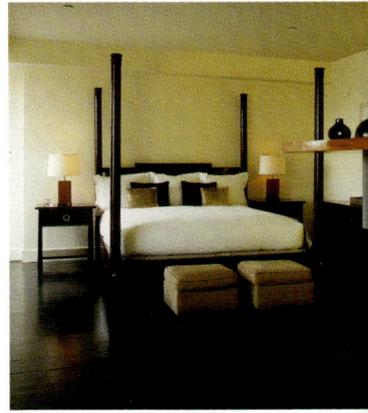

60 Thompson is located in the heart of New York's SoHo neighborhood. Although it is the tallest building in the neighborhood, everything in its interior is carefully designed on a domestic scale and in a minimalist, austere style. The idea was to create a decidedly elegant ambience in a contemporary manner. In order to achieve this the designers used high quality materials such as the marble that covers the floor of the reception area and lobby, along with an exceptional selection of designer furniture. A careful, subtle lighting design has been devised in order to create a warm and inviting ambience. In the public areas the table lamps that illuminate specific areas, such as the tables in the small living rooms or lobby, stand out. Small lights, embedded in the floor, flank the stairs, directing traffic and creating a dramatic effect.

The rooms are characterized by their ample interior space and the careful design of all the details. Even the toilet paper is printed with the hotel logo. The soft tones, chosen for the walls, as well as the natural fibers and materials, such as the dark wood beds and leather headboards, create a cozy and sophisticated atmosphere. Once again the materials are the stars. They have been treated in such a way that their natural textures and properties enrich the entire space.

Designer: **Thomas O'Brien** Photographer: **Pep Escoda** Location: **New York City, United States** Opening date: 2002

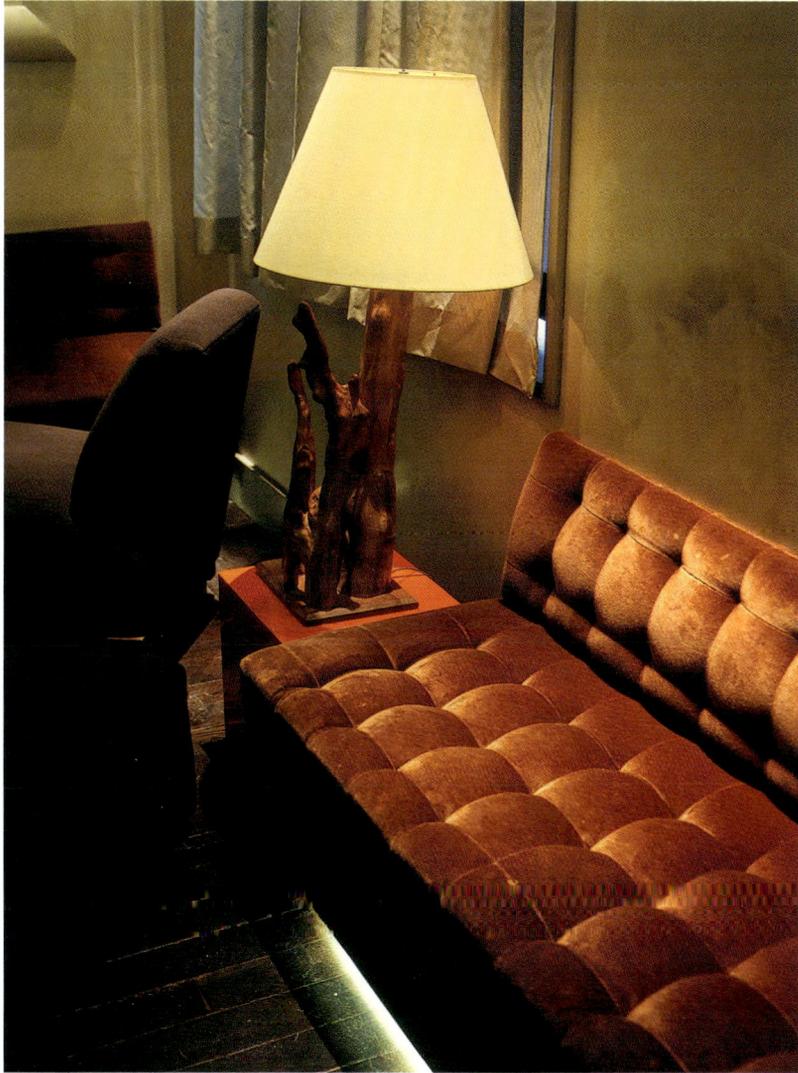

Dark tones have been used to create private corners in the public areas. In the guest rooms, the character of each space is obtained by utilizing very different pieces of furniture and lighting, so that each room is unique.

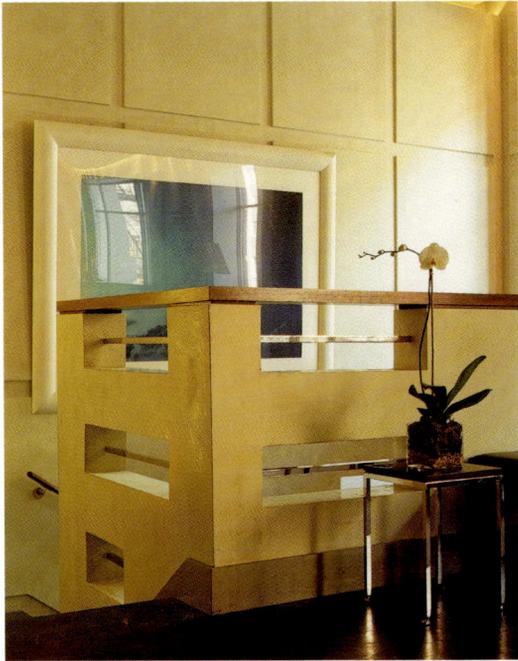

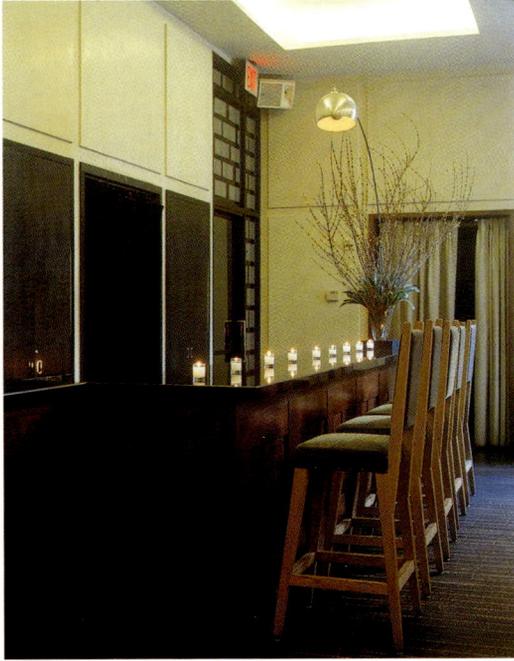

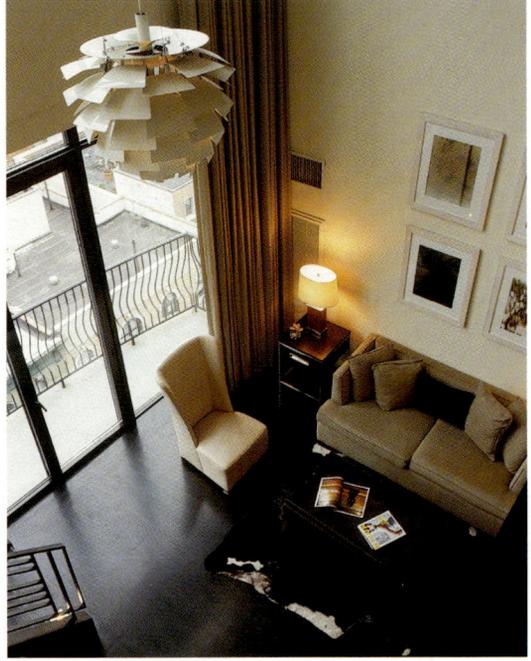

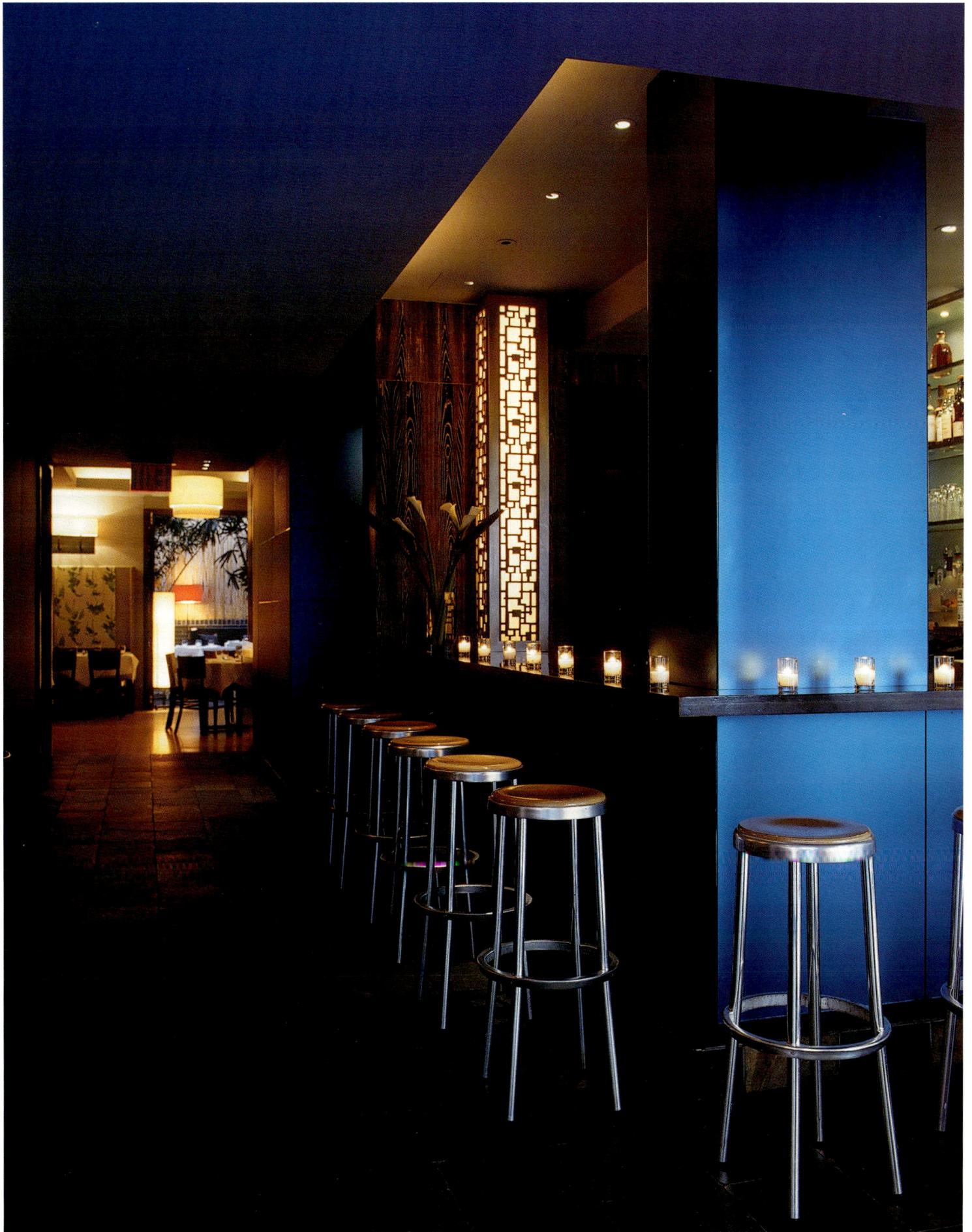

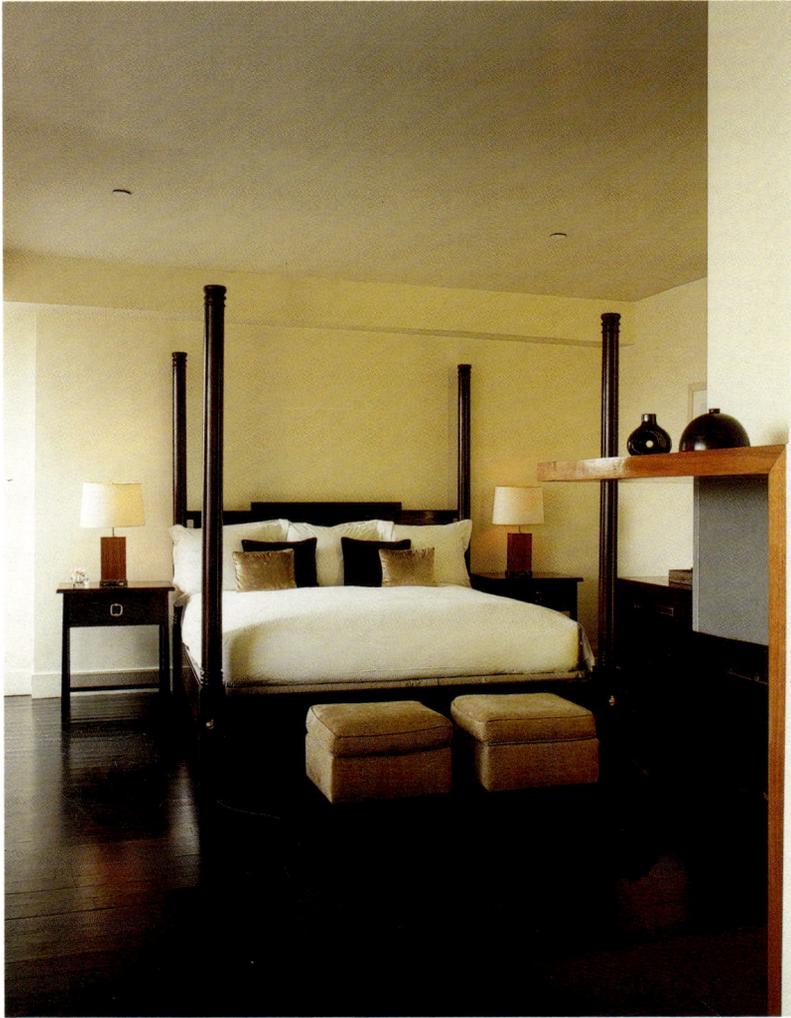
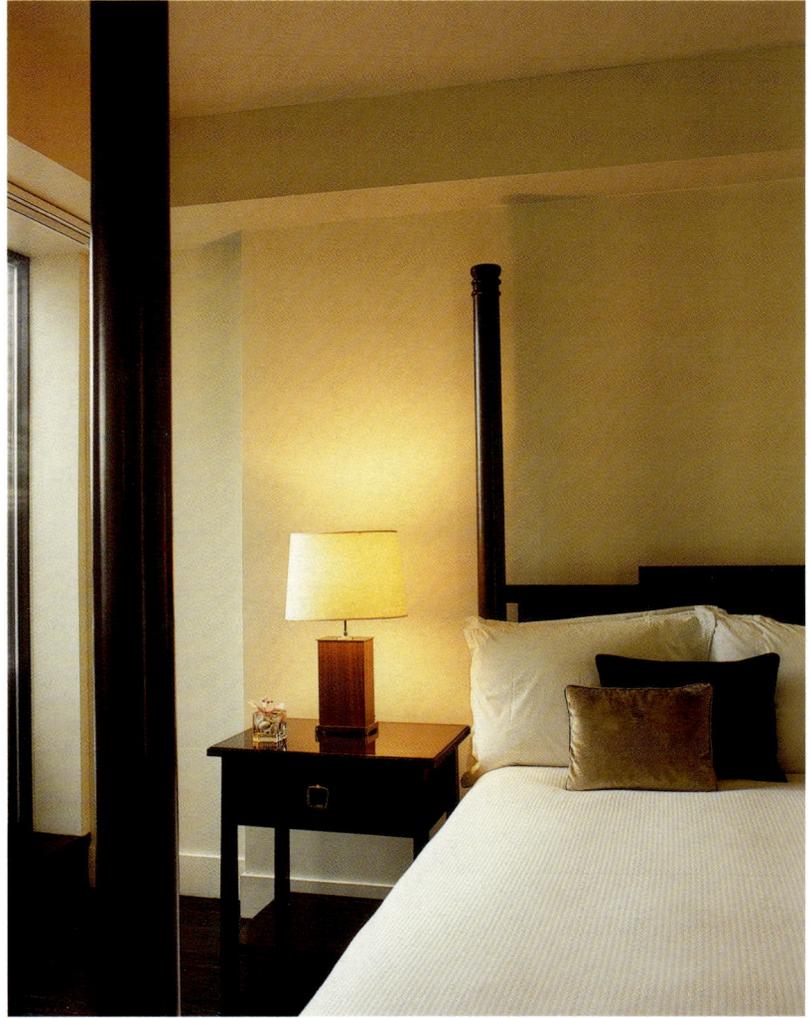

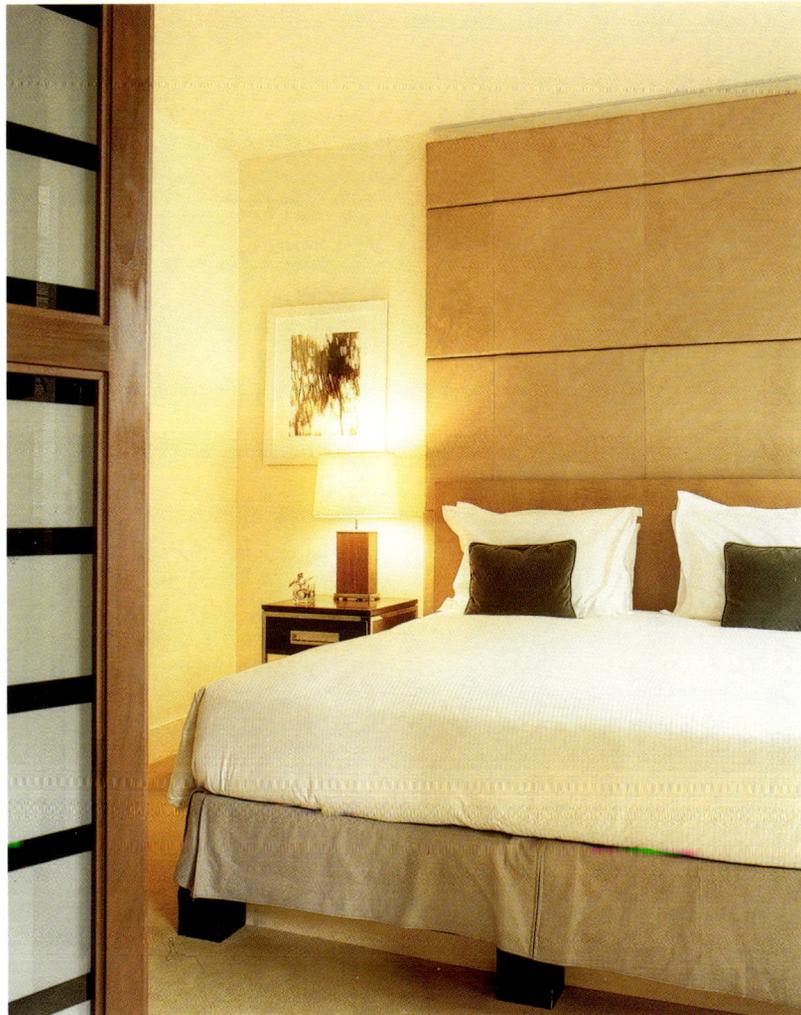

The sophisticated materials contrast with the restrained and austere design, creating a very warm ambience in guest rooms where all the comforts are found without any excesses of style.

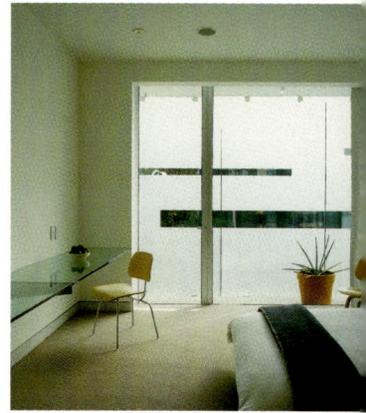

Habita
Hotel

Av. Presidente Masaryk 201, Col. Polanco 11560, Mexico D.F., Mexico Tel: +52 55 5282 3100 Fax: +52 55 5282 3101 info@hotelhabita.com www.hotelhabita.com

The Habita Hotel, part of a new generation of establishments in which the priority is contemporary design, leaves all conventions behind. This is reflected not only in the operation, service, and technical sophistication, but in the design and construction as well. The challenge of transforming this old 1950s apartment building in Mexico City became similar to a complicated surgery. The decision to make use of the existing building and to retain, at least partially, its structure and incorporate new elements, was due to legal issues revolving around renovations versus new constructions.

The building was adapted to the various characteristics of its urban surroundings as well as to the necessities of a hotel. So the glass façade, which creates a new, weightless image of the building that changes according to the intensity of the light, is also a protective element, like a barrier that blocks out the intense noise and congestion of this central part of the city. In the interior, holes were cut in the structure in order to widen the elevator and other vertical shafts. Finally, after careful planning, 36 rooms were accommodated where there had once been three apartments per floor. This planning resulted in an architectural structure that masterfully combines light and shadows, angular and irregular perspectives with diverse materials such as stainless steel, glass, Canadian maple, and blue Mexican agave.

Architect: **Ten Arquitectos** Photographer: **Undine Pröhl** Location: **Mexico City, Mexico** Opening date: **2001**

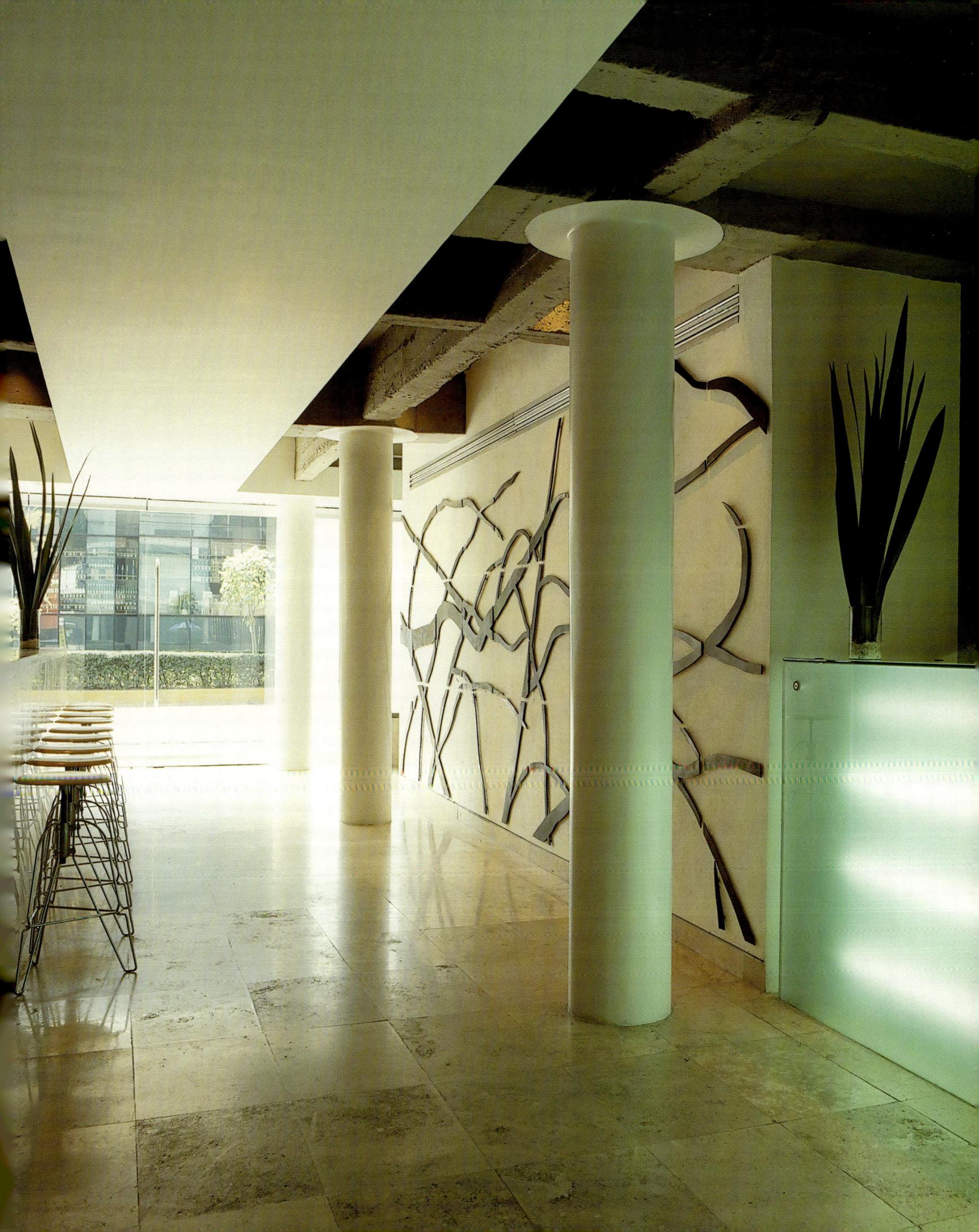

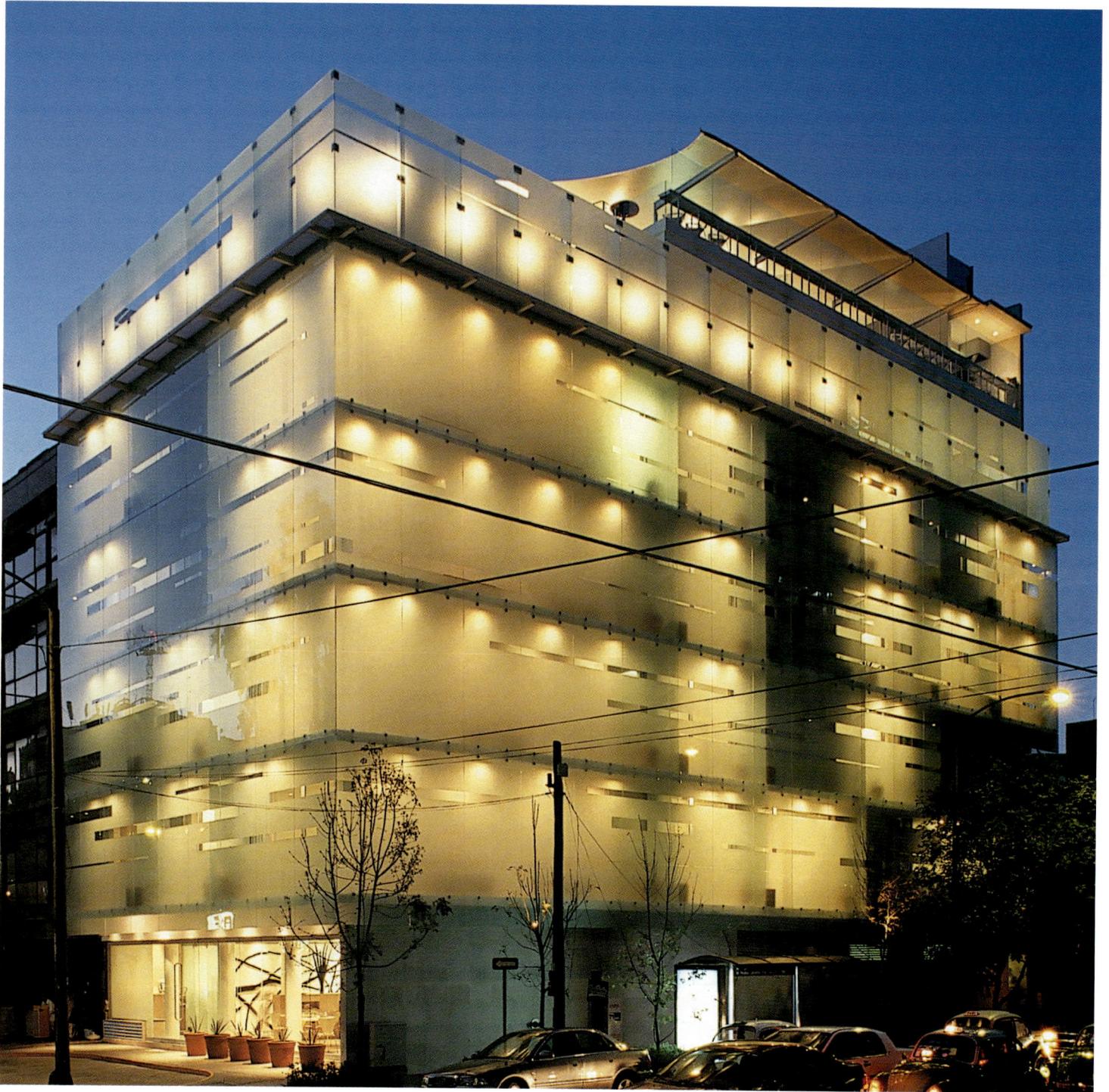

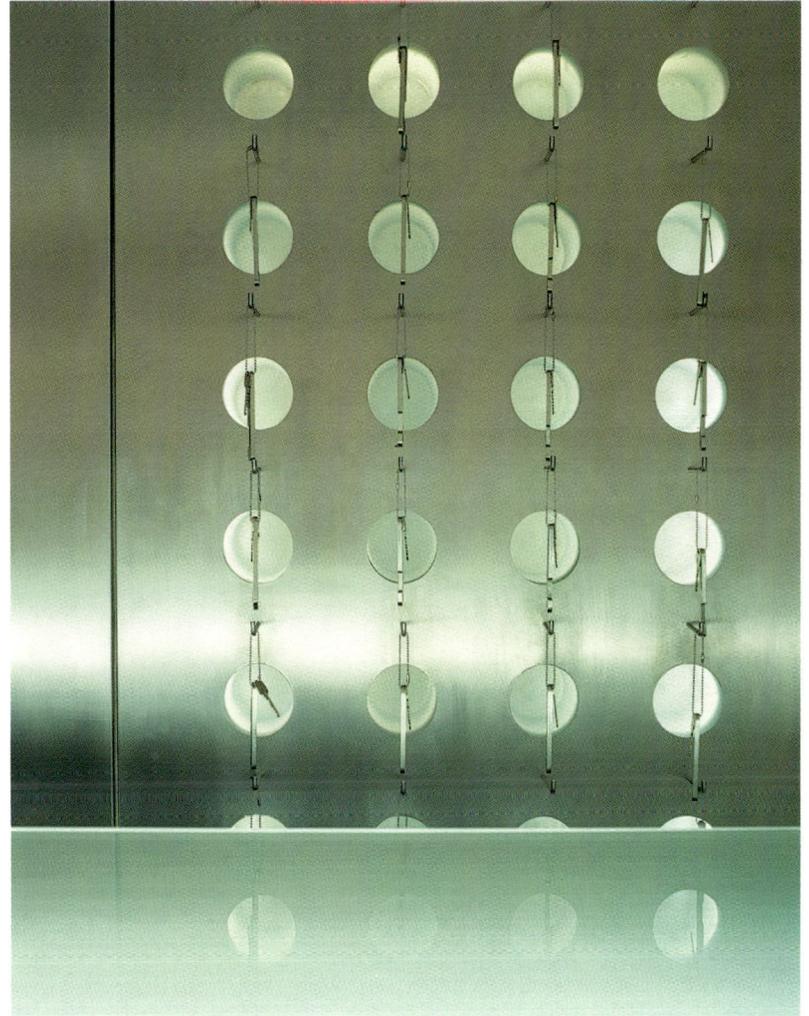

In the space between the reinforced concrete of the original structure and the new skin of translucent blue-green polished glass a series of balconies can be seen through the openings in the façade.

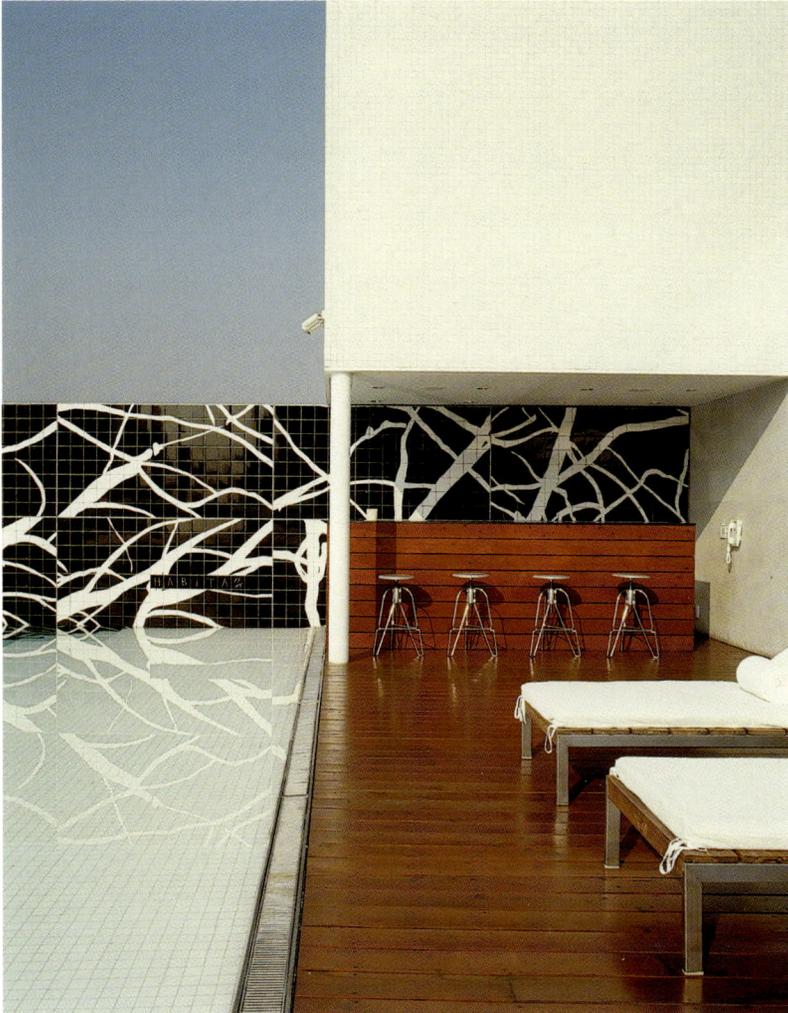

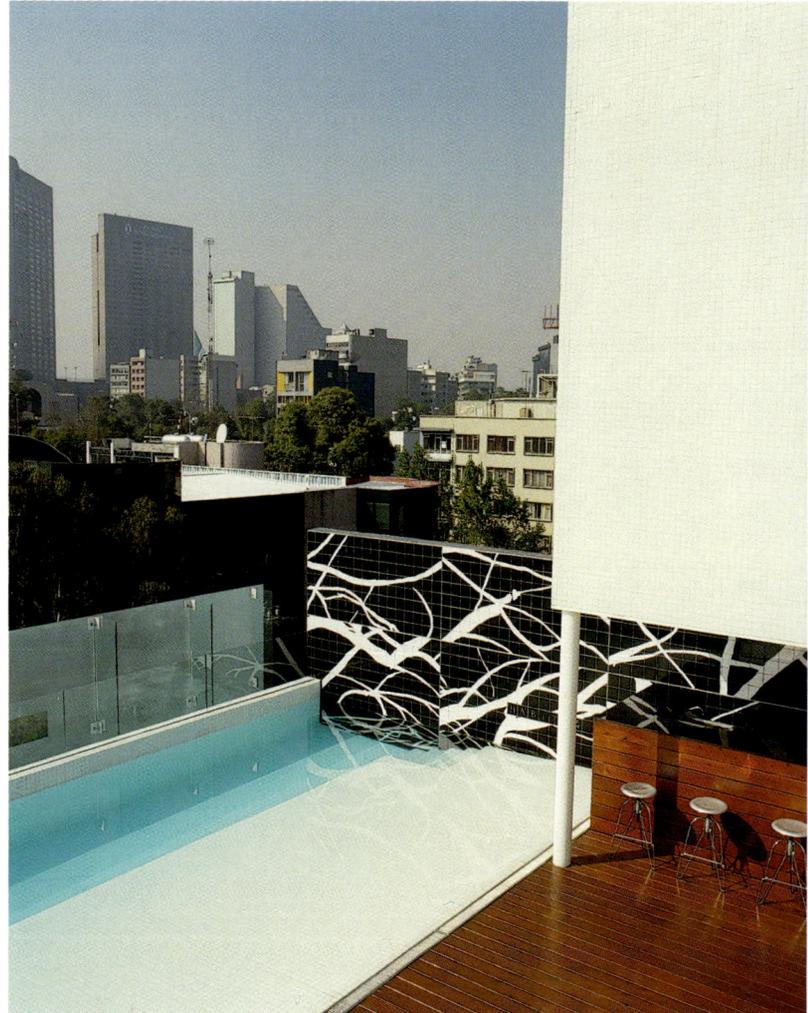

On the second-to-last floor there is a deck with a pool that has splendid panoramic views of the city. A black and white mural designed by Jan Hendrix adds a dramatic touch.

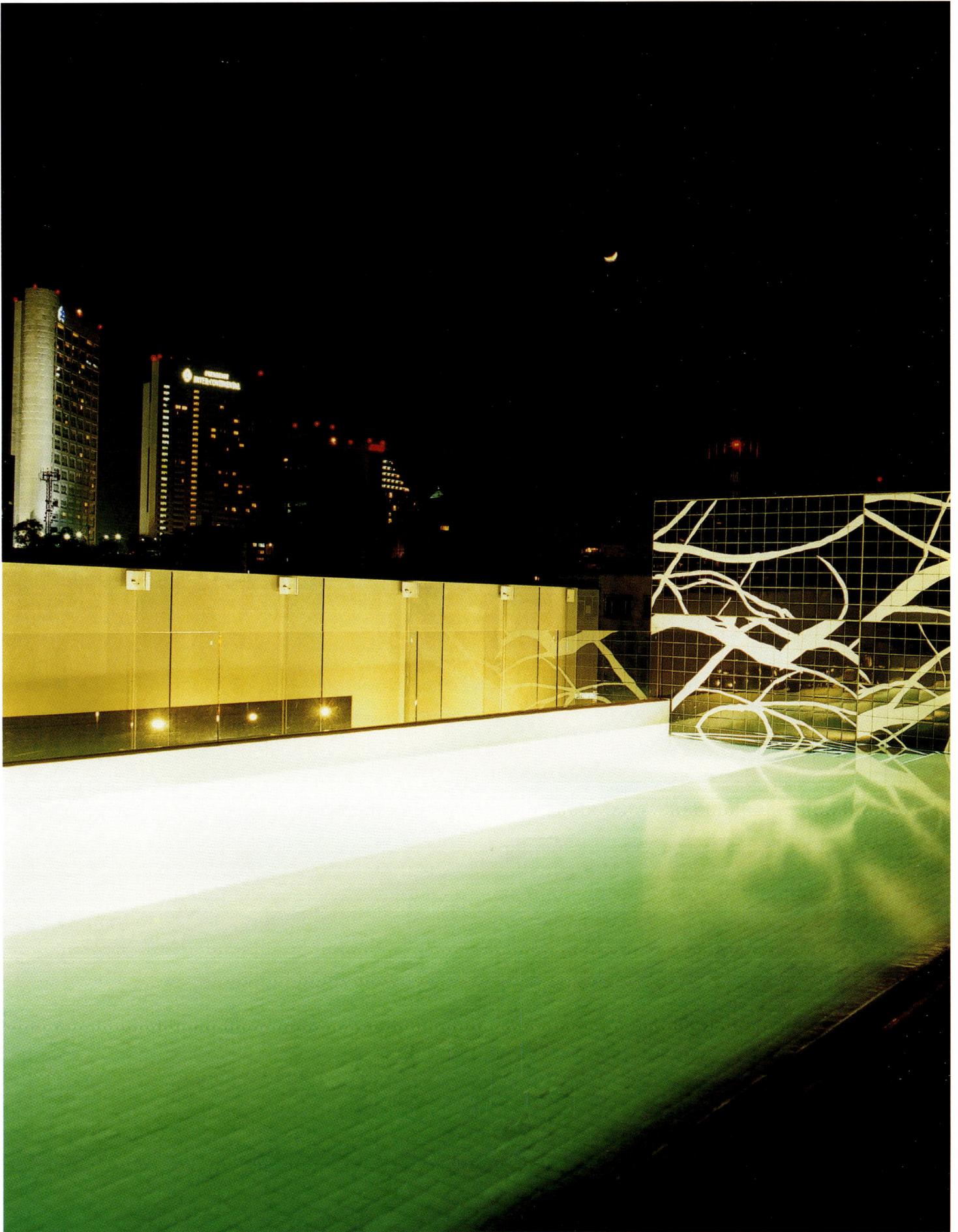

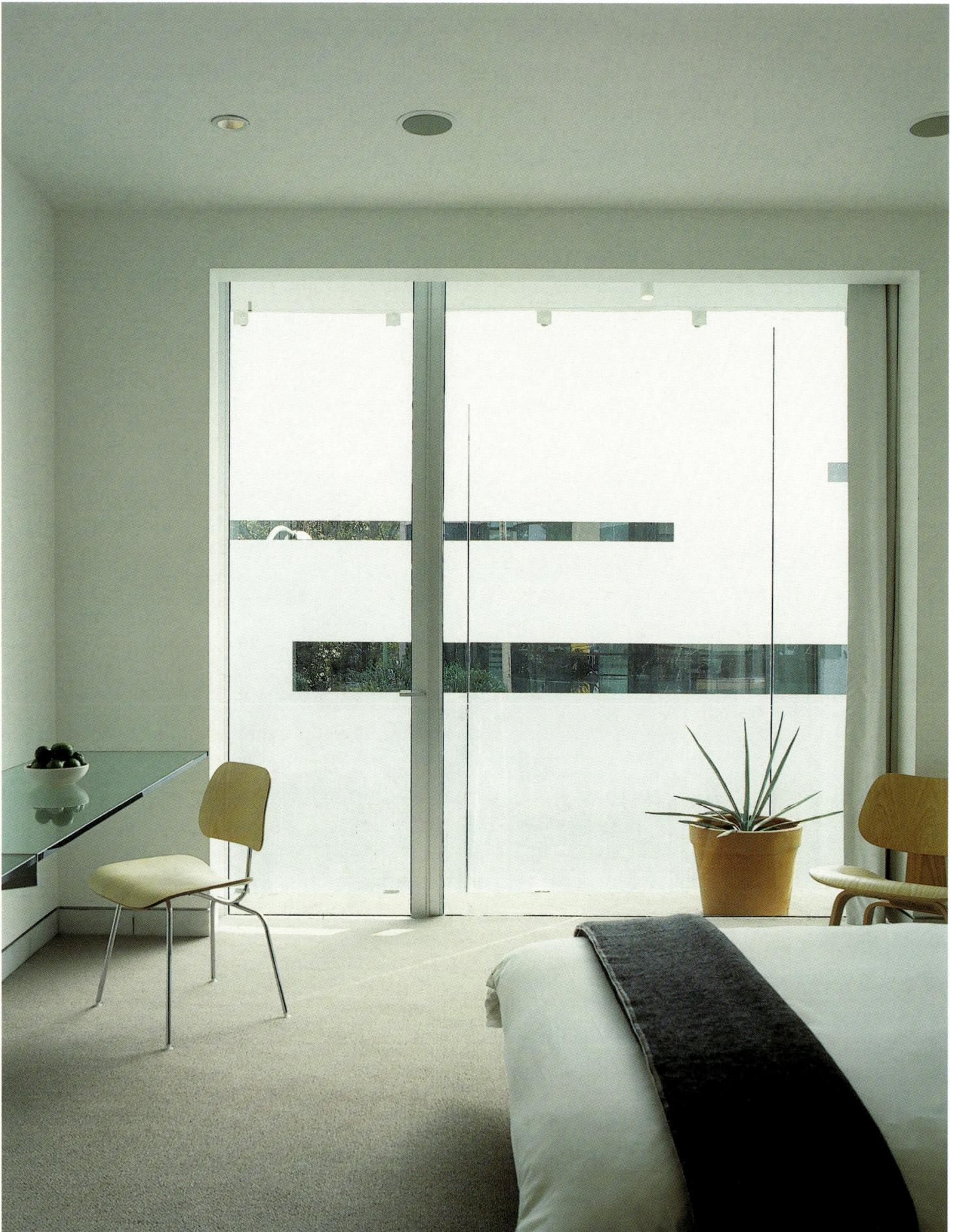

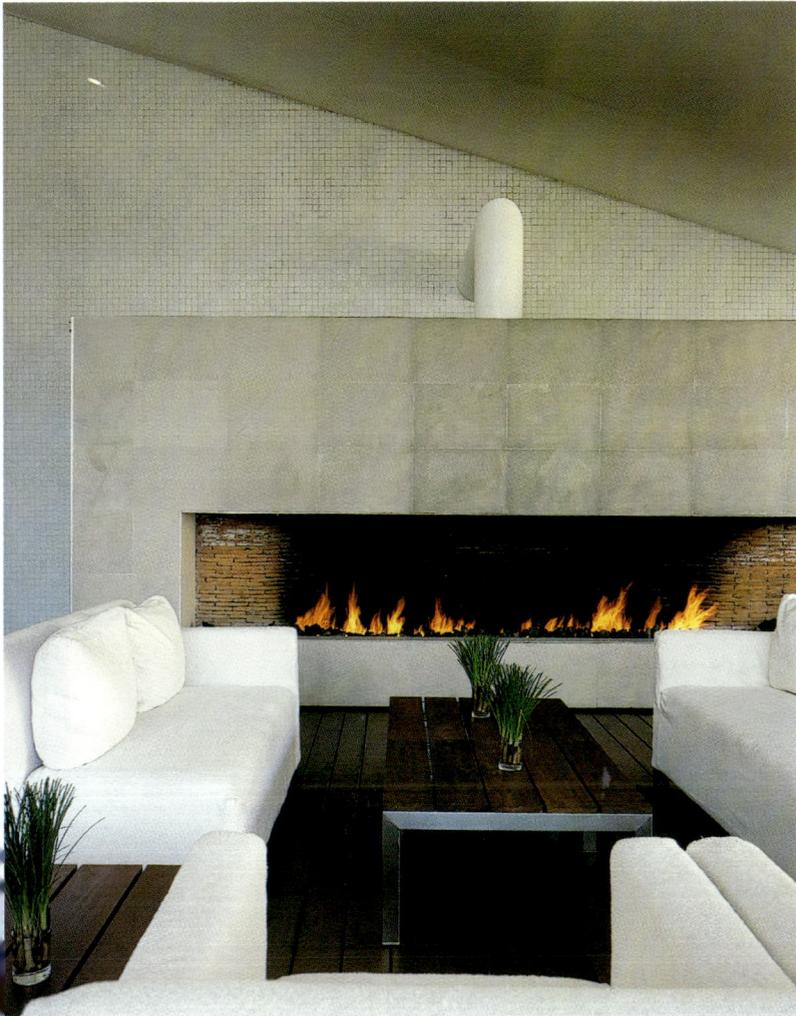

In the rooms, the large, floor-to-ceiling windows provide access to the exterior balconies and emphasize the big, open space filled with light. The double skin created glass façade helps maintain the inside temperature.

COLD

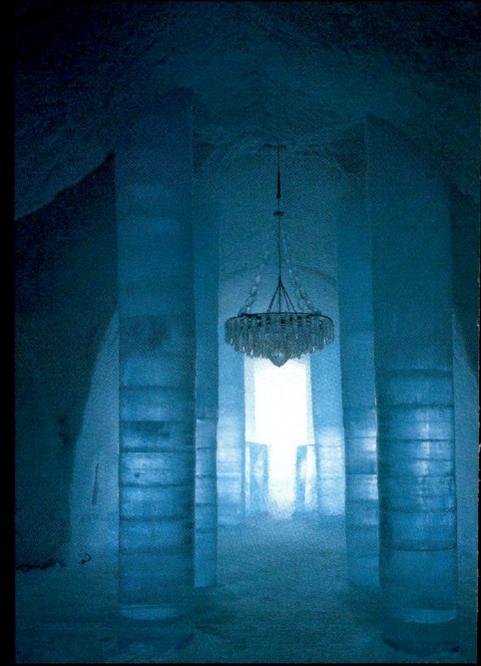

Extreme temperatures can inspire striking interpretations of how to shape and utilize an interior space. A hotel's activities, from winter sports to spa facilities, define its form as well as its use. Approaches to construction can be as different as a floor where sliding walls incorporate various rooms within one space, or the use of fitted blocks of ice in construction techniques drawn from traditional North Pole cultures.

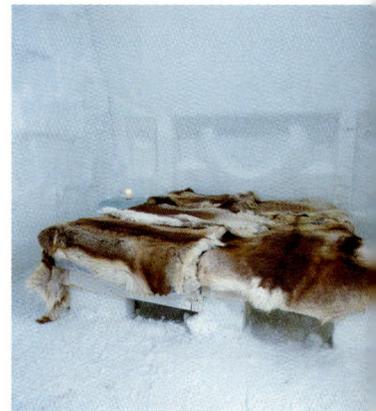

Icehotel

981 91 Jukkasjärvi, Sweden Tel: + 46 980 66 800 Fax: + 46 980 66 890 info@icehotel.com www.icehotel.com

This hotel might be one of the most original and striking tourist accommodations available today, at least in terms of construction. The Icehotel is really just that, a complex of structures made entirely of blocks of ice, including even various pieces of furniture such as beds, tables, and chairs. Its construction and availability depend on the wintry weather, as every spring when the temperature rises the hotel disappears, melting away like the icecap that covers the area. The Icehotel, a few miles north of the Arctic Circle, has become an icon in experimentation in hotels as well as in art and architecture.

What began as an unusual gallery for an art exhibition has become a tourist complex that opens its doors every year to people who venture to live for a while in the Arctic style. Several years ago the first igloo, shaped like a cylinder, went up to house a contemporary art exhibition. Many of the visitors, excited by what was then referred to as the Arctic hall, decided to spend the night in improvised sleeping bags. Now the hotel includes a reception area, a hall of columns, a bar sponsored by Absolut vodka, a movie theater, a chapel, and sixty rooms. Every year, at the end of October more than thirty architects and artists collaborate on the design and decoration of each room so that they are ready for the arrival of the first guests in mid-December.

Designer: **Yngve Bergqvist** Photographer: **Jörg Hempel** / artur, **Roland Halbe** / artur Location: **Jukkasjärvi, Sweden** Opening date: **2000**

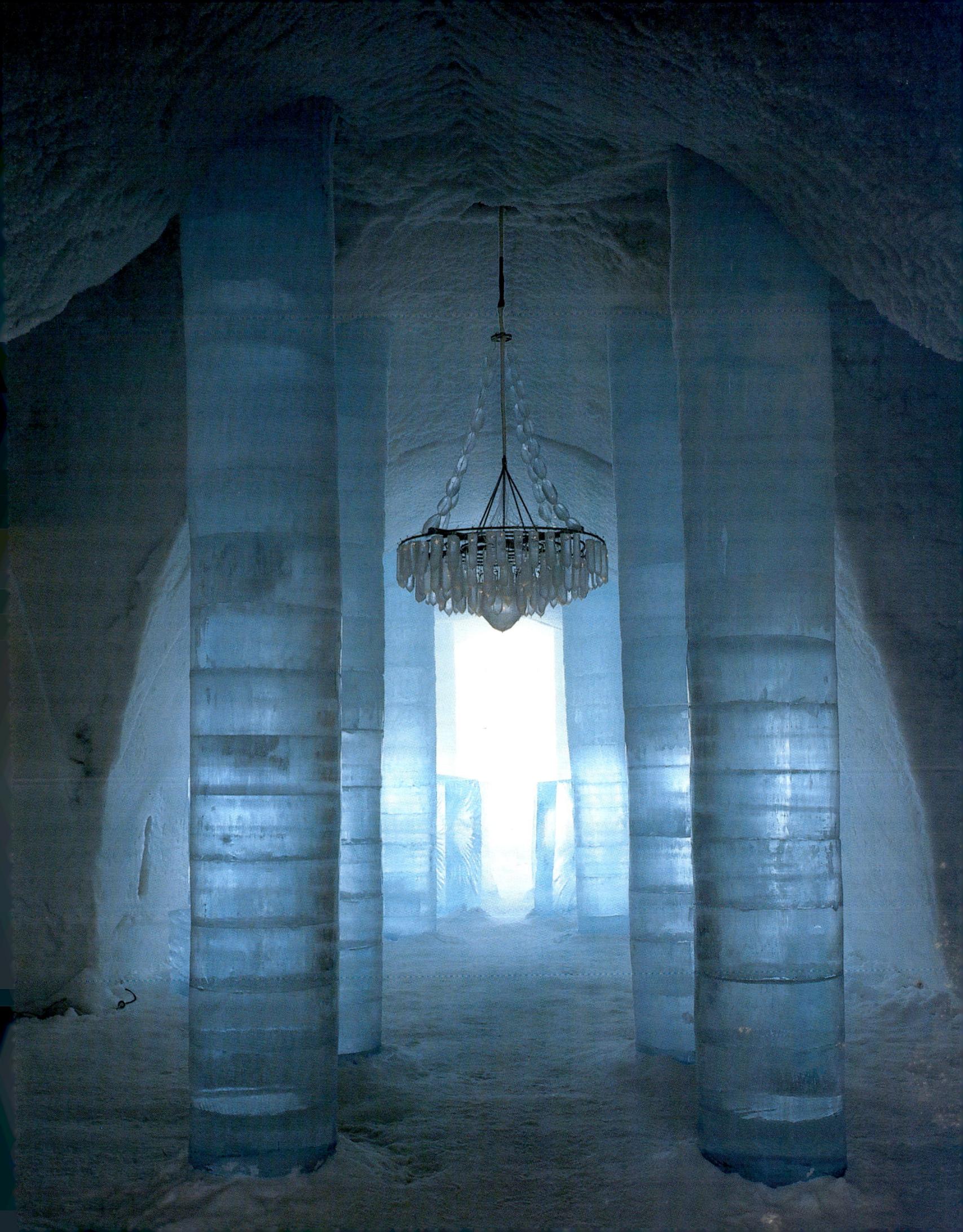

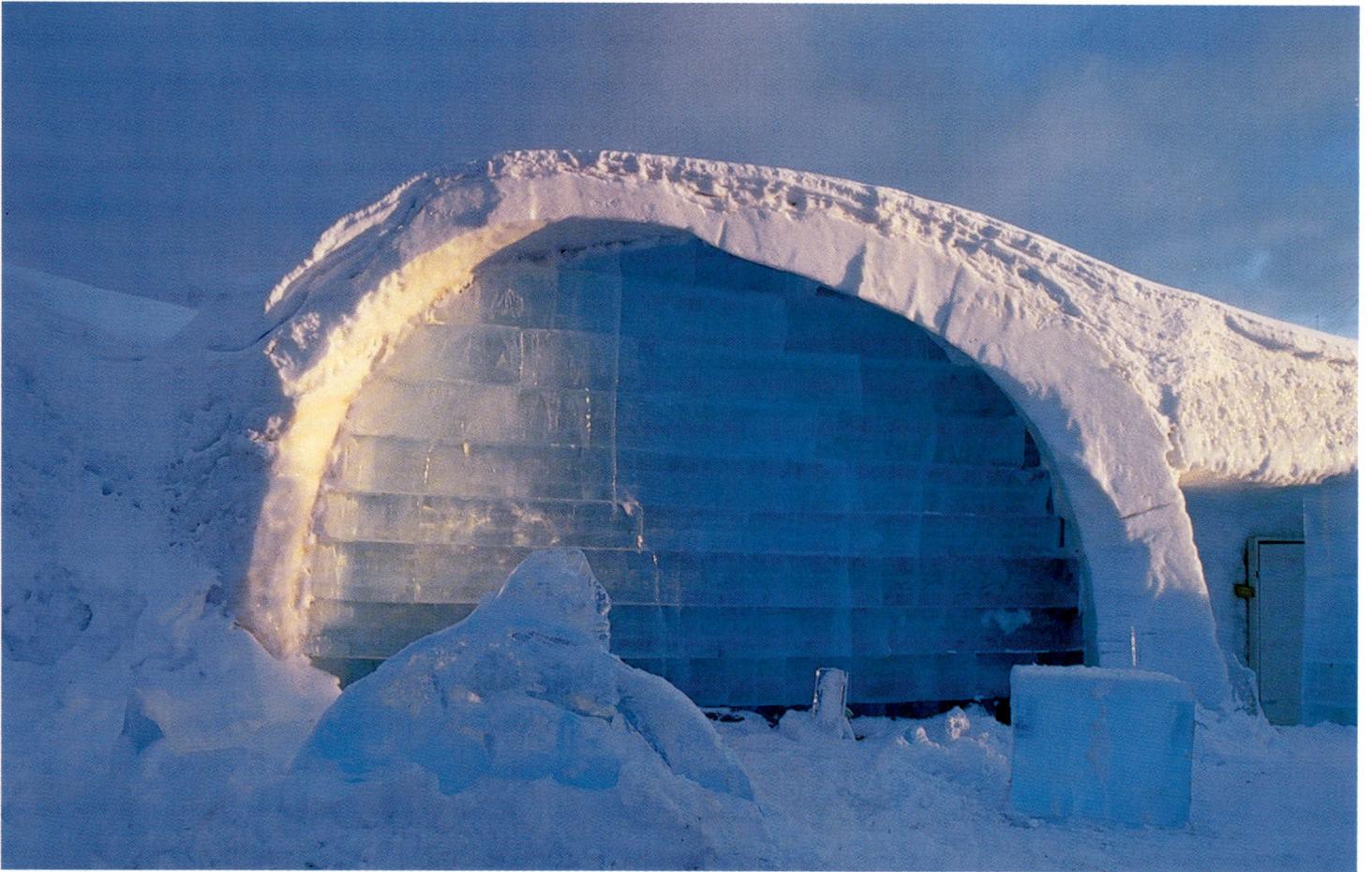
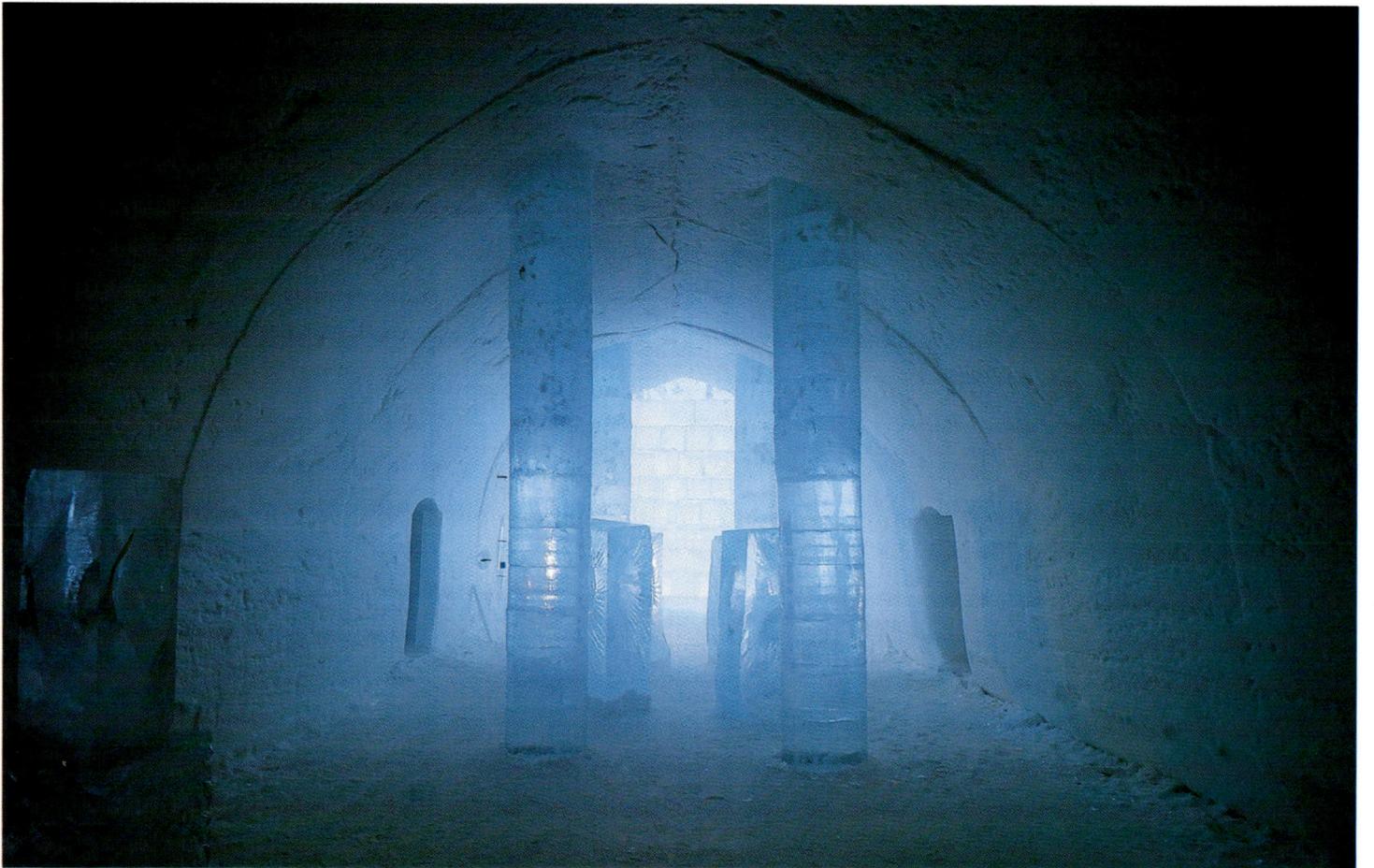

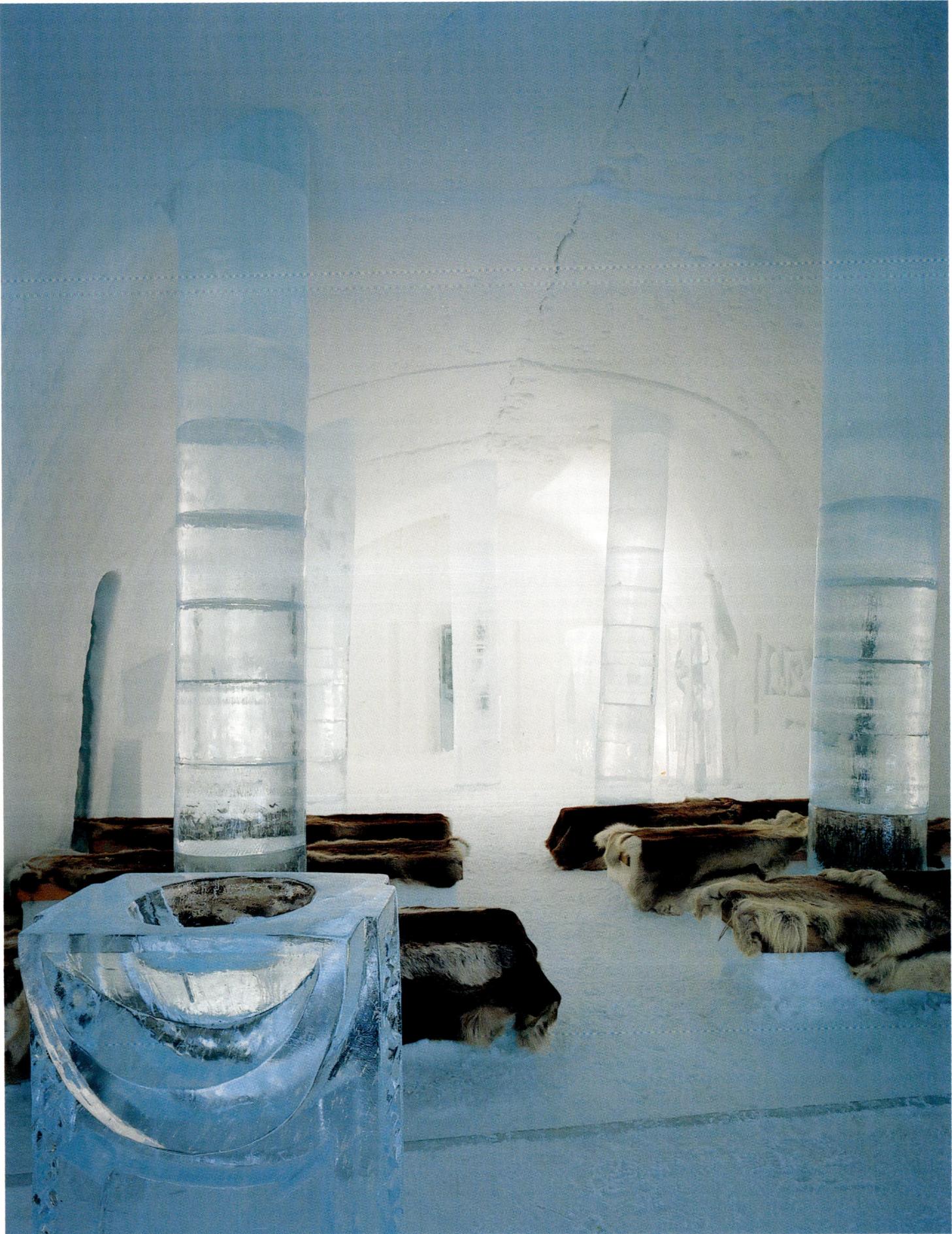

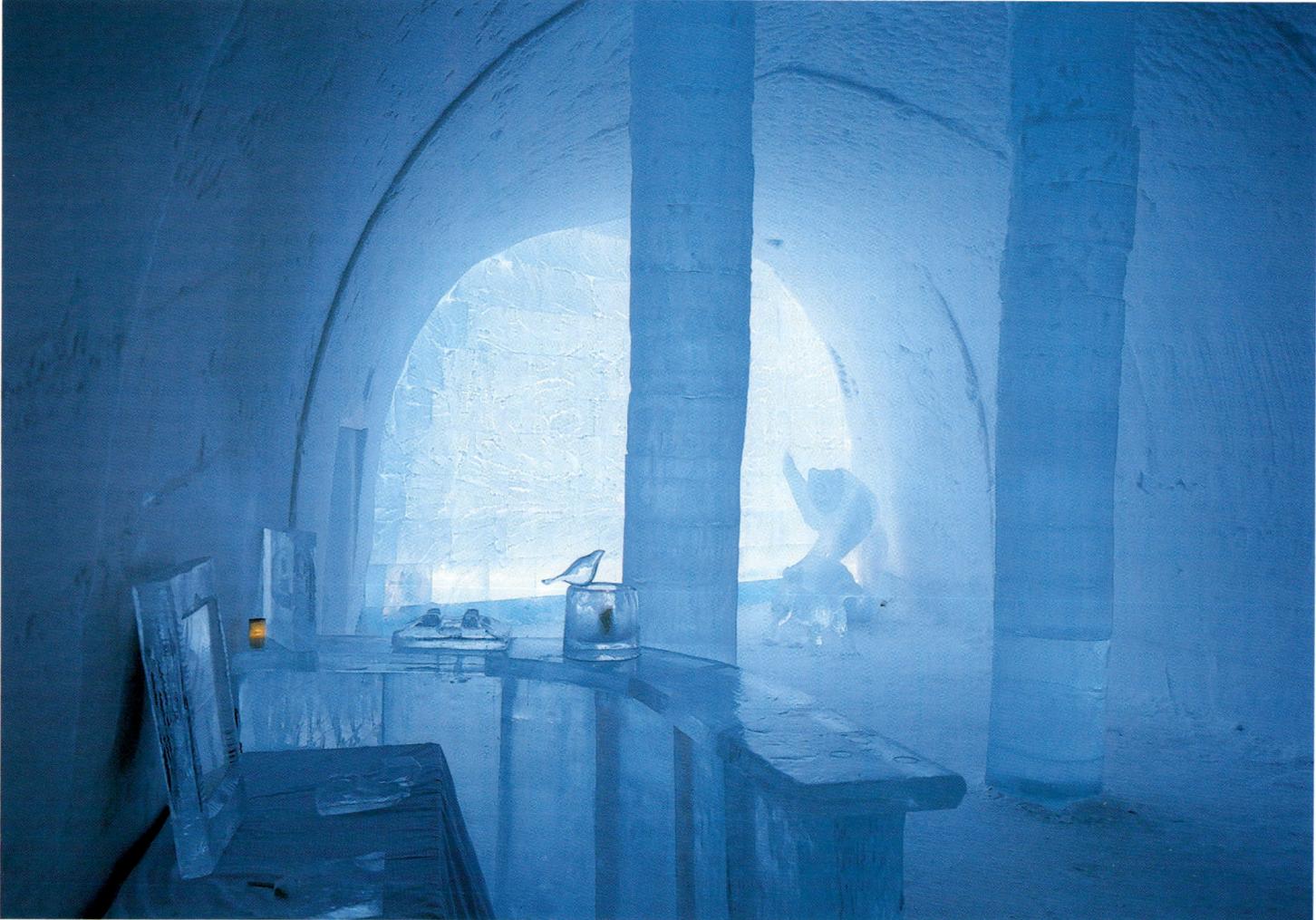

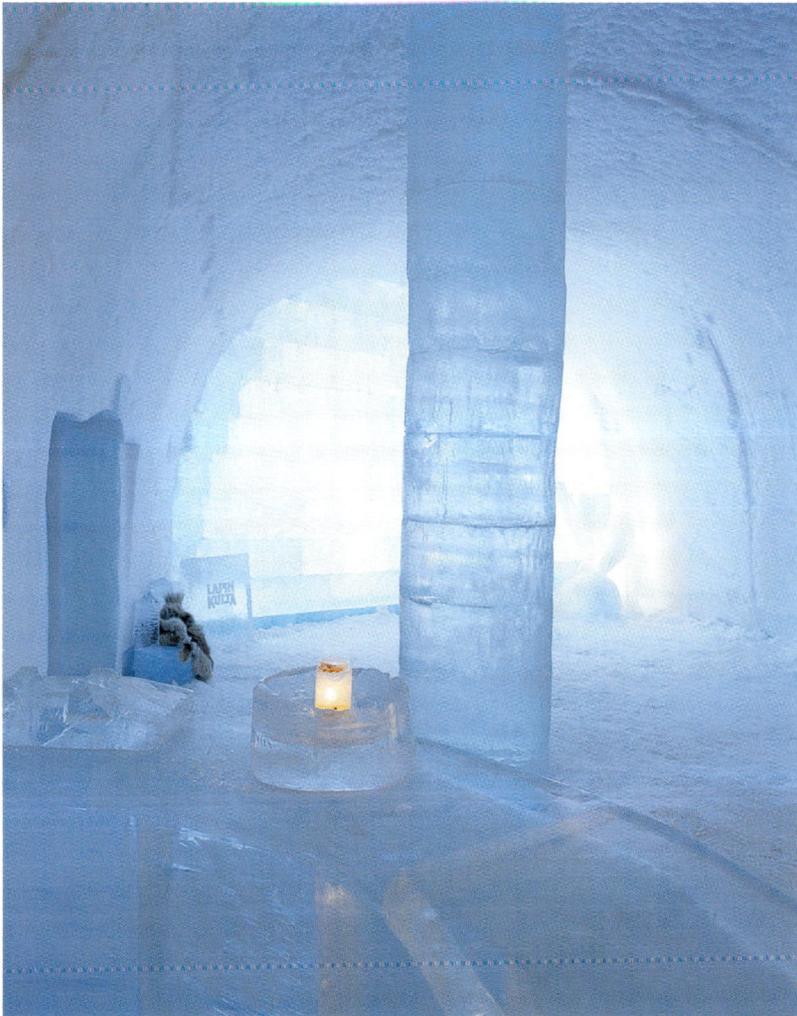

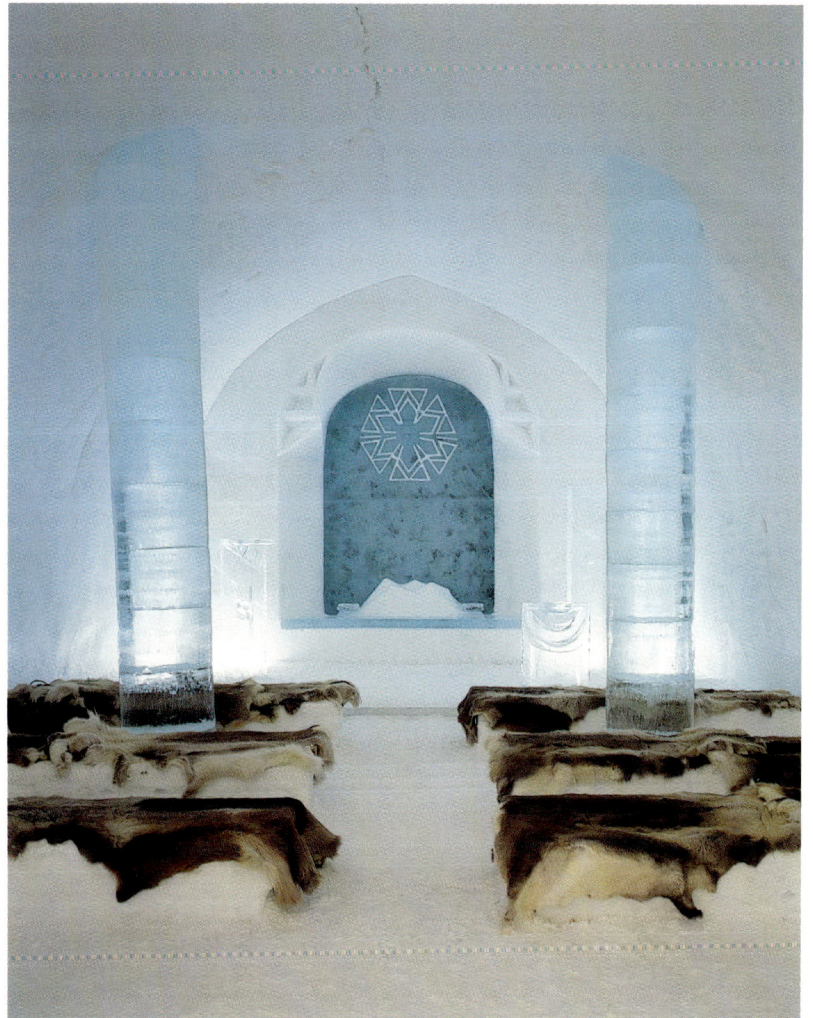

Sculptors meet every year to carve the large blocks of ice that form not only the structure and parameters of the space but also the main furnishings and various decorative elements as well.

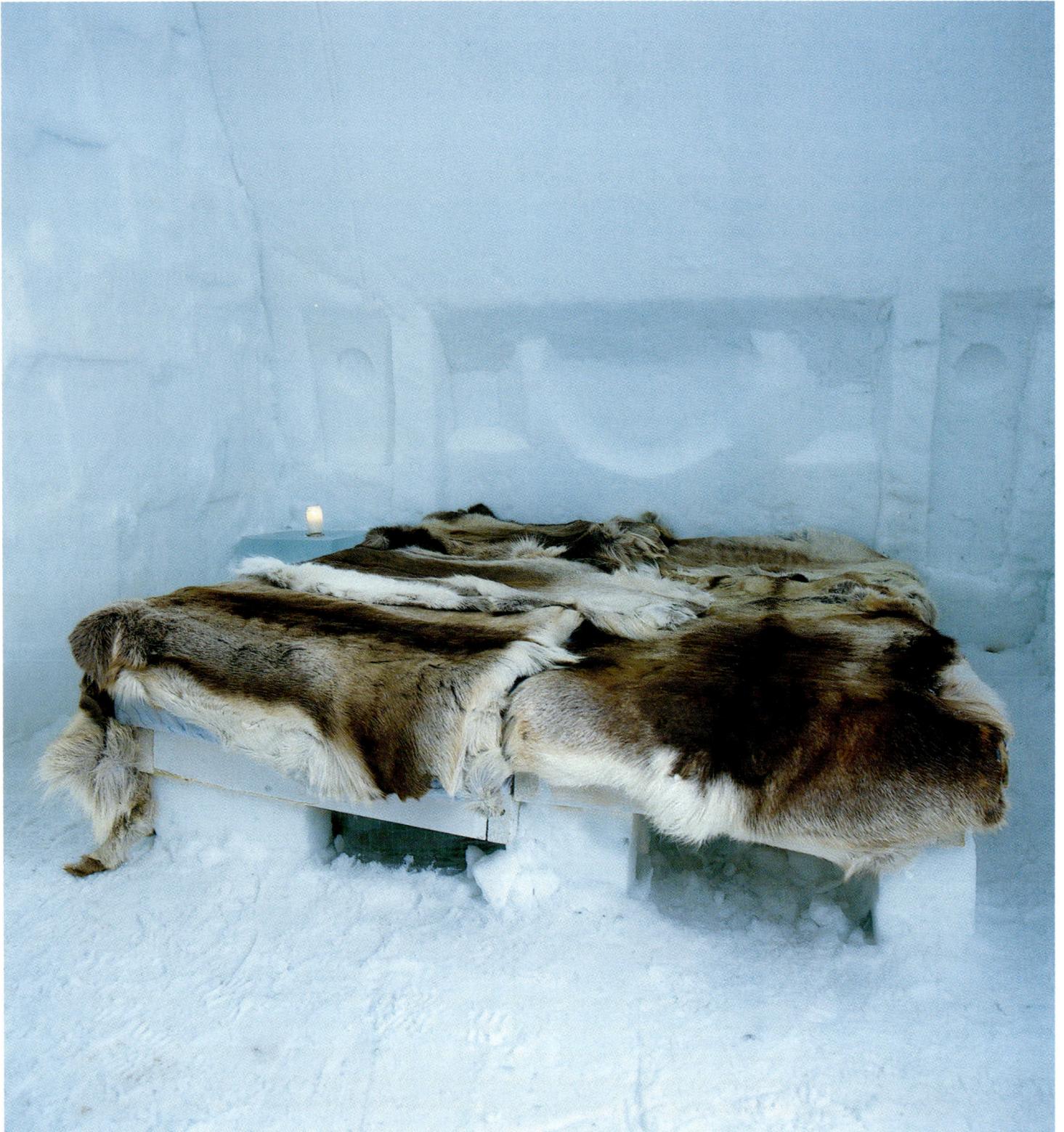

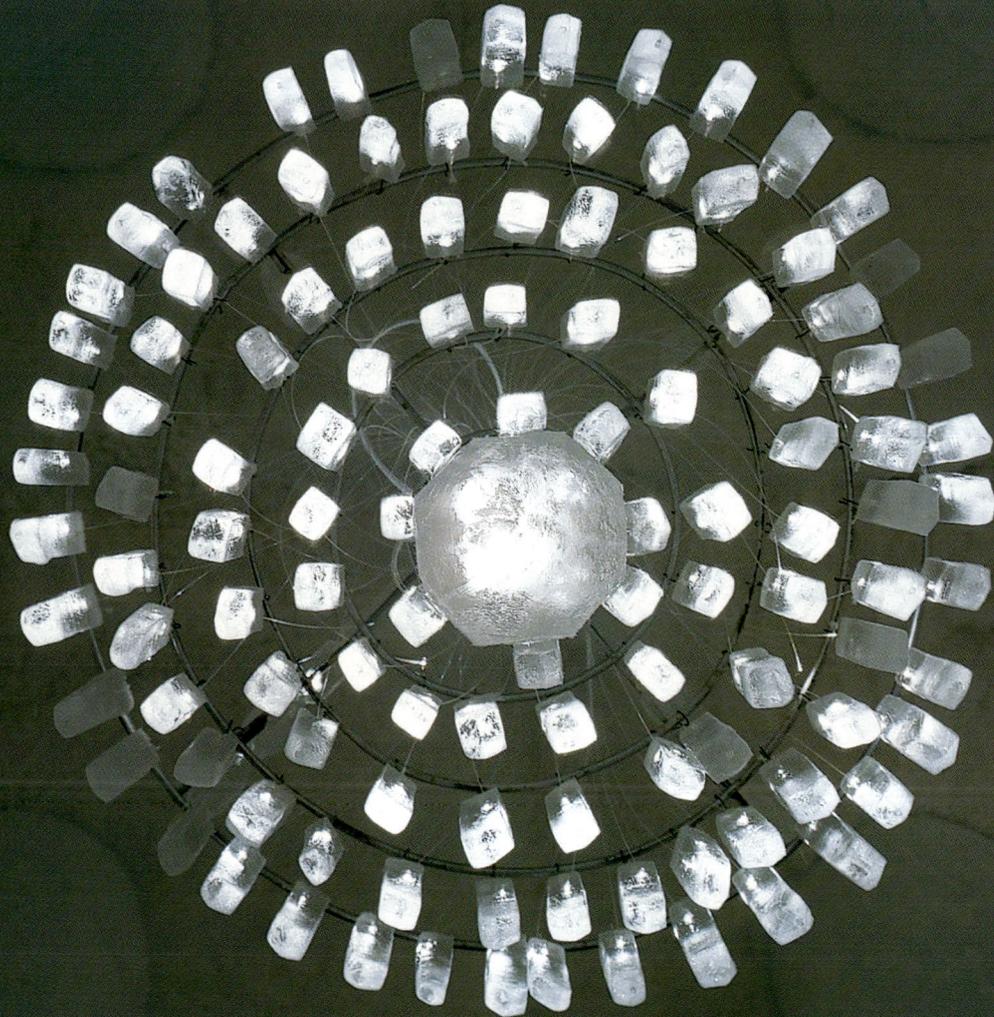

The beds are made of big blocks of ice covered with reindeer hide. The guests sleep in special sleeping bags that protect them from the cold.

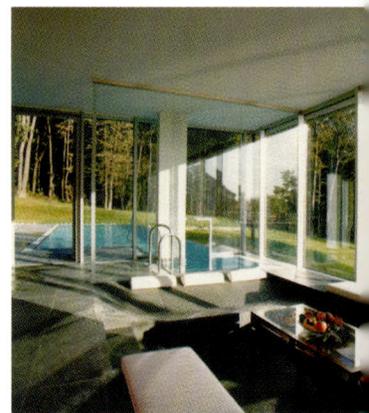

Hotel
Tulbingerkogel

Tulbingerkogel 1, 3001 Mauerbach, Vienna, Austria Tel: +43 2 273 7391 hotel@tulbingerkogel.at

This addition to an existing hotel is located in a small forest on the outskirts of Vienna. The small, new, three-story building is strategically located in order to take advantage of the spectacular views of the area. The project houses a spa that takes up the entire first floor and six additional rooms from which to enjoy the views of the surrounding forest and Schneeburg Mountain. An attempt was made to respect the natural surroundings, and this is reflected in the building's scale as well as its materials. Of all the building's features, the design of the vertical screens, which unfold to provide privacy or protection from the sun and have an image of the forest behind the building printed on them, stand out as examples of this goal.

The principal criterion for the design of the interior, including the spa and the guest rooms, was to try and continue the sensation of continuous space found outside and to retain a high regard for the surrounding landscape. Consequently, open, ample spaces were planned in which partitions were avoided, especially on the façade. On the first floor an orange shape, like a sculptural object in the middle of the space, contains the sauna, the steam room and the showers. Other spa activities take place in the rooms that open to the outdoor pool. In the large rooms upstairs, the living and sleeping areas are separated by glass. This creates a continuity of space and allows the landscape to be present in the most intimate rooms of the hotel.

Architect: **Archisphere** Photographer: **Archisphere** Location: **Vienna, Austria** Opening date: **2001**

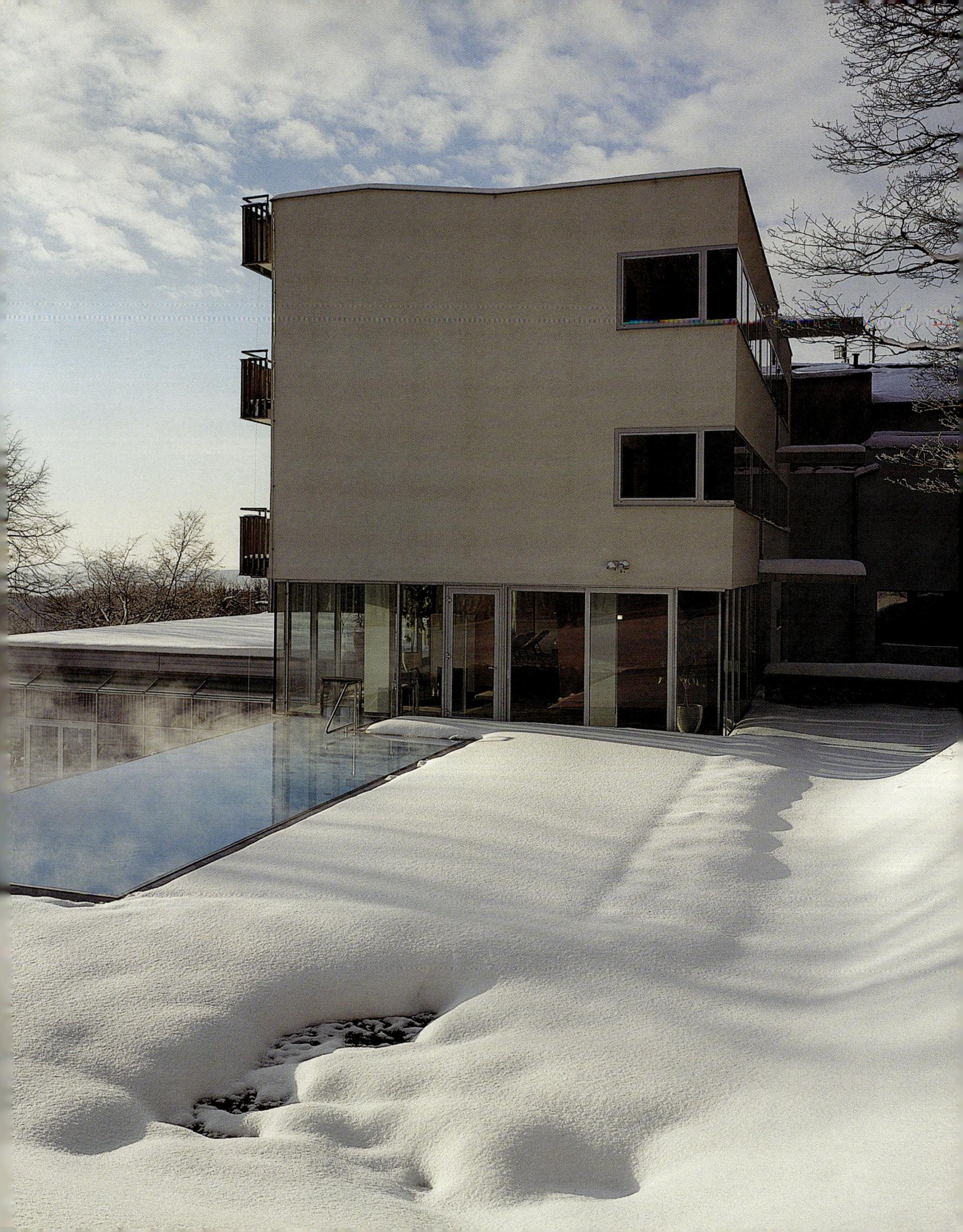

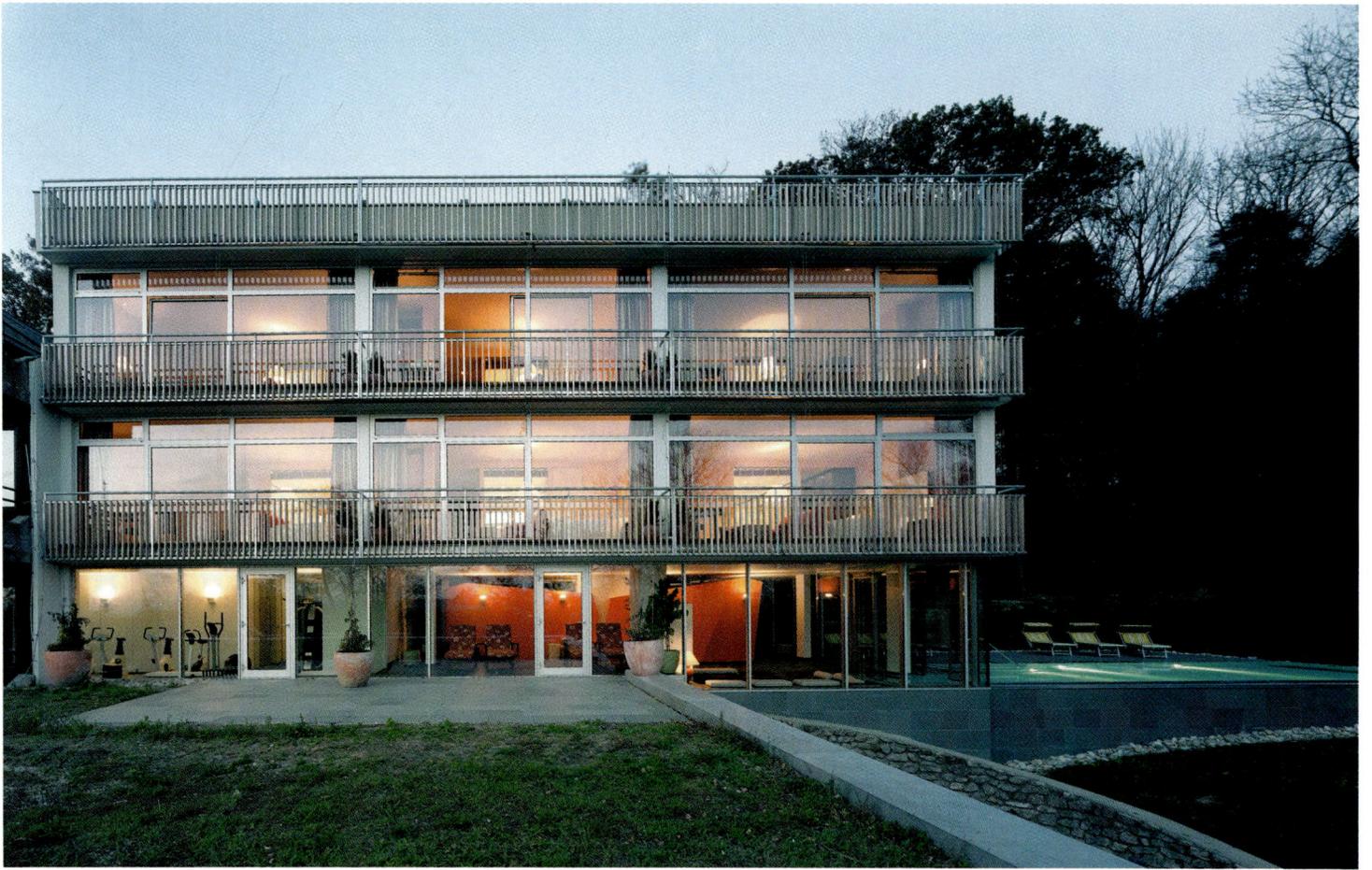

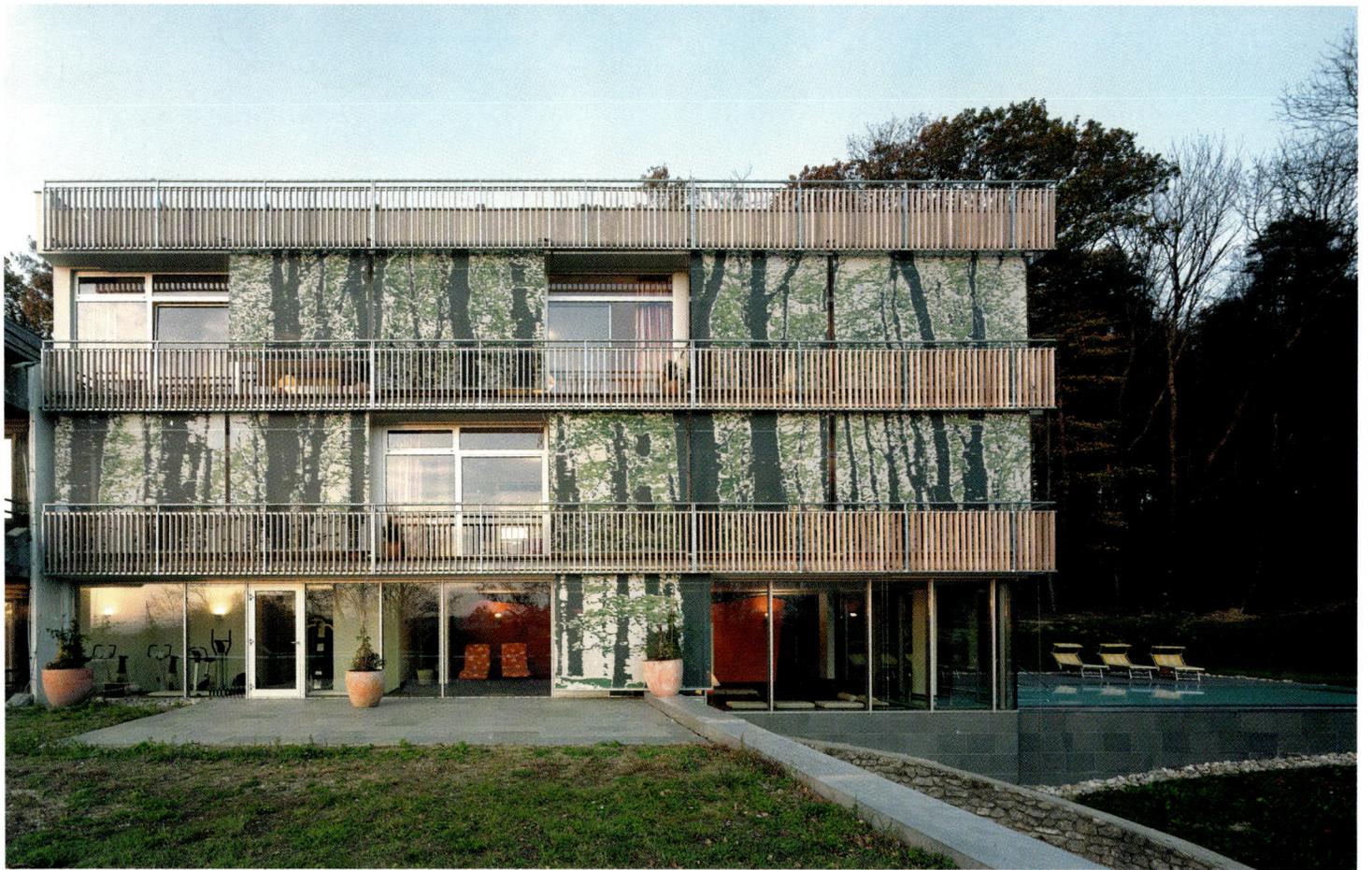

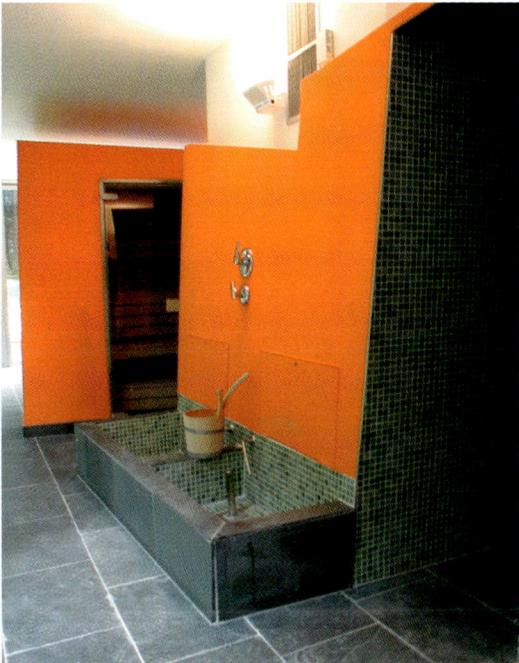

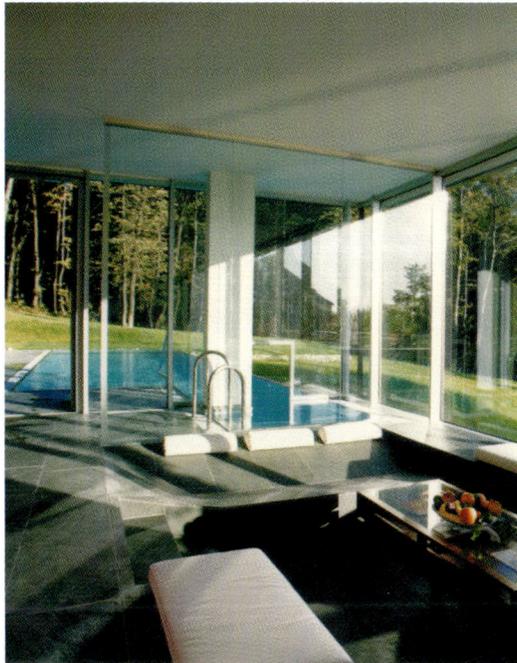

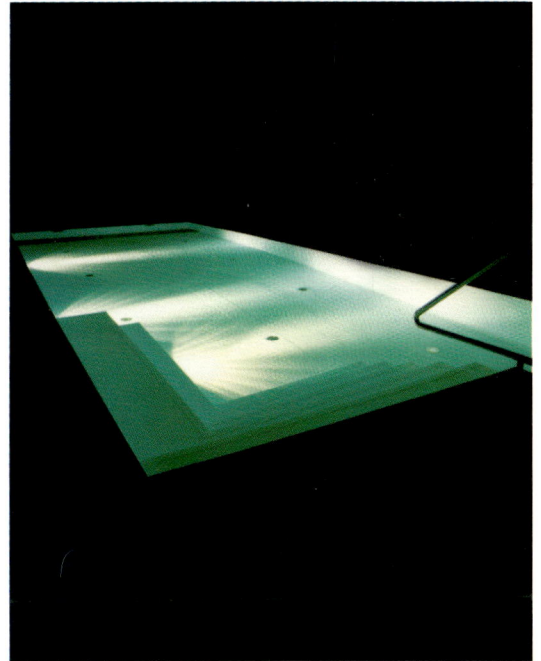

In the spa area an angular play of geometric shapes, rich textures, and bright colors enrich the interior space, which contrasts with the restrained, surrounding exterior landscape.

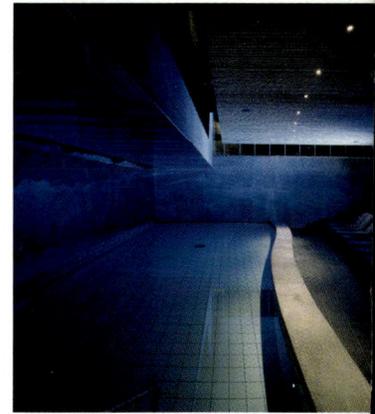

Black
Spa

Florianigasse 15, 6370 Kitzbühel, Austria Tel: +43 05356 6911 hotel@adlerkitz.at www.adlerkitz.at

The Black Spa is located on a fairly narrow triangular lot in downtown Kitzbühel, a small city in western Austria. It is an extension of the nearby Schwarzer Adler Hotel. The first floor connects to the basement, which reflects all the traditional elements of Tyrolean architecture, and is meant to contrast with the rest of the space. The underground location, and the way the openings to the exterior are constructed, makes this a real refuge from the bustling outside. A long, greenhouse-like space provides the treatment area with natural light and connects to the main pool. The light flows in and spreads throughout the interior by the reflections of the water. The metal leafing over the ventilation ducts emphasizes the effect of the light and water.

The project invokes sensations and spatial qualities that range from caves to water worlds to meditation spaces. Despite the drama created by the use of light and color, the hotel was built with low-cost materials, which, according to the architect, emphasize its sensuality. On the top floor there is a gym that faces the exterior and a garden has been planned for the roof. Regardless of its name, which refers to the black floors in the rooms, color is very important and present throughout the spa.

Architects: **Wolfgang Pöschol, Thomas Thum** Photographer: **Paul Ott** Location: **Kitzbühel, Austria** Opening date: **2000**

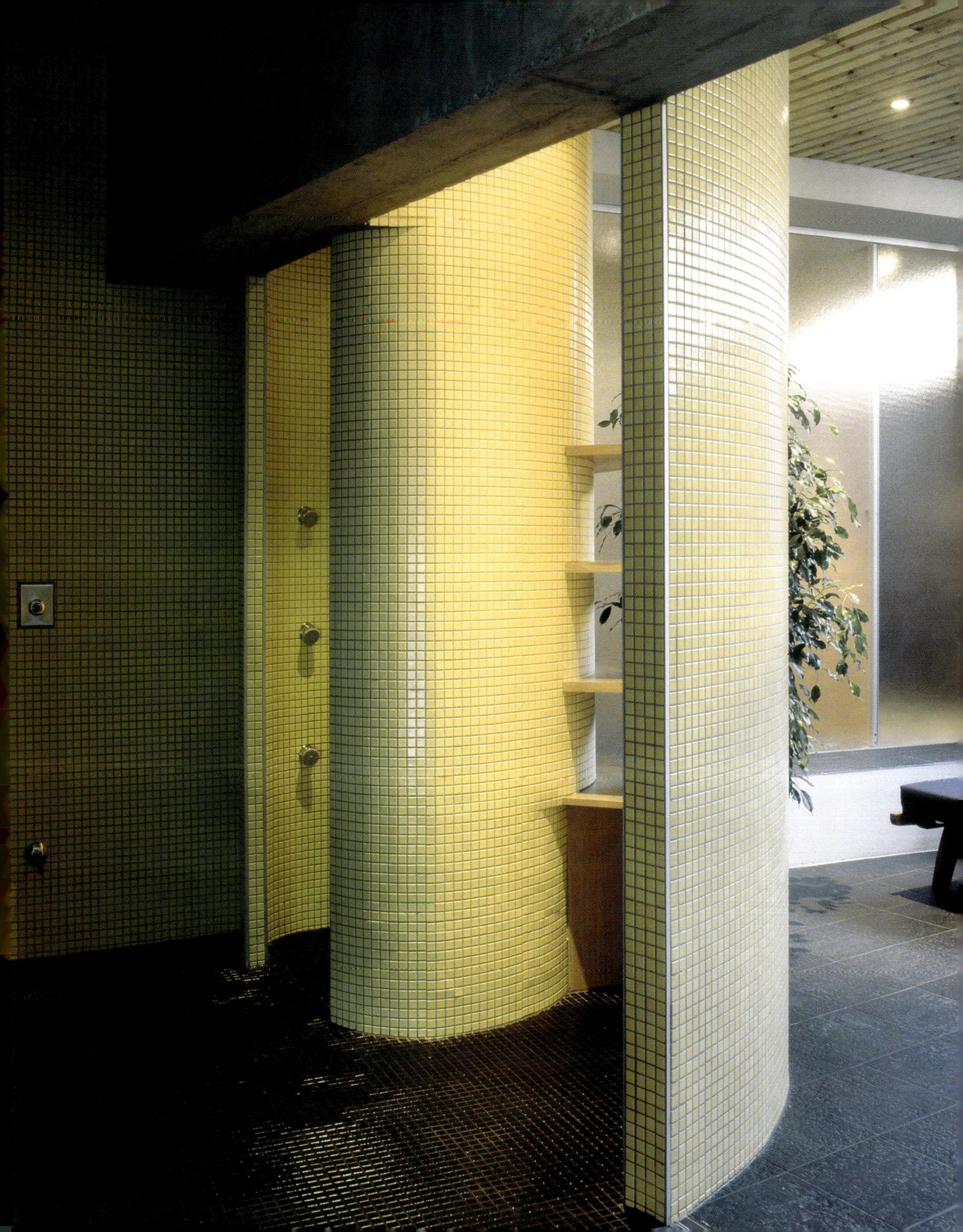

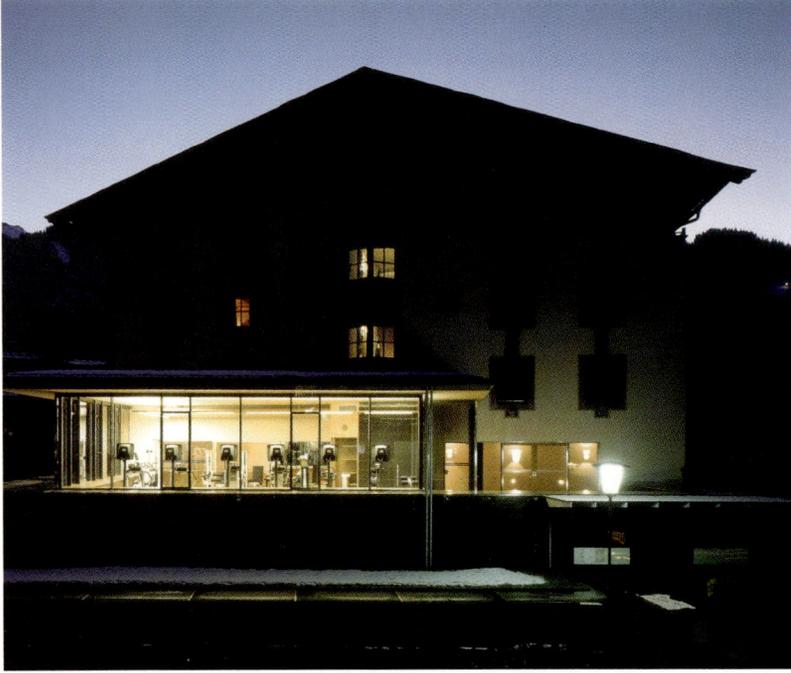

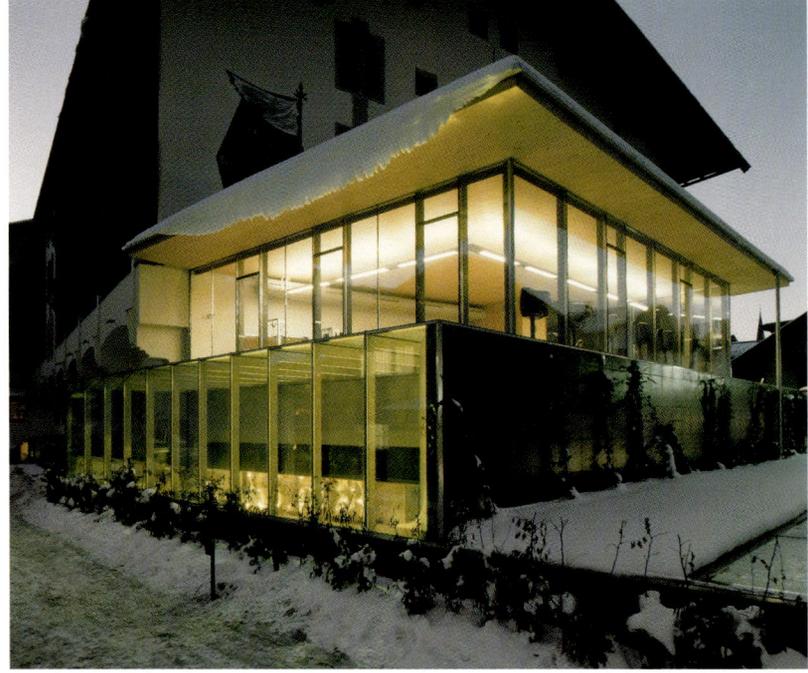

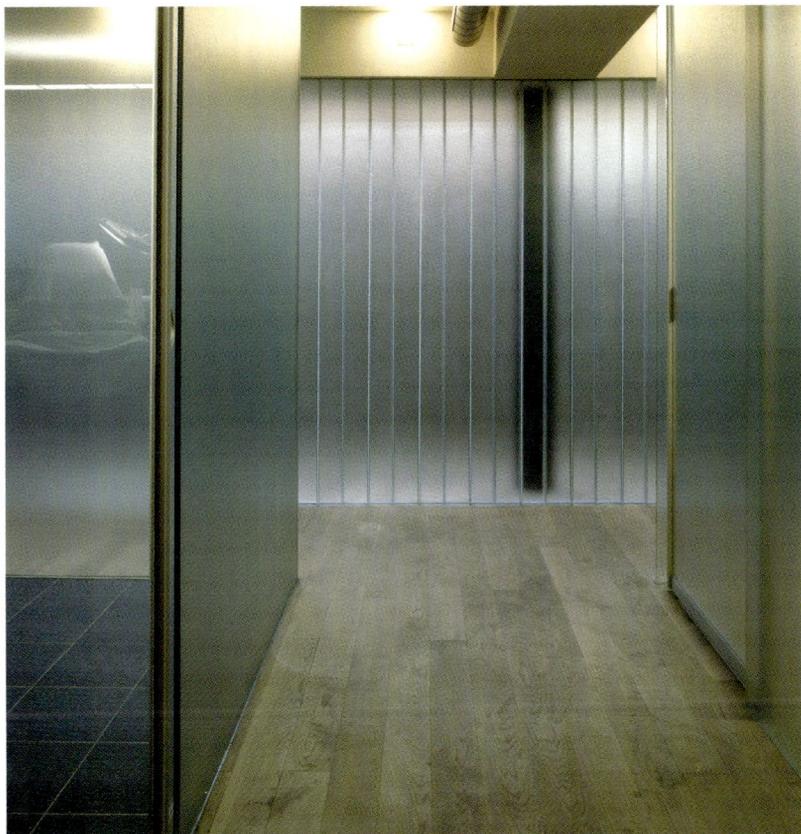

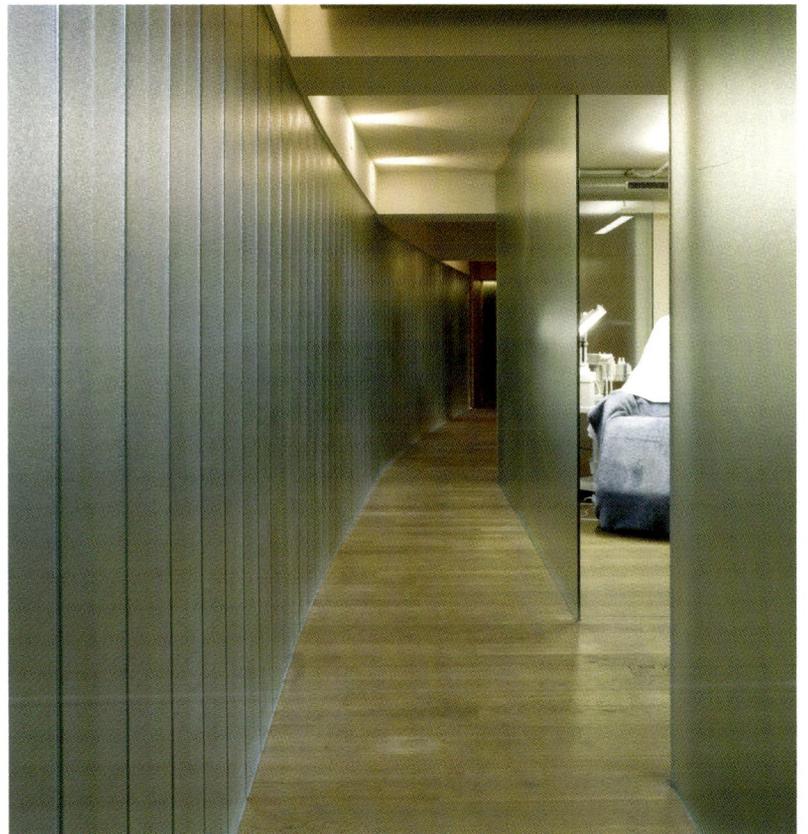

Lightweight, translucent materials allow natural light to flow from space to space and create a clean atmosphere, constantly repeating the water metaphor.

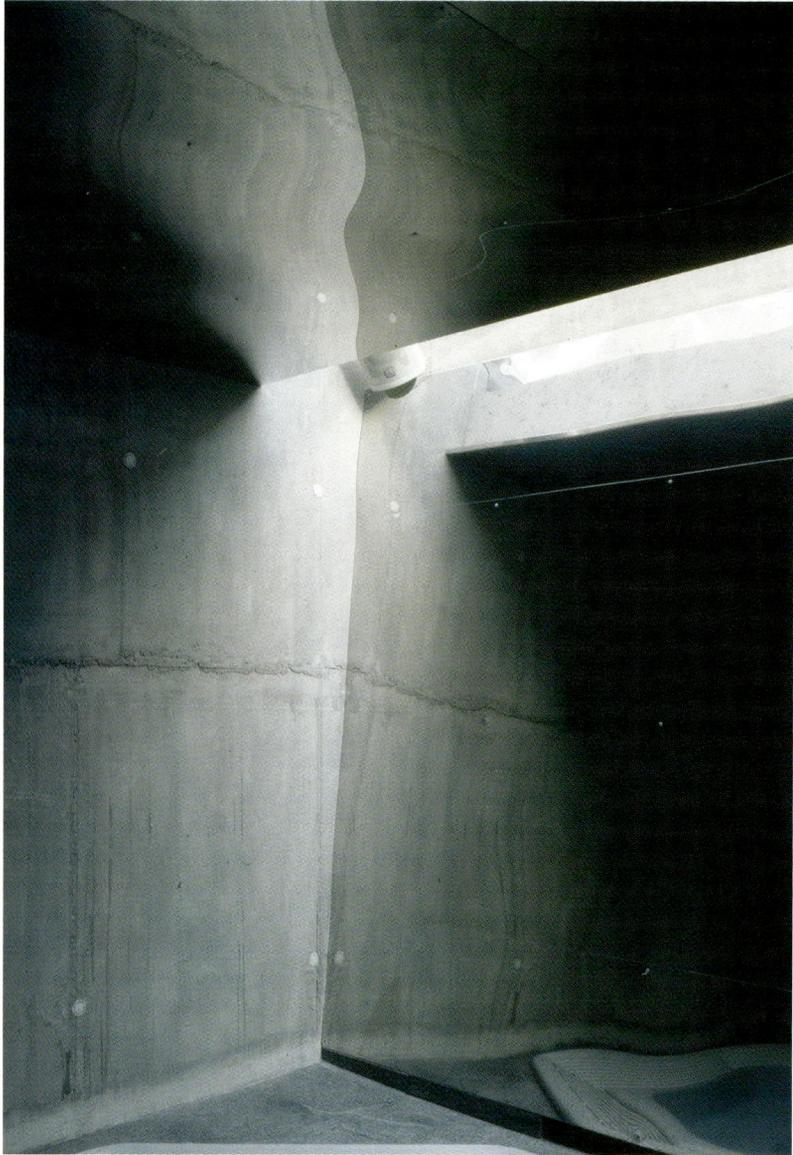
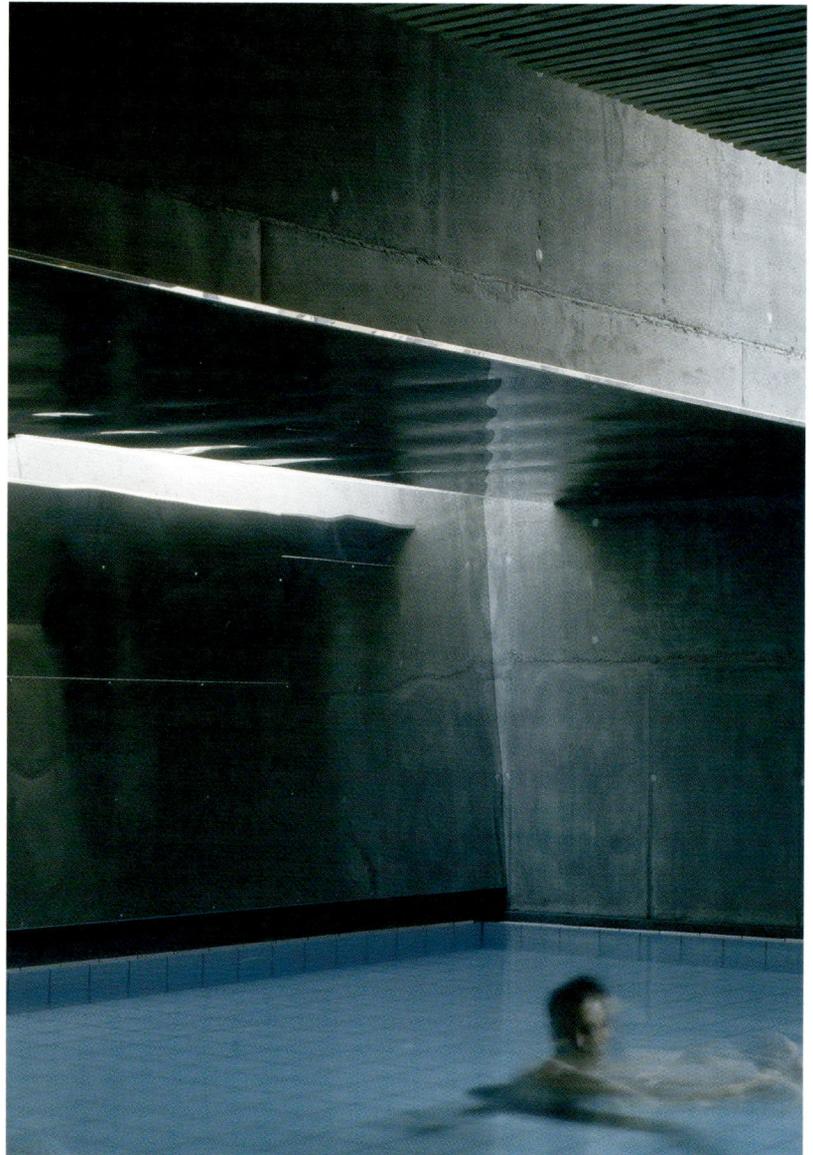

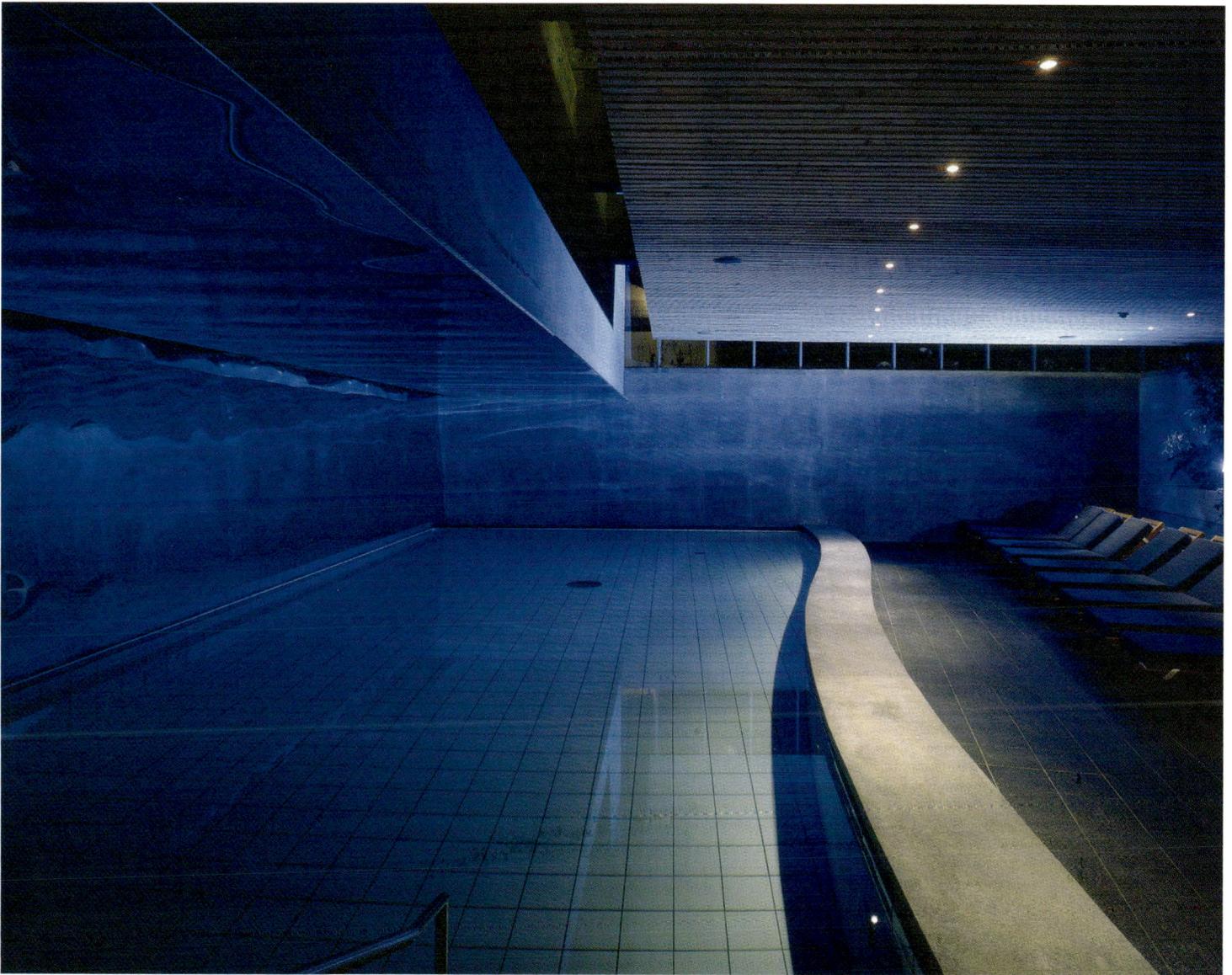

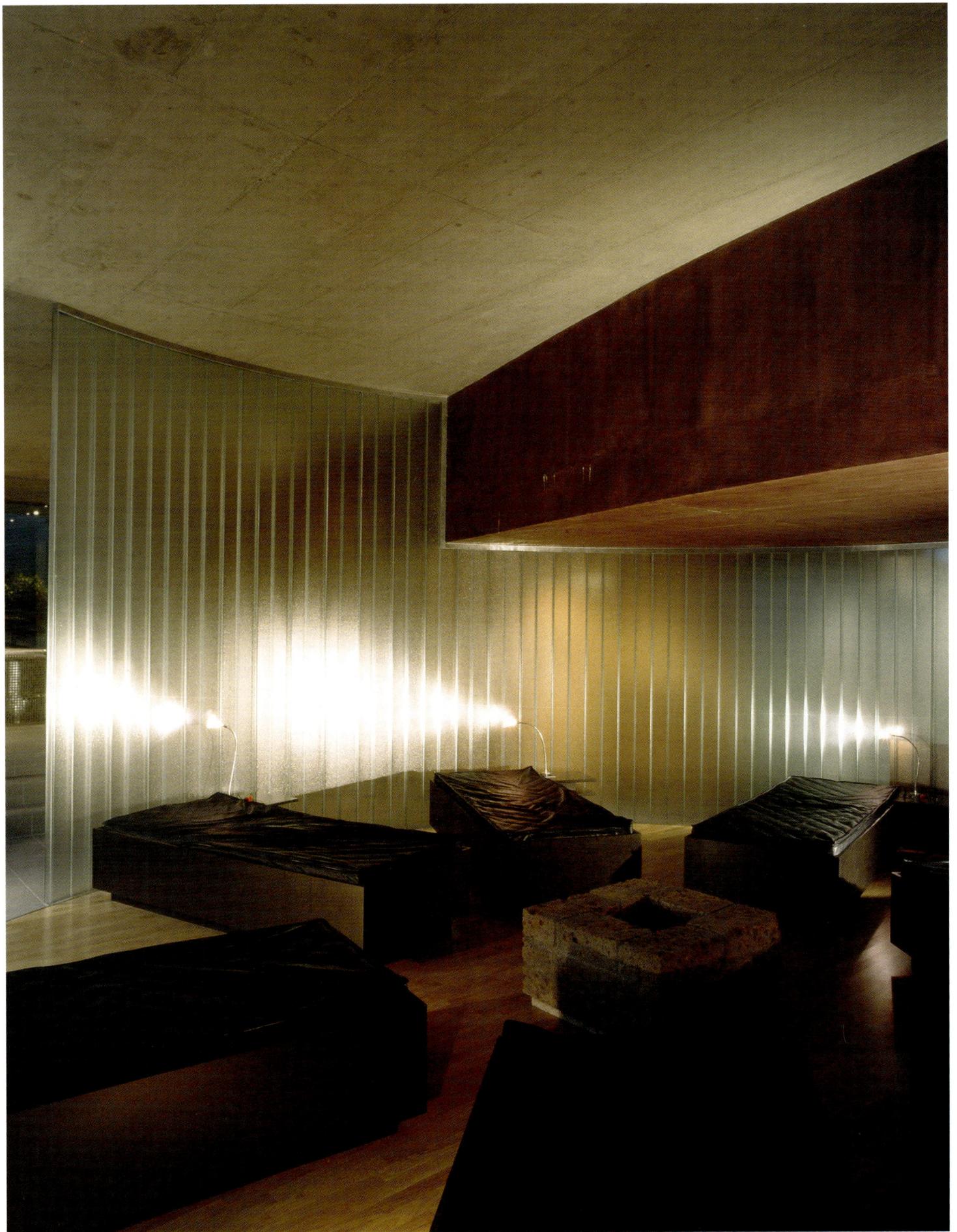

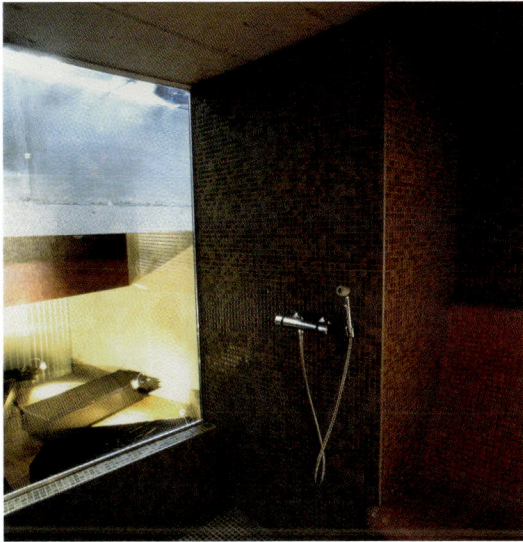
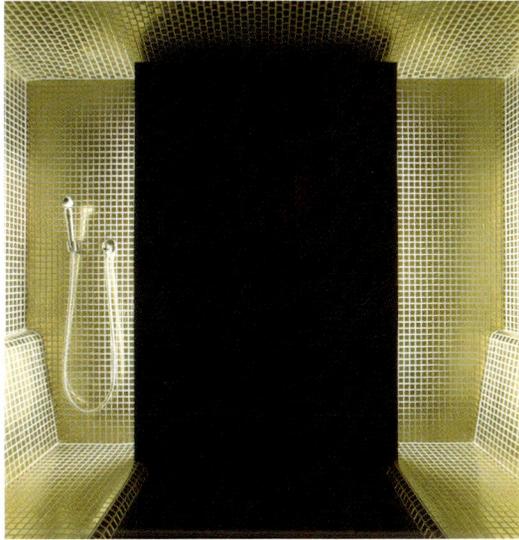
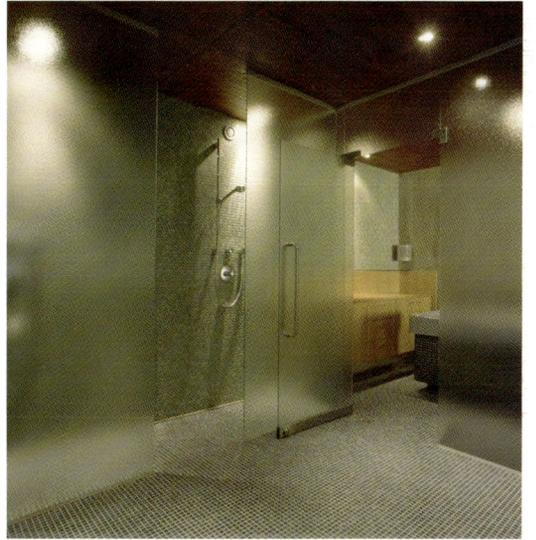

The careful use of color and lighting highlights contrasts, more so than luxurious materials or complicated details, and brings a sense of sophistication and drama to the project.

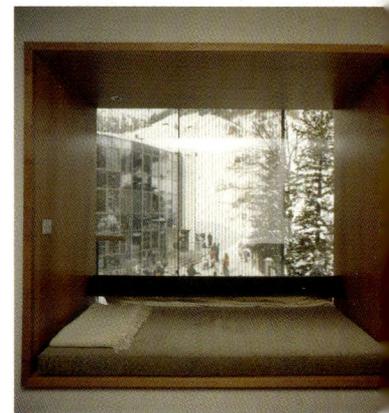

Anton

6580 St. Anton am Arlberg, Austria Tel: +43 05446 2408 Fax: +43 05446 2408-19 www.anton-aparthotel.com

Tyrol's extreme surroundings strongly influence the kind of tourism and hotels found in this area. The Anton Hotel, in the town of St. Anton am Arlberg, is a new interpretation of the traditional model but one that adapts to the area's dizzying demand for hotels, as well as to the needs of the contemporary traveler in search of someplace authentic with its own unique character. In this sense the Anton Hotel continues in the tradition of the typical Tyrolean ski lodge, but at the same time incorporates new materials and technology that attract visitors and make the hotel a special space. The materials used, including the light wooden structures supported by a backbone of reinforced concrete combined with metal and glass, provide a new, up-to-date image for the area's traditional types of hotels.

The cleanness and flexibility of the forms were the principal factors in designing the workings of the building as well as its exterior and interior appearance. The rooms vary in size and are connected, often by a kitchen that comes with one or two of the rooms, making the spaces into much larger suites. The interior of the rooms is similar to the area's traditional ski lodges, but moveable panels, bathrooms done in glass, and luminous colors create a very contemporary atmosphere. A combination of efficient and inventive design is the main feature of the entire building.

Architects: Wolfgang Pöschol, Comploj Dieter, Thomas Thum Photographer: Paul Ott Location: St. Anton am Arlberg, Austria Opening date: 2000

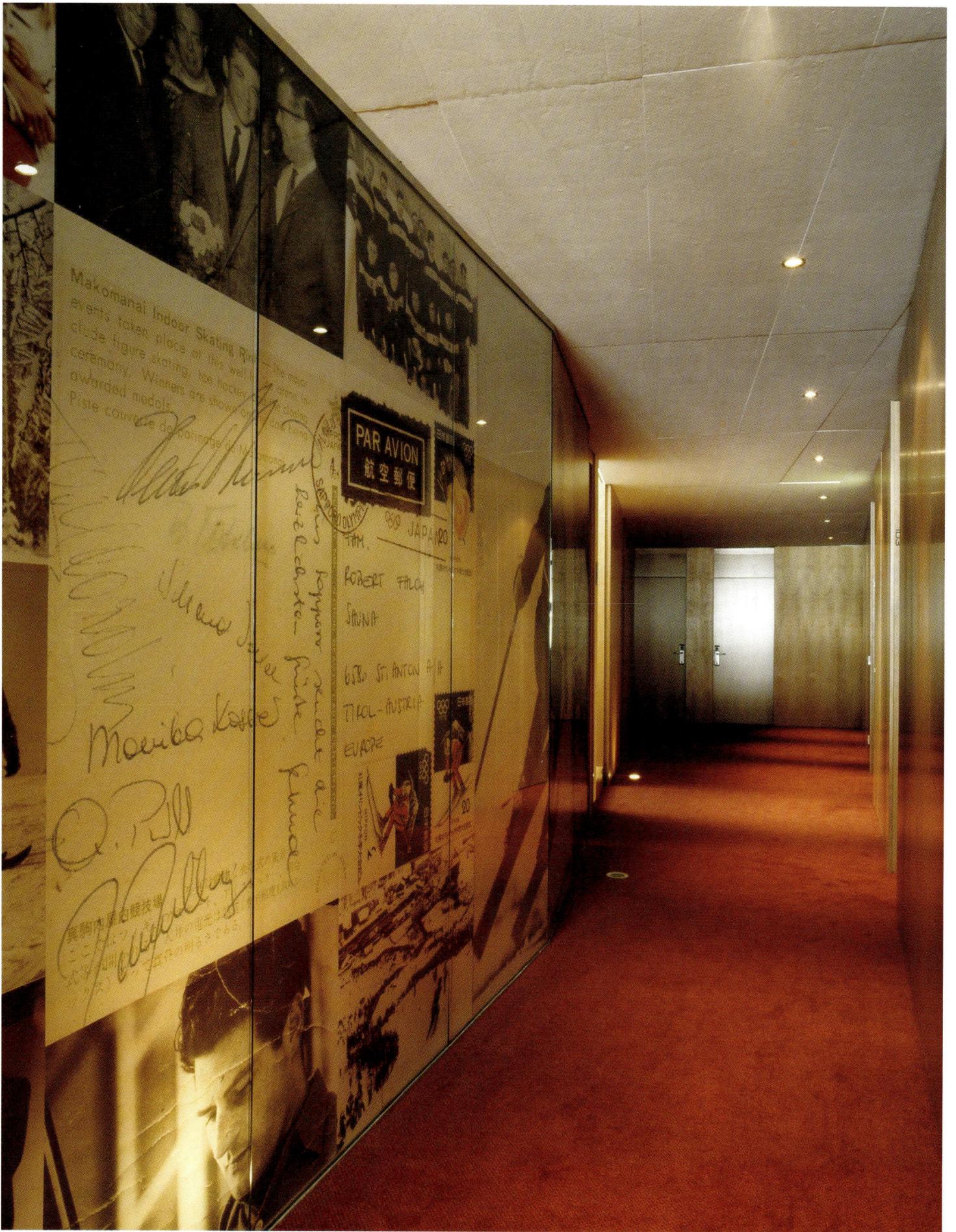

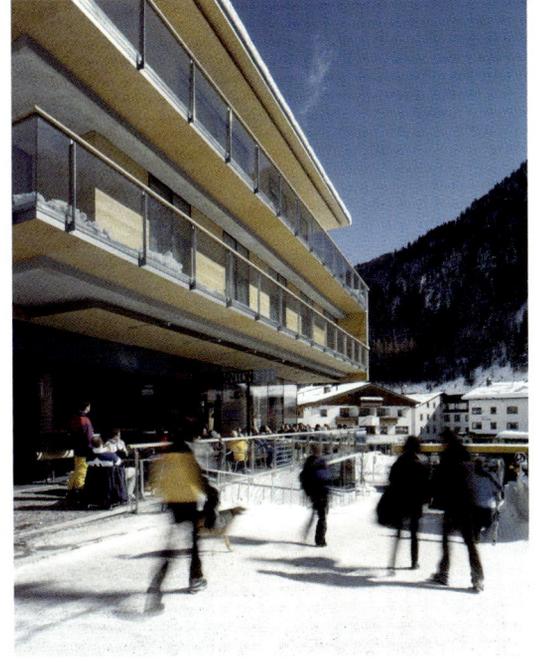

Long balconies that run along the façade emphasize the flexibility of the interior while allowing for a better view of the magnificent landscape around the building.

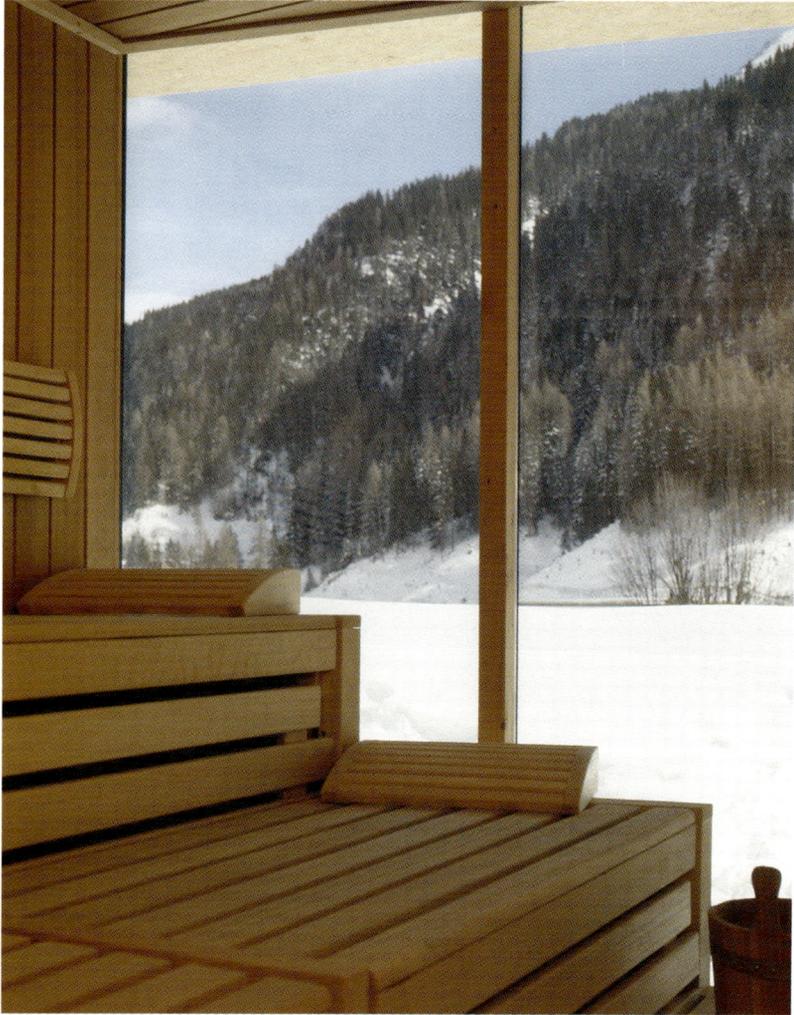
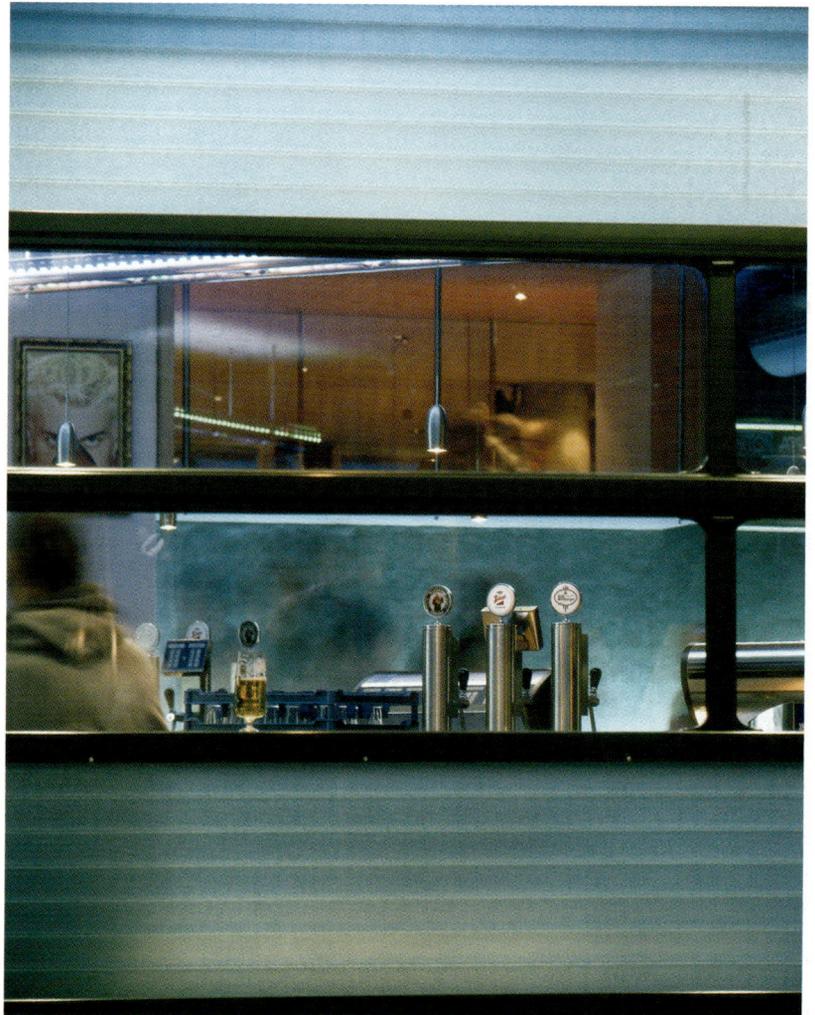

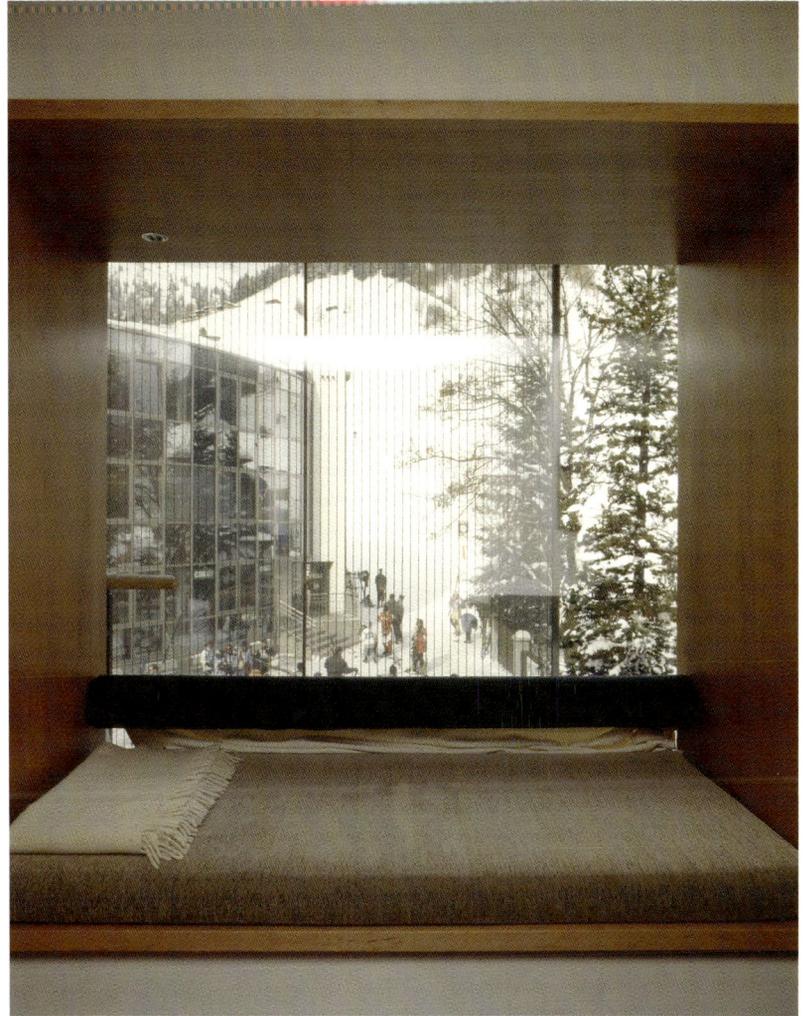

Careful details were incorporated in order to improve the interior of the rooms, such as mirrors on the connecting doors. Such details provide stronger sound-proofing so the uncomfortable sensation that these doors can trigger in a hotel is avoided.

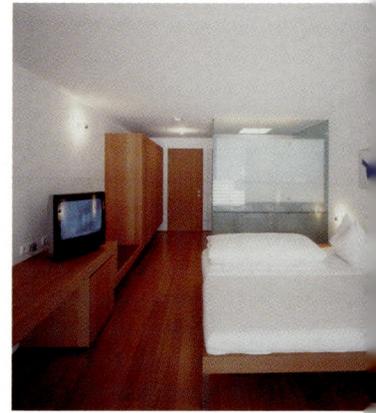

Hotel
Post

Brugg 35, 6870 Bezau, Austria Tel: +43 5514 2207-0 Fax: +43 5514 2207-22 office@hotelpostbezau.com www.hotelpostbezau.com

This building is an extension of a mountain hotel in Austria, and was built to house twenty additional guest rooms and a conference room. The prevailing factor in the design, aside from the architectural features, geographic, and climate conditions, was the short time in which it had to be built. The construction had to be completed in just four weeks, while the hotel was closed for vacation. Consequently, the architects resorted to a prefabricated system that allowed for most of the work to be done in advance and the pieces to be assembled in just two weeks. The building consists of a solid base of exposed reinforced concrete that contains the conference room, on top of which a series of prefabricated "boxes" has been added that contains the rooms.

In order to save time, the prefabricated boxes had to contain as many constructive elements and interior details as possible. Except for the glass doors that divide the bathroom and living areas, the boxes already had all the finishes as well as the heating and plumbing installations. Each cell has its own self-bearing system, which consists of a metal frame about 13-feet wide and 24-feet long. The internal walls have been made out of chipboard panels and drywall for the final finishes. The space between the boxes is used for the installations. The floor of each one is done in light concrete, which retains and distributes heat and also blocks out sound.

Architects: **Johannes and Oskar Leo Kaufmann** Collaborator: **Albert Rüf** Photographer: **Ignacio Martínez** Location: **Bezau, Austria** Opening date: **1999**

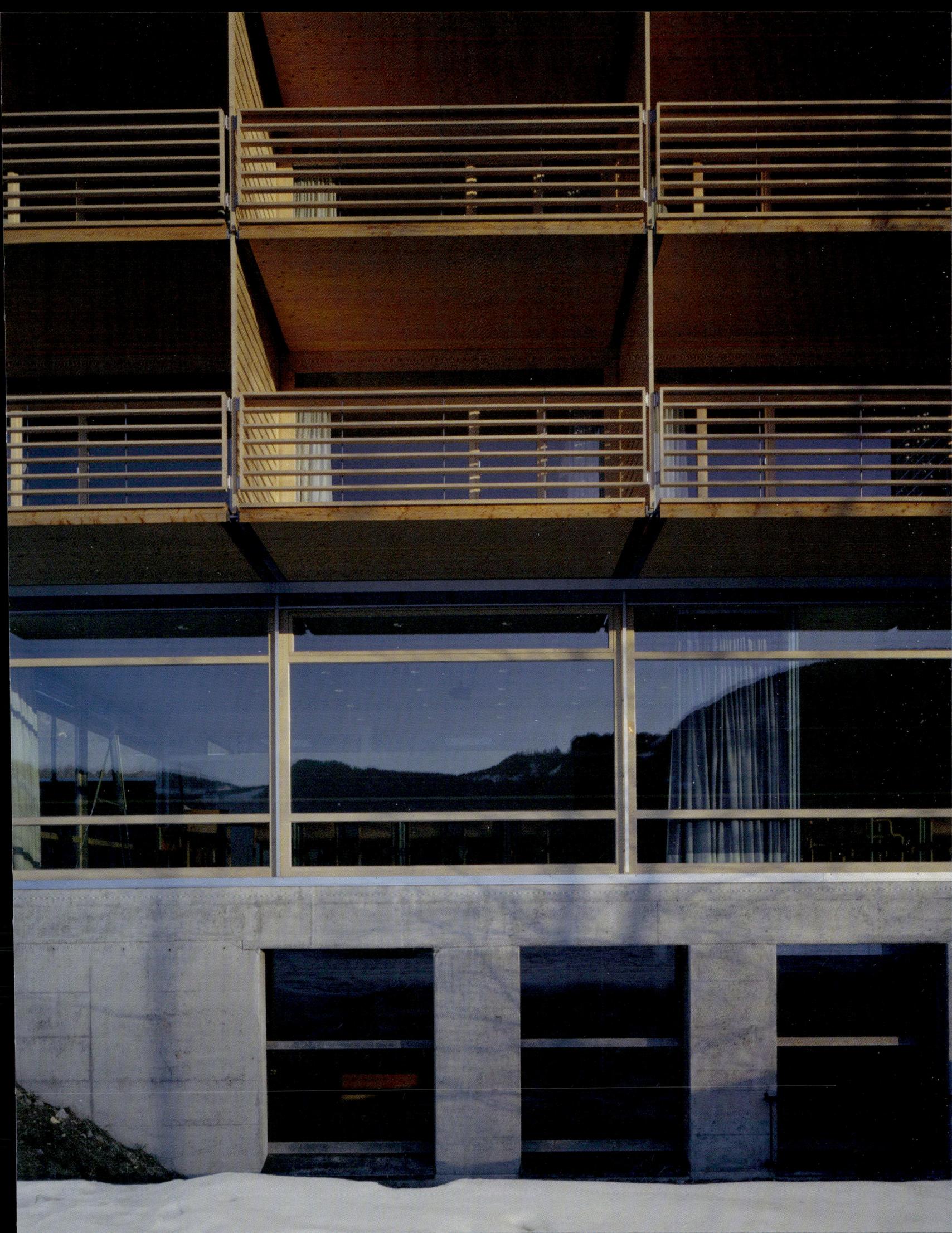

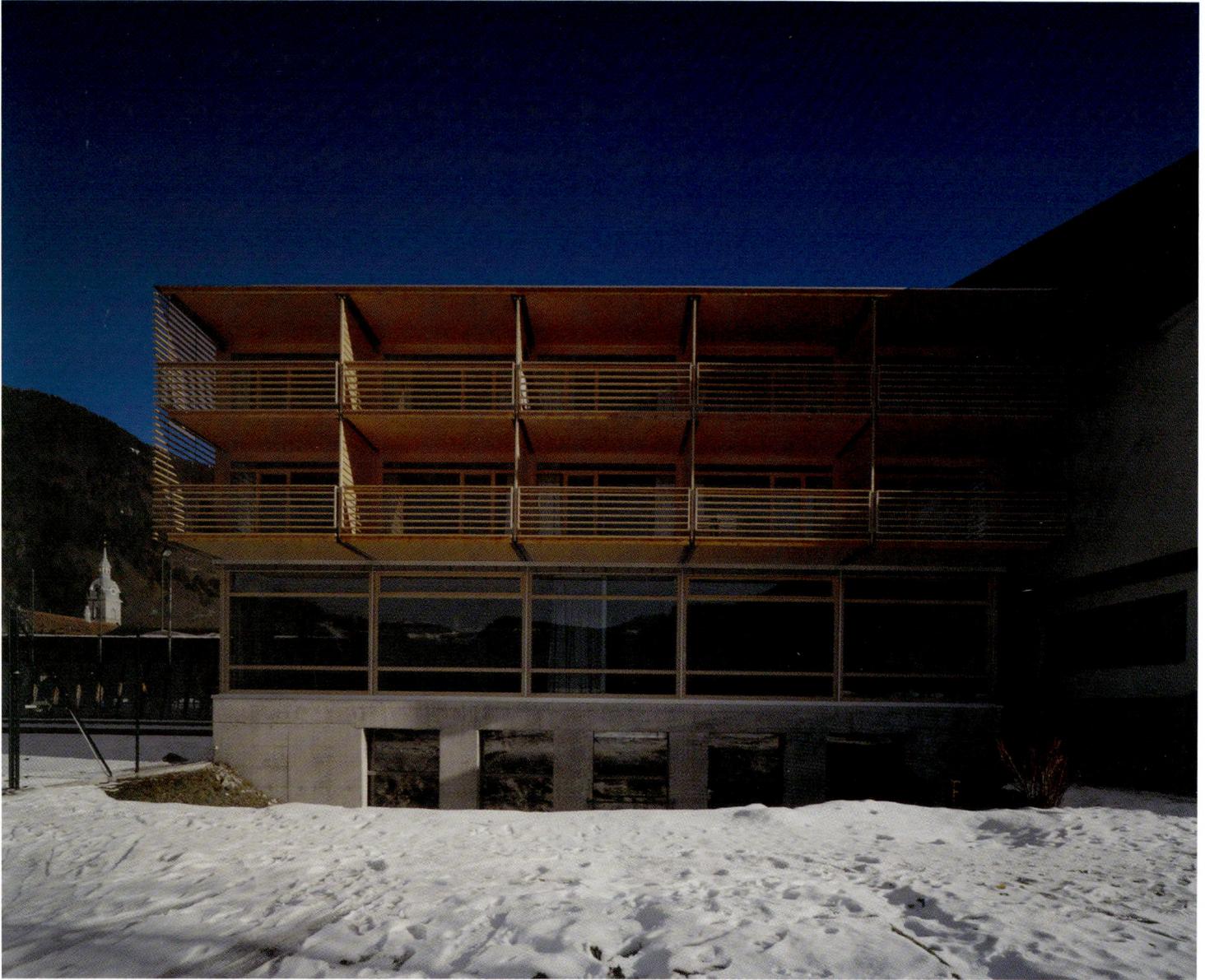

Assembling the boxes on top of the base of reinforced concrete took a total of two days. The system not only solved the time problem, but generated a light image that is respectful of the surroundings due to the use of materials such as wood and glass.

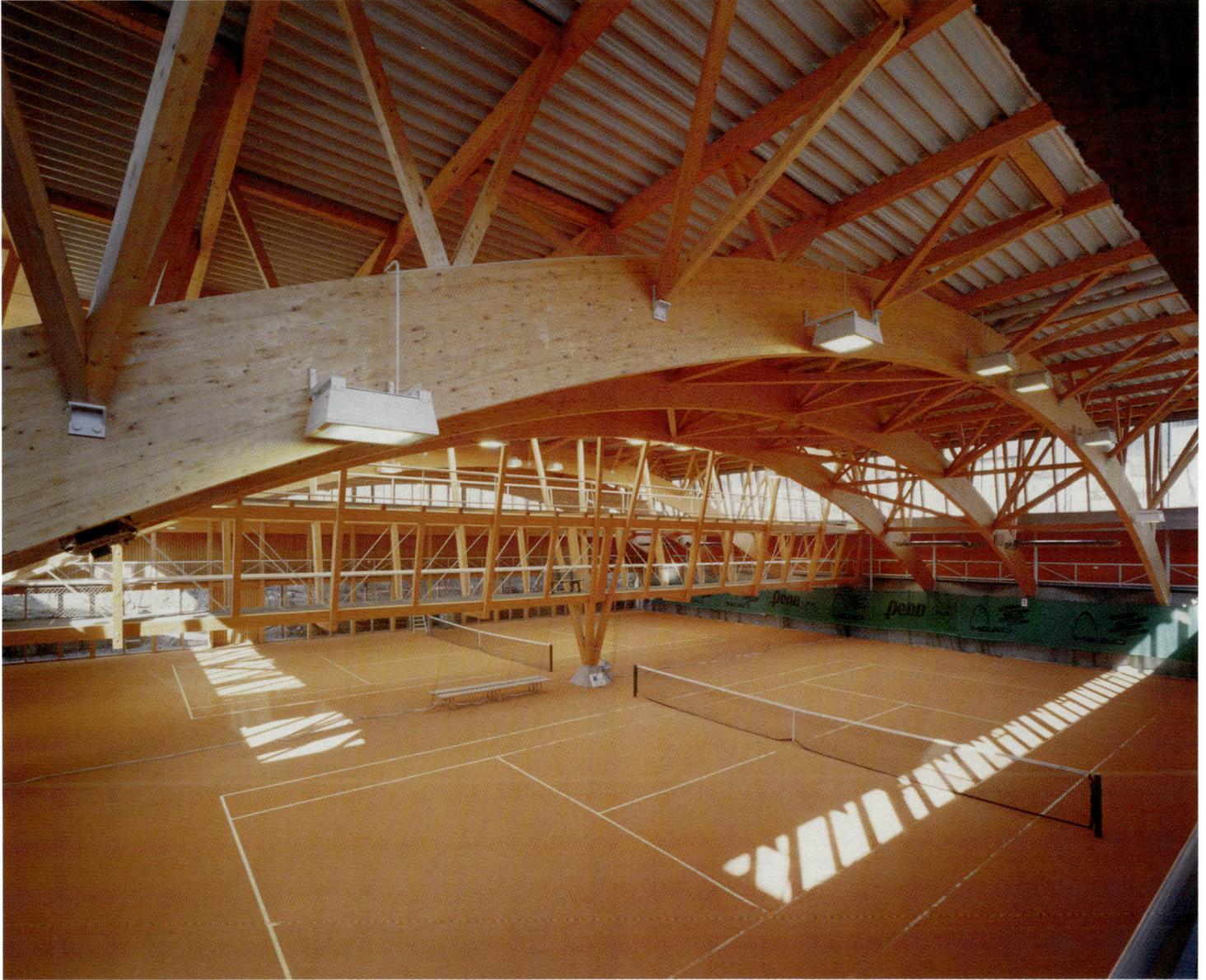

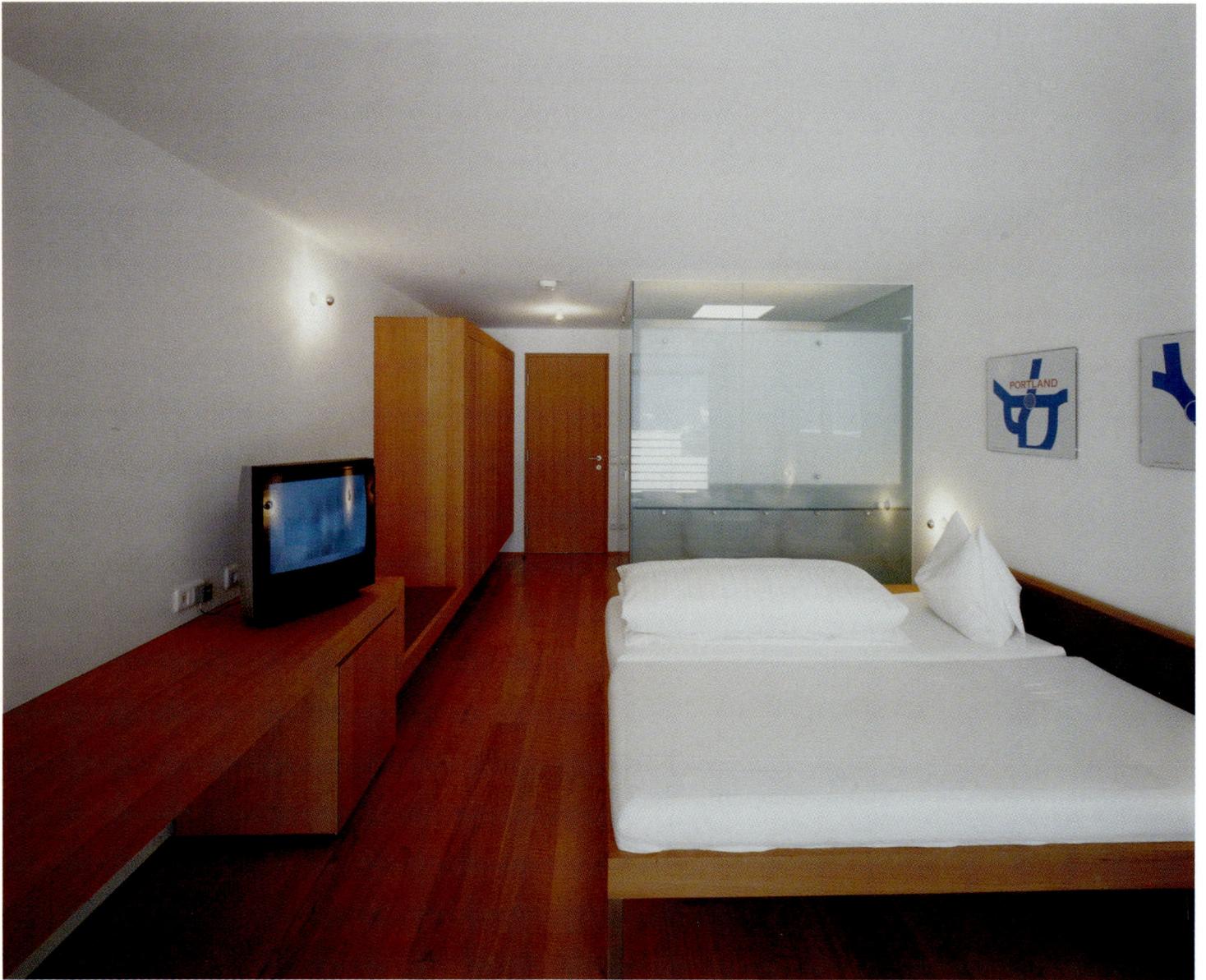

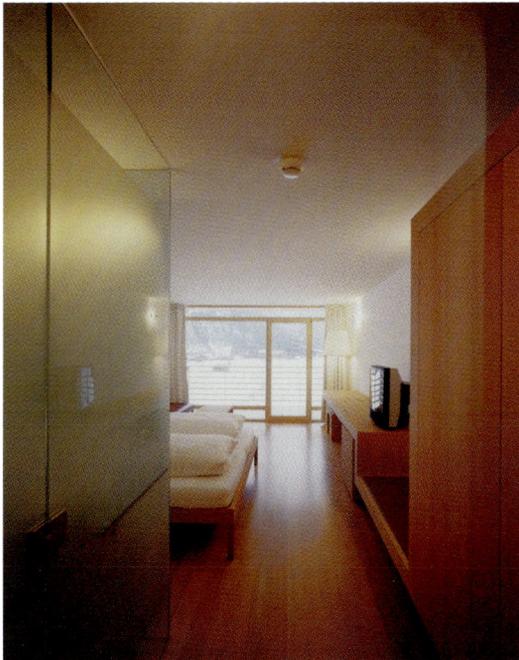
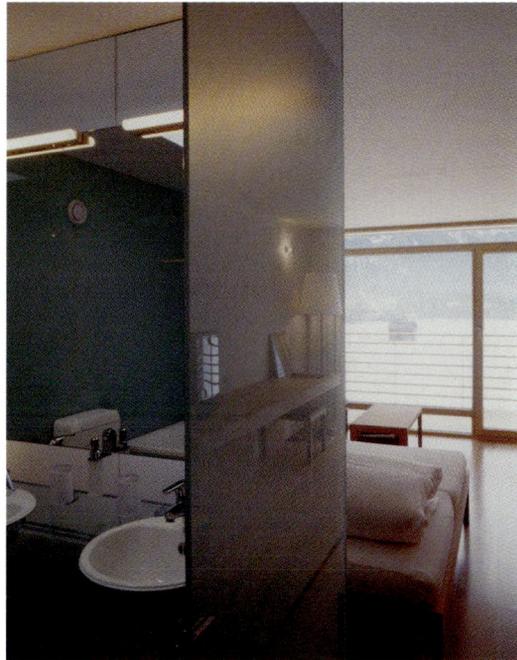
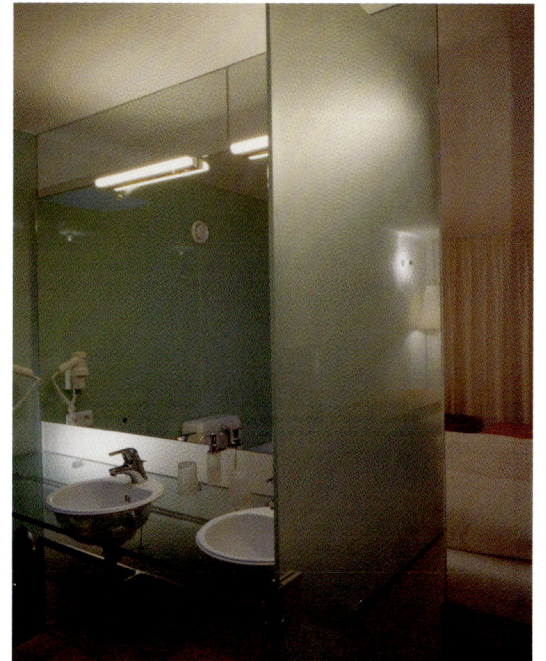

Despite the construction method, the interiors have a solid, contemporary appearance. The furniture, especially designed for the hotel, stands out due to its pure, geometric lines and light feeling. Wood, used for most of the furnishings, and glass, which separates the bathroom from the living area, are the prevailing materials.

HOT

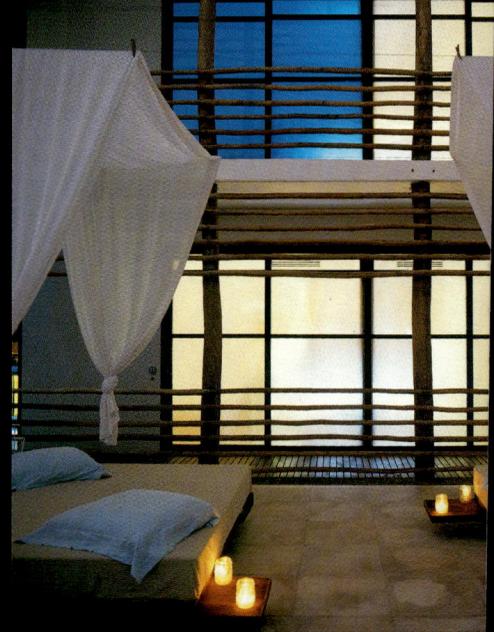

The tropics might just be the world's most popular vacation spot. The warm climate, variety of outdoors activities, exuberant flora and fauna, and proximity to the water are some of their many alluring natural features. In general the interiors of these hotels are in intentional contrast to their surroundings. Elements like blinds, pergolas, or curtains are often used as soft filters to help mark a change in place. Natural materials such as wood or stone are often used while various shades of white create a cooling effect, a welcome relief from the sultry outdoors.

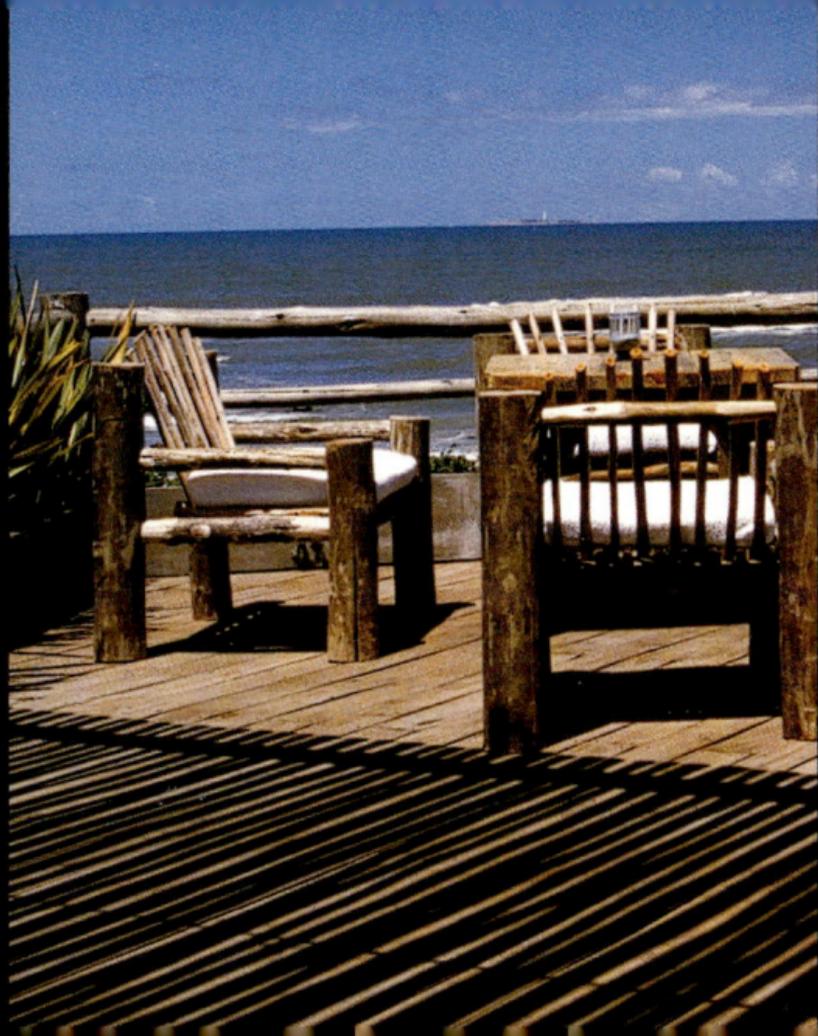

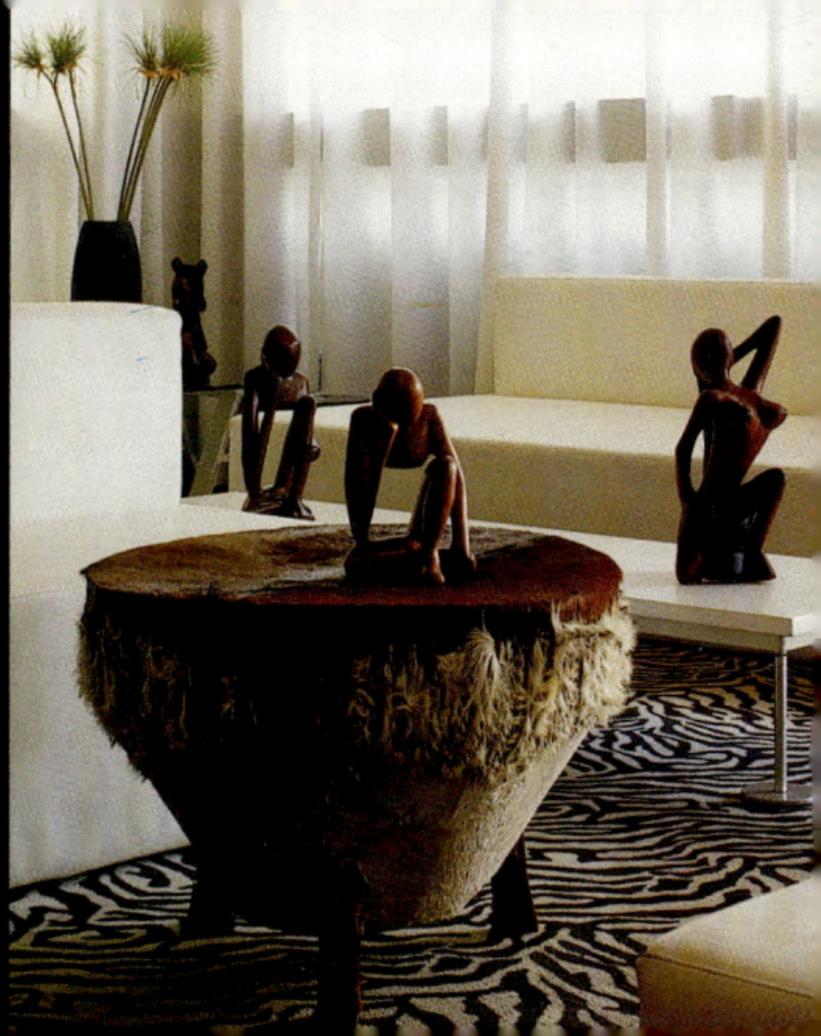

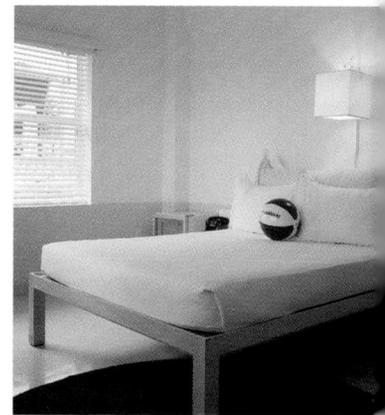

Townhouse

150 20th Street, Miami Beach, FL 33139, USA Tel: +1 305 534 3800 Fax: +1 305 534 3811 Meredith@townhousehotel.com www.townhousehotel.com

Townhouse was originally conceived as an alternative to the growing demand for hotels in South Beach, Miami. The initial idea, shared by the promoter and the designer, was to create a small hotel that was fun as well as welcoming. Without abandoning the glamour just outside the hotel's doors, they wanted to make it modest and affordable. The image and location of this building, built in 1939 in the northern part of South Beach and surrounded by the liveliest part of the city, defined the character of the renovation. The domestic feel of the structure was preserved, but somewhat influenced by the urban renewal that had taken place in the area over the last few decades.

Various traditional hotel concepts were modified in order to create a warmer, more fun atmosphere in the hotel's 69 rooms. The color red, used as a sort of trademark for the hotel, floods the interior and part of the exterior. Instead of the traditional pool, guests find a sundeck furnished with water beds and water sofas which create a playful scene and provide a setting for frequent nighttime meetings. Other more subtle decorative details, such as beach balls on the pillows instead of chocolates, give the hotel its relaxed, up-beat feel.

Designer: **India Mahdavi** Photographer: **Pep Escoda** Location: **Miami, USA** Opening date: 2000

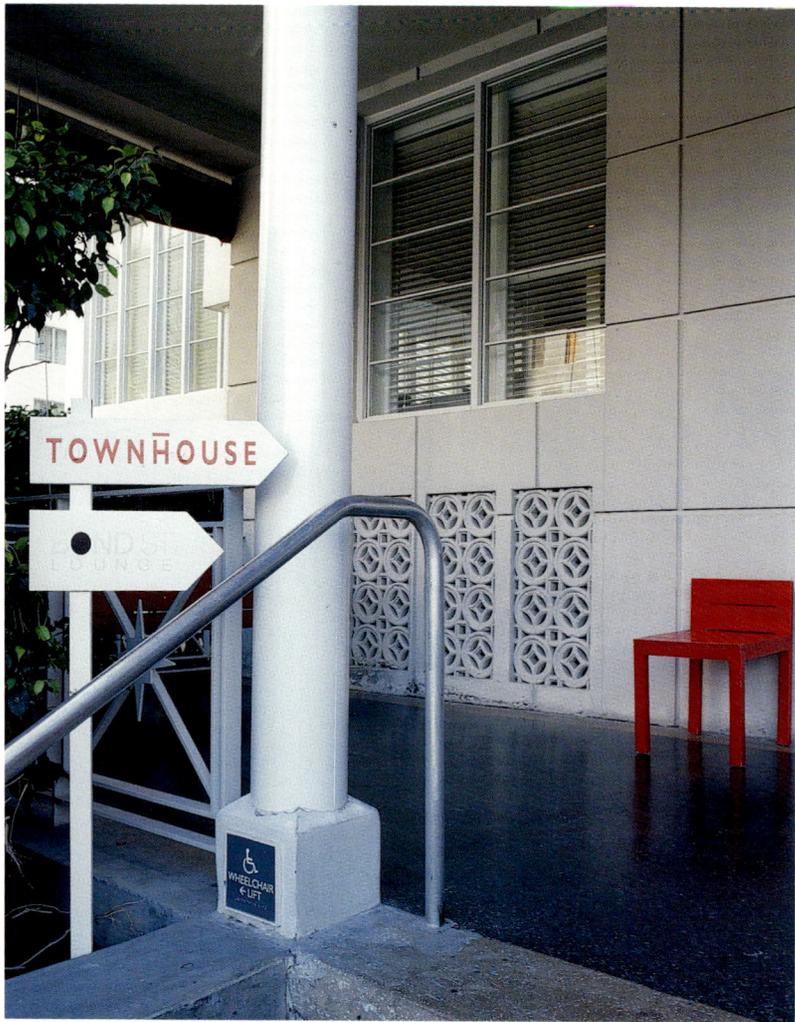

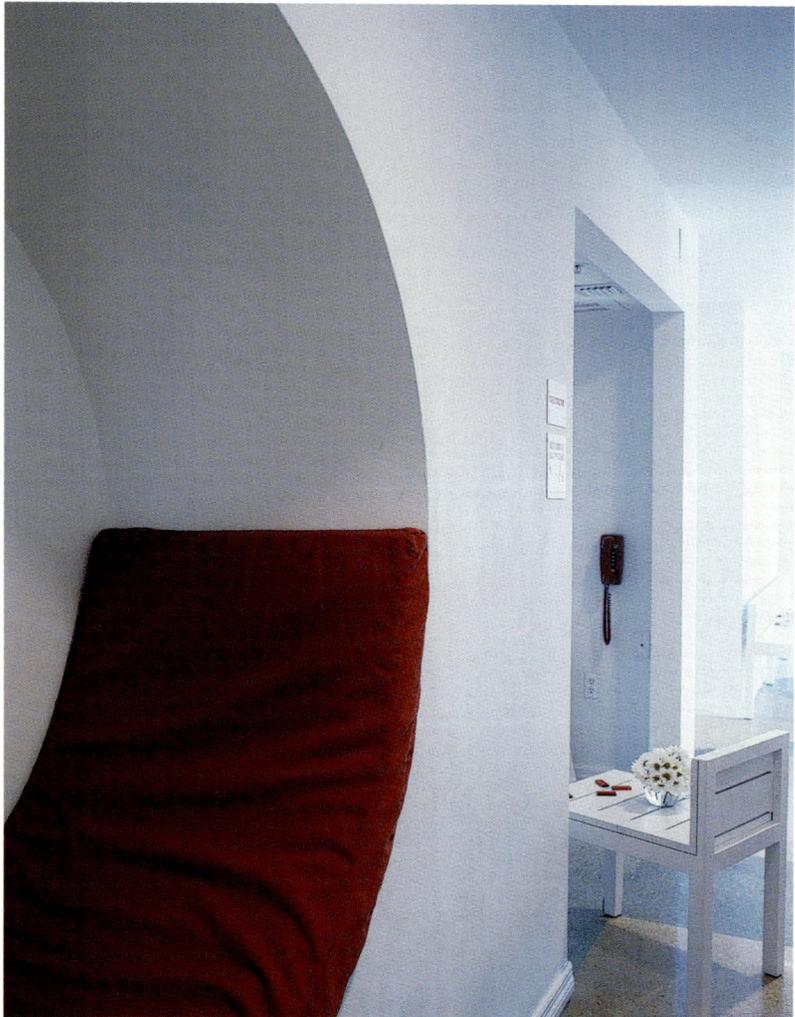

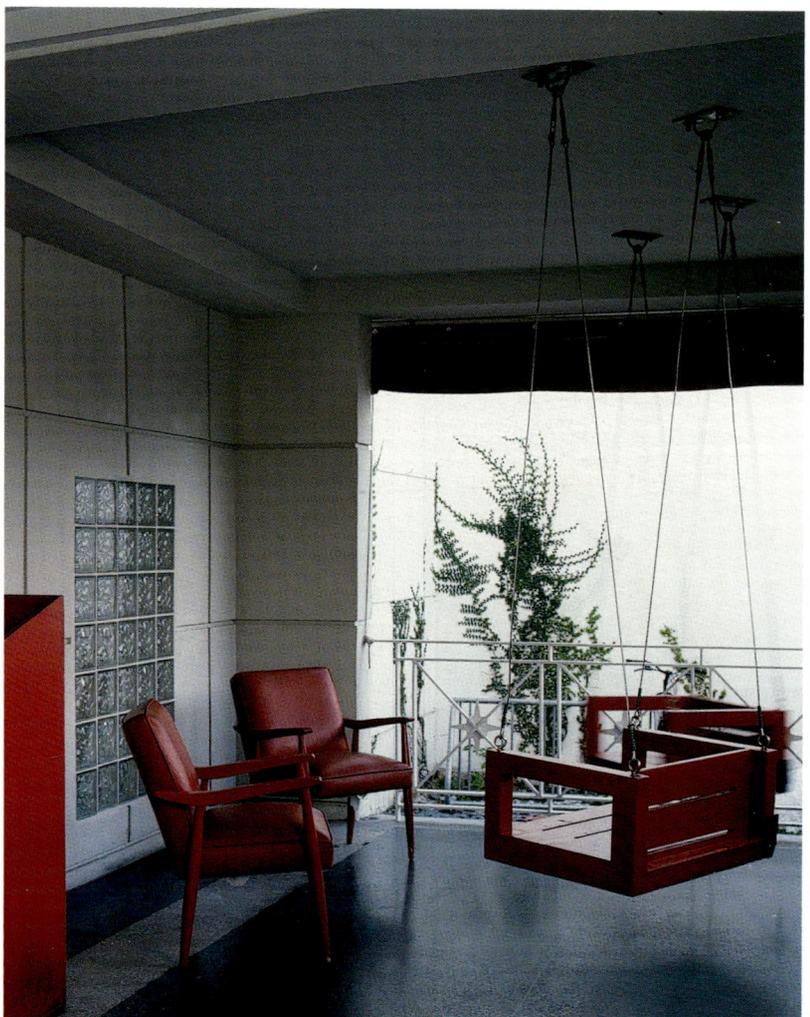

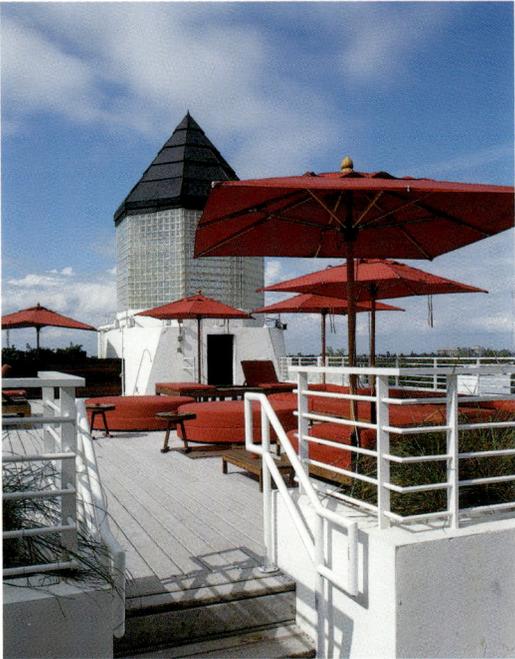

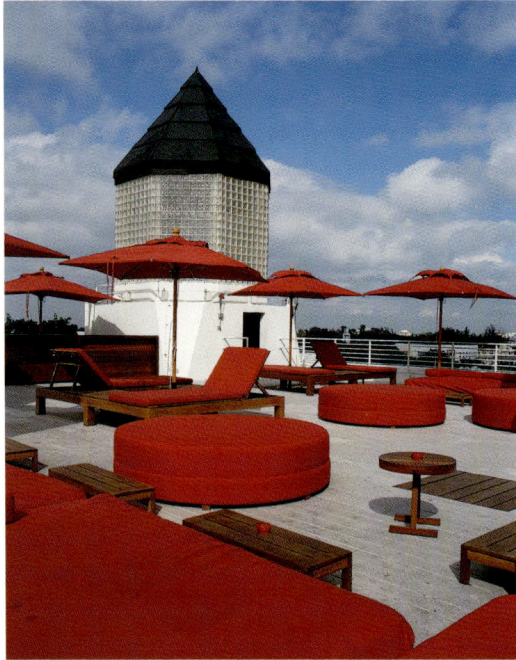

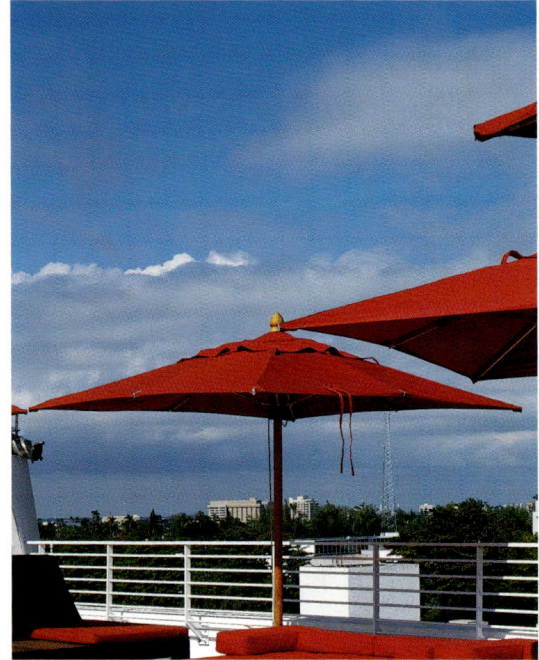

The color red is featured on the sundeck, covering the water beds and sofas and creating a striking contrast against the white deck and the intense blue sky.

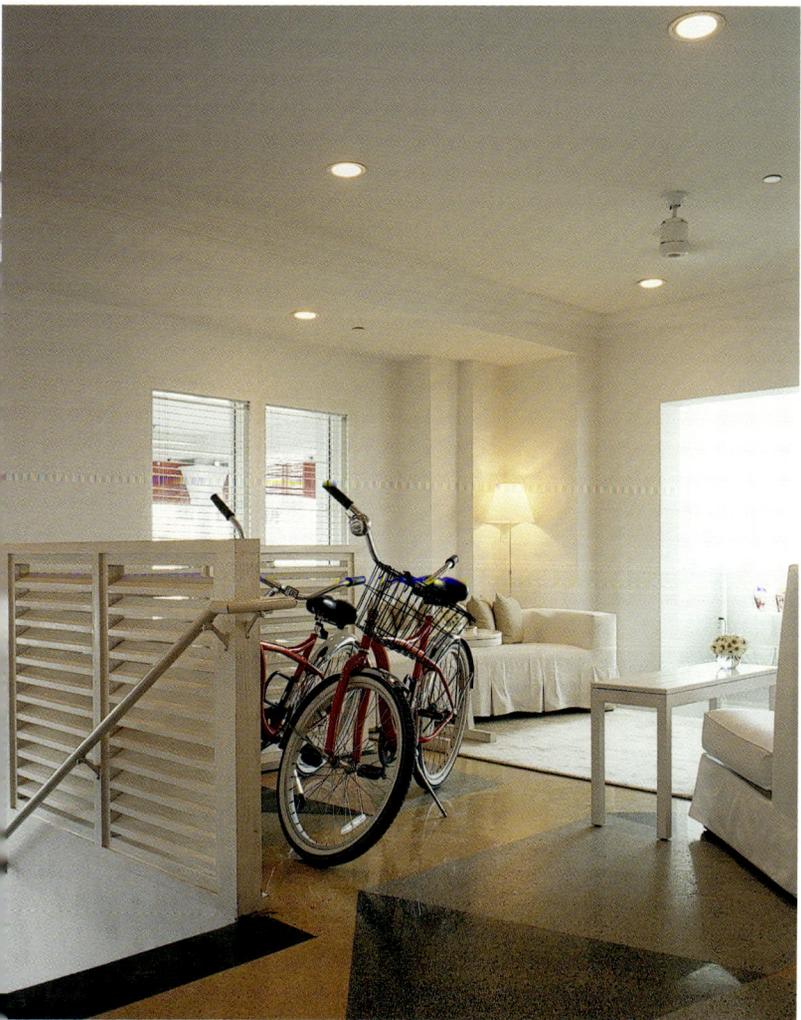

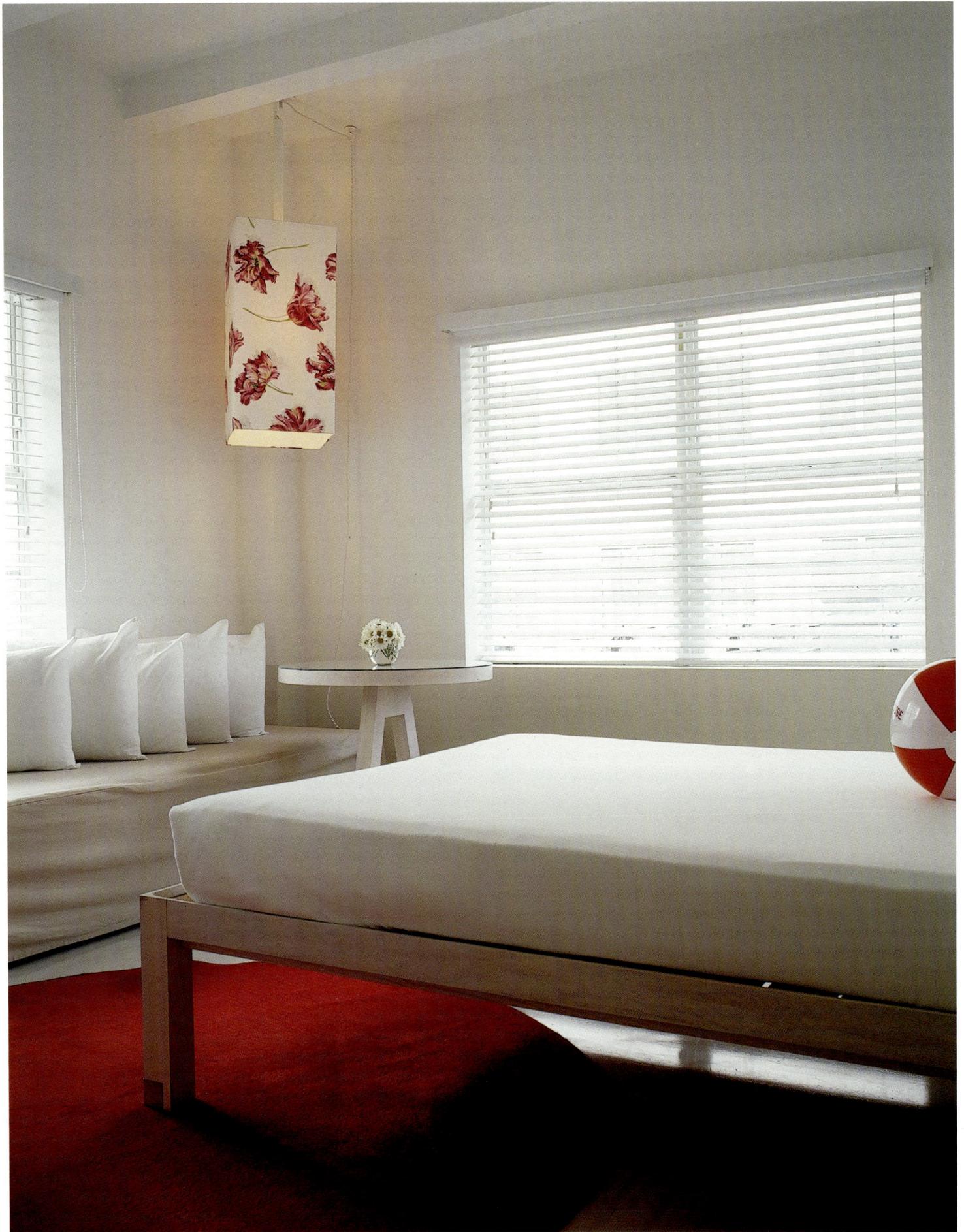

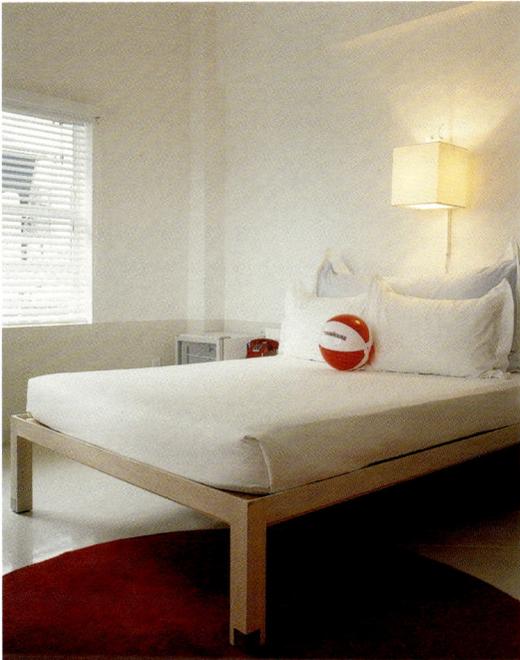
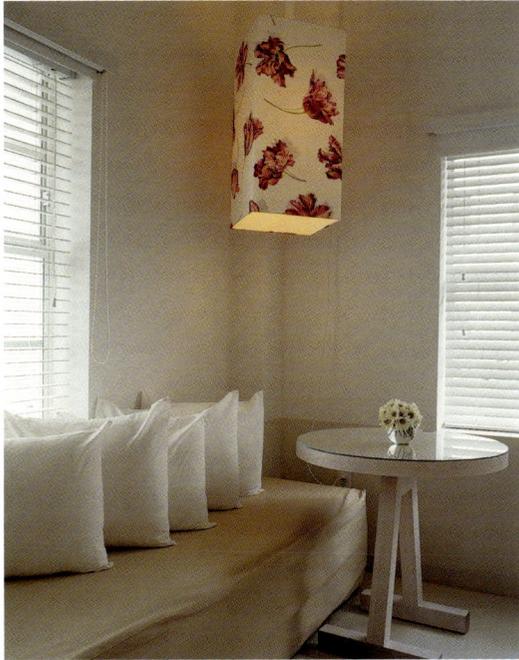
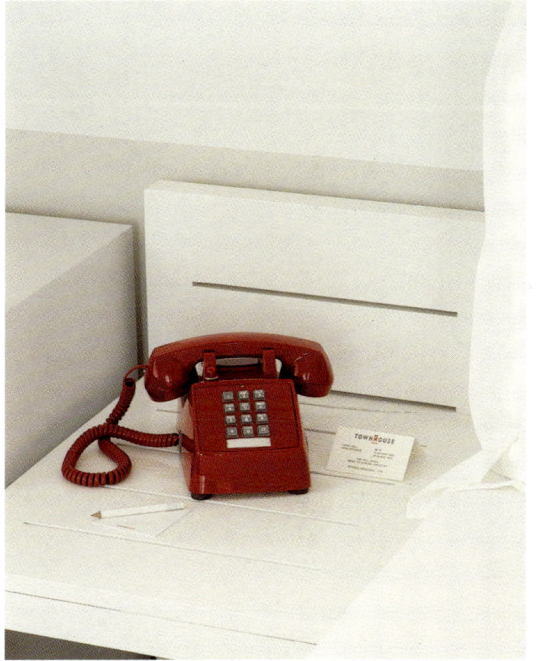

The rooms have a clean, fresh atmosphere where white, with a few touches of color, prevails.

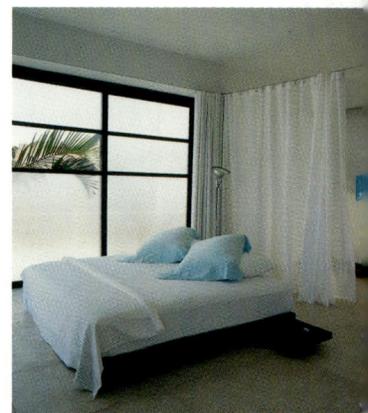

Deseo

5ª. Avenida y Calle 12, Playa del Carmen, 77710, Quintana Roo, Mexico Tel: +52 984 879 3620 Fax: +52 984 879 3621 info@hoteldeseo.com www.hoteldeseo.com

The location of this hotel, about 35 minutes south of Cancun on the Riviera Maya, defines its character. Its paradise-like setting transcends the strict etiquette of urban destinations as well as the massive tourism that reaches neighboring beaches. The tropical climate of the Caribbean characterizes the project, which was planned by the same owners who opened Hotel Habita in Mexico City. The construction in this case establishes a close relationship between the exterior and interior, in which not only the public areas but all the spaces seem to reach toward the outside.

All the areas of the hotel face the central space, a large deck with a pool. The lounge area is a place to meet or rest where guests can enjoy the enormous beds, Jacuzzi, and pool, as well as ongoing music sessions by the resident disc jockey. Although the building exudes a contemporary feel, the materials used—including mangrove wood and Maya cream marble—are associated with architecture indigenous to the region. Subtlety, combined with austerity and theatricality, is the characteristic that best defines the ambience that is achieved with the large beds that surround the deck. Fine cloths made of natural fibers hanging from a simple wire, low wooden tables, and soft colors make this spot the heart of the project.

Architect: **Central de Arquitectura** Photographer: **Undine Pröhl** Location: **Quintana Roo, Mexico** Opening date: **2001**

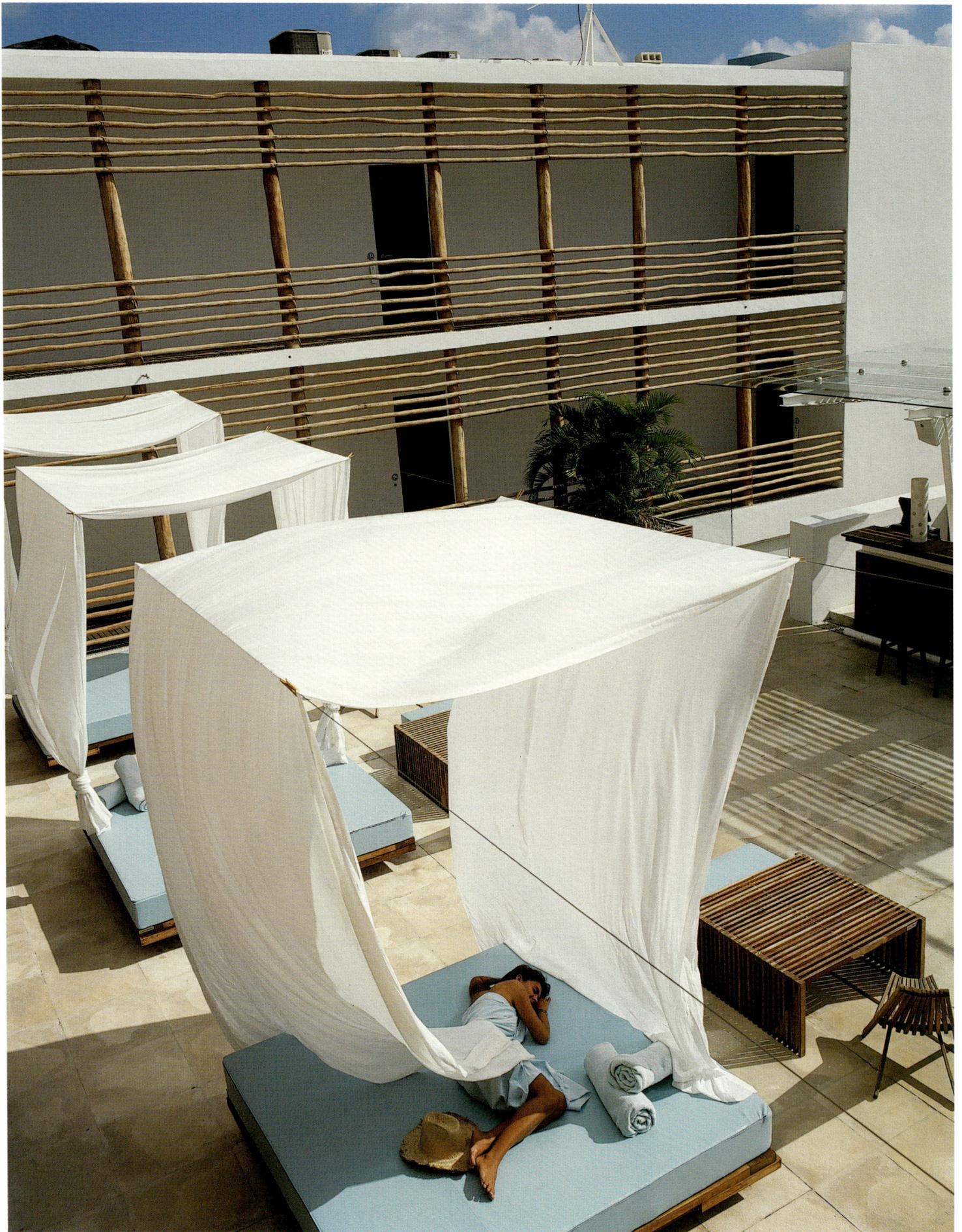

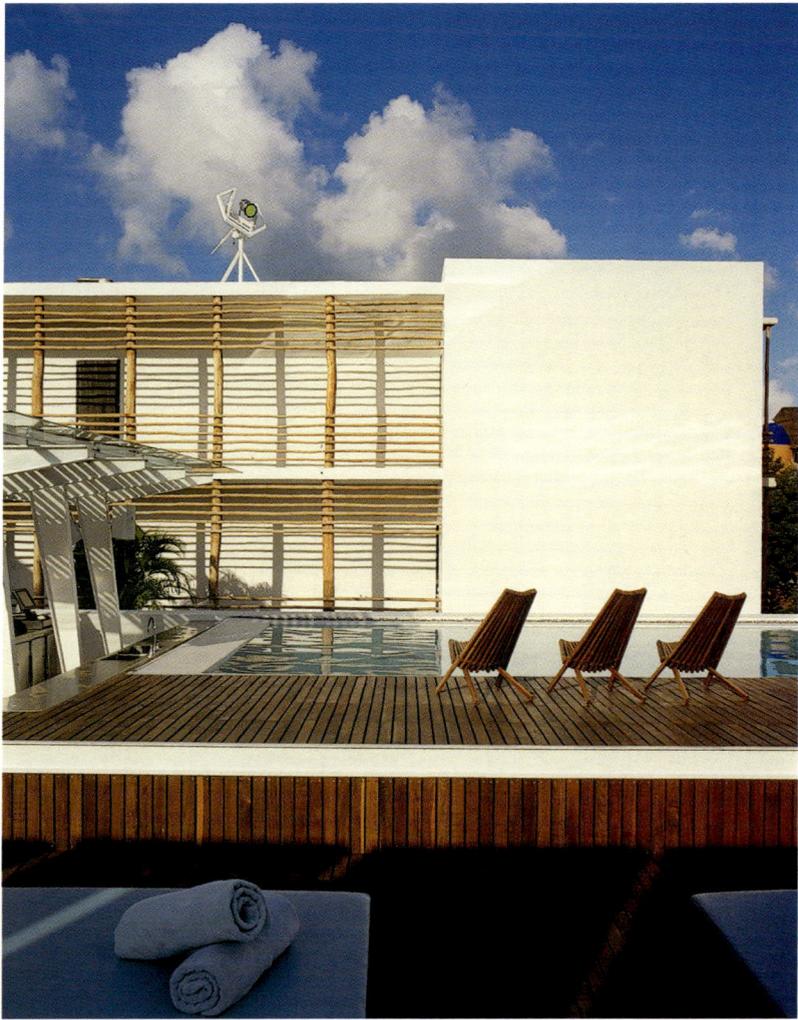
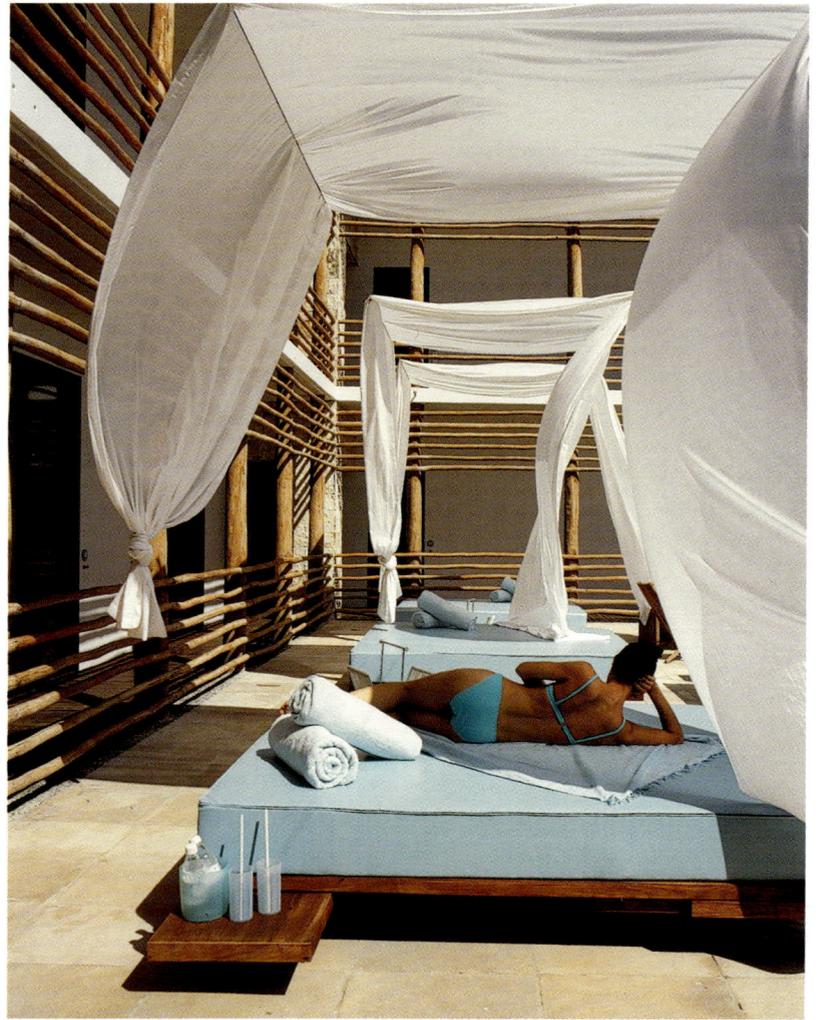
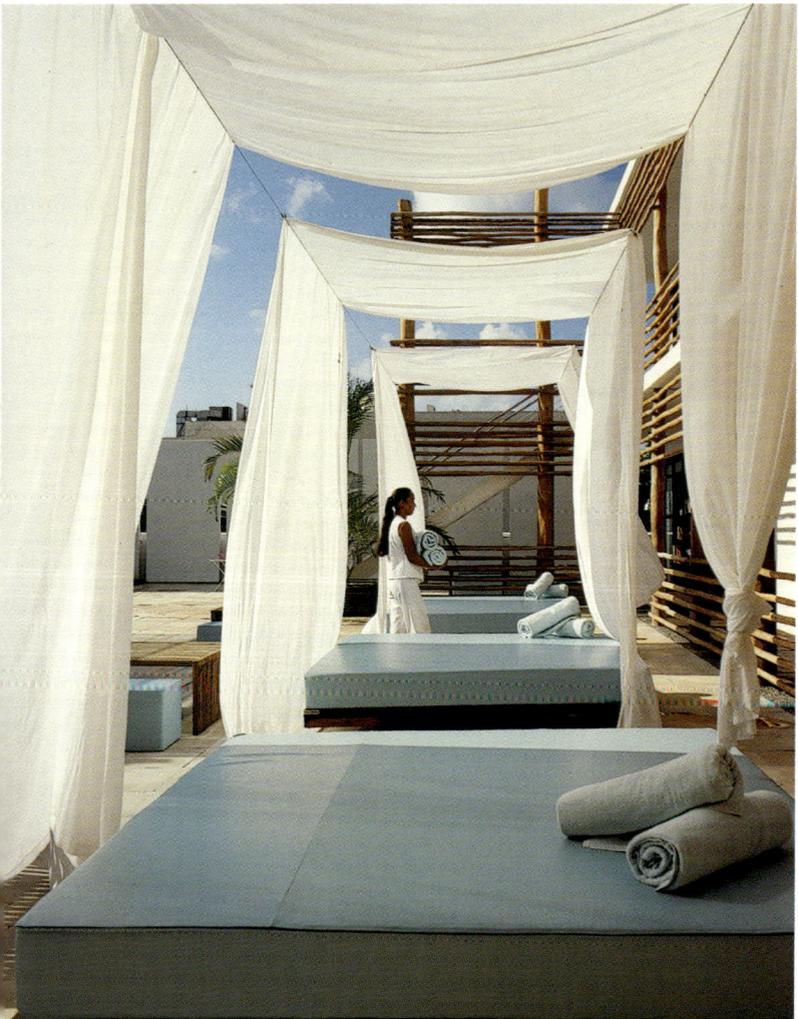
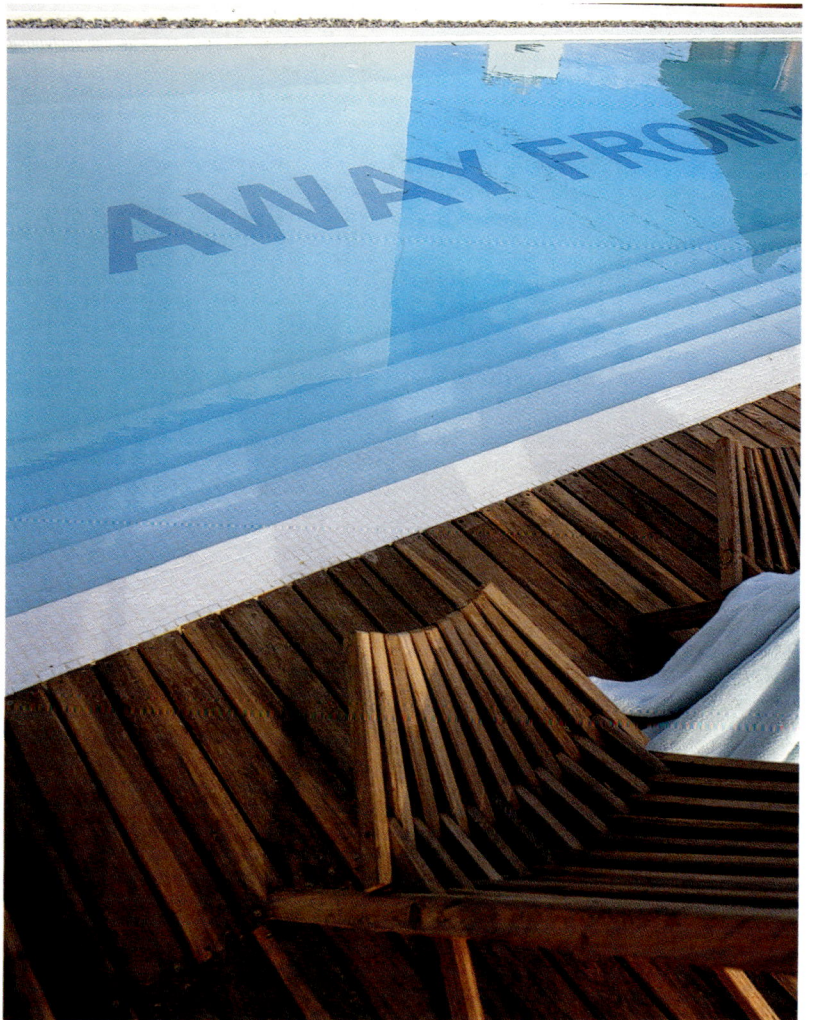

AWAY FROM

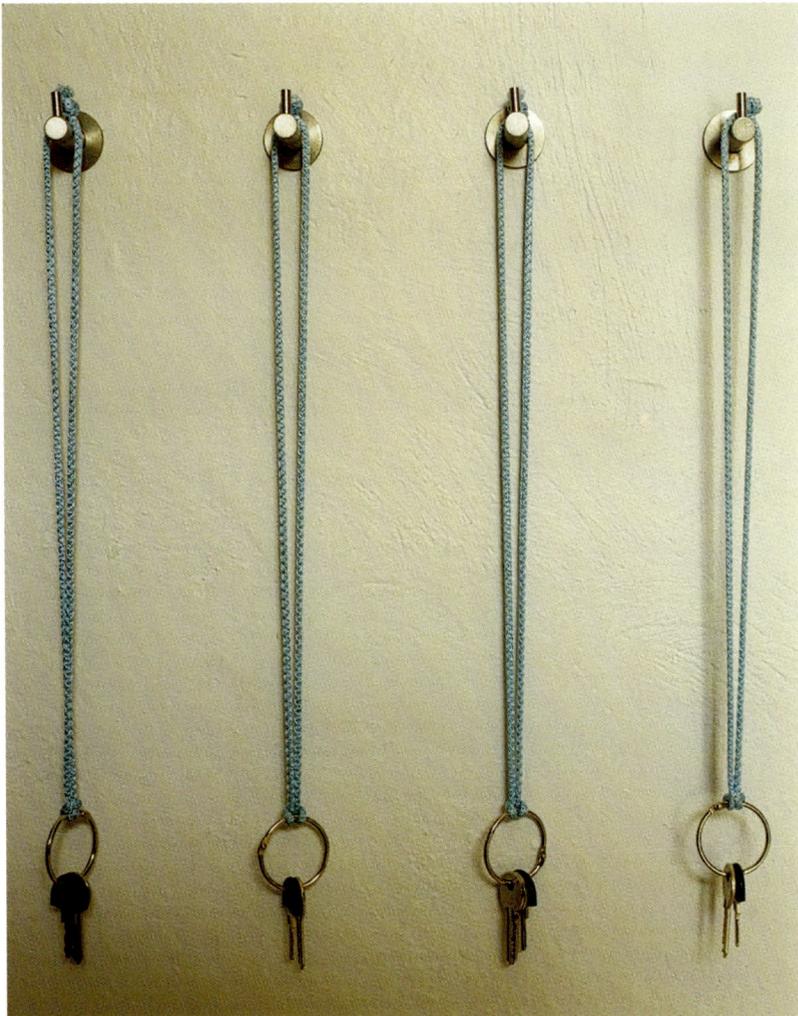

The isolated location of the hotel, its easy beach access, and its interior atmosphere make this a relaxed place. Instead of a traditional restaurant, the hotel offers an open kitchen and self-service so guests can eat whenever they choose.

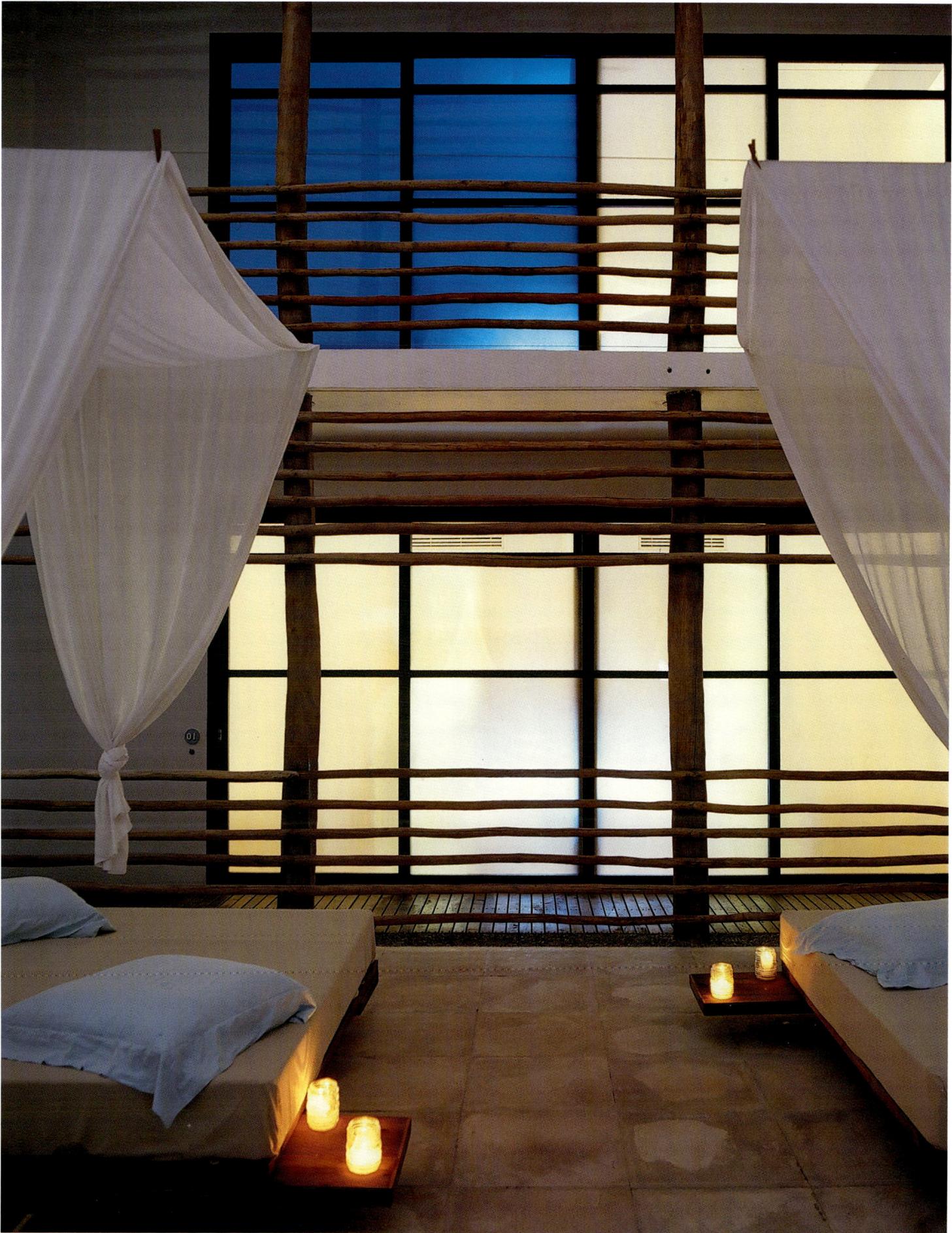

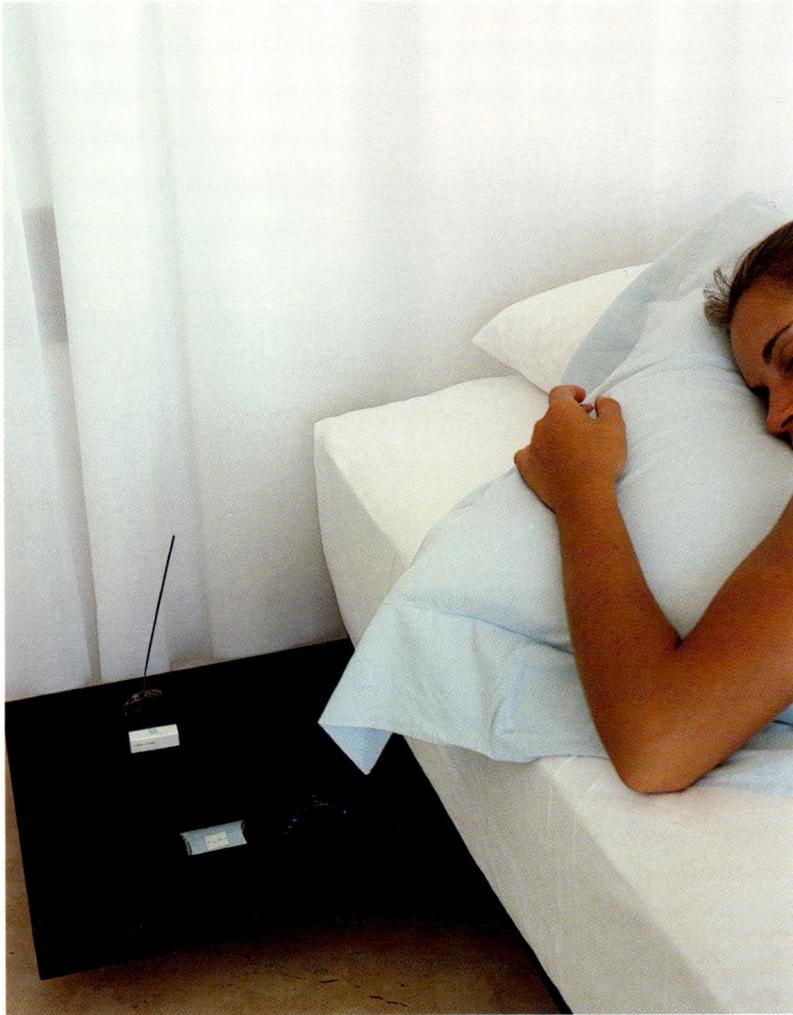

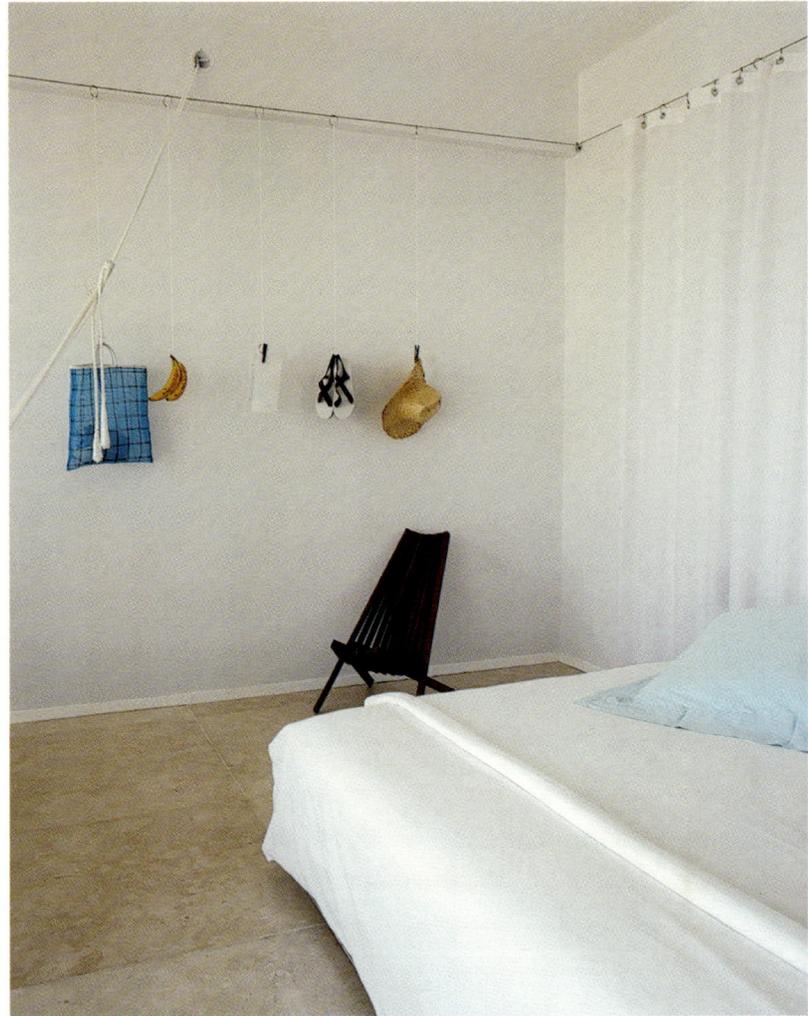

During the day the fifteen rooms, each of which have private terraces, are transformed into living rooms where guests can sunbathe and enjoy the view.

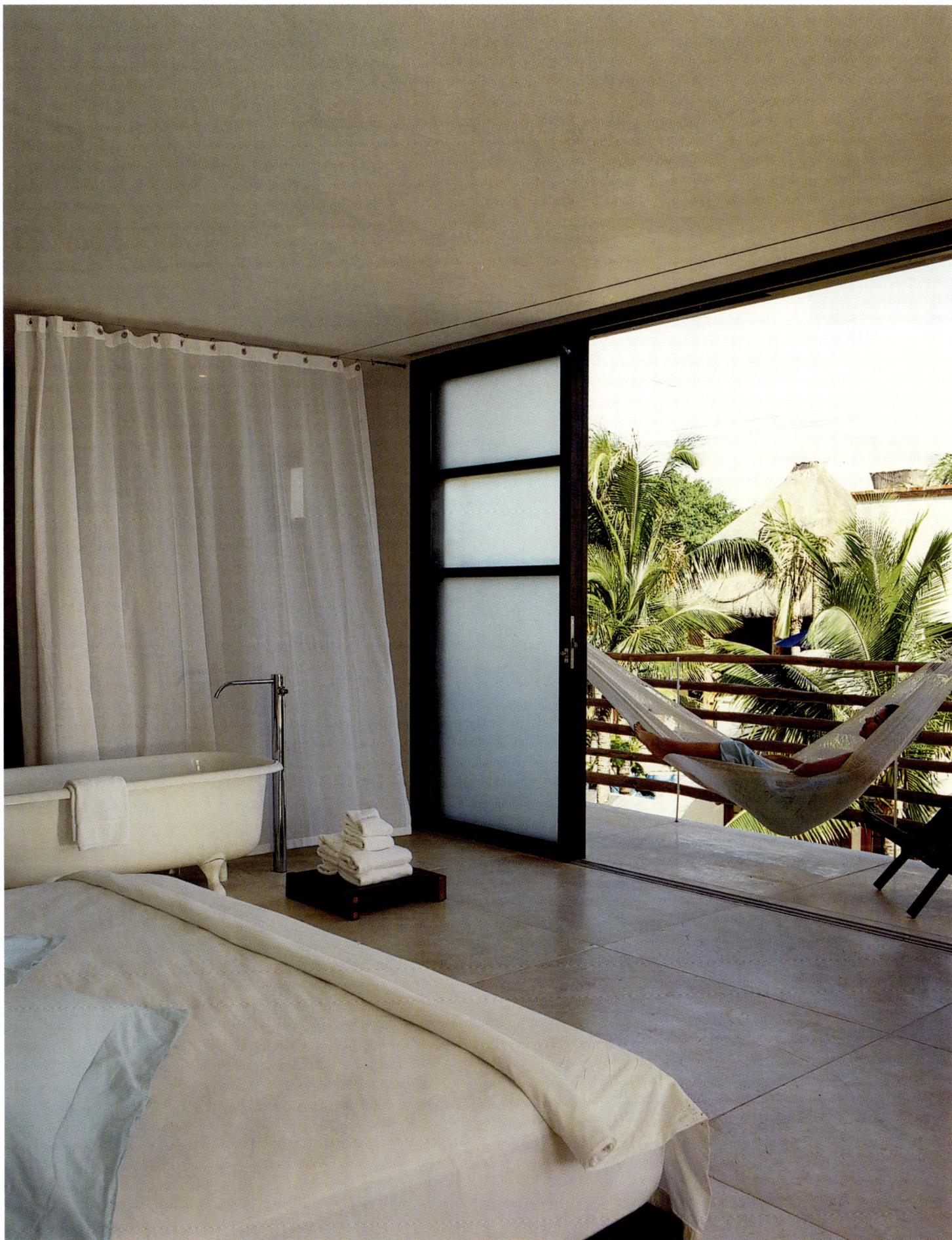

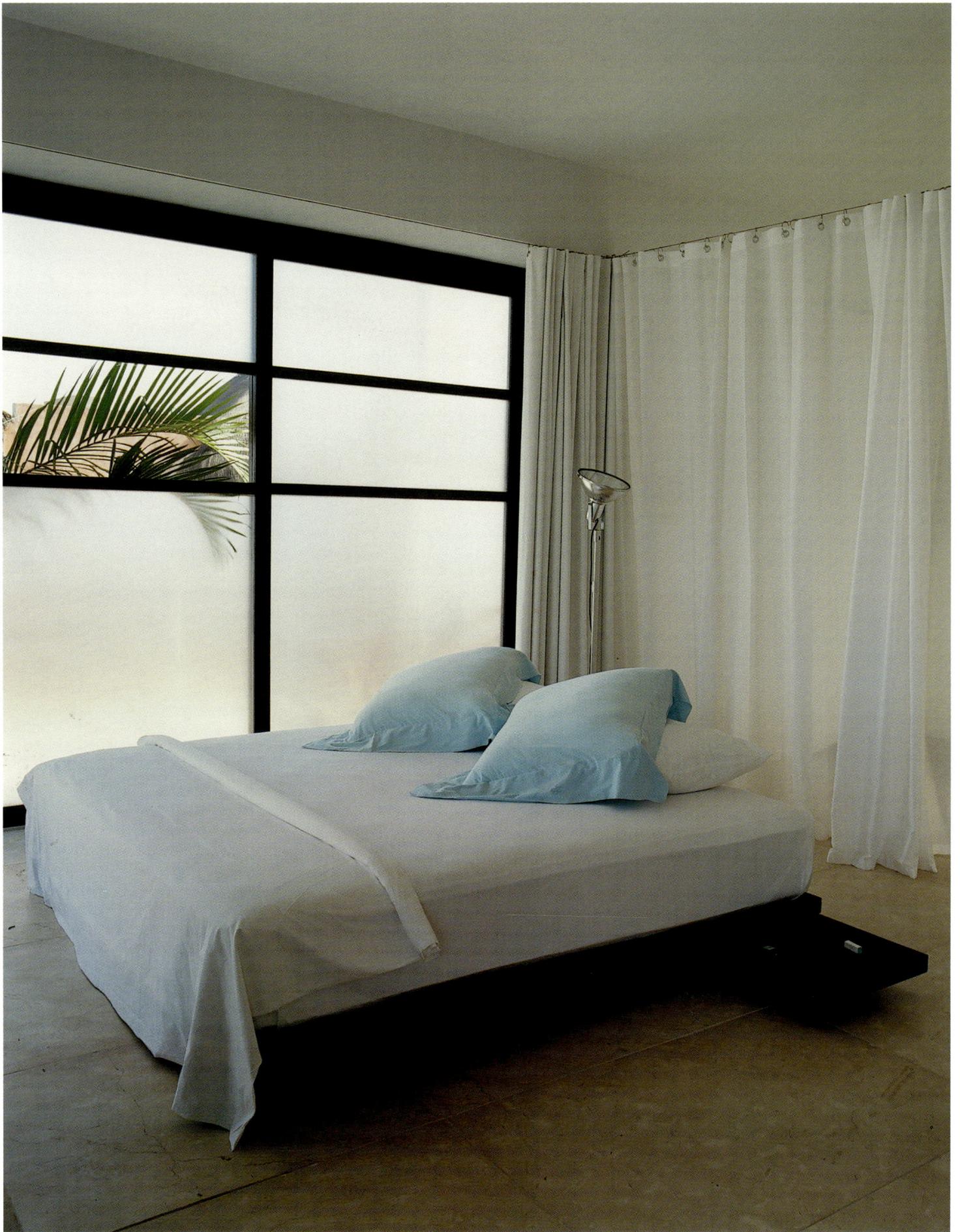



DESEO

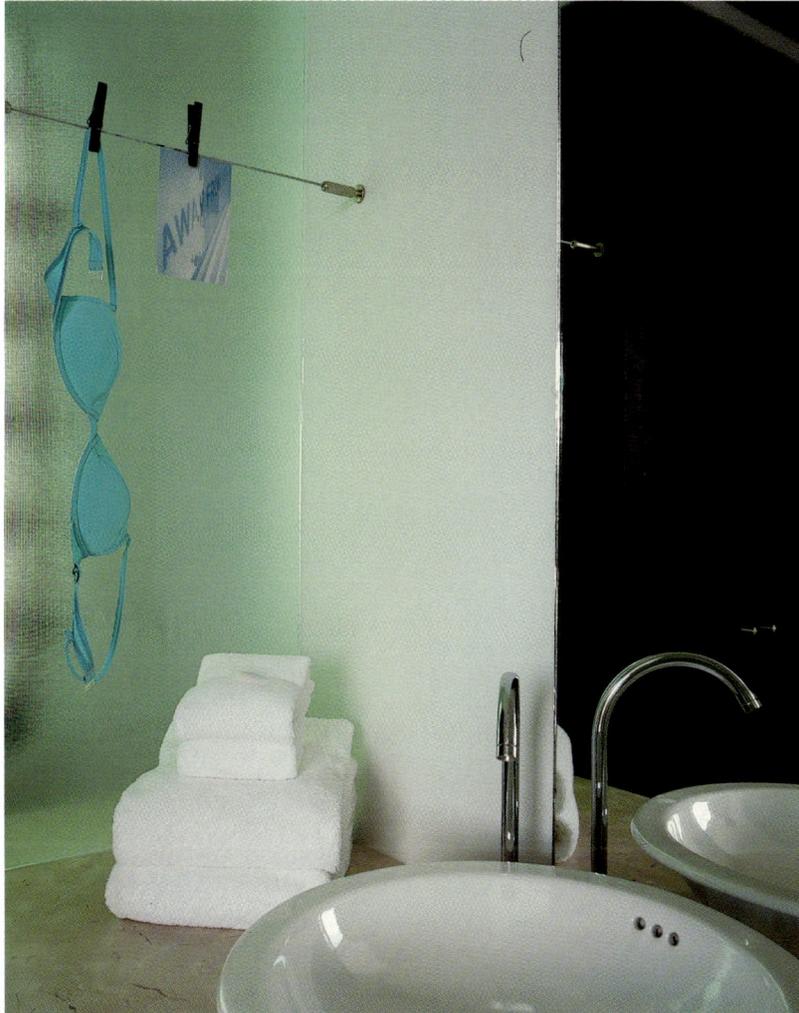

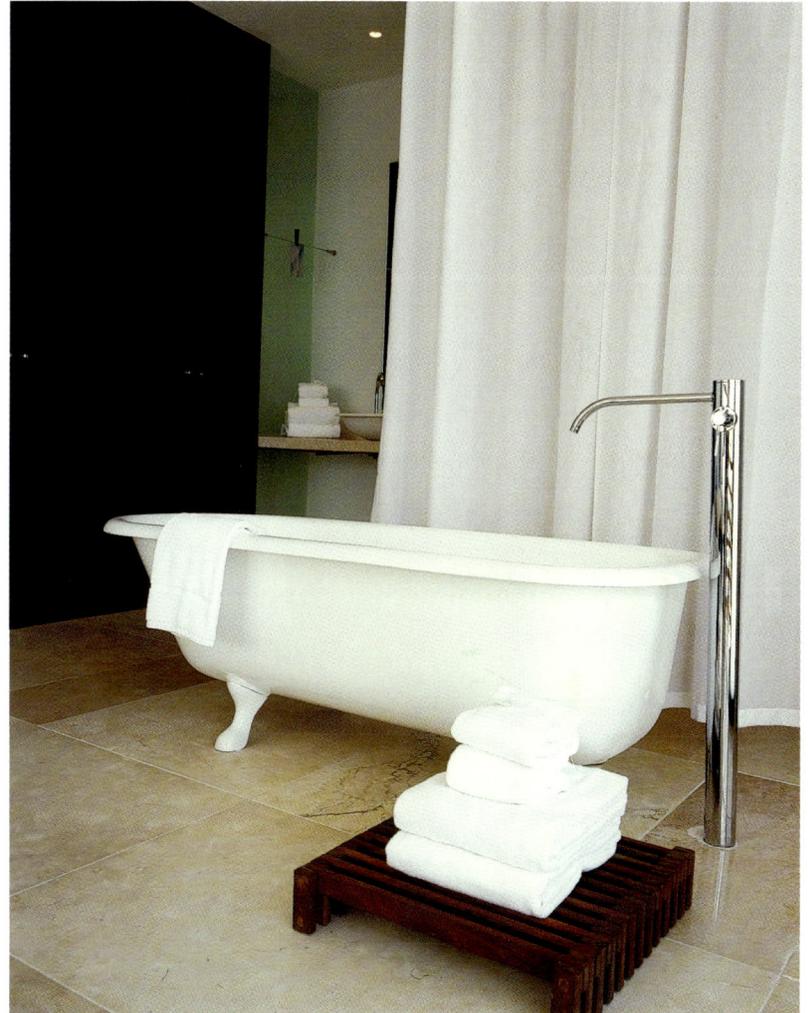

The furnishings and amenities are a pretext for ingenious interior decorating. A beach and party kit, the bed in the center of the space, the hammocks, and the curtains all become elements of great formal richness.

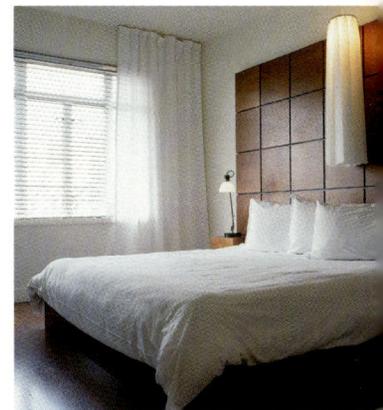

Chesterfield

855 Collins Avenue, Miami Beach, FL 33139, USA Tel: +1 305 531 5831 www.southbeachgroup.com

The interior of this hotel fuses three different styles in order to obtain its very own personal style in the heart of Miami Beach. On the one hand, the original character has been restored to the structure, built as an apartment building in 1938 with many typical Art Deco details. On the other hand, architectural elements and furniture incorporate a much more contemporary feel. Finally, in the interior, a finishing touch adds a bit of sophistication and warmth; various decorative objects with African and ethnic references complement the whole. The result is a space full of contrasts where sobriety and comfort and modernity and tradition, combine to create a unique atmosphere.

For the most part, the domestic scale of the building determined the functional and formal solutions to the renovation. In the common areas there are no official areas or heavy foot traffic between rooms. On the contrary, the spaces are all closely linked in an informal way so that they feel more like a home than a hotel. The luxury lies in the services offered, available technology, and materials used for the details and finishes. In every part of the hotel curtains divide the spaces, unifying different styles in the interior and softening both the natural and artificial light.

Architect: **Alan Liberman** Photographer: **Pep Escoda** Location: **Miami, USA** Opening date: **2002**

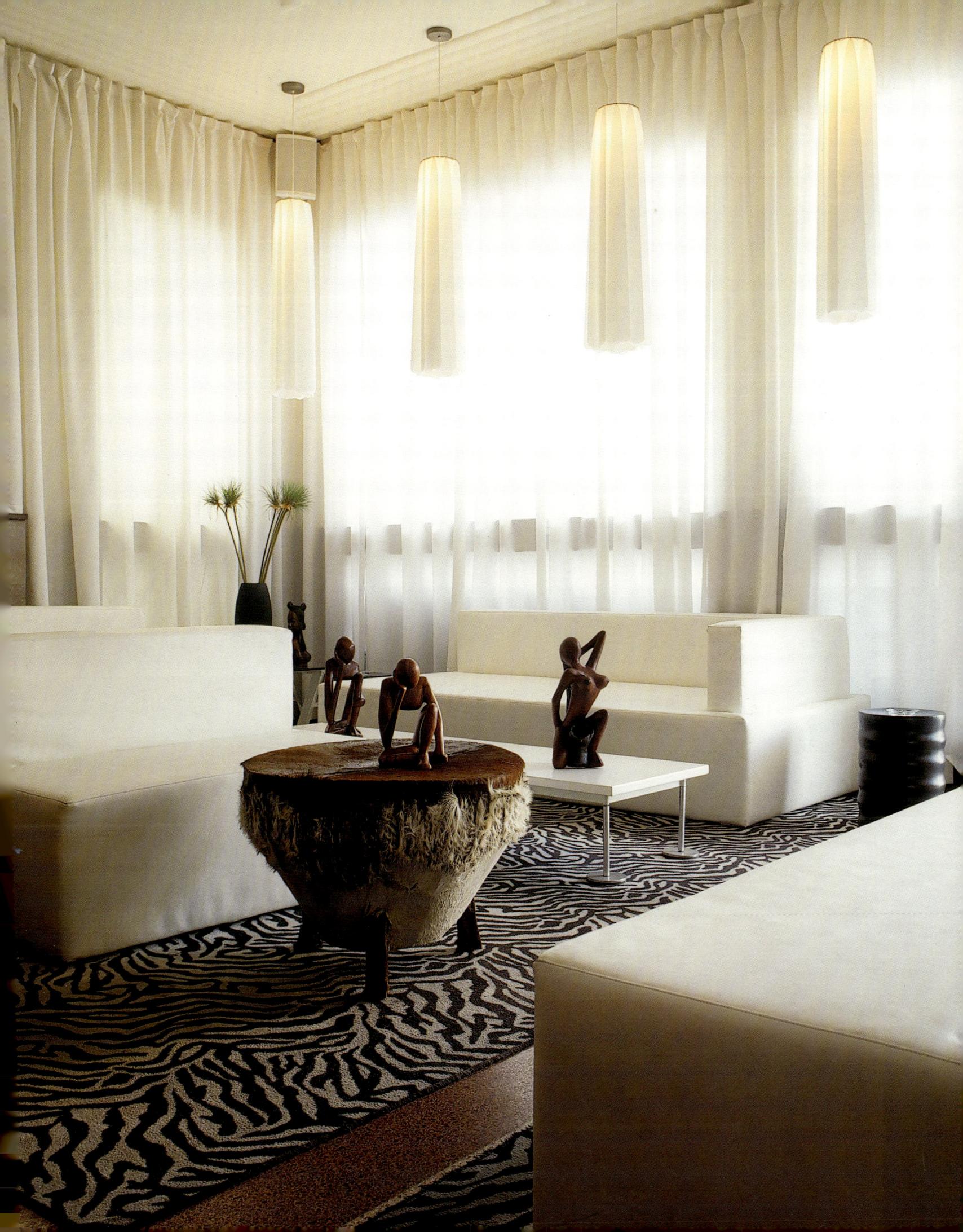

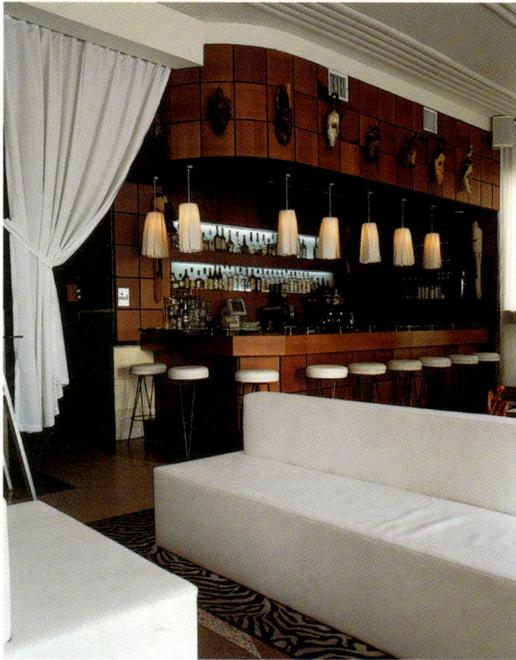
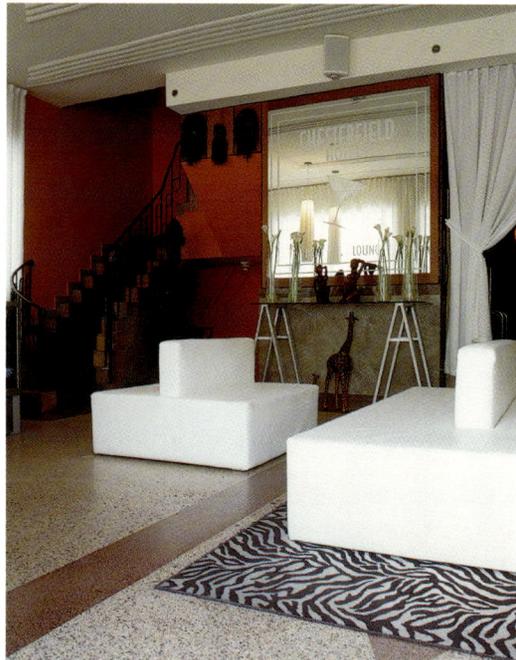
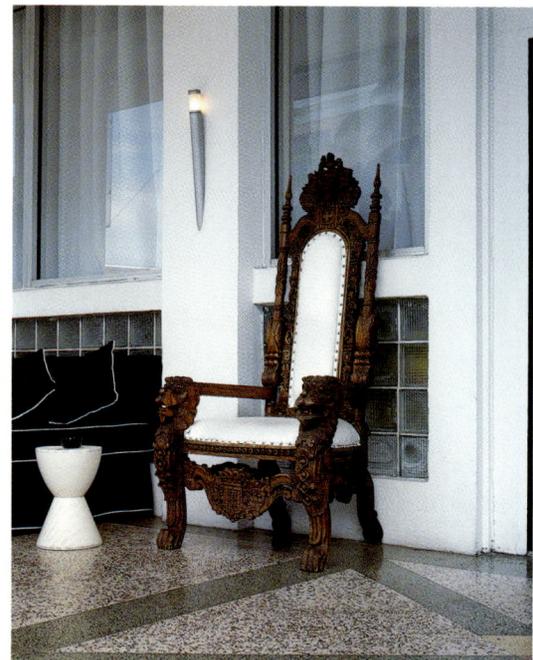

A contrast is present in the palette of colors; the white of the curtains, ceilings, and sofas serves as a background for the furniture, rustic and contemporary alike, in dark wood and intense colors.

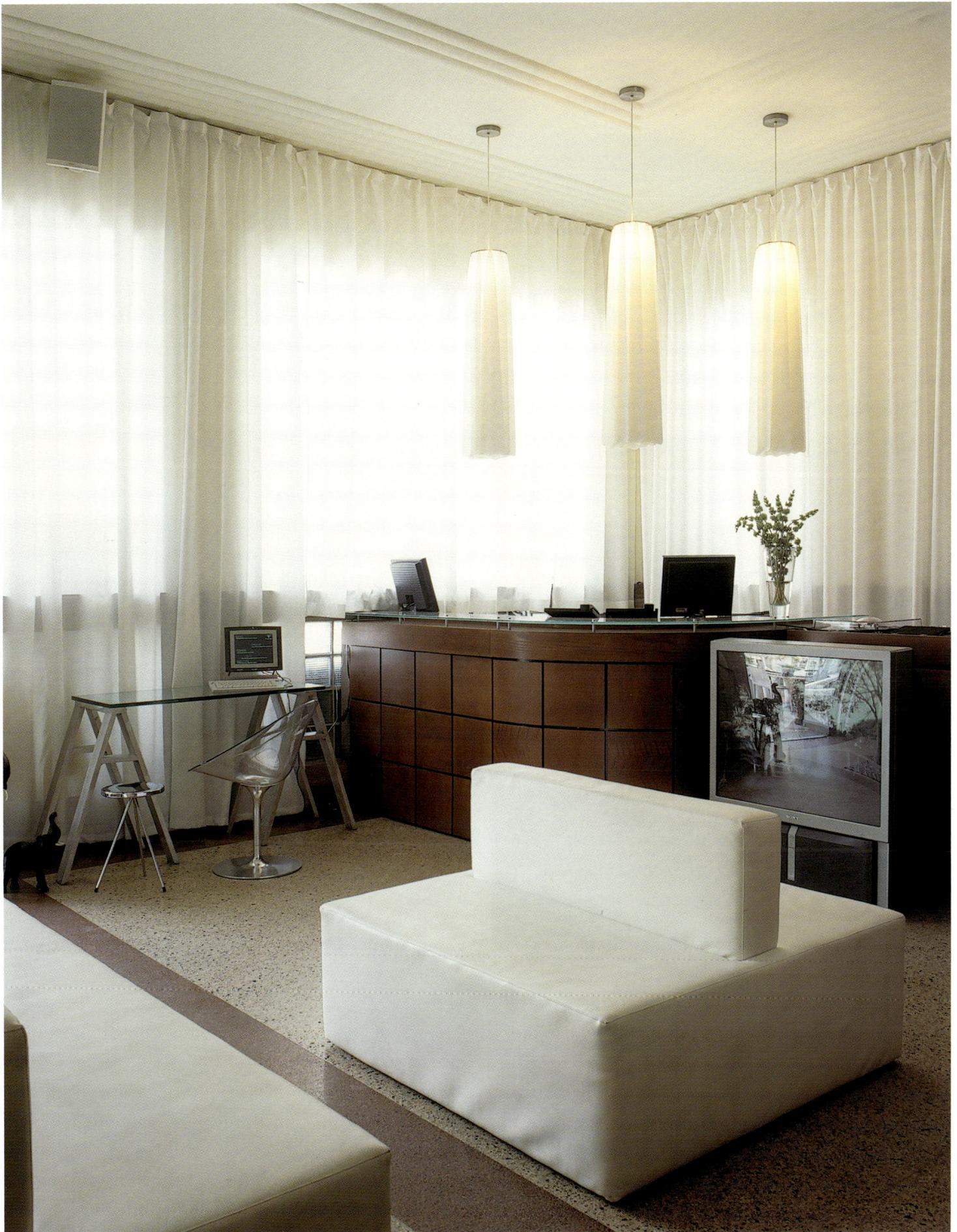

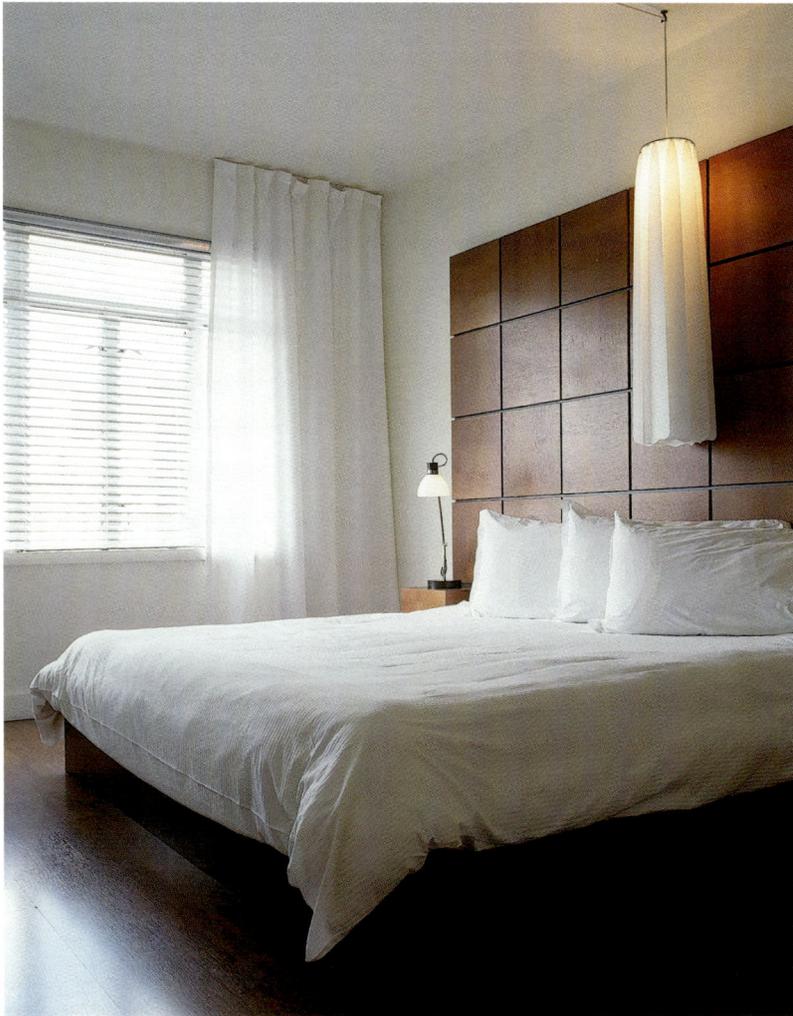

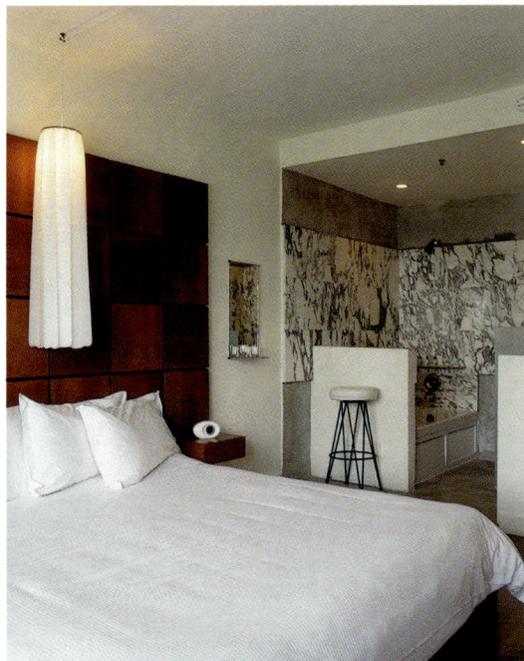
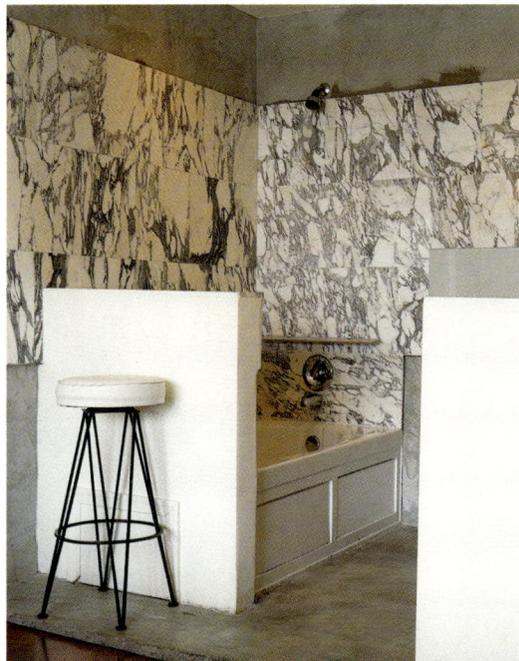
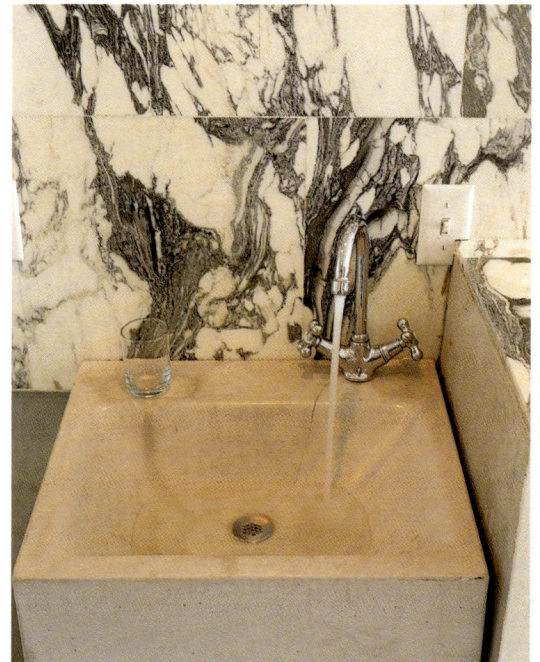

The wall coverings play an important role in the composition of the rooms. The bed is against a wall that has been covered with square panels of dark tropical wood, while the bathroom, open to the rest of the room, is framed in gray and white marble.

Le Club

Av. de los Cangrejos y Av. del Mar, Punta del Este, La Barra, Uruguay Tel: +59 842 77 2082 Fax: +59 842 77 0246 leclub@fibertel.com.ar www.leclubposada.com

This popular seaside resort in Uruguay has some of the most spectacular landscapes in Punta del Este. The characteristics of the region, its casual atmosphere and the architectural style of the nearby buildings, were the inspiration for the design of this project. Despite the resort's popularity, the beaches and picturesque surroundings have preserved their natural charm. The massive city skyline in the distance seems like an optical illusion in the midst of these virtually untouched surroundings. The architecture in this area, despite the fact that it is composed principally of expensive housing, reflects the traditional character of the region. The houses are known for using traditional materials, such as wood or palm roofs, and for blending in with the landscape. So, although there wasn't any penny pinching when it came to providing comfort, the hotel is characterized by its lightness and respect for its surroundings.

Restrained, rational lines characterize the building. In the common areas, such as the lobby and restaurant, the idea of open, continuous space predominates. The details and finishes utilize conventional materials translated into a more contemporary language. White is the prevailing color in the rooms, framing several contemporary design pieces and a few more rustic pieces. The large windows allow for sweeping views, and the terraces invite guests to enjoy the outdoors.

Architect: **Horacio Ravazzani** Photographer: **Ricardo Laougle, Victor Carro** Location: **Punta del Este, Uruguay** Opening date: **2002**

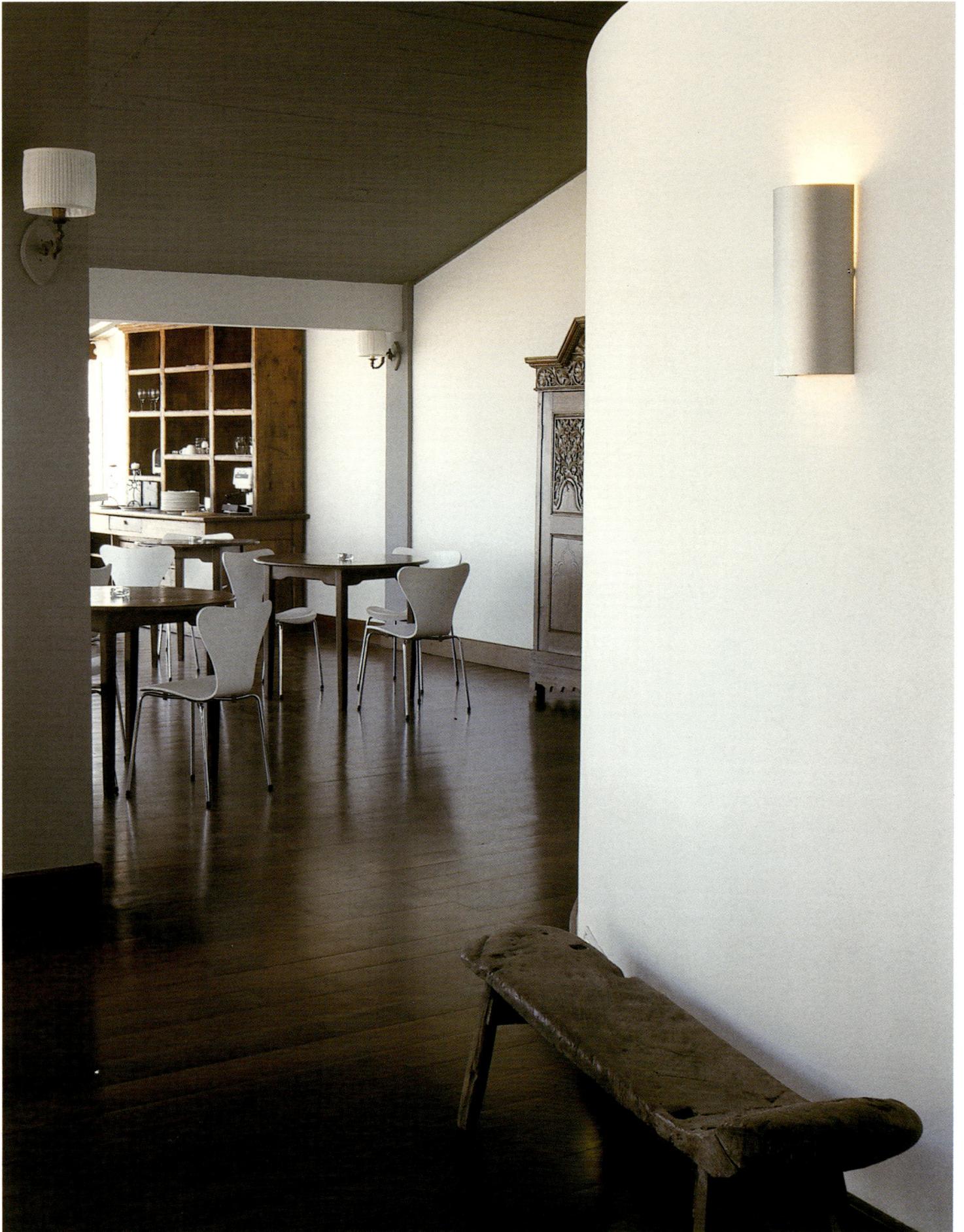

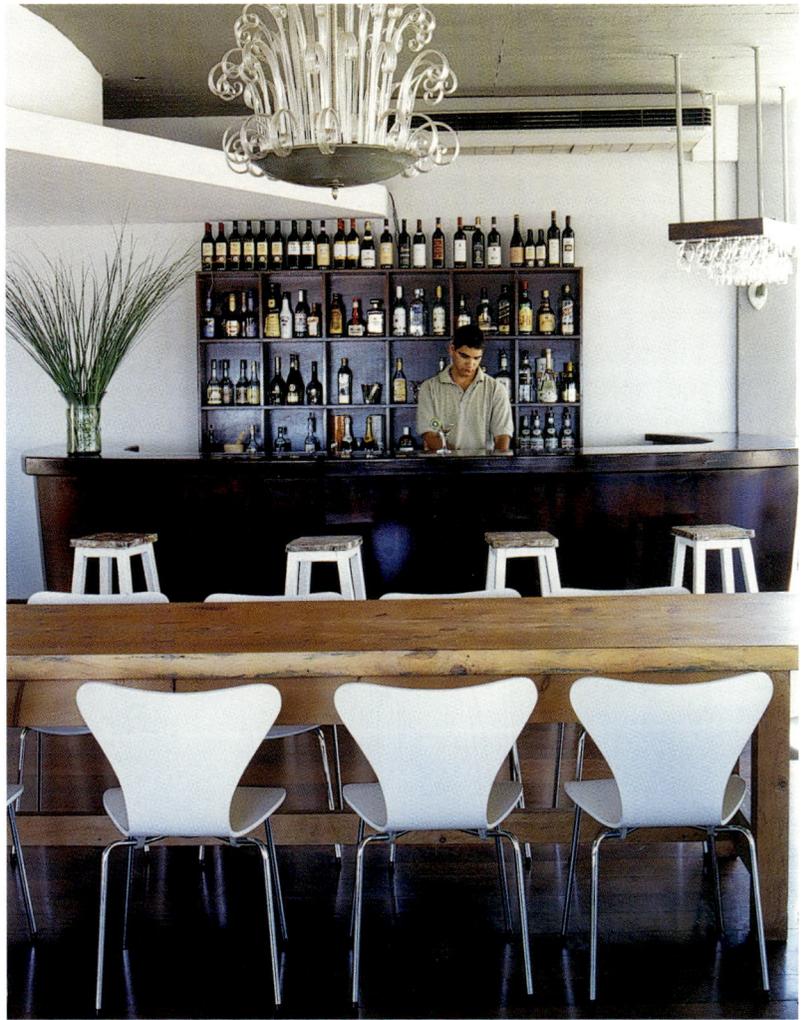

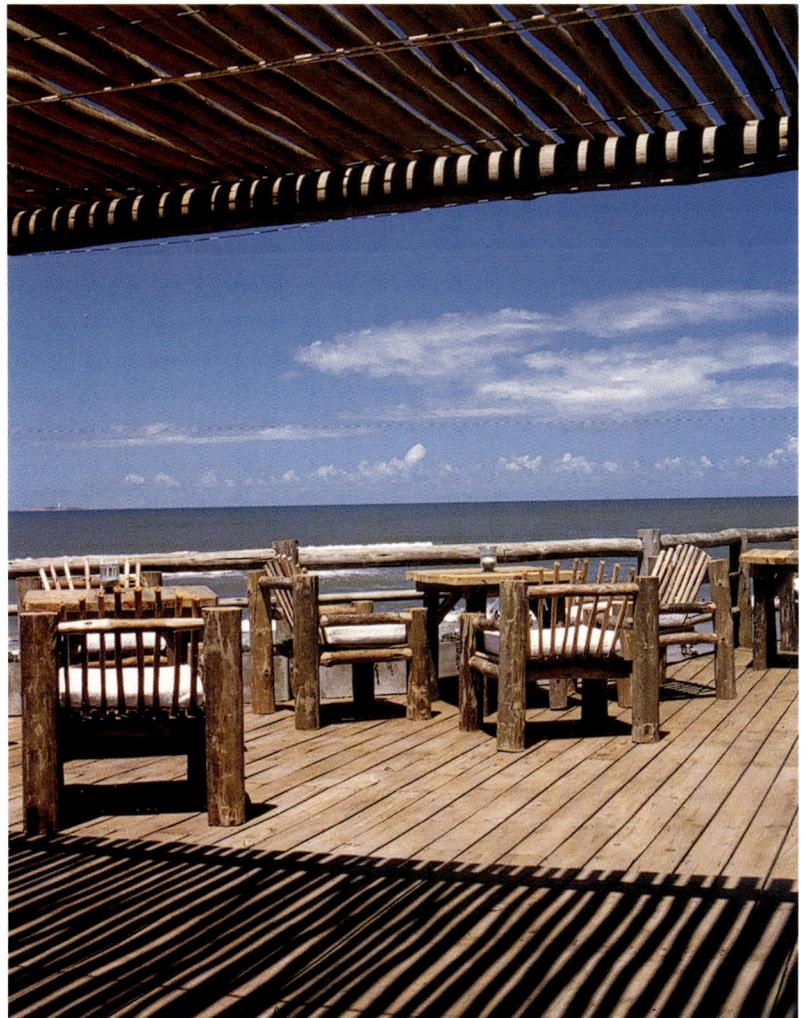

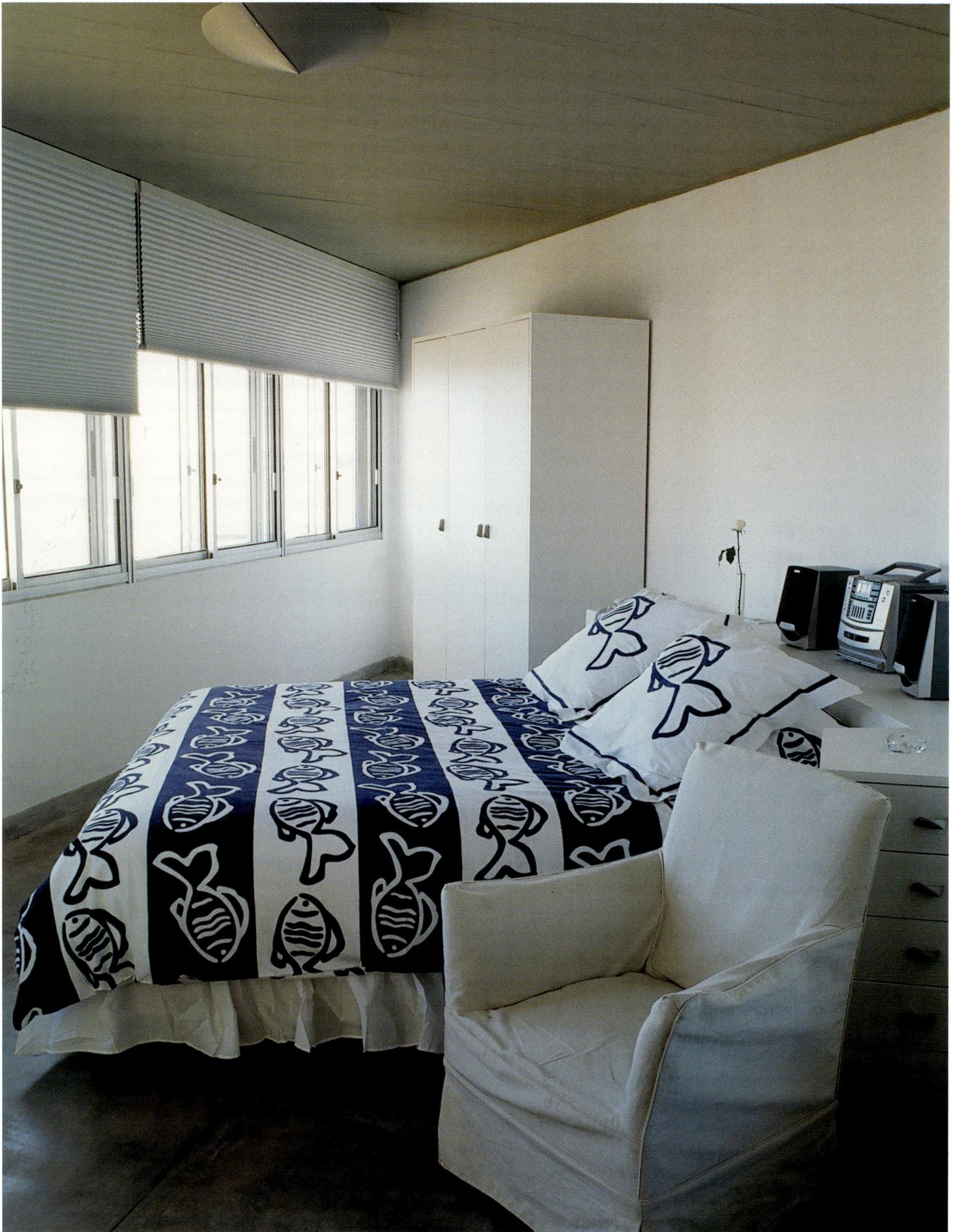

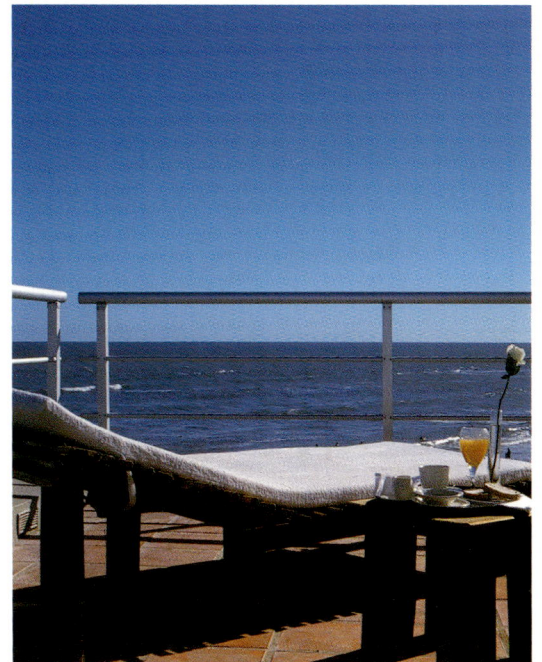

The warm, welcoming atmosphere, which makes Le Club feel like more of a country house than a hotel, is achieved through a balanced mix of architecture, design, and traditional elements.

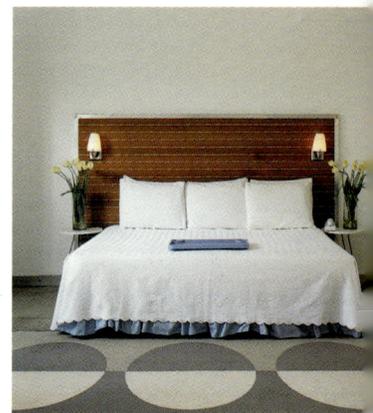

Aqua

1530 Collins Avenue, Miami Beach, FL 33139, USA Tel: +1 305 538 4361 Fax: +1 305 673 8109 www.aquamiami.com

This structure, originally built in 1954 by MacKay and Gibbs Architects as an apartment building, has all the formal features and functional characteristics of postwar architecture. It is a restrained and austere construction in which construction, efficiency, and rational shapes stand out instead of sophisticated details or expensive materials. In 2001, during the renovation, completely forgotten parts of the space were restored with just a few touches—details and furniture that splash the space with color and life.

The new design places special emphasis on the maritime theme taking pre-renovation details as a point of departure. Examples include the mosaic on the vestibule floor and the formation of the rooms that all look out onto an elongated patio shaped like a boat. The atmosphere, fun and relaxed, is reached through a careful balance of original stainless steel furnishings, pieces by contemporary designers—for example the Karim Rashid sofa in the vestibule—and some very dramatic accessories placed throughout the hotel's rooms. Without overdoing things and highlighting the preexisting style perfectly, a harmonic whole is achieved which respects the original architecture and carries with it a great formal expressiveness.

Designer: **Eric Gabriel** Photographer: **Pep Escoda** Location: **Miami, USA** Opening date: **2001**

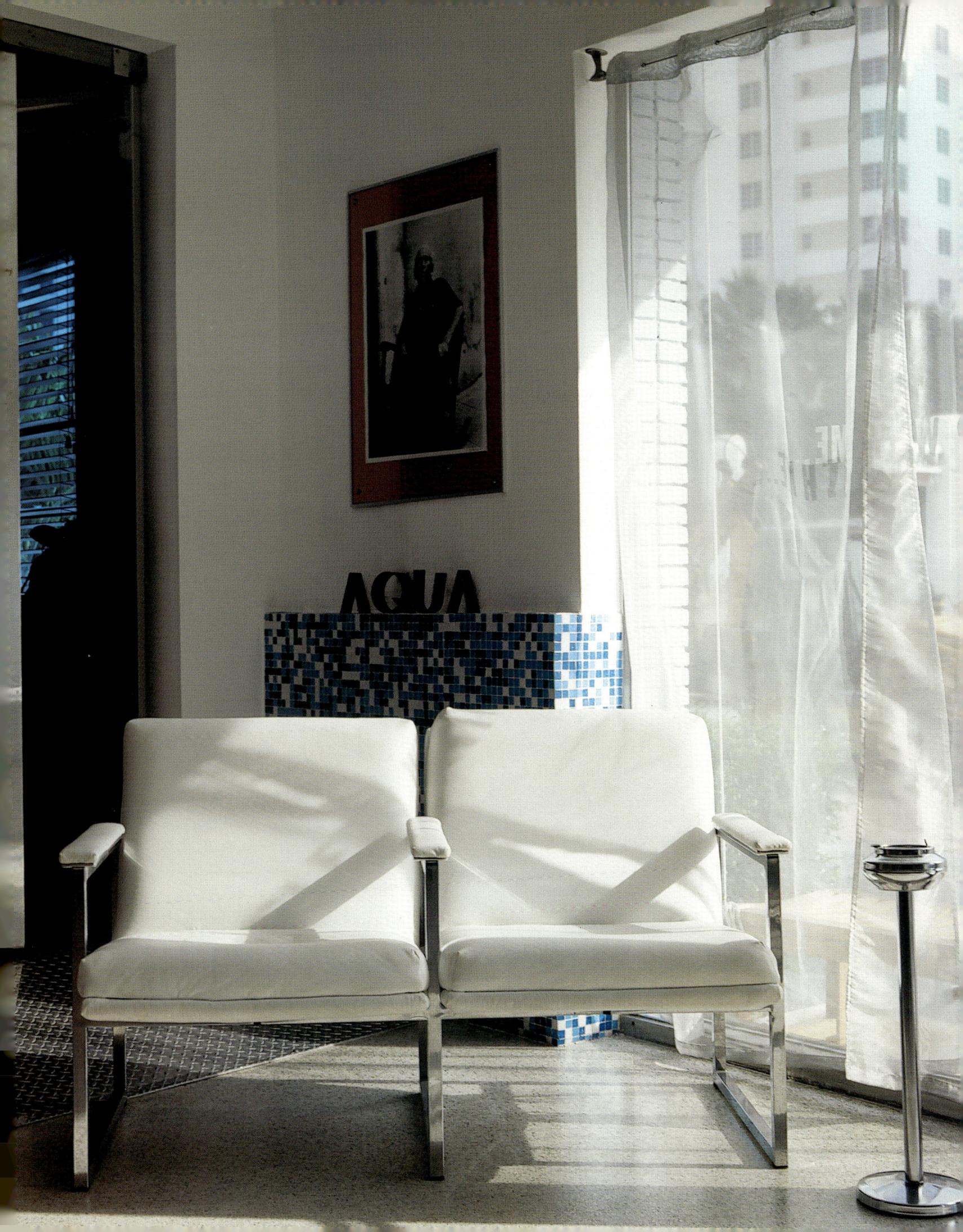

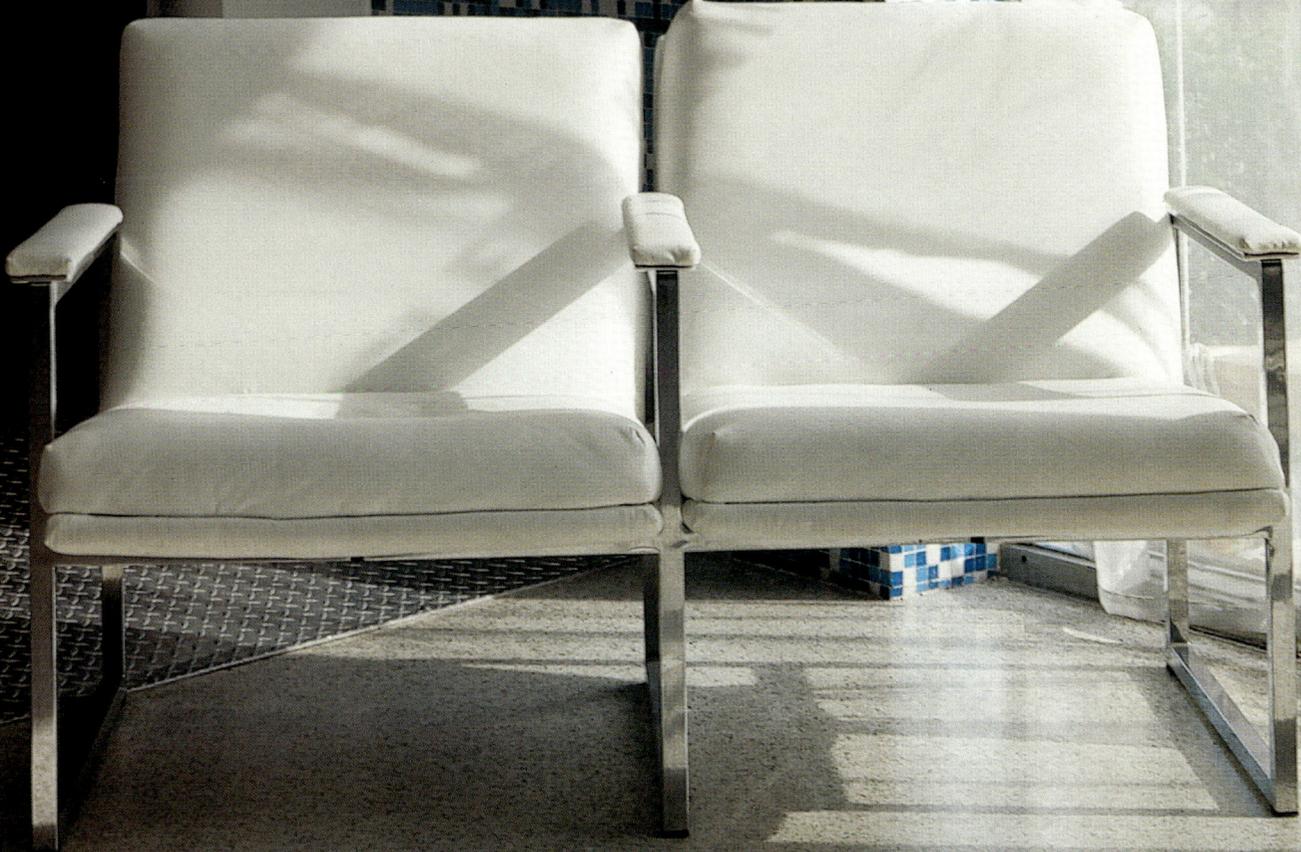

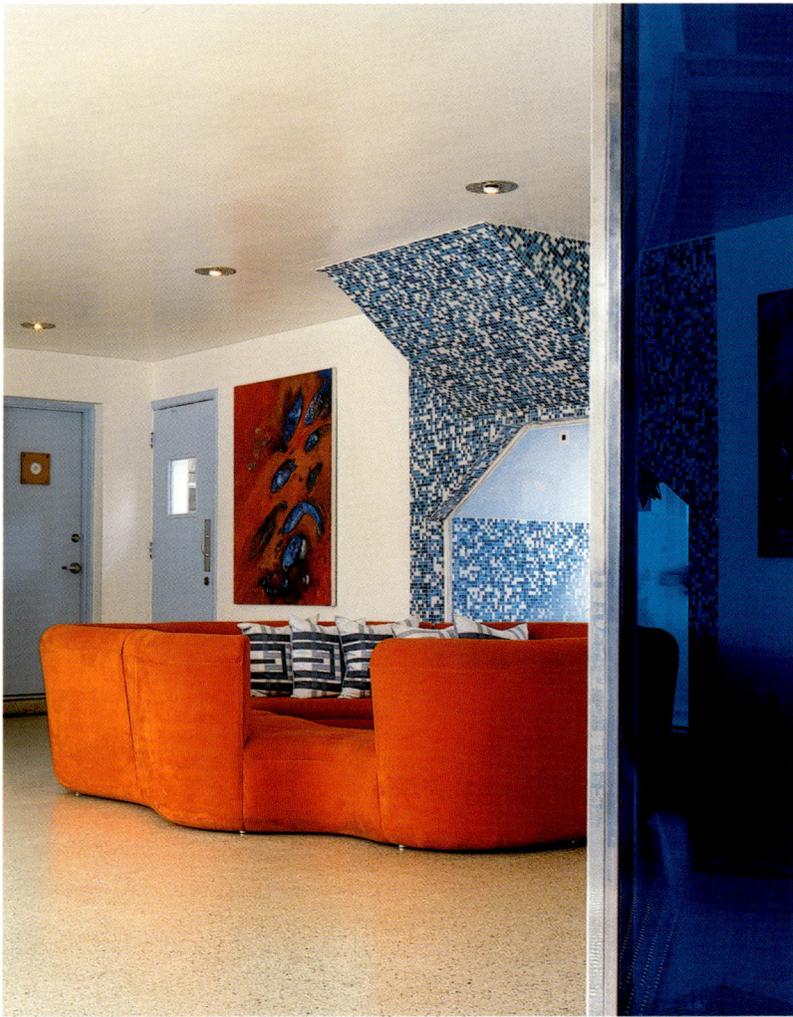
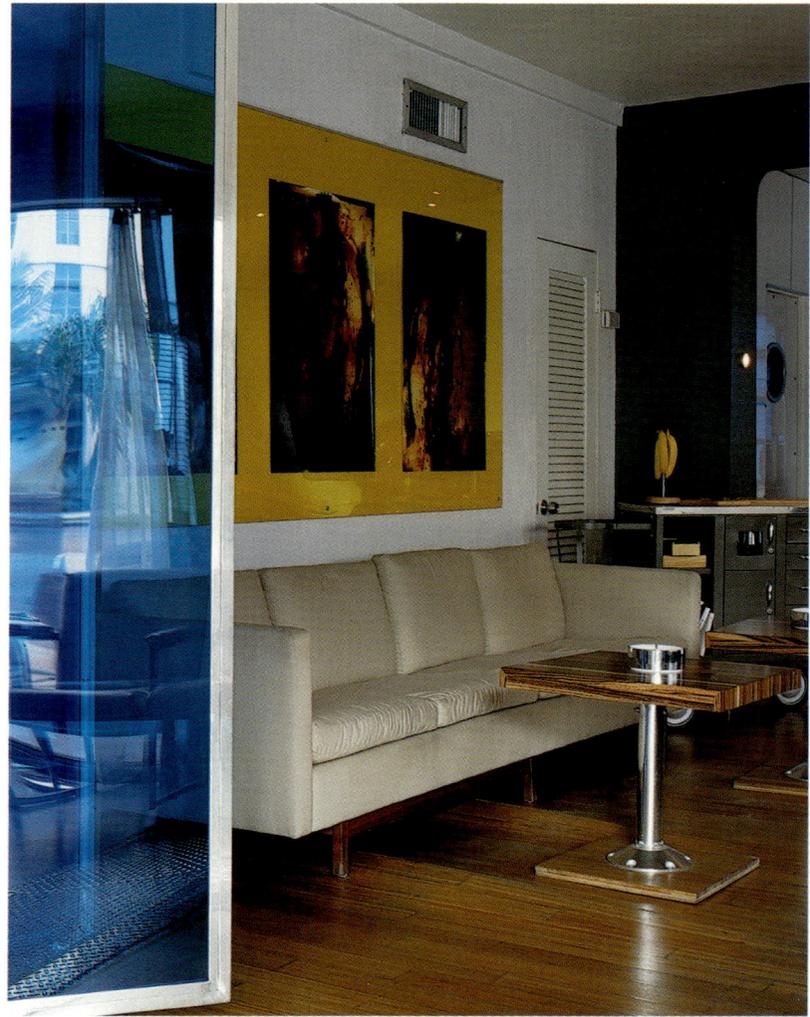
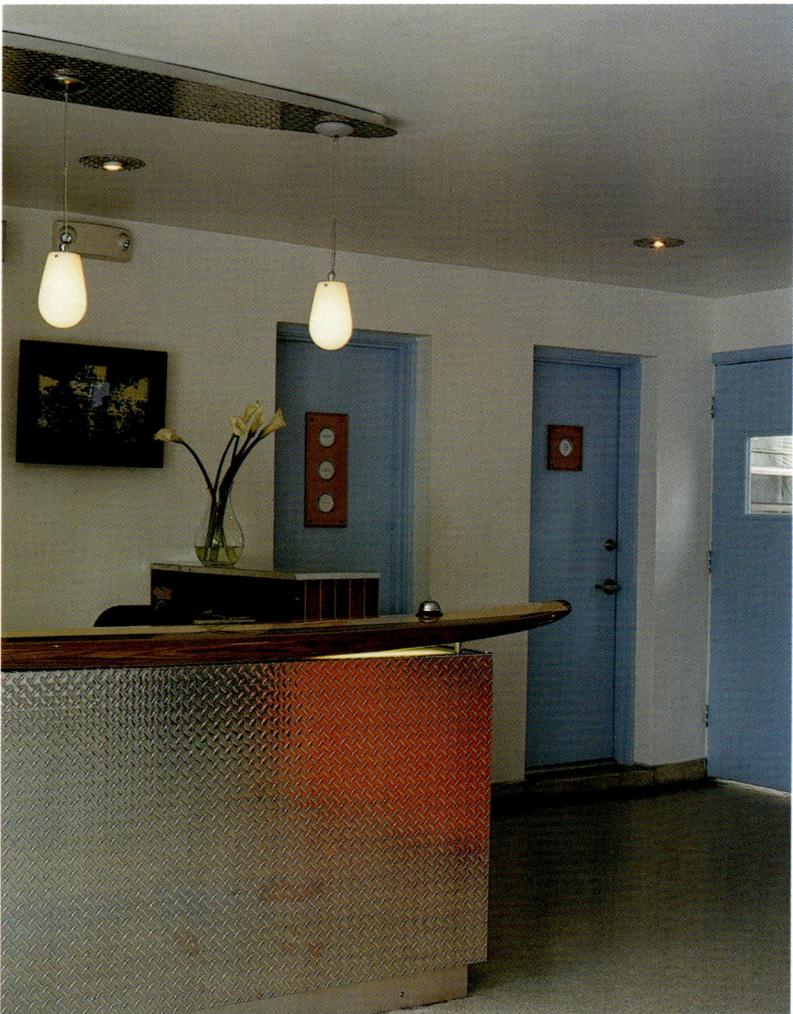
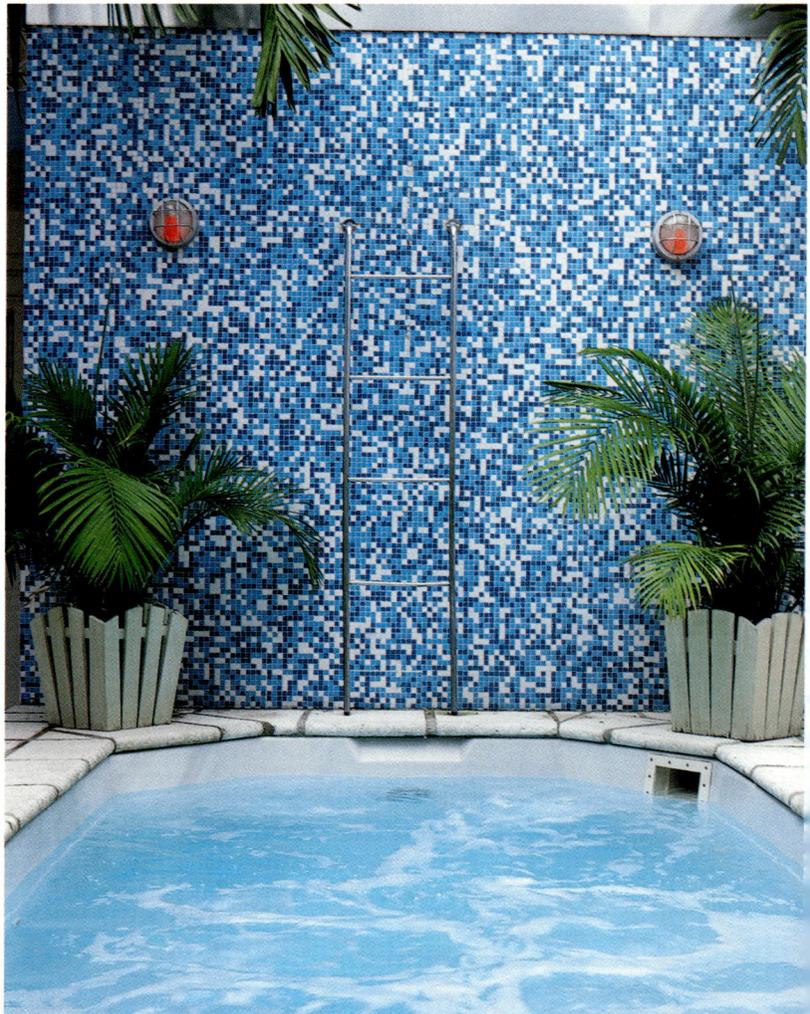

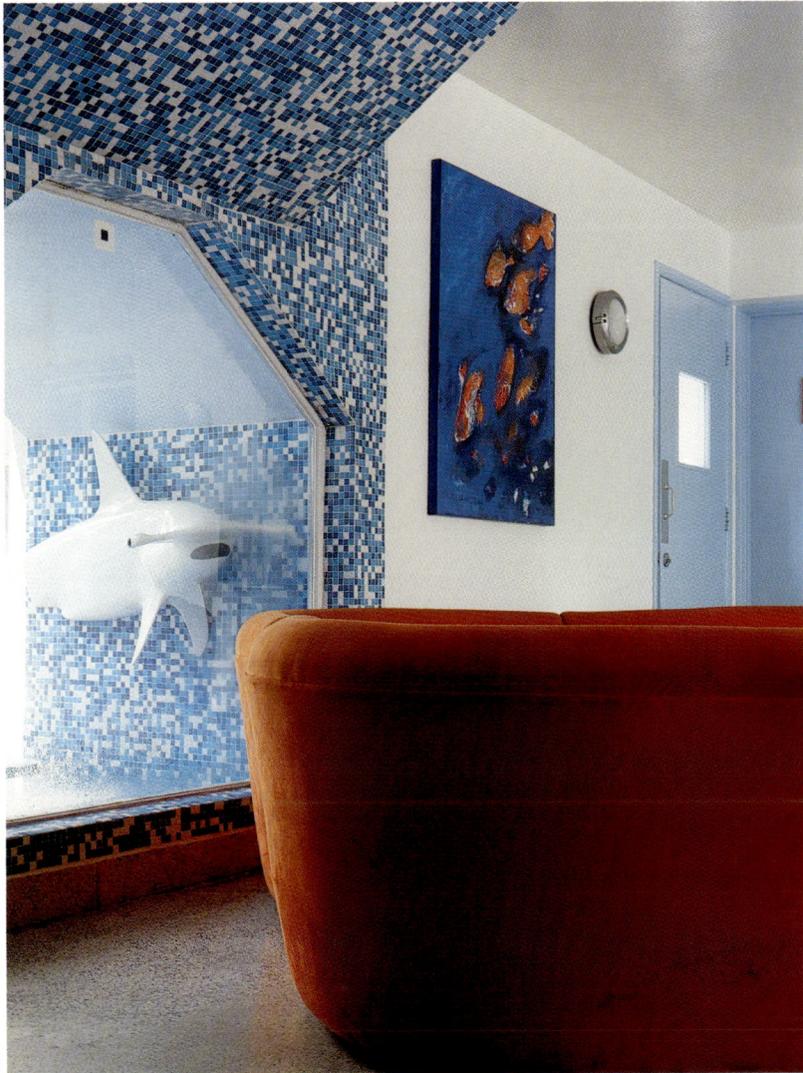

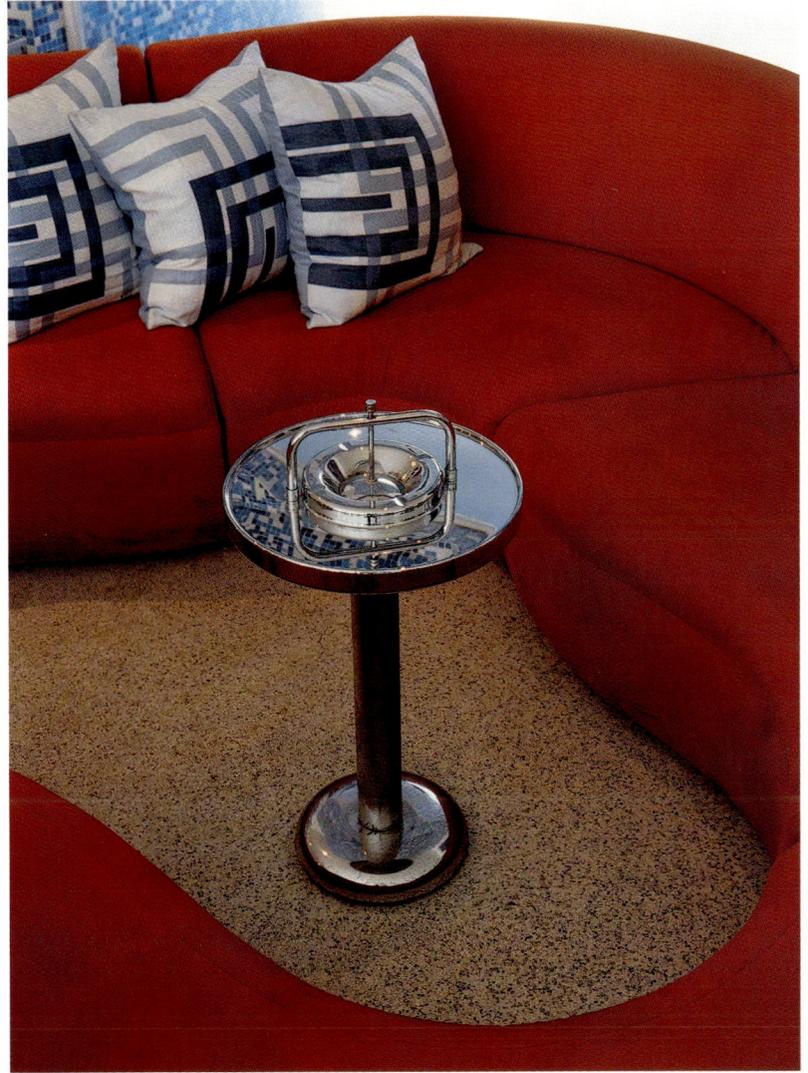

A bright orange sofa by designer Karim Rashid takes up a large part of the vestibule and becomes an important focal point inside the hotel.

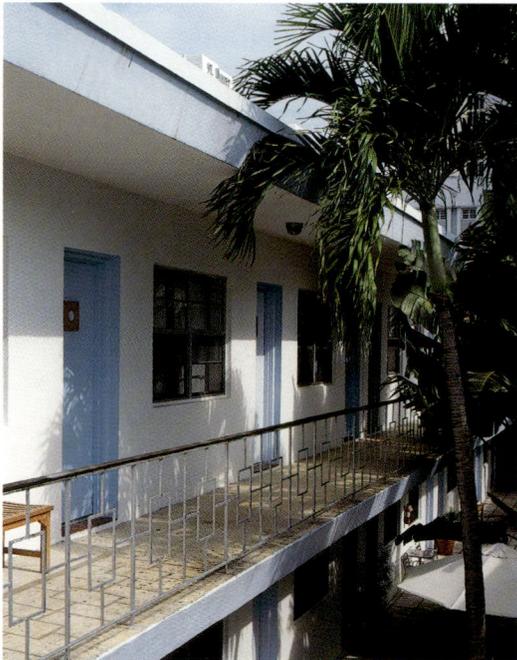

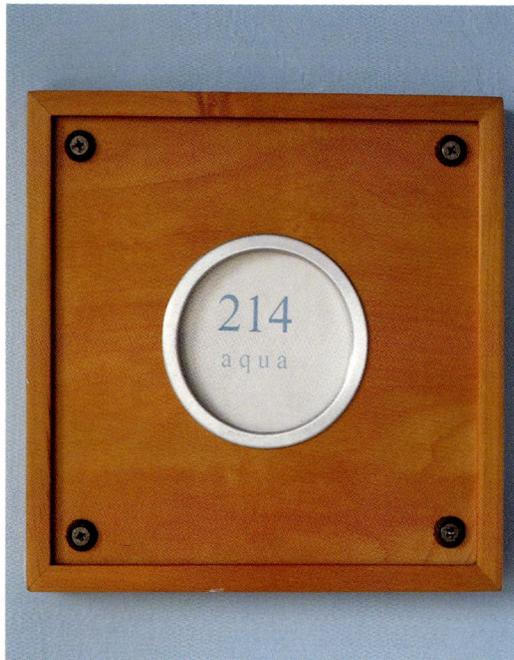

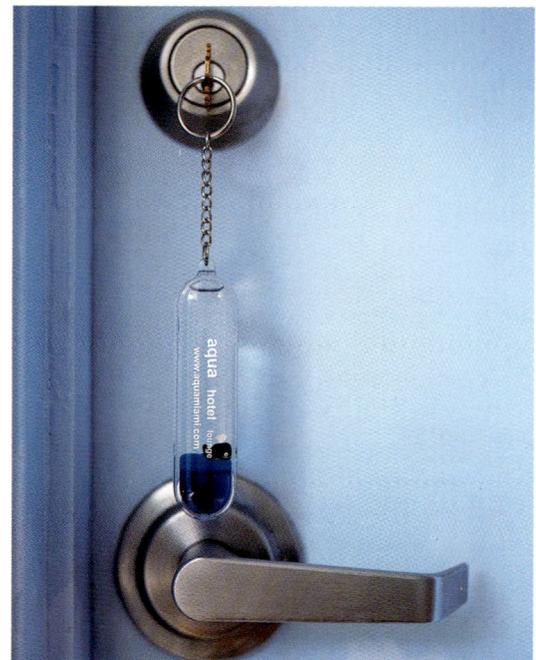

The water theme is present in the colors as well as the finishes, including the smallest details of the decoration. The lava lamps, the key ring filled with water, and the room numbers modeled on the numbers on lifeboats are just some of these details.

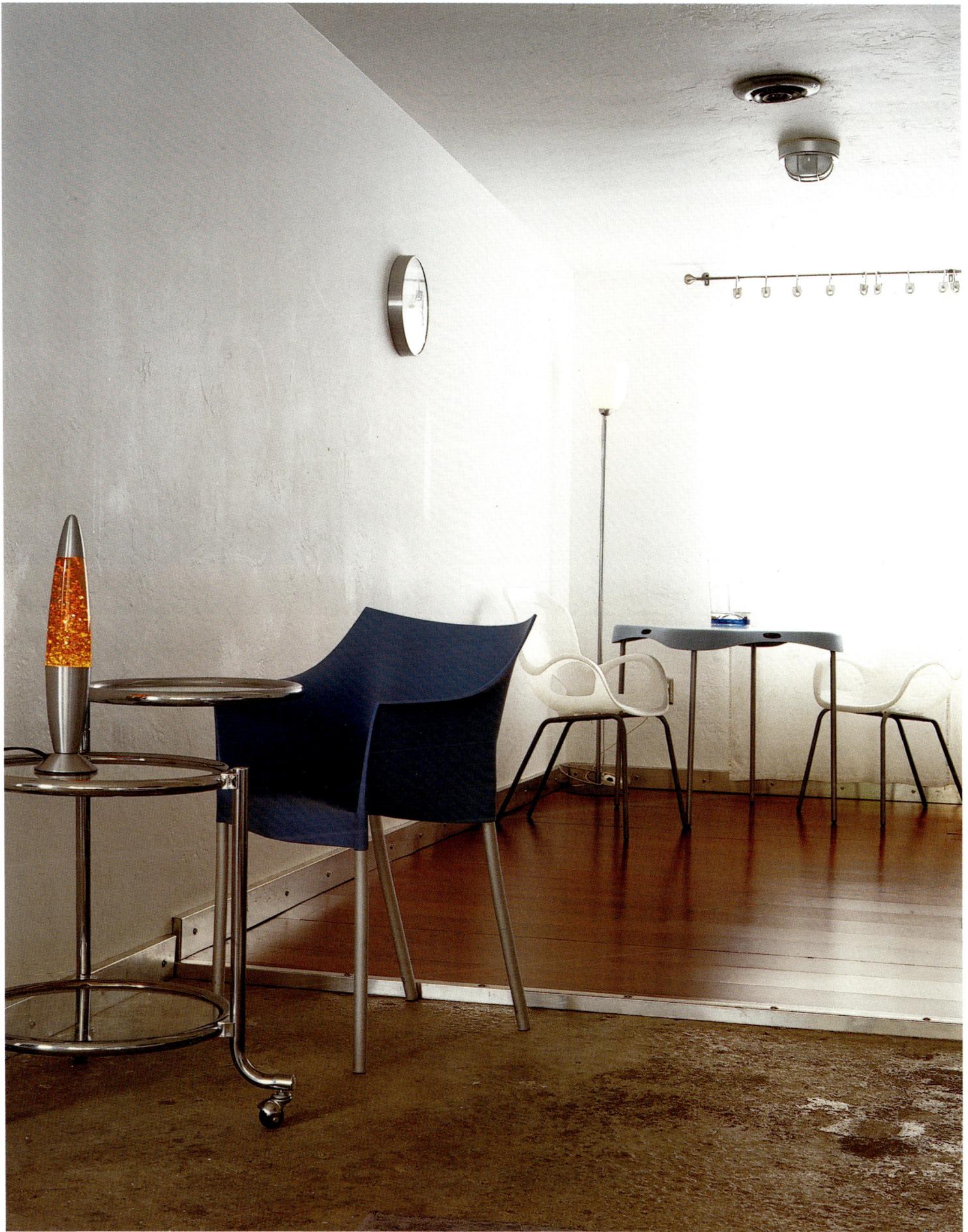

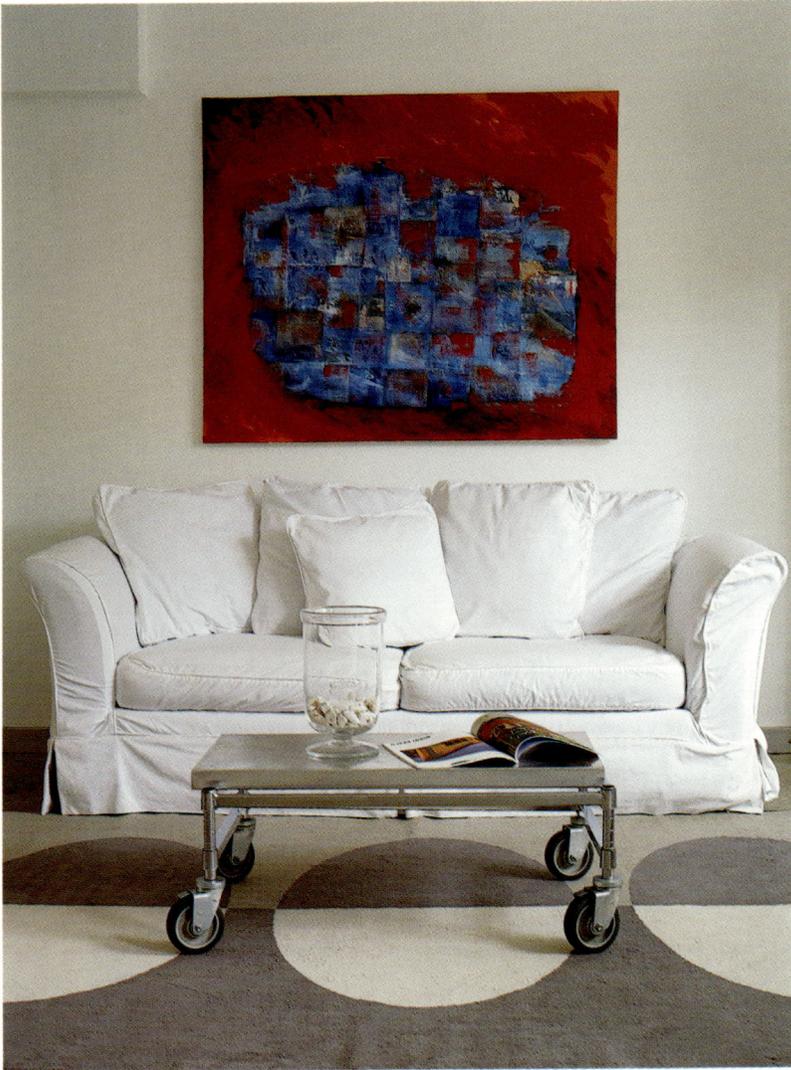
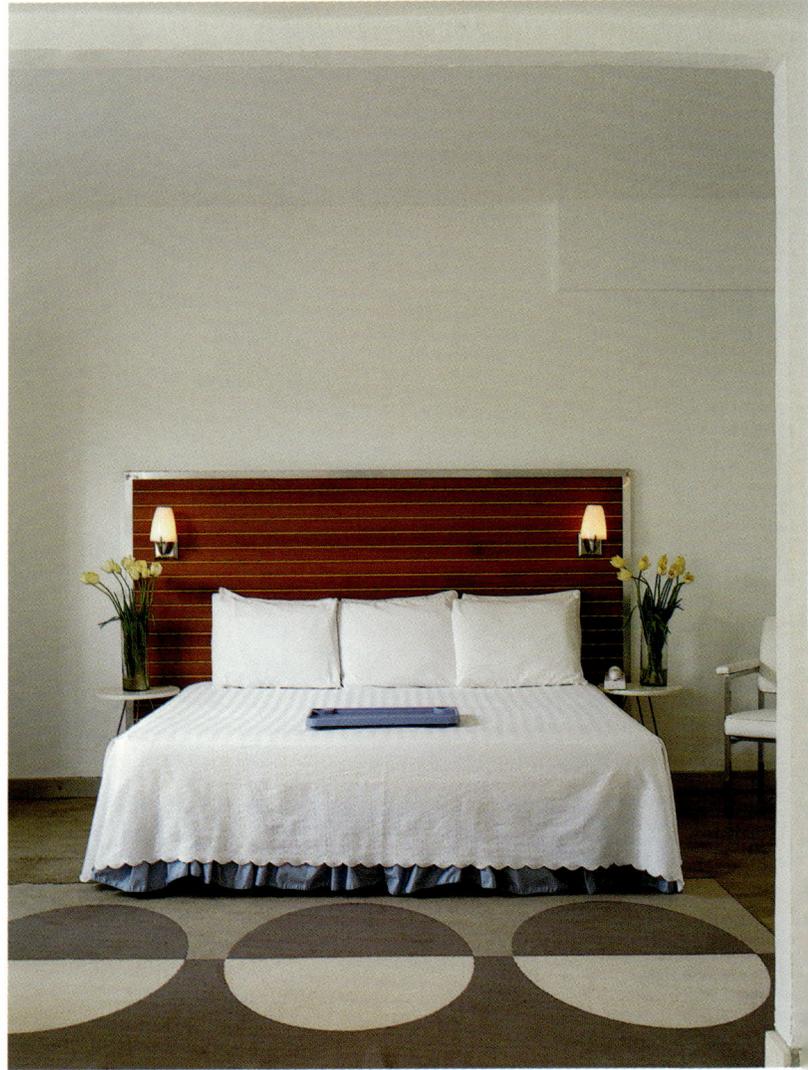

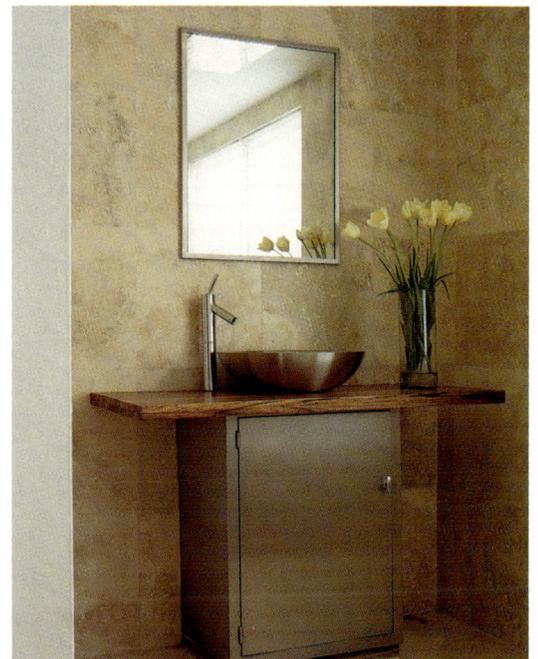

aqua
hotel lounge

Minimal decorative elements, an abundance of white, and the headboards that allude to the planks of a sailboat create a cool ambience in the guest rooms.

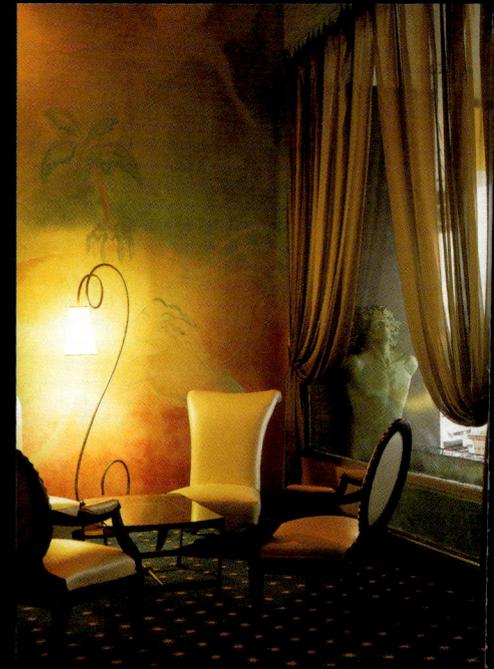

A room, a
WORLD

Since the advent of boutique hotels, special attention has been paid to the design and effect of individual rooms, not just public and exterior spaces. Hotel rooms are no longer just a place to sleep. Design strategies include converting the rooms into individual apartments, adding new functional spaces or a pool, and creating a thematic wonderland where the artists' work and labor gain a greater impact when melded with the room itself.

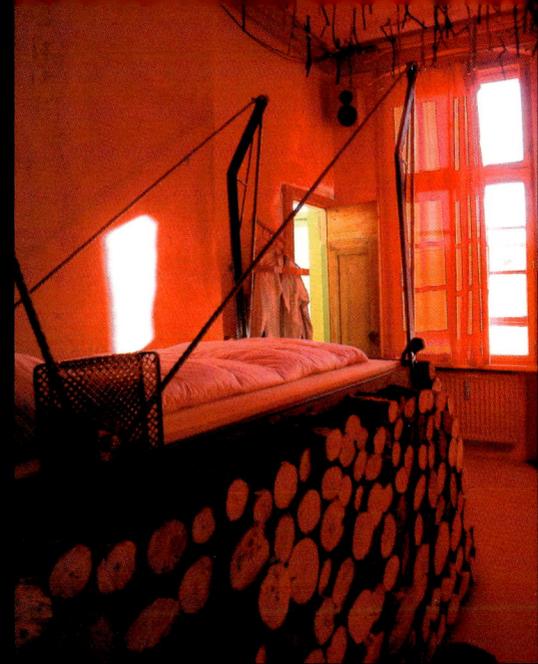
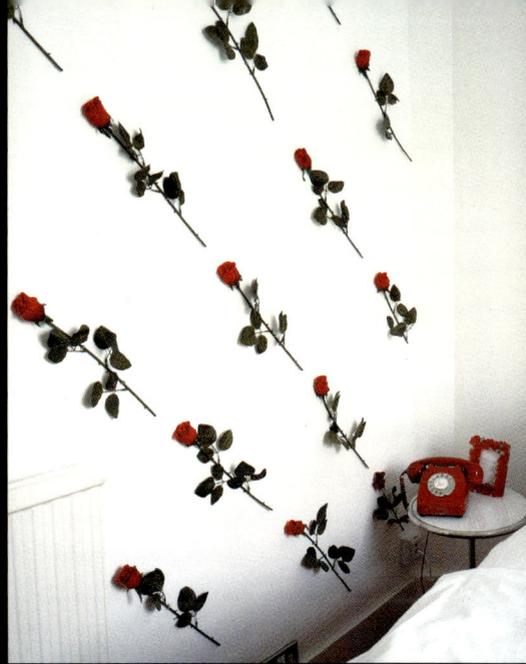
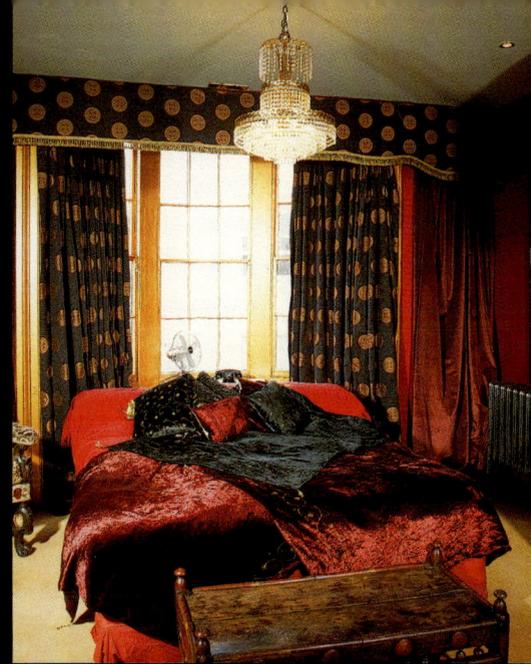

The
Shore Club

1901 Collins Ave, Miami Beach, FL 33139, USA Tel: +1 800 258 7503 www.southbeach-usa.com

What has been said over the last few years about designer hotels being built on a small scale is completely unfounded when it comes to The Shore Club, directly in the art-deco district of Miami Beach. In this complex, two historic Miami Beach hotels have been restored, and an additional building for guests, which houses 400 rooms, suites, and small villas, a private marina, exotic gardens, an infinite amount of public and private pools as well as all the spaces and services of a first-class hotel have been added. So, by achieving a whole that unifies the complete program of a resort yet still values its urban and architectural surroundings, the project becomes a real alternative for tourists visiting this city.

The interior atmosphere exudes a sensation of lightness, softness, and transparency. A small number of elements have been used to achieve this: very light colors, candles and curtains that function as lamps, and a close relationship between exterior and interior. The large curtains, which give the space warmth, are flexible elements that can integrate or divide spaces. Special attention has been paid to the exterior, especially in relation to the rooms, therefore enhancing them even further. On the top floor there is a duplex apartment that has a terrace and a private pool as well as an impressive panoramic view of the city and the coast.

Designer: **Anda Andrei** Photographer: **Pep Escoda** Location: **Miami, USA** Opening date: **2003**

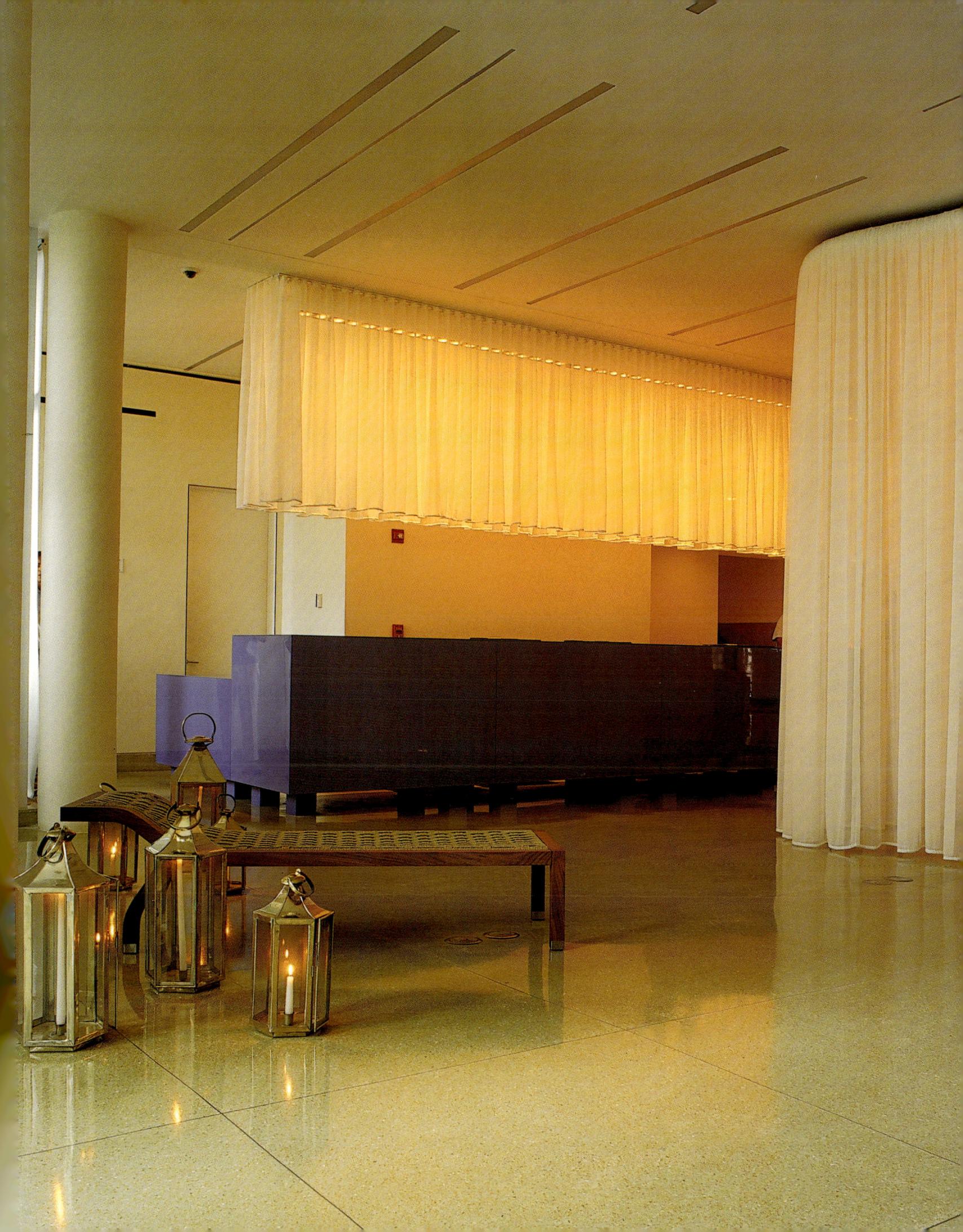

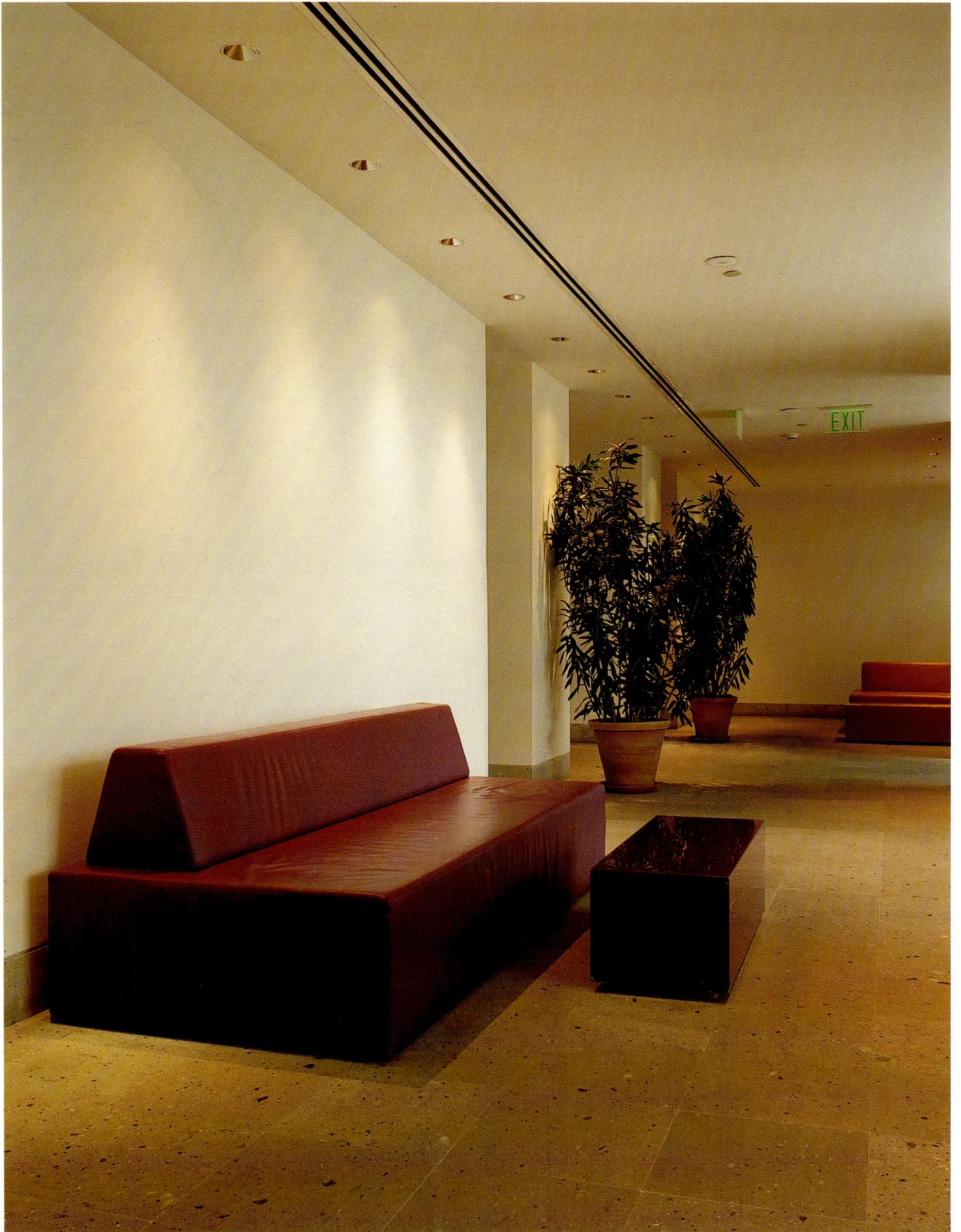

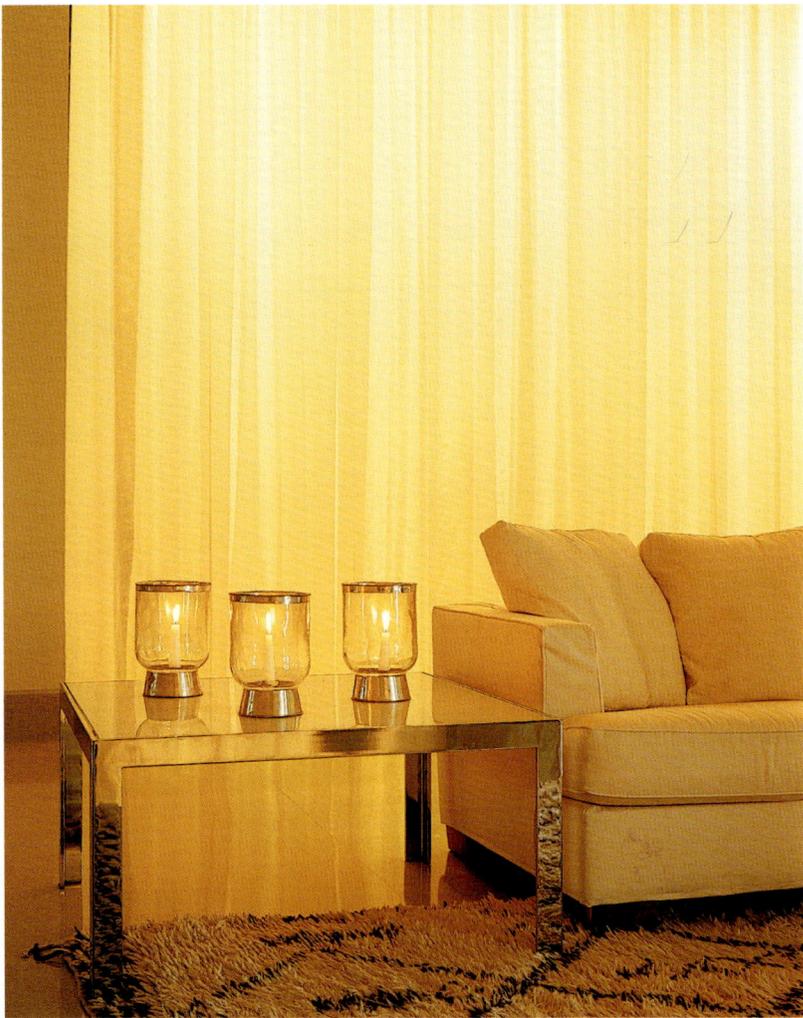
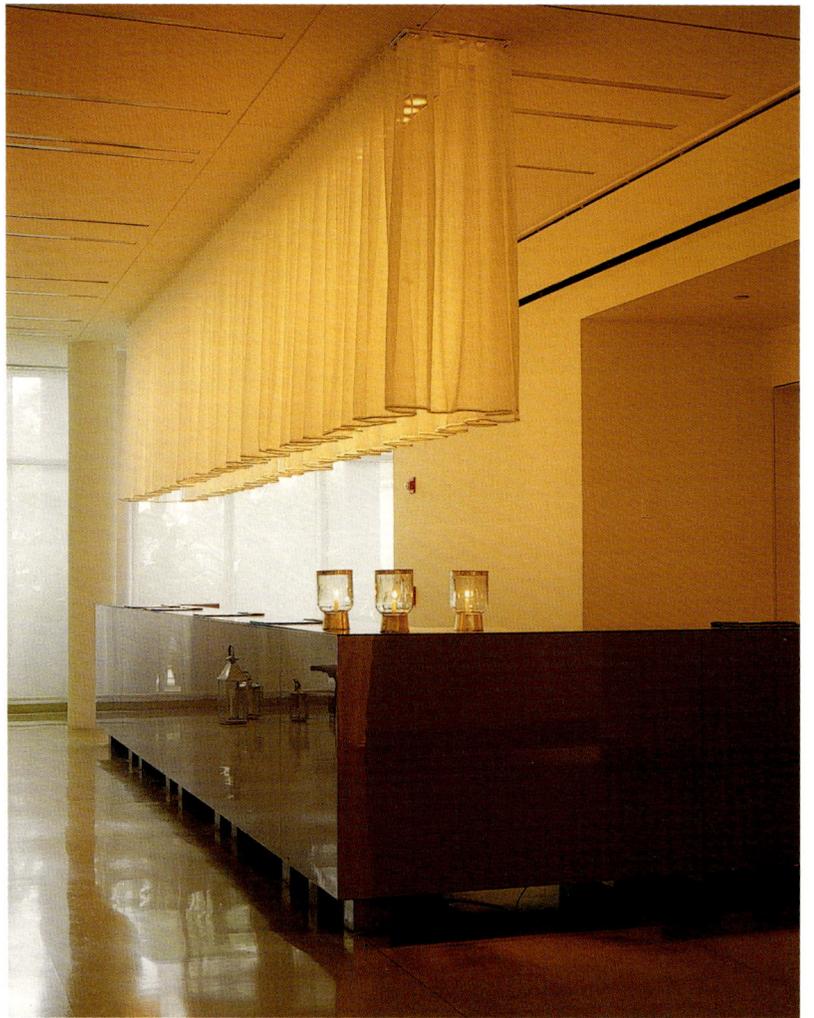
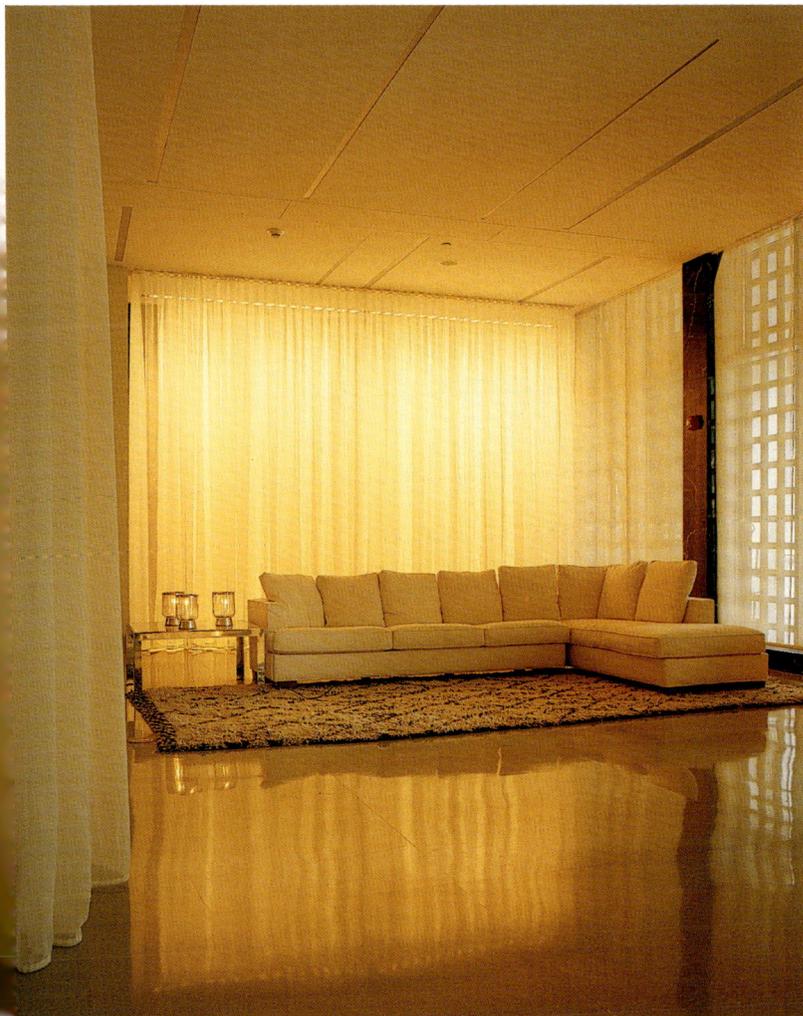
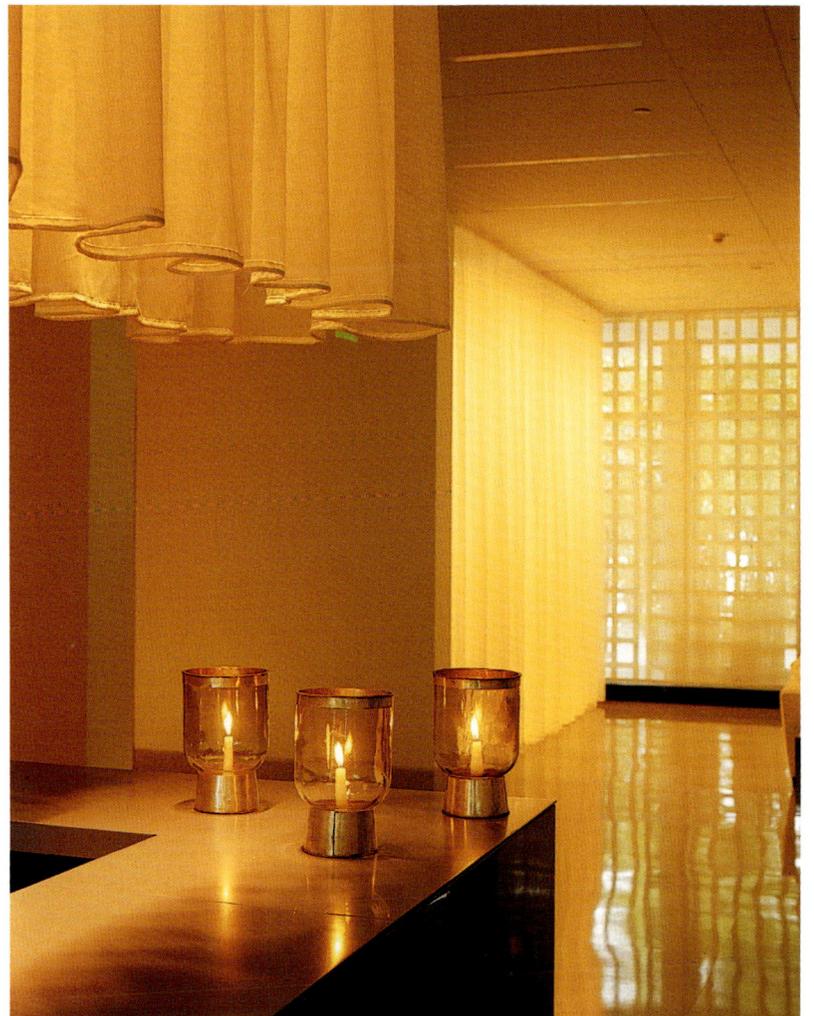

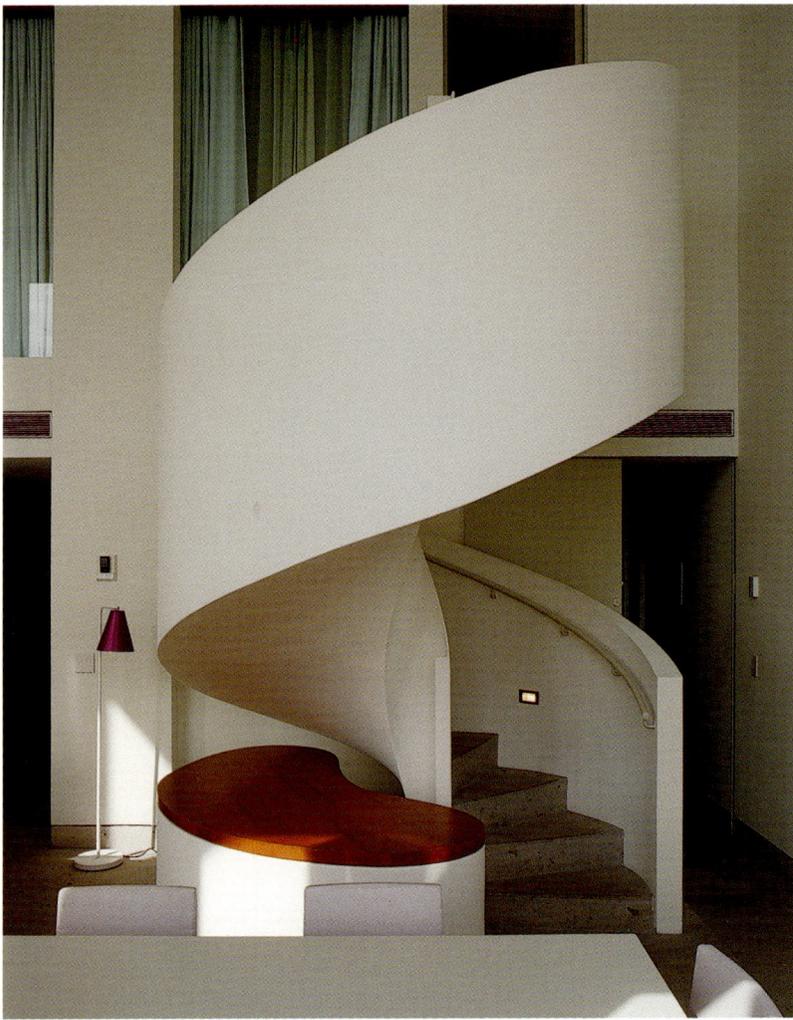
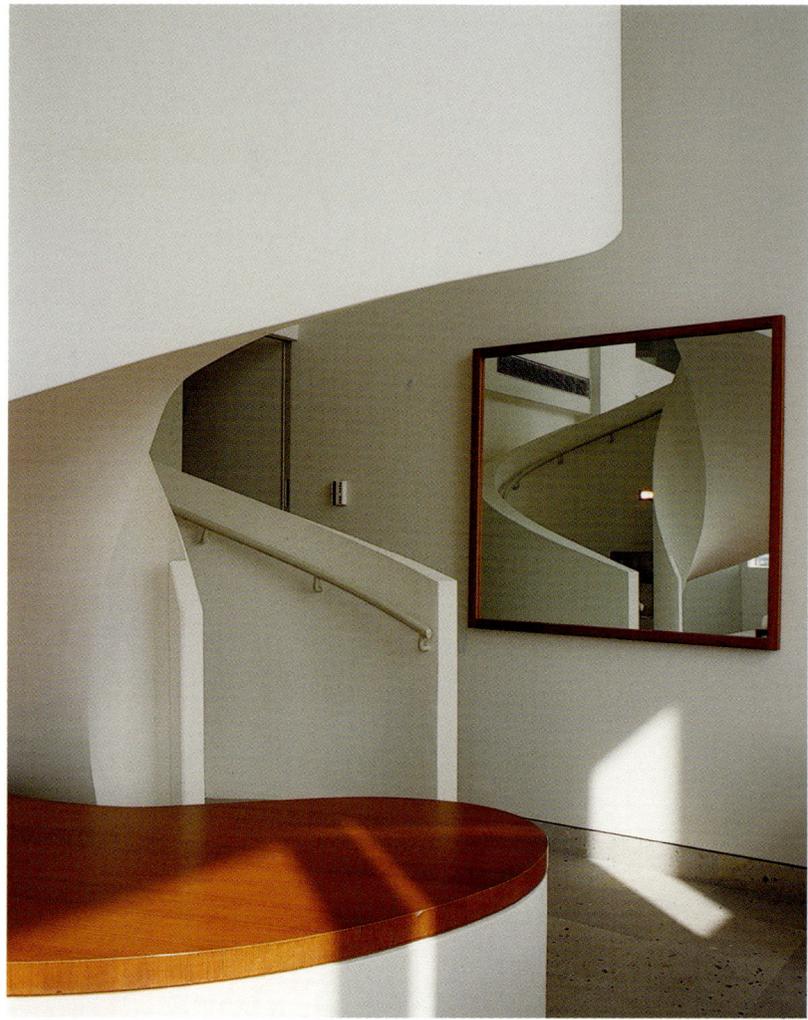
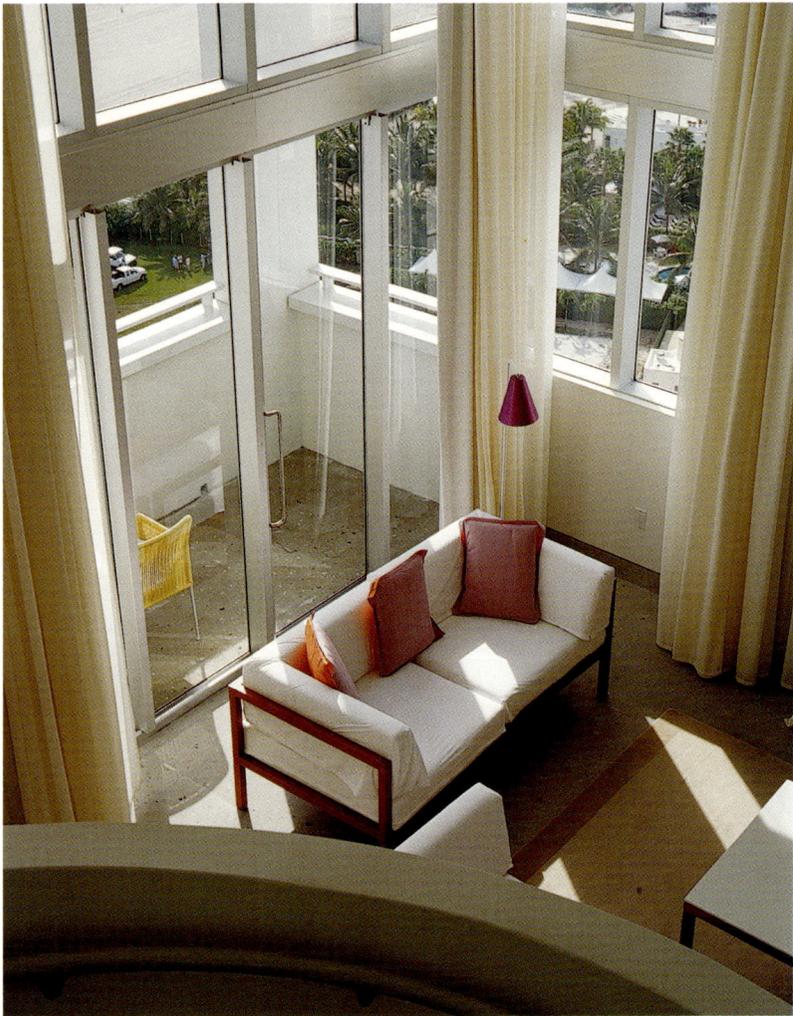
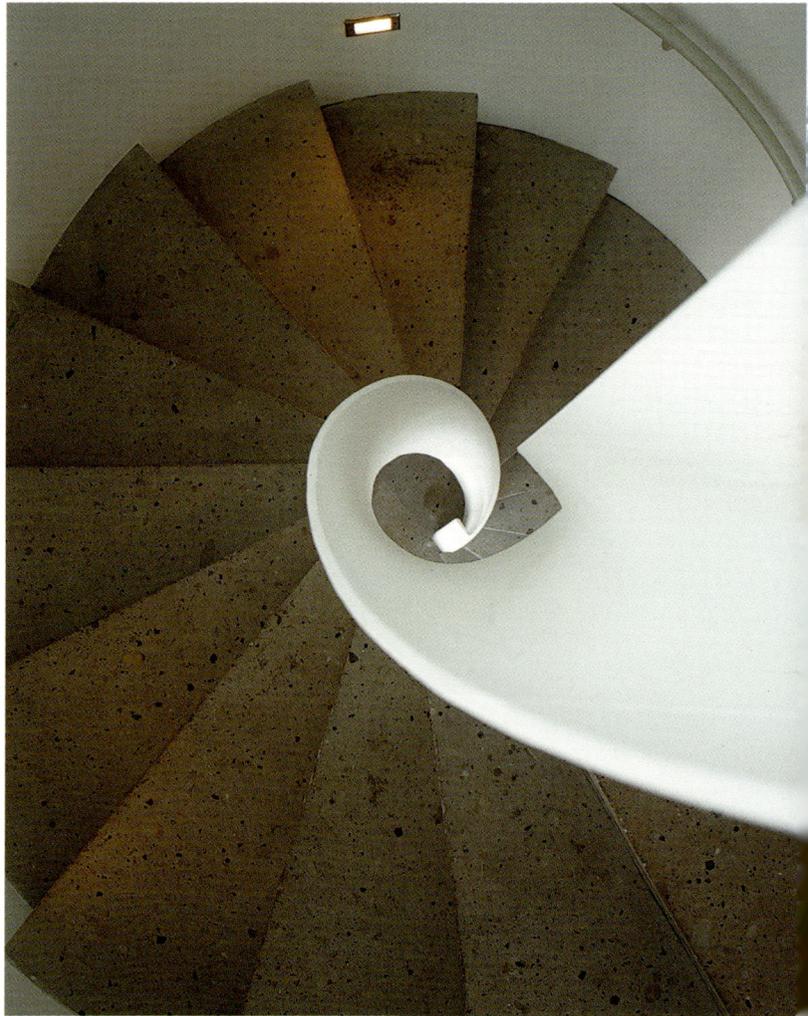

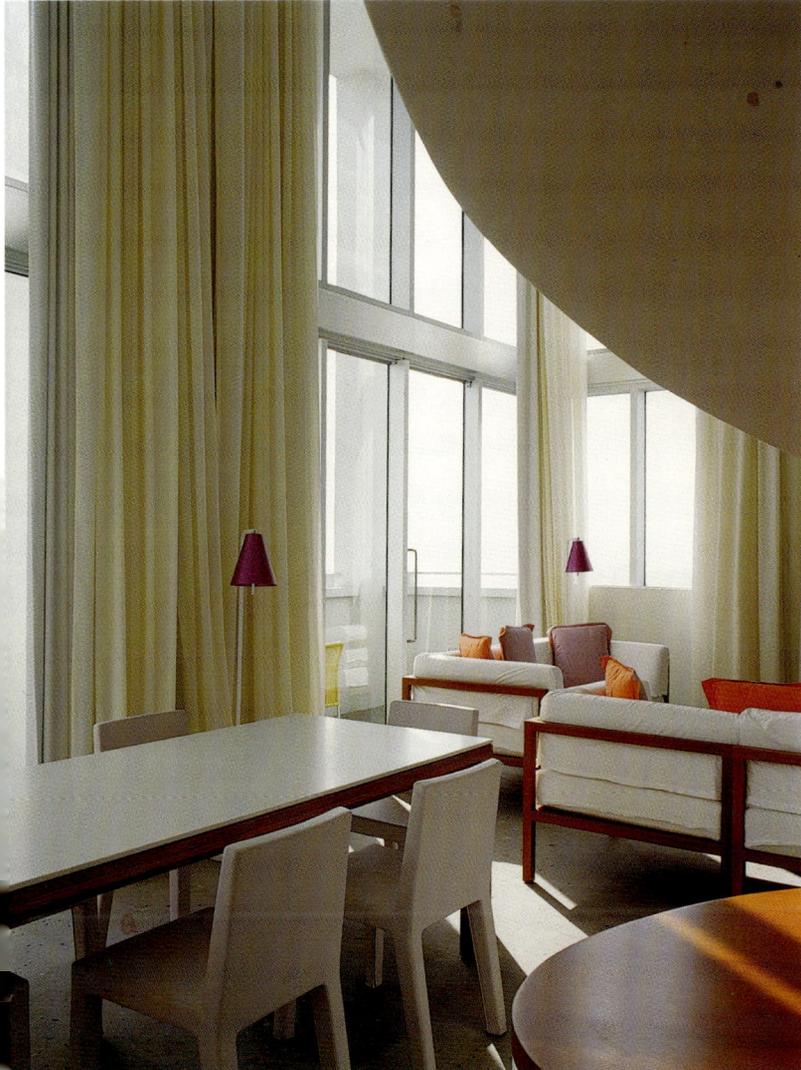

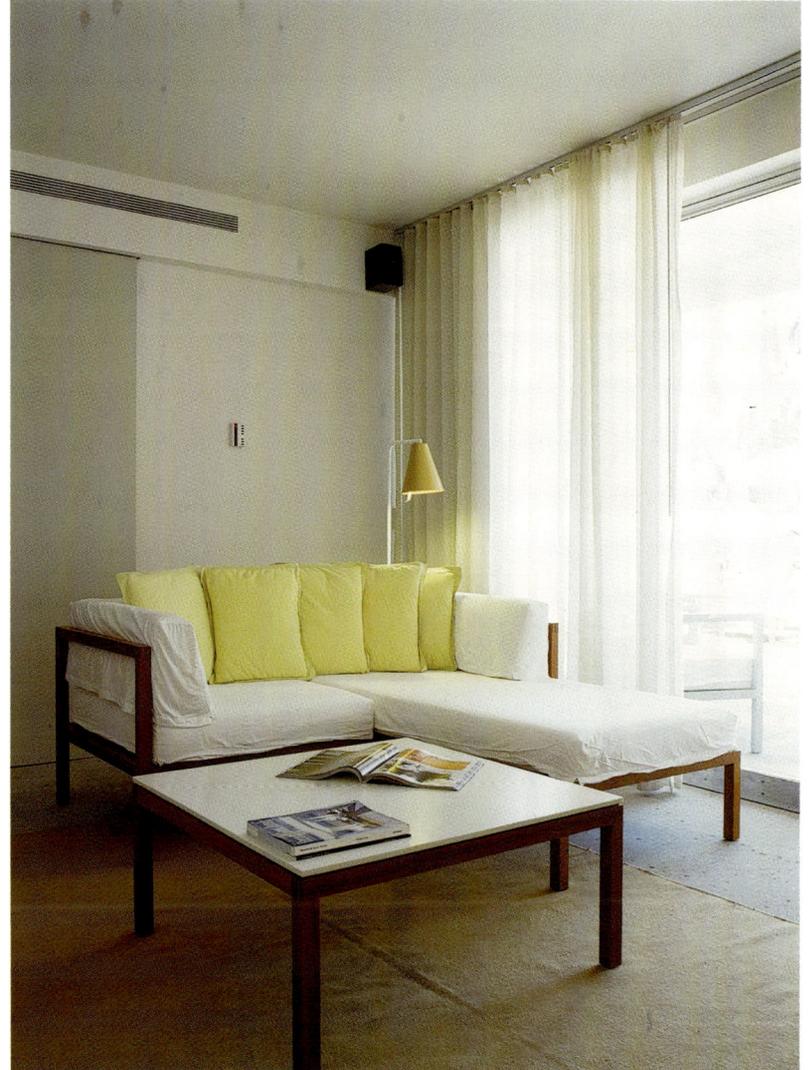

The apartment on the top floor is an impressive, high-ceilinged space with all the details needed to make one feel like just another inhabitant of the city. Simple furnishings, without being strident or extravagant, provide character to the interior.

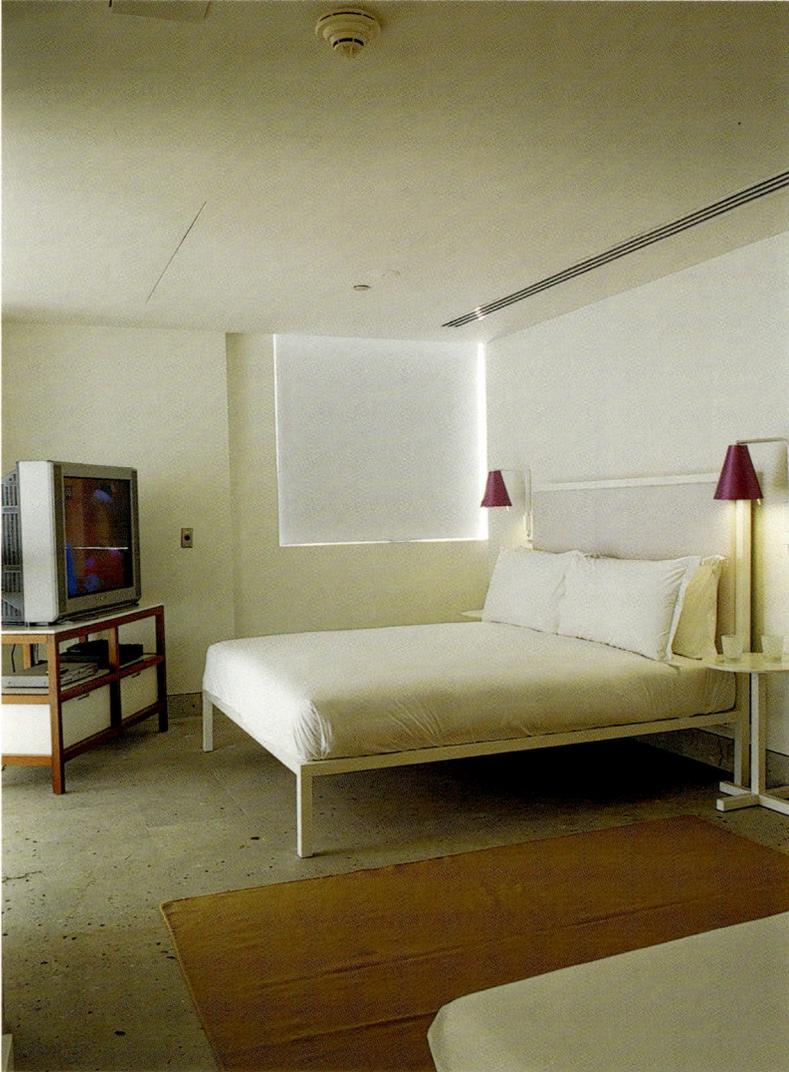
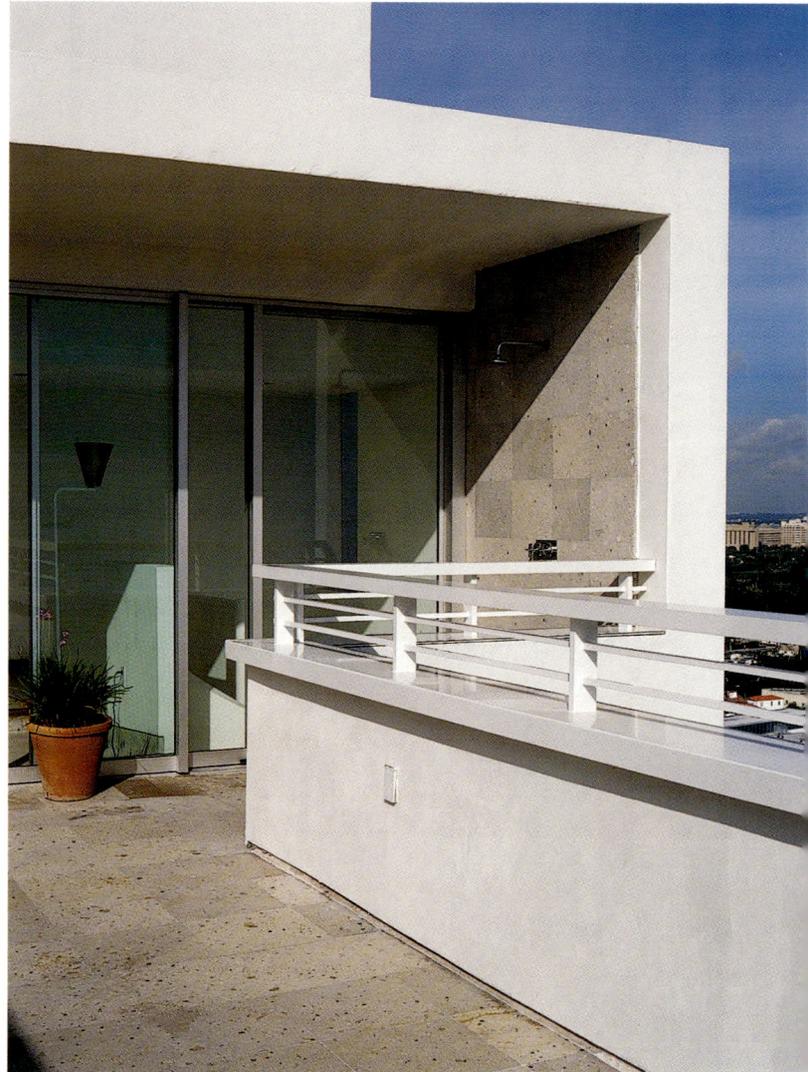

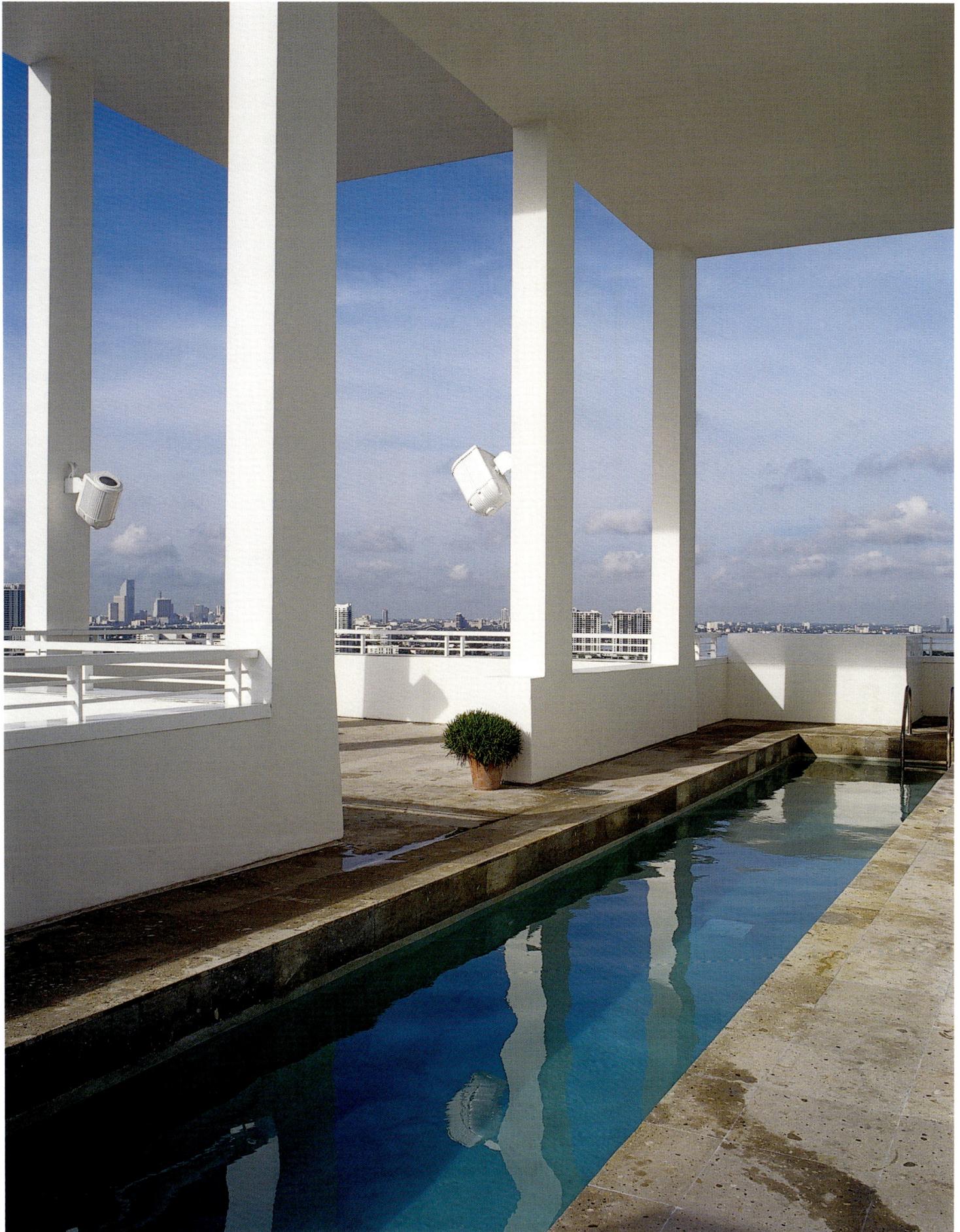

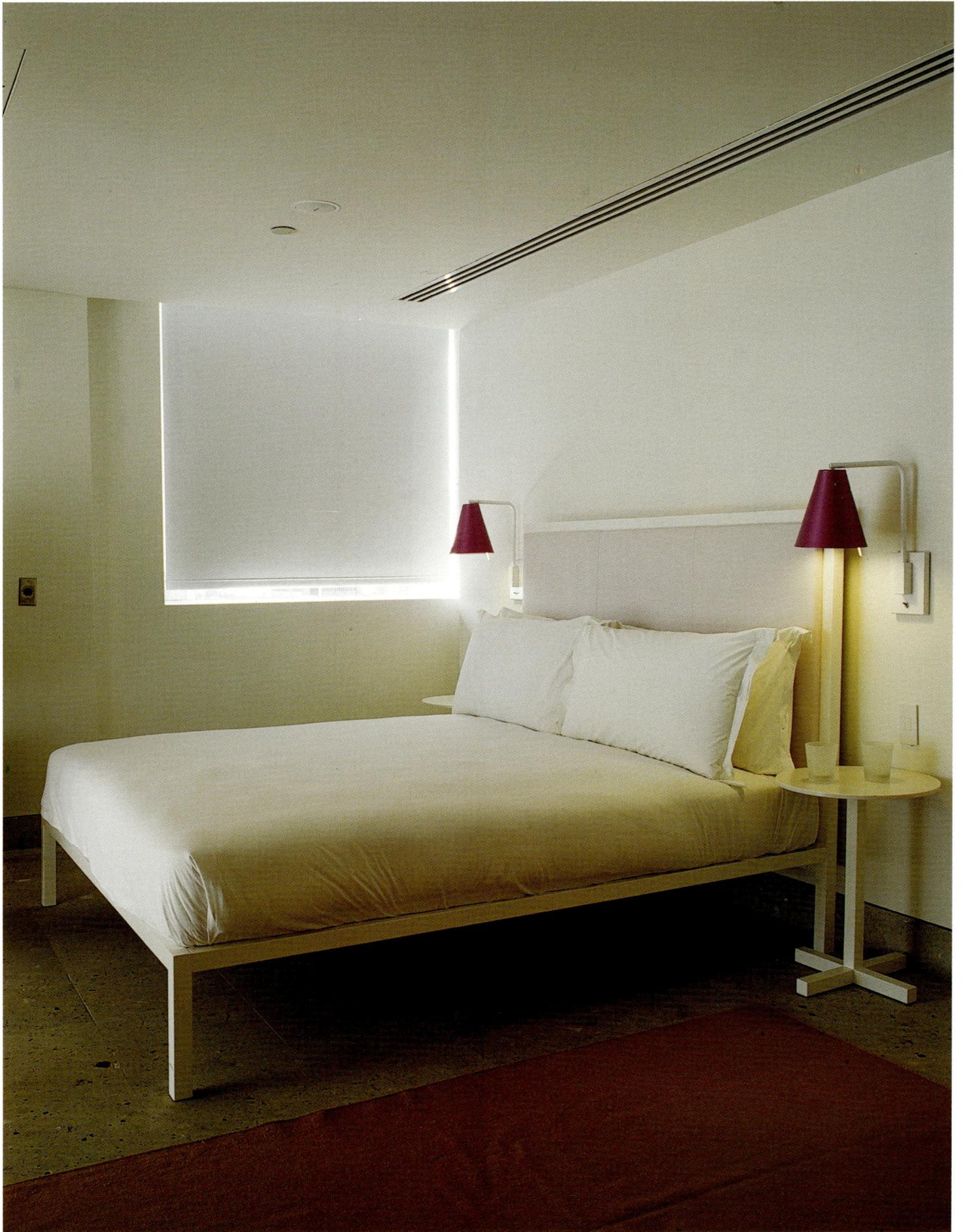

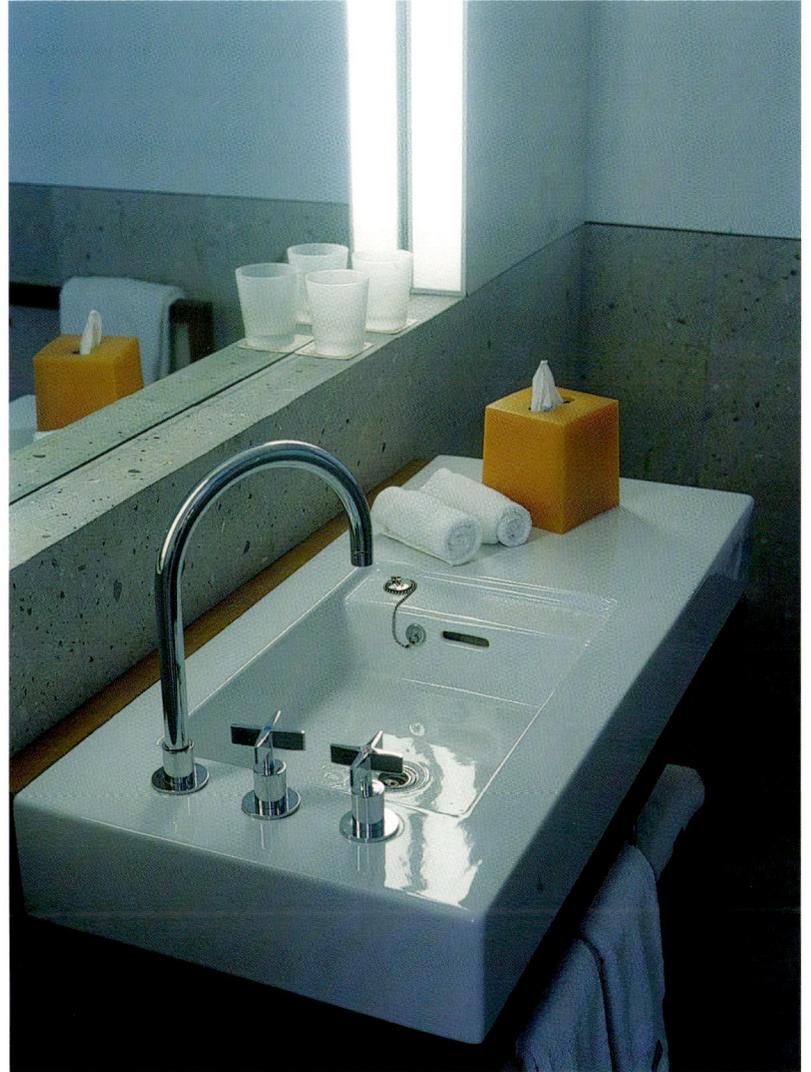

In the midst of its austerity, the hotel's sophistication is revealed through small details including the bathroom faucets or pieces such as the wooden bathtub. White prevails in the rooms that exude a fresh, clean ambience.

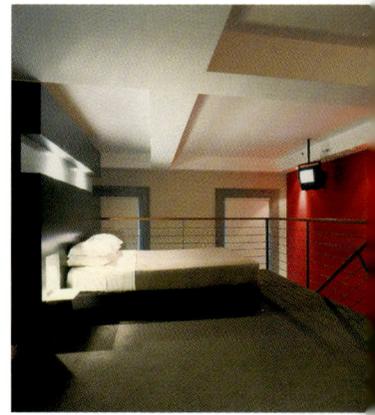

Blacket
Hotel

70 King Street, Sydney, NSW 2000, Australia Tel: +61 (0)2 9279 3030 Fax: +61 (0)2 9279 3020 theblacket@theblacket.com www.theblacket.com

Located in the heart of Sydney's financial district, the Blacket is a mix of old and new, and a special piece of the city's architectural heritage. The building was once the Scottish Bank of Australia, designed by Edmund Blacket, one of Sydney's most prolific architects of the 1950s. Many of Blacket's architectural details have been preserved in order to imbue the interior space with more character; examples include the marble floor in the lobby, the central staircase with its splendid iron banister, and a few Victorian details in the private rooms.

The interior design projects a decidedly renewed image, employing pieces of contemporary art and design, but without becoming cold or intimidating. The different spaces all have a warm, comfortable, and peaceful atmosphere. This is due, for the most part, to the range of colors used—soft, neutral tones among which cream, gray, and chocolate prevail. Some elements of color, used in elements of the design, furniture, and art objects, create contrast and focal points in the rooms. The restaurant is the bridge between the original building and the new addition, which is used for offices. It is notable for its lightweight roof, a metal and glass structure that allows for the passage of light and a skyward view of the surrounding architecture. The overall whole, because of the structure's history and the way it is reflected in the interior, presents itself as a sensitive space within the urban surroundings.

Designer: **John Harrs** Photographer: **Marian Riabic** Location: **Sydney, Australia** Opening date: **2001**

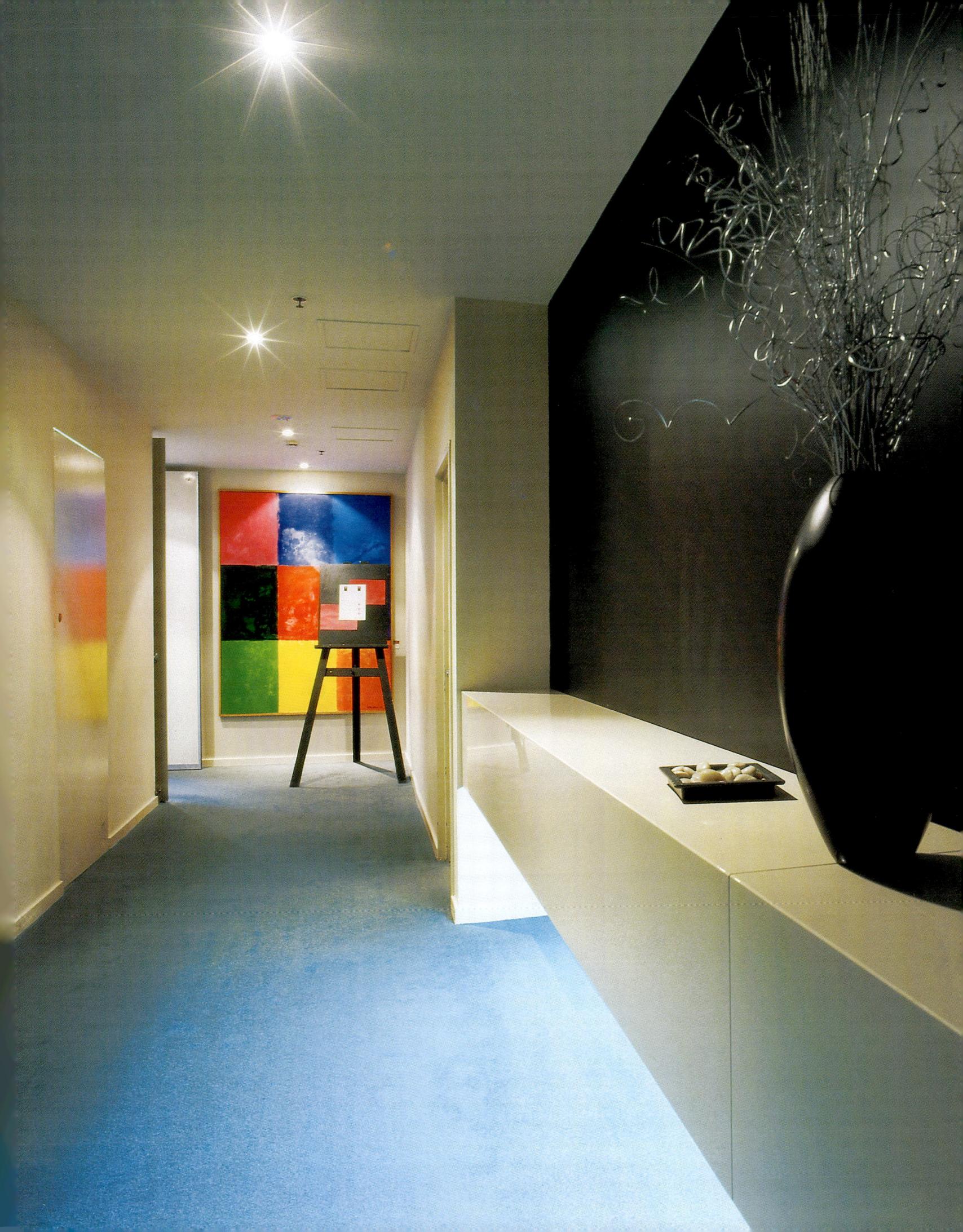

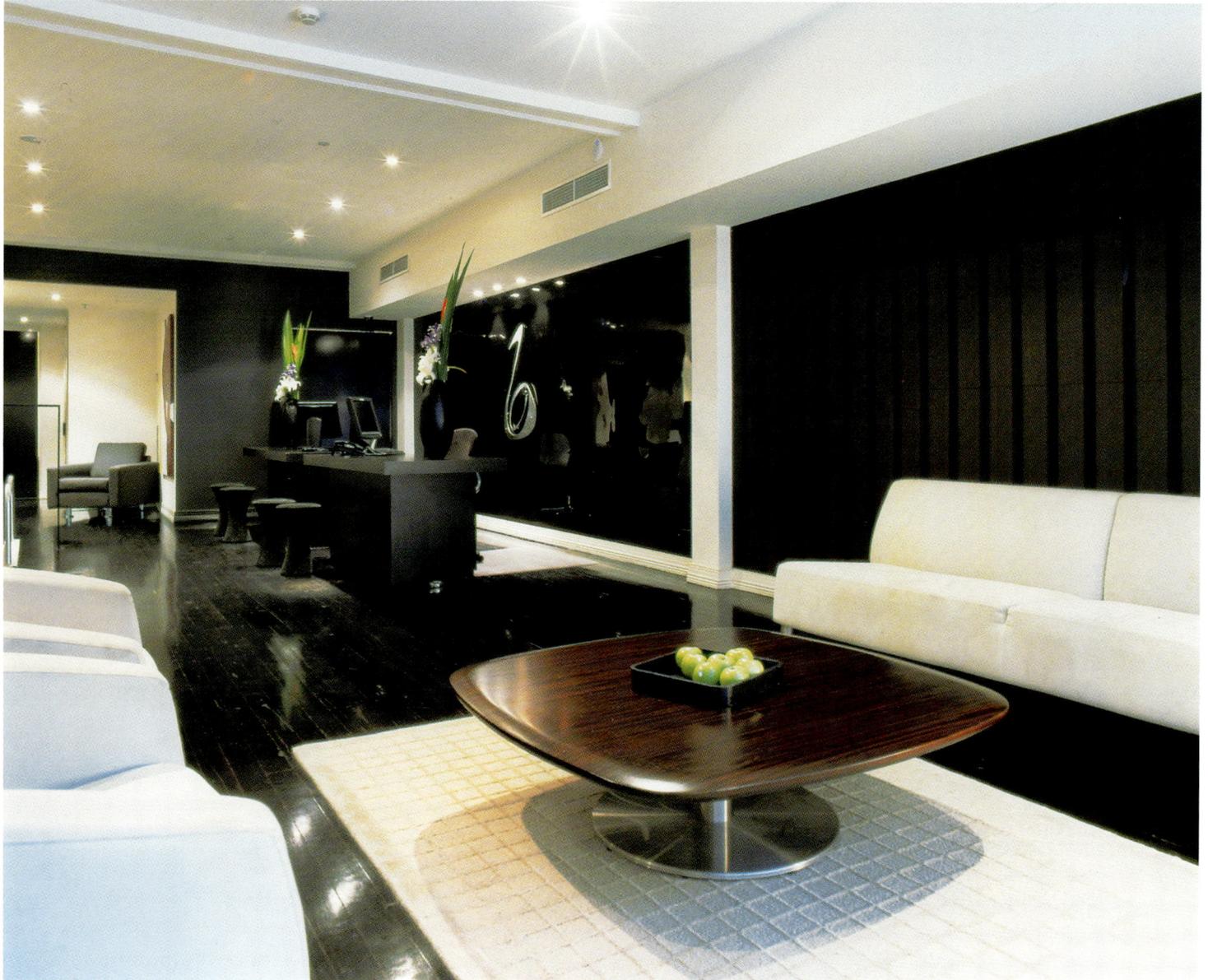

The bar, an enclosed, intimate space, makes reference to the Ottoman style, while the restaurant, just next to it, is an open space, filled with light. A dramatic effect is achieved with the contrast between the white bench and the prevailing black and rose colors.

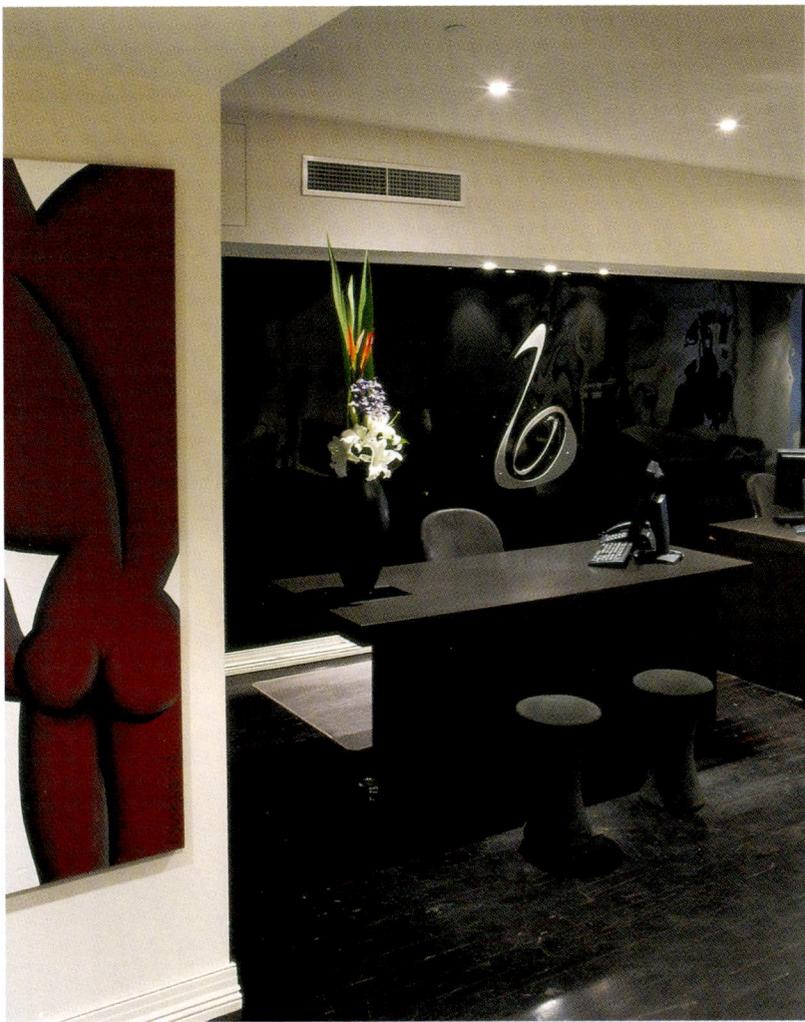

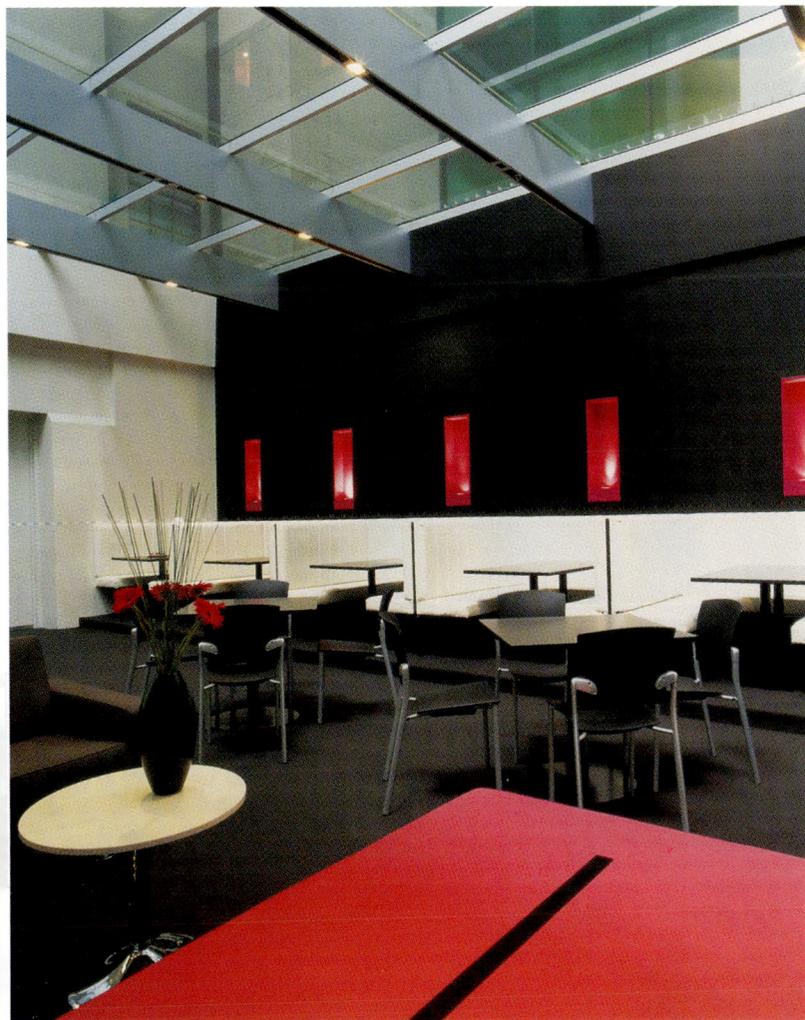
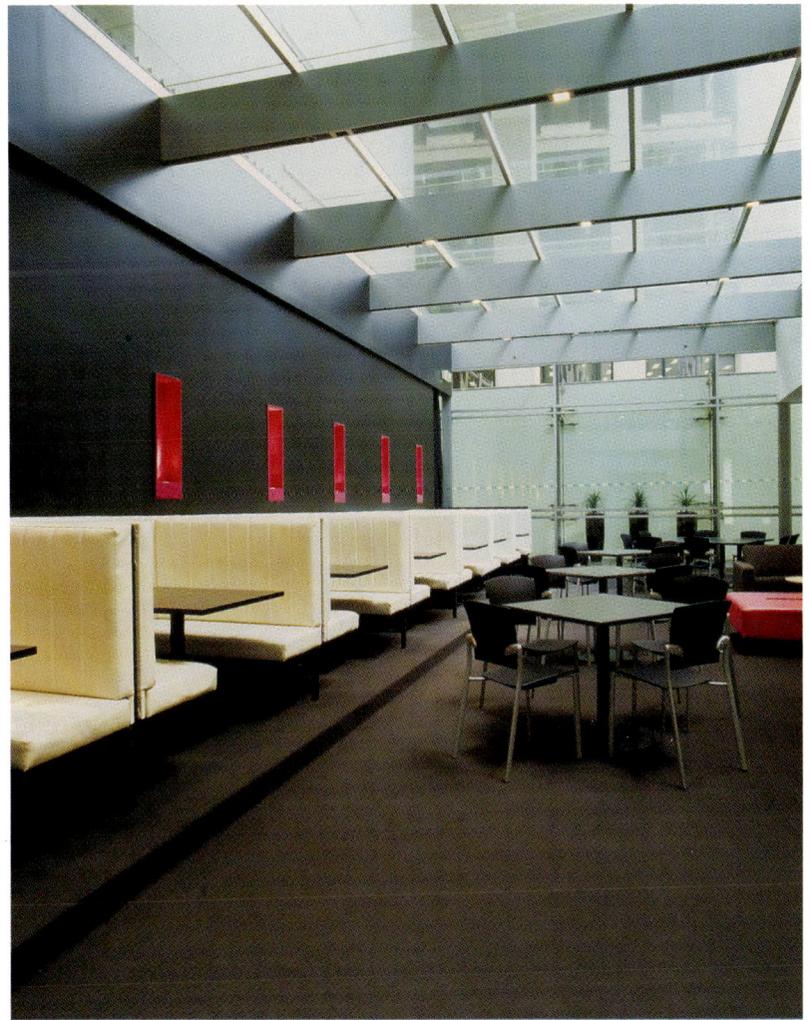

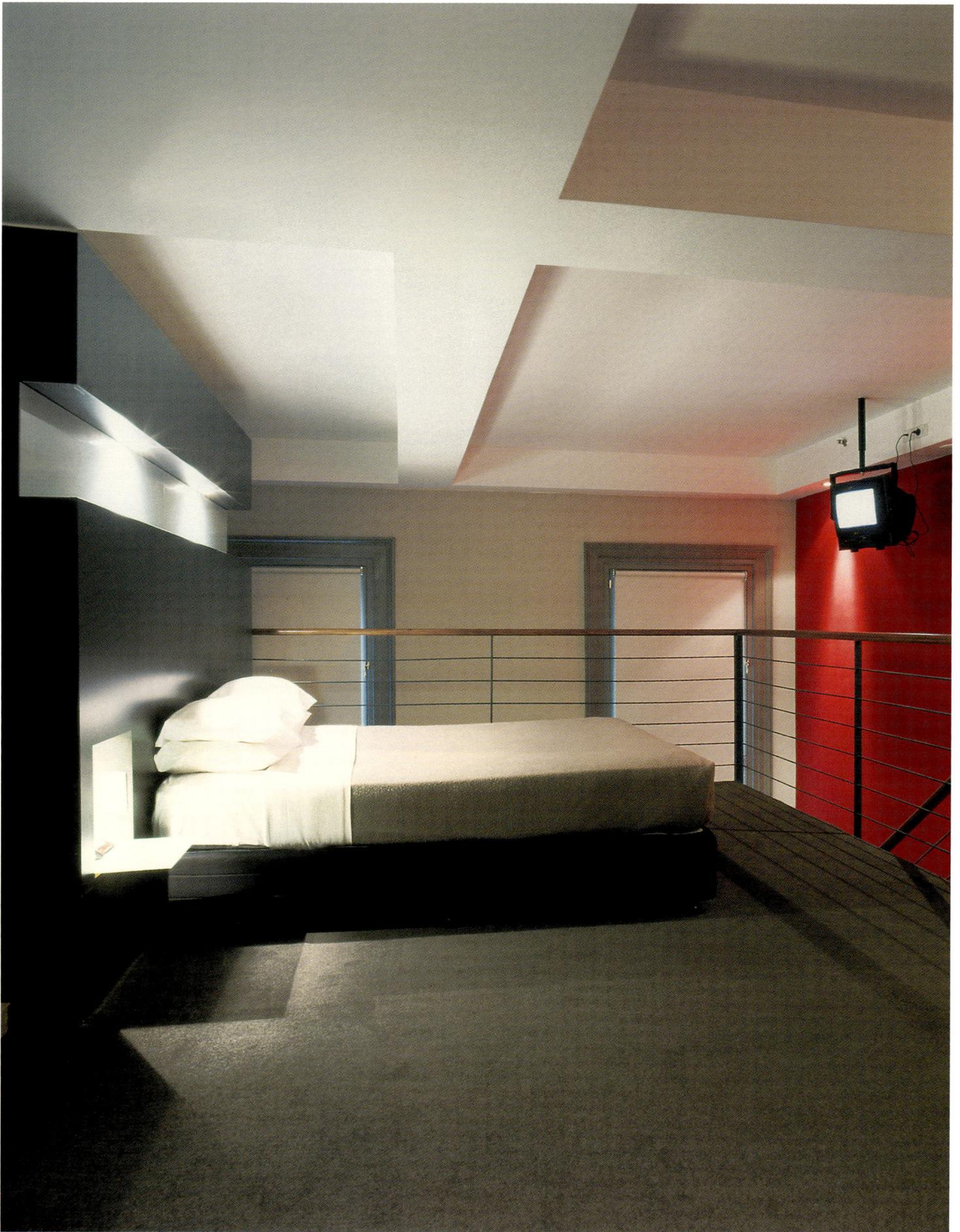

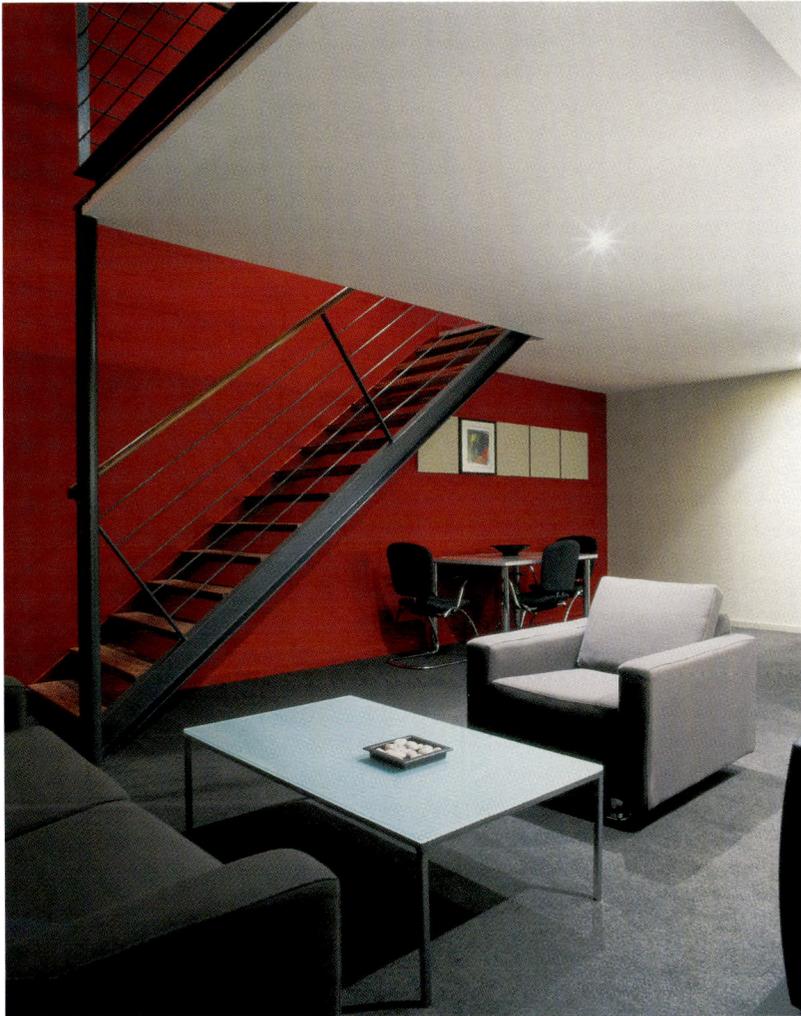

The 42 rooms of the hotel have an interesting layout and special interior décor. Some, like this one, are similar to small studio apartments with a sleeping loft for the bed.

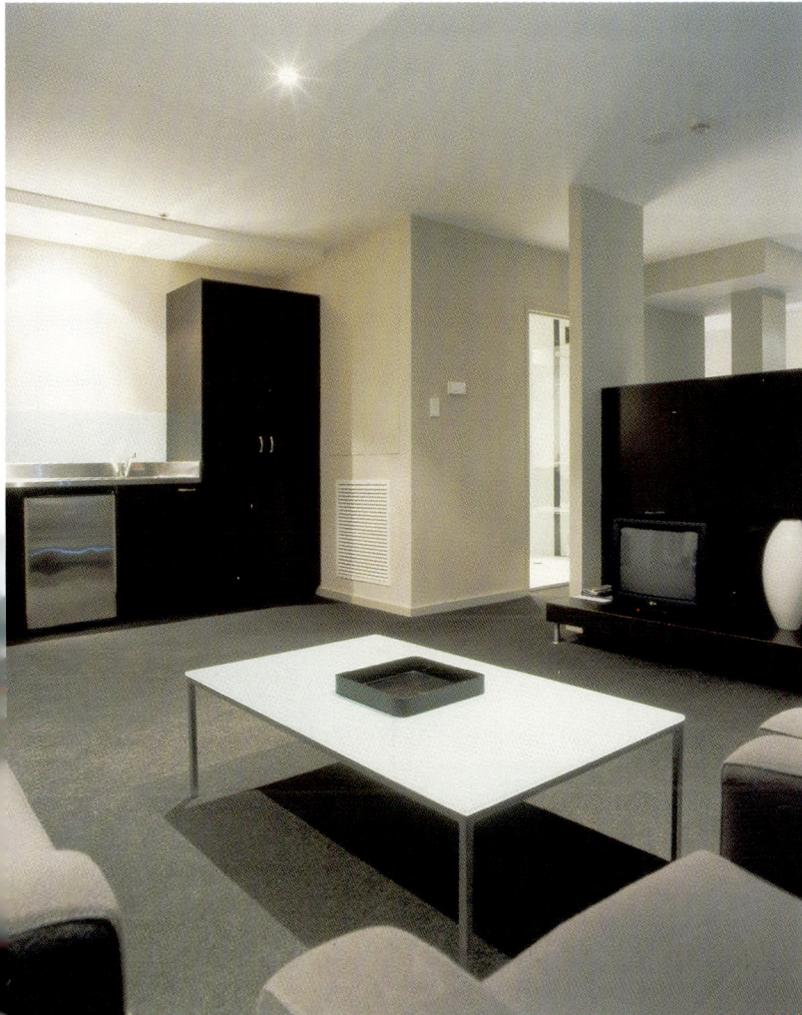

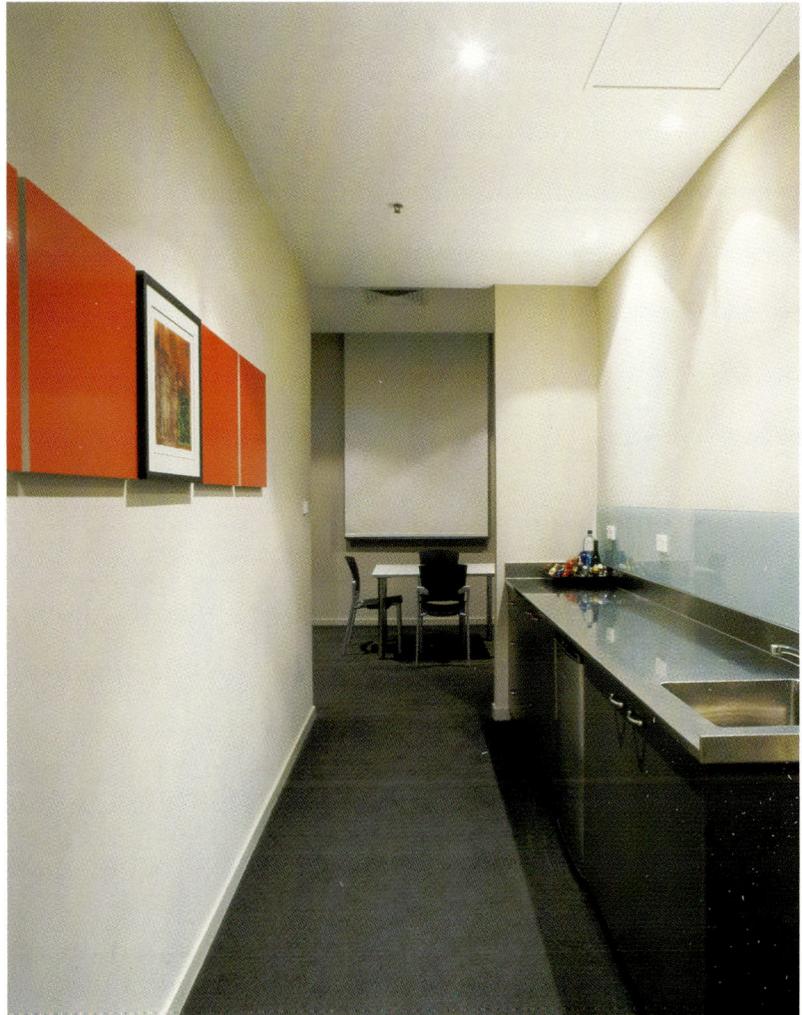

The designers tried to achieve an atmosphere closer to that of a home than that of a hotel by looking for pieces of furniture that would reflect the same style but enhance the space.

Blanch House

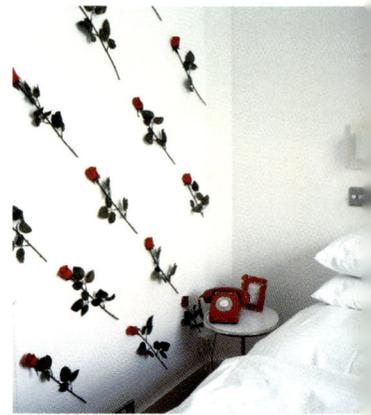

17 Atlingworth Street, Brighton BN2 1PL, United Kingdom Tel: +44 1273 603504 Fax: +44 1273 689813 info@blanchhouse.co.uk www.blanchhouse.co.uk

Blanch House is located in an old house in a typical Georgian terrace very close to the waterfront in Brighton, a small city in the south of England that is very popular during the summer. Its attractive spatial proportions and the idea of creating truly original accommodations were the starting point for this little hotel, where the owner herself, along with her husband, took charge of the interior design. The dining room is a light, clean space where the dark wood of the floor and tables stands out against the rest of the white furnishings, coverings, and lamps. In order to maximize the space, they placed a modular sofa along the perimeter of the room, providing more seats and a sensation of spaciousness.

The owners' goal of designing original guest rooms is clearly achieved. Various themes reminiscent of landscapes, other countries, or periods of art history comprise the decoration of each room. This way each room has its own style so that every visit to the hotel becomes a one-of-a-kind, fun experience. Many of the pieces of furniture were especially designed for the hotel while others were found in bazaars, secondhand shops, and designer furniture stores.

Designer: **Amanda Blanch** Photographer: **Leigh Simpson** Location: **Brighton, United Kingdom** Opening date: **2000**

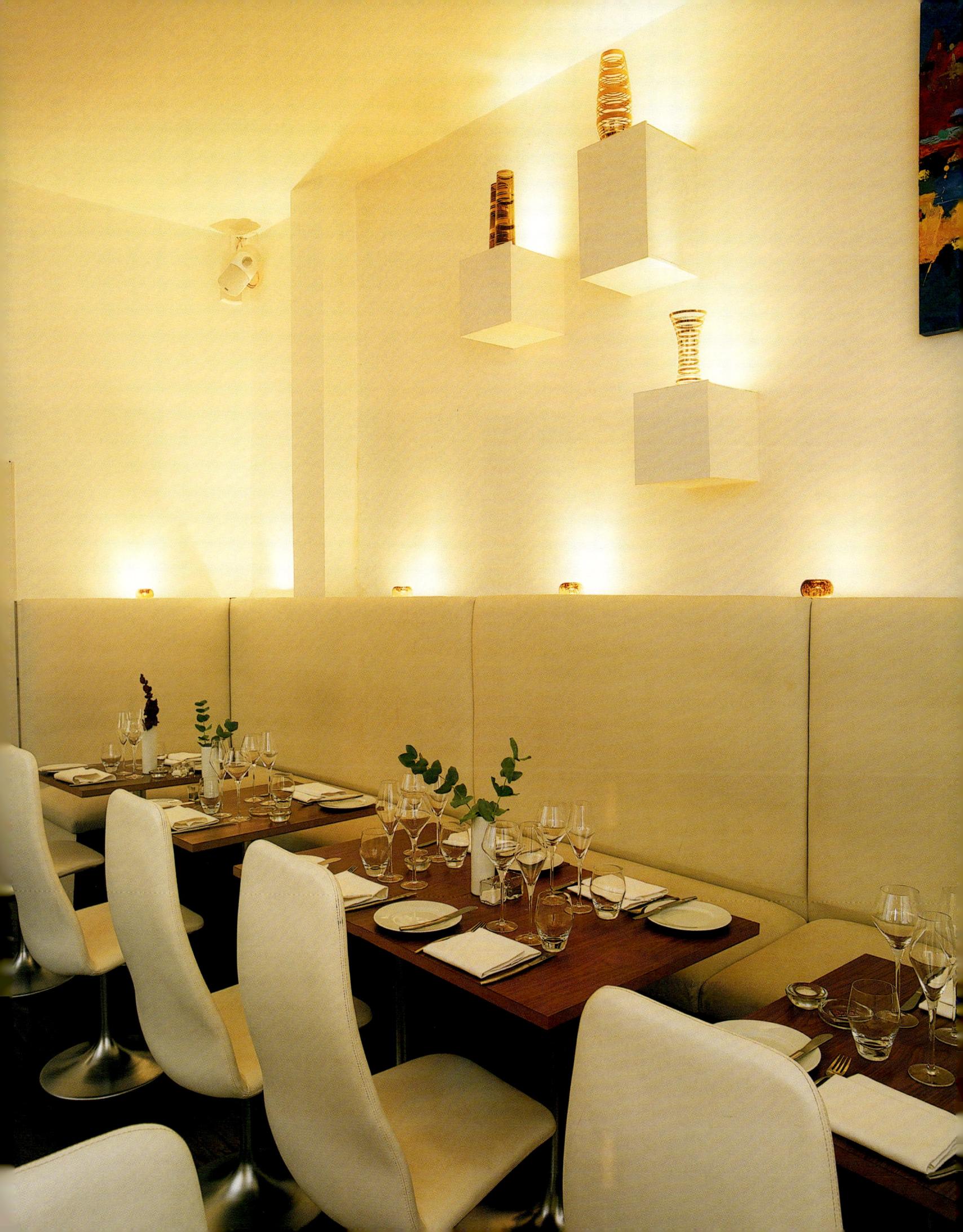

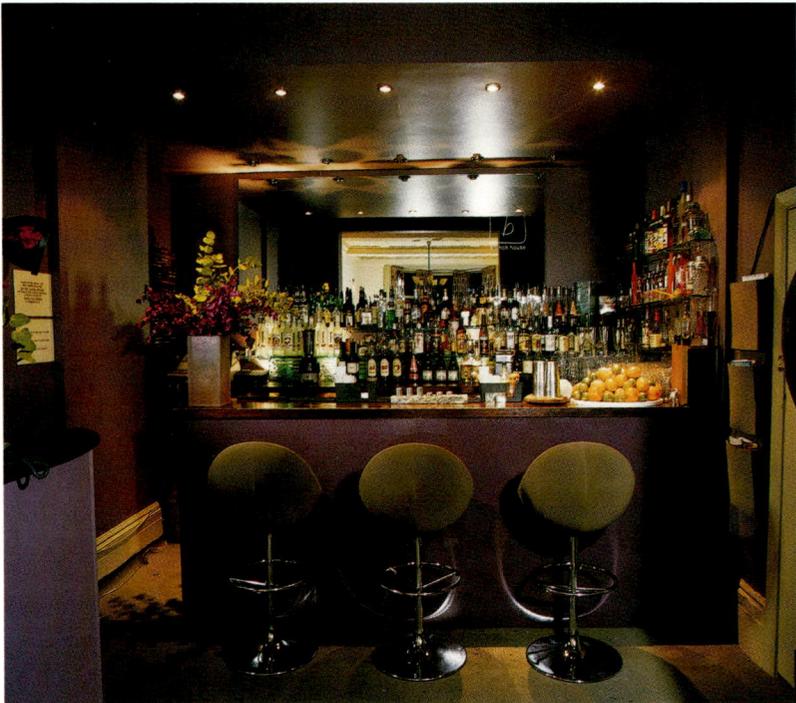

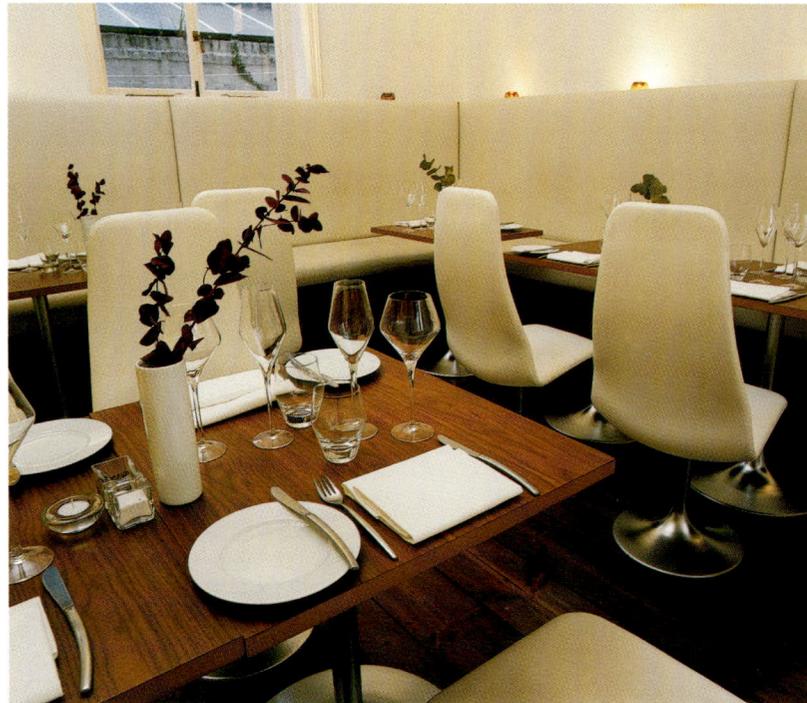

The size of the public areas of the hotel is kept to a minimum in order to use the majority of space for the guest rooms, which include a small living area and a generously-sized bathroom.

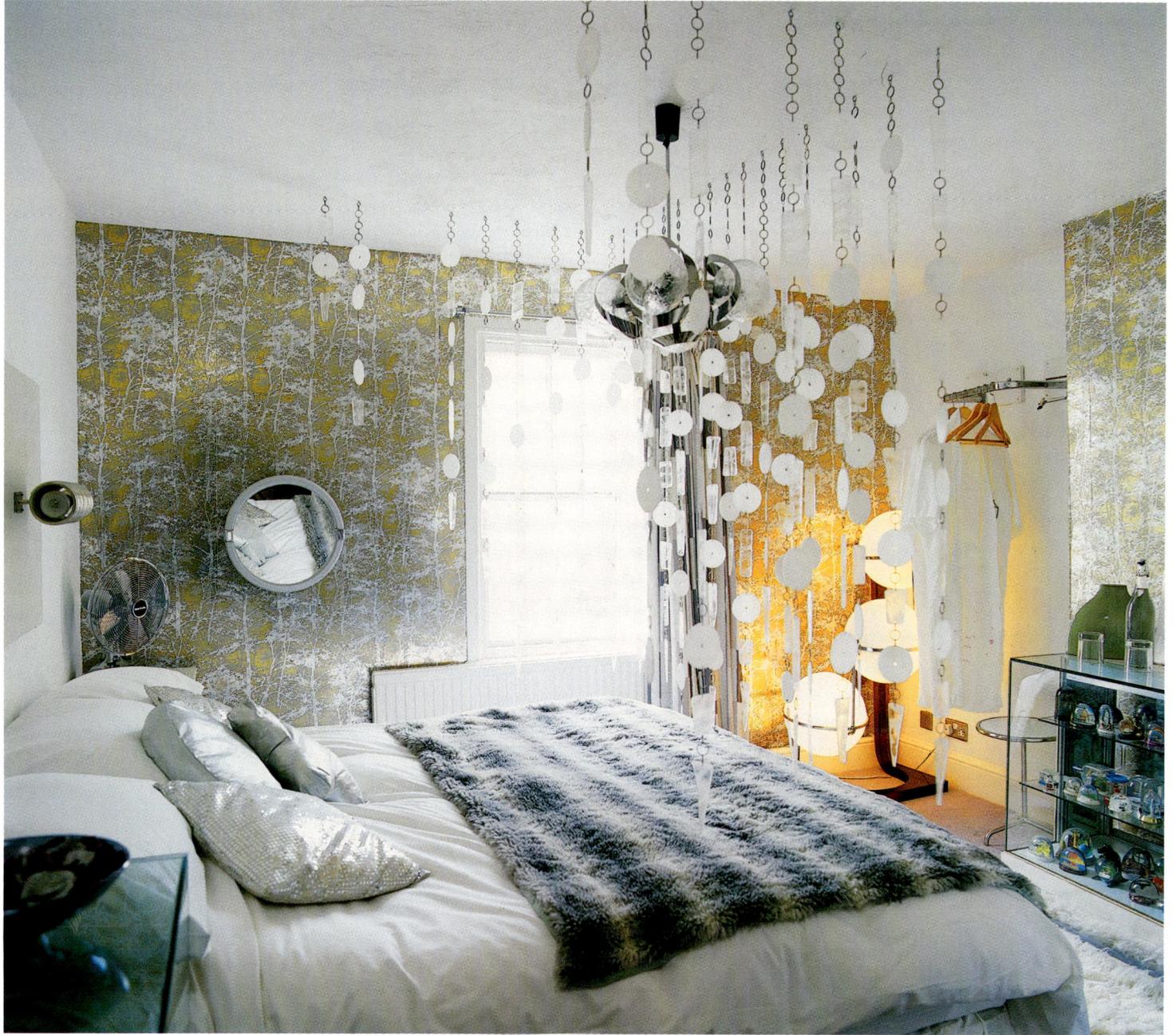

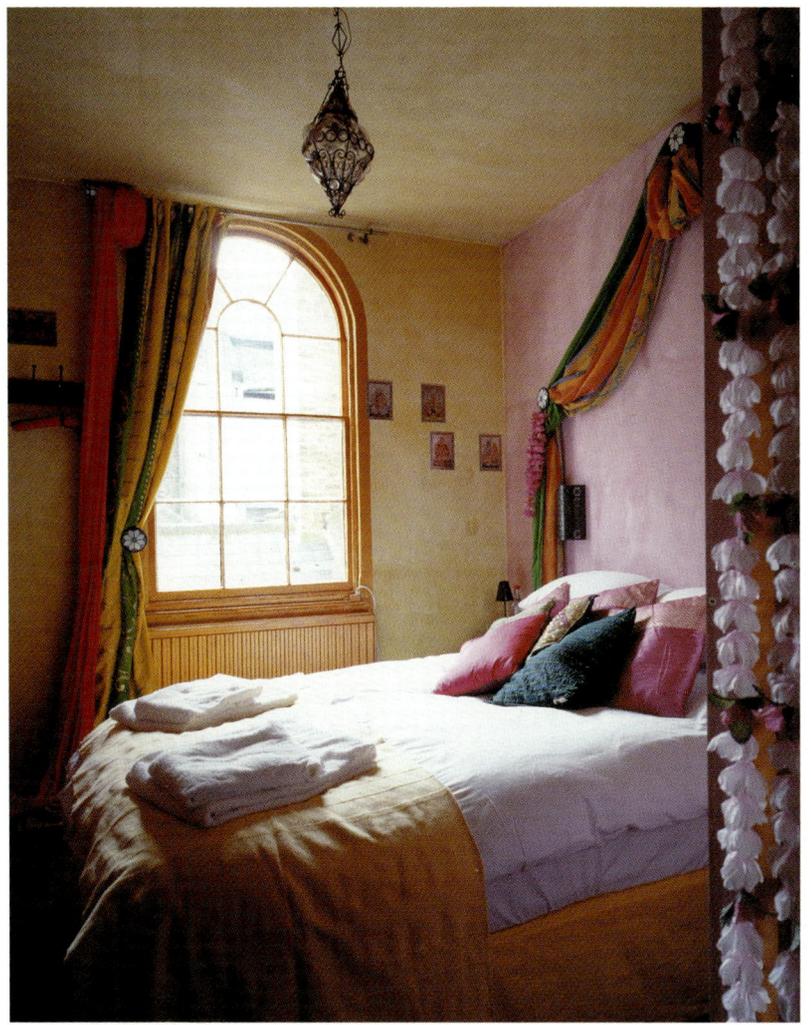
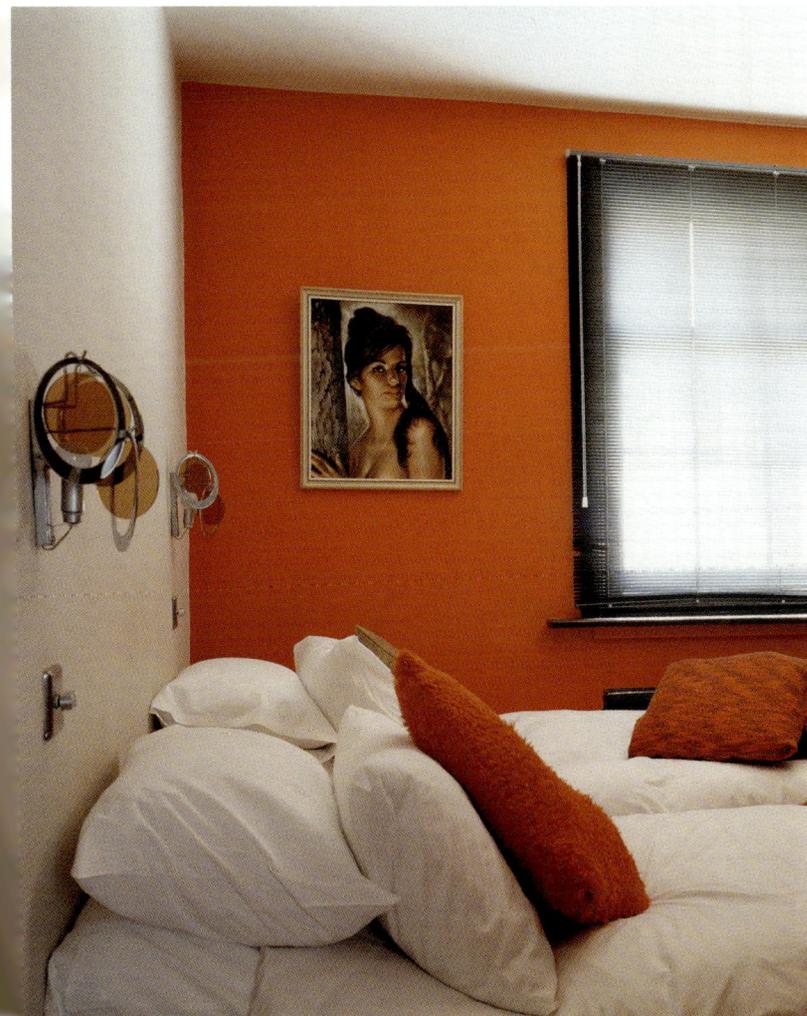
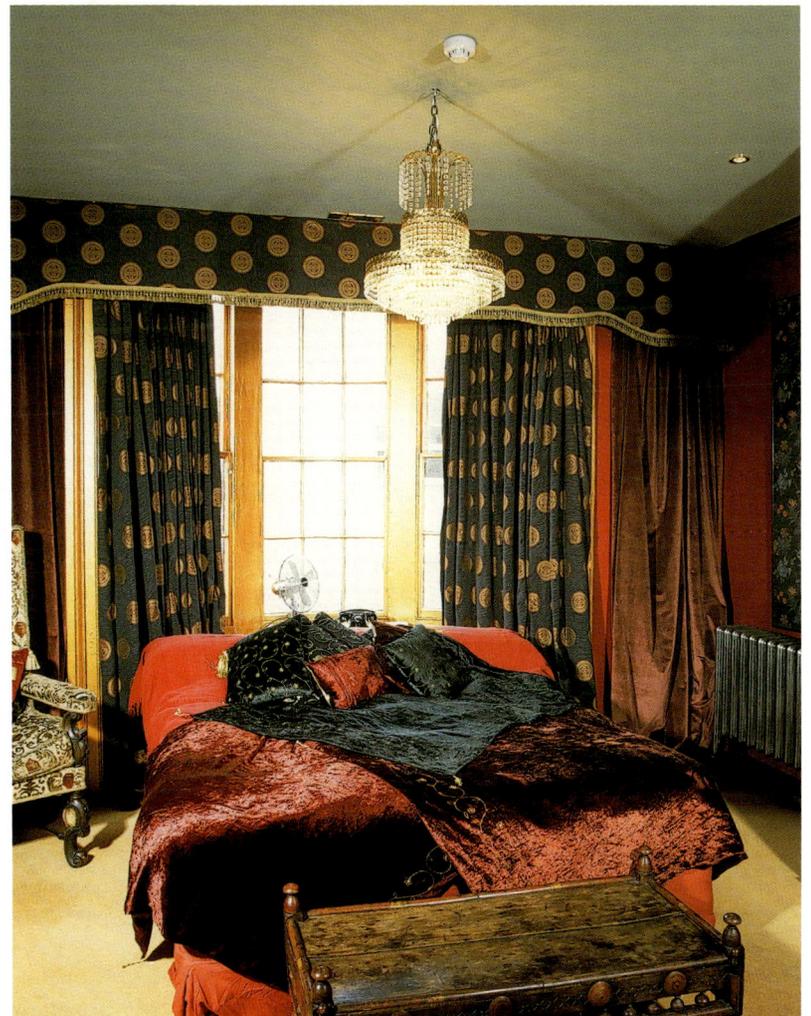

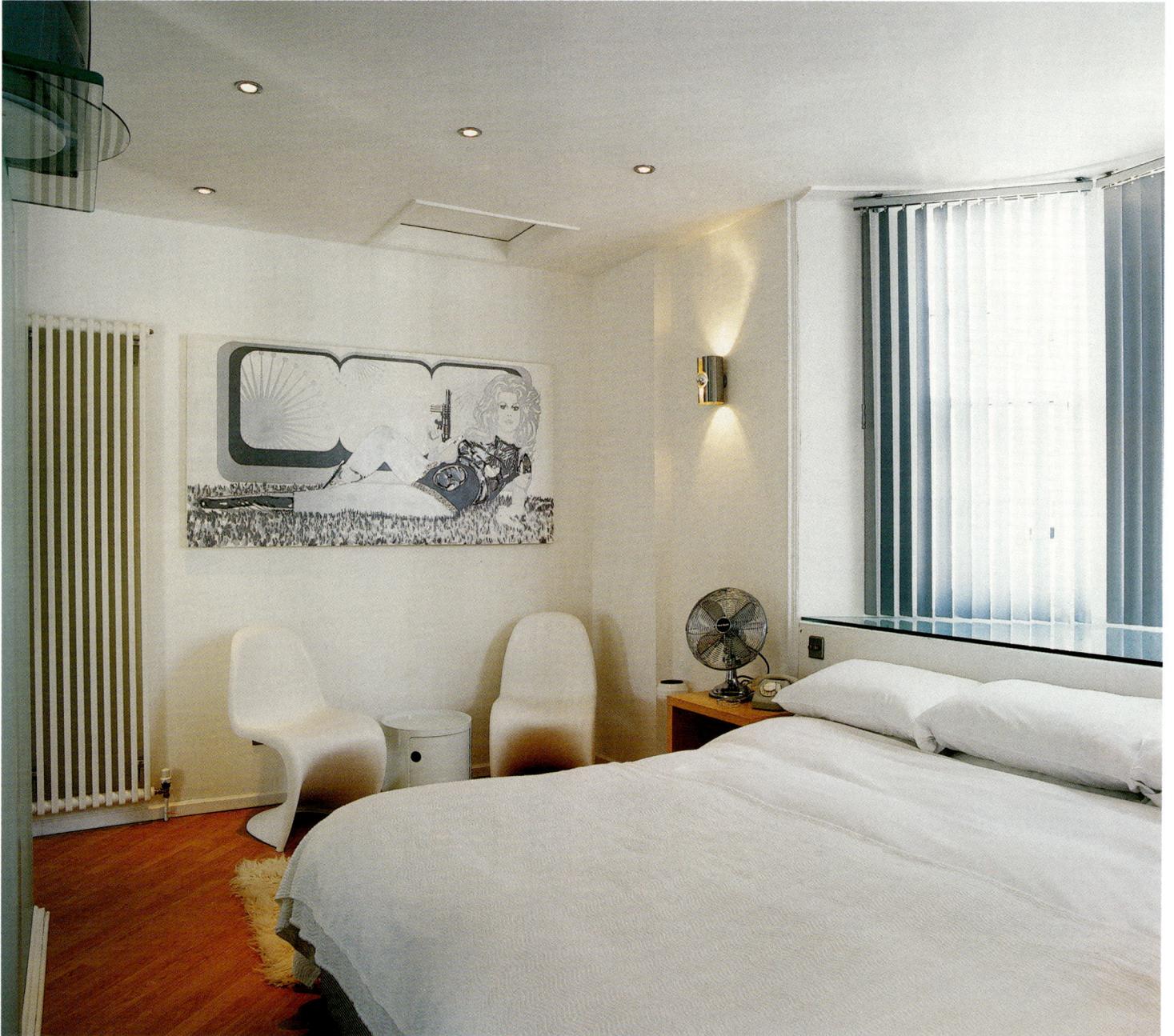

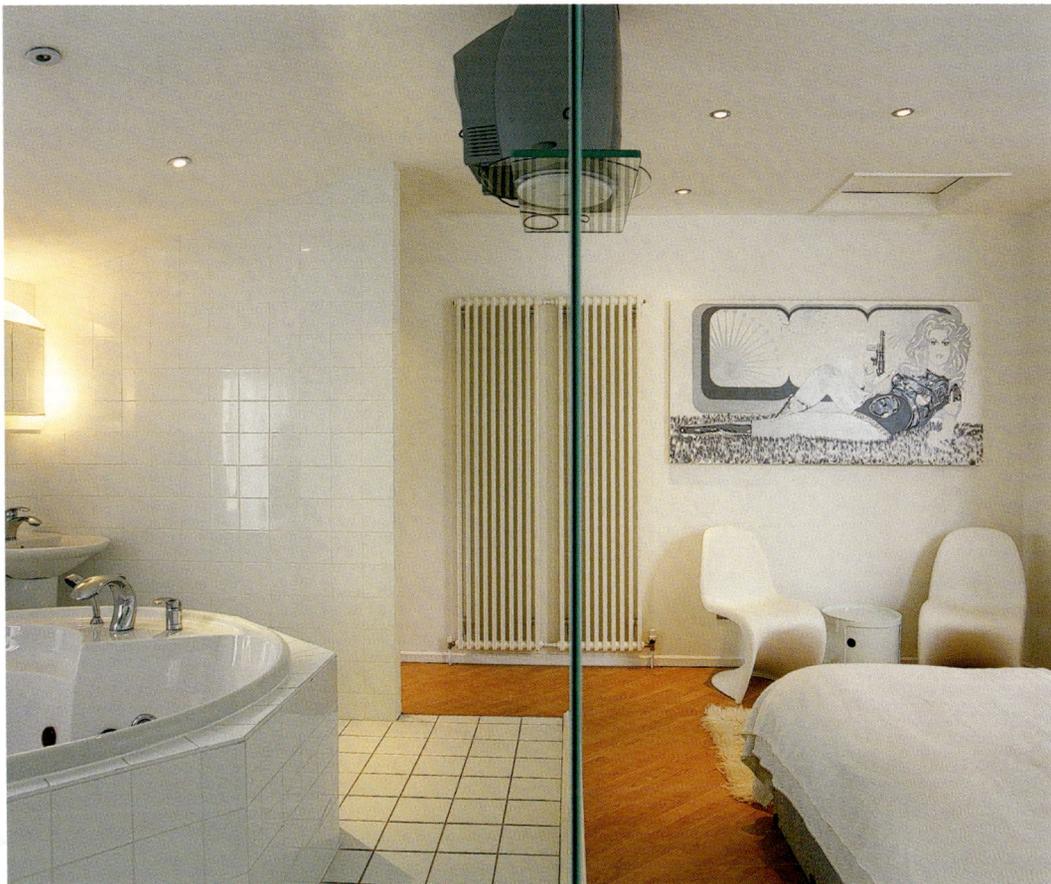

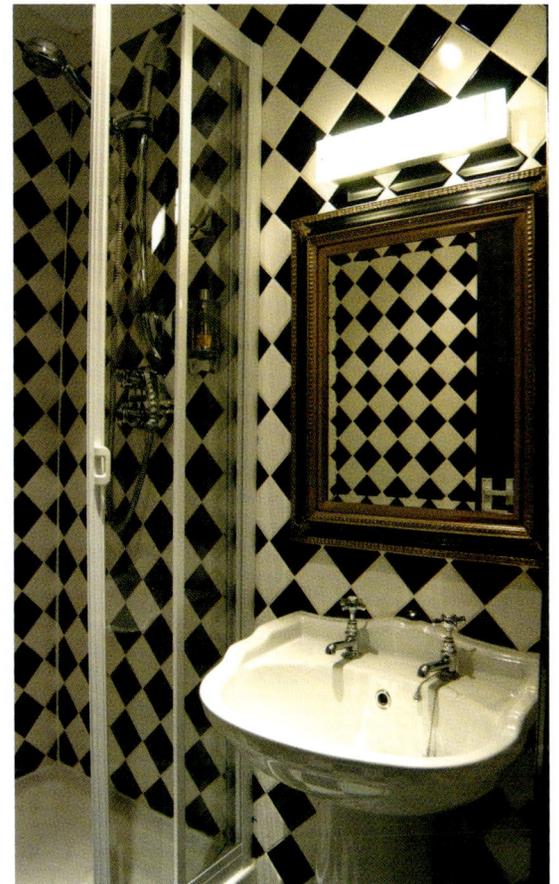

The interior design and decoration of the bathrooms is similar to the rest of the room. In some cases the bathroom is integrated into the rest of the living space by glass elements or curtains.

Dar
Kawa

Tel Morrocco: +212 44 44 24 48 Tel France: +33 1 43 25 98 77 www.marrakech-medina.com

This rental house for tourists is in an original Riad in downtown Marrakech. The owners, with the help of the architect in charge of the restoration, decided to restore the building, recapturing its original character, which had been hidden due to years of deterioration, and enrich the project with various touches of contemporary design. These sumptuous little palaces are characterized by their austere façade practically closed to the urban exterior while the interior stands out due to its luxury and formal wealth. The typology is always the same, constructed around a courtyard that is usually composed of four trees and a central fountain. All the rooms of the house are grouped around this space so they can enjoy the soft, placid ambience of the courtyard.

The goal of the owners was to create a comfortable ambience, complete with the modern elements that tourism demands without destroying the soul of this hundred-year-old building. Many parts of the building were rebuilt, eliminating superfluous annexes that altered the original spirit of the house, and the original floor plan was reinstated. They even made the bricks out of mud the old, traditional way in order to respect the original methods of construction.

Architect: **Quentin Vilboux** Photographer: **Manolo Yllera** Location: **Marrakech, Morrocco** Opening date: **1999**

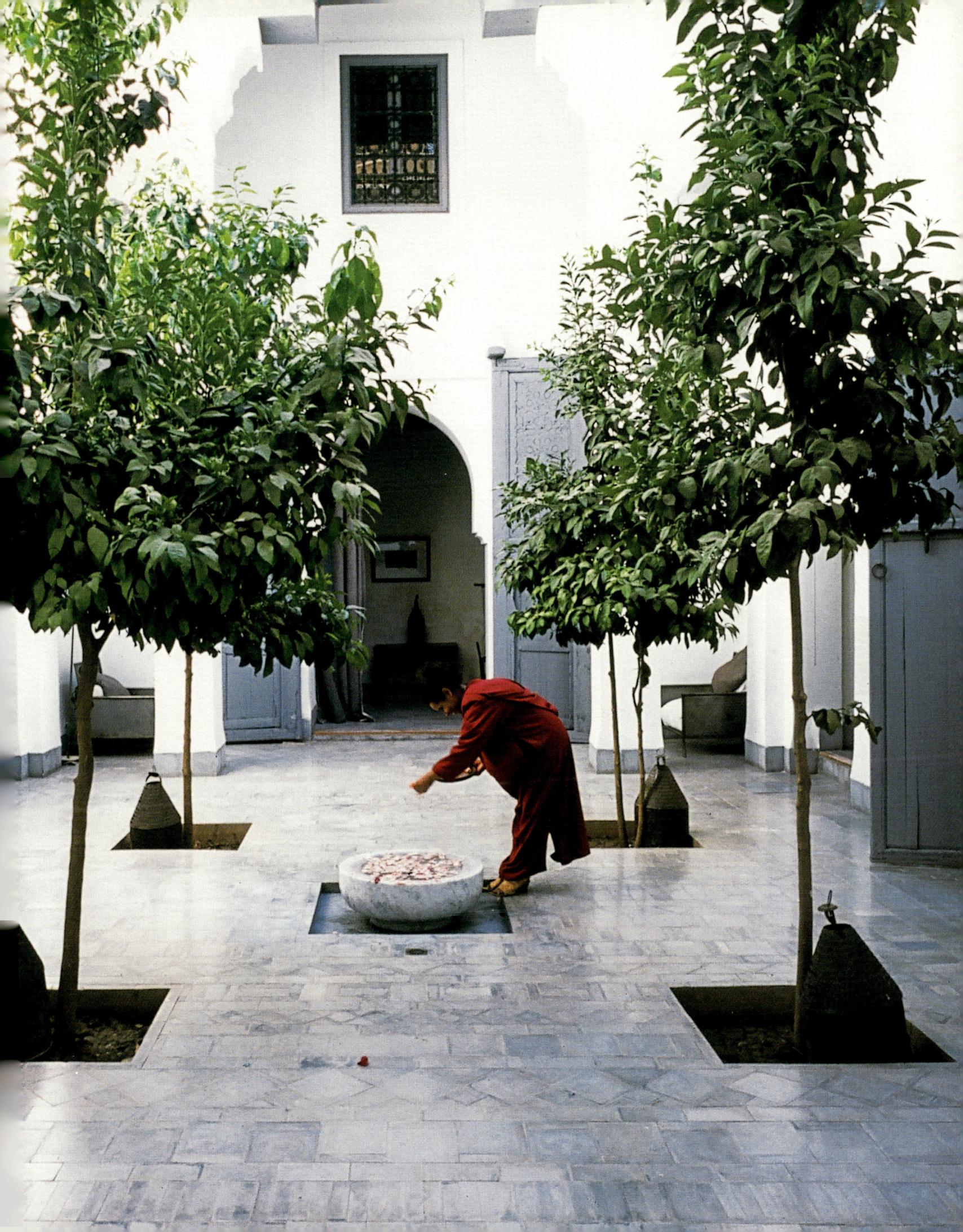

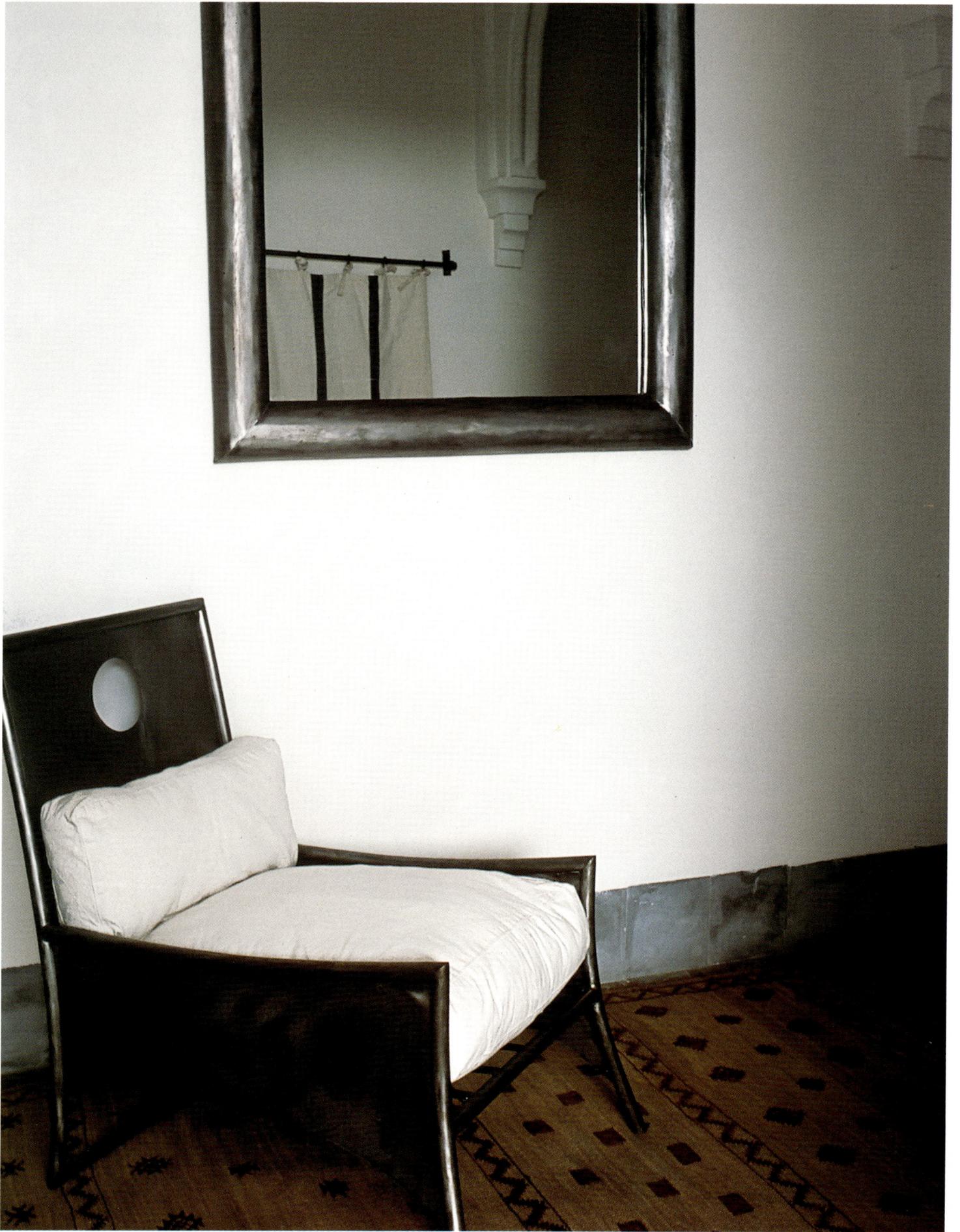

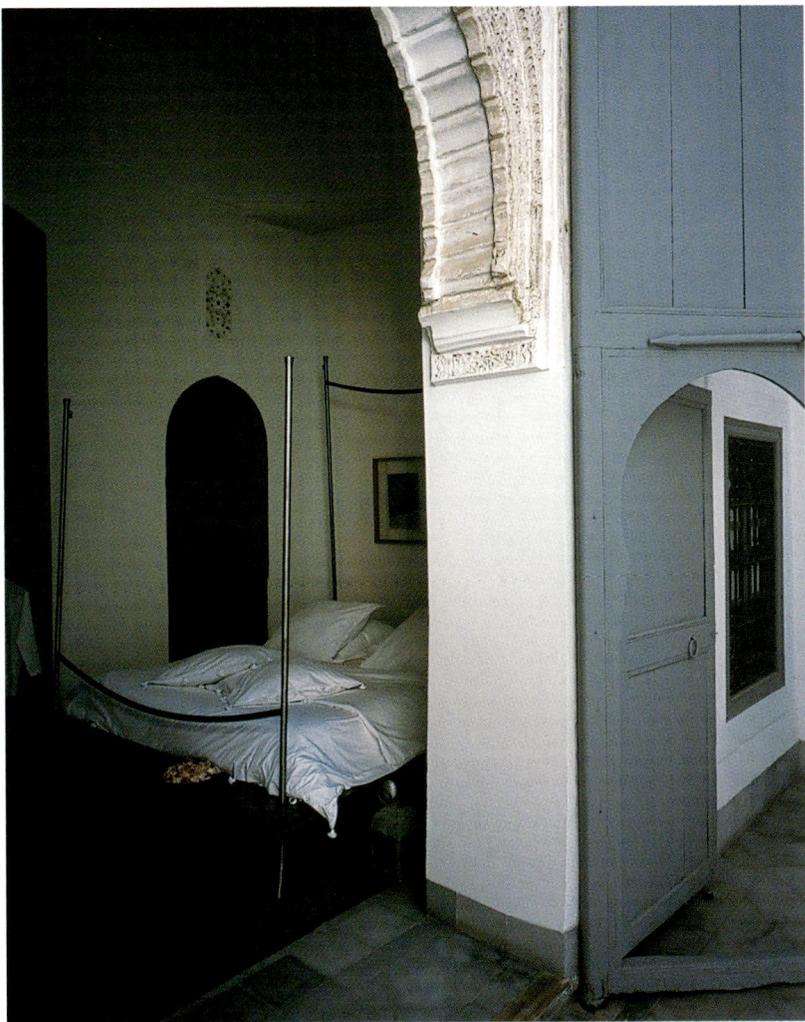
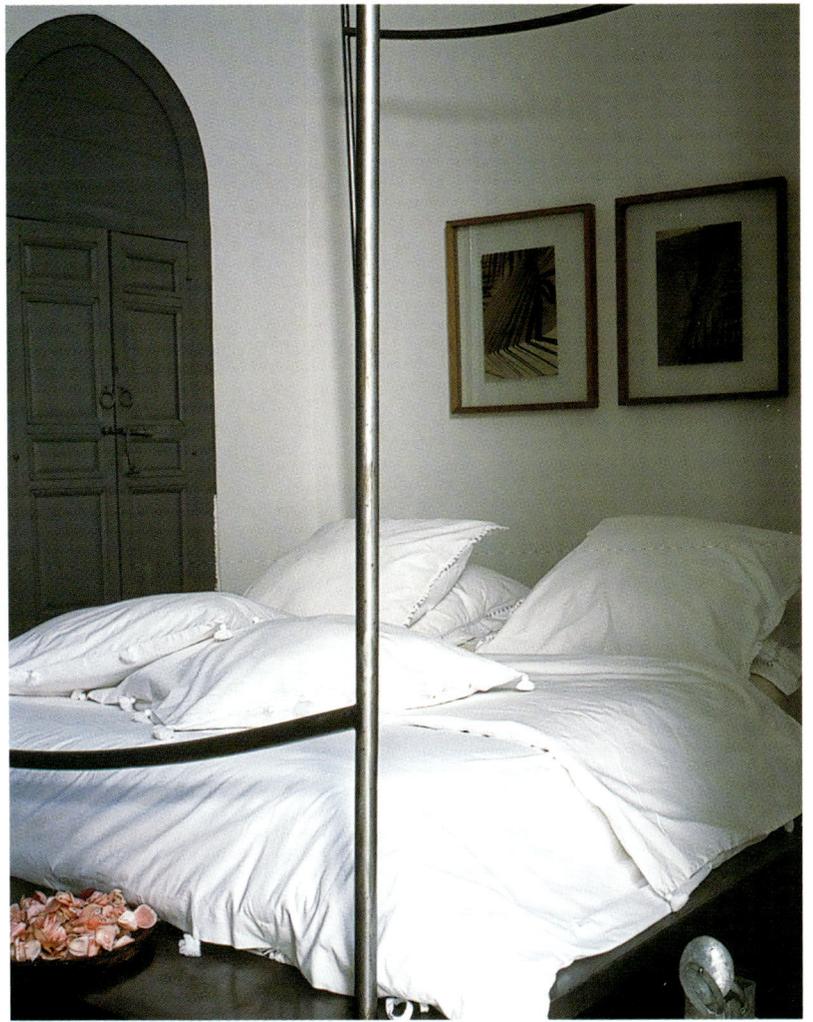
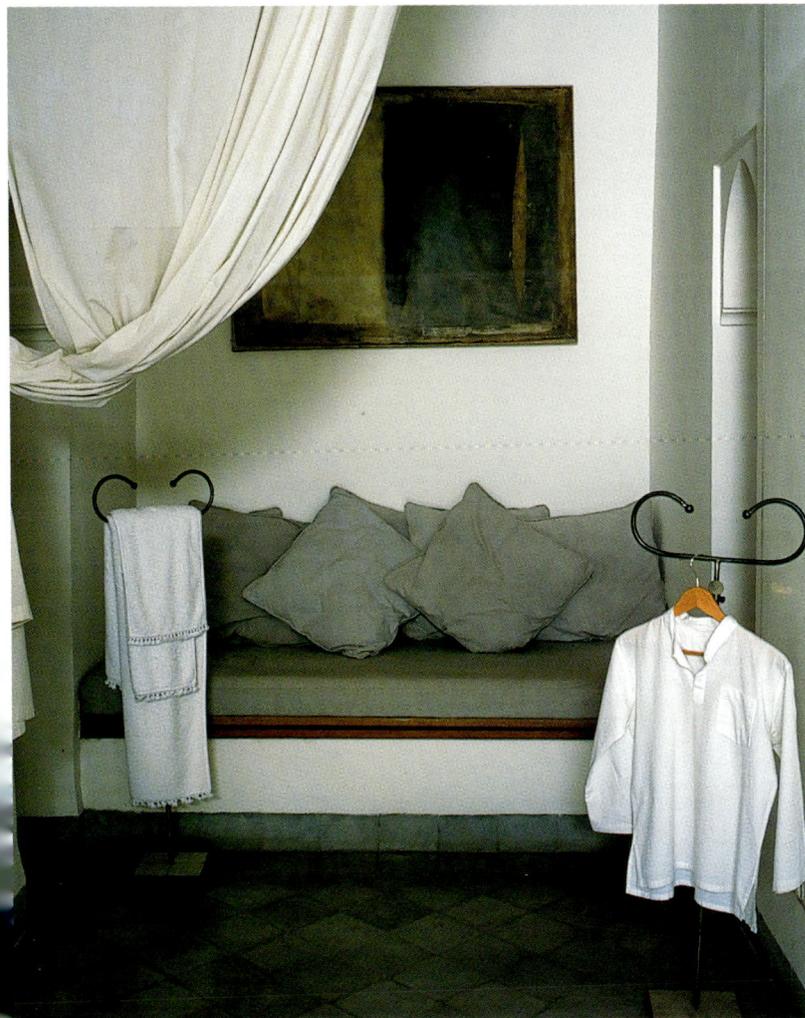
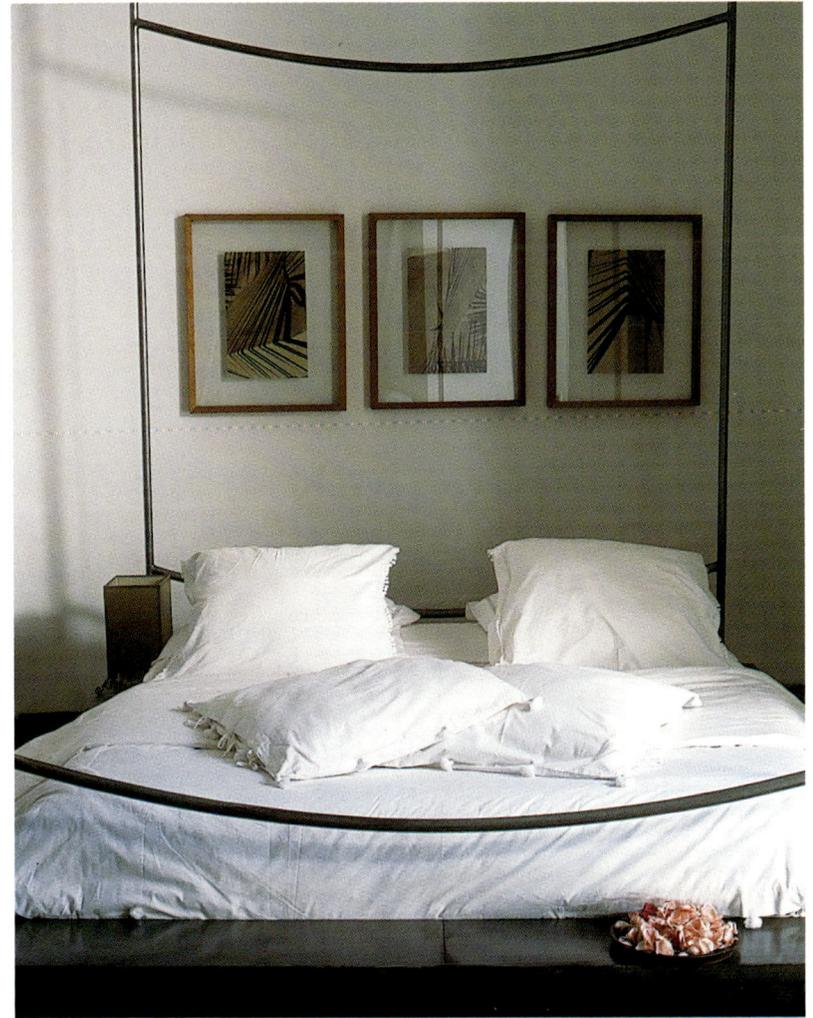

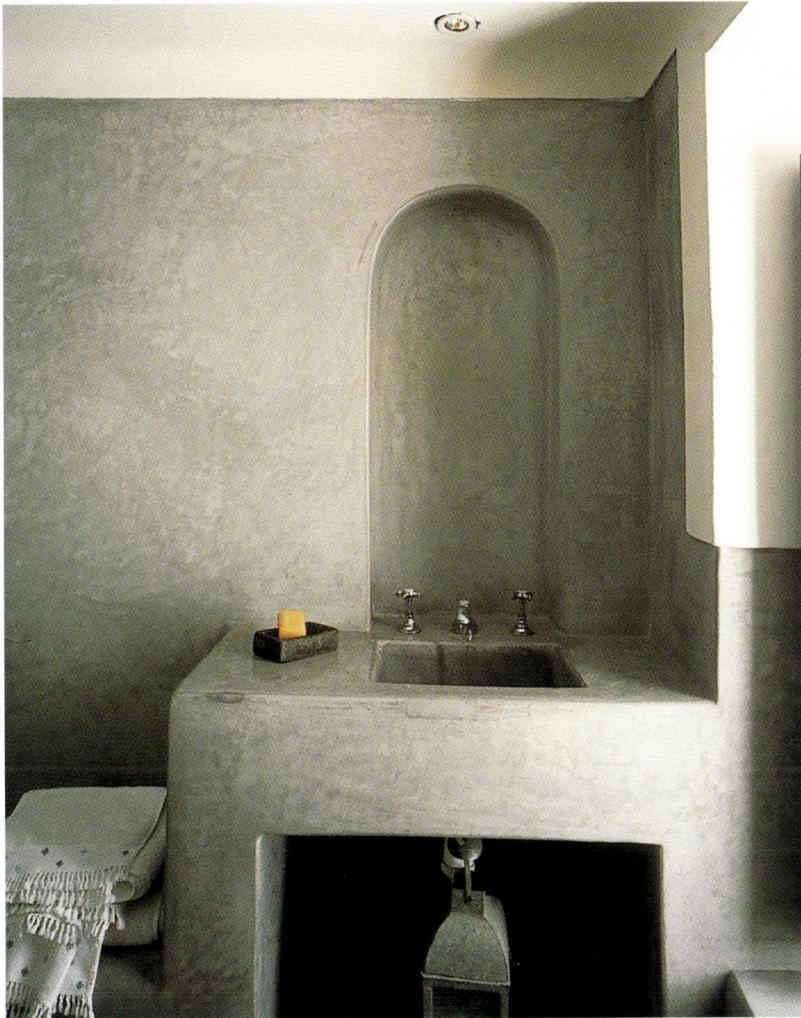

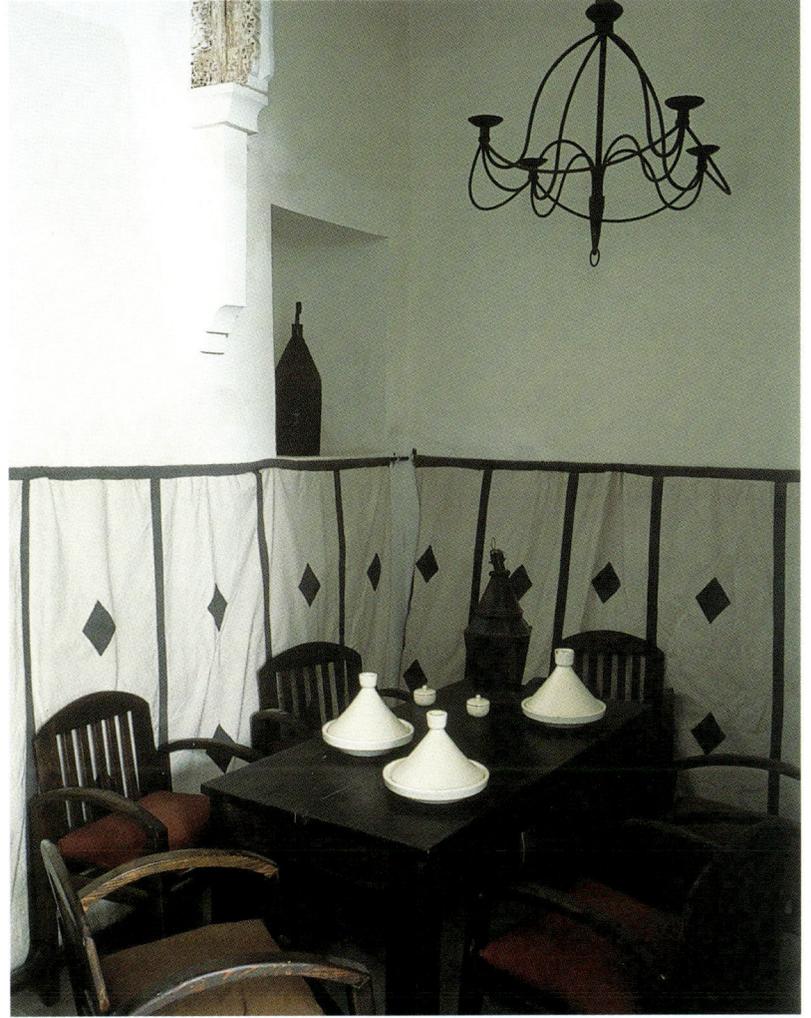

The house is equipped with everything one needs for daily life Moroccan style, making it an appealing alternative to staying in a hotel. Here, guests can be closer to the rhythms of the city.

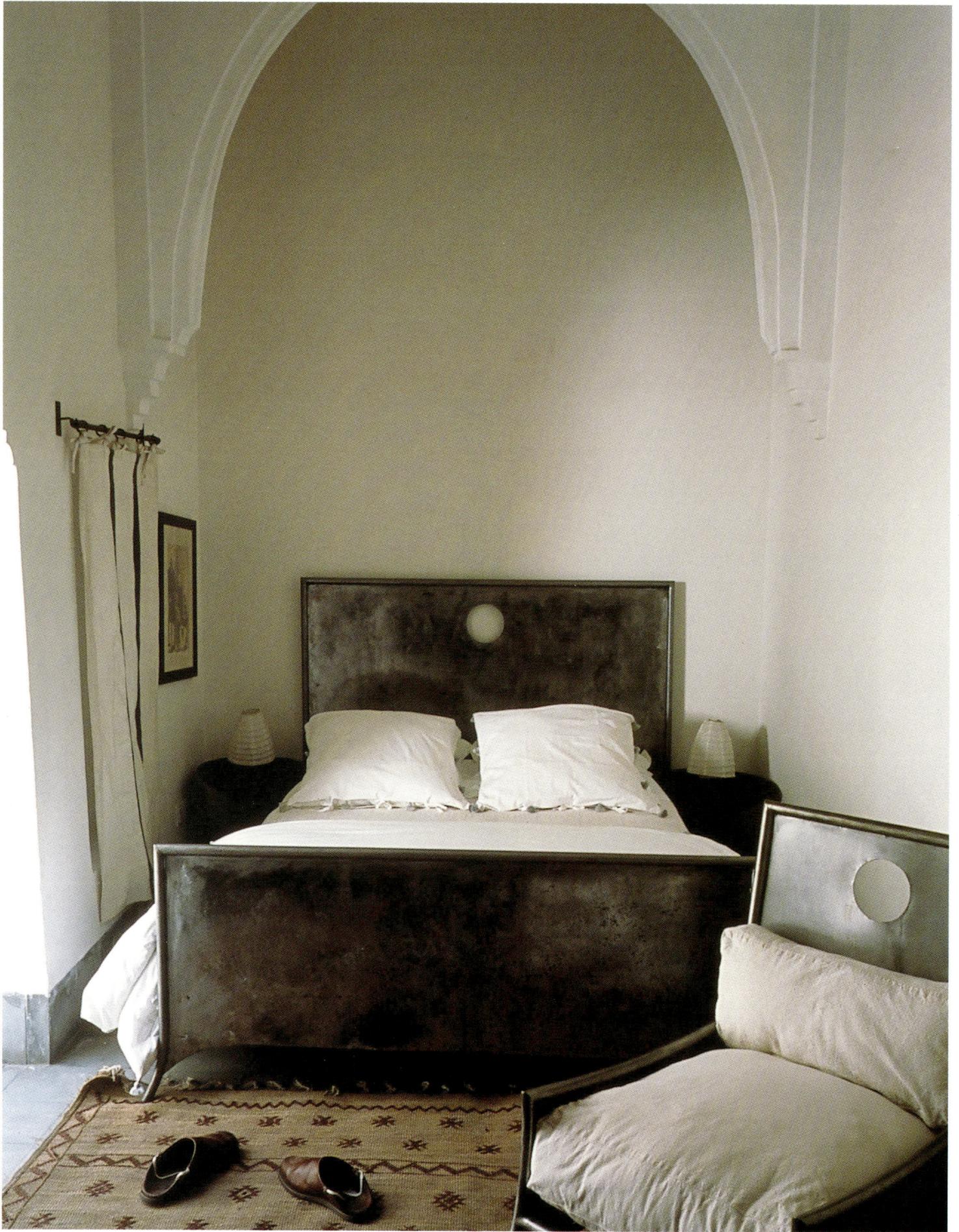

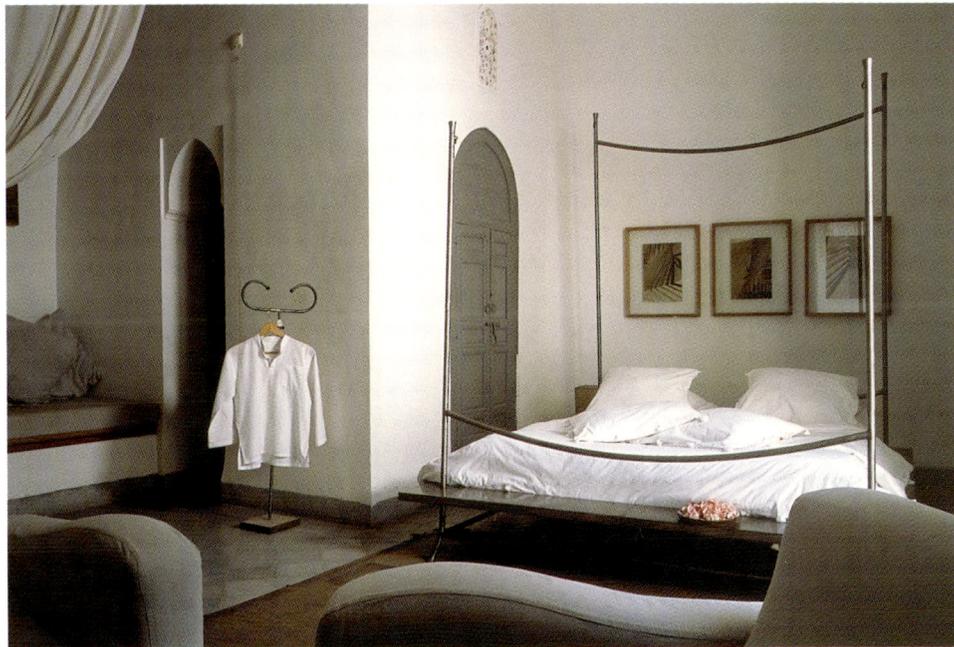

The contemporary furnishings, in polished metal, contrast with but also fit the style of the house. The polished concrete sink and bathtub are the perfect link between new and old.

Hotel
Triton

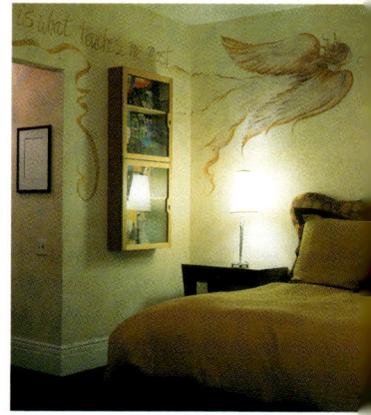

342 Grant Avenue, San Francisco, CA 94108, USA Tel: +1 415 394 0500 Fax: +1 415 394 0555 www.hotel-tritonsf.com

The goal of this project was to create a truly alternative hotel in San Francisco that would avoid any standard formal or functional elements. Various artists—a total of one hundred and forty—were contracted in order to achieve this. Their original works created a unique, dreamy, and extravagant world that is reflected in each and every room. The big challenge was combining this idea with the concept of a comfortable, domestic space where guests would feel welcomed. The general decor, risky and powerful, guarantees that the journey through this hotel will be a real adventure. Elements such as the velvet in the elevators and the extravagant yellow ducks in the bathrooms elicit a smile out of any visitor.

Every space, from the entry hall to the interior of the guest rooms, is designed and decorated figuratively, clearly alluding to various themes. In the main entrance enormous golden columns, called "The Laughing Pillars" by their creator, Arlene Elizabeth, stand out. They extend the entire height of the space and have a dramatic presence. A hand-painted mural with mythological and fantastical motifs adorns the lobby. This creation, part of a series by the artist Hill Baker, incorporates subtle images of human figures and marine life. The sinuous lines and diffuse brushstrokes create a sense of movement so that the visitor feels submerged in this dream-like universe.

Designer: **Michael Moore + Various Artists** Photographer: **Roger Casas** Location: **San Francisco, USA** Opening date: **2001**

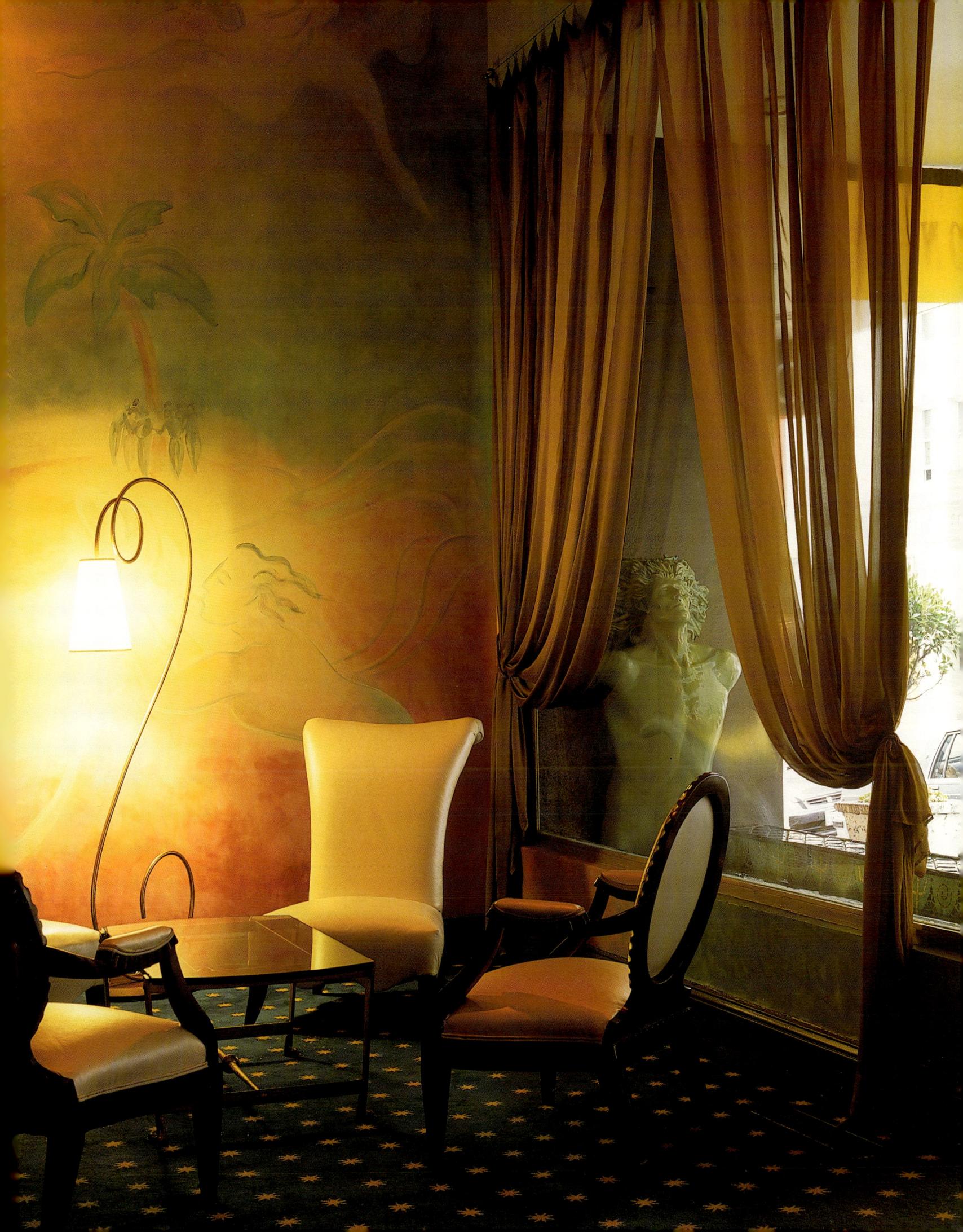

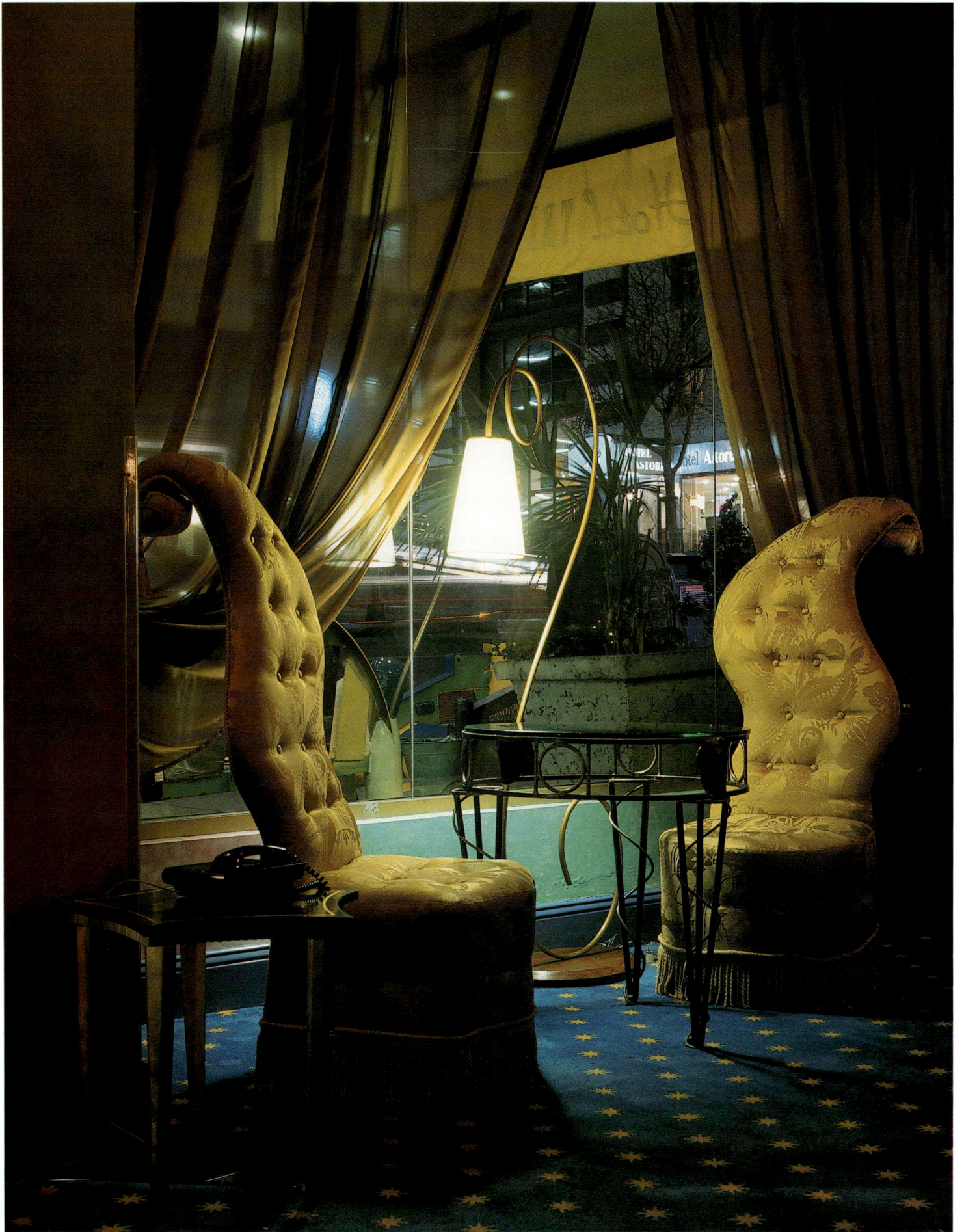

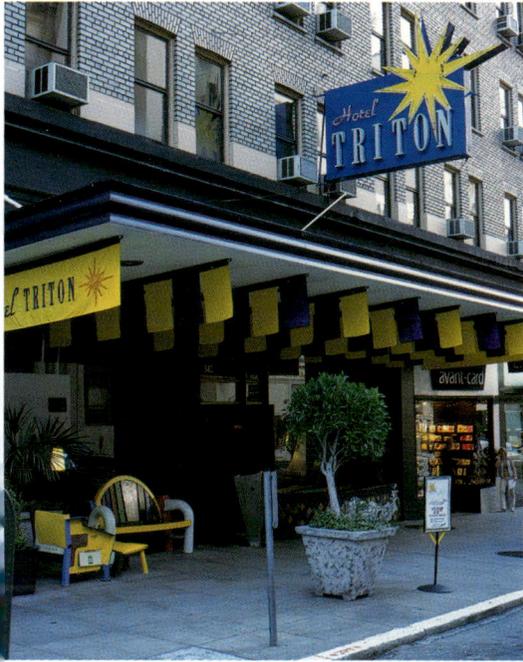
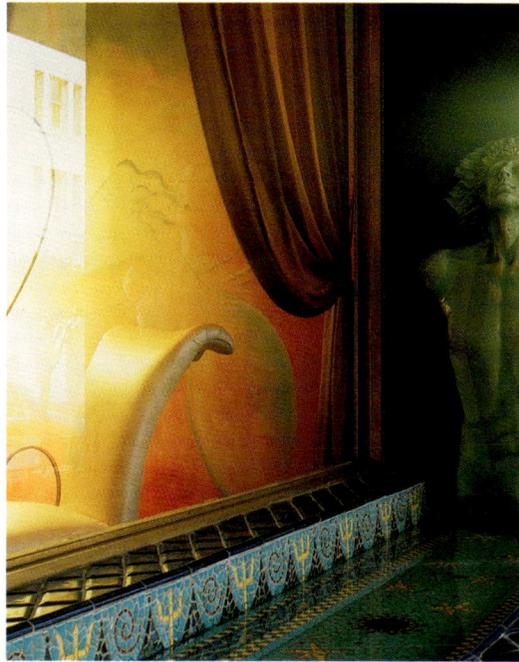
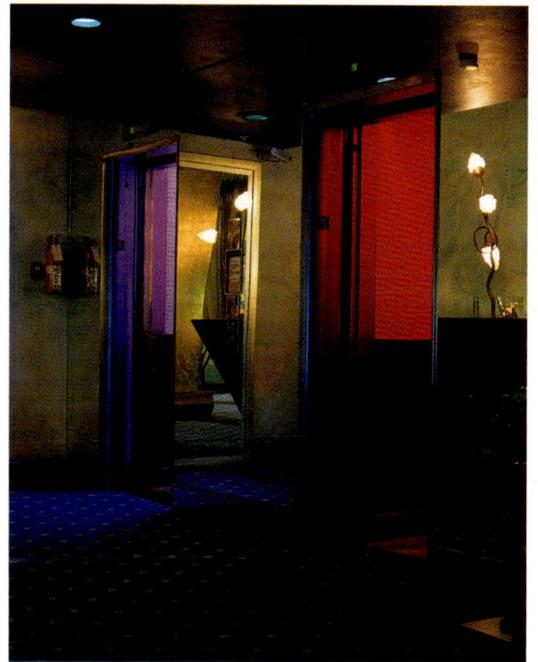

The mythological references and the use of some traditional details such as tapestries, rugs, and curtains give the interior a mix of multiple references, styles, and colors.

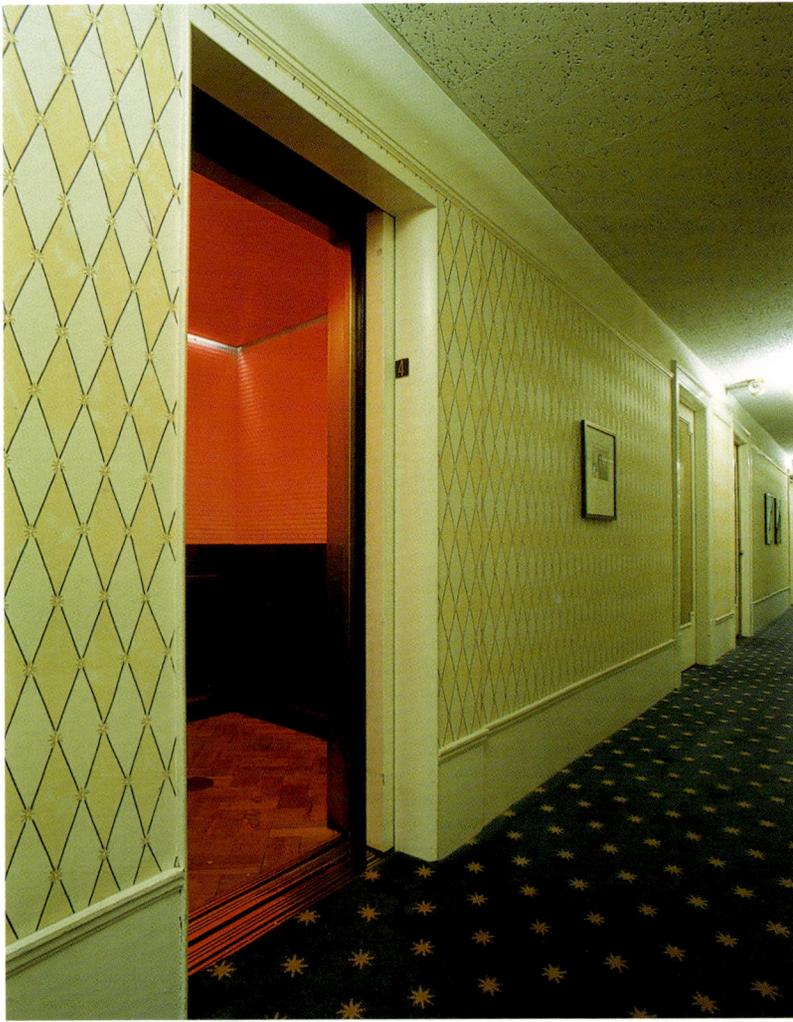
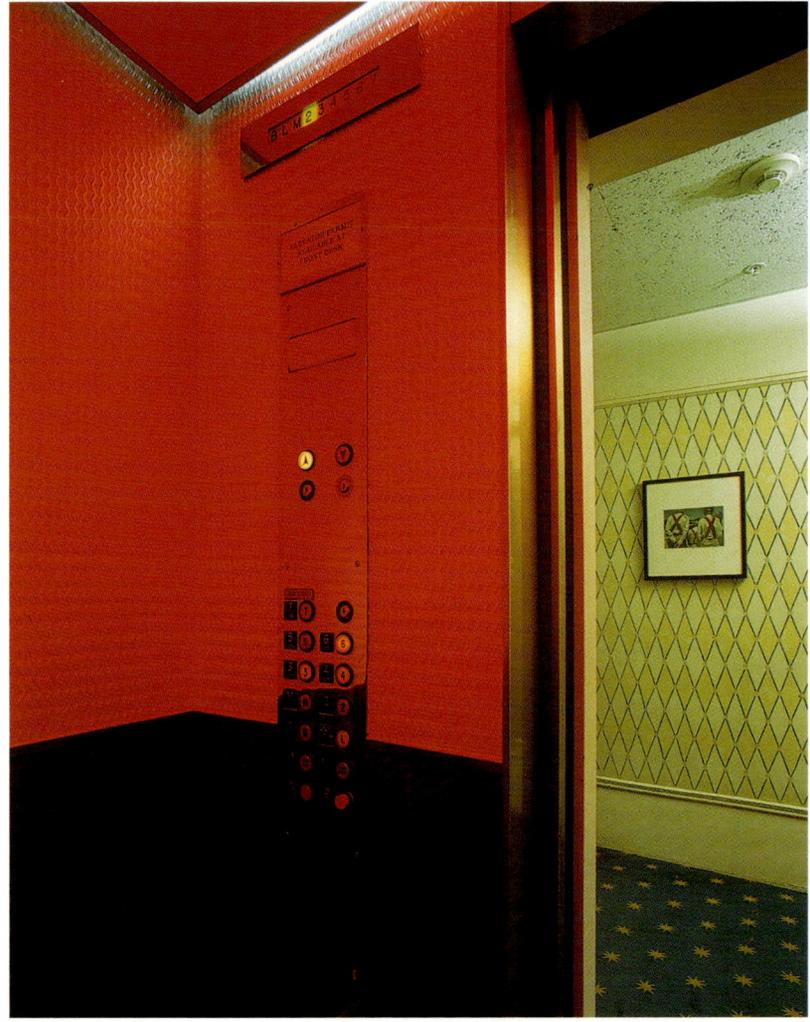
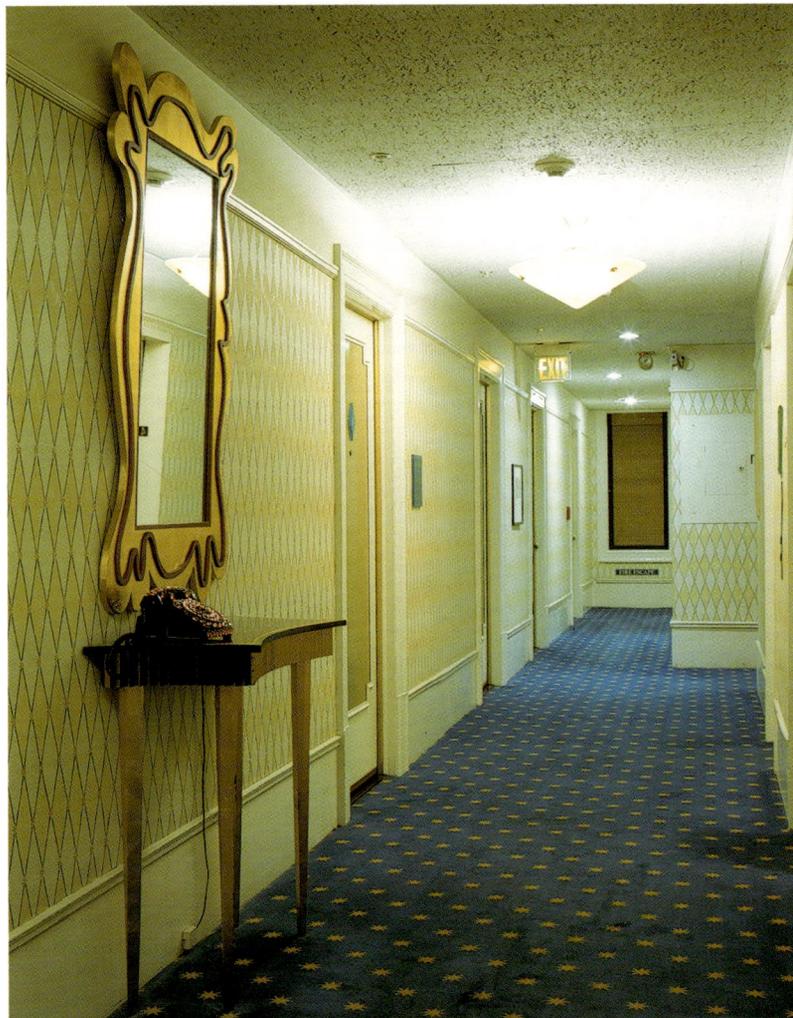
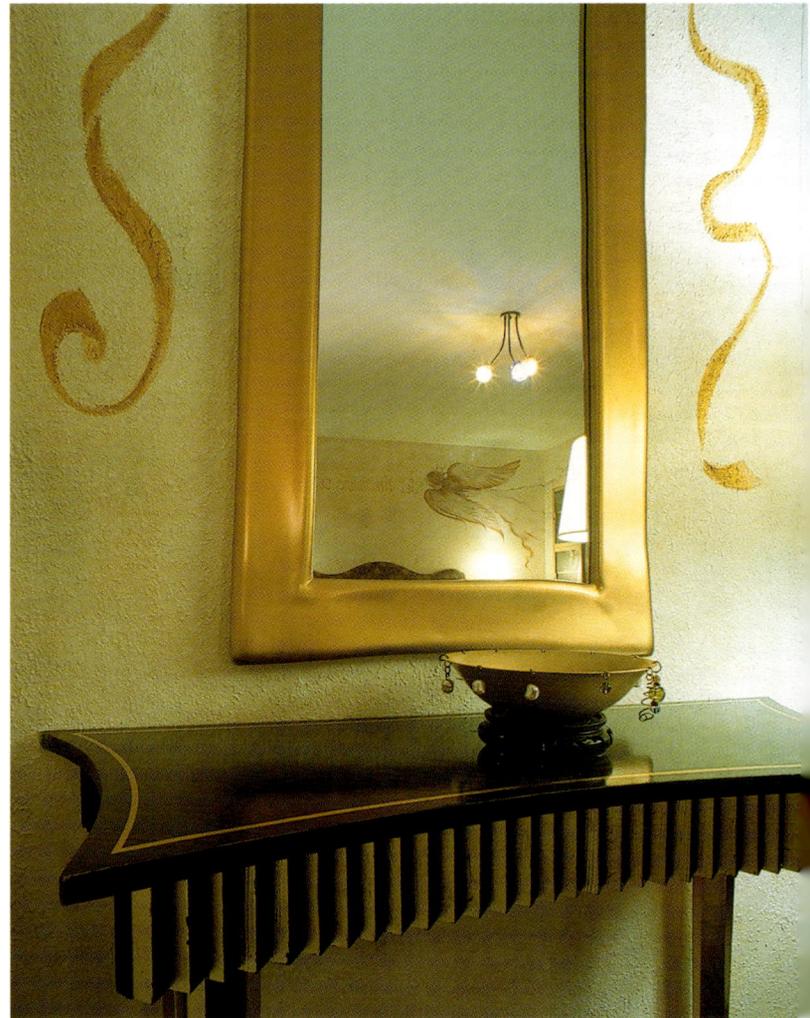

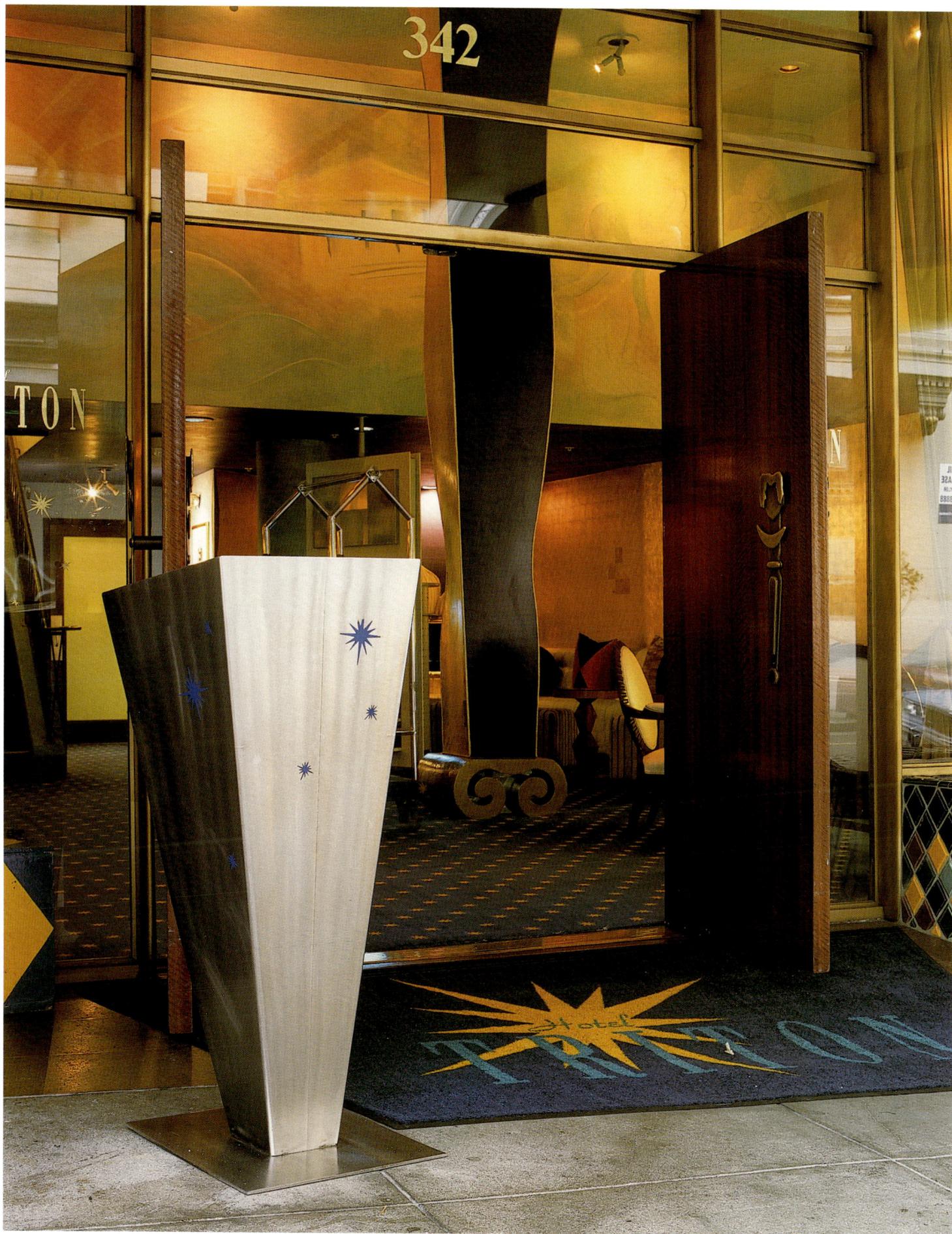

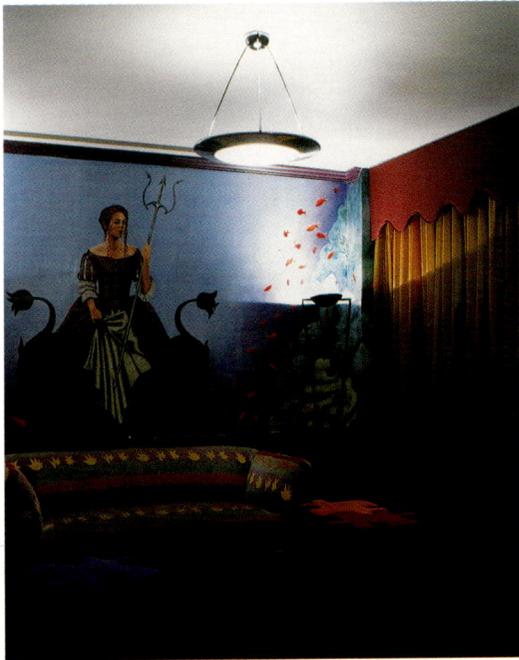

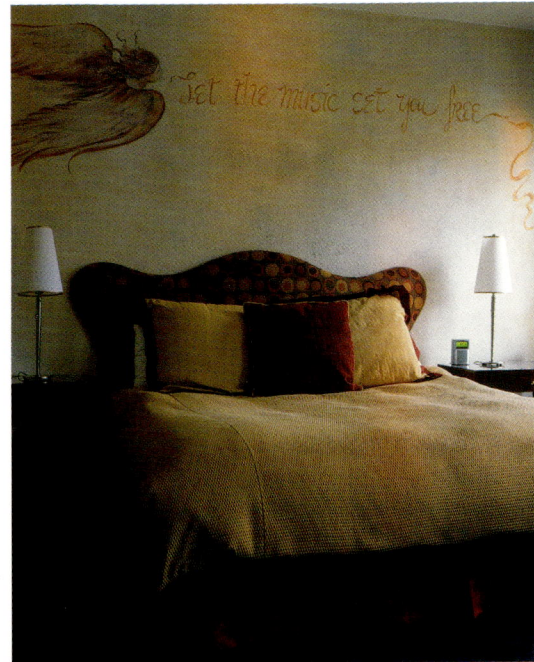

The palette of colors is quite varied, ranging from warm to cold tones within the same room, creating an atmosphere rich in colors and textures. Although many artists participated in the decoration of each space, there are common elements that unify the whole.

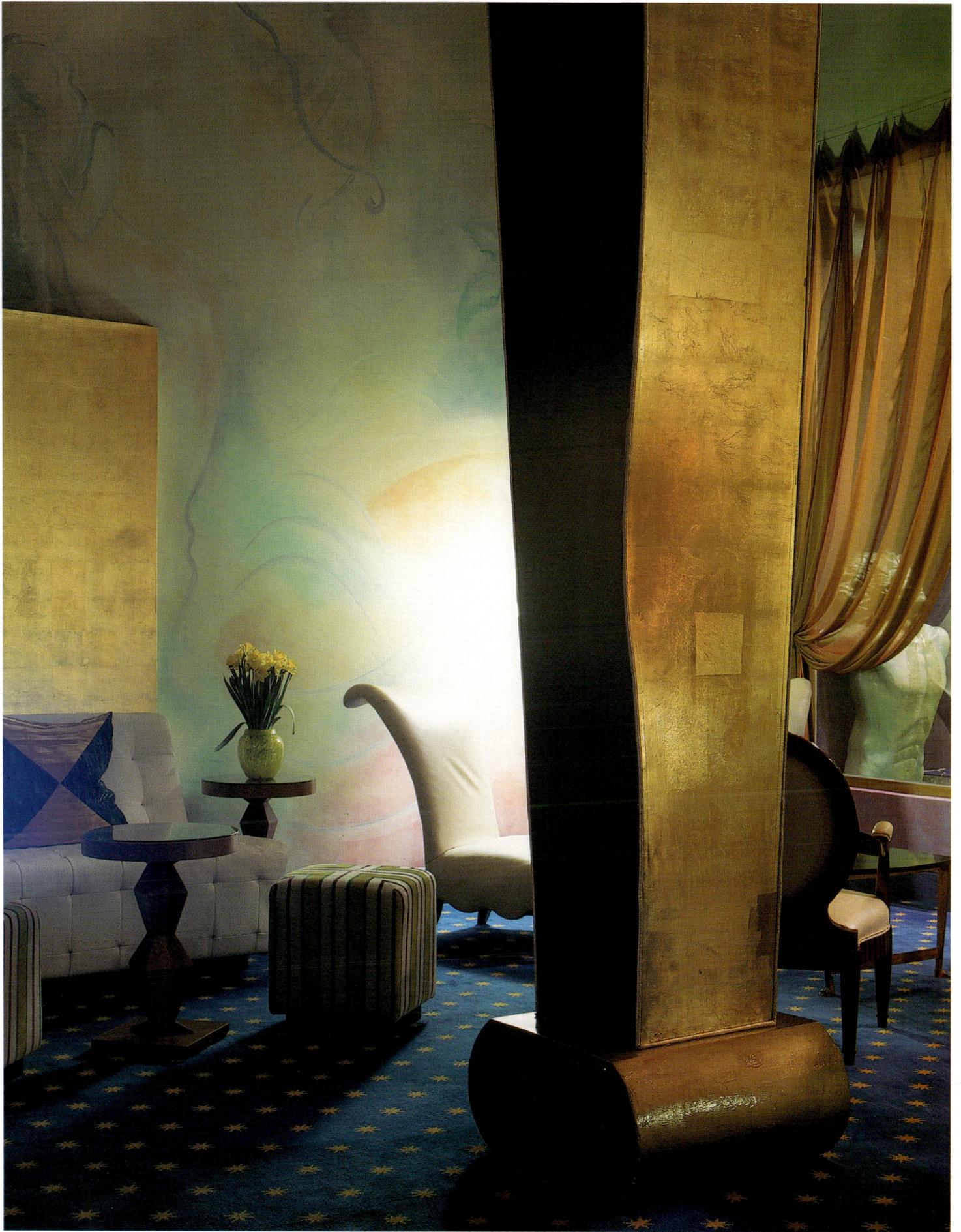

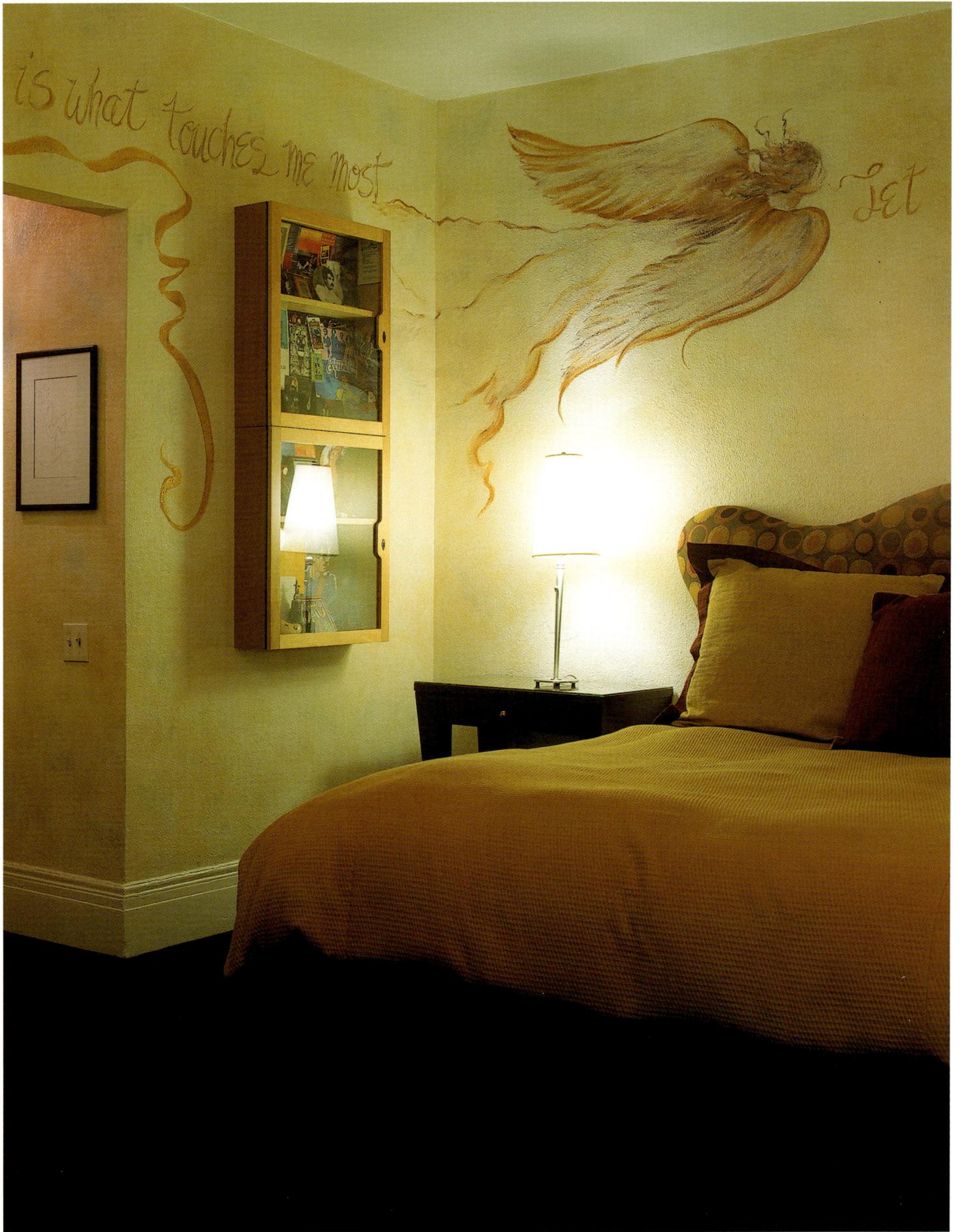

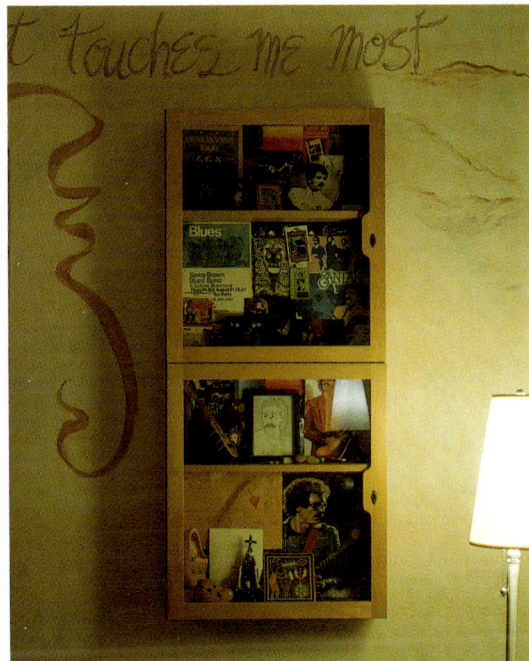

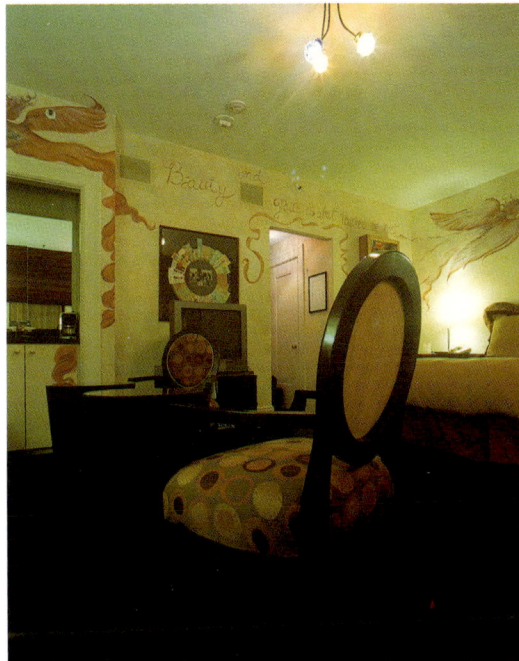

Aside from the single rooms there are also luxury suites decorated with specific themes that dictate the design of every detail. These themes not only create an atmosphere for each room, they guarantee that each visit to the hotel will be a different experience.

Propeller Island

Albrecht Achilles Str. 58, 10709 Berlin, Germany Tel: +49 30 891 9016 Fax: +49 30 892 8721 www.propeller-island.de

According to the designer, a professional artist and also the owner of the hotel, the best way to describe Propeller Island City Lodge is as a work of art. Each of the 30 rooms has its own unique and personal character. Each room is one of a kind, designed, furnished, and decorated by hand with elements that are not at all run-of-the-mill. The hotel can be thought of more as an art gallery where guests stay in constantly changing installations. Maintaining low prices is fundamental to the hotel's philosophy so that a varied clientele can enjoy this experimental space. This philosophy is reflected in some aspects of the hotel's operation and overall aesthetic.

There is no reception area, which reduced both construction and operational costs. Additionally, a reception desk would generate a concrete, defined image, something the owners wanted to avoid. Instead, there is an office that manages all the hotel's various functions. Each room is designed and built based on a theme in which forms are modified to such an extent that they seem to alter reality. The rooms are so different that each one has its own "user manual" that guests should read carefully before deciding which room best suits their sense of adventure.

Designer: **Lars Stroschen** Photographer: **Lars Stroschen** Location: **Berlin, Germany** Opening date: 2002

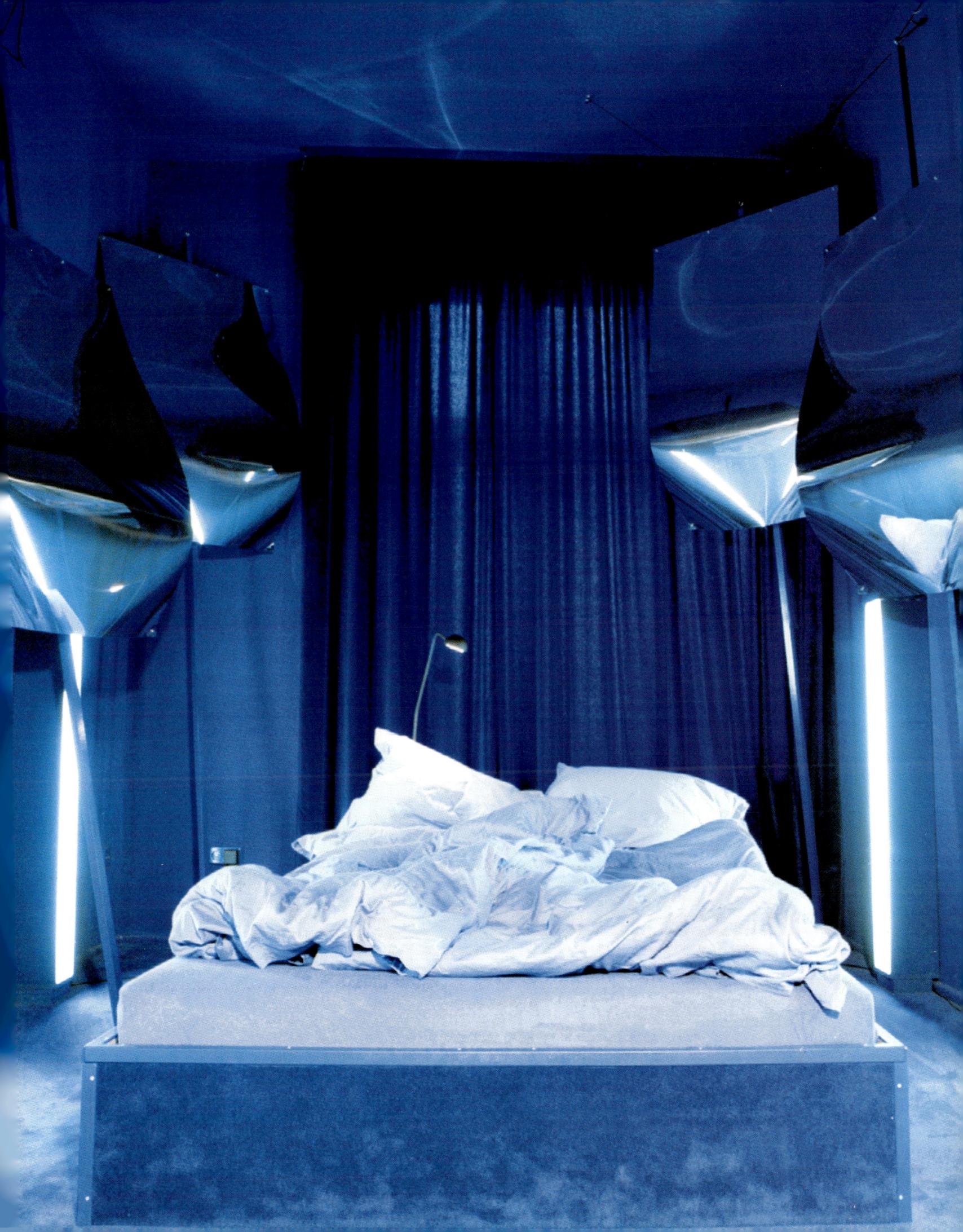

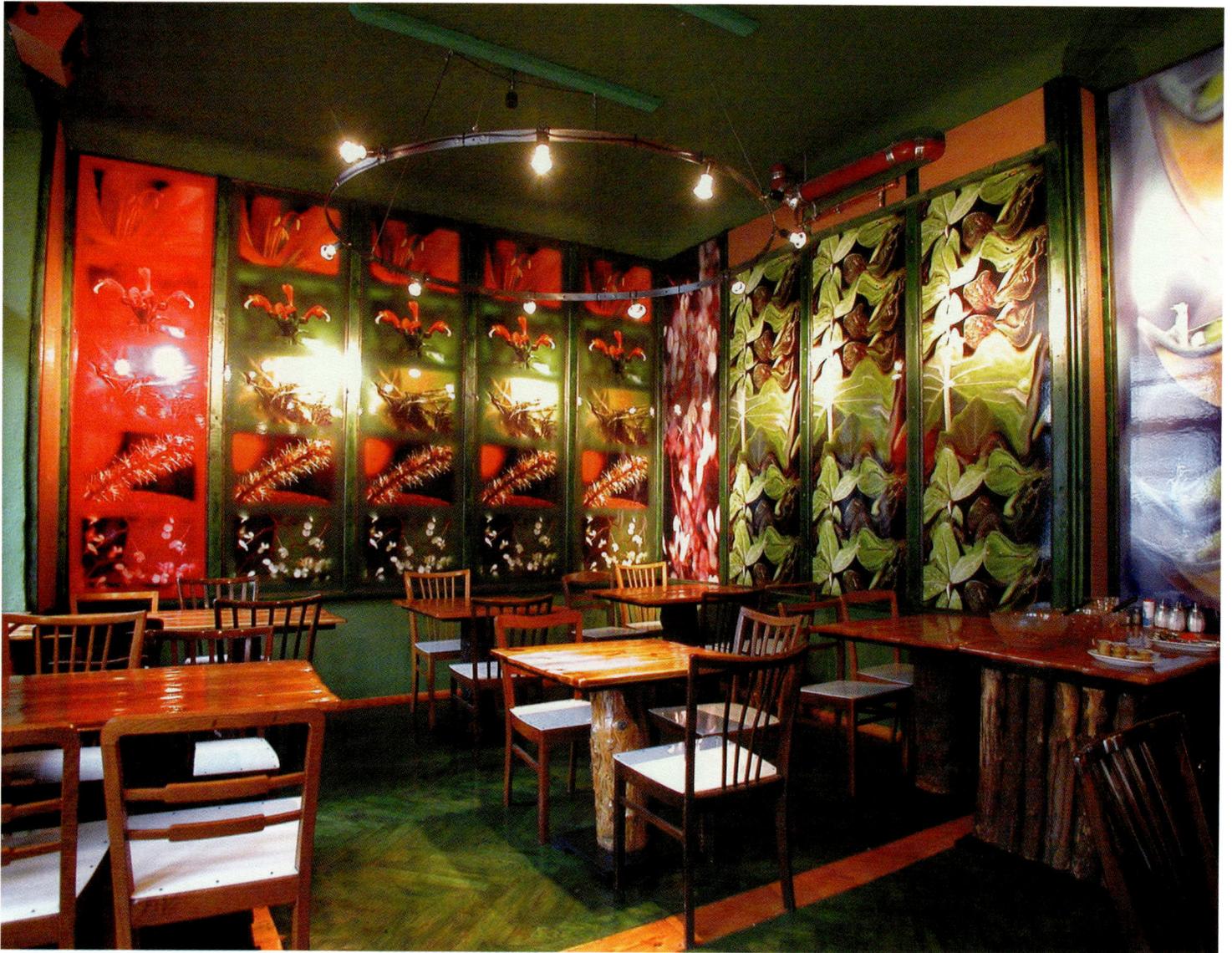

[204]

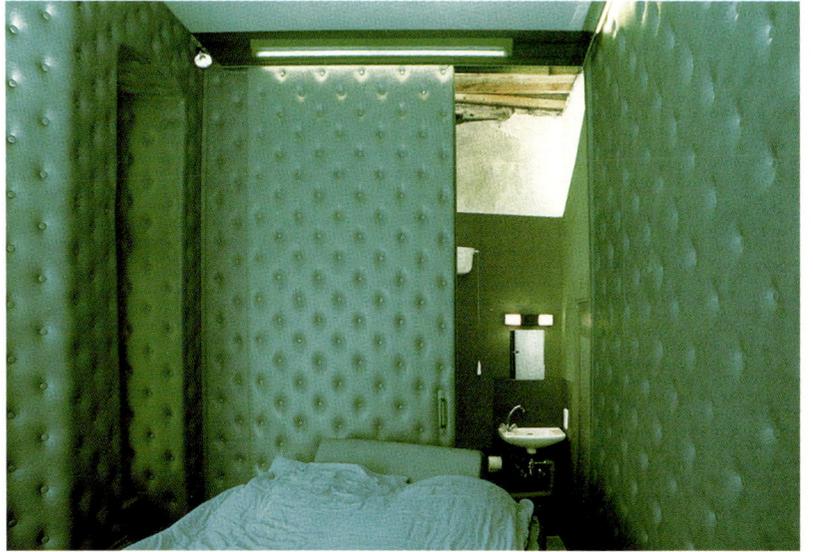
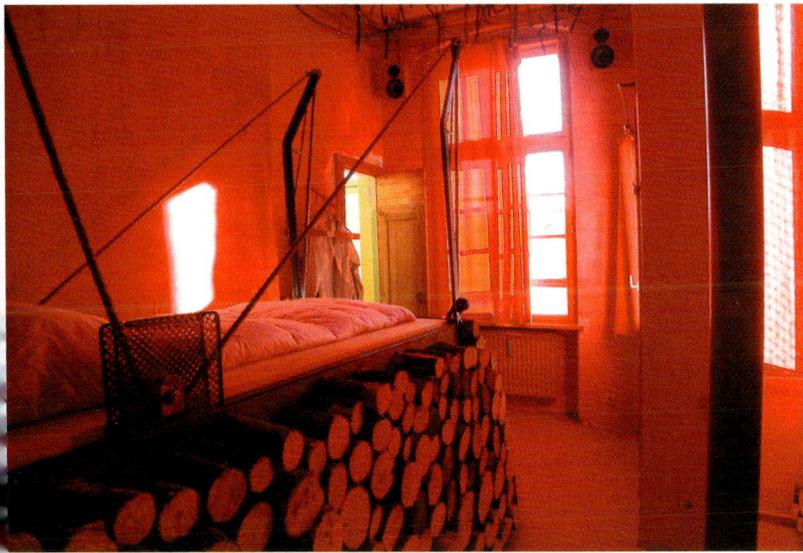
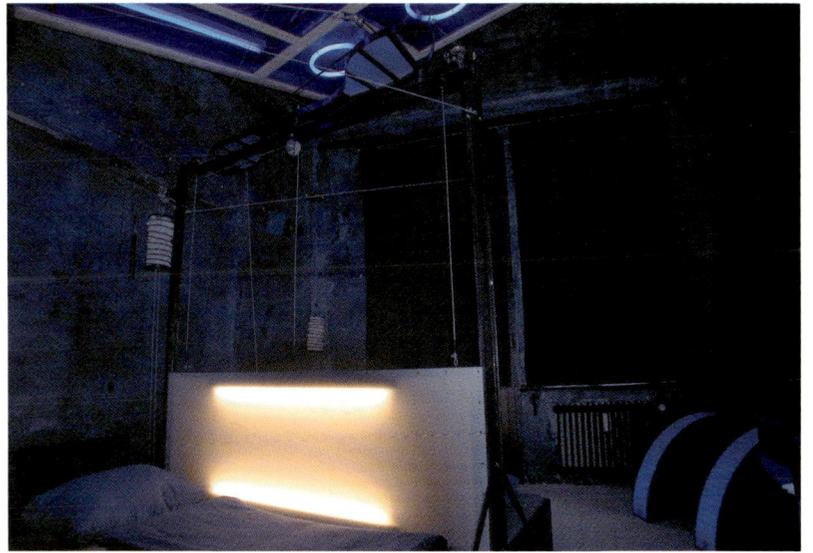

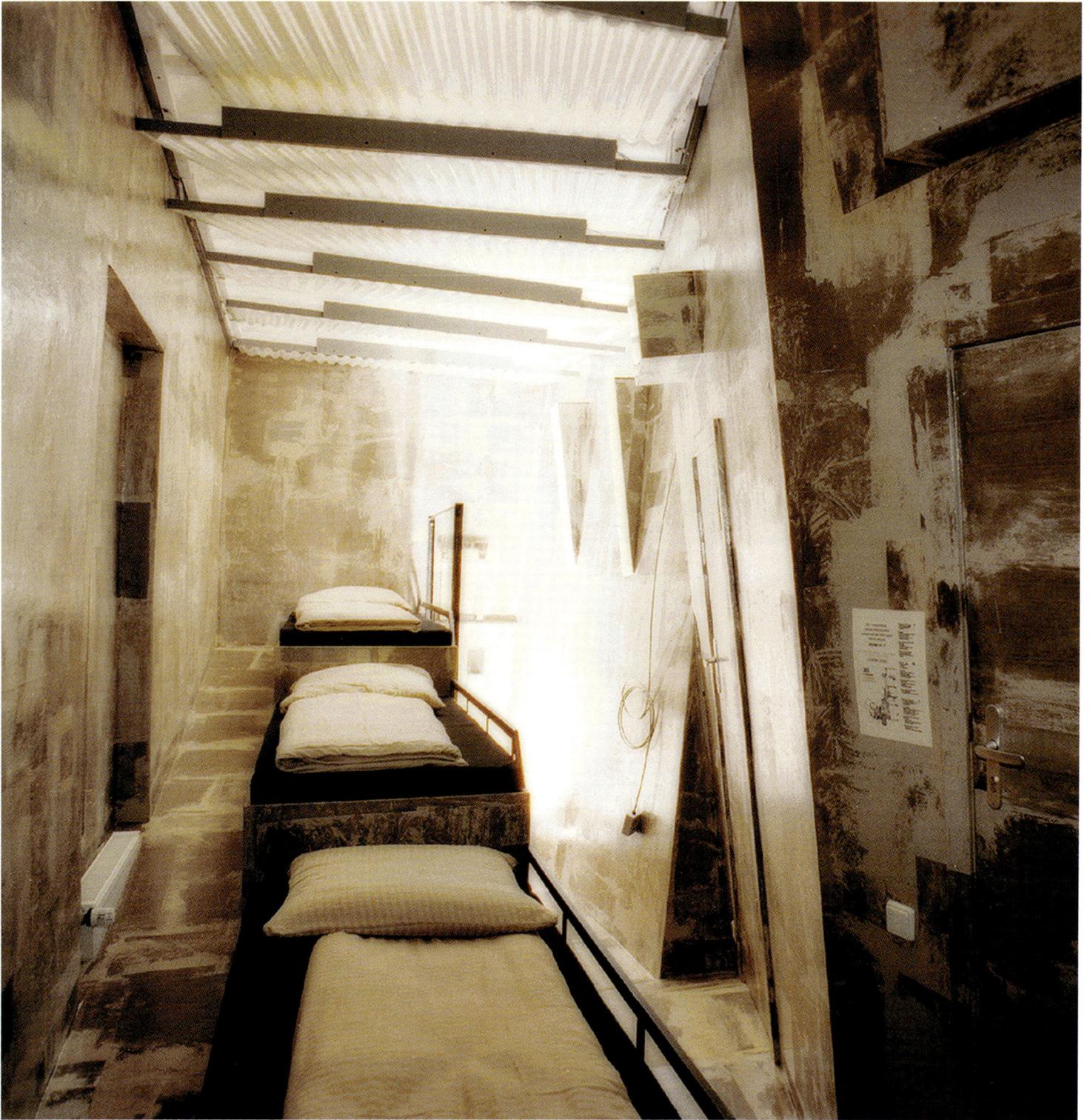

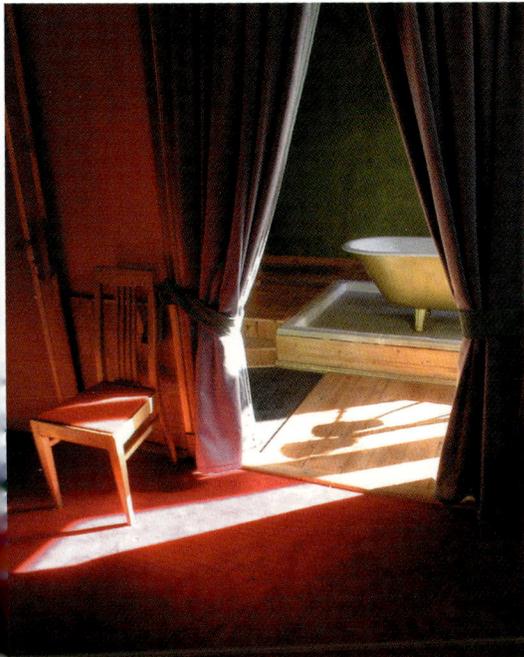

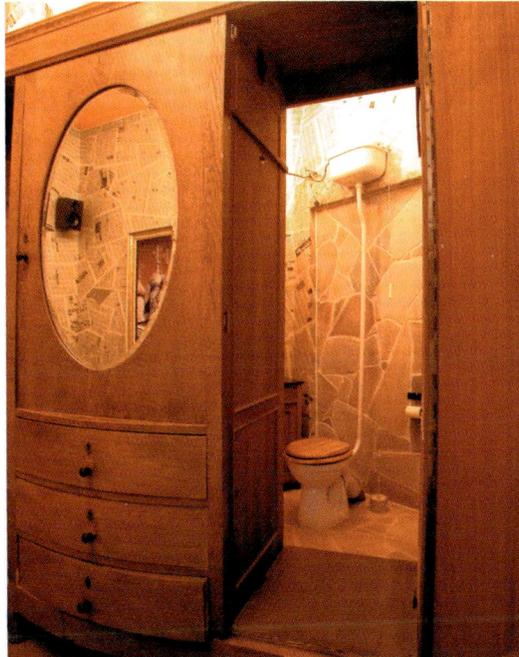

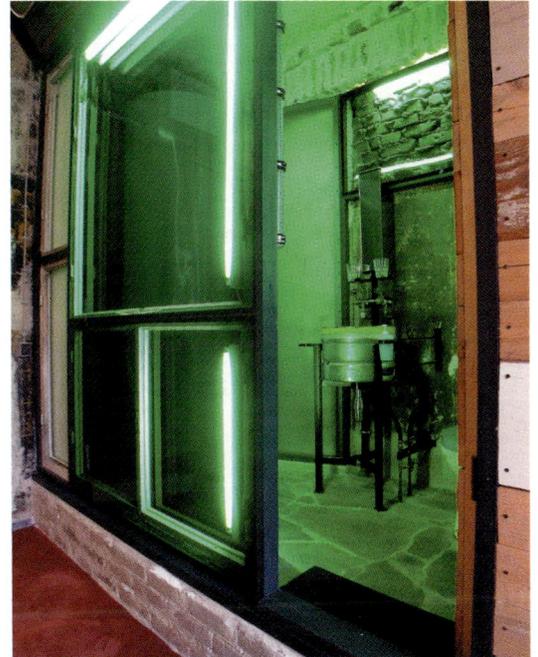

The theme of each room is varied—from conventional domestic concepts to contemporary and futurist ideas—so that they create an entire world of interior landscapes full of contrasts.

REMODELING

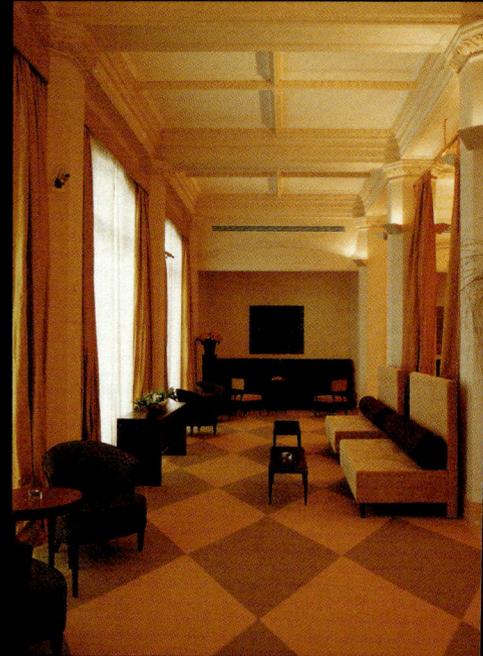

Converting an old structure to new use, while retaining or restoring elements of its original character, can achieve a uniquely pleasing effect. To create this atmosphere, many hotels are located in old buildings, on sites of various scales, and in very diverse architectural surroundings, creating a dialogue between old and new. The previous role of the building influences the form and function of its new life. The interaction of the old and new through contrasting elements, classic components, or restored features from the building's heyday, generates a wide range of exciting projects which can revitalize the hotels' surroundings as well as their guests.

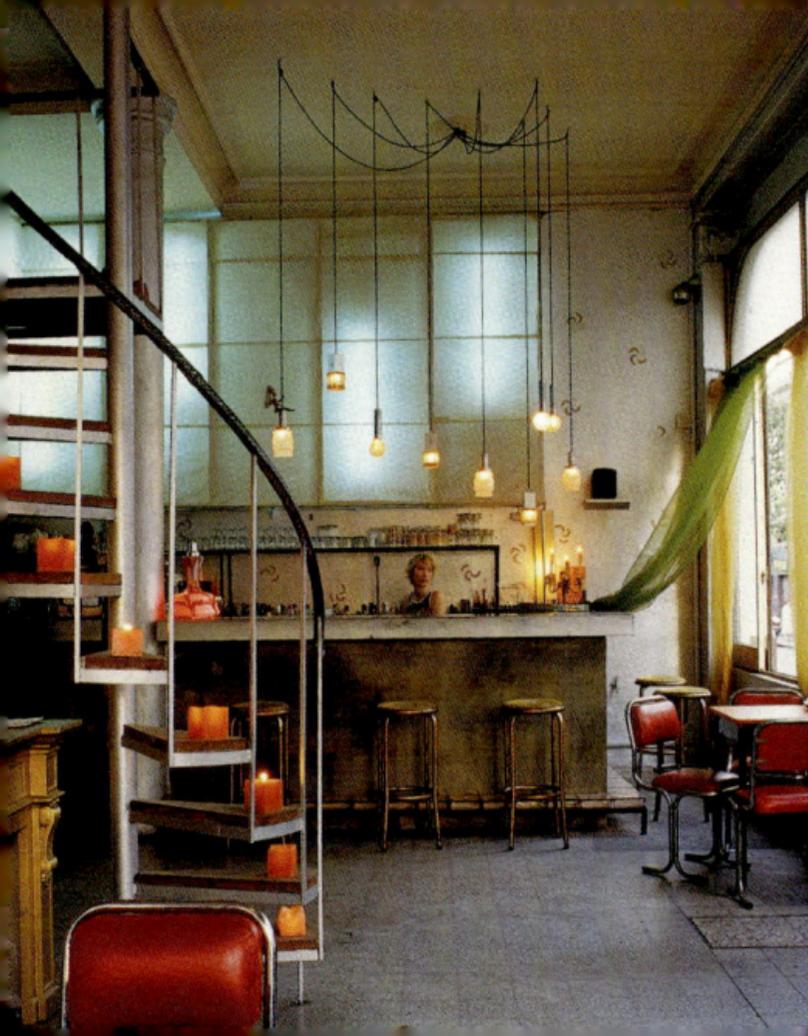

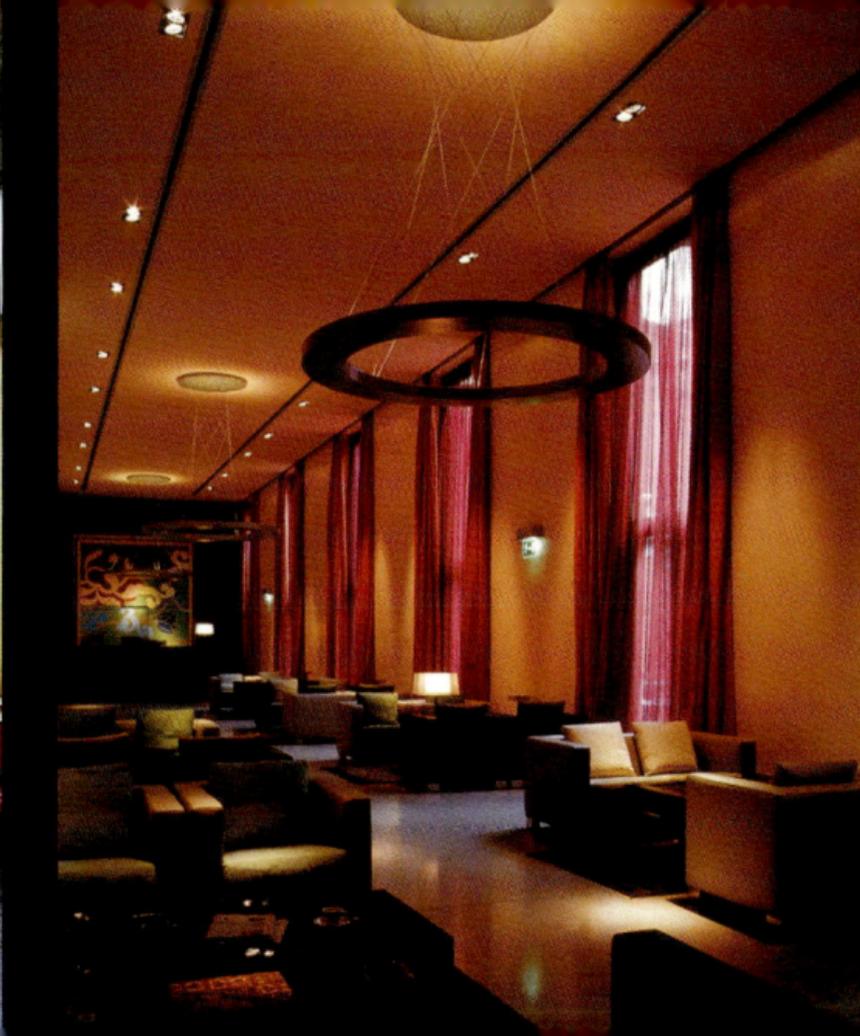

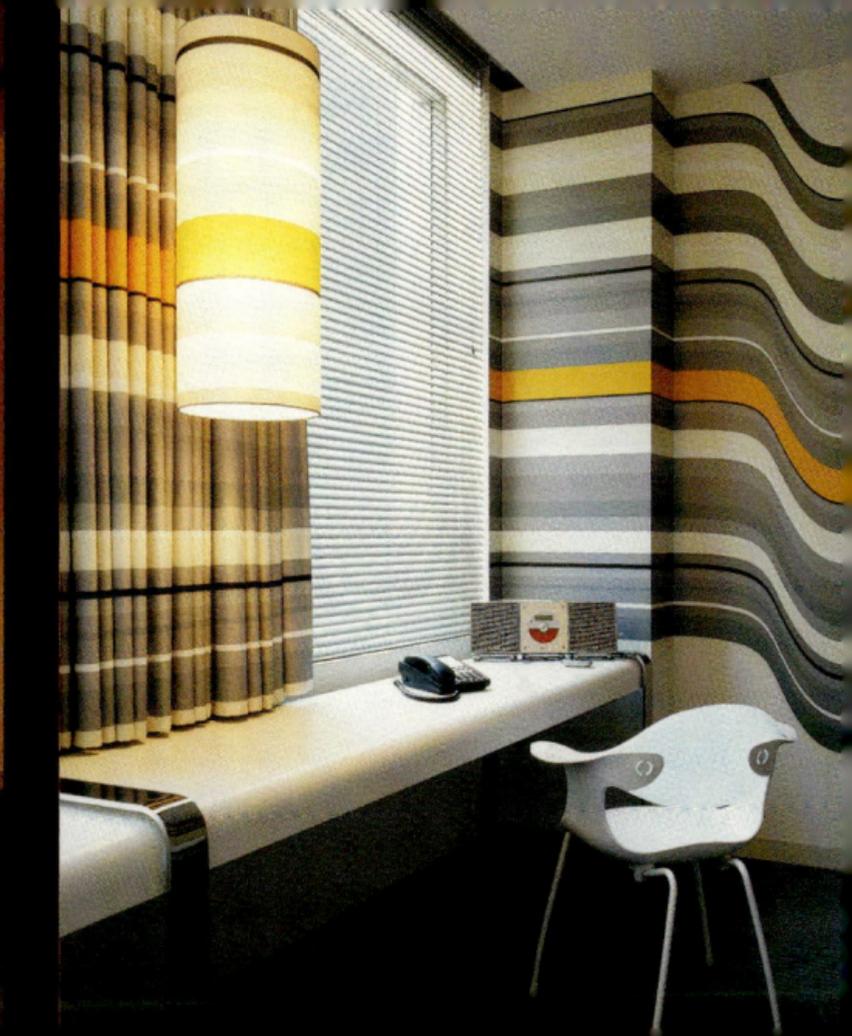

Boquitas
Pintadas

Estados Unidos 1393, 1101 Buenos Aires, Argentina Tel: +54 11 4381 6064 pop-hotel@boquitas-pintadas.com.ar www.boquitas-pintadas.com.ar

The peculiar name of this hotel (translated into English it means "Little Painted Mouths") pays homage to a book by the famous Argentinean writer, Manuel Puig, that is a love story set in the middle of the twentieth century. This stately house dates back to that same glorious era in Buenos Aires. Not long ago the owners, taking care of all the details, converted it into a hotel. The building is located in San Telmo, an older city neighborhood that was deteriorating but has experienced a comeback among artists and intellectuals. The structure retains many elements characteristic of the aristocratic architecture of the time, rich in interesting details of great quality, such as the molding, sunken arches, hardwood floors, and even a few pieces of decoration in their original condition.

During the renovation the living room was converted into the master suite, but for the most part the original layout was not changed. This allowed the character of the interior to be preserved. In terms of decorating and design details, the owners took pains to restore many pieces of furniture from that era, found at bazaars, antique stores, and secondhand sales. They also, after doing some research, turned to textile designs from the 1950s and '60s to make curtains and bedspreads. A personal and contemporary touch came with the placement of each element and its new use, achieving a new interpretation of this particular style.

Designers: **Heike Thelen, Gerd Tepass** Photographers: **Ricardo Labougle, Ana Cardinale** Location: **Buenos Aires, Argentina** Opening date: **2000**

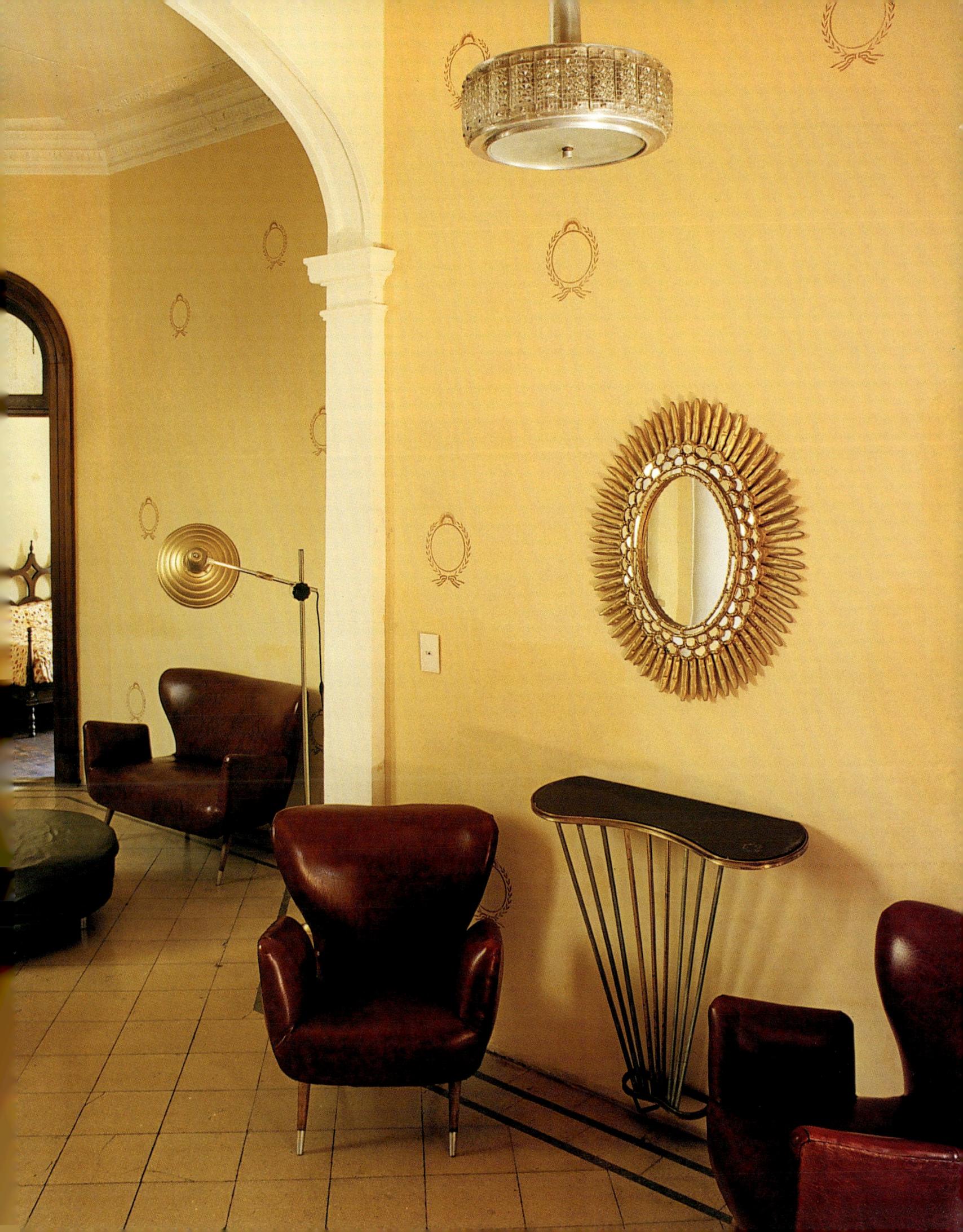

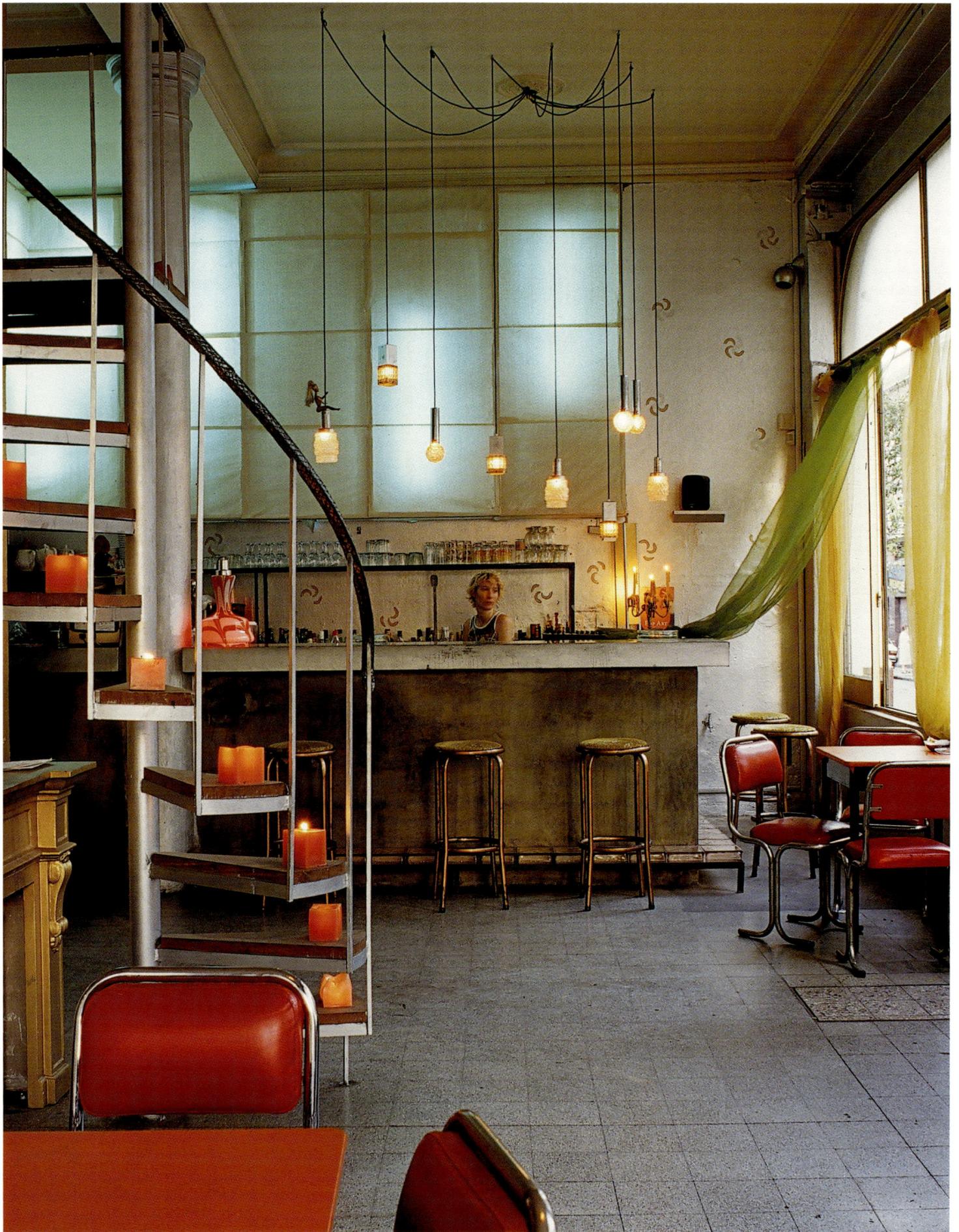

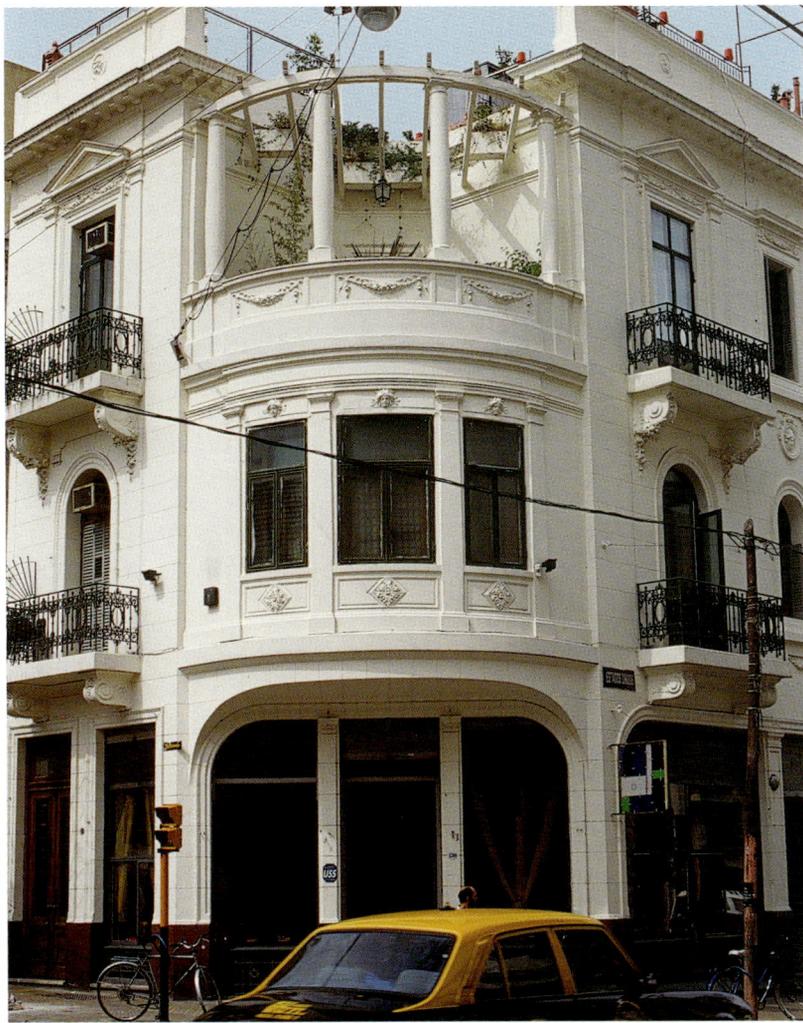
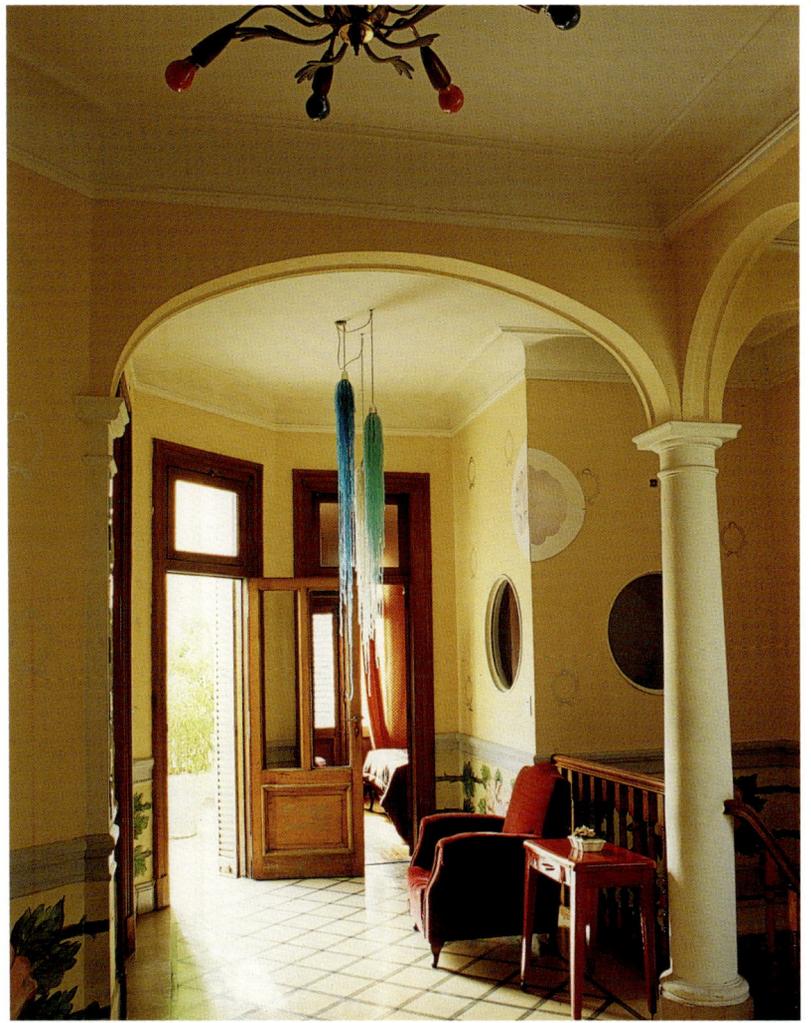
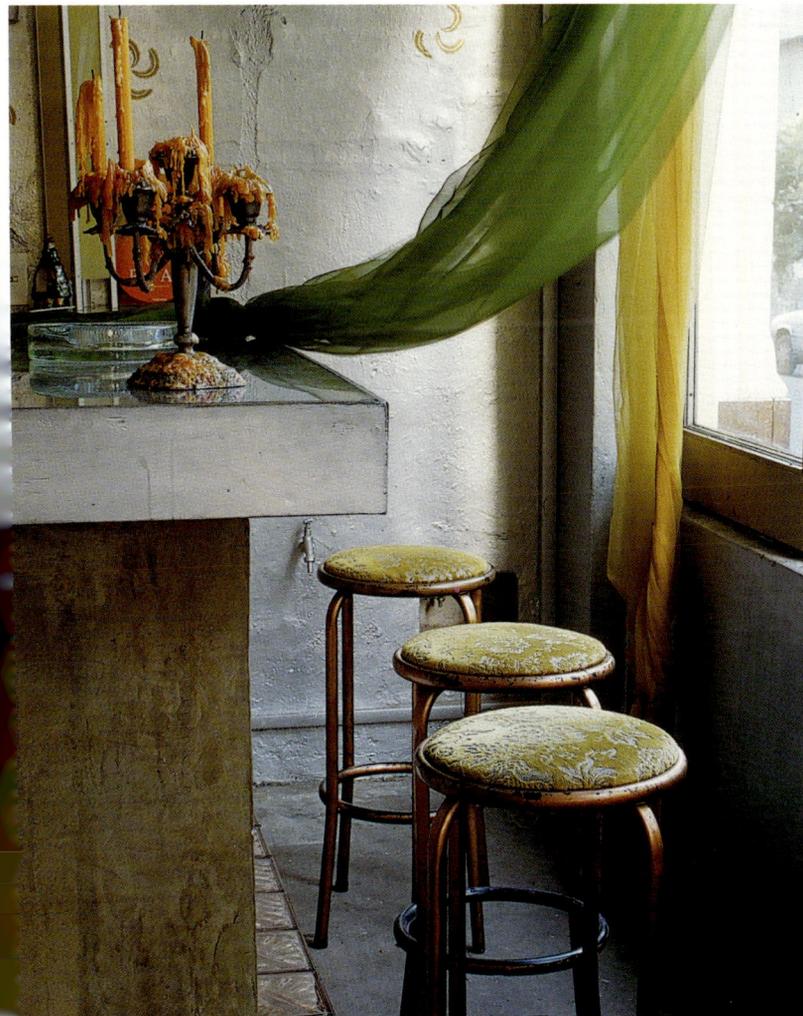

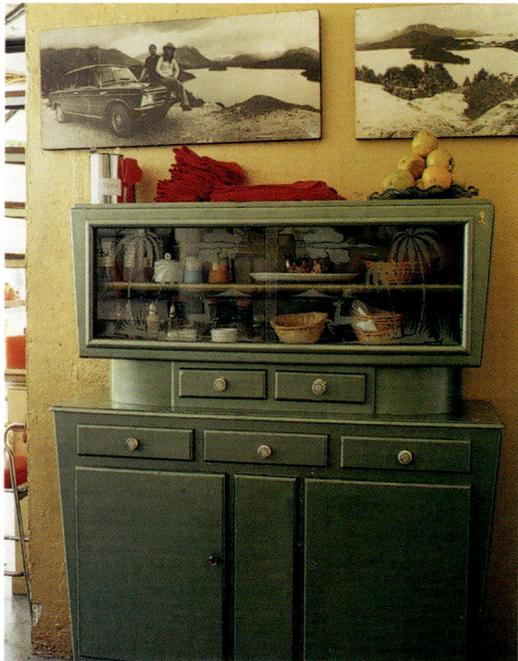

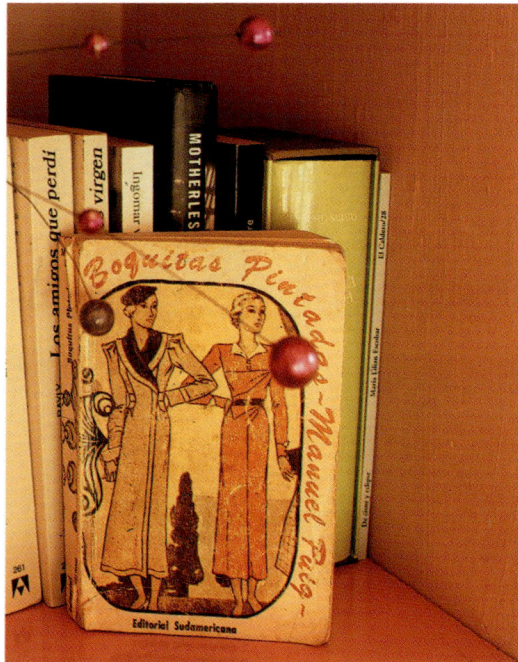

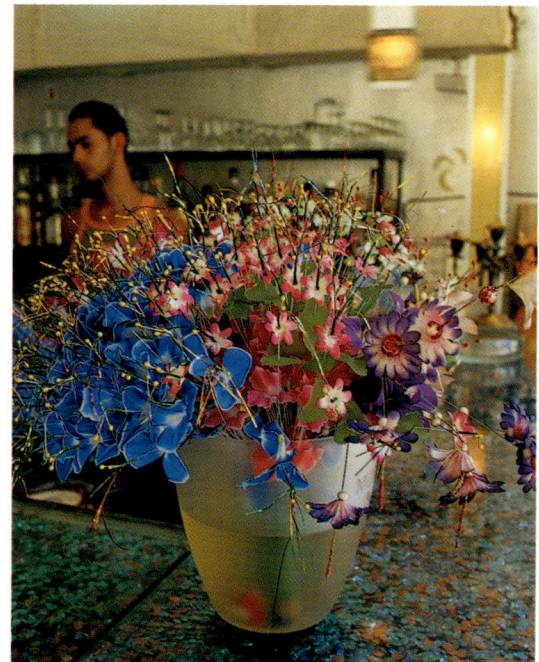

The colors of the rooms as well as the upholstery, bedspreads, and curtains were chosen based on the original elements that were already in the house. Although the details are complementary, many utilitarian and decorative pieces ended up defining the space.

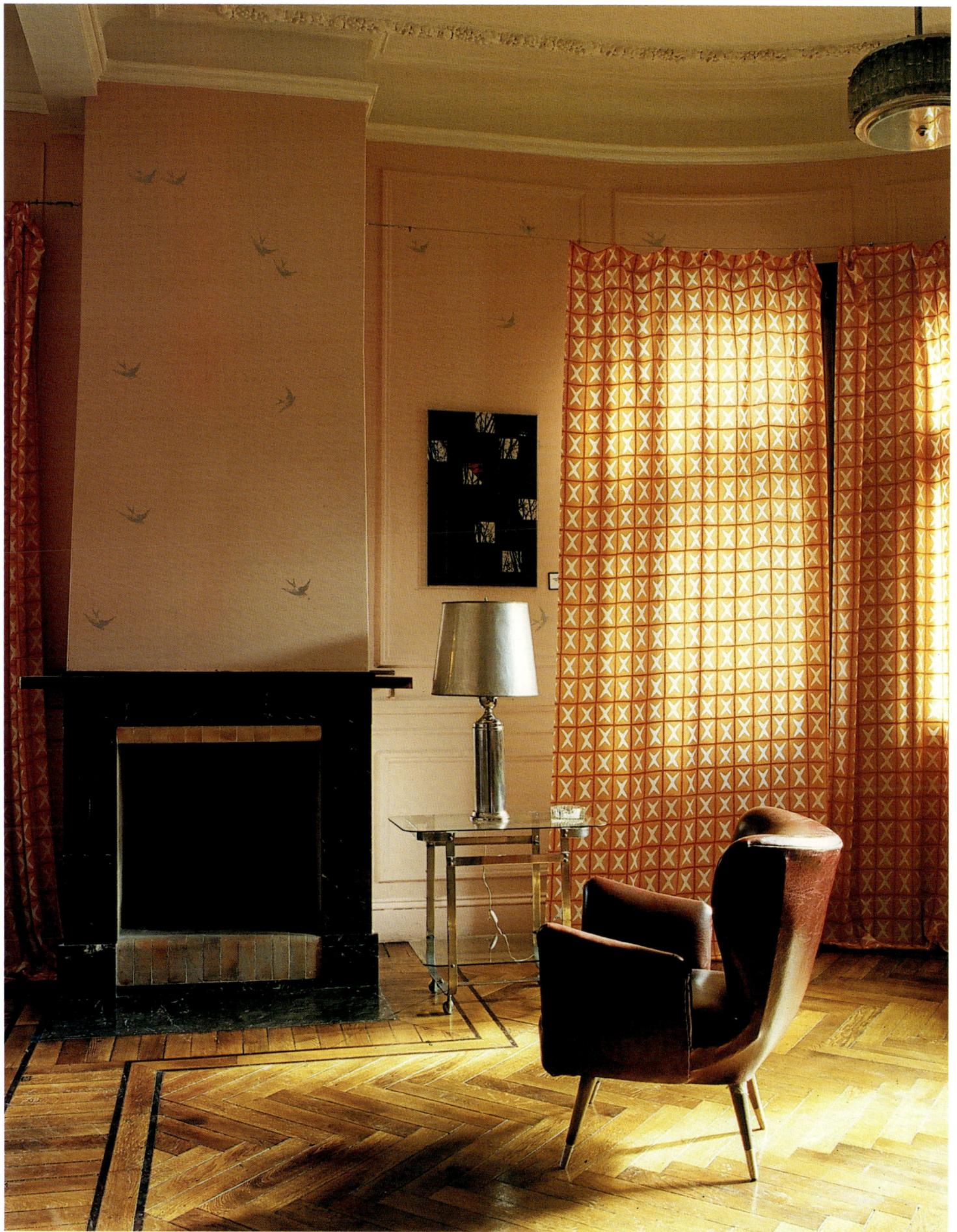

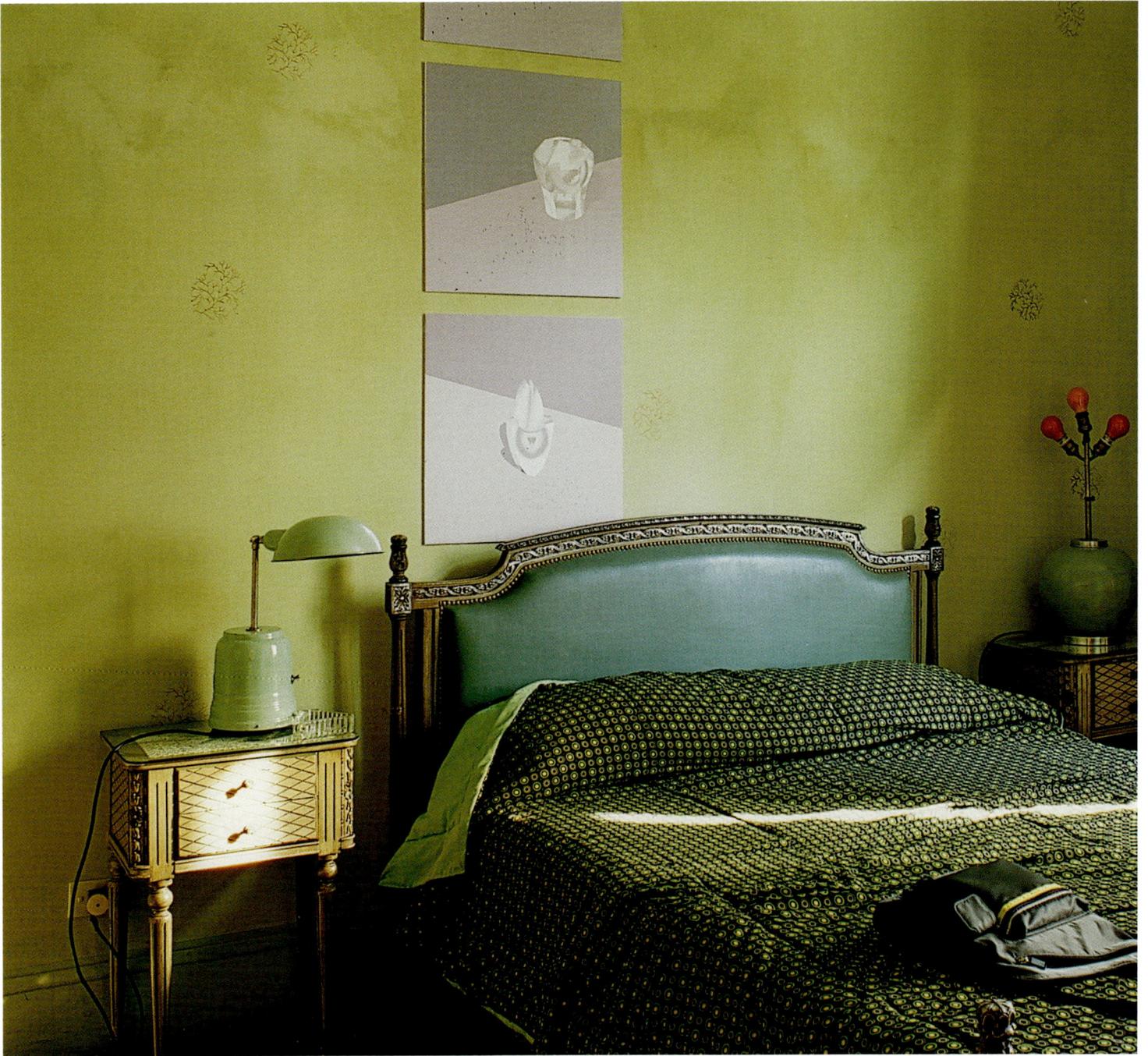
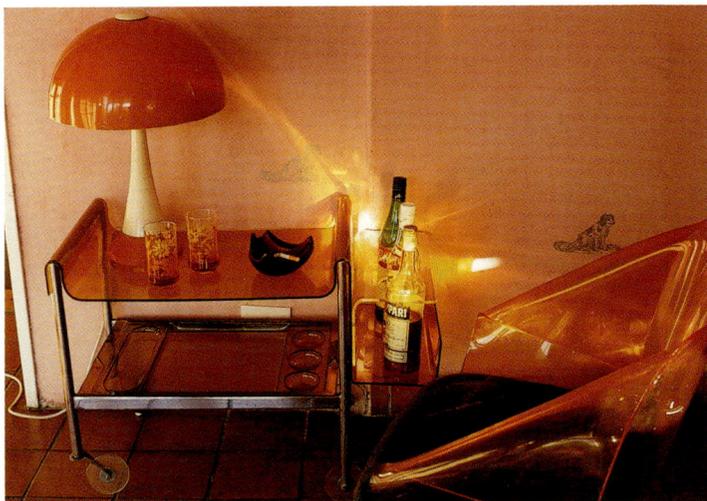

The hotel still maintains the ambience of an aristocratic, single-family home. This is achieved through pieces that seem to belong in the space and that give character to the more private areas and the exterior terraces.

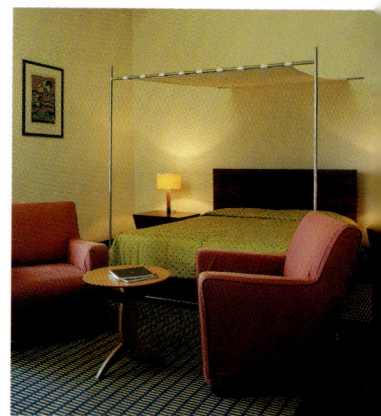

Flor

da Rosa

7430 999 Crato, Portugal Tel: +351 24 599 7210 Fax: +351 24 599 7212

The architectural heritage that composes the old part of this hotel derives from diverse eras and uses. Located in the southwest of Portugal, the structure was originally built in the fourteenth century as a castle and later became a convent. During the Renaissance, it was enlarged and remade into a palace, incorporating some exterior areas and gardens. The building is surrounded by a valley of great natural richness not far from Crato, a town known for its ceramics that are still made by traditional methods. As part of the program Posados de Portugal, Flor da Rosa brings a new life to this great historic structure and adapts it to the needs of a luxurious, comfortable hotel.

The renovation restored the original structure, which is used mostly for public spaces, and incorporates a totally new annex in order to meet all the needs of the hotel. The design of the interior renovation and the new annex is rooted in the original character of the building, which has been respected and which served as a reference for the project. The restrained, austere language of the new renovation, which, in some ways recalls monastic spaces, counterbalances the extremely expressive columns and arches of the original building. The general lighting creates a dramatic effect with the large-scale lamps that emphasize the character of the space. As a result, an overall feeling of great sparseness has been created, which, although it preserves the characteristic elements of the original structure, exudes a decidedly contemporary ambience.

Architect: **Carrilho da Graça** Photographer: **Pep Escoda** Location: **Crato, Portugal** Opening date: **1999**

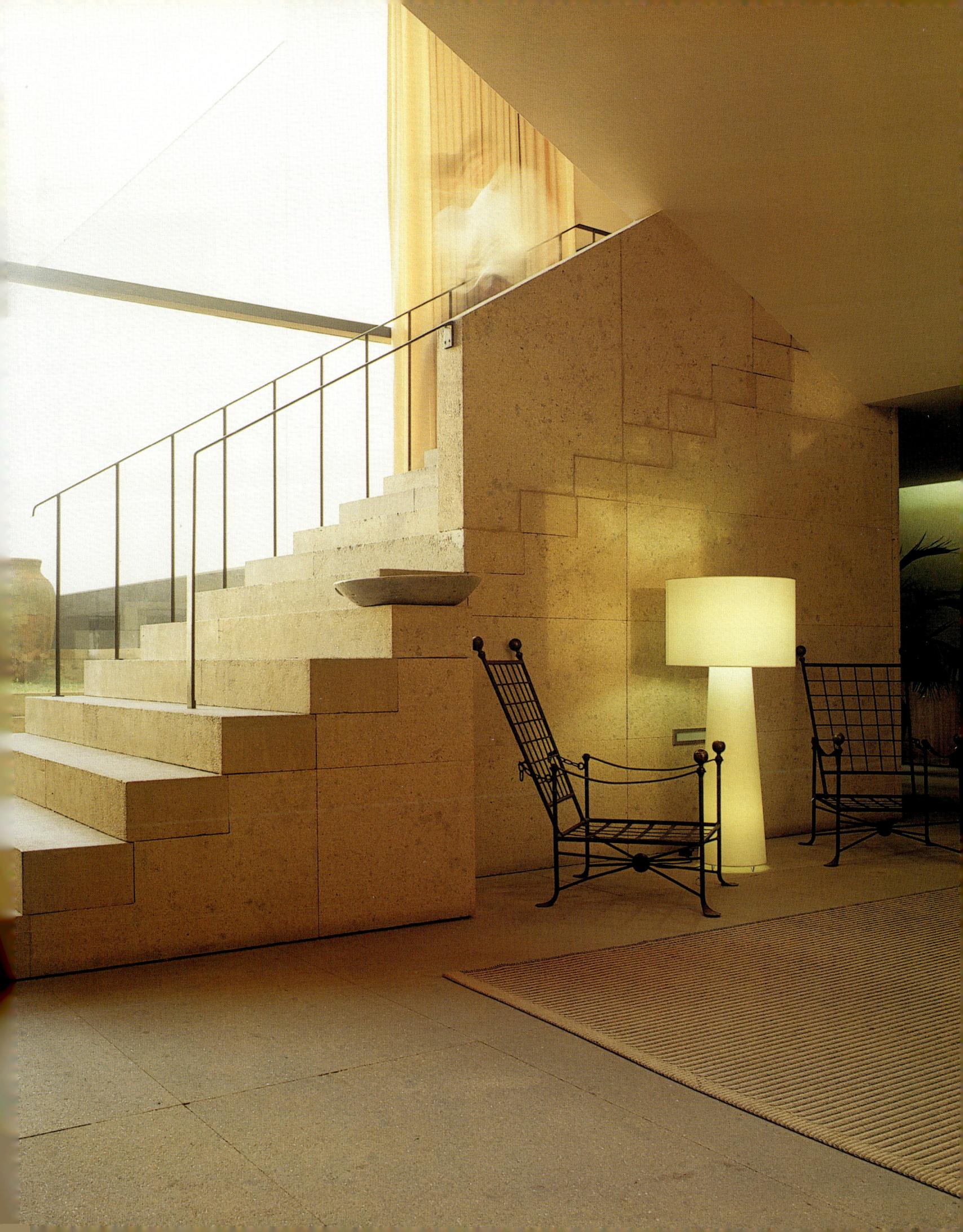

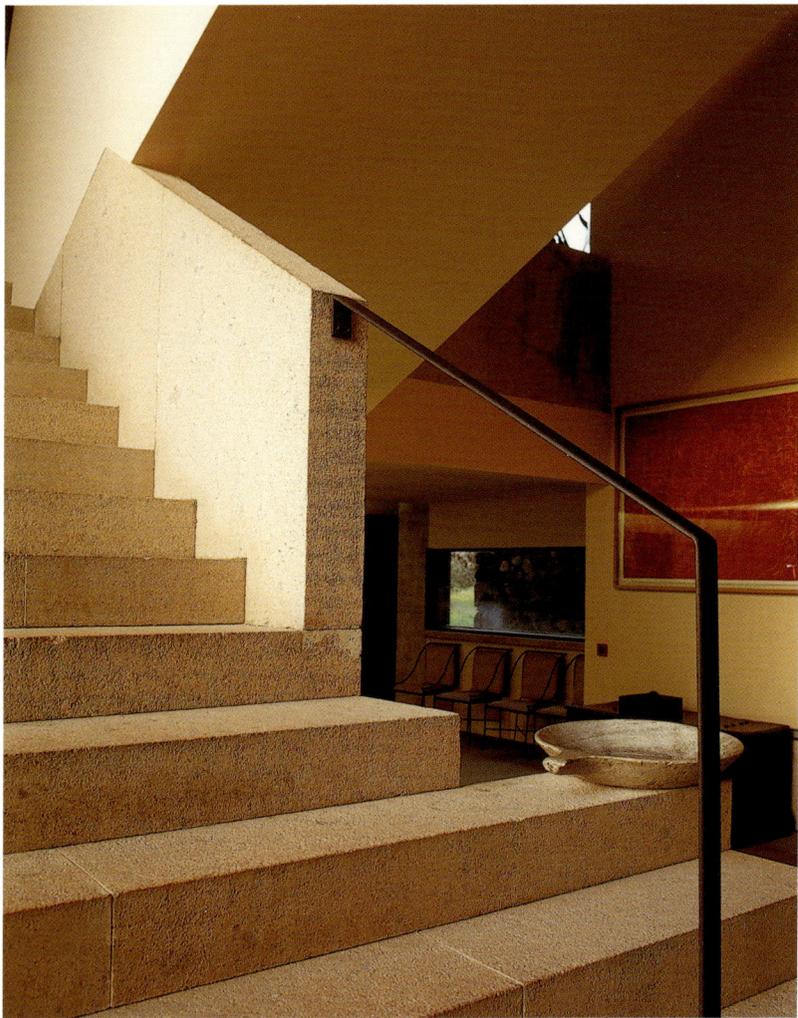
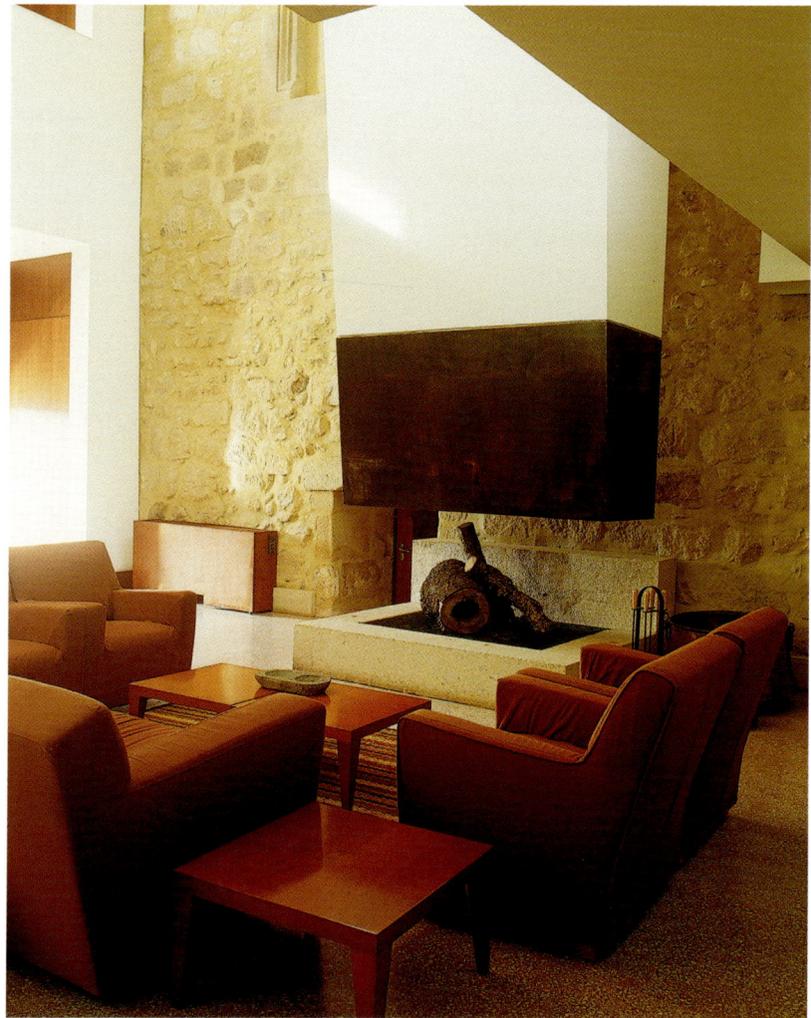
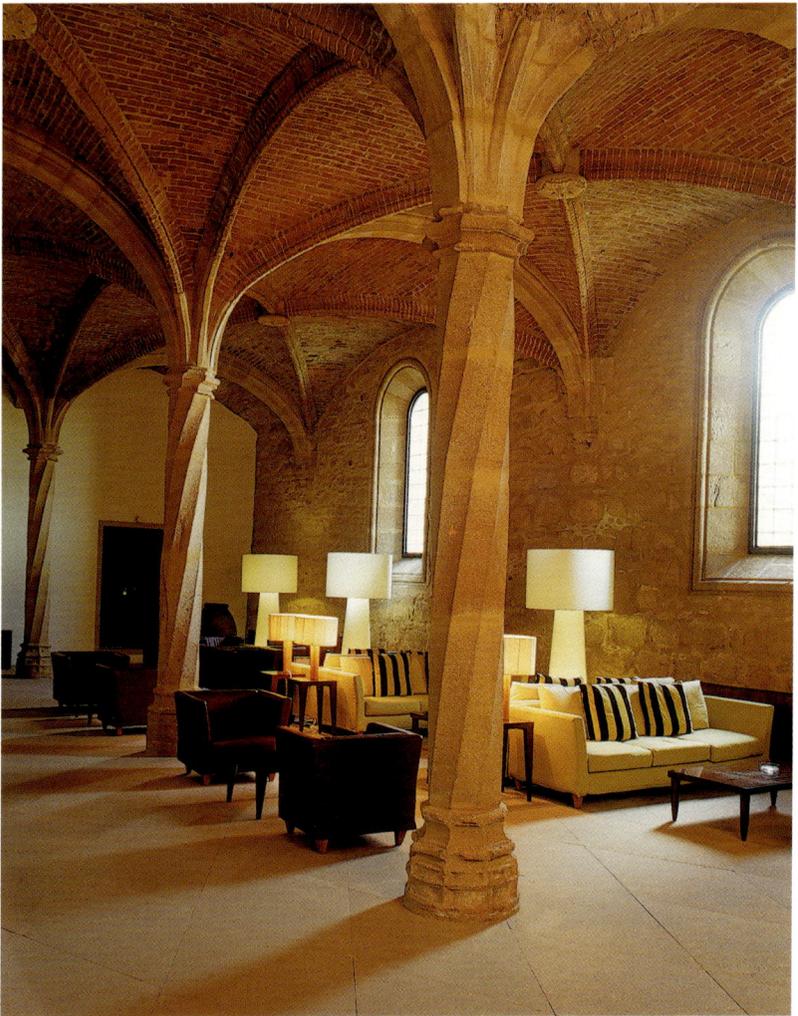

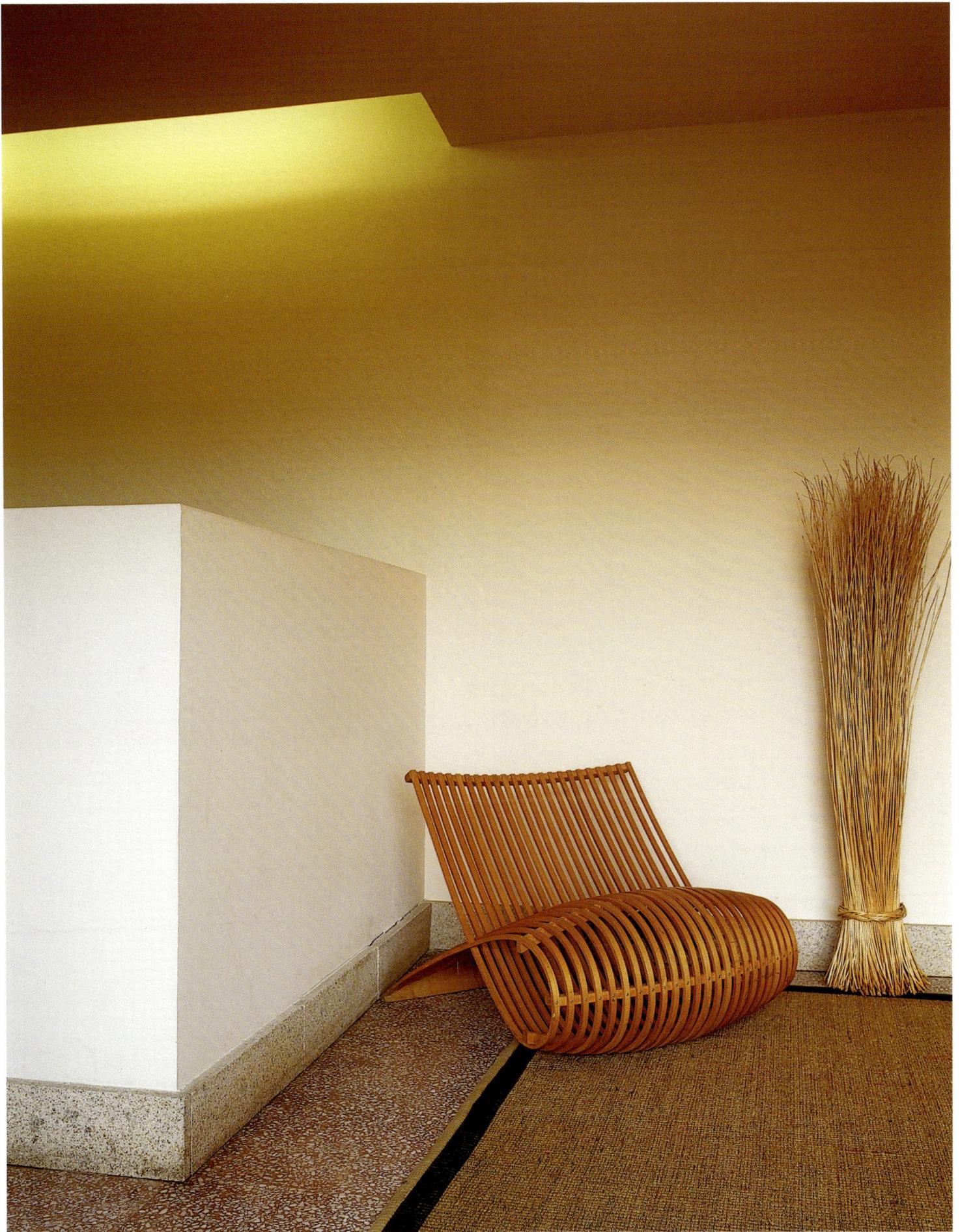

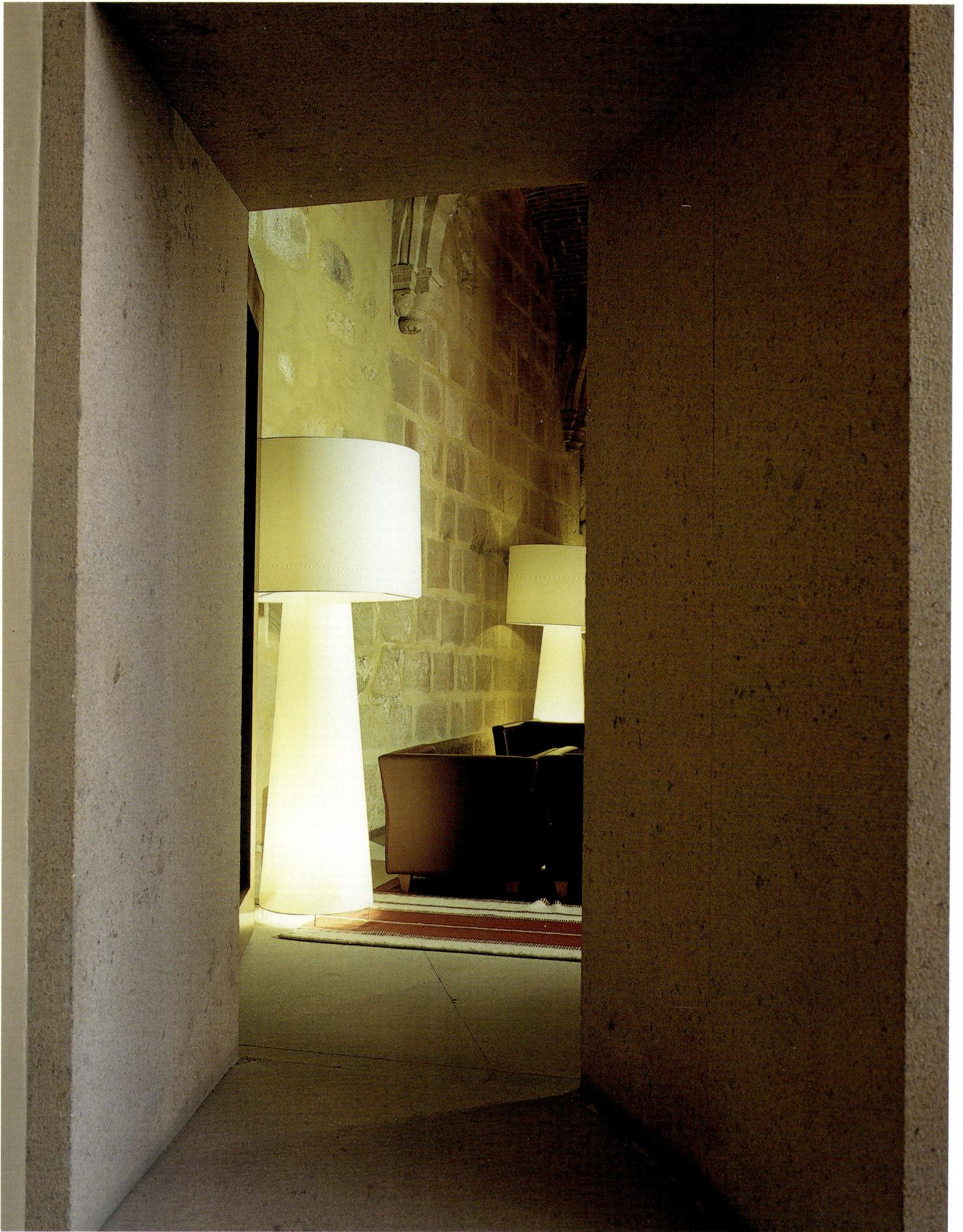

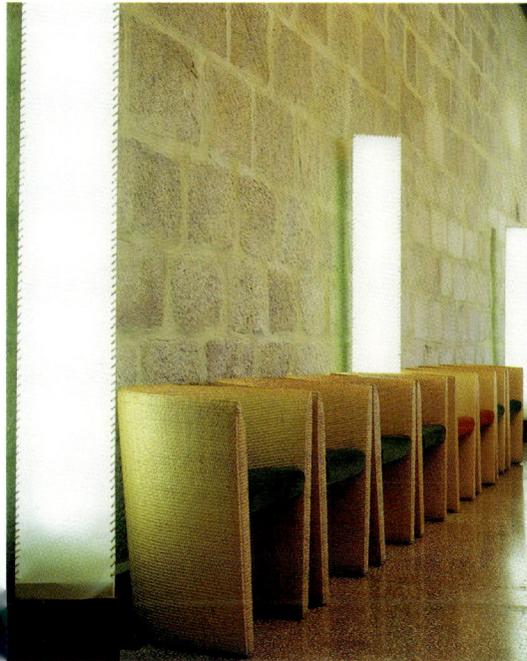

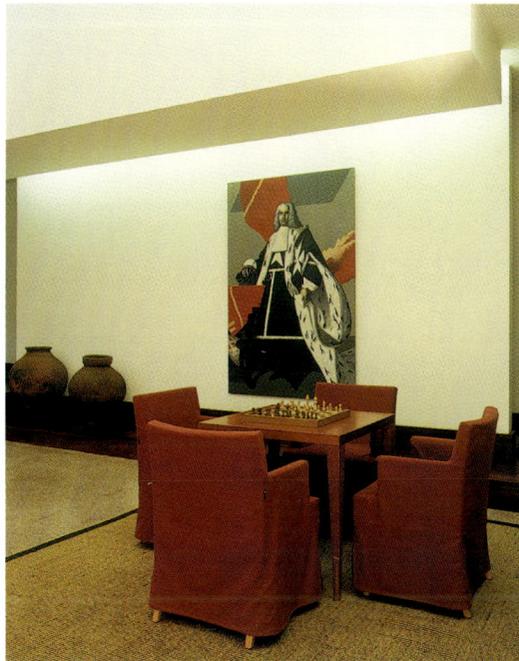

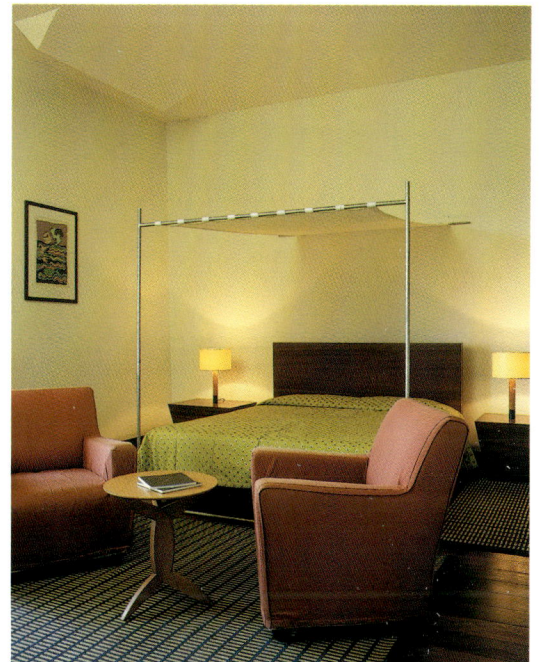

Some of the materials used in the annex are the same as those used in the original structure, such as the natural stone in the flooring, the iron for the banister, and some of the furniture, creating continuity between the buildings. In the rooms the designers opted for a richer interior featuring natural fibers, materials, and textures that imbue the room with warmth.

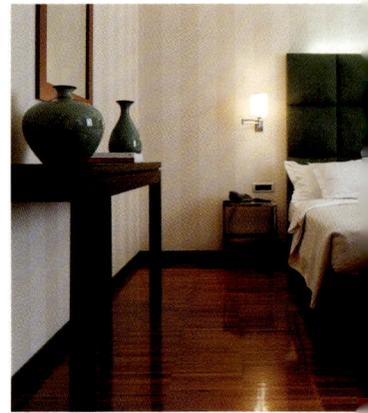

Enterprise
Hotel

Corso Sempione 91, 20154 Milan, Italy Tel: +39 02 318181 Fax: +39 02 31818811 info@enterprisehotel.com www.enterprisehotel.com

The main headquarters of this hotel is an impressive and an expressive building. Störmer Architekten, one of the most prestigious architecture studios in Germany, needed more than three years to design and erect this large eight-story mass of stone and glass. The spectacular façade rises up out of the heart of the city, a showpiece among the buildings around it. It is a unique five-star place of lodging, with a style all its own.

German architects Gregor Gerlach and Jan Störmer and the Italian architect Matteo Thun collaborated, with Thun's interiors nicely reflecting the building's glass-and-stone facings. The main space, and physically the central space, is 79 feet in height. There is a distinct absence of parallel lines here, as the ground plan is a trapezoid and the glass front is biased at a three-degree angle. The resulting tension is an attractive feature, heightened by Robert Wilson's creative lighting (computer-assisted impulses modifying the space throughout the day according to weather and season). Atop this transparent interior, eight stories up, a huge lobby has been set and offers two views. Looking out through the transparent walls, one sees Hamburg harbor and Lake Alster; inside is the patio 79 feet below.

The bar and the Fusion Restaurant are on the ground floor. There is a view of the lobby from this point, used as a rendezvous setting for guests and their visitors. The red bar is decorated to see and be seen.

Architects: **Chris Redfern, Cristina Di Carlo** Promotion: **MN Studio** Photographer: **Santi Caleca** Location: **Milan, Italy** Opening Date: **2002**

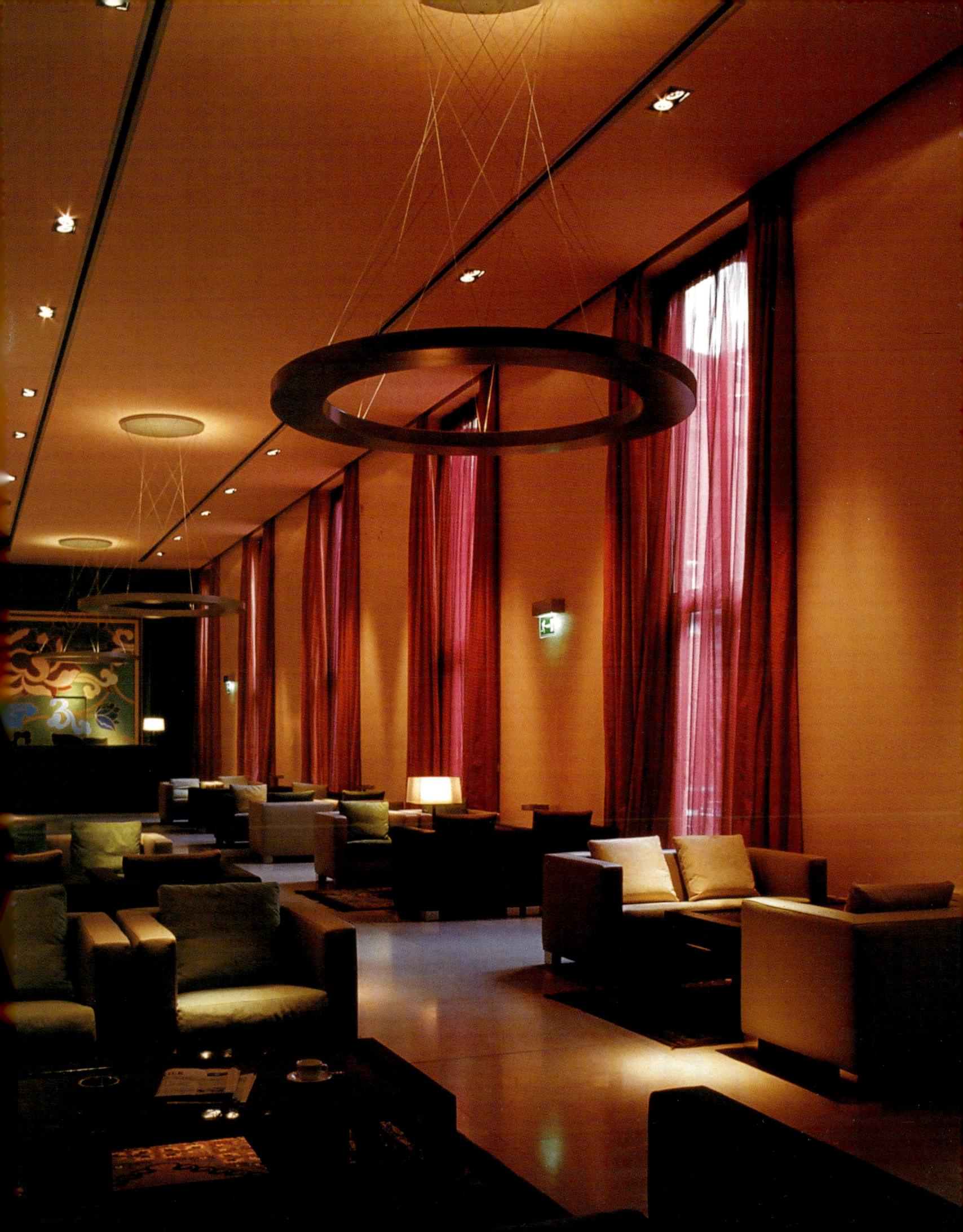

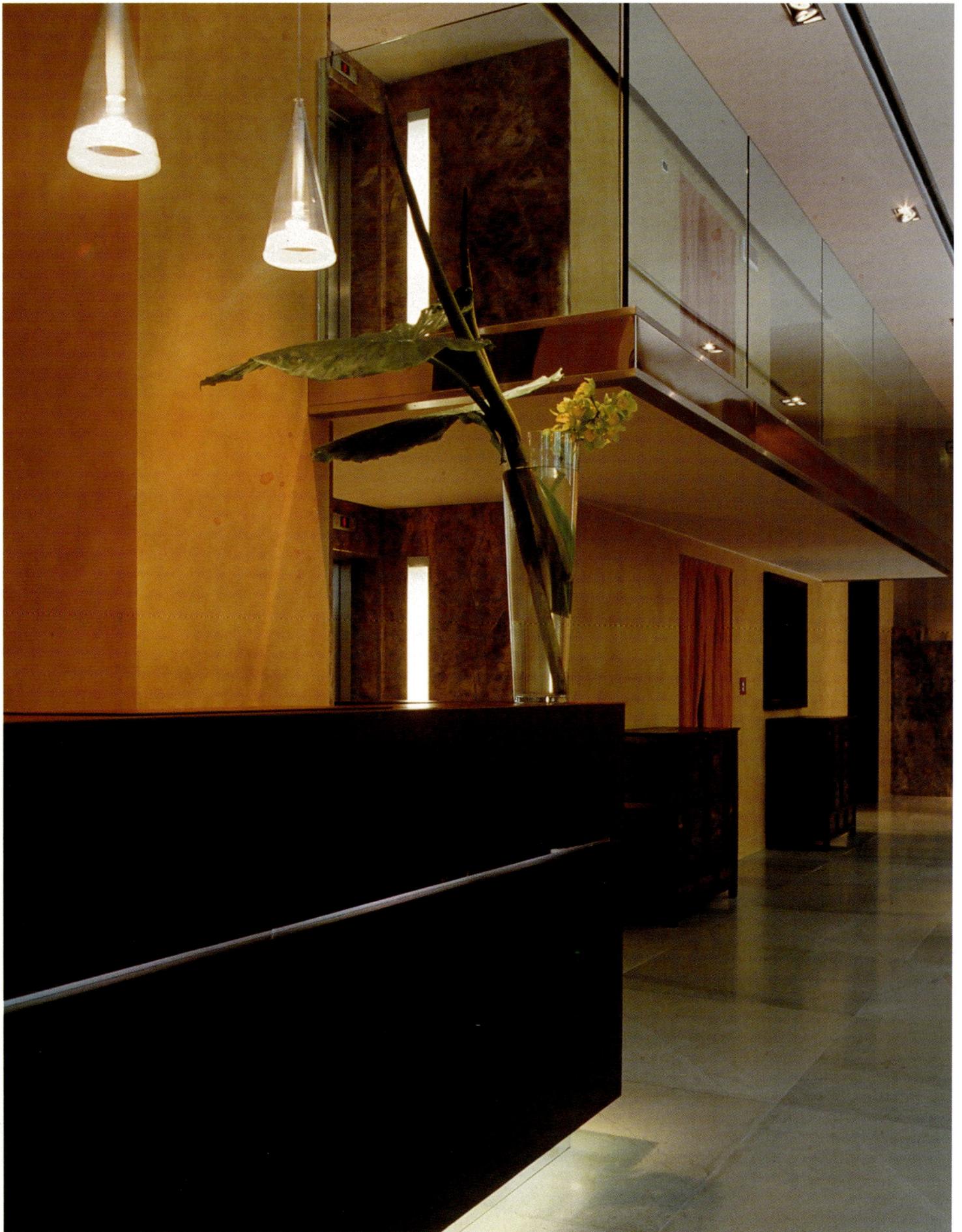

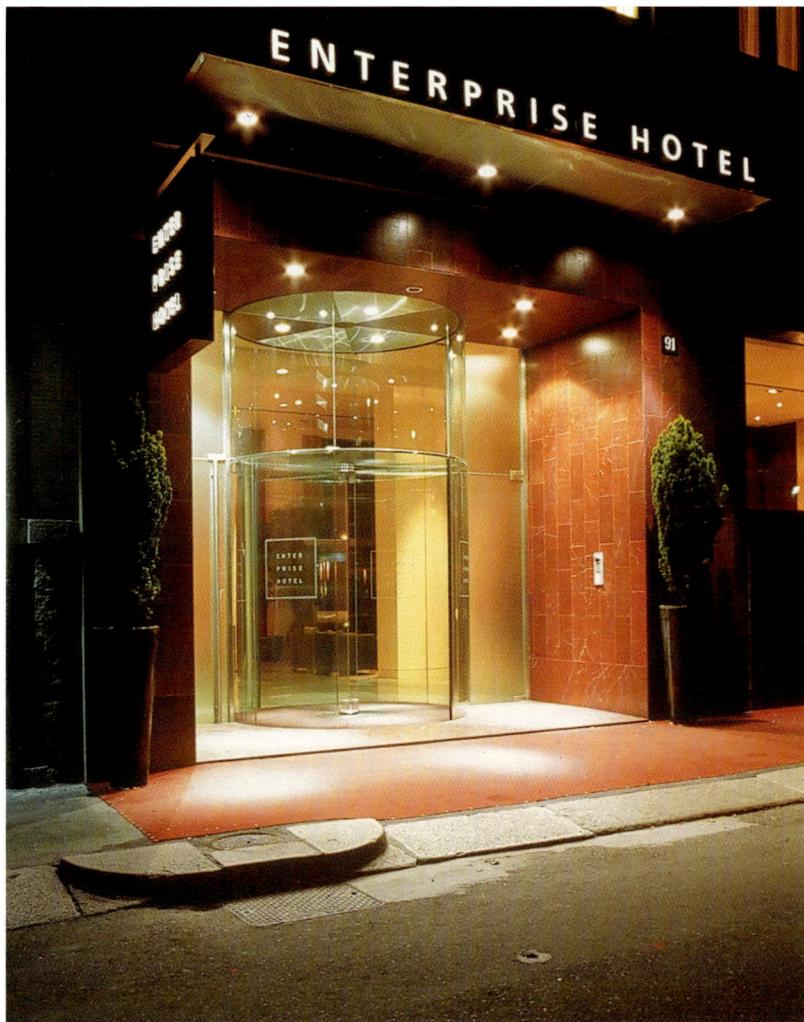

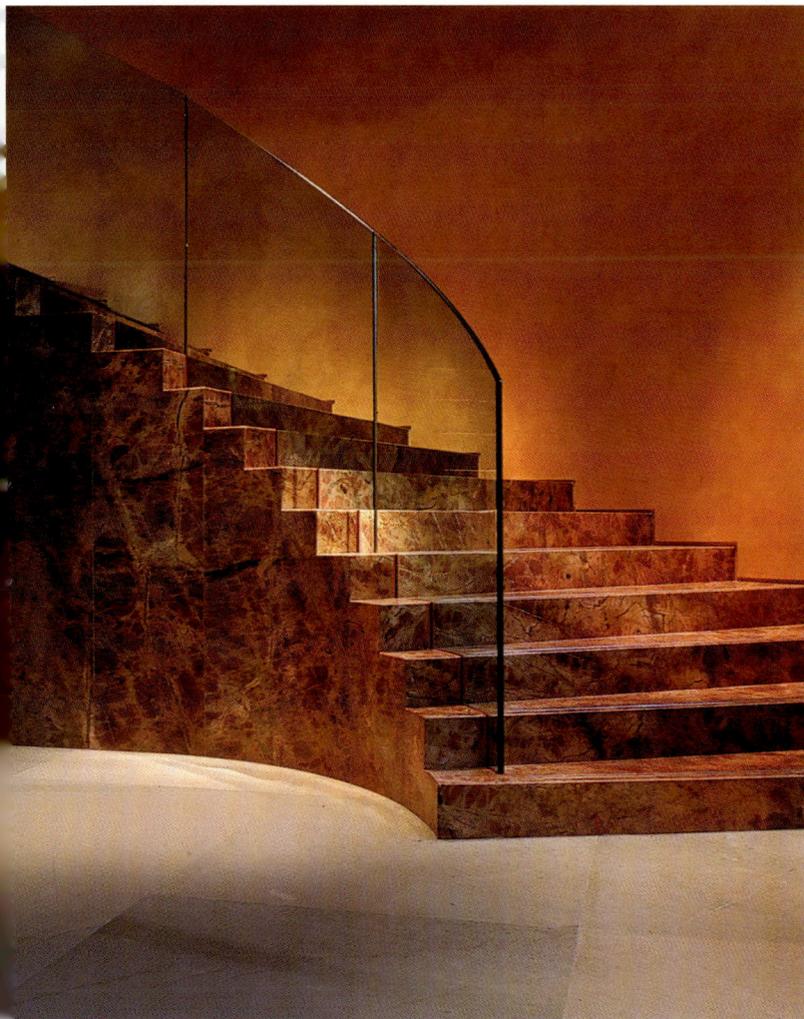

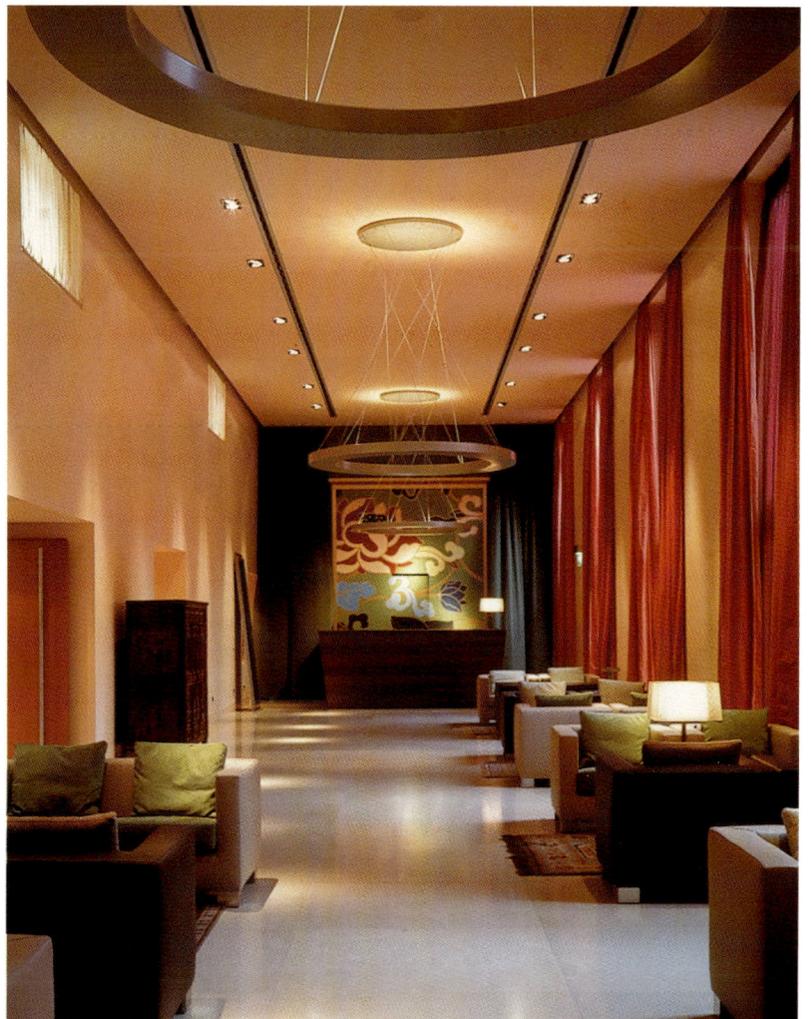

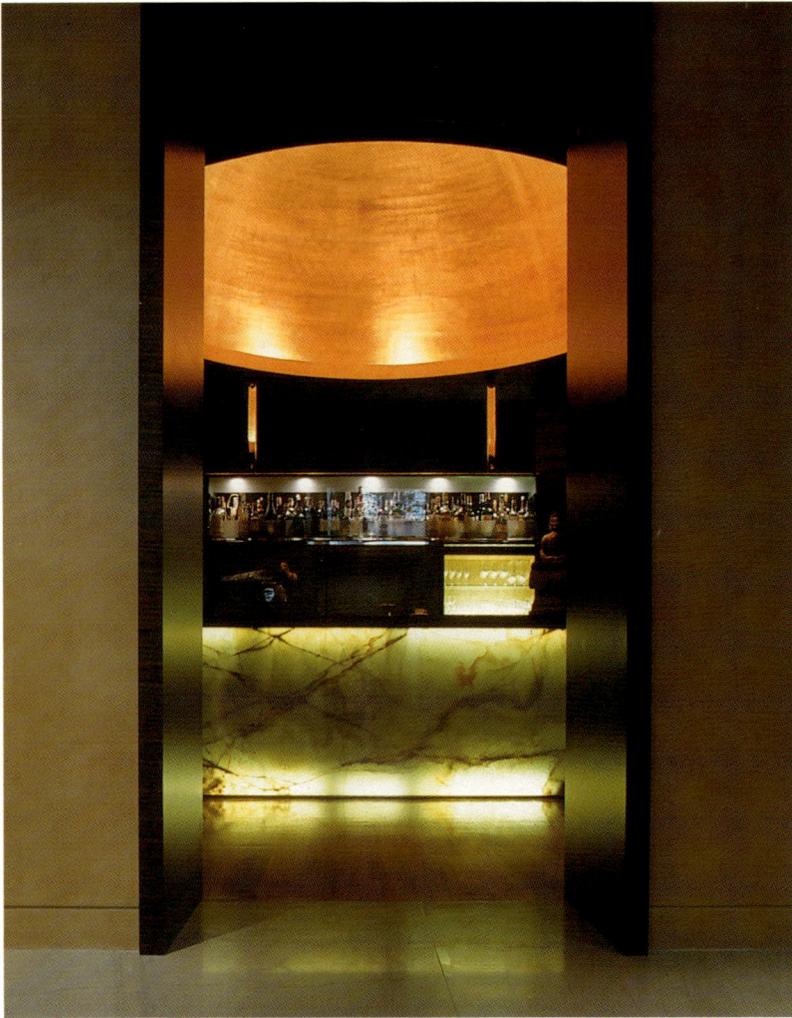

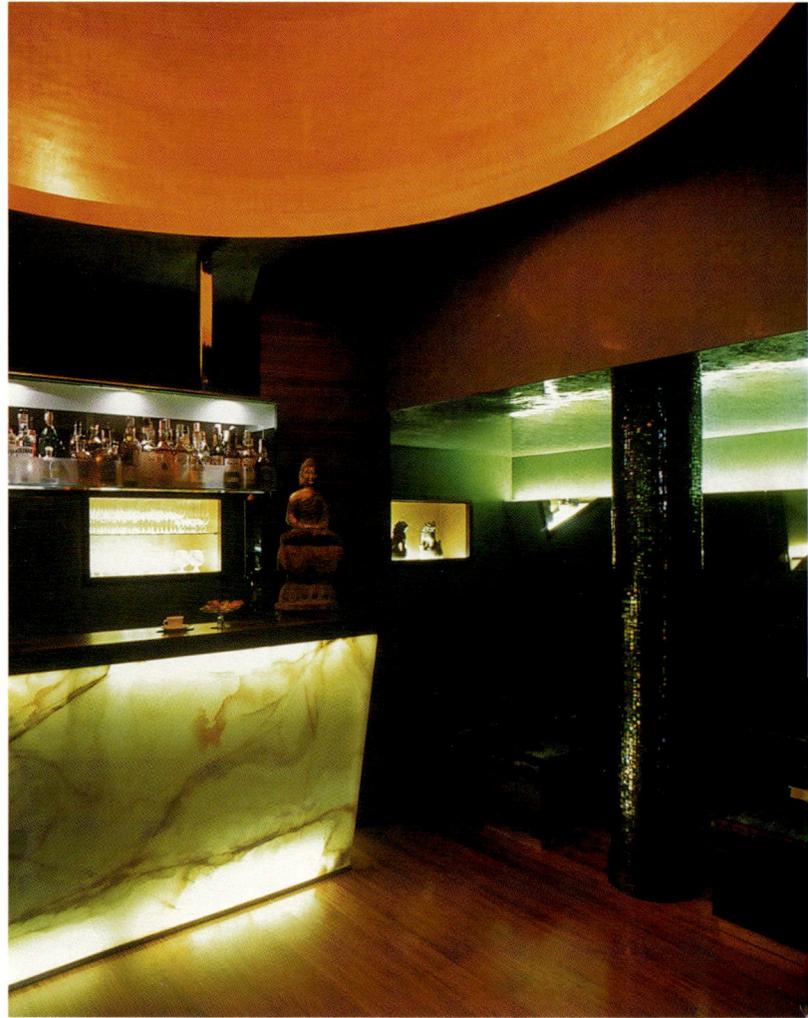

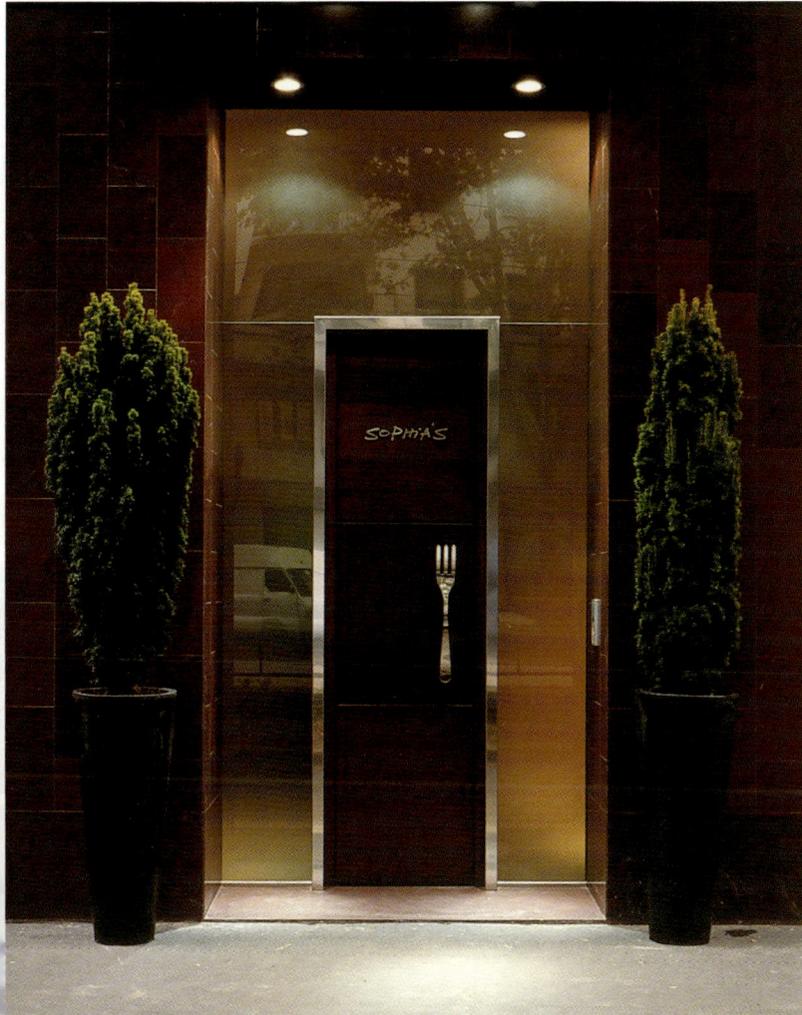

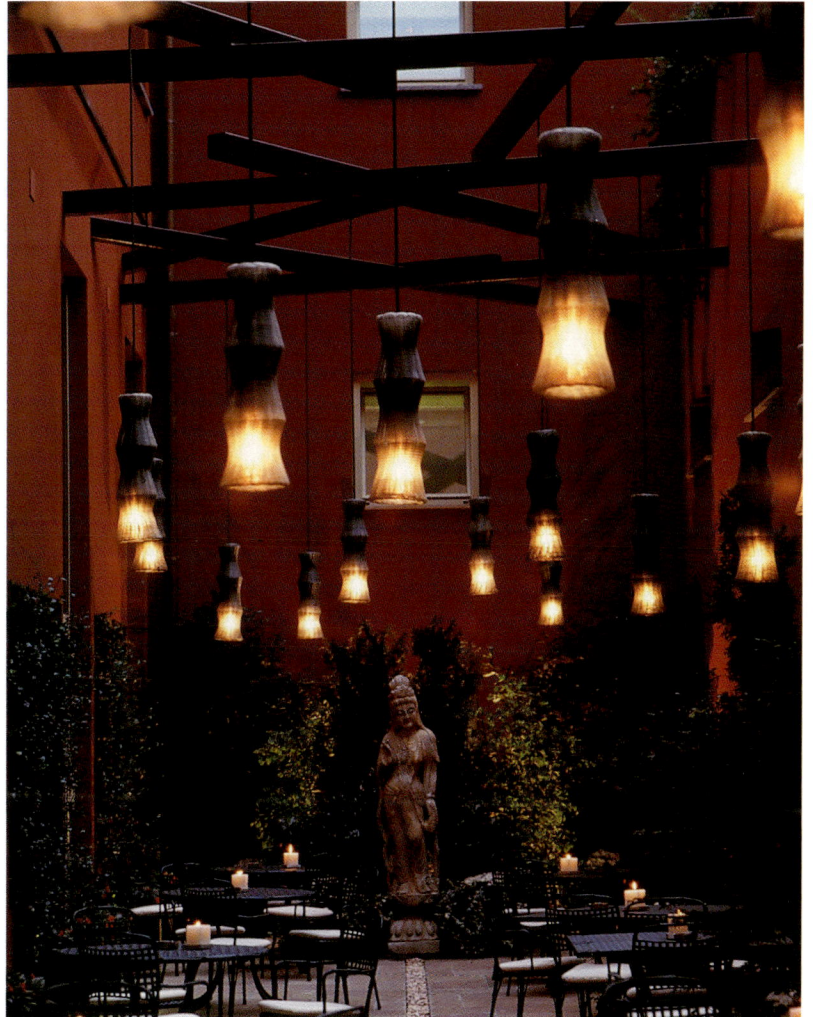

The colors, as well as certain materials such as the marble, the small ceramic pieces, or even the vegetation used in the exterior areas, allude to the classic traditions of Italian architecture.

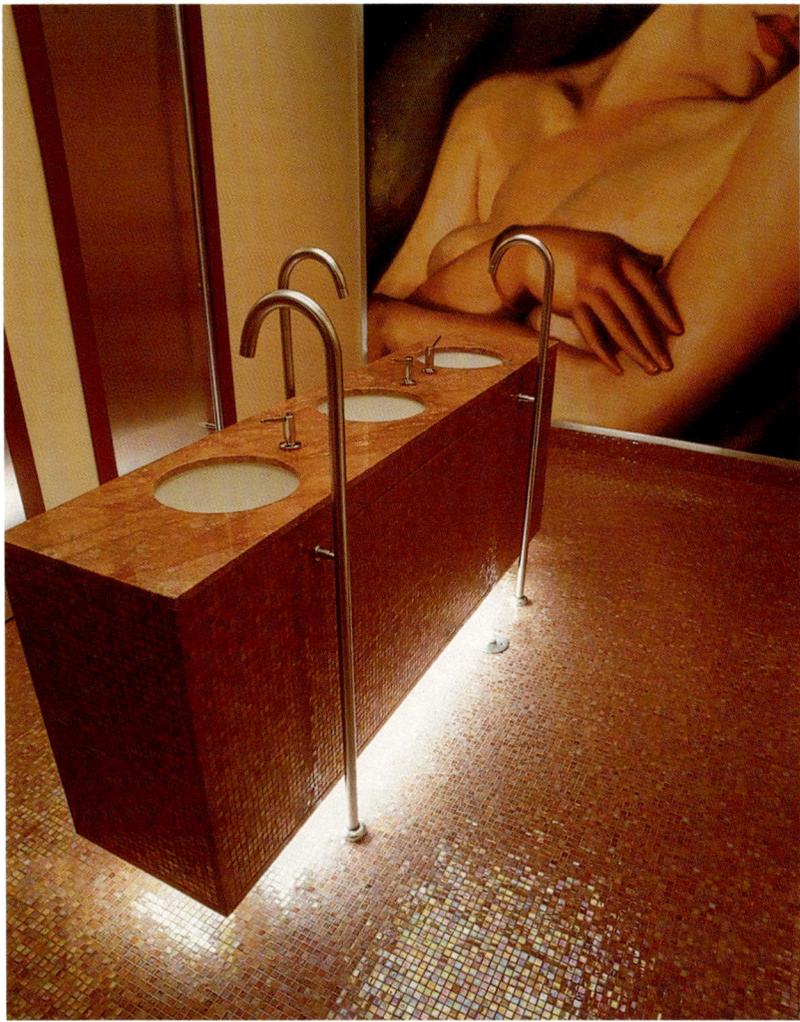
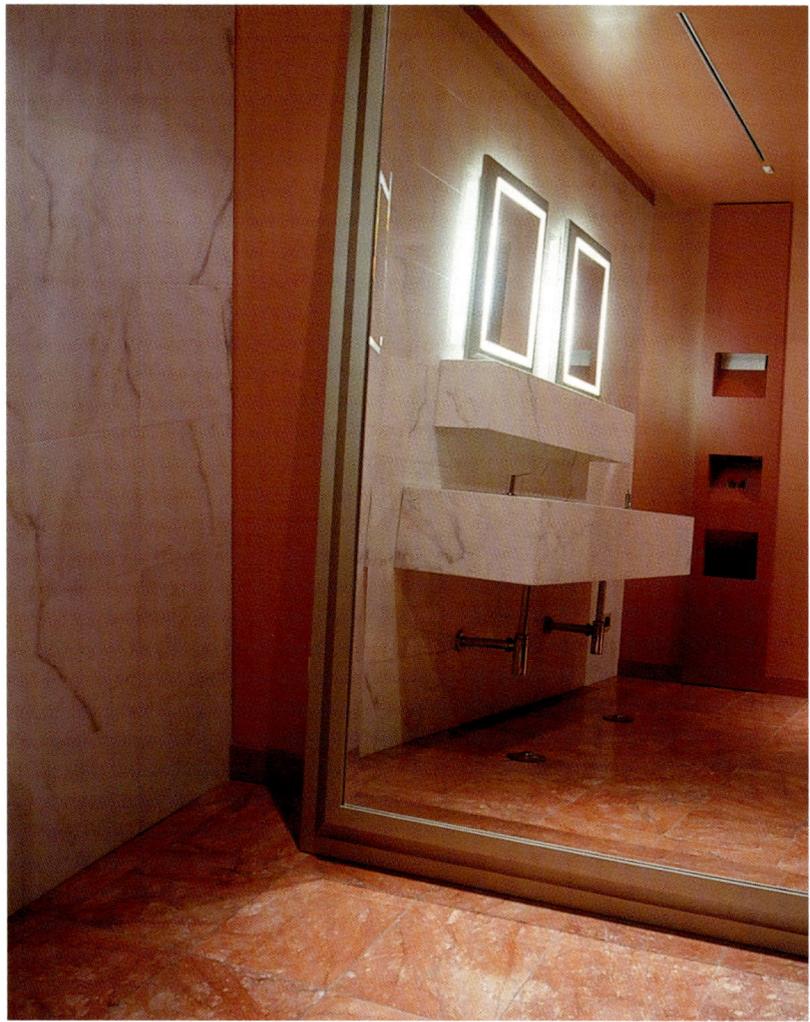
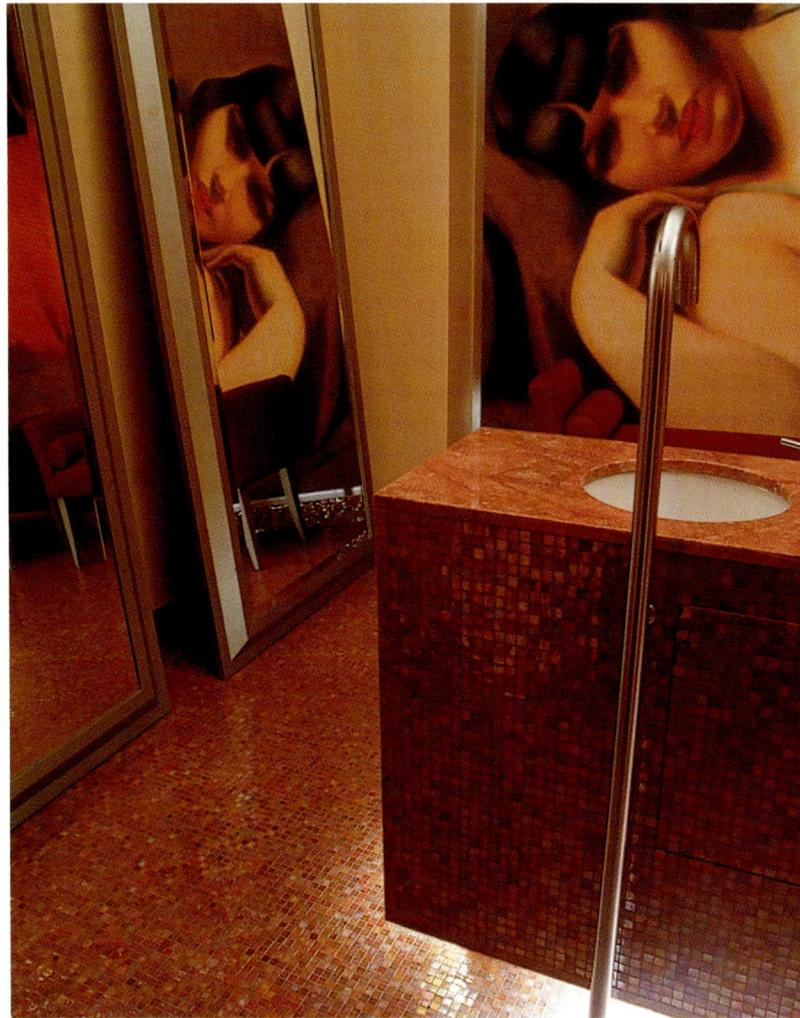
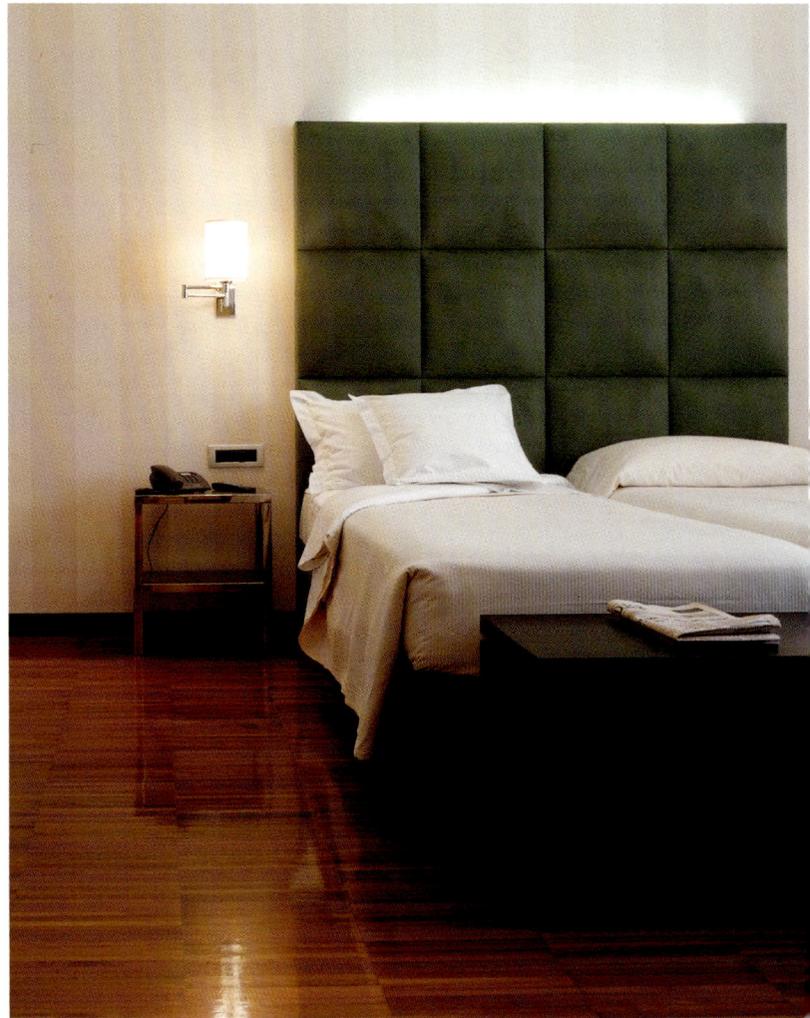

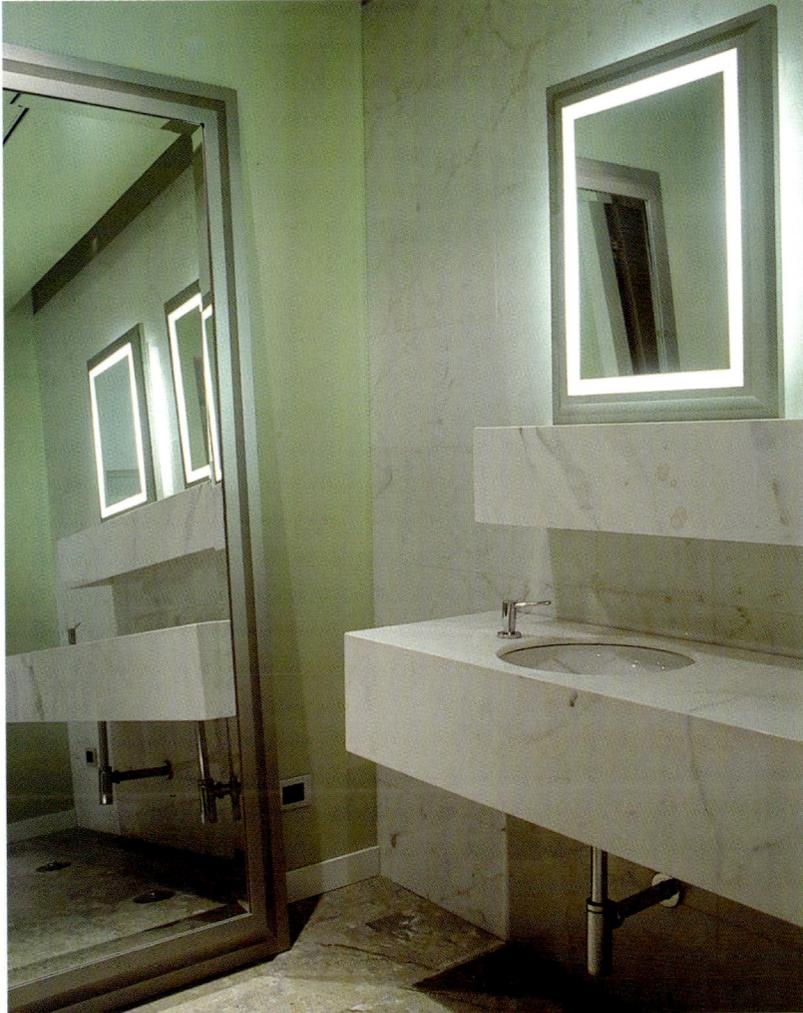

The interior of the bathrooms is subtly enhanced with high-quality materials and finishes—such as faucets, fixtures, marble, and mirrors—that create rich textures.

Banys
Orientals

Argentería 37, 08003 Barcelona, Spain Tel: +34 93 268 8460 Fax: +34 93 268 8461 www.hotelbanysorientals.com

The building that houses this small hotel, located in one of the most vibrant neighborhoods in Barcelona, is brimming with history that is reflected in the renovation. It is an eighteenth-century building located on one of the busiest commercial streets in the area, very close to such important landmarks as the Sagrada Familia, the palaces of Calle Montcada, and the old Borne Market. A hostel was once located in the building, and during the renovation ruins of Arab bathhouses from the eighth century were found. This discovery gave the hotel its name and inspired the idea to build a spa in the hotel during the second phase of the renovation.

The goal of the renovation was to create a personal and elegant atmosphere without relying on classic styles or a standard formula. In order to achieve this, materials were used that in some way give the space character while at the same time highlight and respect the original characteristics of the building. The courtyard plays a starring role; it is the light source for the staircase and hallways leading to the rooms. Except for the reception area, the floor is made of oak planks emulsified in black, while the walls and ceilings are painted in light tones. The range of colors runs from black to white, passing through a wide array of grays, a simple detail that brings a feeling of elegance to the entire project.

Designer: **Lázaro Rosa Violán** Photographer: **Pere Planells** Location: **Barcelona, Spain** Opening date: 2002

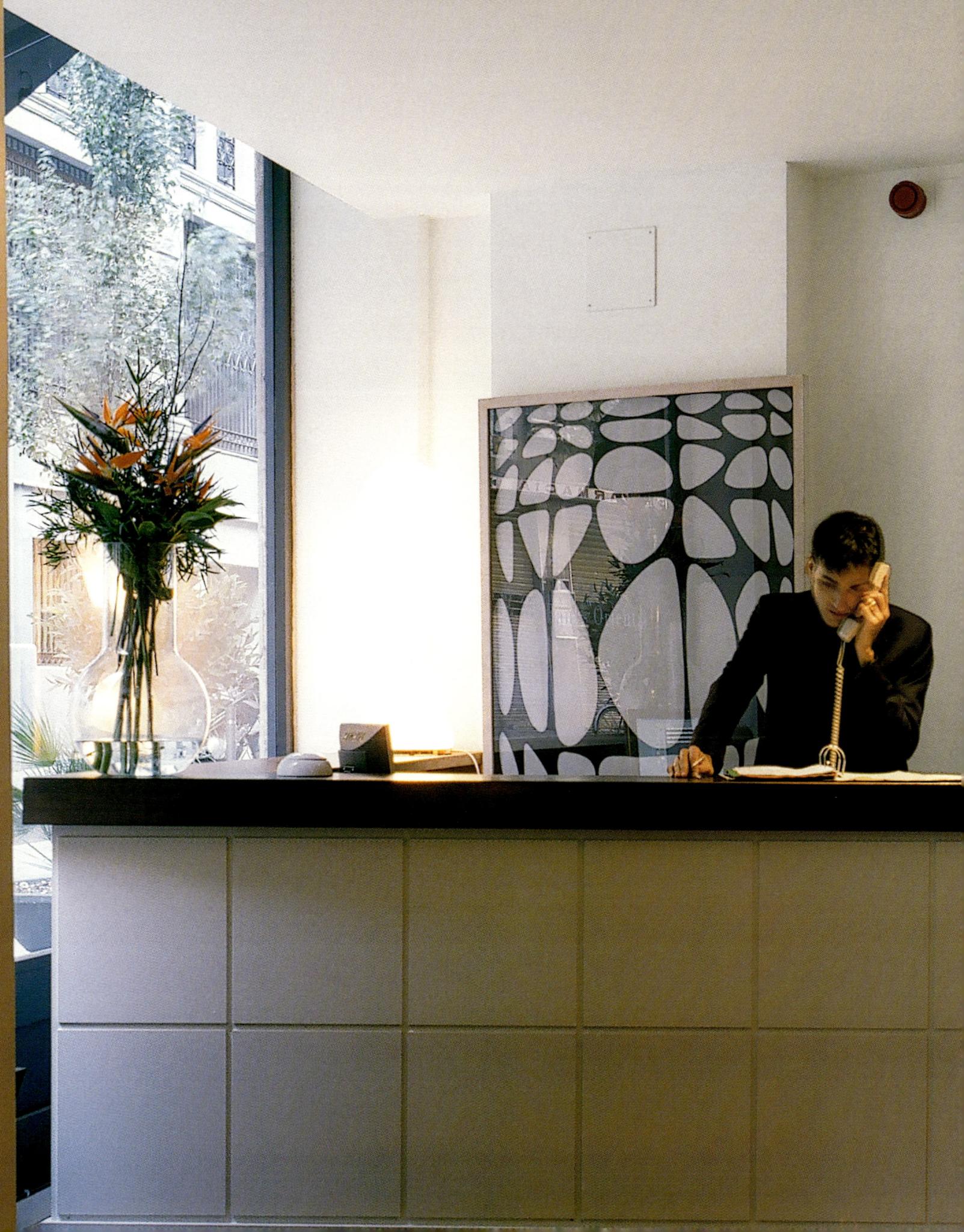

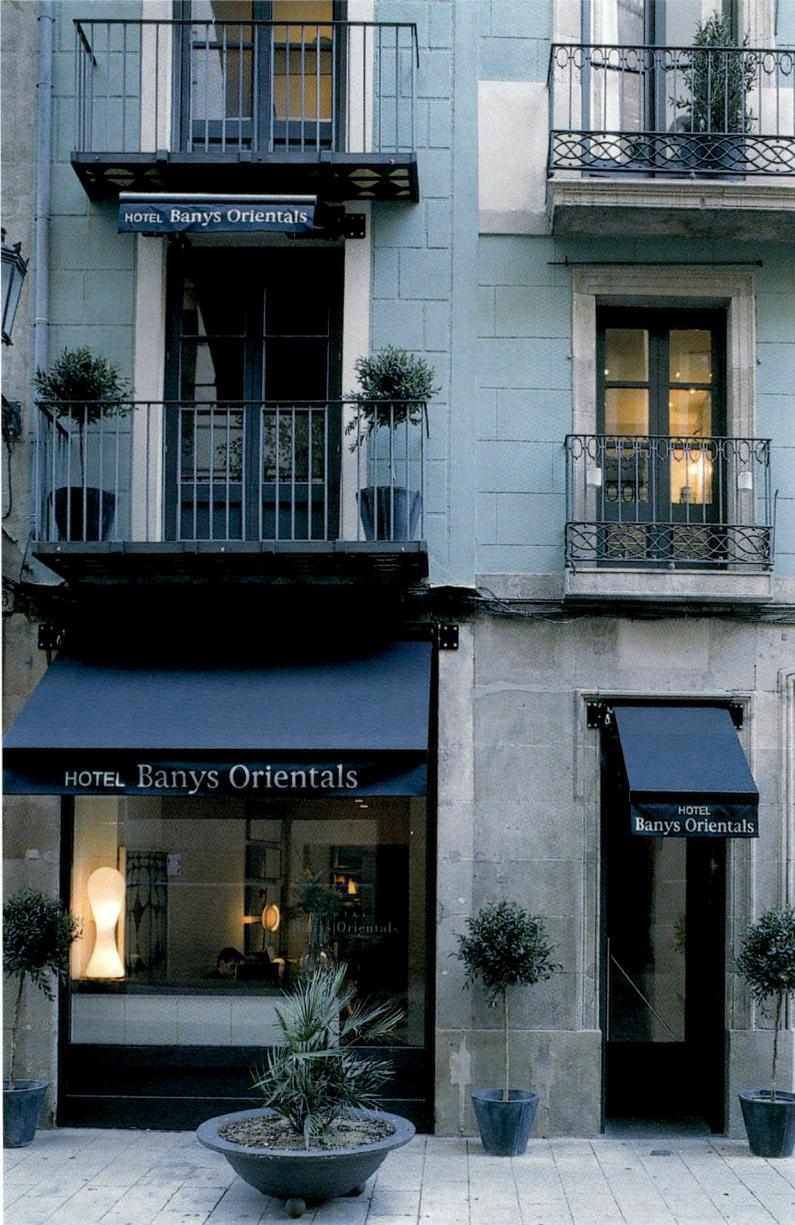

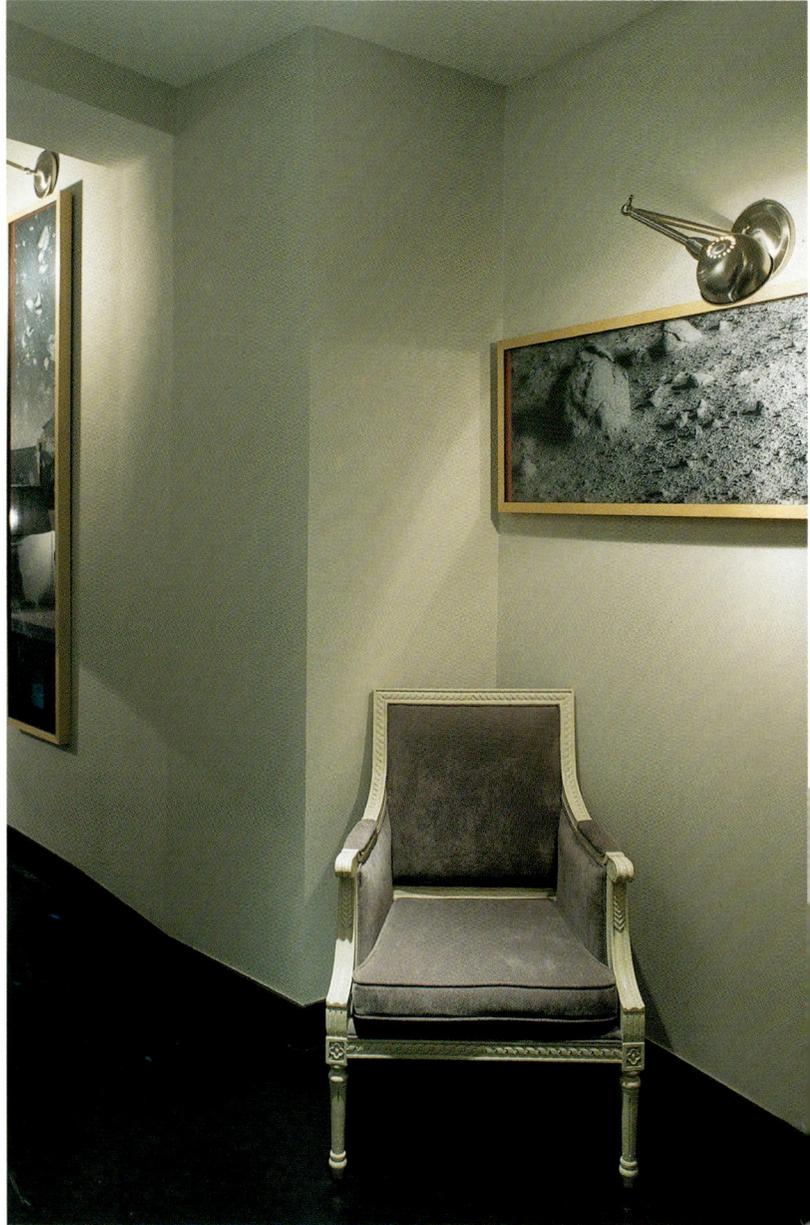

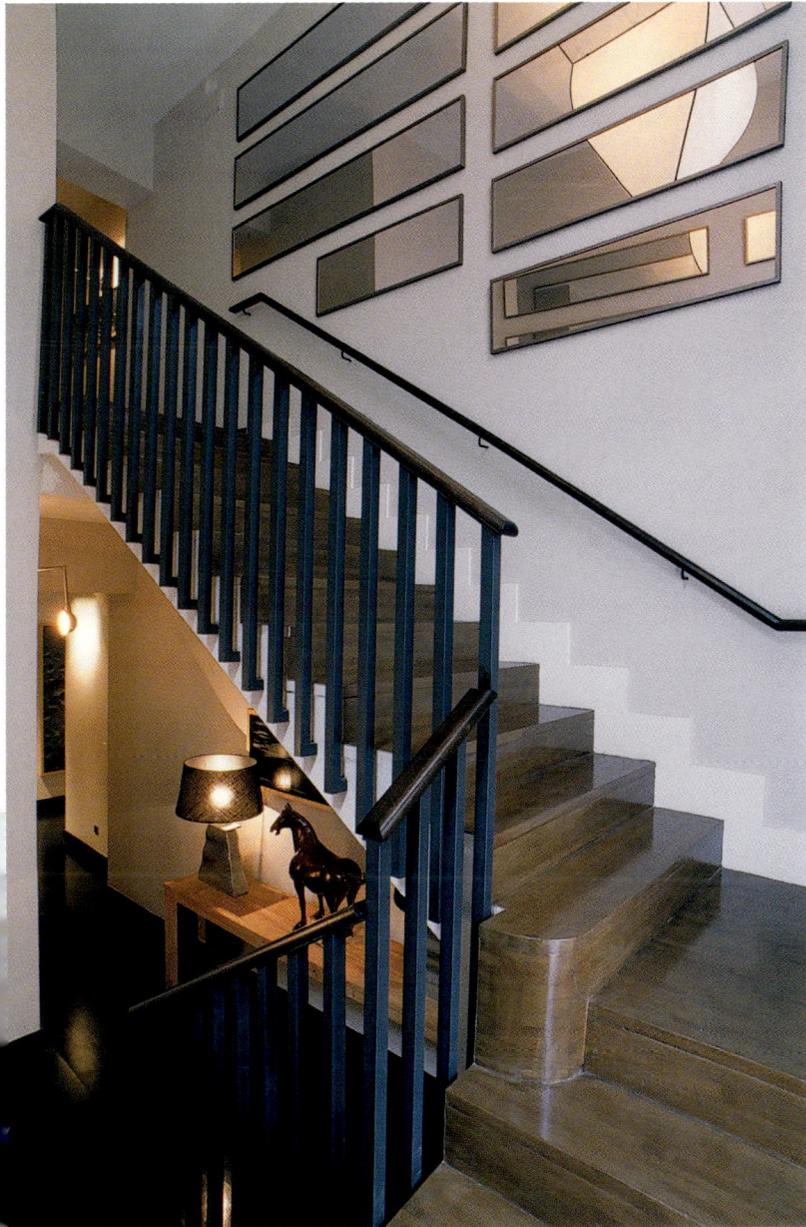

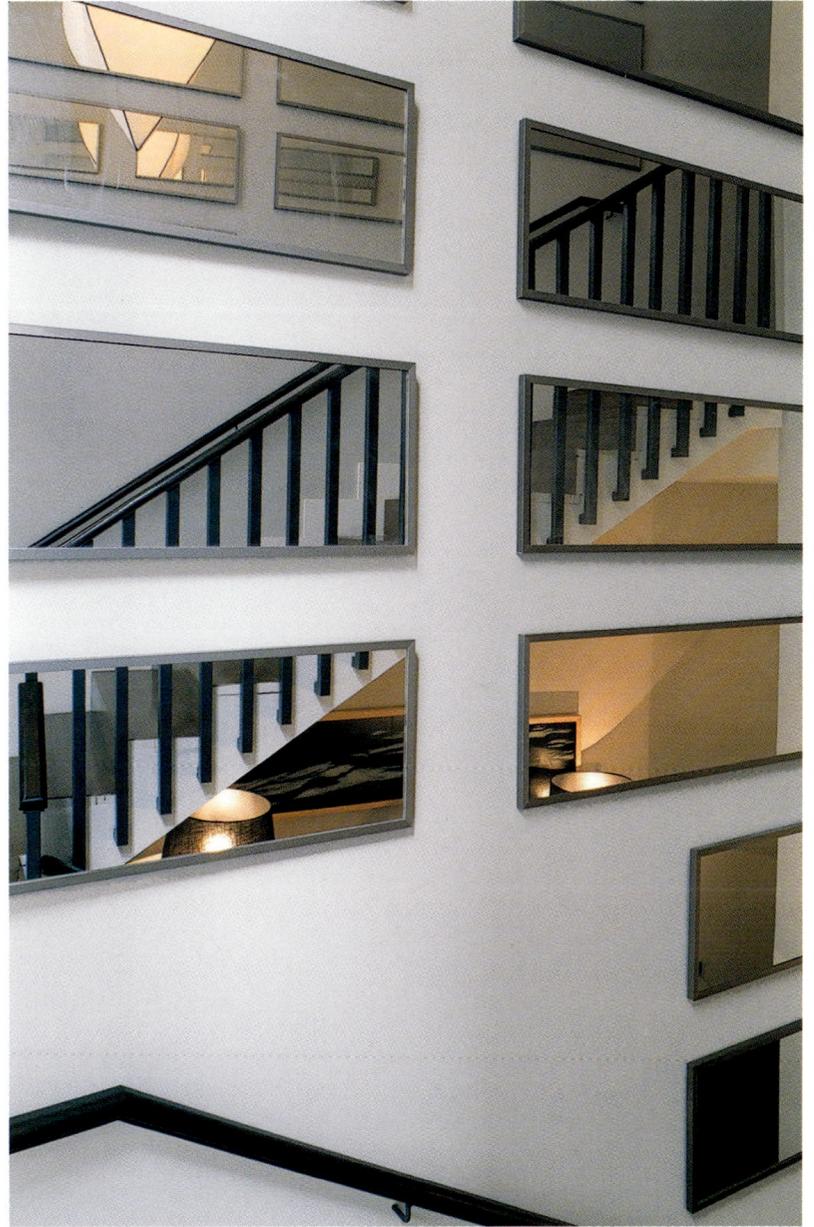

Old engravings of Eastern architecture and large-scale photos of the surface of the moon hang in the hallways. Although historical references are present, hotel guests finds themselves in a modern, timeless space.

Along the staircase the images reflected in the rectangular mirrors seem like framed pictures, while the rooms feature photographs of exotic landscapes from various regions.

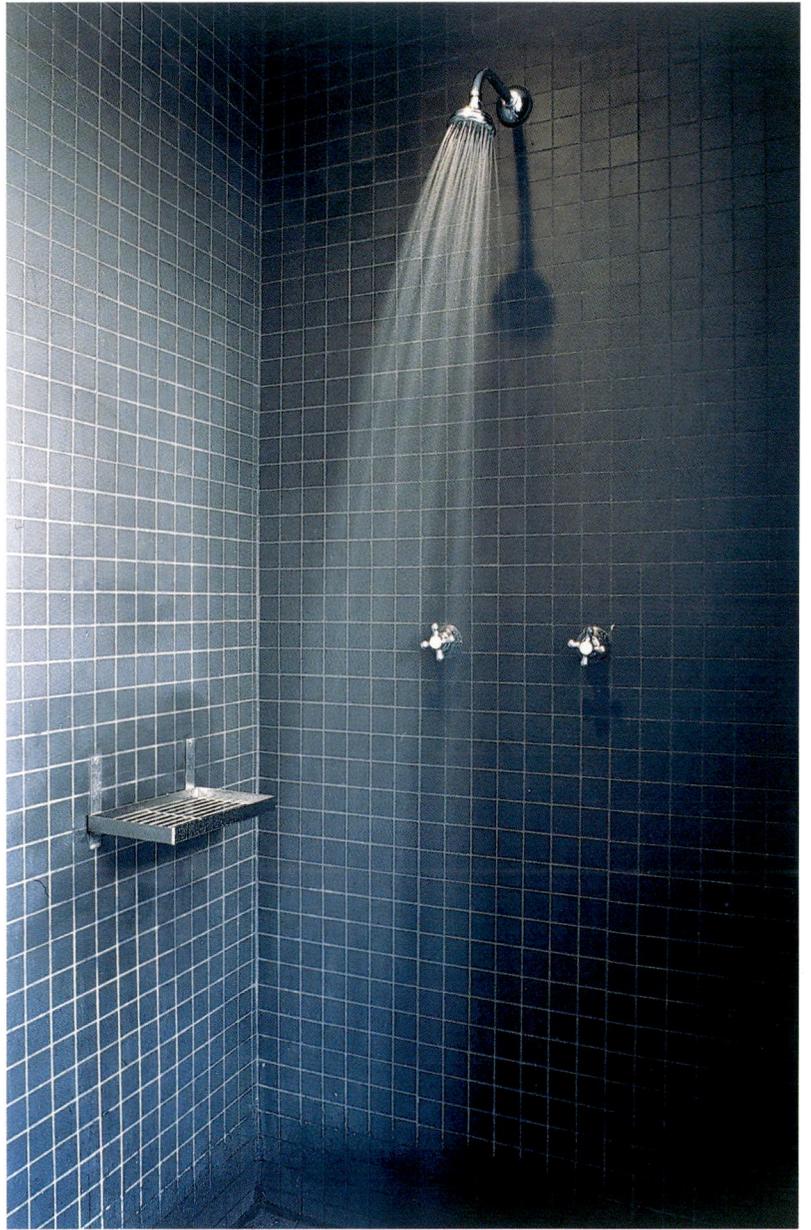

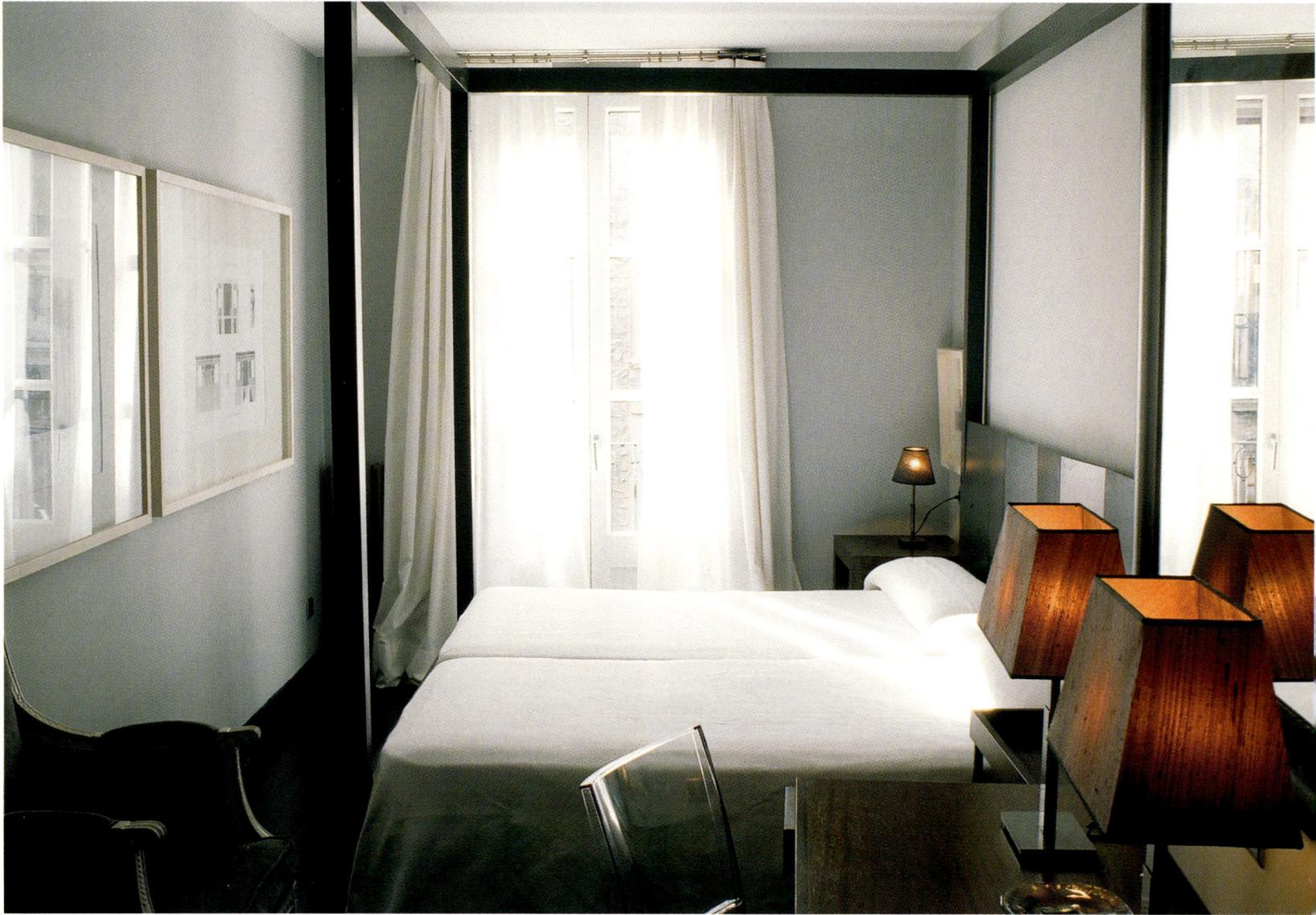

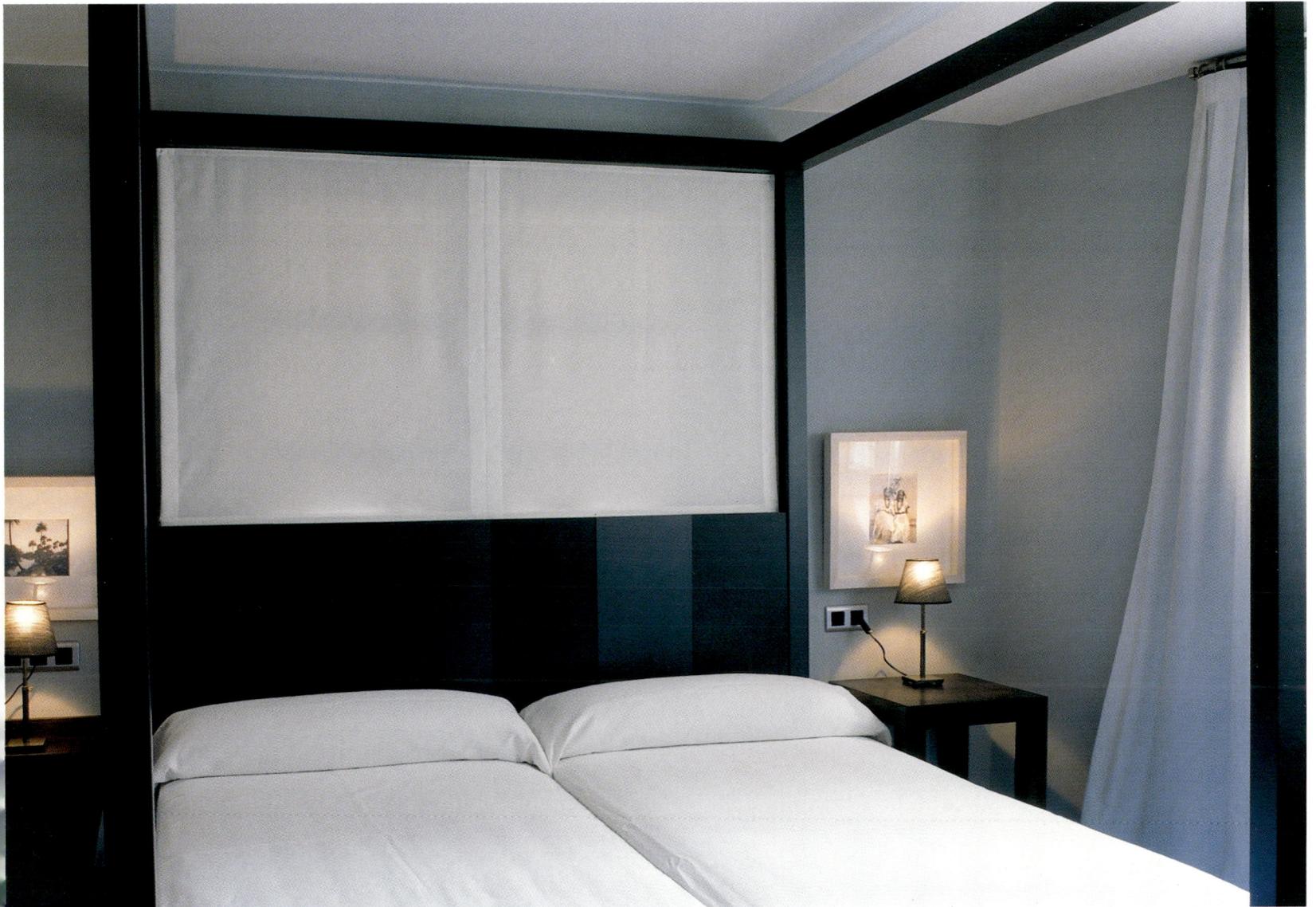

In the rooms a restrained and elegant atmosphere is achieved by using few elements, such as objects with light geometric lines, and by playing with a gray color scheme where the lamps provide the only bit of color.

Columbus
Monaco

23 Avenue Des Papalins, Monte Carlo 98000, Monaco Tel: +377 92 05 9000 Fax: +377 92 05 9167 columbus-hotel@monte-carlo.mc www.columbushotels.com

The owner of the Columbus, a small, exclusive hotel in Monaco, explains his plan for the project: "To achieve what we define as a special combination of elements of luxury, difficult to find anywhere else, a place where the whole world will want to be." The first factor that defines this idea is the location of the hotel in the high part of the city, where hotel guests can enjoy panoramic views of the Mediterranean Sea on one side and Princess Grace's gardens on the other. The character of the architecture and style of the area, one of the most exclusive on the Mediterranean, serve as a reference point for the interior decoration of the hotel, a mix of classic and contemporary designs, elegant yet informal. The most important objective, according to the

designer, was to create an atmosphere of well-being and tranquility that would contrast appealingly with the hustle and bustle of the other establishments in the area.

Instead of searching for an overall image or an unforgettable motif that would be recognized in every corner of the hotel, the design aimed to give each space its own style. The subtle blend of classic and contemporary was reached by using natural fiber fabrics, a carefully considered palette of colors, and emphasizing textures, colors, and shadows. The entrance area and lobby on the first floor are decorated with original 1930s black-and-white photographs of the Riviera. The light tones of the walls and sofas contrast with the dark tones of the natural wood floor and tables.

Designer: **Amanda Rosa** Photographer: **Richard Waite** Location: **Monte Carlo, Monaco** Opening date: **2001**

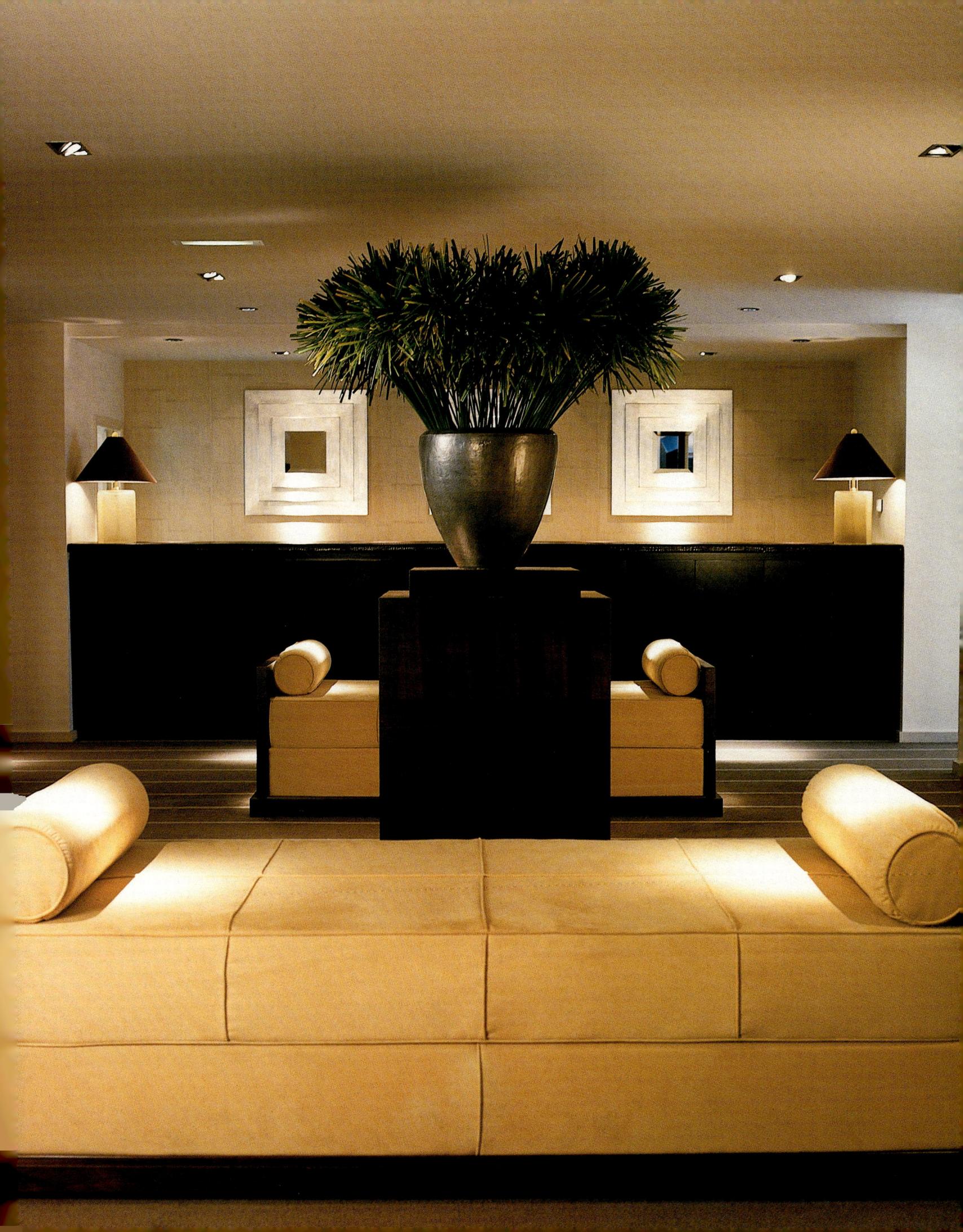

The conference rooms have a secluded and elegant atmosphere where the comfortable leather chairs, wooden wall lamps, and indirect lighting that directs the foot traffic stand out.

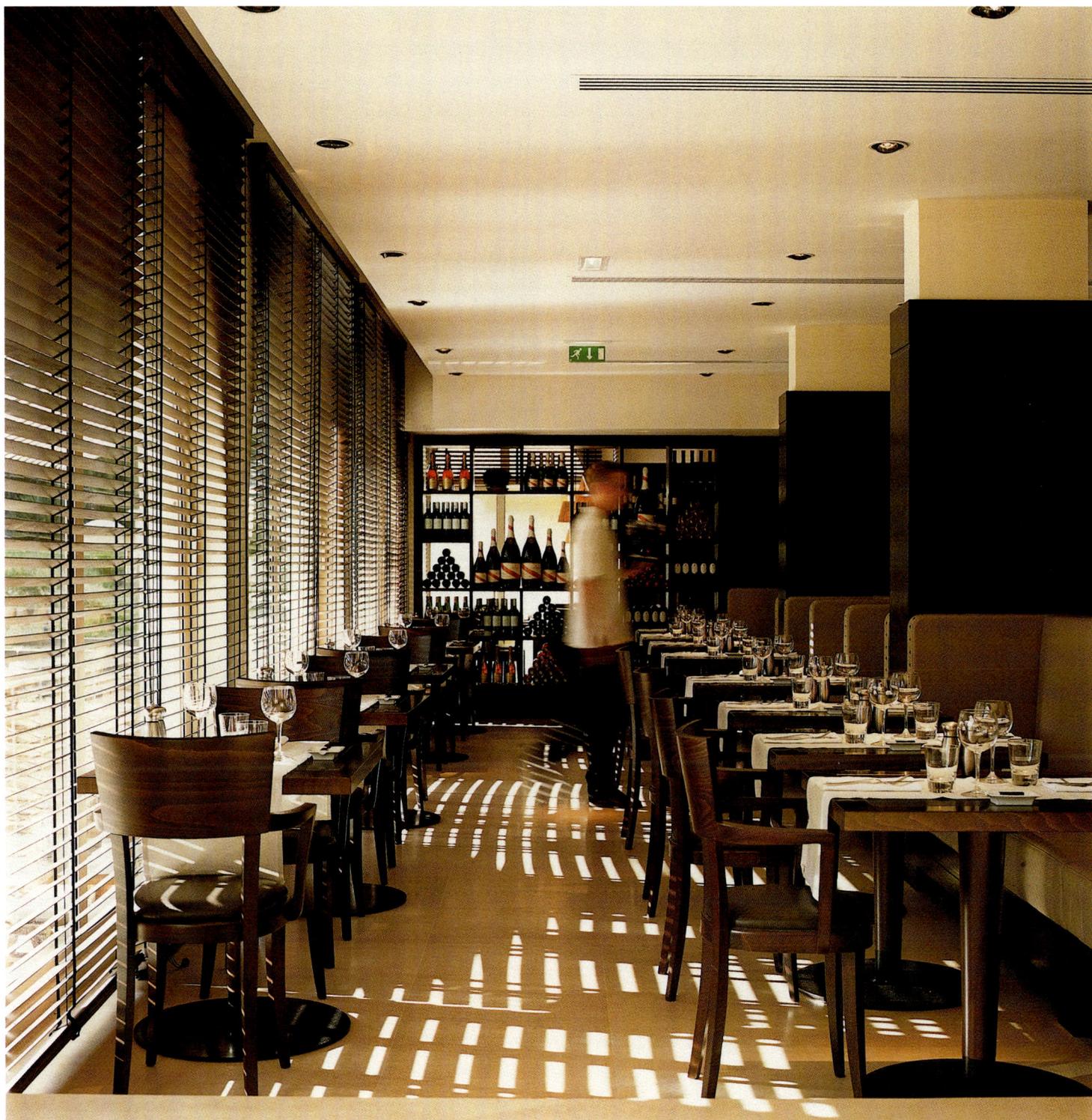

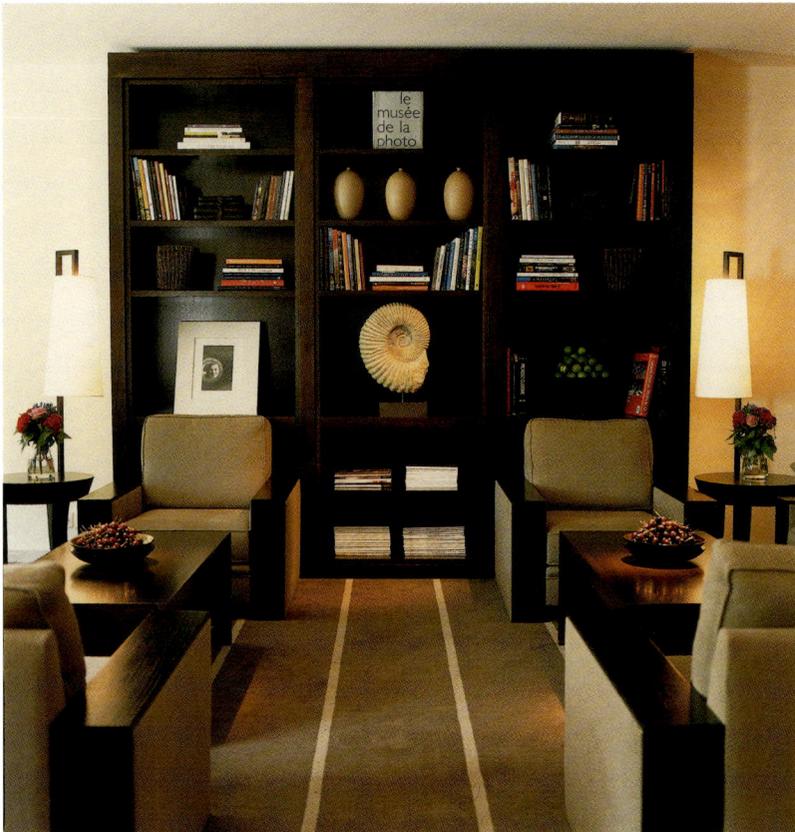

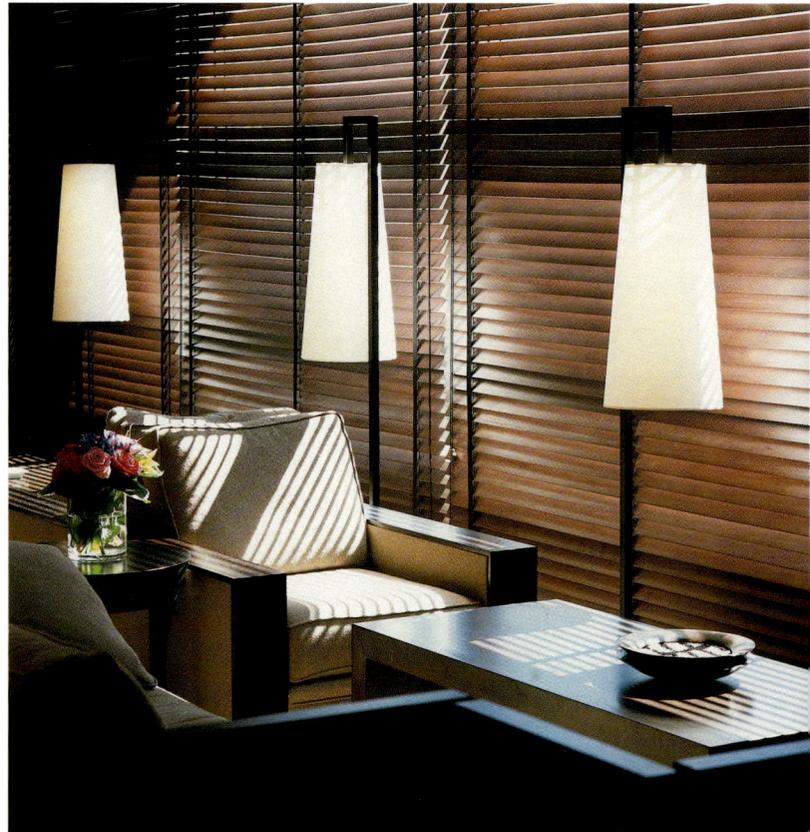

The bar and restaurant have a warm ambience, created by the natural light filtering through wooden shutters. All the furniture was designed especially for the hotel and many pieces can be purchased through the hotel gift shop.

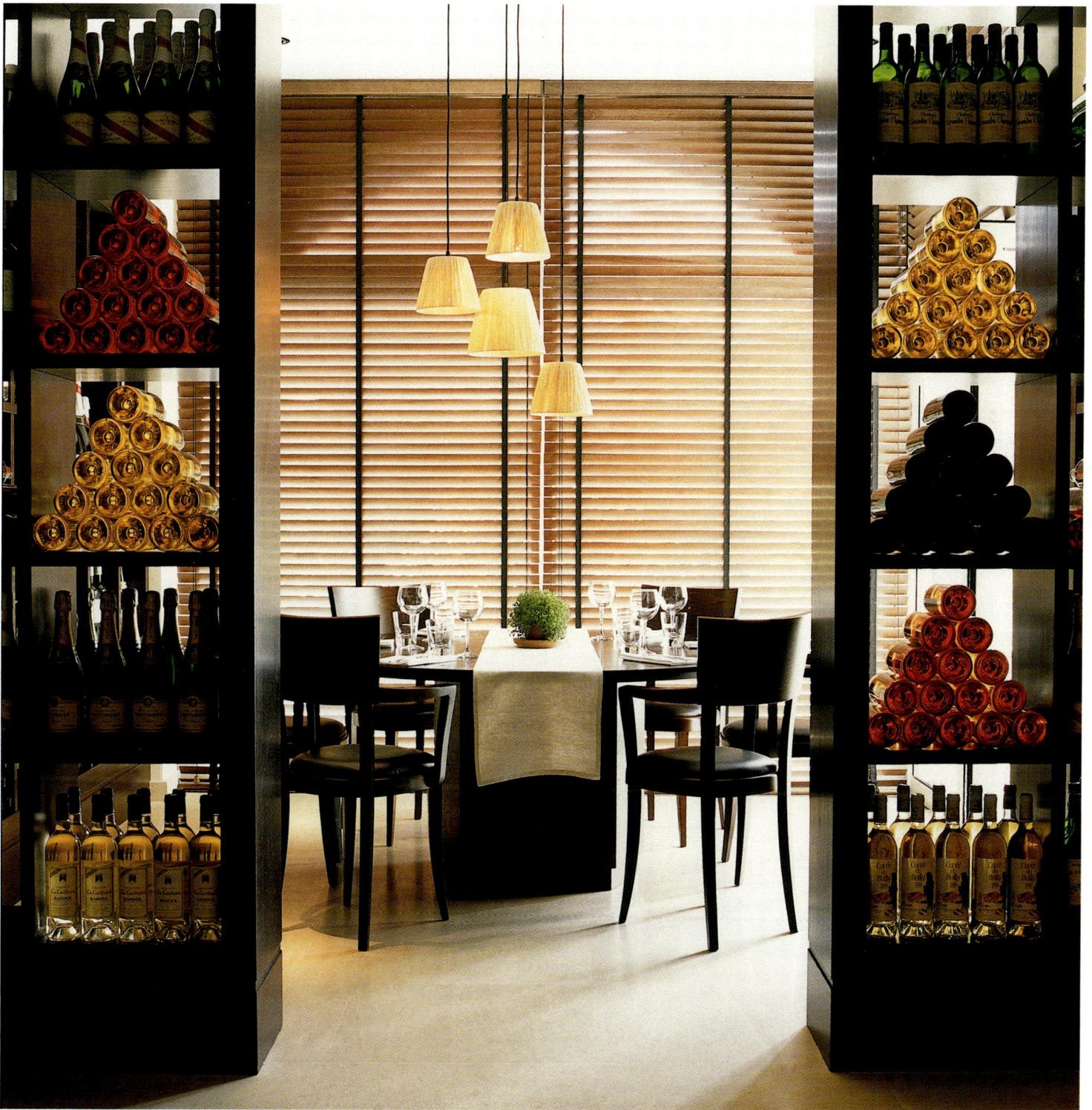

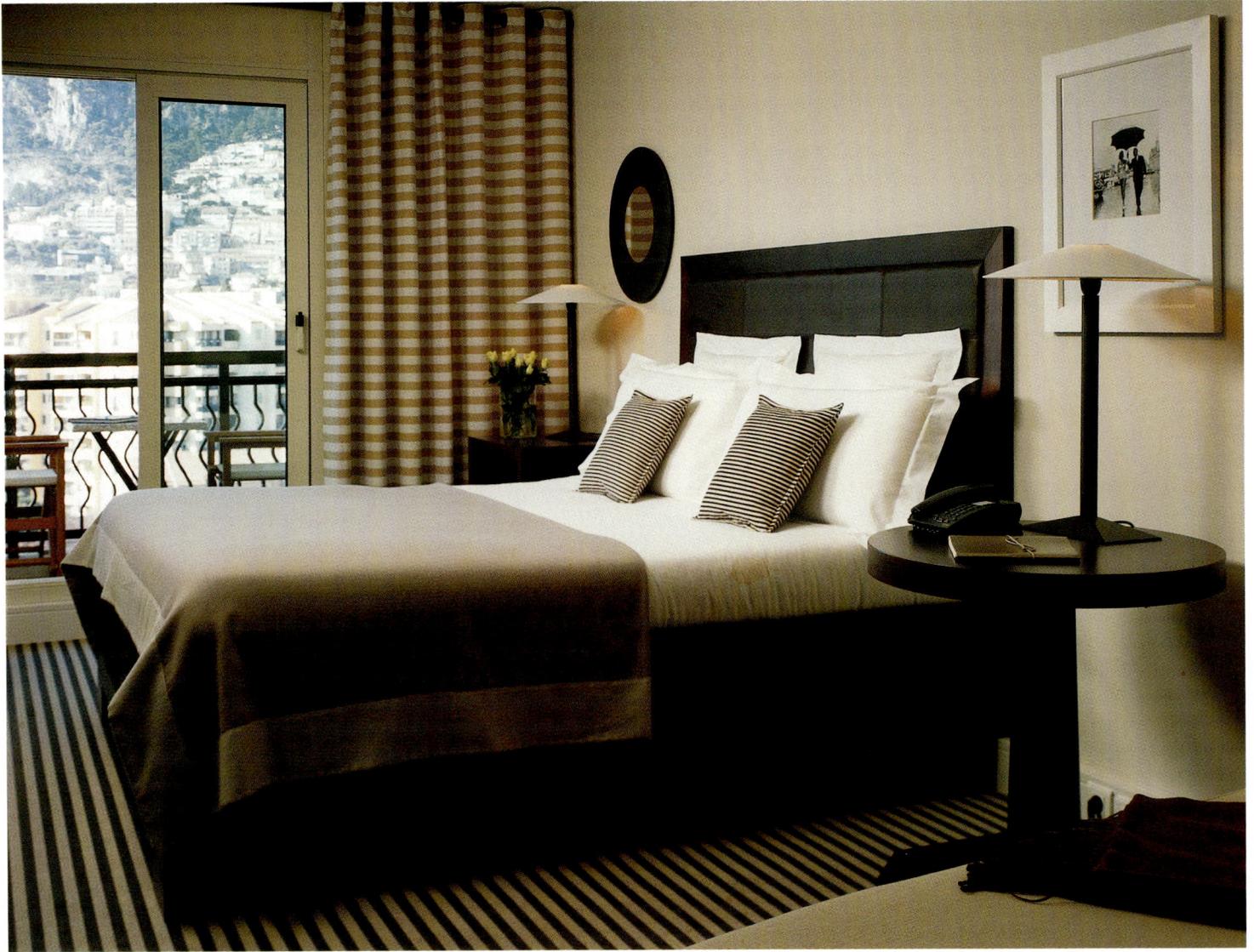

[247]

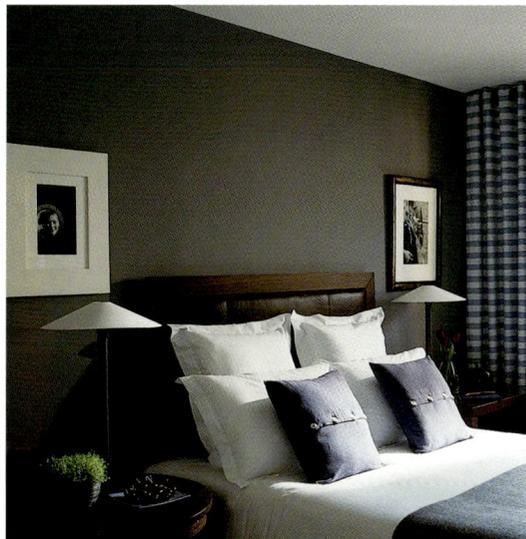

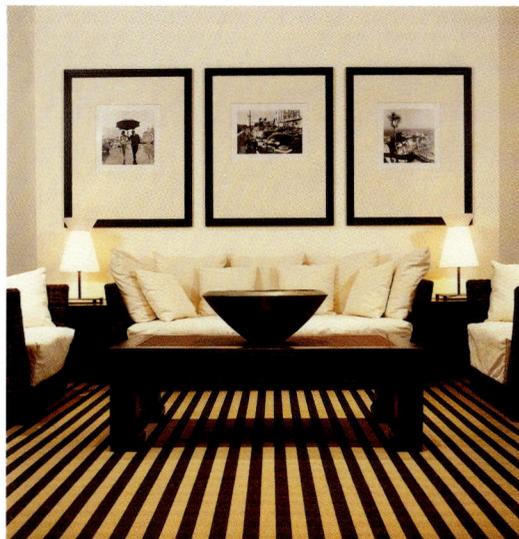

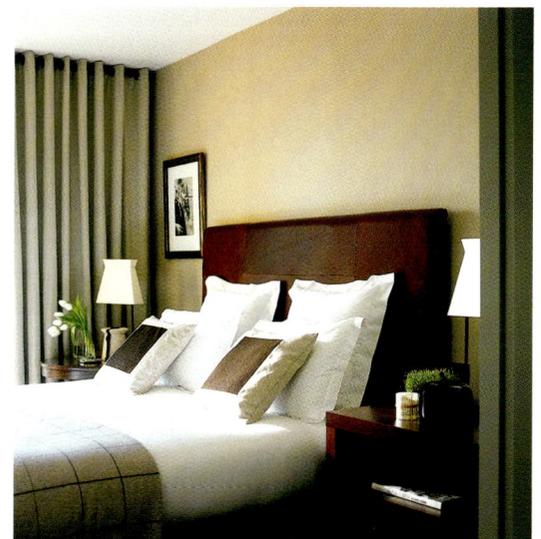

In the guest rooms, basic geometric shapes and lines of contrasting colors create a play of textures on the floor, furnishings, and curtains.

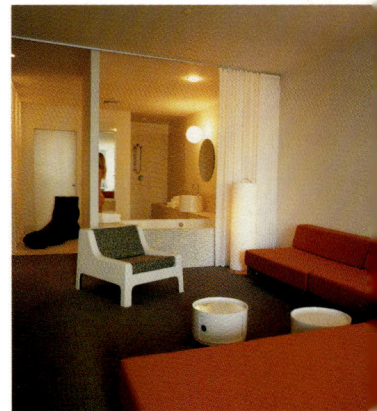

The Standard

550 South Flower Street, Los Angeles, CA 90071, USA Tel: +1 213 892 8080 Fax: +1 213 892 8686 downtownla@standardhotel.com www.standardhotel.com

Downtown Los Angeles is experiencing a boom due to the renovation of several apartment buildings as well as institutional and commercial buildings that had gone unused for decades. Such is the case with this building, the former headquarters of Superior Oil, one of the largest independent oil companies in the world, originally built in 1956. The rationalist features, decorative details that hark back to the modern movement, and excellent location, were the factors that persuaded hotel developer André Balazs into establishing a second location of The Standard.

The initial idea for the project was to recapture the original character of the building, accentuating it with a subtle renovation beginning with certain decorative pieces and furnishings. The first step was to identify and restore the original elements, such as the Carrara marble panels in the vestibule, the built-in stainless steel clock, the bronze doors with the letter S, and the steel elevators. The new materials and design elements that were incorporated allude to the 1950s, but combine to create a unified, modern whole, yet still the hotel still feels as if it has been plucked from another era. The public areas of the hotel, such as the vestibule with its high ceilings, have a cold, corporate feeling. A large mobile inspired by sculptor Alexander Calder's designs hangs in the middle of the vestibule while a set of low Omnibus sofas designed by Vladimir Kagan gives the space some color.

Architect: **Koning-Eizenberg Architects** Interior Designer: **Shawn Hausman** Photographer: **Undine Pröhl** Location: **Los Angeles, USA** Opening date: **2002**

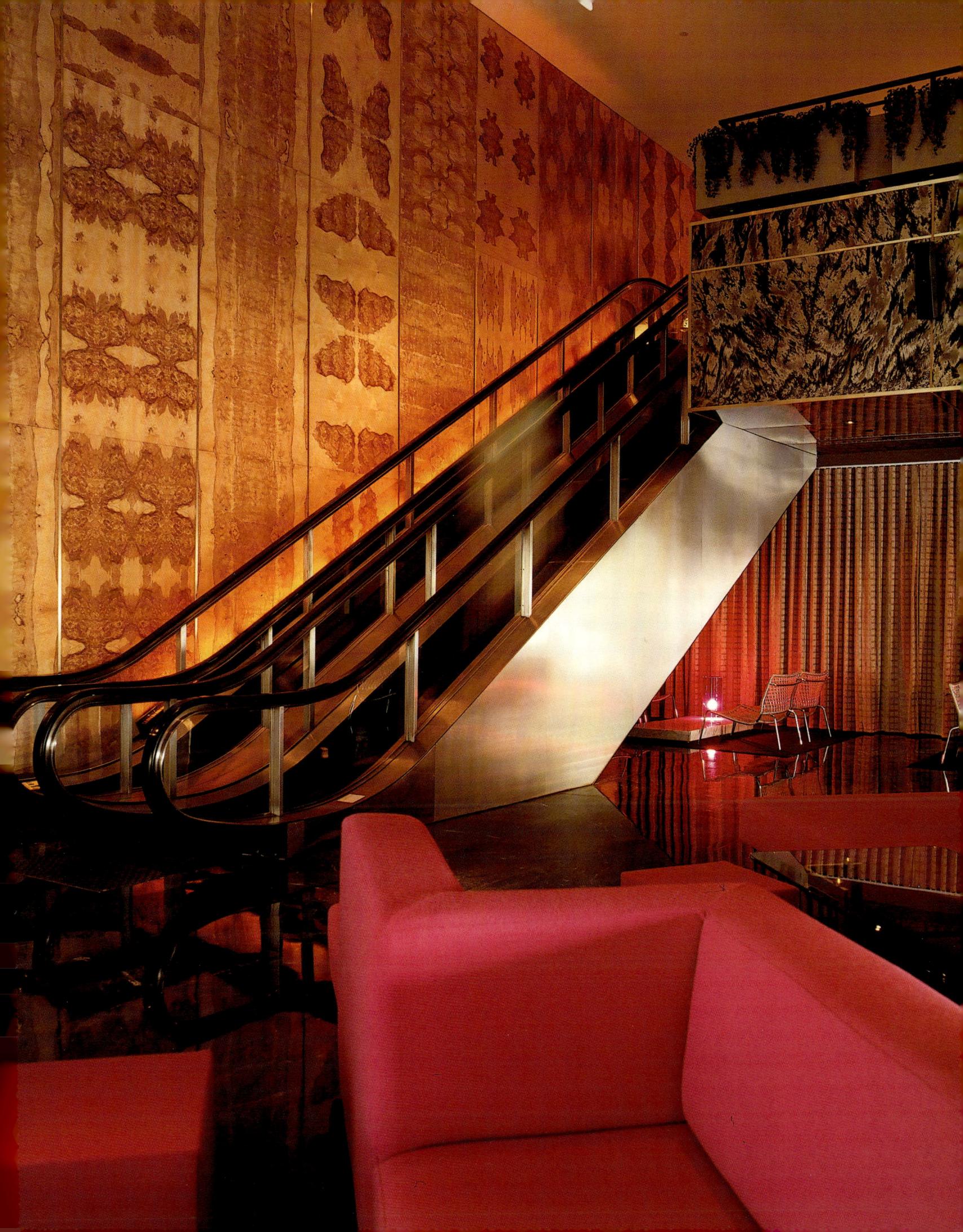

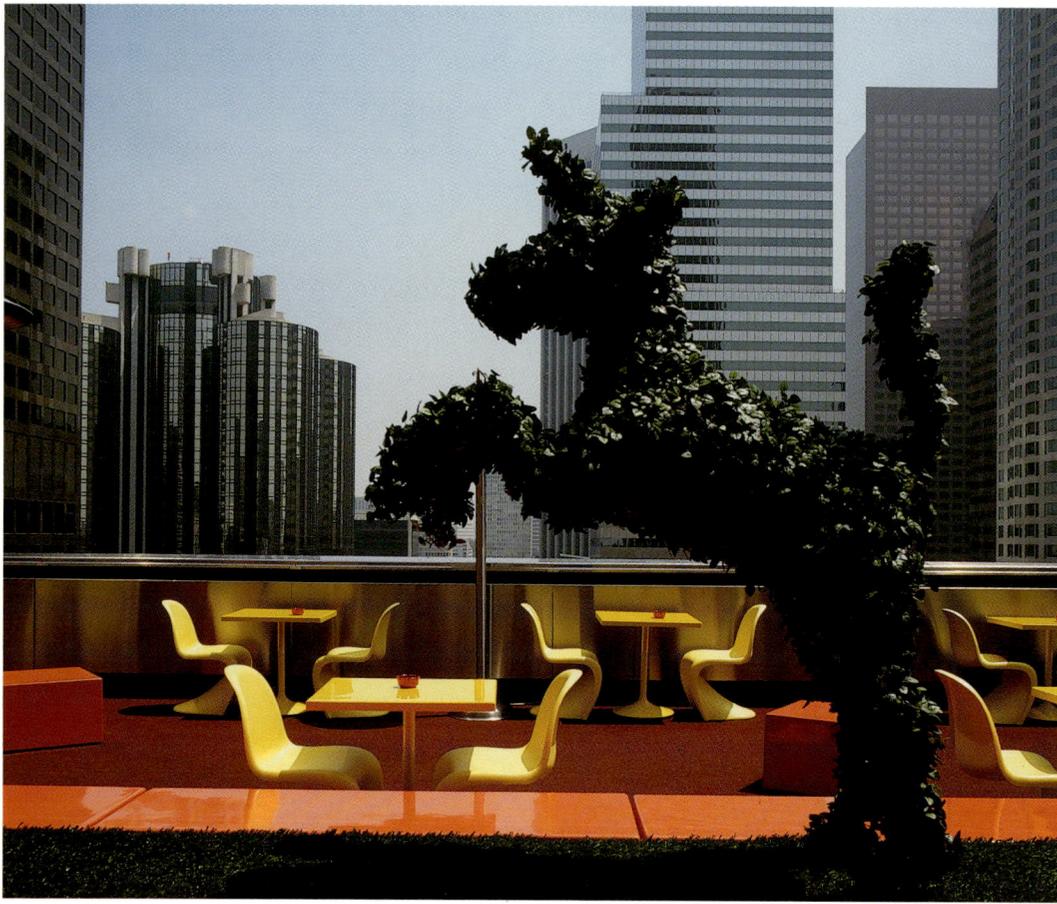

On the hotel deck, where guests can enjoy spectacular panoramic vistas of downtown Los Angeles, the ambience becomes somewhat seductive. The idea was to create a party and meeting space that downtown Los Angeles had been lacking.

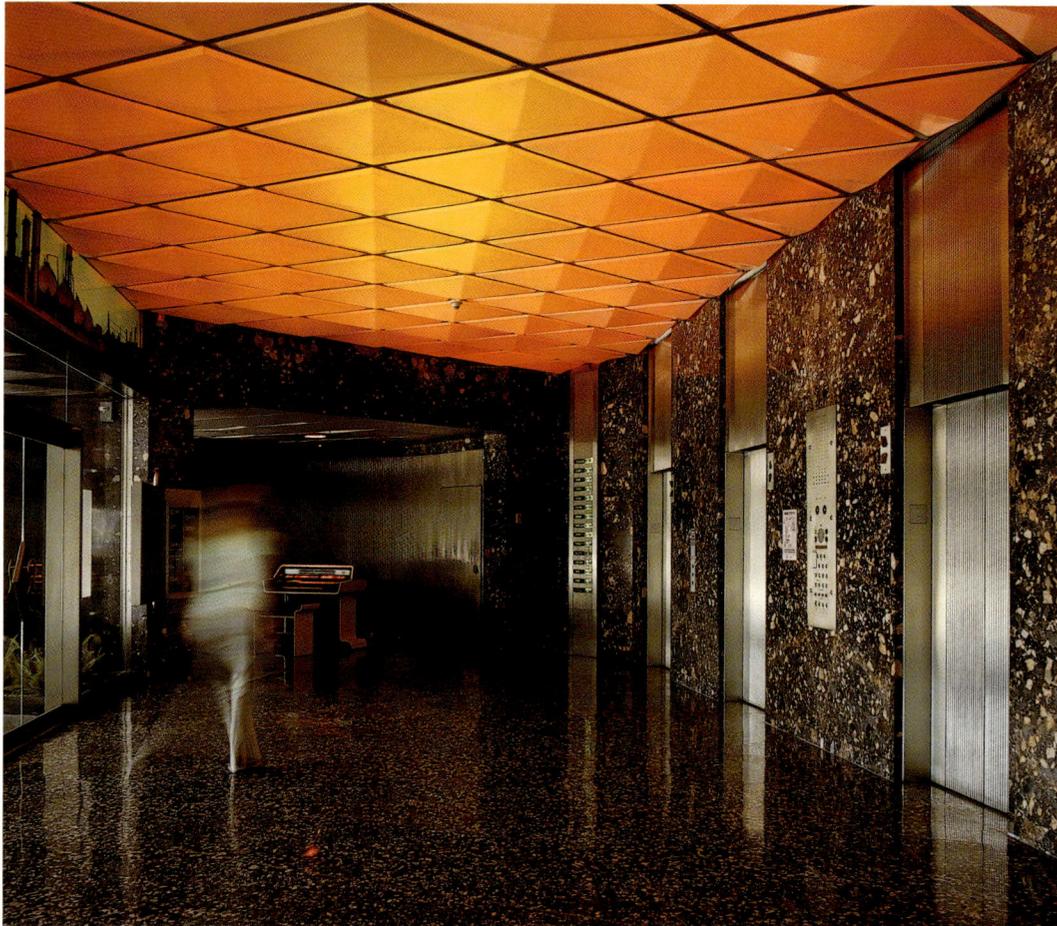

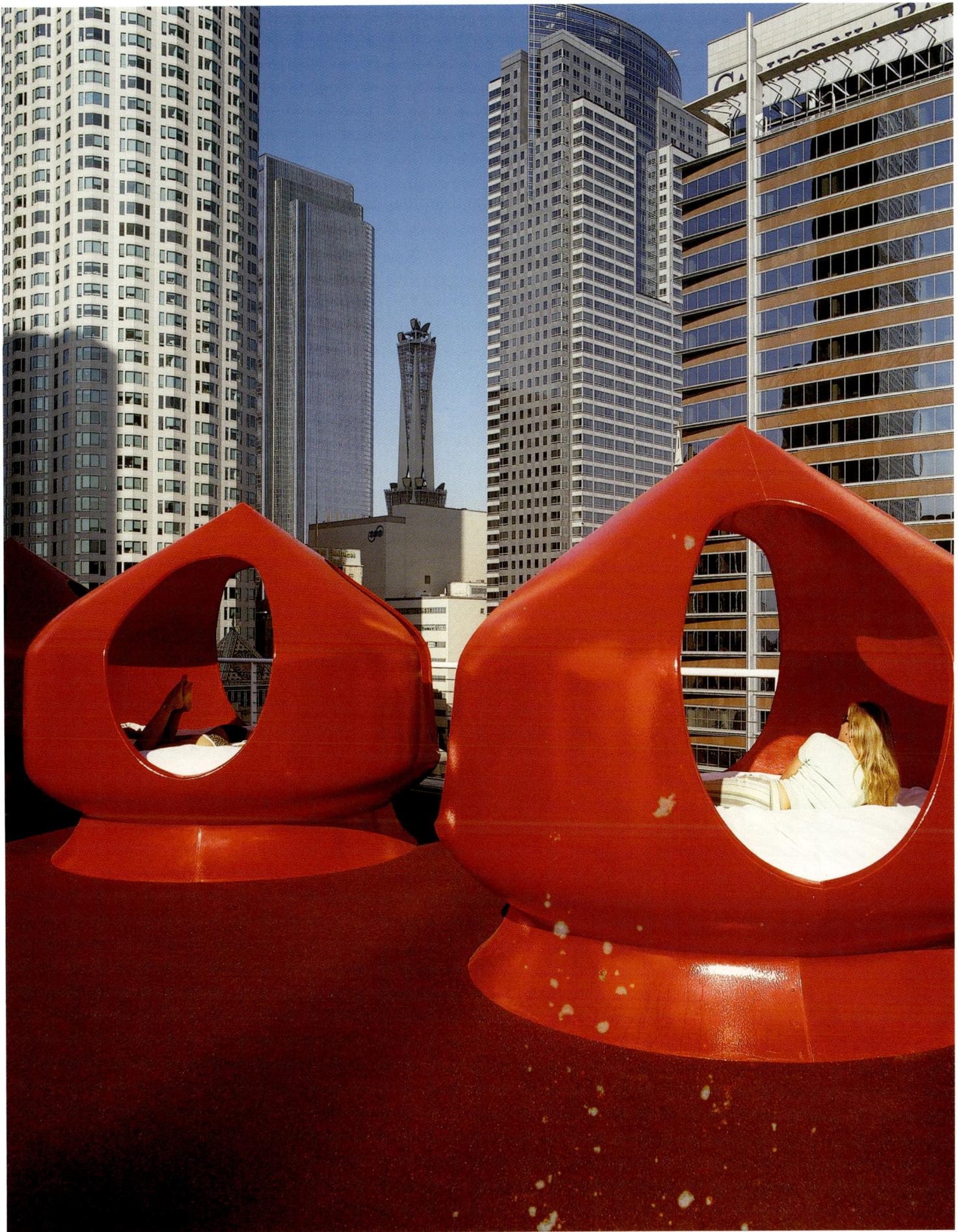

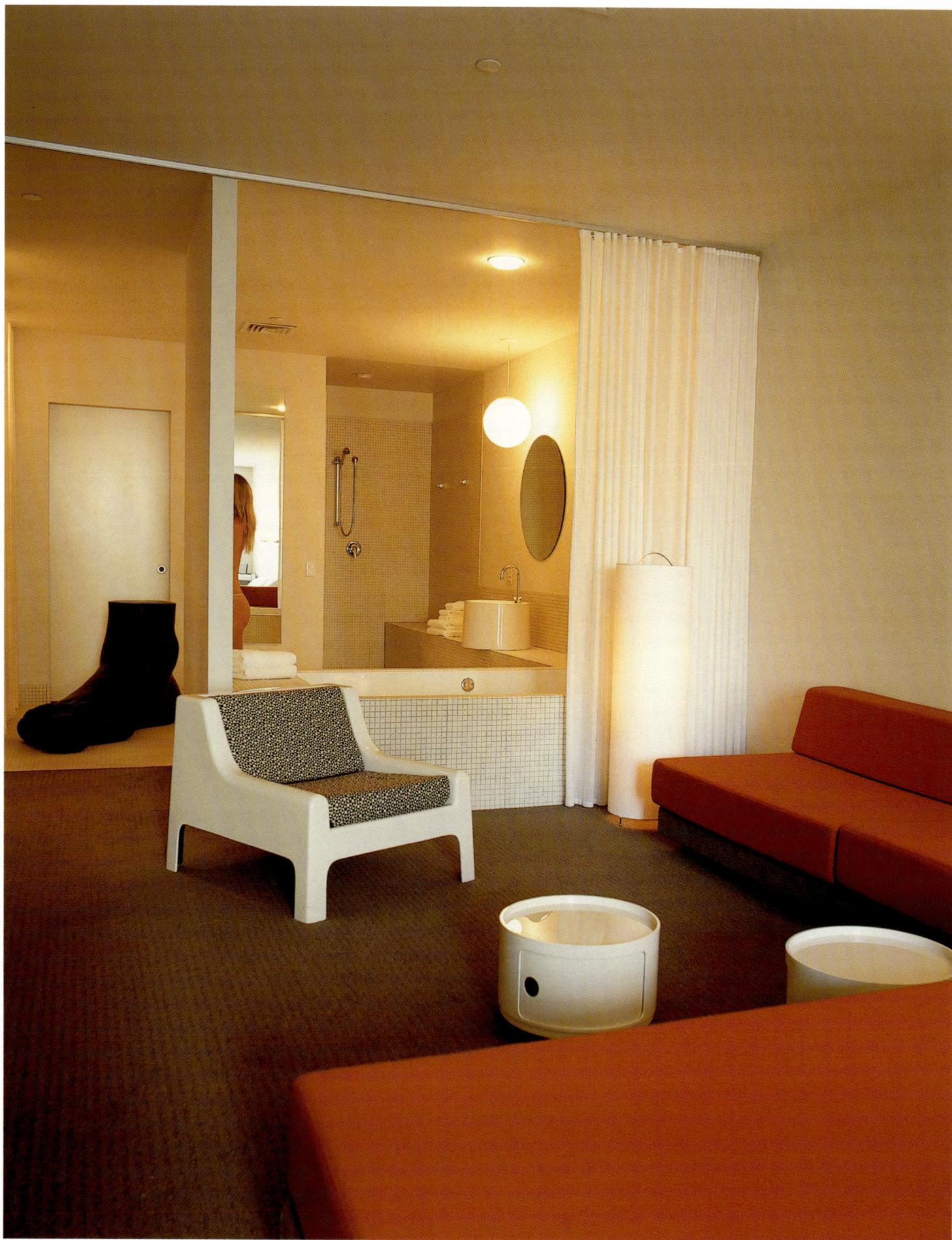

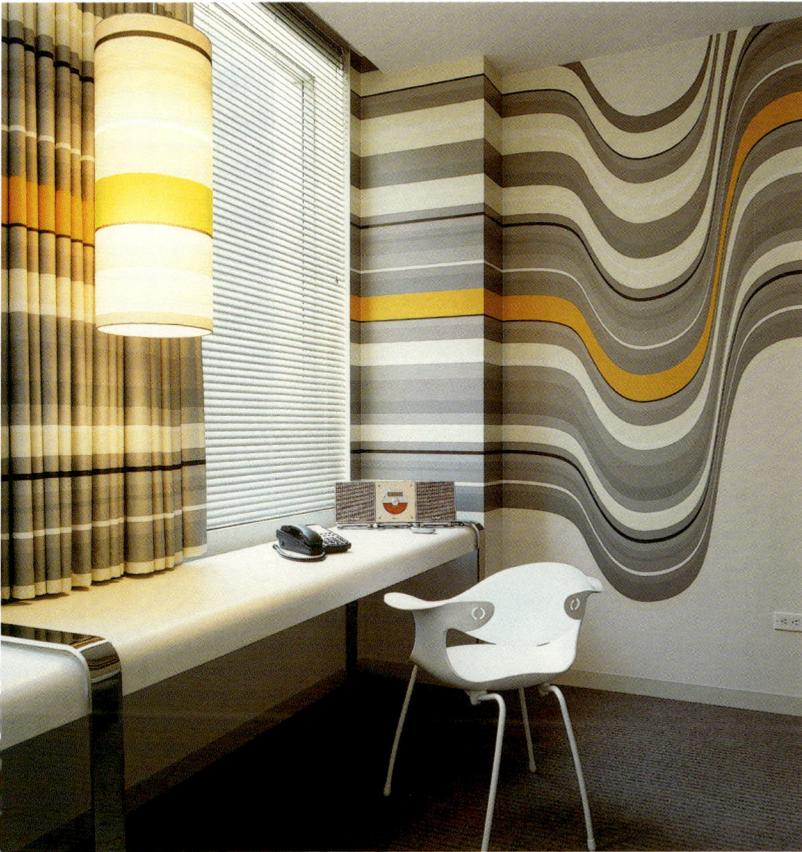

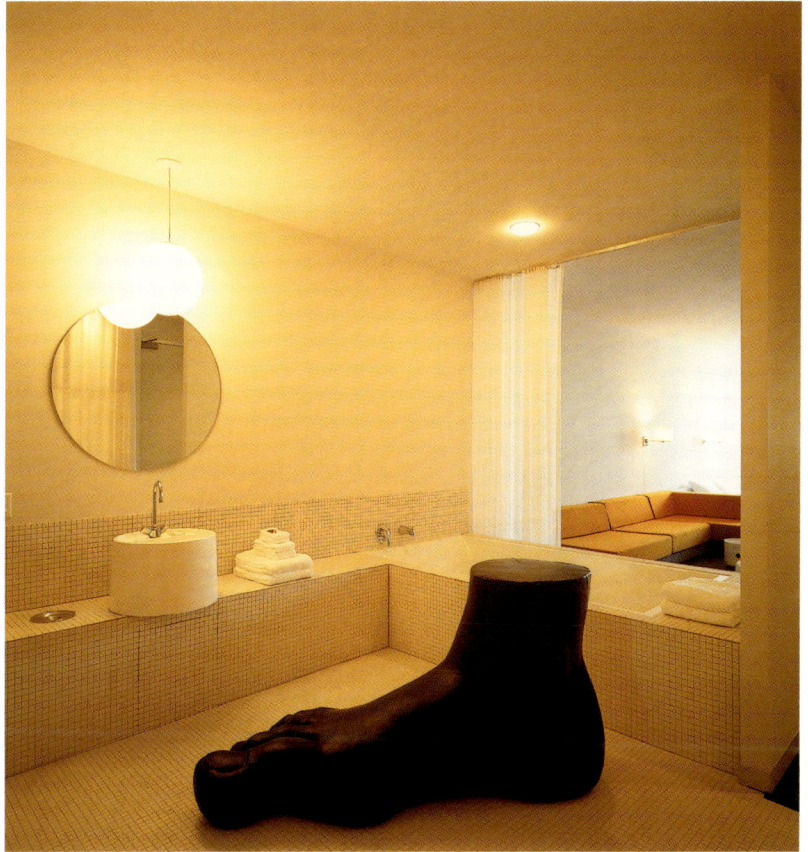

The designers wanted a much more seductive, warm, and relaxed atmosphere in the hotel's two hundred rooms. White and light colors dominate, along with stronger elements such as the platform beds and various decorative elements. The bathroom is integrated into the room with a glass door. From the tub guests can enjoy the atmosphere of the room or create more privacy by drawing the curtains and enclosing the space.

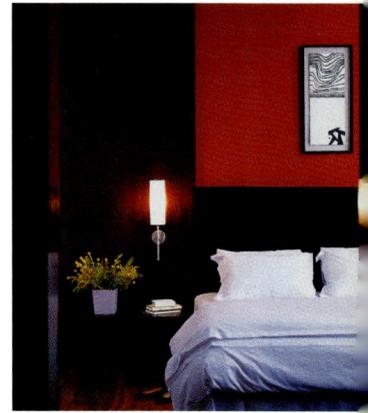

NH
City Hotel

Bolivar 160, C1066AAD, Buenos Aires, Argentina Tel: +5411 4121 6464 Fax: +5411 4121 6450 info@nh-city.com.ar www.nh-hoteles.com

This hotel occupies an old building that dates back to the 1930s, located in the heart of Buenos Aires. The building's special style, a combination of classic elements and Art Deco lines, was the determining factor for the interior design. The goal was to use a contemporary language that would interpret the original features of the hotel in the new design of the details, finishes, and pieces of furniture. In this manner an interior rich in styles, shapes, textures, and colors was achieved. In the lobby, different lounge areas were created using different types of furnishings, generating more intimate ambiences within the large central space. The furnishings, designed especially for the hotel, recreate various interpretations of classic furniture in a contemporary language. A collection of works by both established and up-and-coming artists adorns the walls of this space.

The contrasts between light and dark tones stand out in the interior of the guest rooms. Another highlight is the warmth provided by the mahogany floor, which in turn complements the similarly toned furnishings, the red and black upholstery, and the leather headboard. In contrast, the white bed and curtains reveal expansive views of the city and the Río de la Plata. Decorative details such as the skirting boards, lampshades, and weighty curtains reinforce the classic references of the design.

Architects: Cora Entelman and Roberto Caparra / Caparra Entelman & Associates Collaborators: Lucila Pérez Elizalde, Lucas Gashu
Photographers: C&E, NH, Sur-Press-Hitters Location: Buenos Aires, Argentina Opening date: 2000

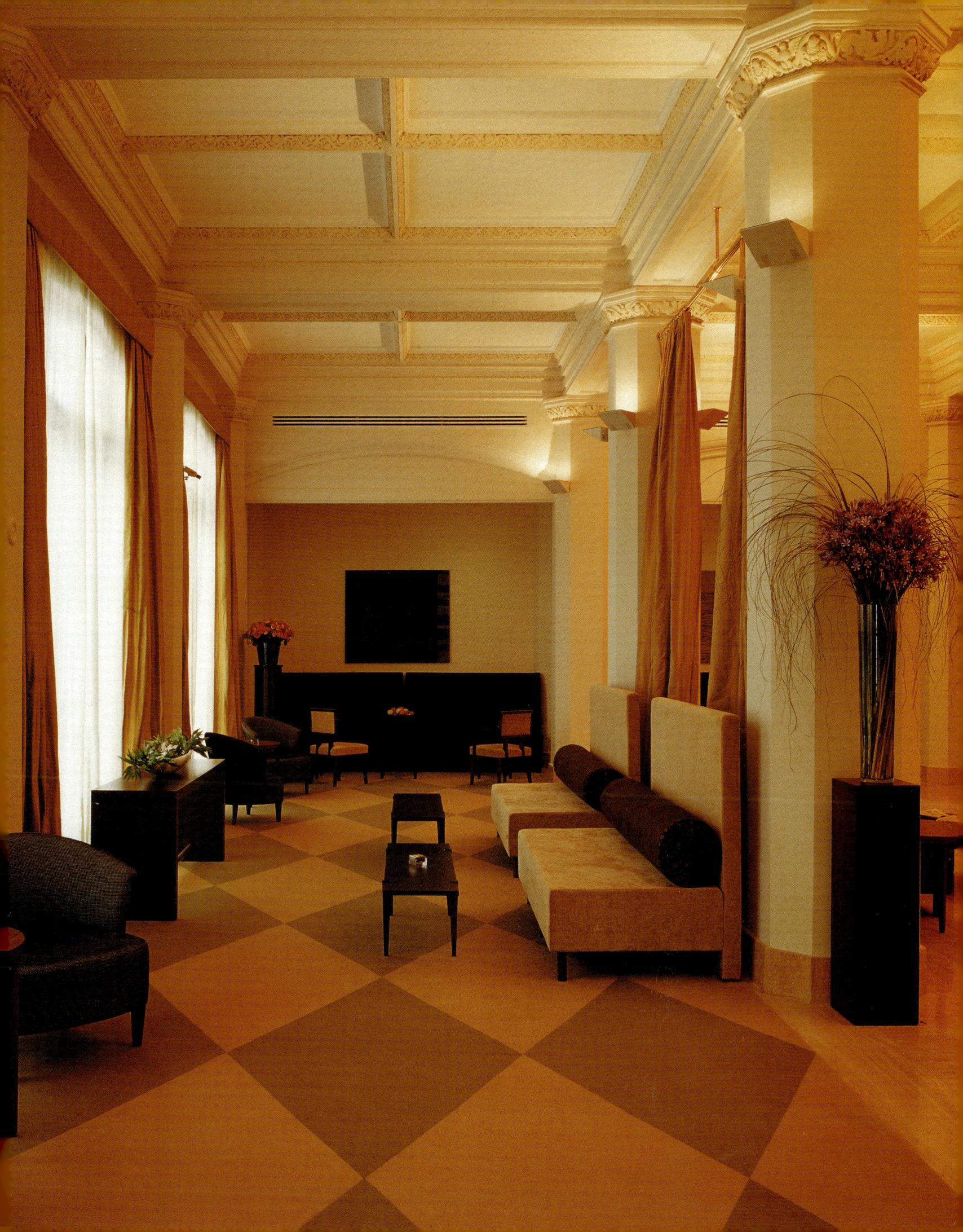

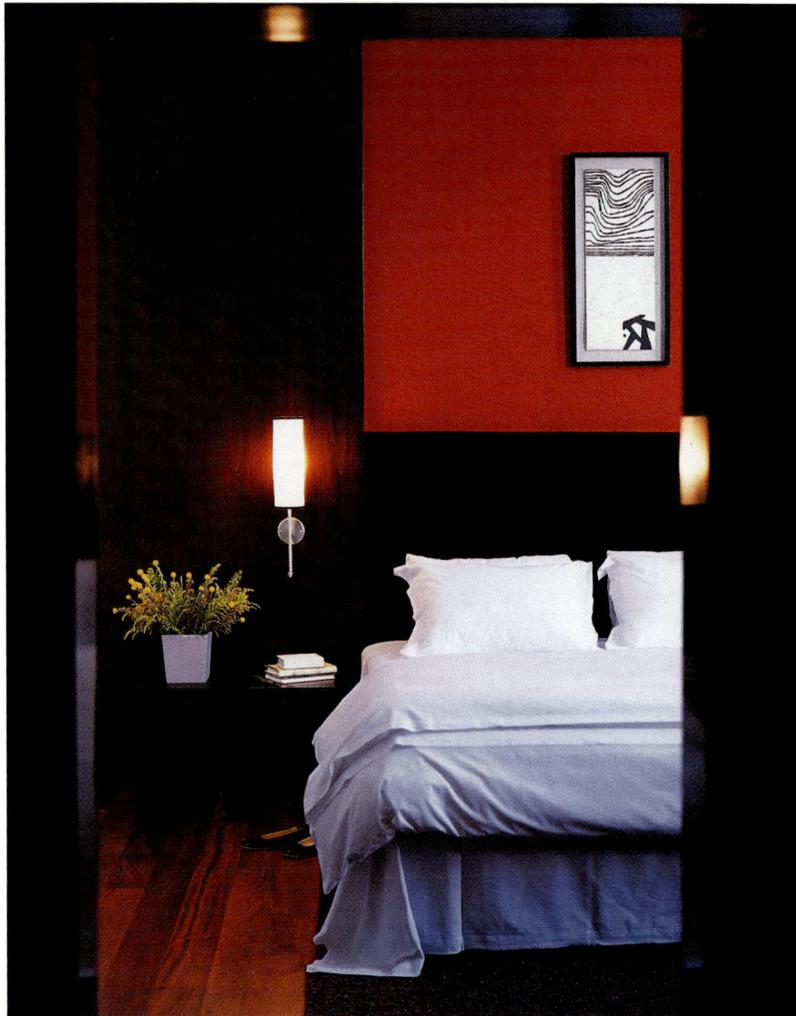

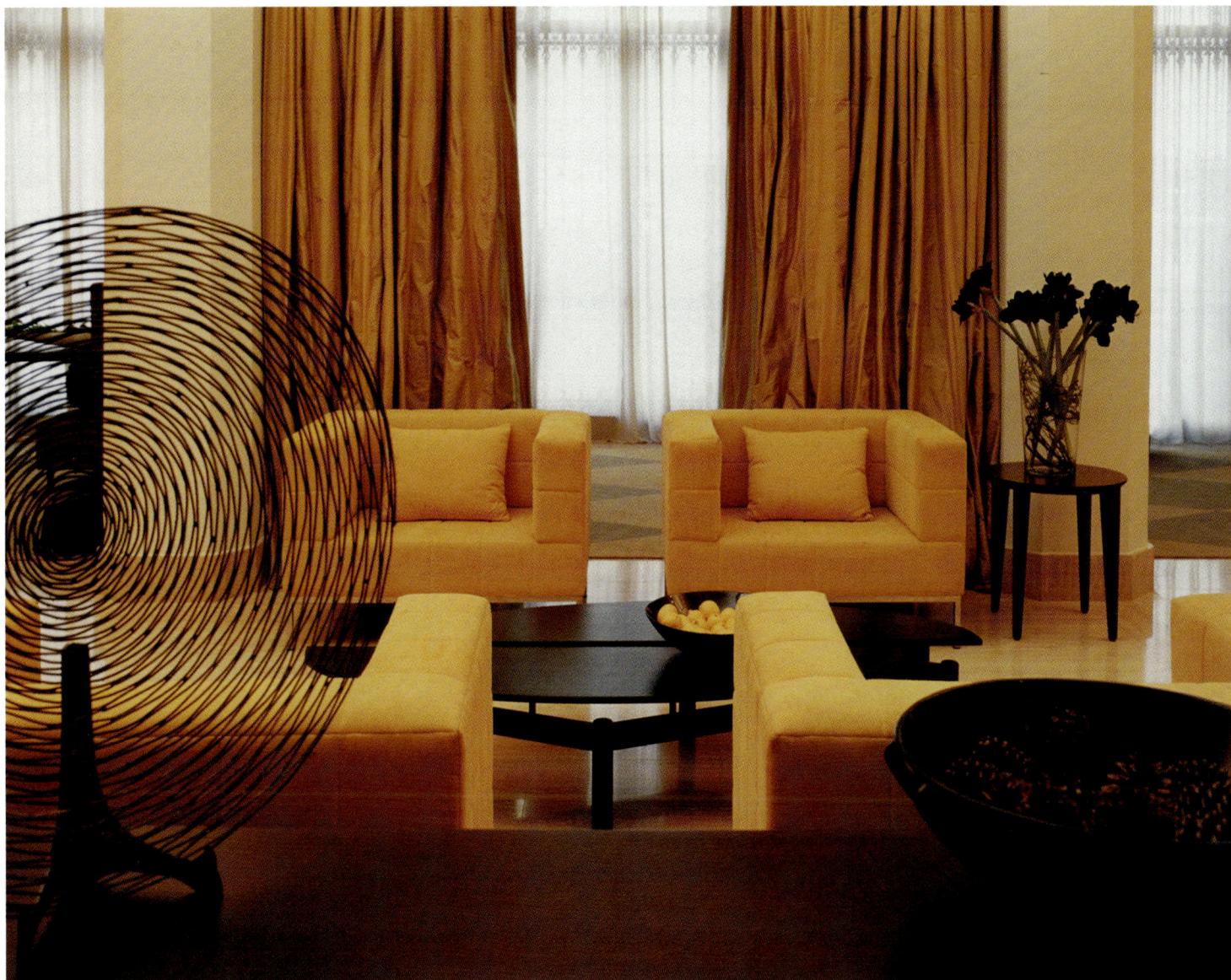

The character of the different rooms, a cross between classic and contemporary, is achieved with just the right balance of furnishings and decorative pieces. As a result a totally timeless space is created.

Carducci 76

Viale Carducci 76, 47841 Cattolica, Italy Tel: +39 541 95 46 77 Fax: +39 541 83 15 57 info@carducci76.it www.carducci76.it

Located on the Adriatic Riviera, right in Cattolica, this hotel occupies what was a classic summer villa during the middle of the last century. The original construction was inspired by the summer homes of the wealthy residents of Istanbul which extend along the shores of the Emilia-Romagna, the province where this hotel is located, is internationally known for its capital, Bologna, and for the lively nightlife of neighboring cities such as Rimini and Riccione. These factors were carefully considered when it came time to decide to create an exclusive hotel, as well when determining the interior renovation and the design of every detail.

The hotel has an atmosphere that exudes a contemporary air with clear Islamic and African influences. In the interior design, rather than masking the space with affected gestures, creating comfort for the visitor was paramount. The interior layout gave priority to a small number of rooms, in that each one became similar to a little apartment. In the rest of the public areas of the hotel, the rooms are a clear exercise in compositional balance, where Asian objects, old black-and-white photographs of Indochina and Thailand, Indian cushions, tribal sculptures, and Japanese crafts are strategically arranged. A mix of ethnic objects in dialogue with a modern and minimalist environment is nothing new; however, such a harmonious and balanced whole is rarely achieved.

Architect: **Luca Sgroi** Photographer: **Marchi & Marchi** Location: **Cattolica, Italy** Opening date: **2000**

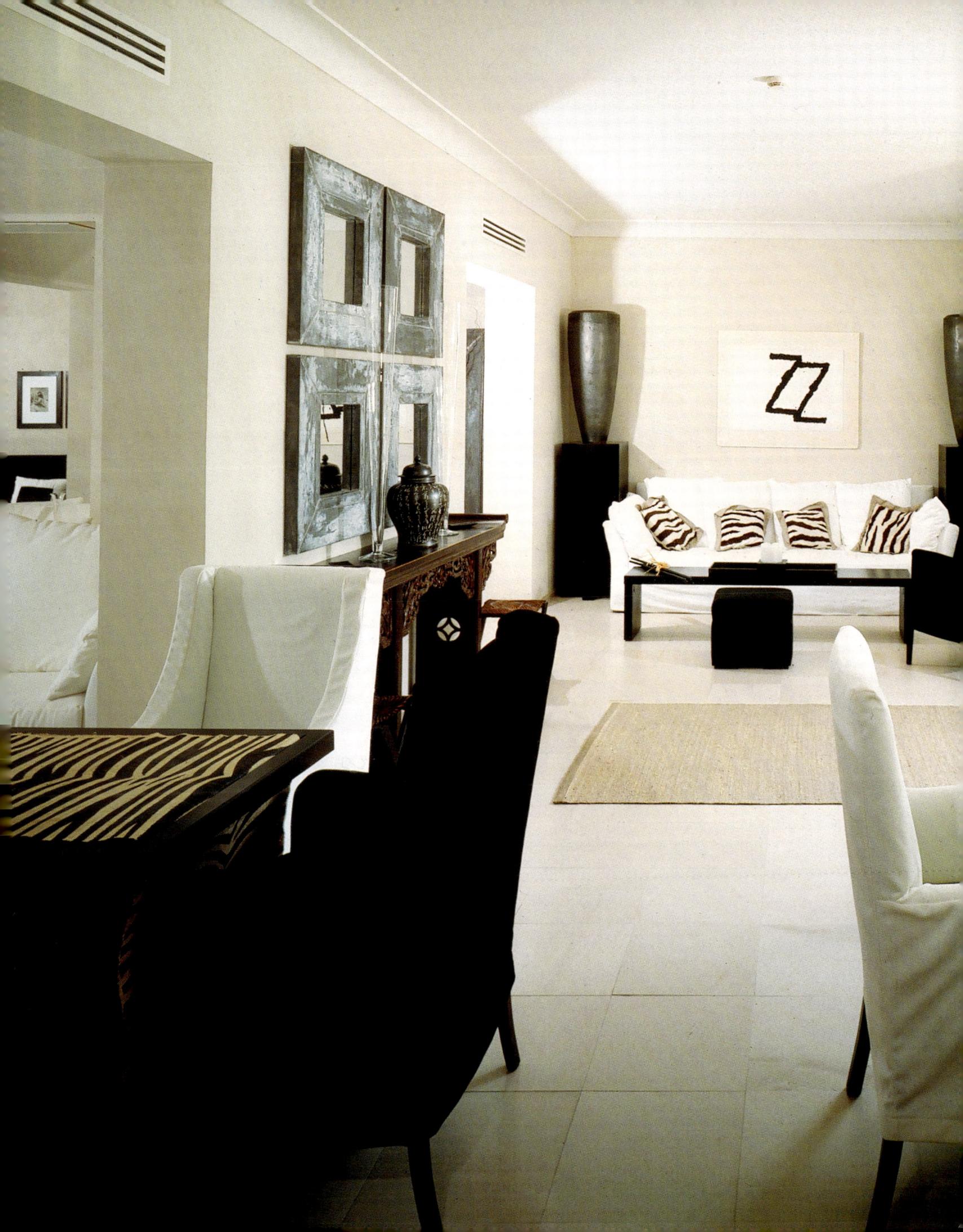

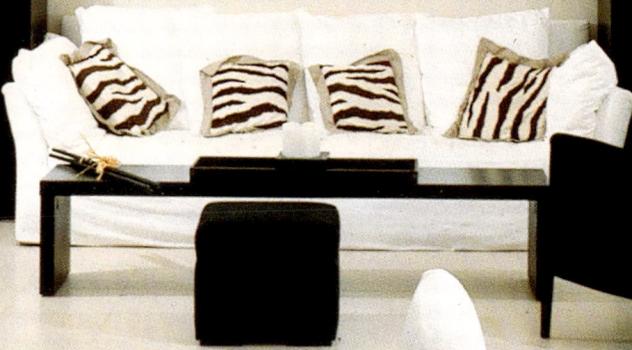

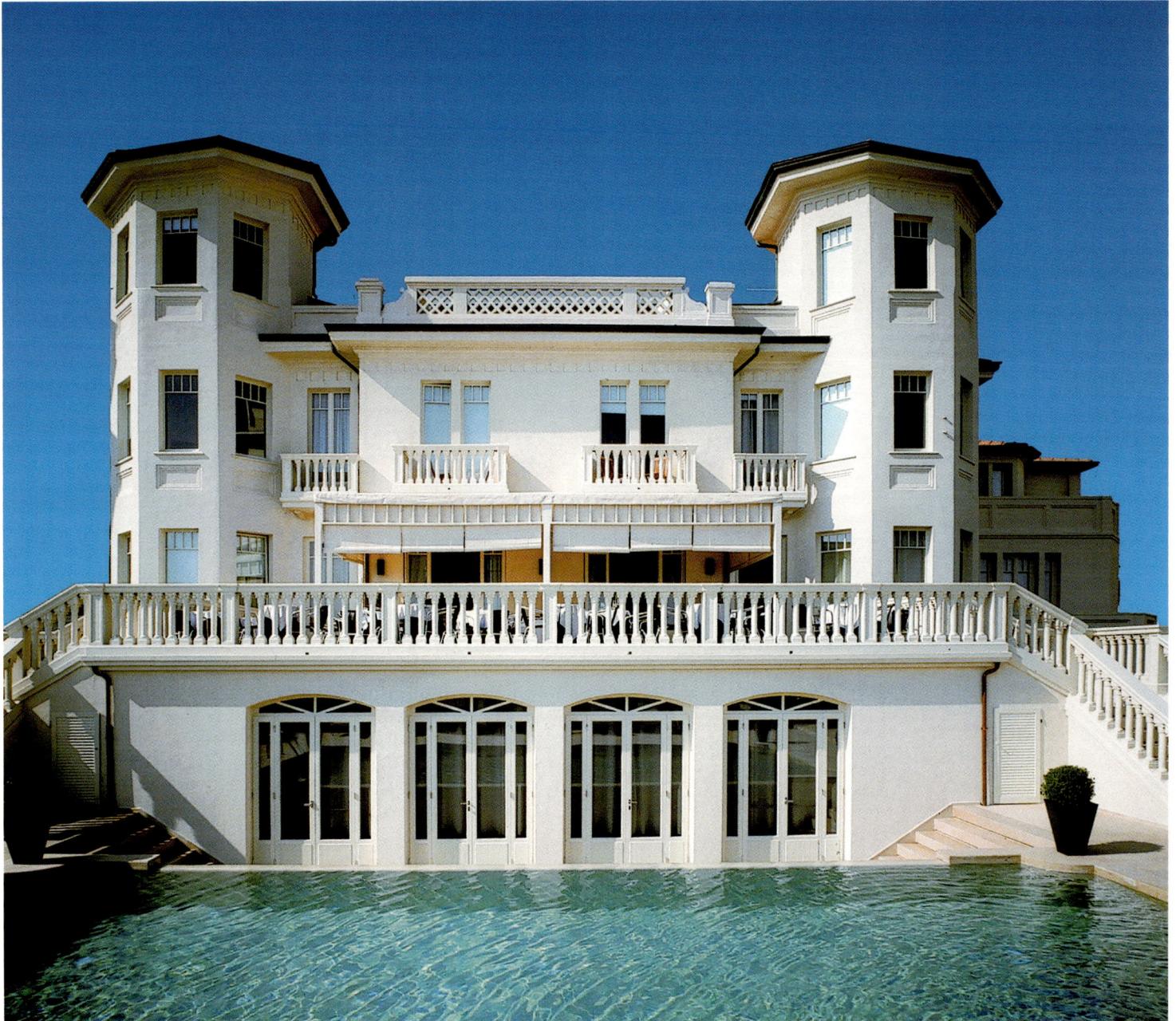

The exterior appearance of the villa was restored, respecting all of its original architectural qualities. The location of the pool opposite the main terrace emphasizes its monumental character and takes advantage of the expansive views of the coast.

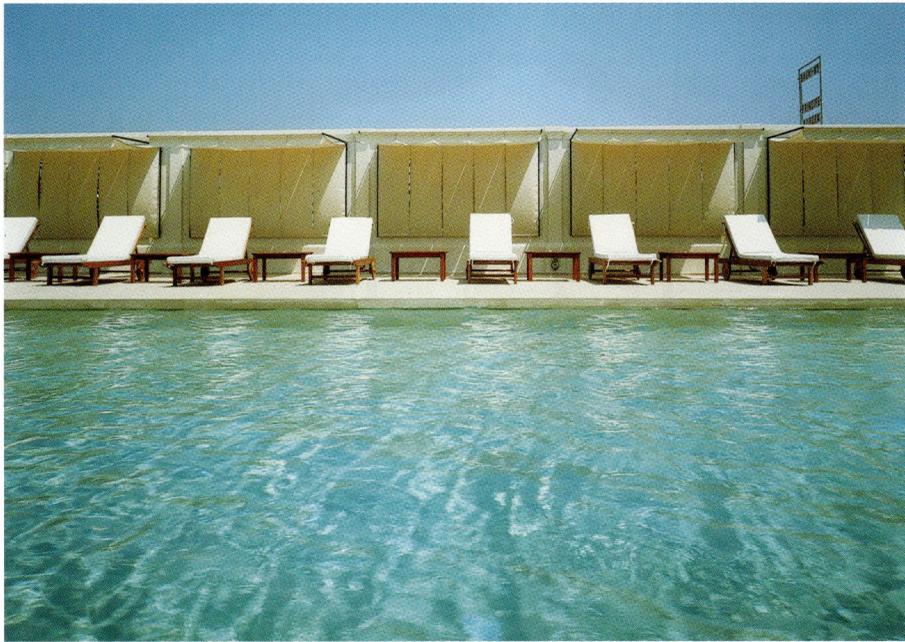

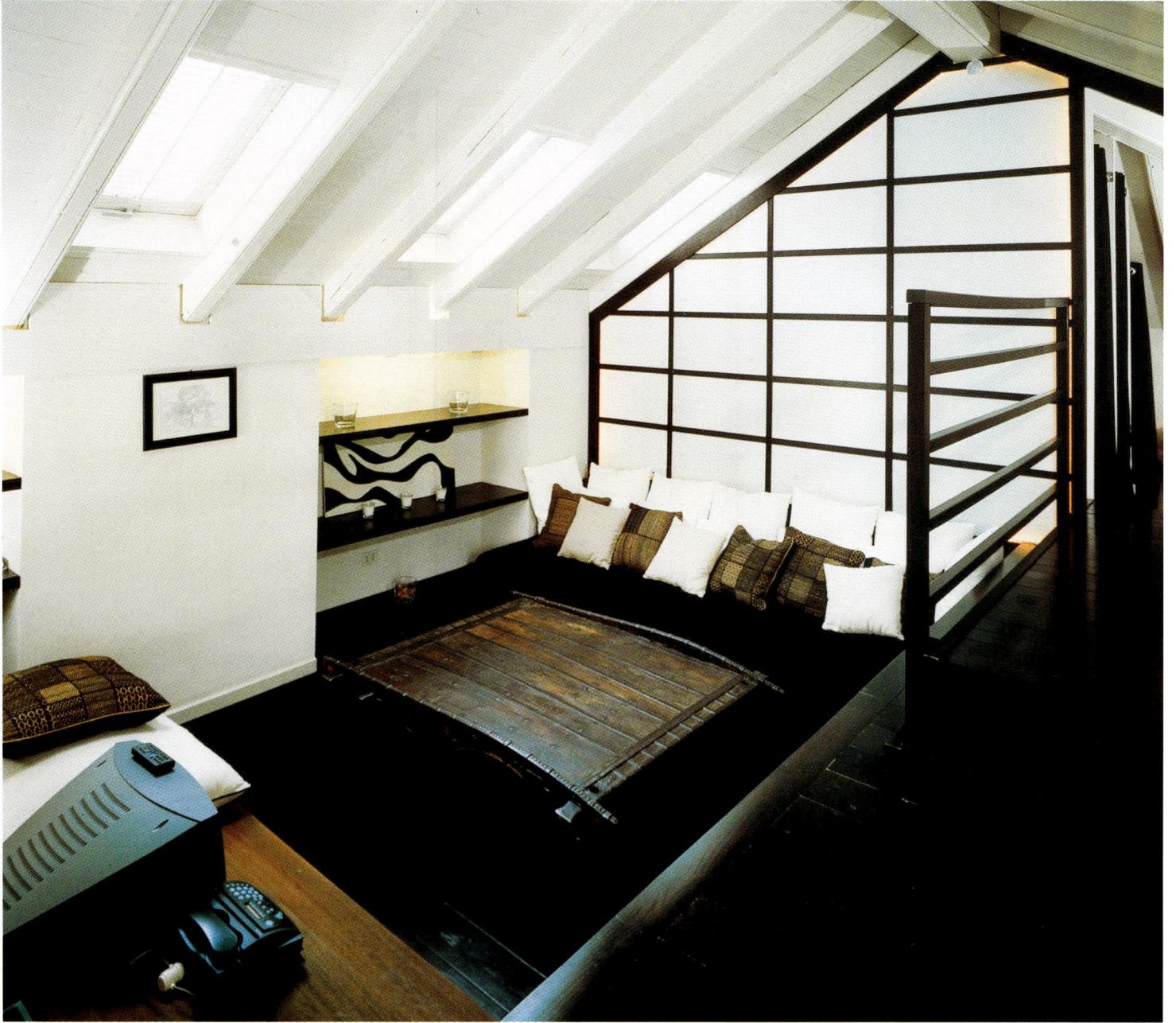

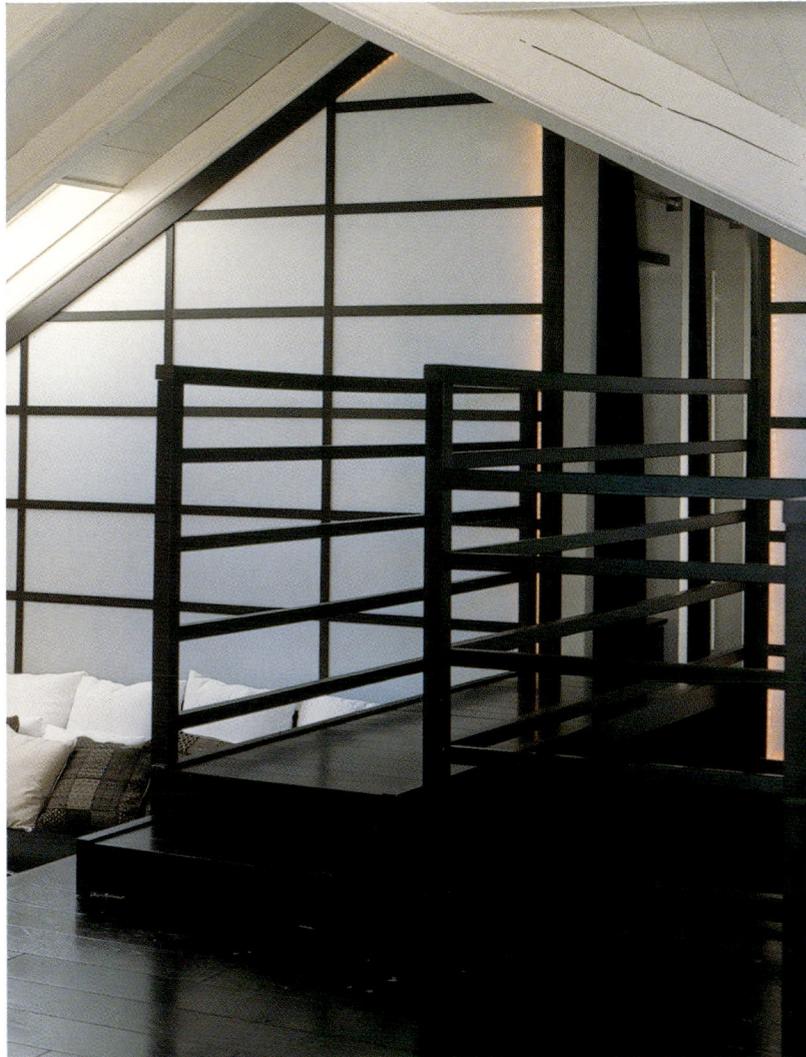

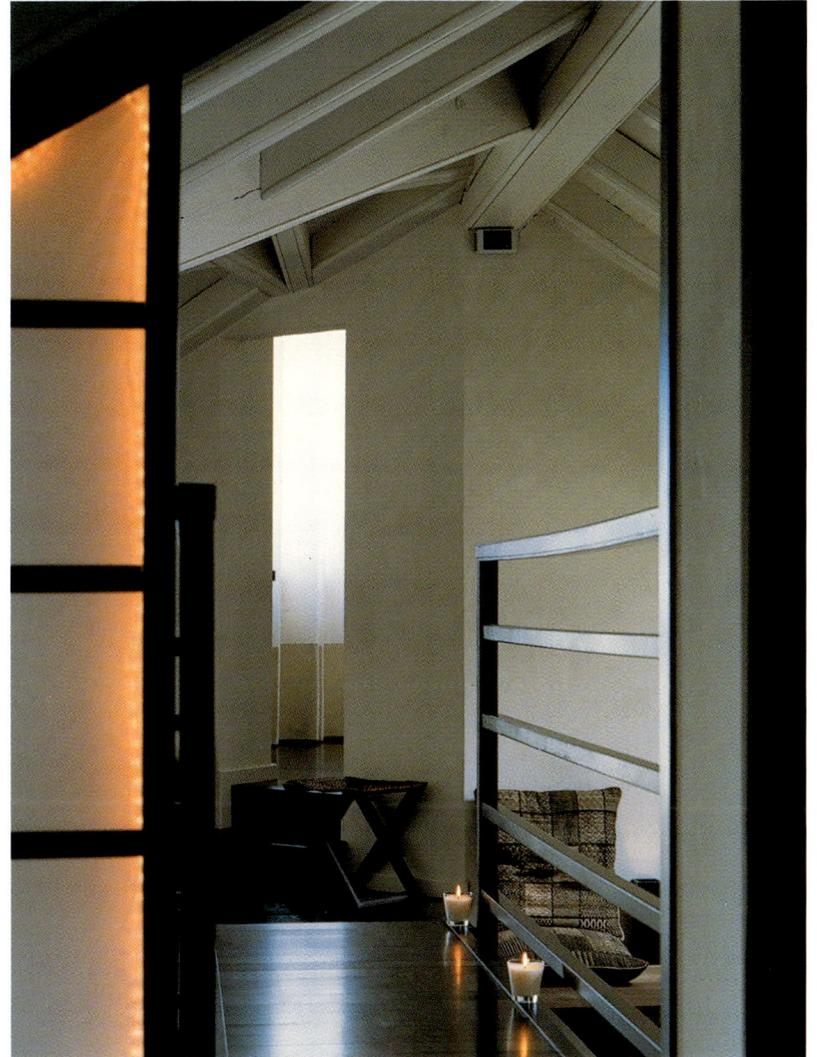

The rooms become a world of contradictions in which the clean lines and clarity of the space, composed mostly of white which covers the walls and ceilings, contrasts with the rest of the decorative details. The natural materials and fibers create a wide range of earth tones that enrich the ambience.

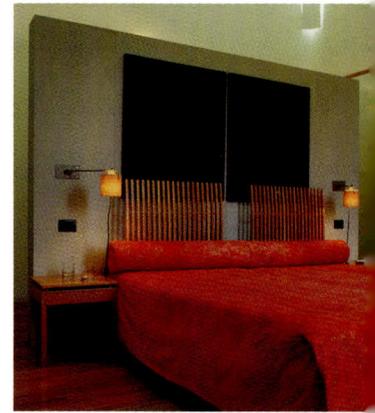

Pousada de N. Sra. da Assunçao

Apartado 61, 7040 909 Arraiolos, Portugal Tel: +351 26 641 9340 Fax: +351 26 641 9280 www.jpmoser.com/pousadadensradassuncao.html

The region where this hotel is located, in the southern part of Portugal, has a very valuable architectural heritage scattered among its villages, monasteries, and country houses. The excellent preservation of the region's monuments, and its proximity to Arraiolos, a town known around the world for its production of handmade rugs, make it a very attractive spot for tourists. It is known for the peculiarity of its hotels, in small structures, old country houses, or, as in this case, in buildings that form part of the region's architectural legacy. This building is an ancient monastery that dates back to the sixteenth century and has been restored and renovated in order to house this exclusive mountain hotel.

The project, in addition to the restoration of the original structure, required that an annex be built in order to accommodate thirty-one guest rooms, an outdoor pool, and some public areas. The result is a clear example of harmony between tradition and modern concepts of Portuguese architecture. The new building, constructed in a clean-lined, contemporary language that contrasts with the old building, stands out due to its austerity and simple form. It is a longitudinal block that extends over a high plateau in order to get the best view of the surrounding valleys. The lobby, some rooms, a church, and the public areas are located in the old building. A subtle connection between the two buildings is made by a patio formed by both structures, keeping them from meeting, and creating an interesting succession between exterior and interior spaces.

Architect: **José Paolo Santos** Photographer: **Pep Escoda** Location: **Arraiolos, Portugal** Opening date: **1999**

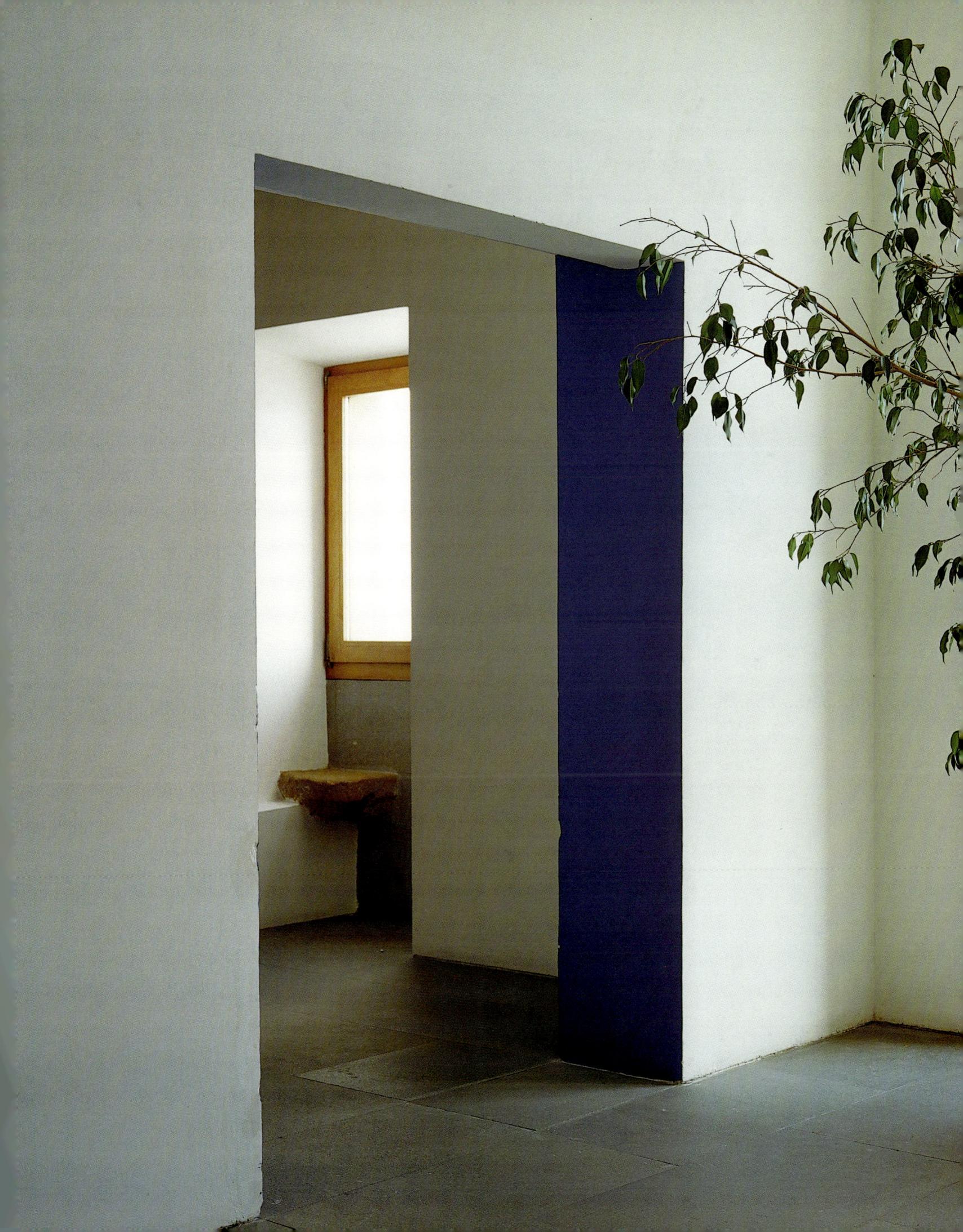

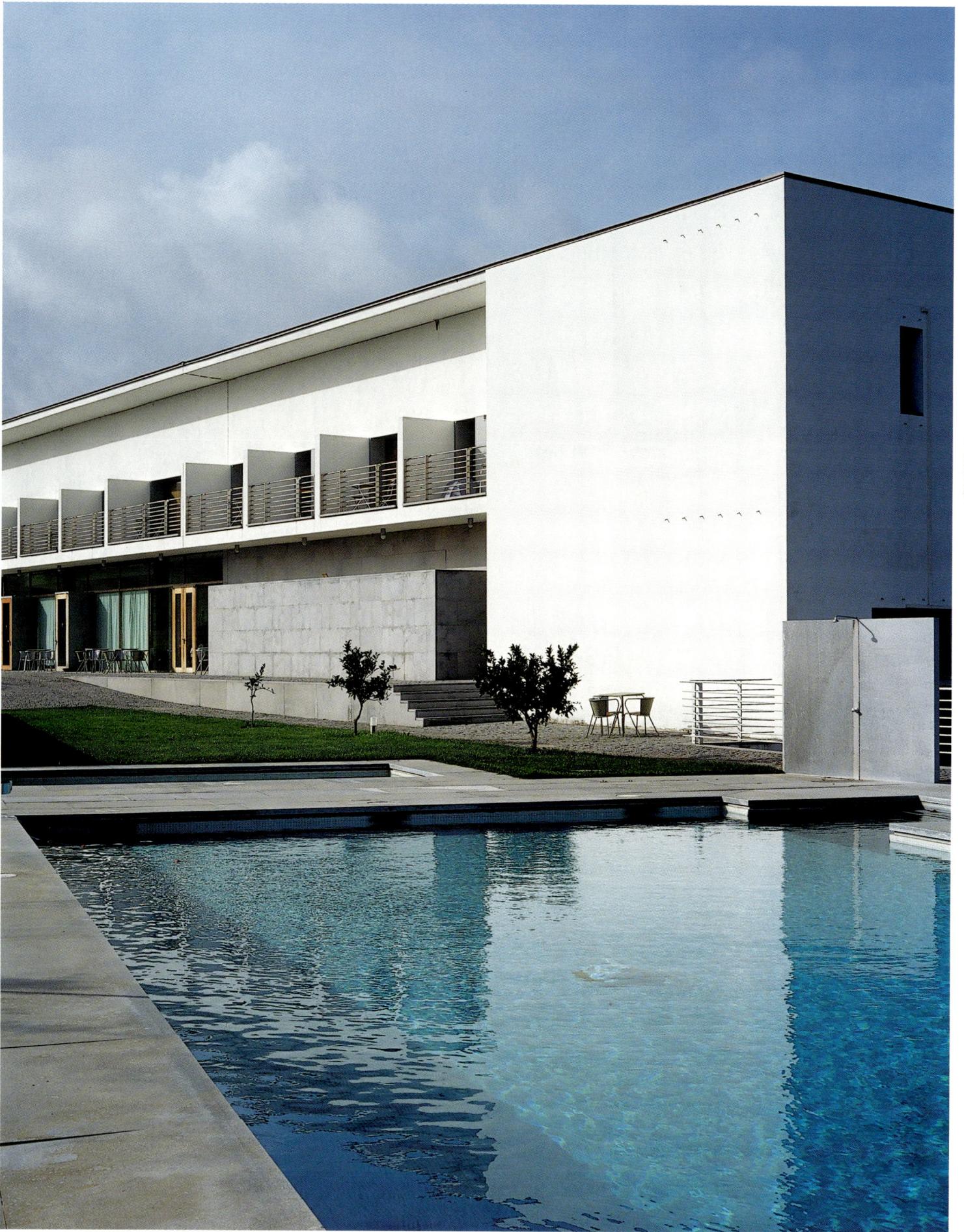

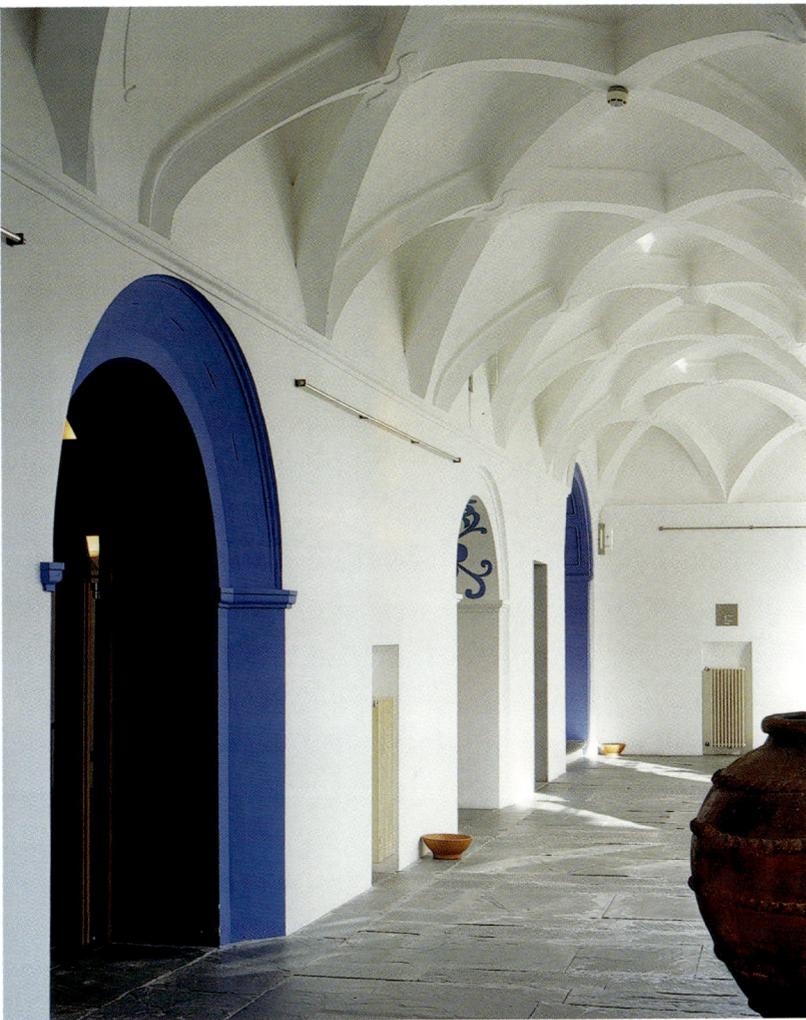

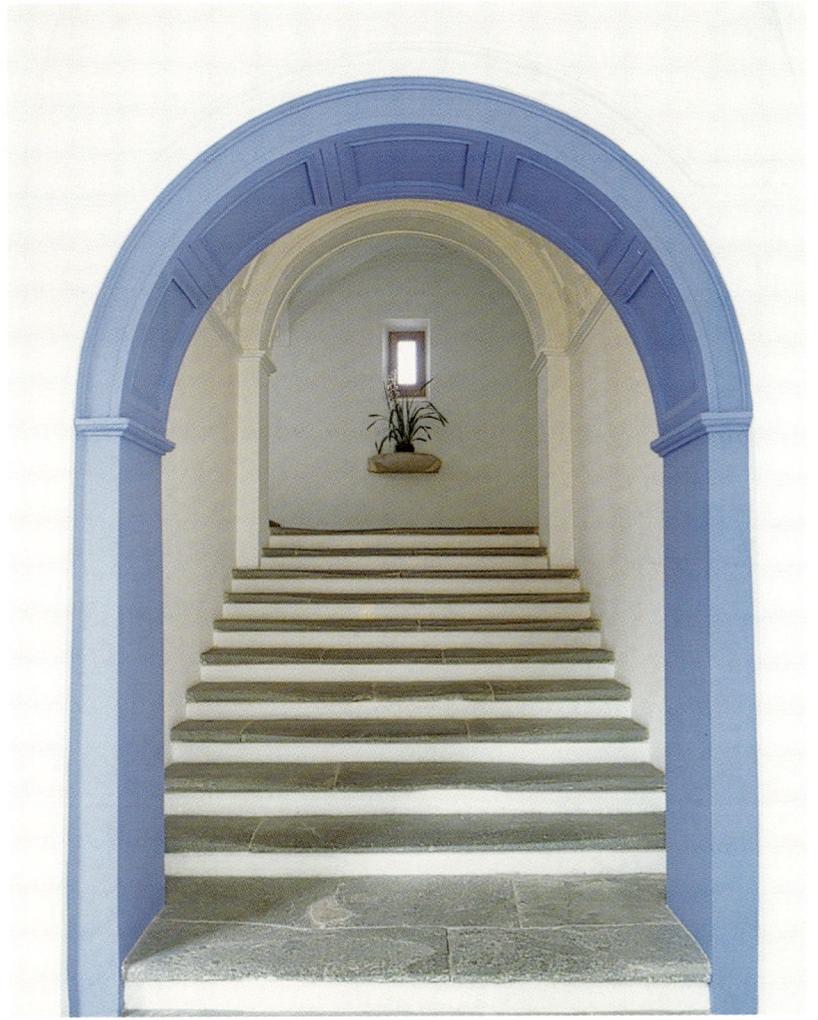

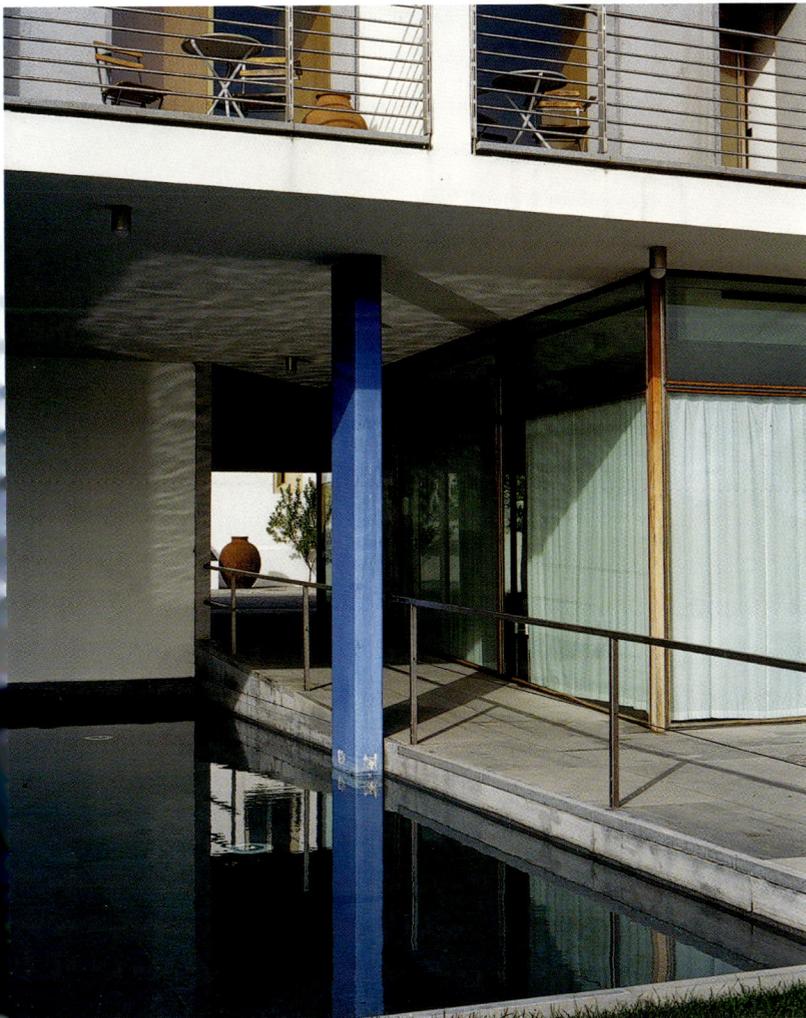

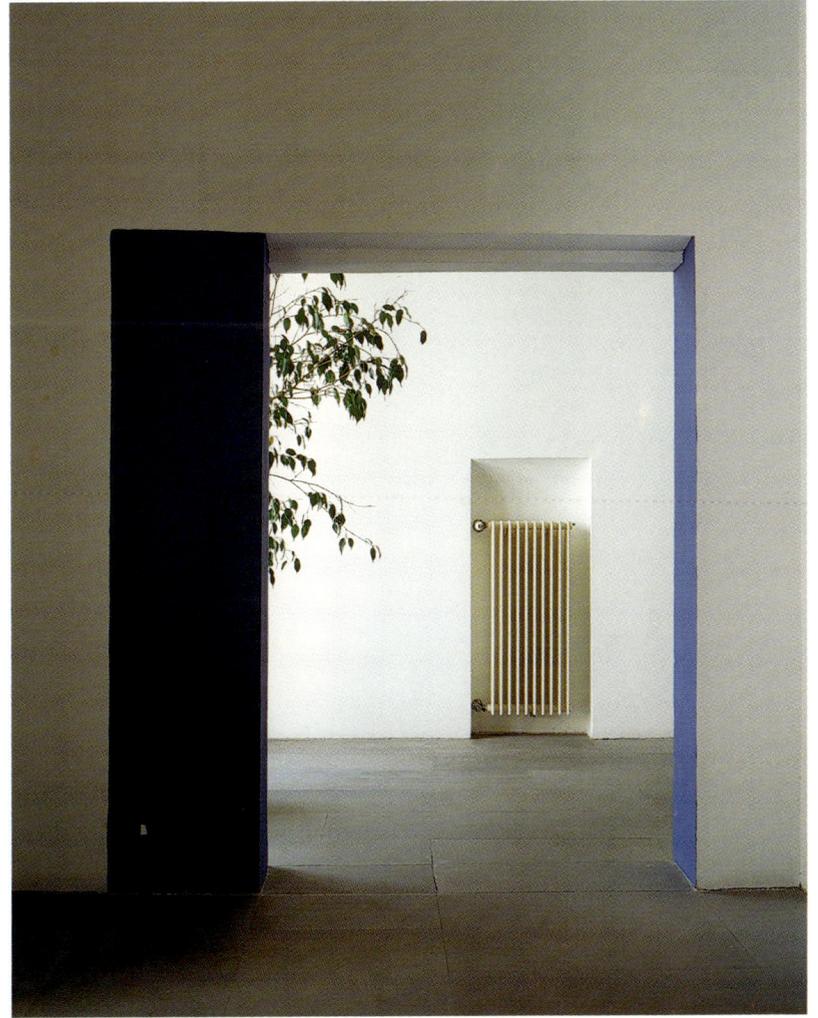

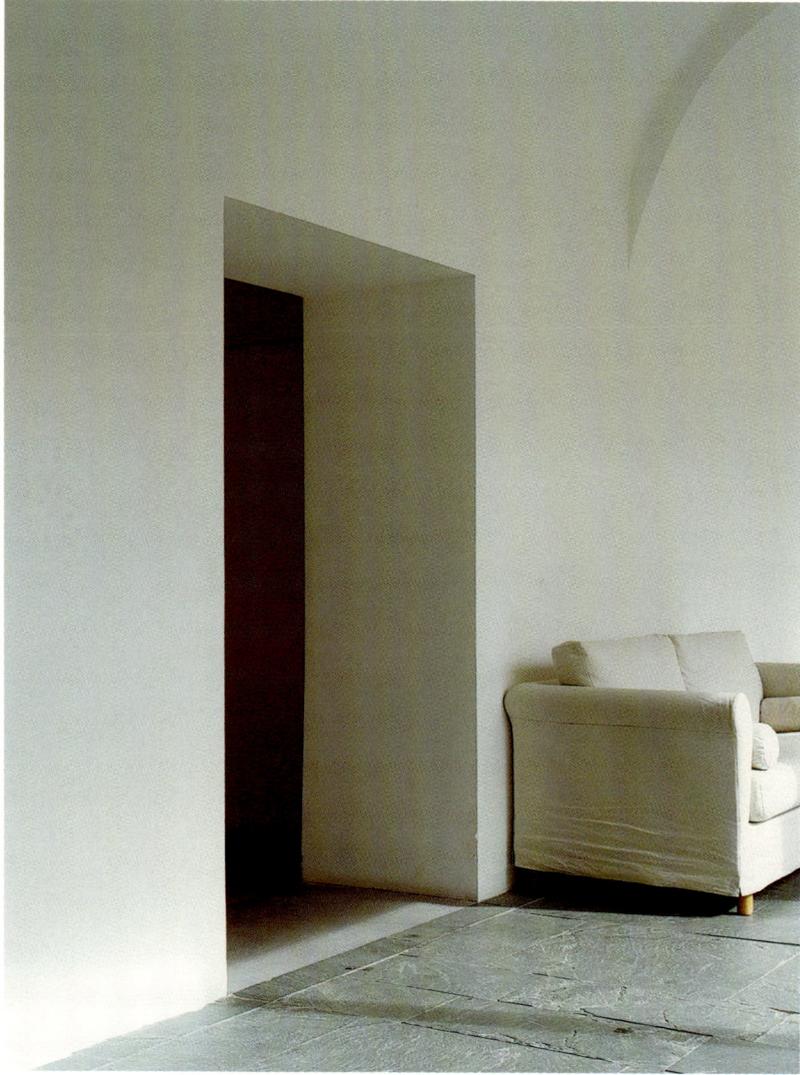

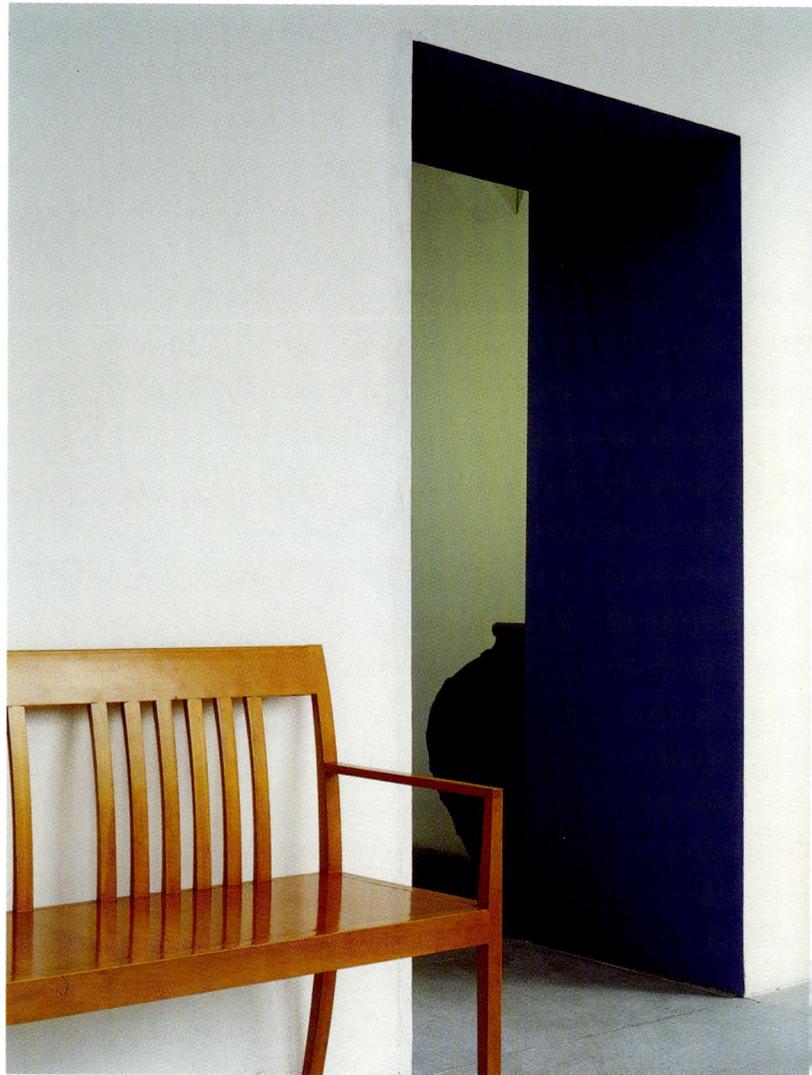

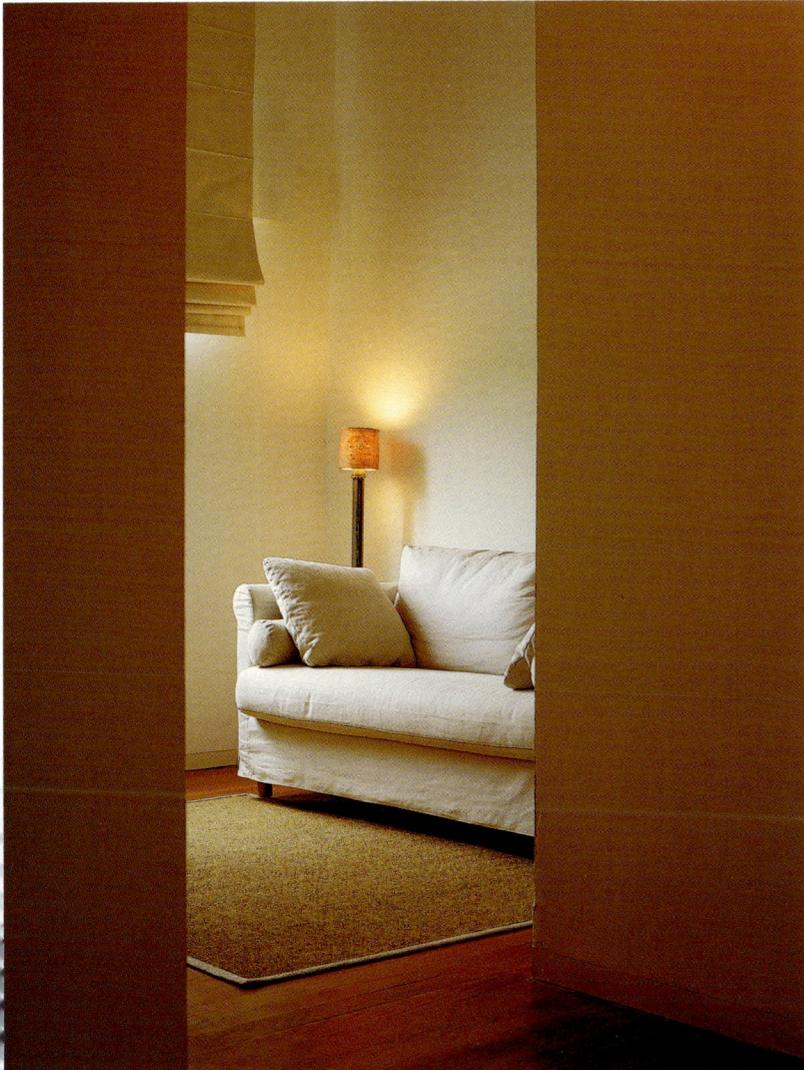

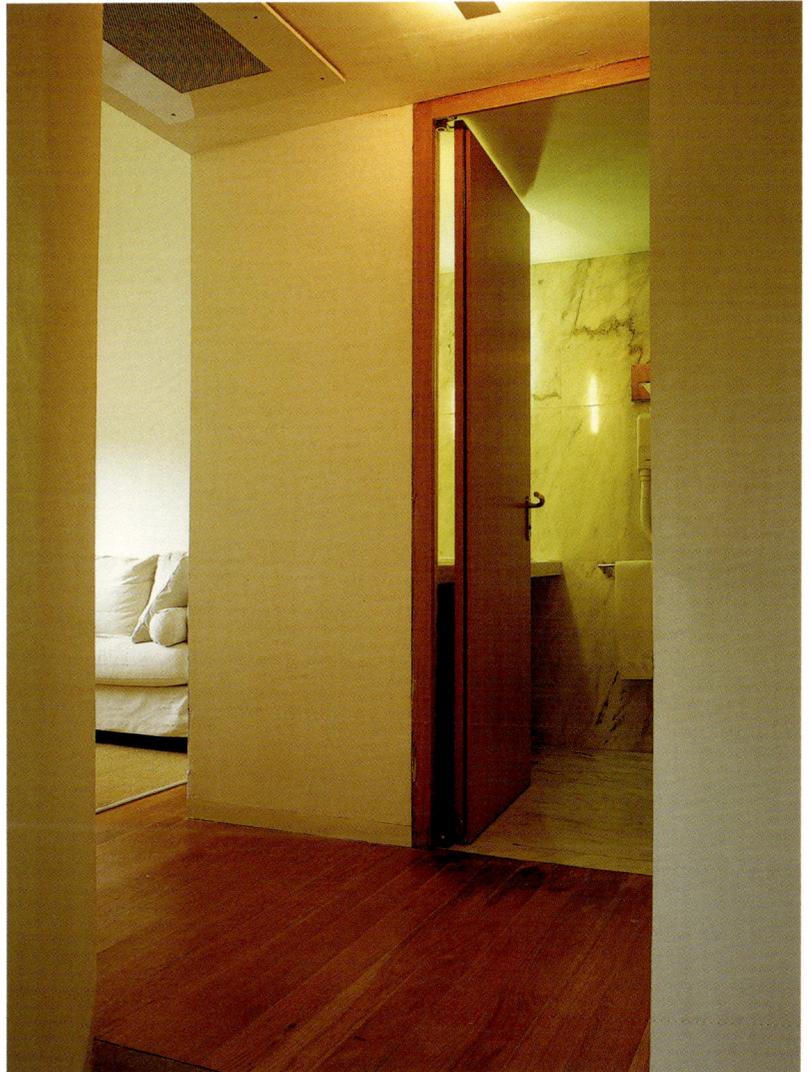

Materials such as natural stone and lime walls, and the color blue, common in both buildings, reinforce the architectural dialogue. The furnishings, in the interior as well as exterior, recall the building's monastic austerity without renouncing contemporary comfort.

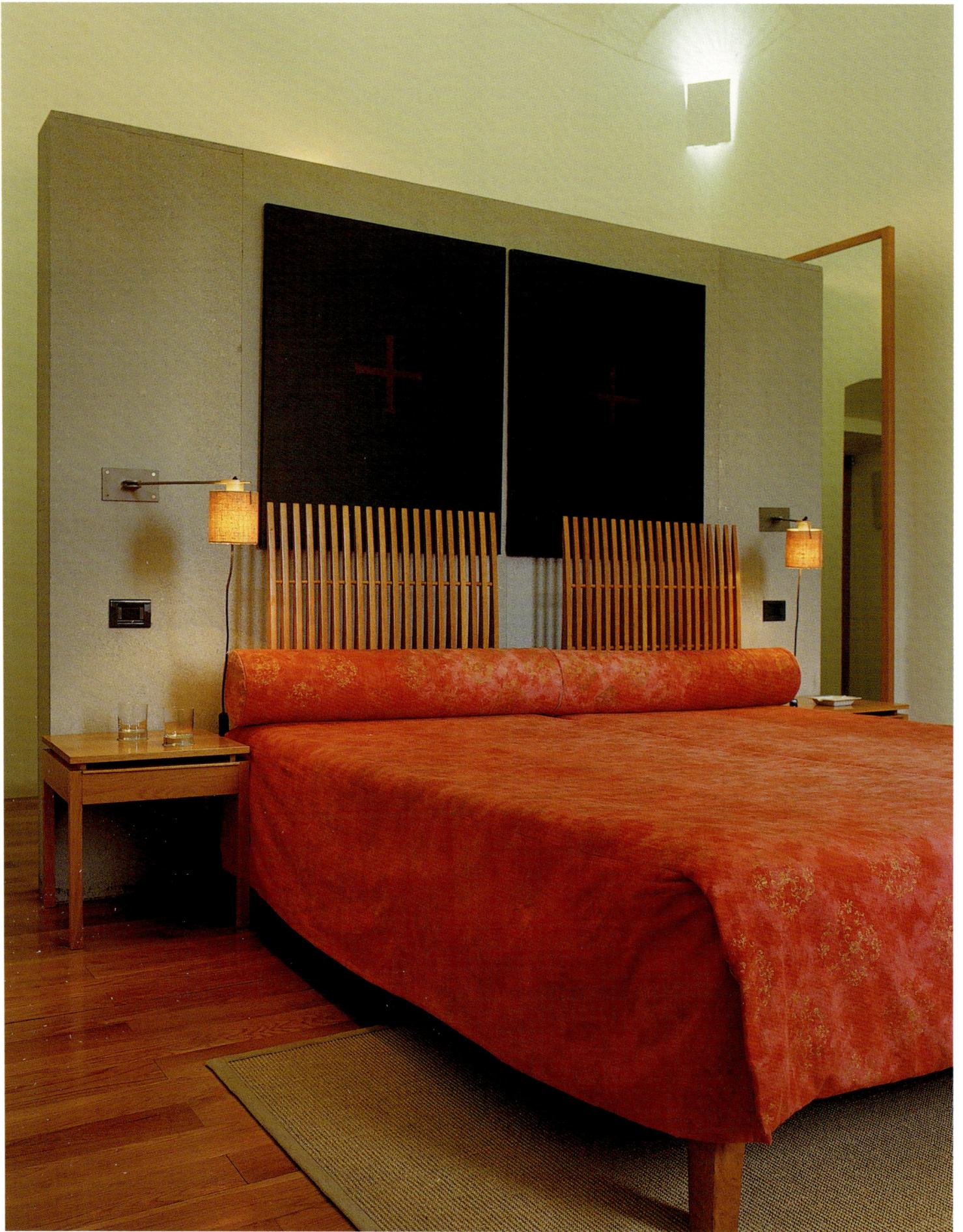

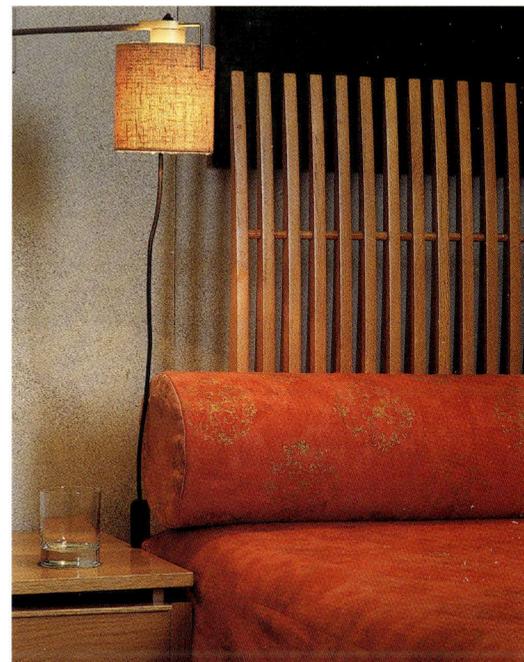

Bright colors and warm materials such as wood, used for the flooring, the furnishings, and headboards, enrich the interior of the rooms. The natural, rustic textiles used for the rugs and curtains evoke the country surroundings.

ARCHITECTURE

When thinking about the needs of the hotel and its desired character, creating a totally new building can be the best way to achieve the desired effect. In these projects there is a clear, deliberate relationship between interior and exterior. In some the intention is to stand out from their urban environment, while others try to allude to the area's history. All of these hotels are notable for the great scale reflected in their forceful interiors through the use of high-ceilinged lobbies, large cityscape windows, or wide corridors. The proportions, lighting, details, and finishes of each space follow the same grand plan that harmonizes each hotel as a whole.

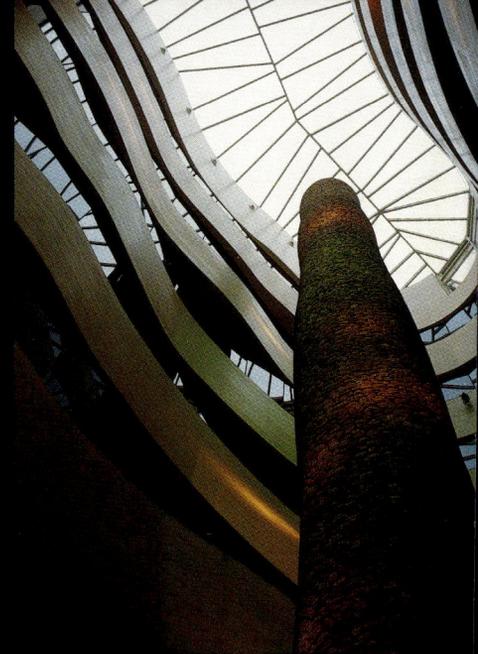

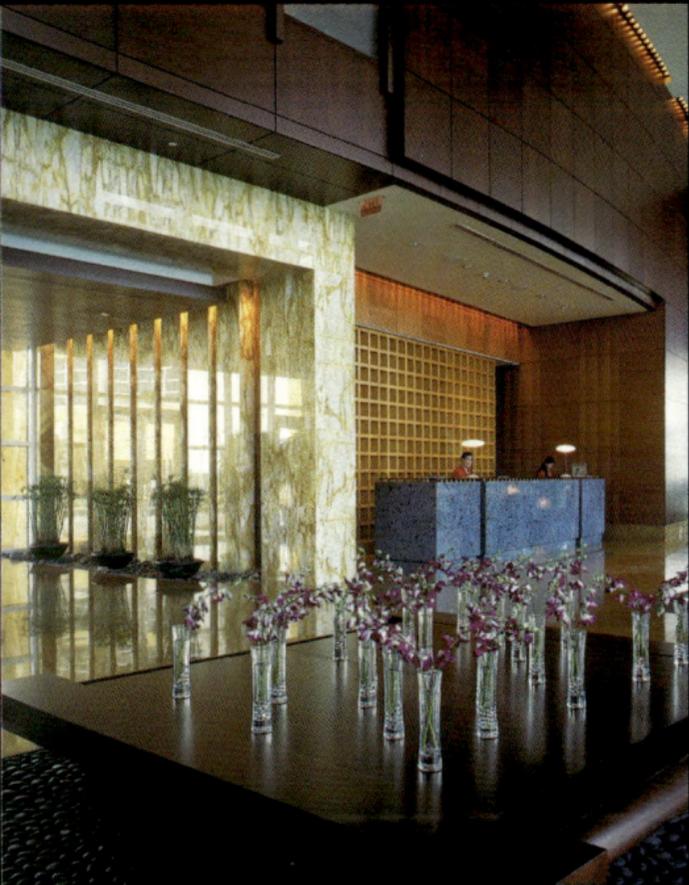

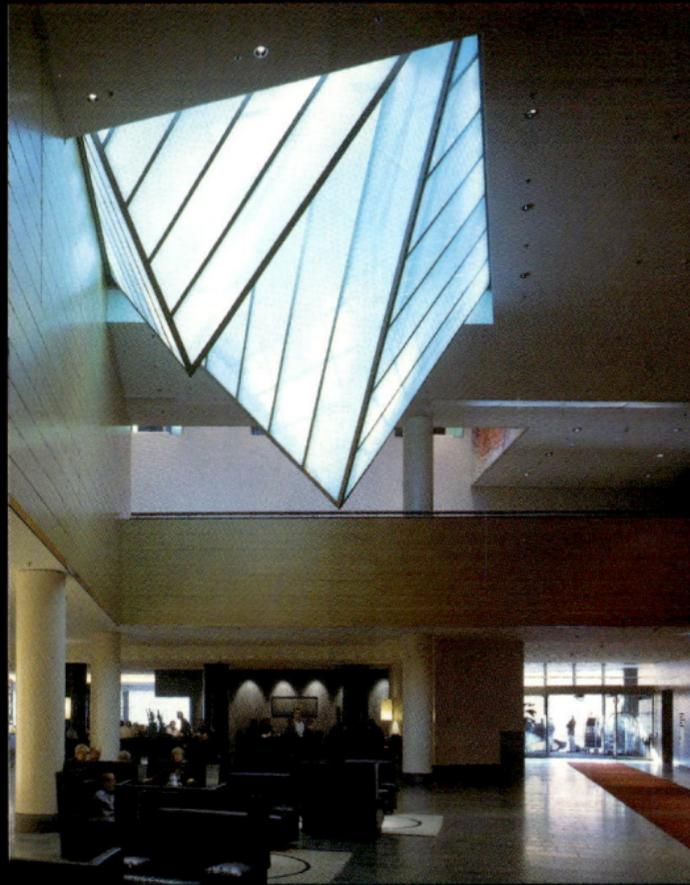

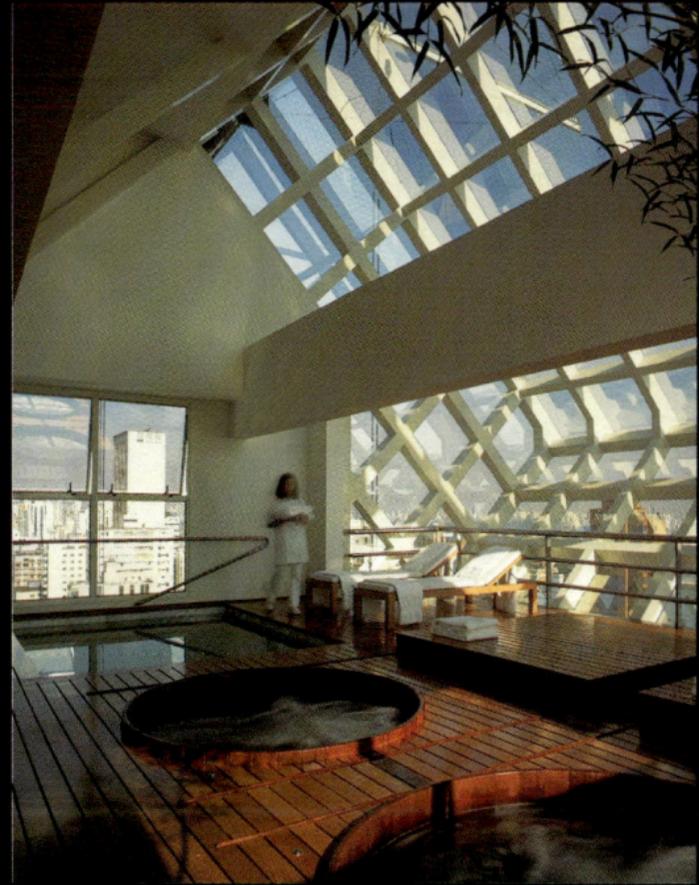

Gran
Domine

Alameda de Mazarredo 61, 48009 Bilbao, Spain Tel: +34 944 253 300 Fax: +34 944 253 301 silken@hoteles-silken.com www.hoteles-silken.com

Obviously, the most influential factor in the design of this building is the powerful presence of its neighbor, the Guggenheim Museum Bilbao, which served as a point of departure when it came time to develop this project. So that the museum's proximity would be more than just anecdotal, the hotel's design captures some of the spirit of the museum and aims to offer, along with the comforts of a luxury hotel, some of best pieces of twentieth-century design. In order to house all the very relevant pieces under the same roof, designer Javier Marisa took charge of designing a project that could accommodate all of these objects. Every room in the hotel, public or private, has been creat-

ed as an independent space with its own personality. They integrate with the hotel but do not lose their individuality.

The general layout of the hotel is based on clearly distinguishable public and private areas. This concept, with the goal of creating a dynamic ambience in the public areas, allows the hotel to participate in the urban activity right outside its doors. With this in mind, the hotel attempts to become another landmark in the city and, alternatively, to generate ongoing activity inside its doors. Perhaps the most emblematic element here is the Ciprés Fósil, a large sculpture of stone and metal mesh that rises up the entire height of the central atrium. According to Javier Mariscal, the designer, the sculpture reflects the character of Bilbao, "a city of excesses and contrasts."

Architect: **Iñaki Aurrecoetxea** Designer: **Javier Mariscal** Photographer: **Pep Escoda** Location: **Bilbao, Spain** Opening date: **2002**

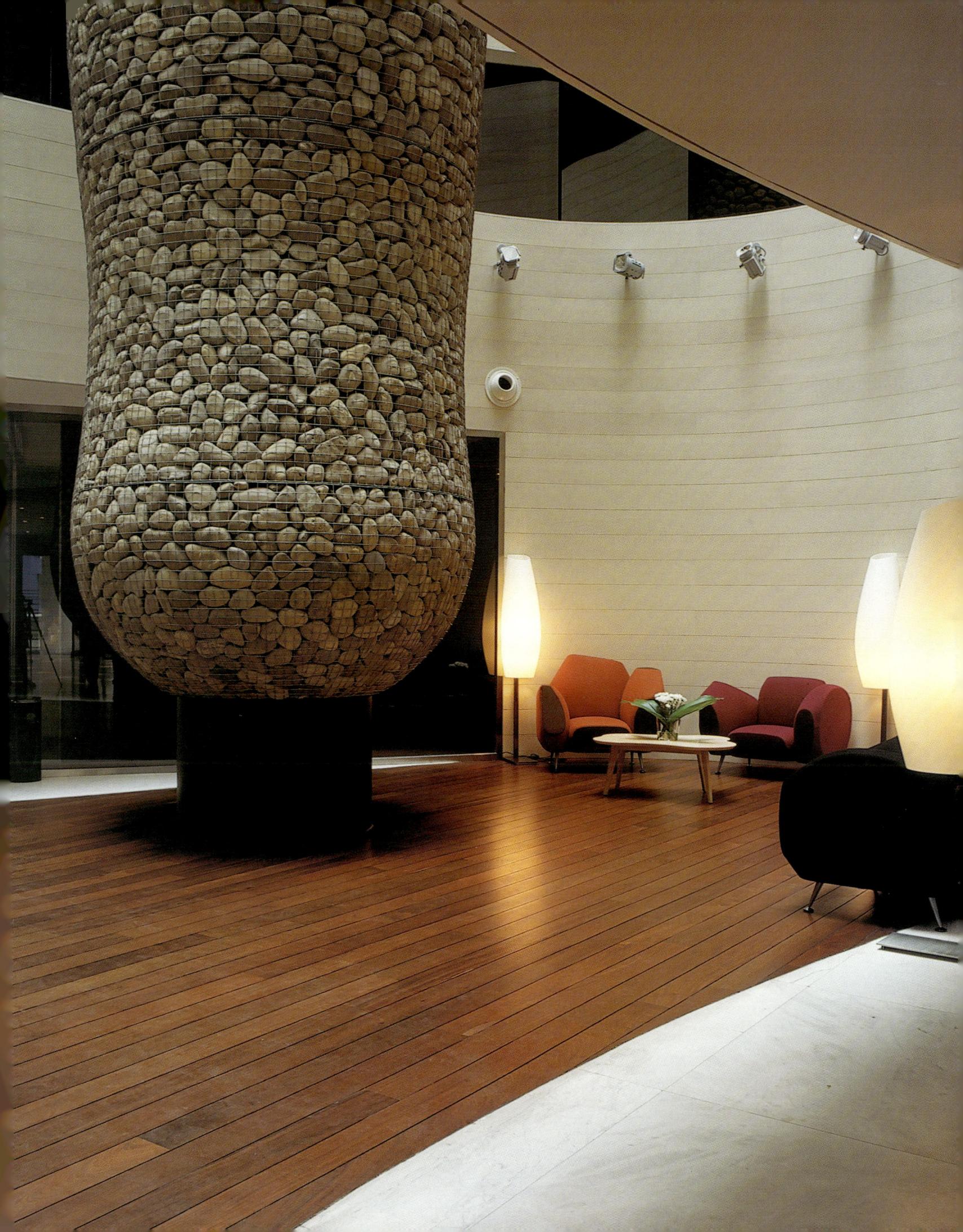

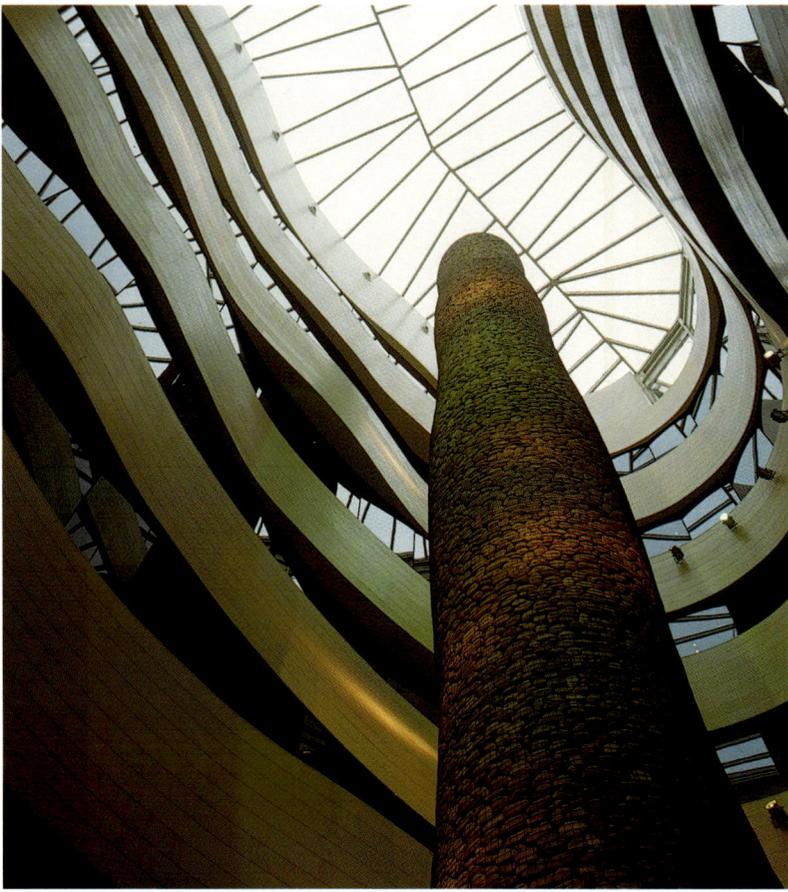

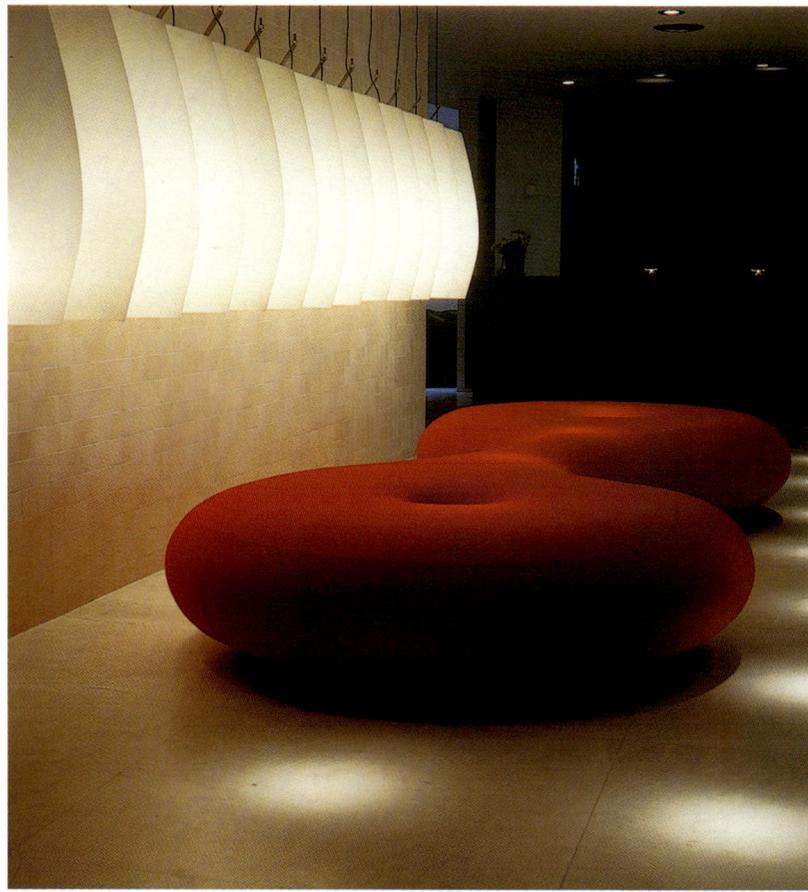

The hall of the hotel is a restrained, monochromatic space and the axis that defines the different areas of the hotel. The marble floor, a sort of indoor street, is restrained, while the red figure-eight sofa is an excellent counterpoint.

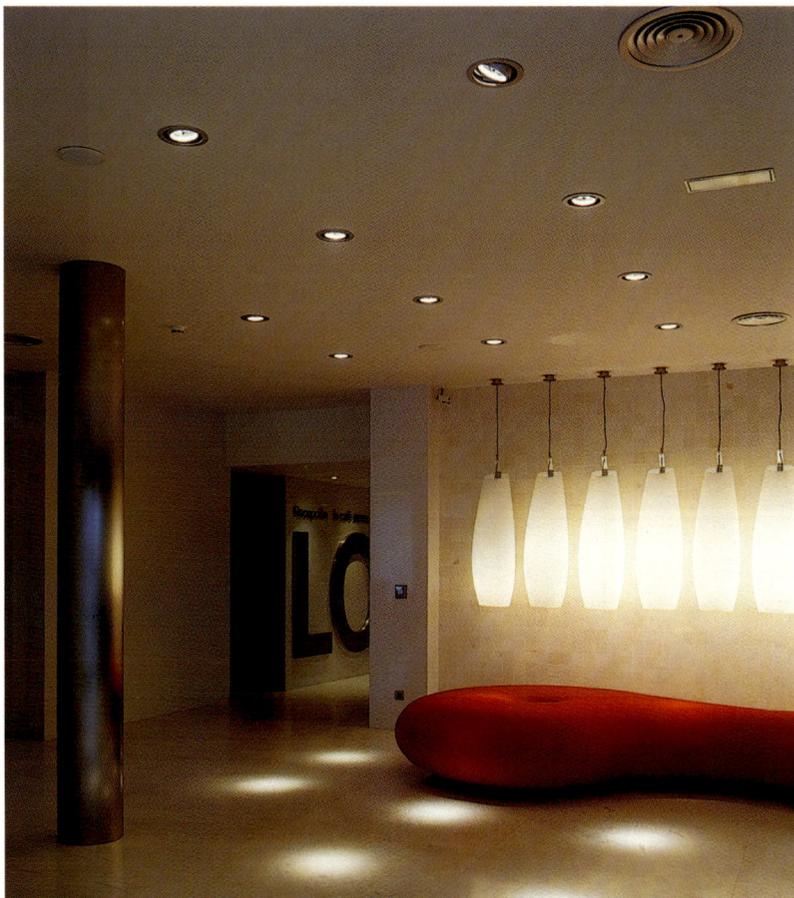

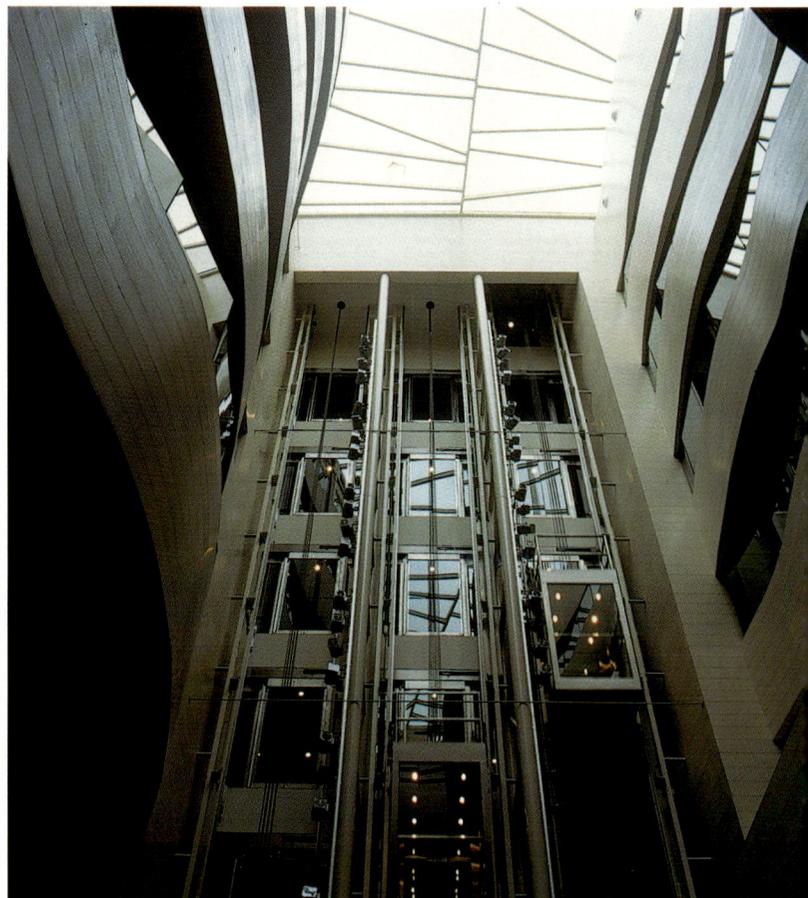

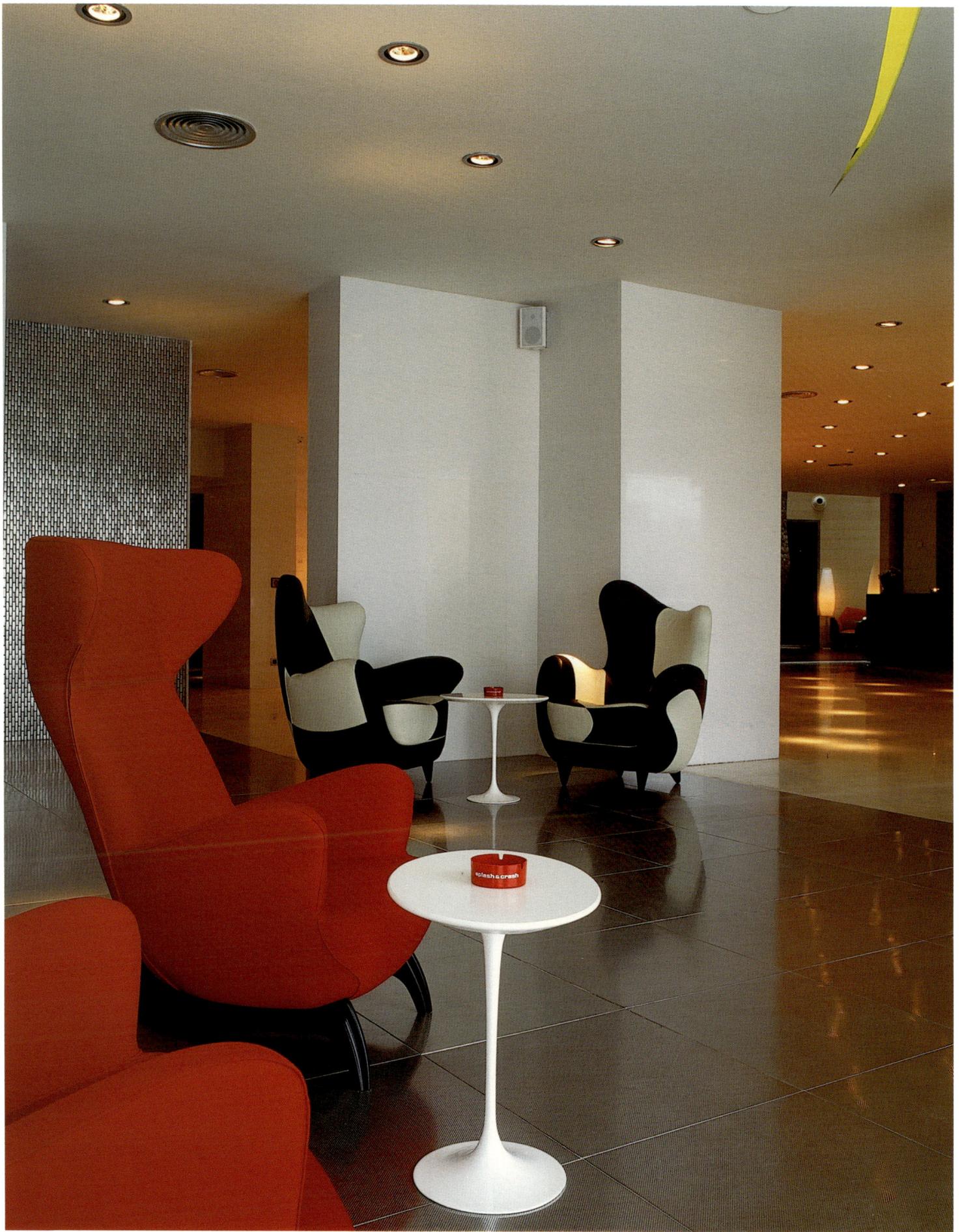

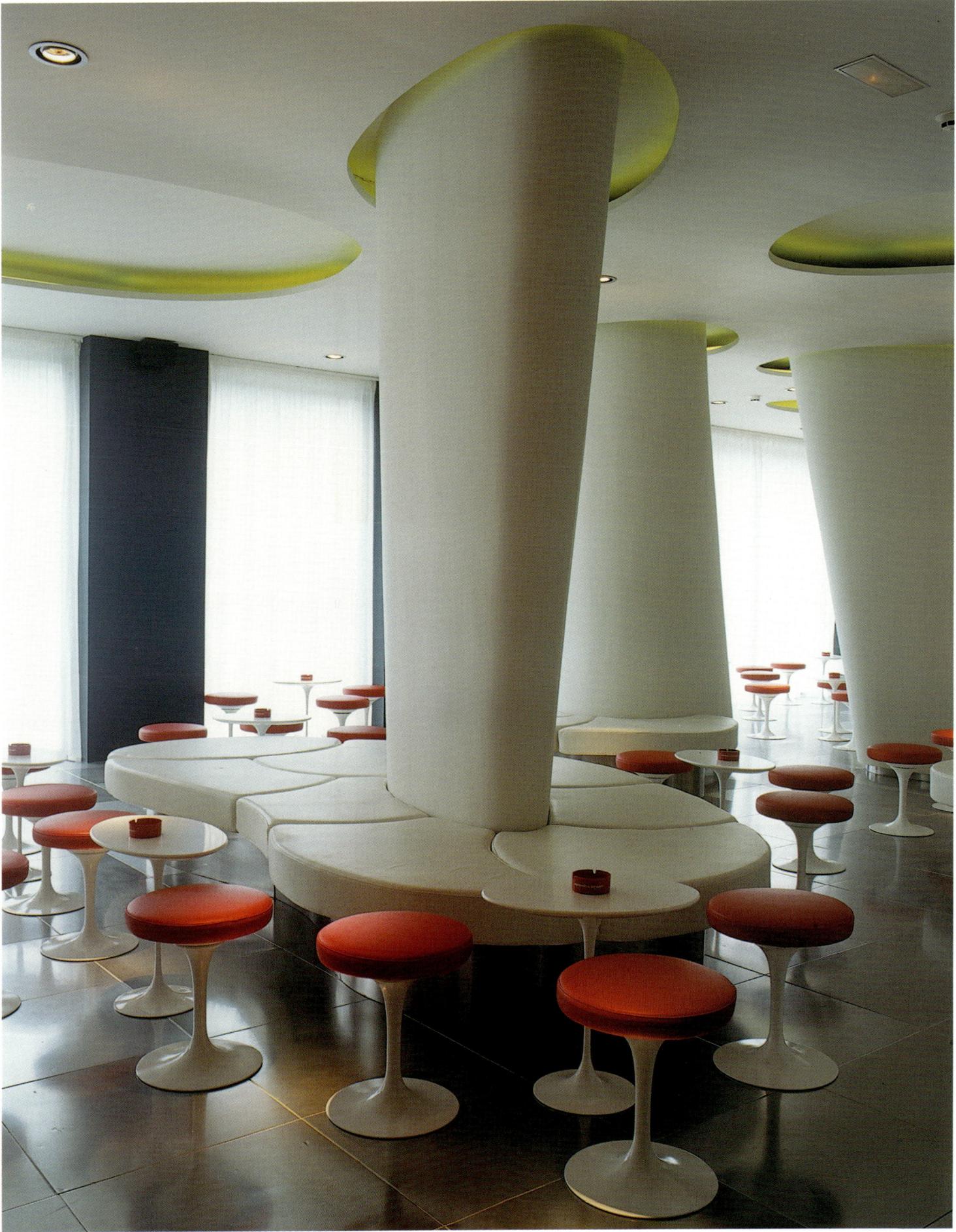

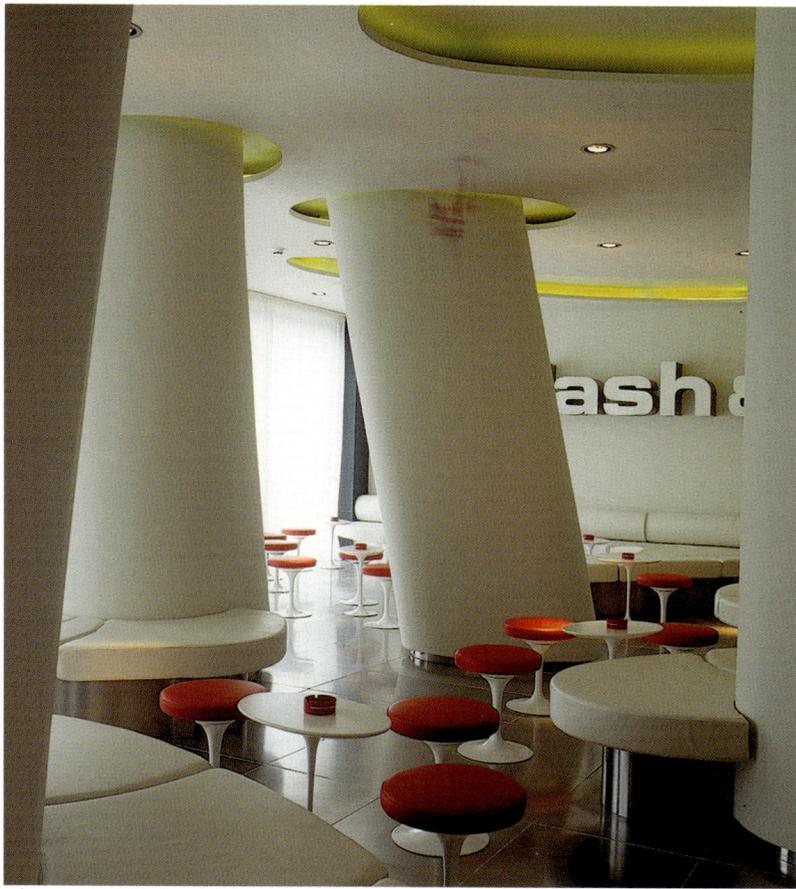

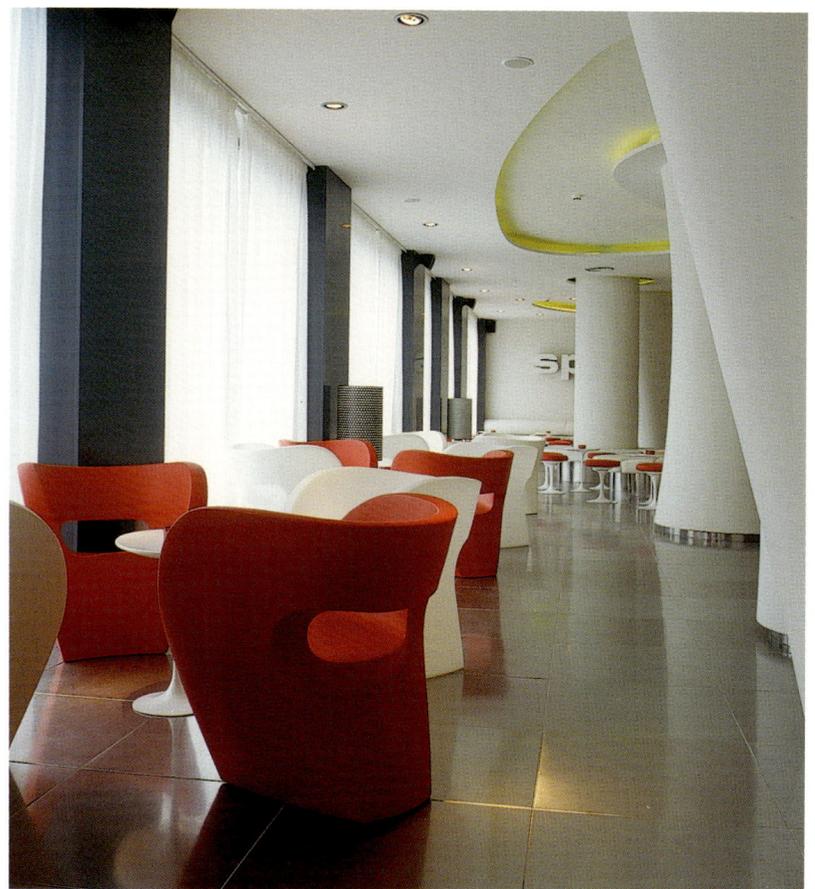

Leaving behind gray and formalities, light and color star in the design of the bar that harks back to the 1960s. Red, white, and brightness are the prevailing elements in this space filled with light and movement.

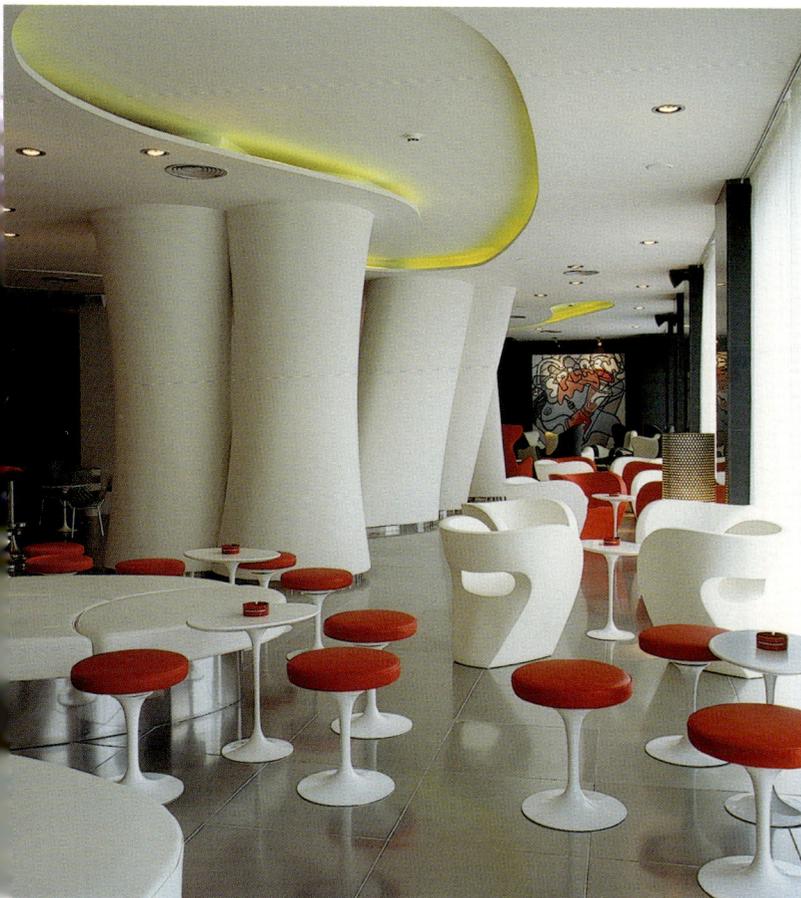

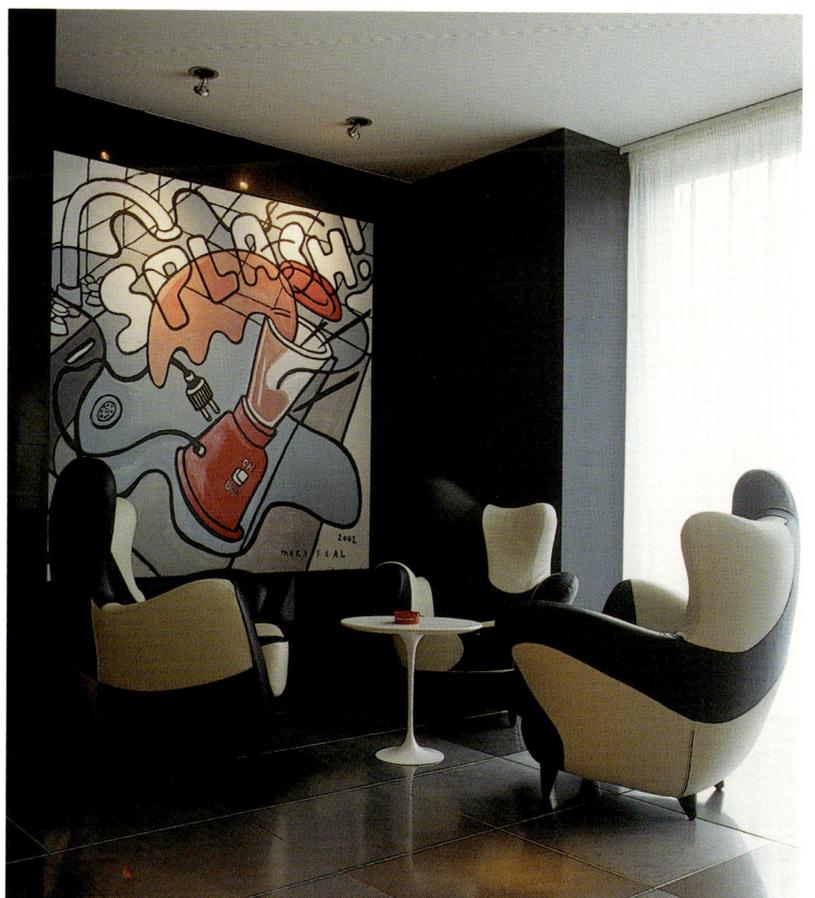

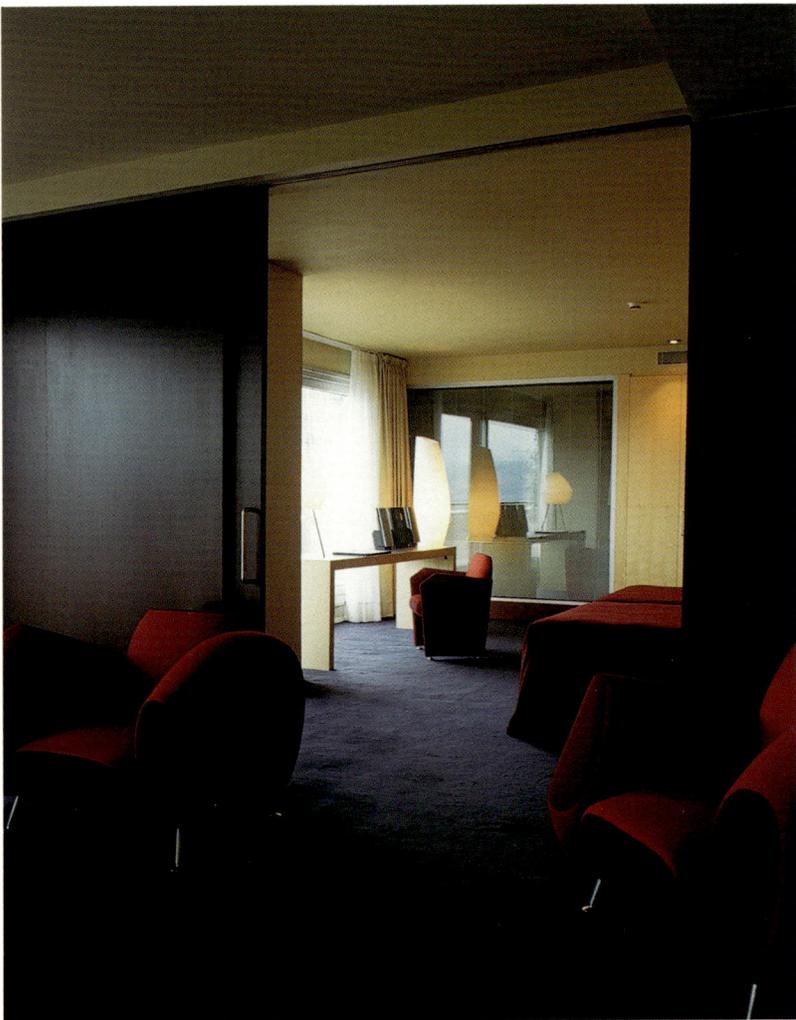
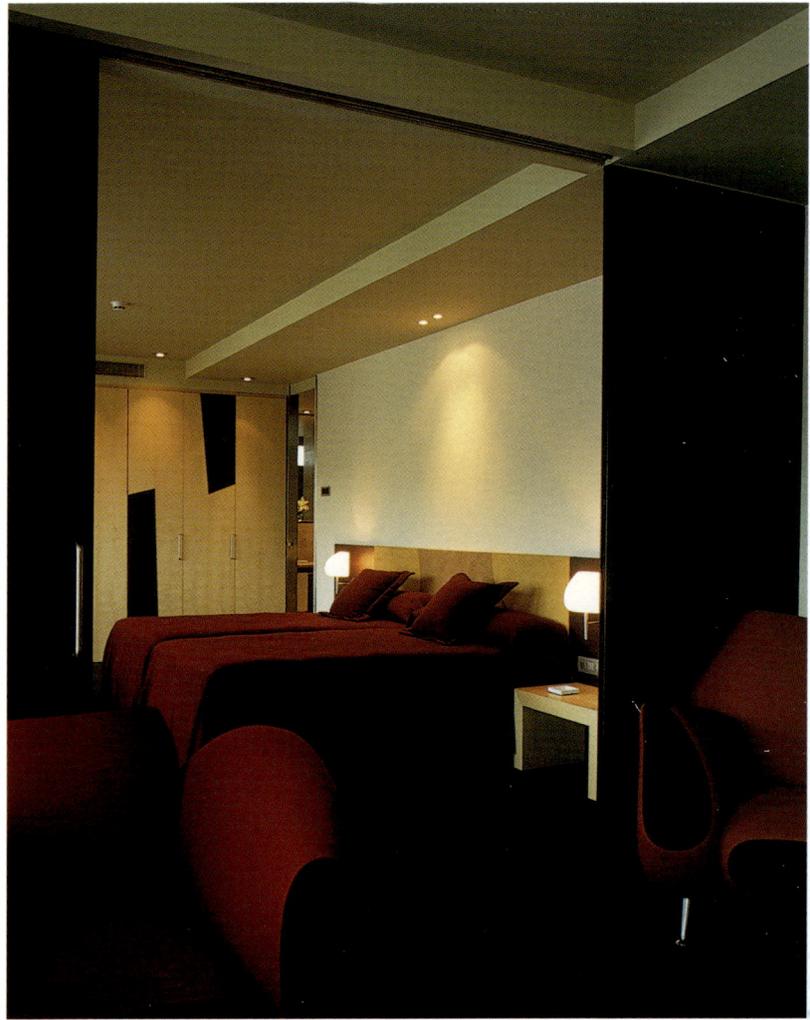
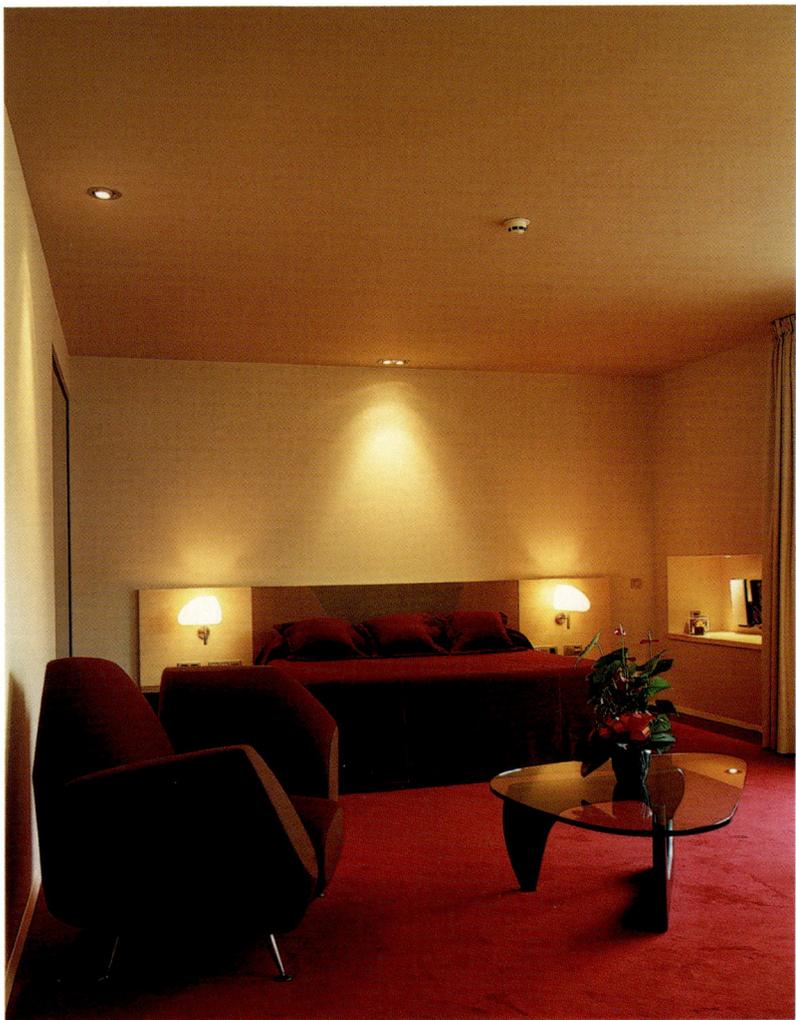
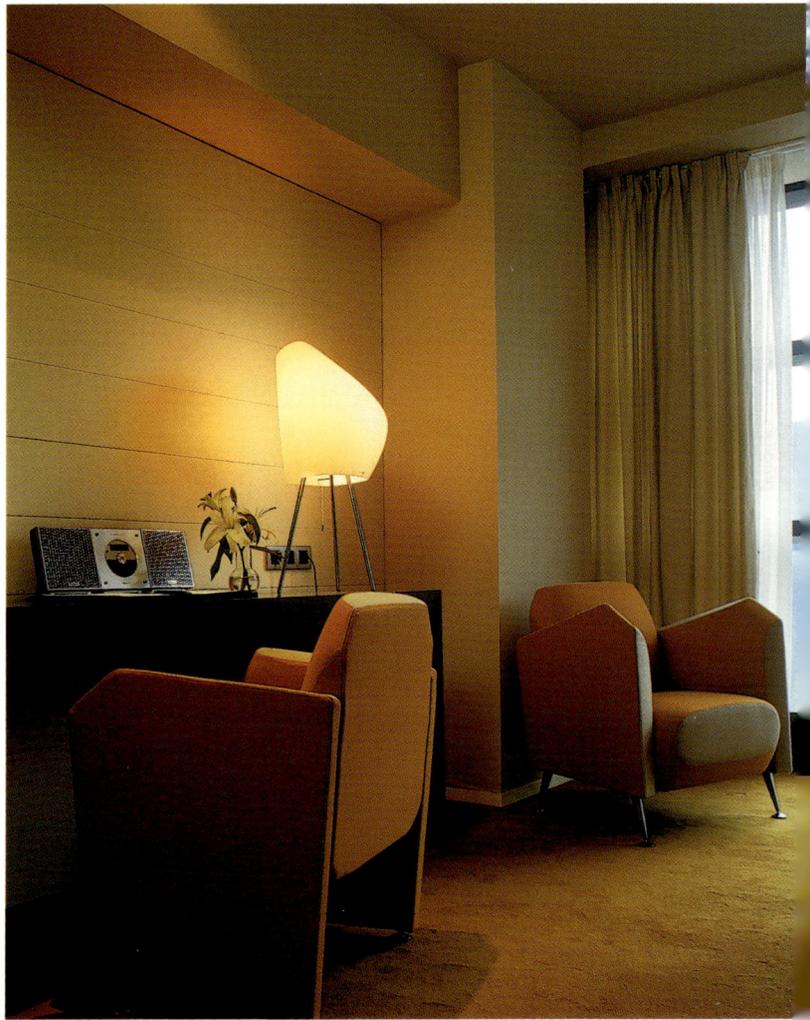

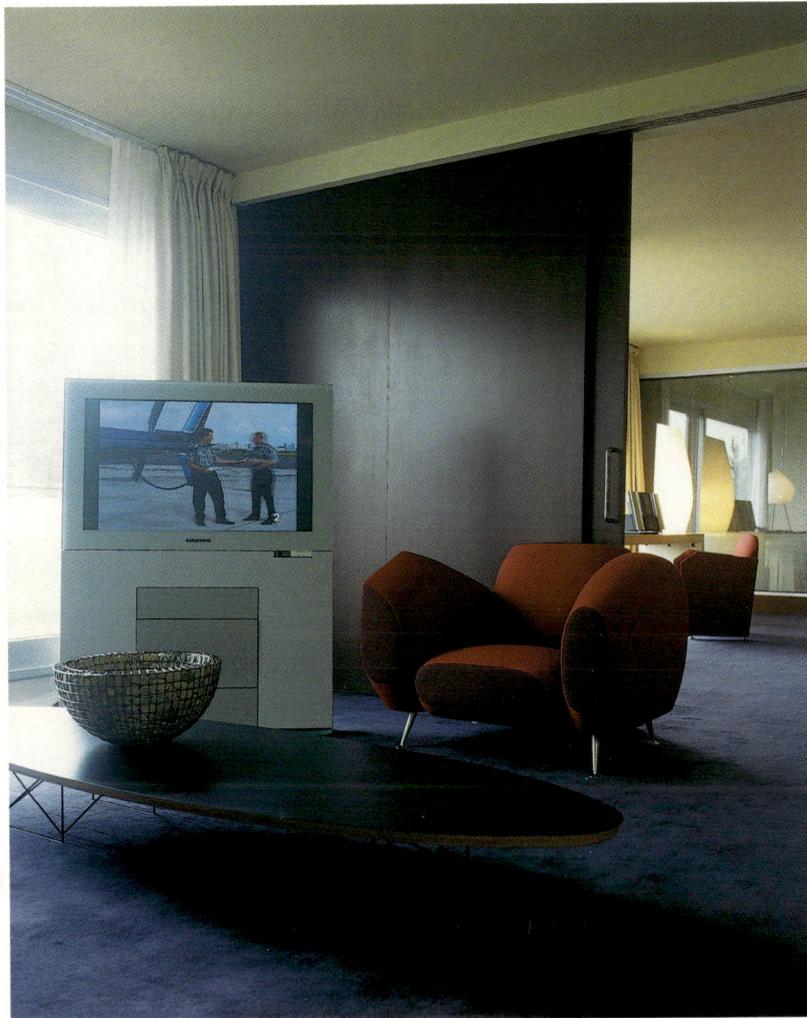

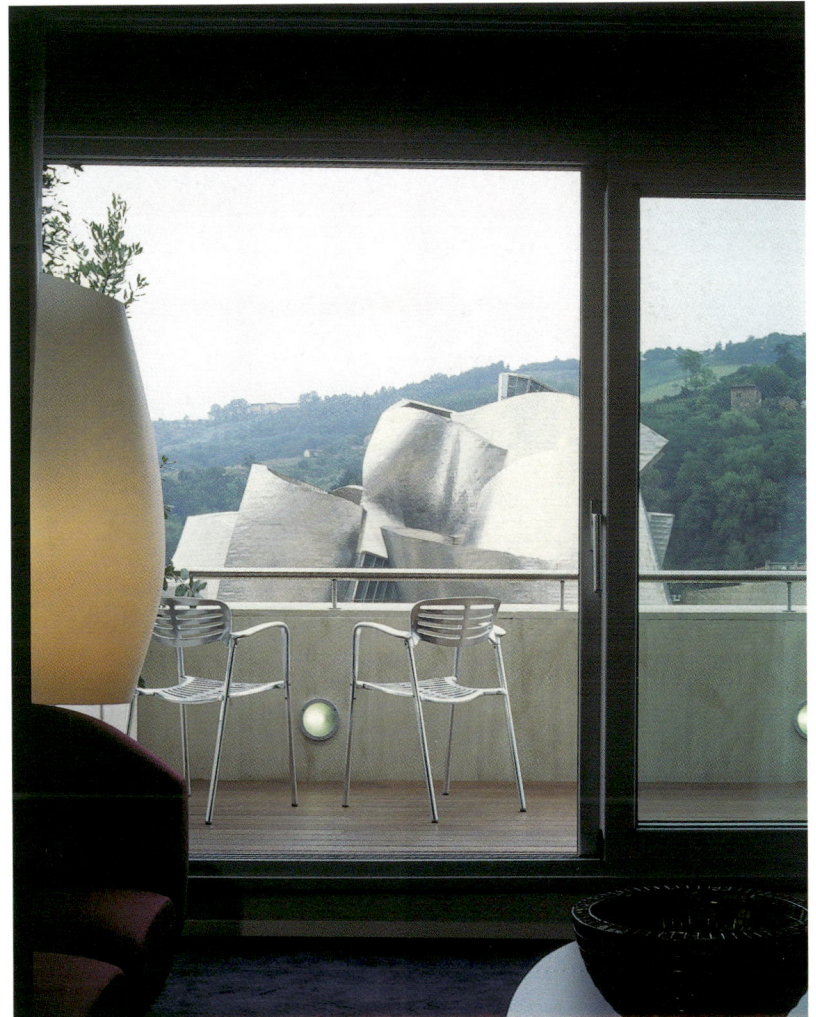

Every floor and the interior of each room have been personalized with a range of colors and special elements that combine to create an extraordinary ambience. The furniture, lighting, and accessories are pieces by designers such as Philippe Starck, Arne Jacobsen, Alvar Aalto, and Le Corbusier.

Hillside
SU

Konyaalti, 07050, Antalya, Turkey Tel: +90 242 249 0700 Fax: +90 242 249 0707 su@hillside.com.tr www.hillside.com.tr

Antalya, the city where this surprising hotel is located, is in the middle of a landscape of sharp contrasts. The main tourist enclave in Turkey, Antalya is an attractive city with boulevards lined with palm trees and a recreational marina where competitions are regularly held and trophies awarded. The surrounding region offers vistas of impressive natural beauty along with amazing historic ruins that date back to the Greek and Roman civilizations. Modern tourist conveniences abound as well as well-preserved historical sites that offer visitors an array of options for sight-seeing. The Hillside SU is a real alternative, different from a designer hotel, not just in this region but for tourism in general.

The design of the building—exterior and interior—is a mix of styles that harkens back to the 1970s and reflects a new interpretation of the big chain hotel. Its angular architecture, details, and finishes make a great white backdrop against which different shapes and grades of lighting, and a great variety of colors and textures, are placed. In the large central space of the building, where the main lobby is located, six large disco balls stand out, creating a permanent show. This atmosphere, exuberant and sophisticated, is one that is found throughout the public areas of the hotel, resulting in an interior landscape of shine, color, and a bit of mystery.

Architect: **Eren Talu** Photographer: **Tamer Yilmaz** Location: **Antalya, Turkey** Opening date: **2003**

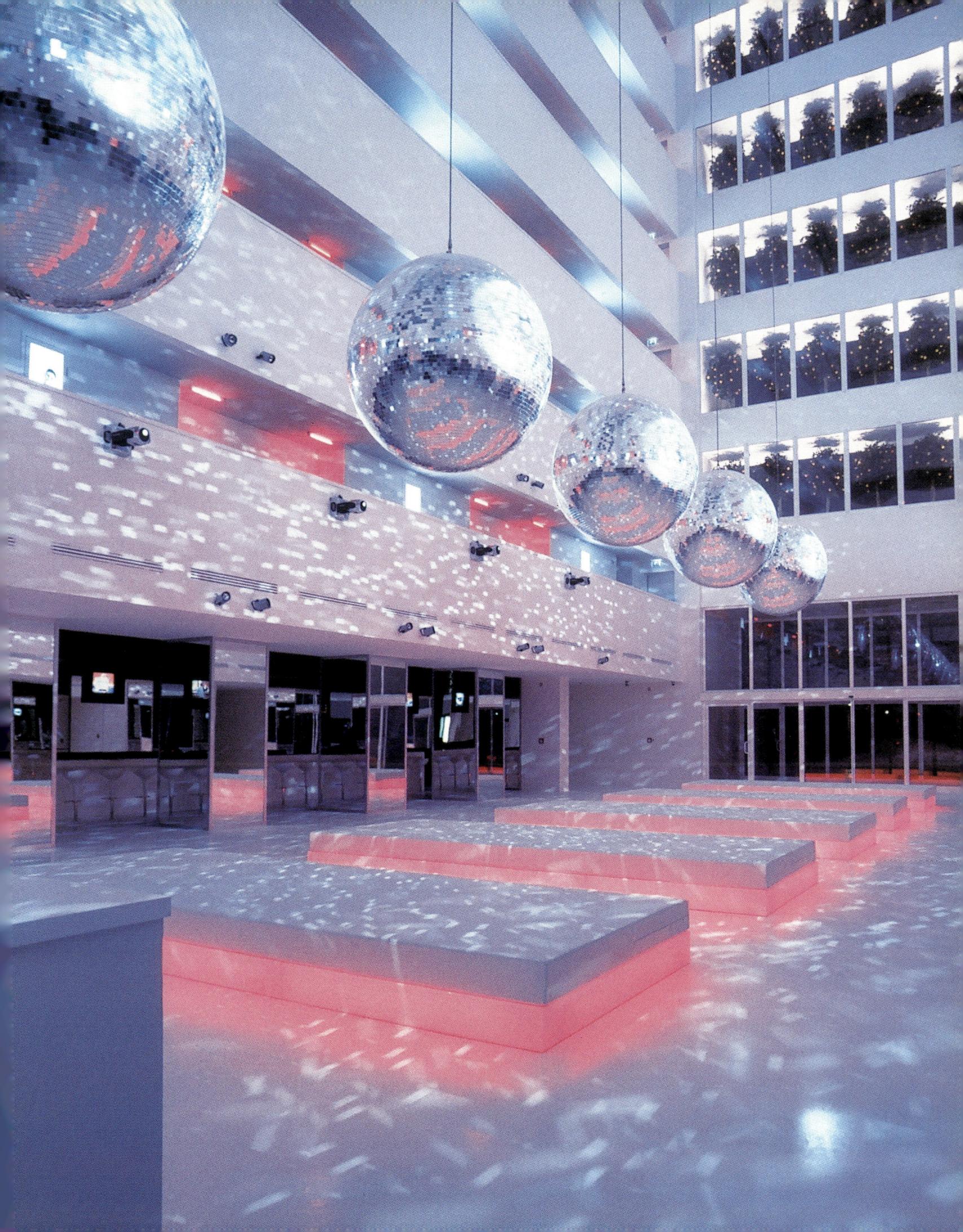

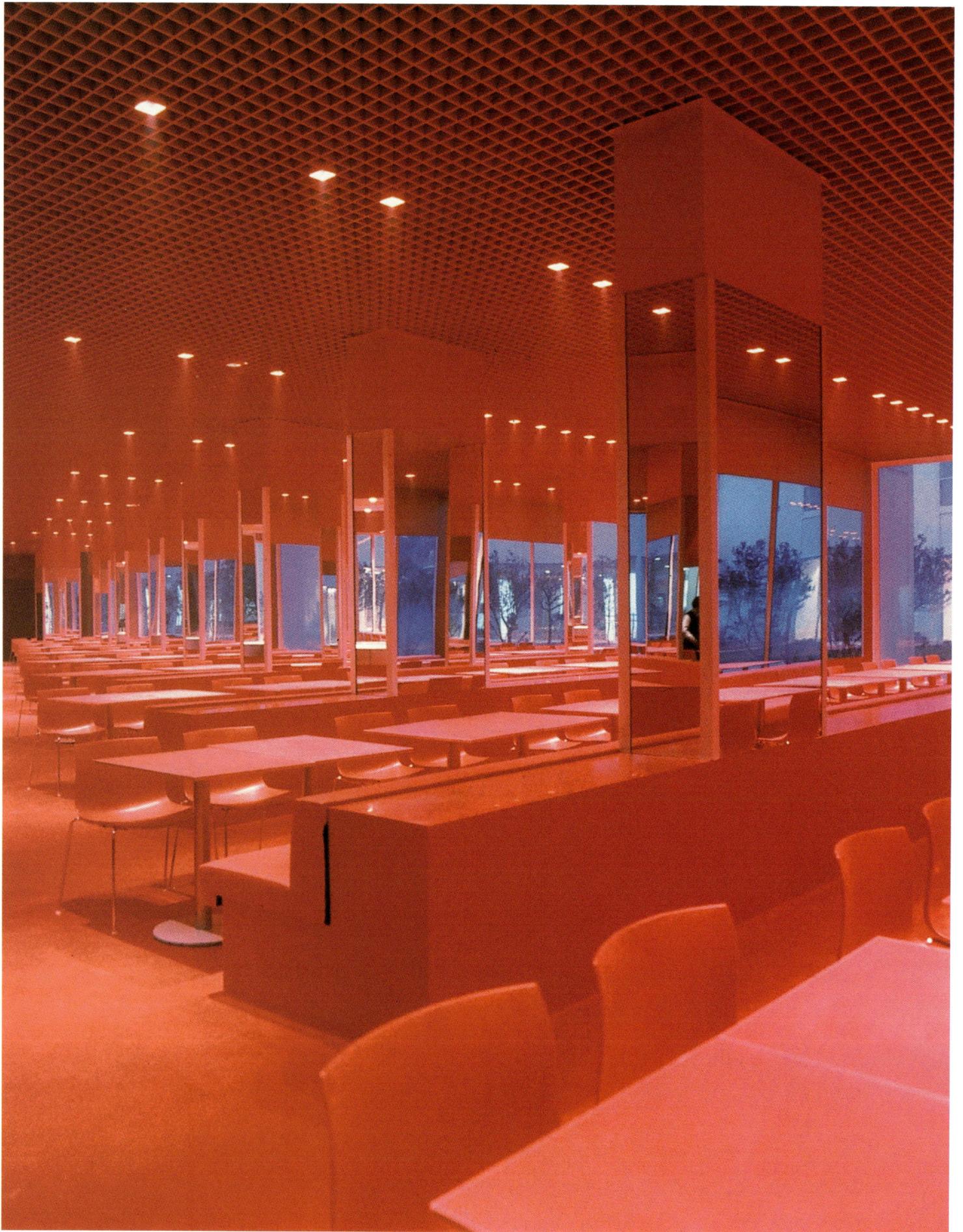

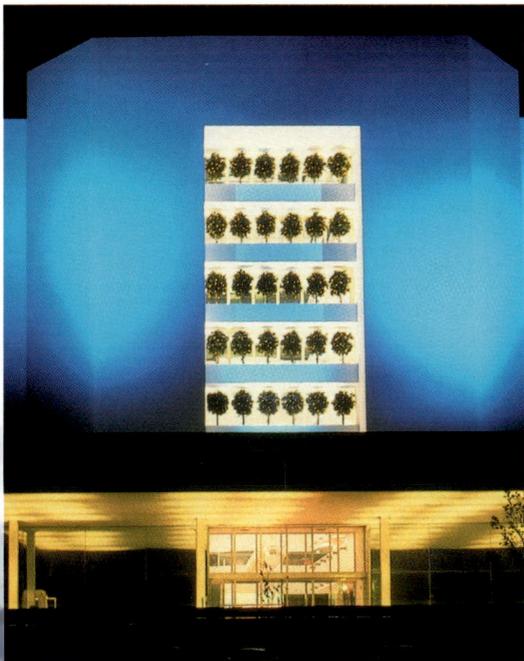

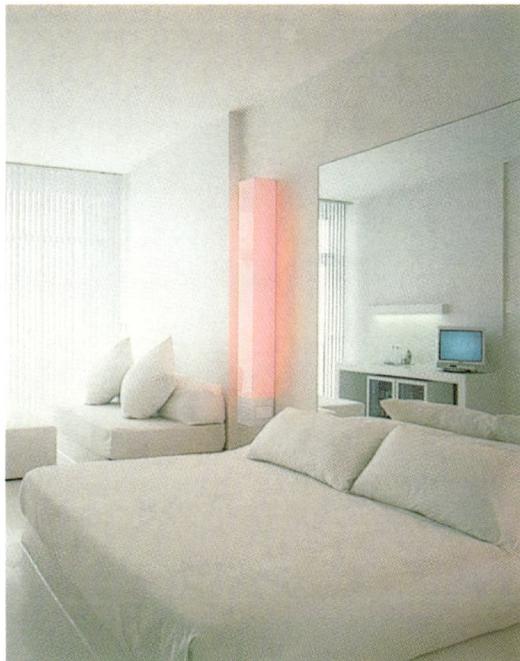

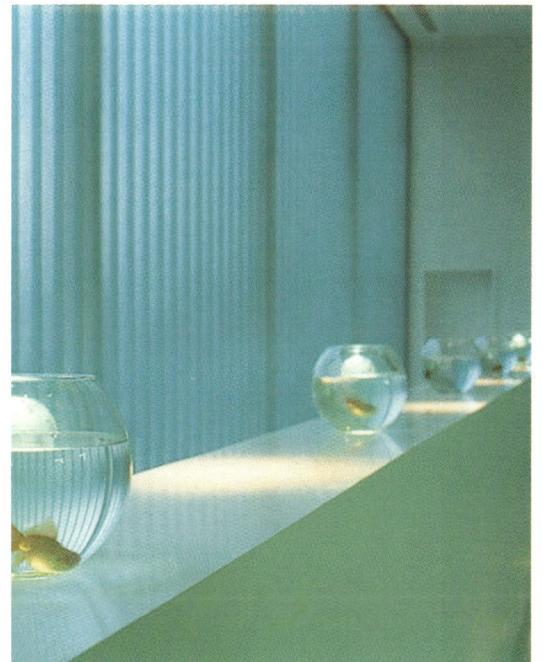

The guest rooms, in contrast to the public areas of the hotel, are characterized by their minimalist, light style. The white décor creates a fresh, relaxed ambience that makes this the ideal place to relax and enjoy the view of the sea.

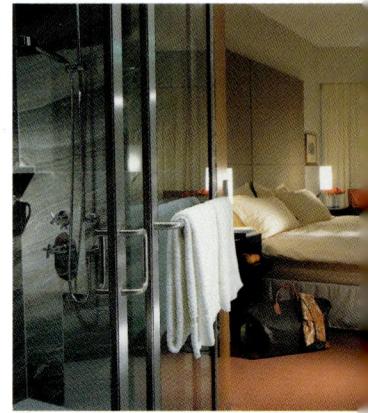

Grand

Hyatt Berlin

Marlene-Dietrich-Platz 2, 10785 Berlin, Germany Tel: +49 30 2553 1234 Fax: +49 30 2553 1235 berlin@hyatt.de www.berlin.grand.hyatt.com

During the nineteenth century Potsdamer Platz was one of the most popular walking spots in Berlin and, during the 1920s, one of the busiest squares in Europe. After its near-complete destruction during World War II and the erection of the Berlin Wall, it became a no man's land. The Grand Hyatt Berlin is anchored in Potsdamer Platz's new development, built to restore the square and convert it into the new financial district of the city. The powerful presence of the hotel, marked by the solid mass of its volume, is a reflection of the city's history of cosmopolitan architecture.

From the exterior the large arcades and the detailed work in sandstone and red brick stand out. In the interior a restrained and elegant style prevails through the use of a contemporary approach and cutting-edge elements. Purely decorative effects have been avoided in order to put more emphasis on objects that accentuate the building's architectural context. In the entrance are two large, eye-catching inverted glass pyramids that hang from the ceiling, producing light and shadow effects over the course of the day. Slabs of illuminated alabaster and a work of art by artist Gerold Millar dominate the main wall. A dark marble staircase leads to the banquet hall.

Architect: **Rafael Moneo** Interior designer: **Hannes Wettstein** Photographer: **Duccio Malagamba** (pages 287–91), **Hyatt Hotel** (pages 292–93)

Location: **Berlin, Germany** Opening Date: **1998**

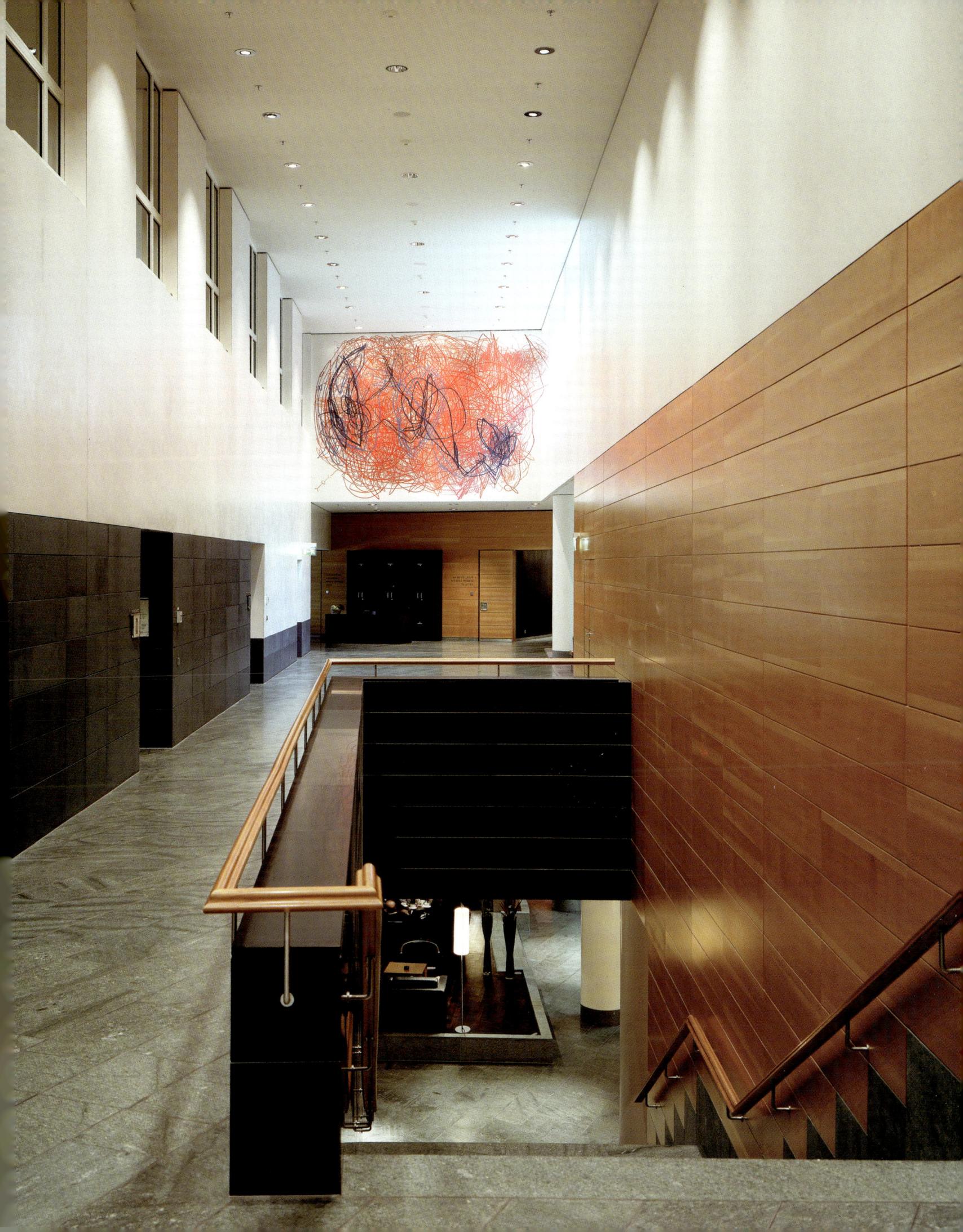

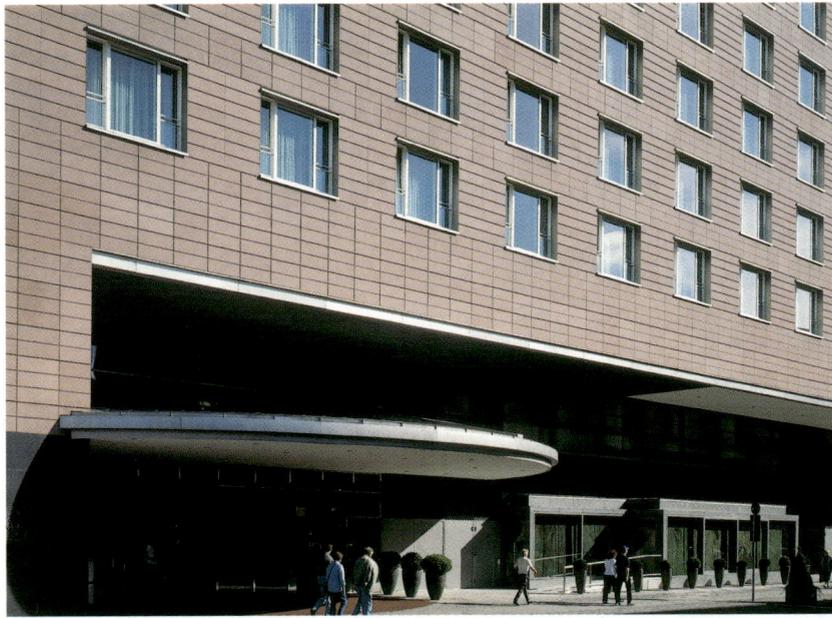

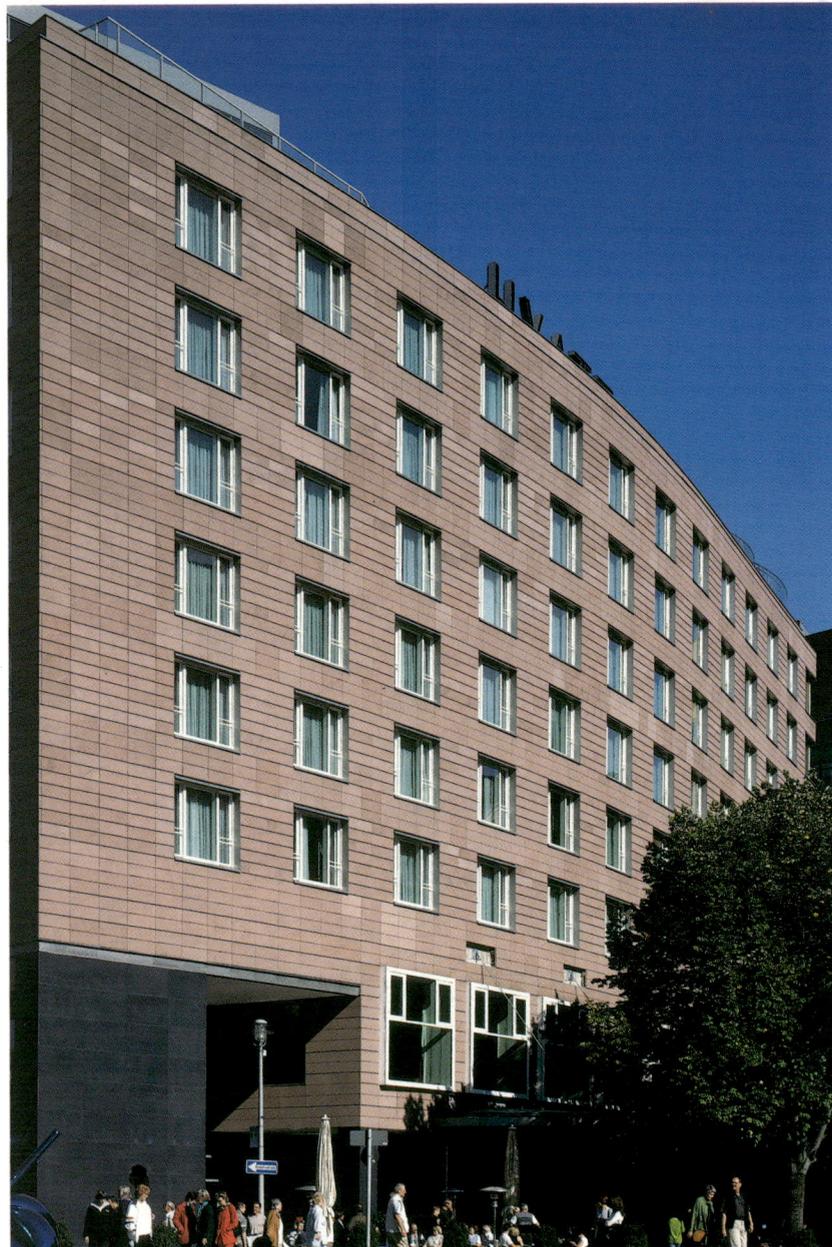

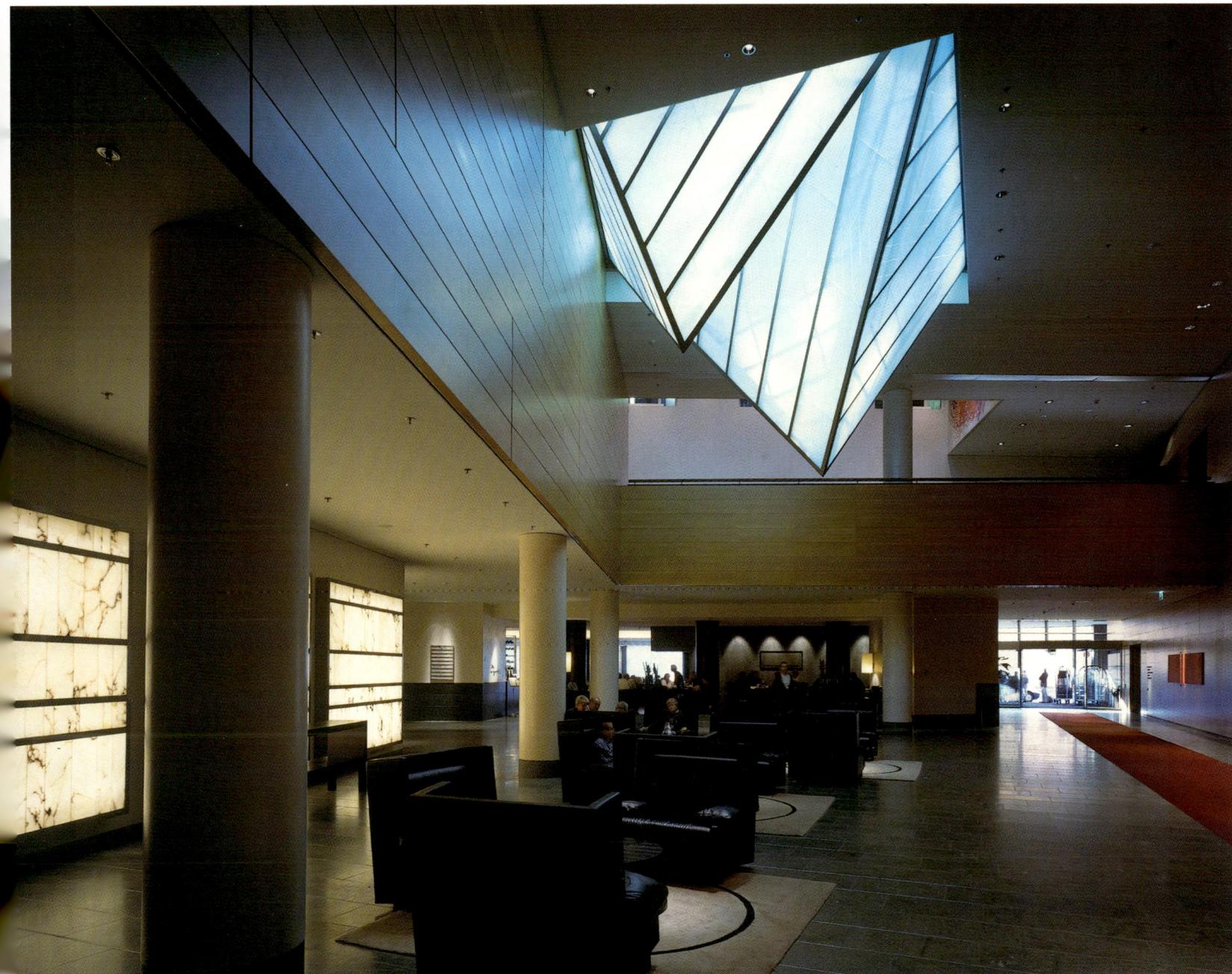

The high ceiling makes it seem as if it were suspended in midair, a gesture which accentuates the entrance to the building while at the same integrates the exterior into the interior.

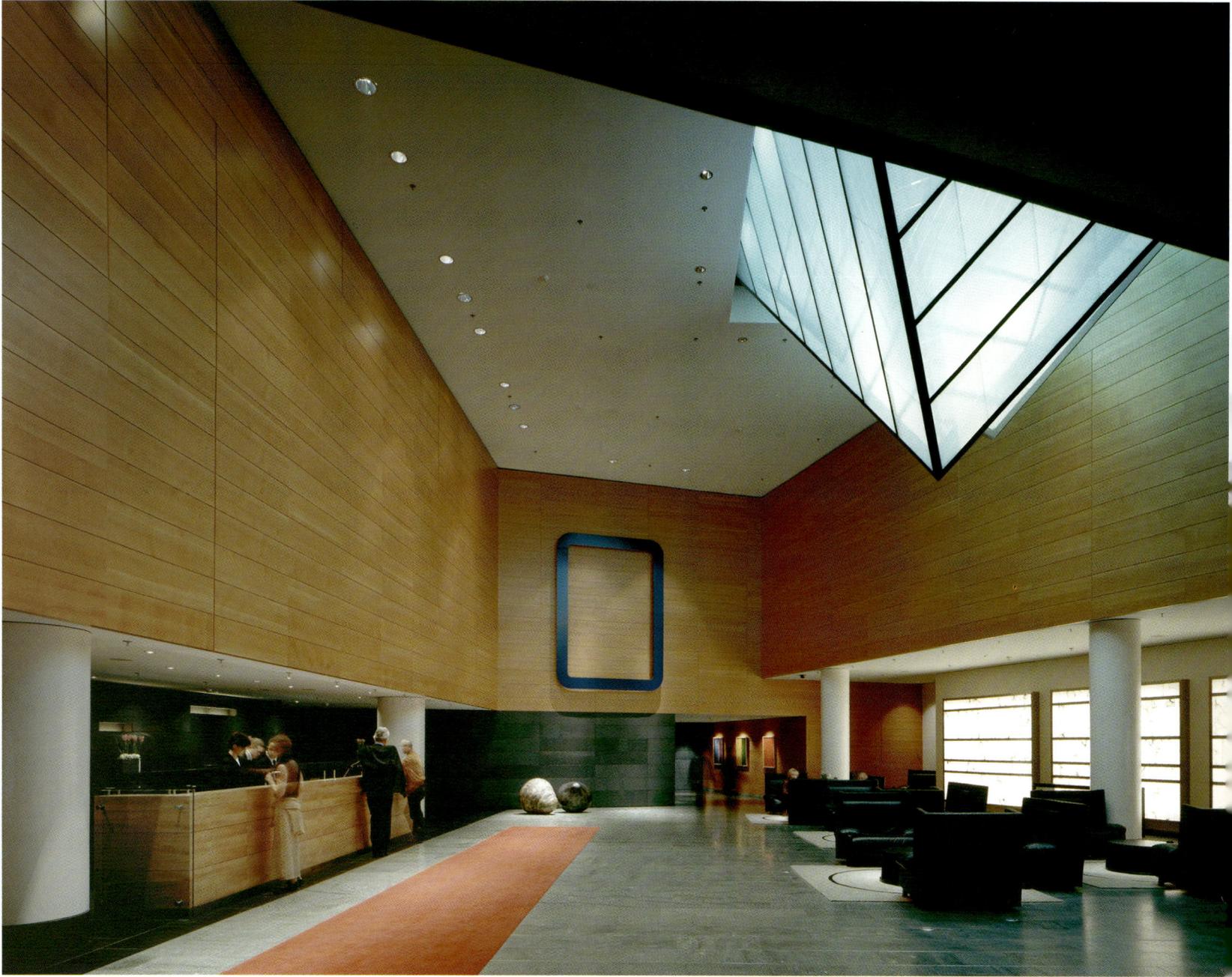

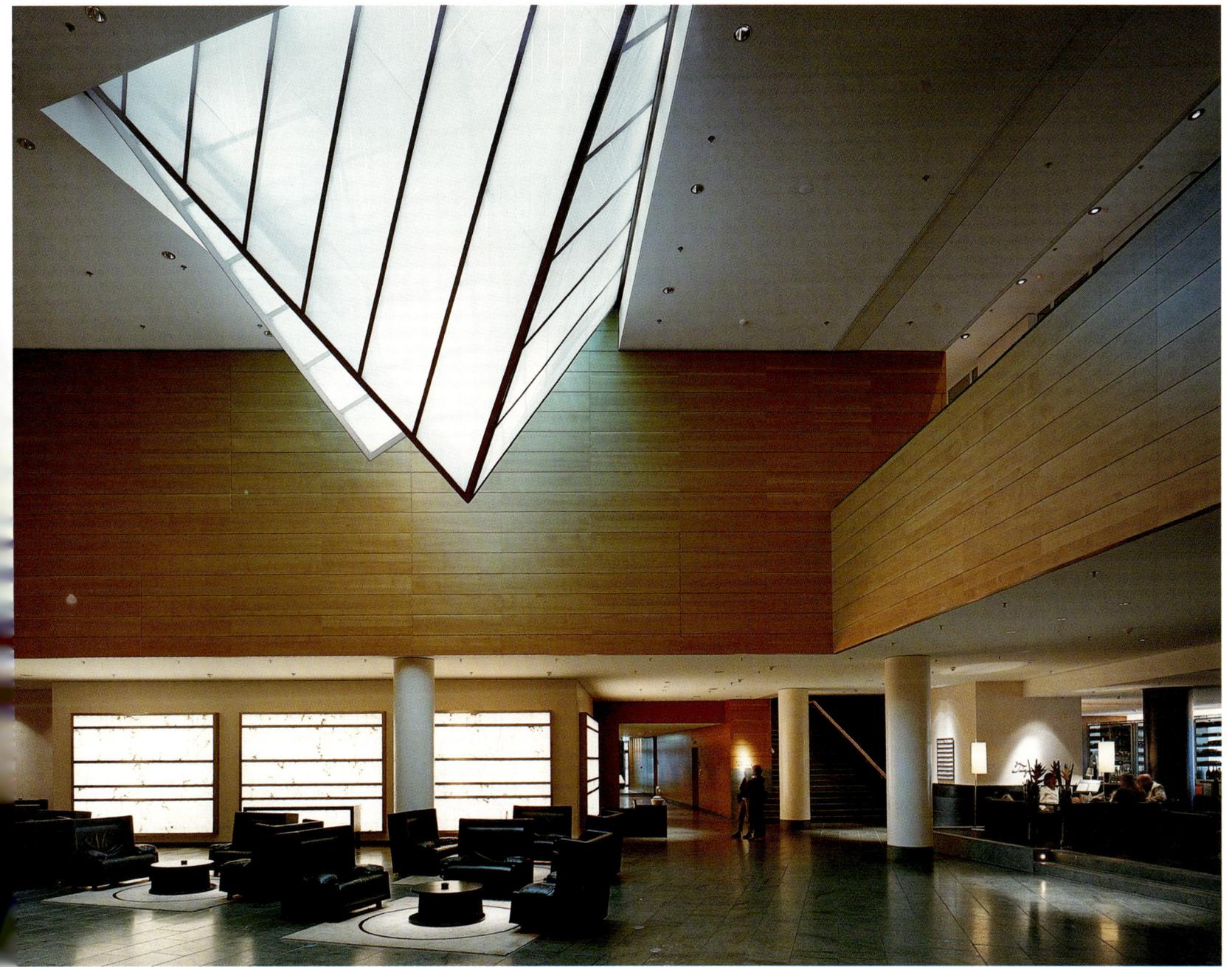

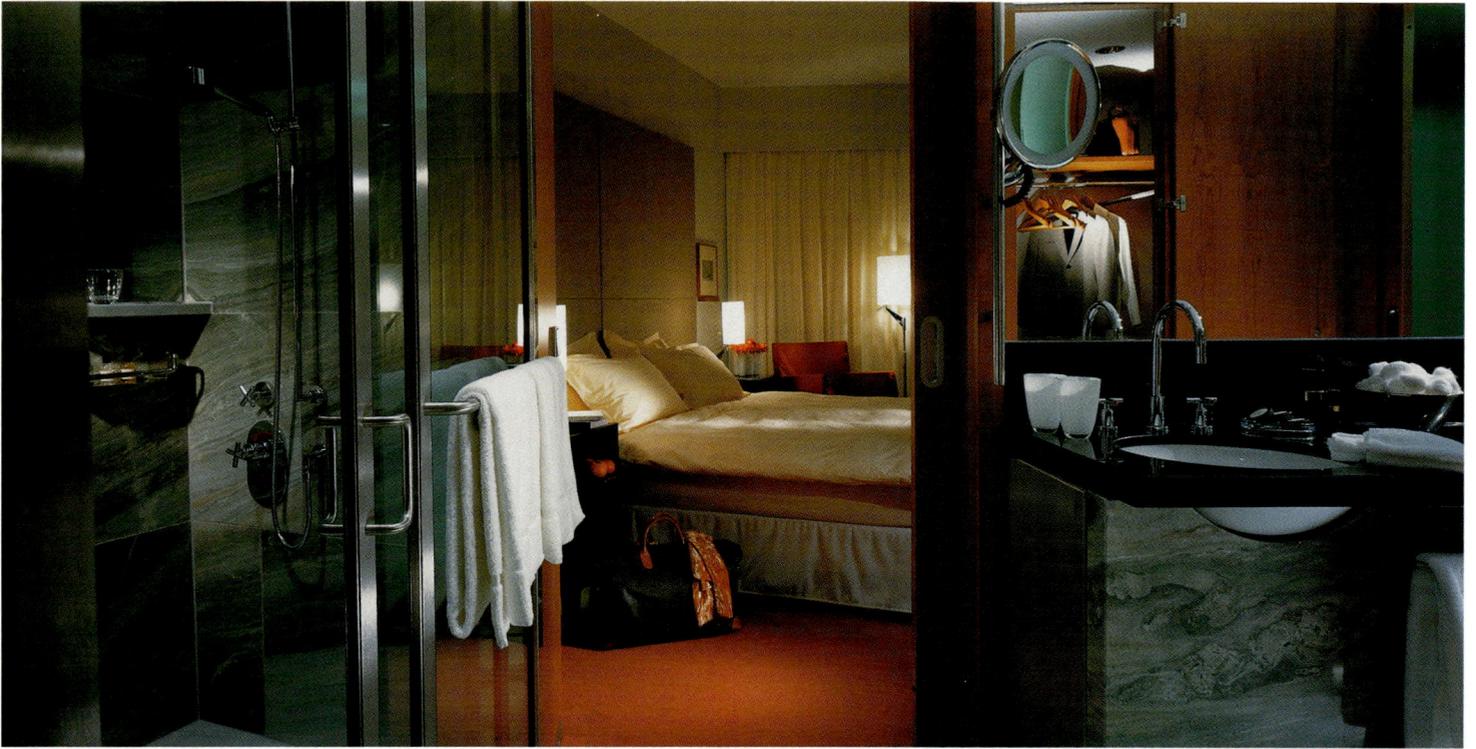
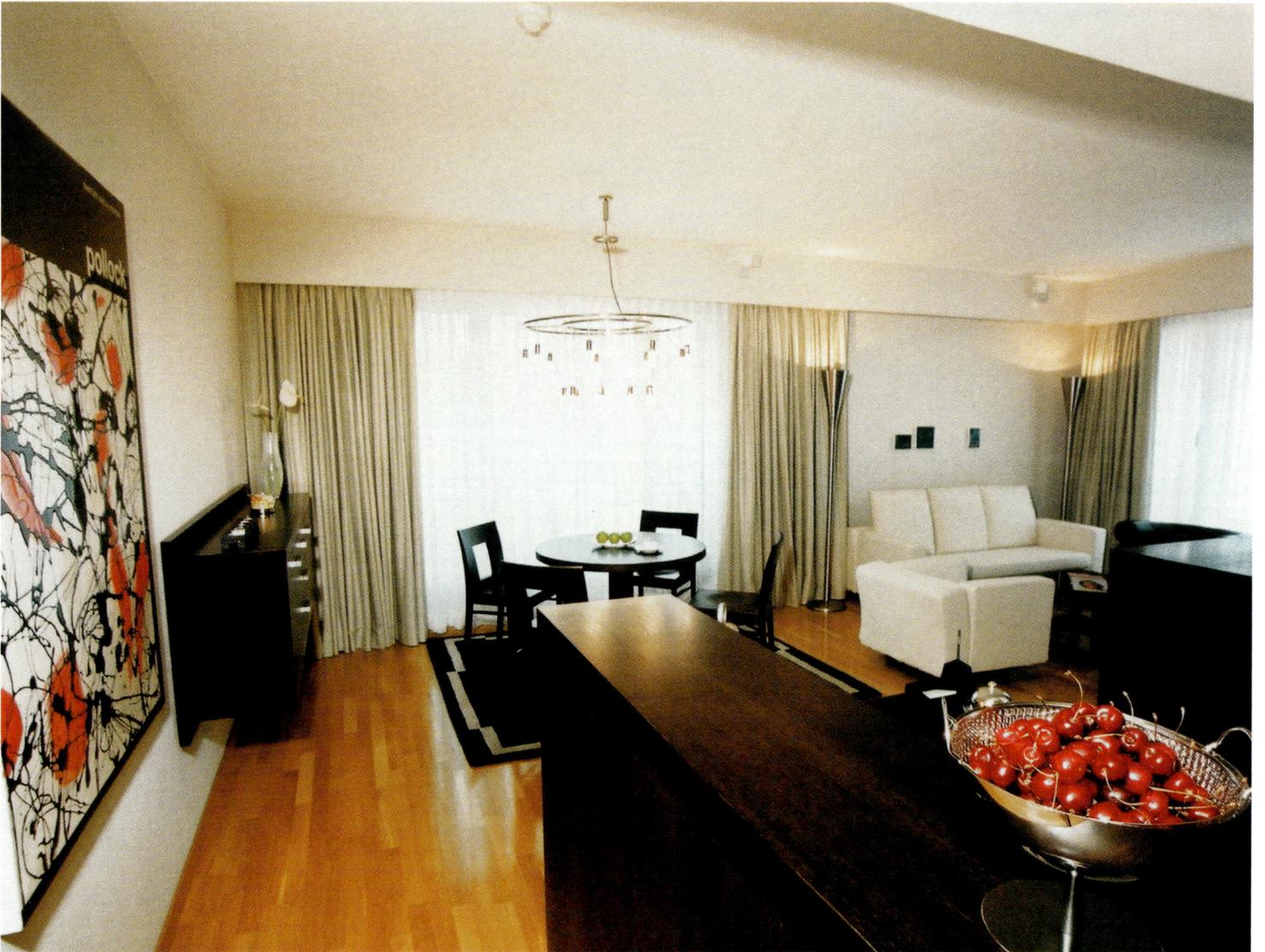

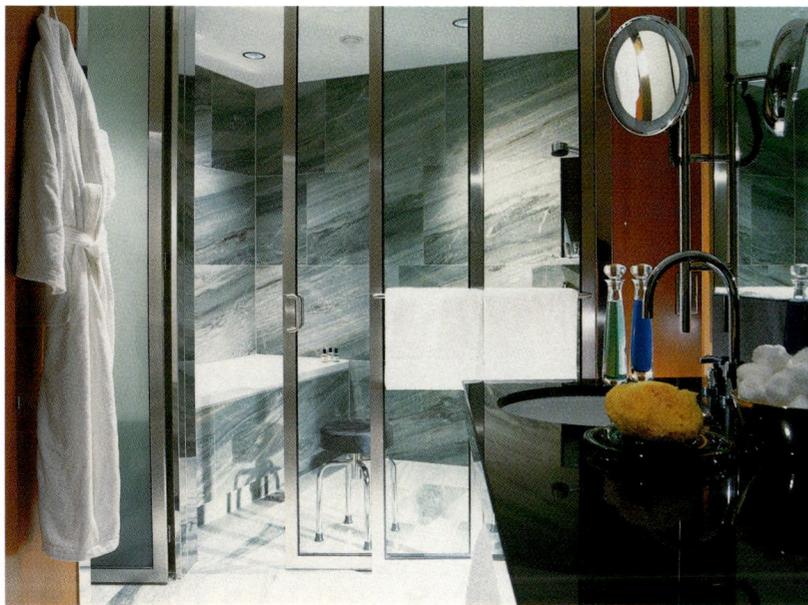

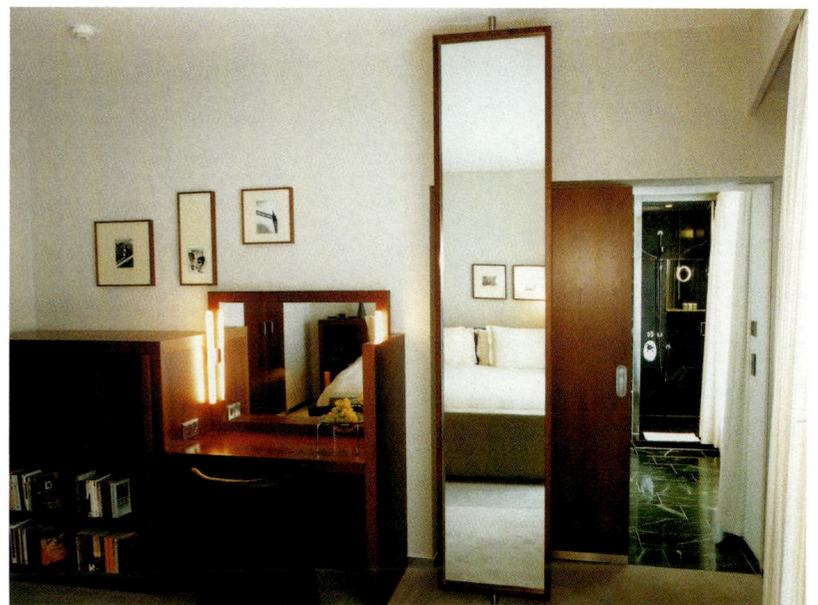

In the rooms a luxurious space is created by using high-quality materials and finishes such as the marble that covers the bathroom walls, the wood used for the floors and pieces of furniture, and the natural fiber textiles for the upholstery, linens, and curtains.

Hotel
Atoll Helgoland

Lung Wai 27, 27498 Helgoland, Germany Tel: +49 04725 800 0 Fax: +49 04725 800 444 info@atoll.de www.atoll.de

An especially picturesque environment filled with a visual richness that evokes relaxation was sought for the location of this hotel. The coast of Helgoland Island fit the bill perfectly. This location, in the north of Germany, is known for its natural beauty and dramatic landscapes. The red clay tiles, the light stone, the sand dunes, and the rising and falling of the tides are the main attractions of this vacation destination, popular with the intellectual elite since the nineteenth century. The design of the building, although impressive, maintains a low profile and uses decoration and materials similar to those of the traditional architecture of the island.

From a distance the two side buildings blend seamlessly into the urban skyline while the central form, which contains the vertical elements, stands out due to its transparency and luminosity.

The interior design was inspired, in general, by the surrounding maritime atmosphere and elements. The structure of the building is divided into three horizontal bodies housing the different areas of the hotel. The first floor is set aside for the spa, where the pool, sauna, steam room, and gym are located. The bar, restaurant, and outdoor terrace, which offers one of the best views on the island, are all located on the top floor.

Architect: **Alison Brooks Architects** Photographers: **H.G. Esch, Anke Müllerklein, Peter Nobek, Arnulf Hettrich** Location: **Helgoland, Germany** Opening date: **1999**

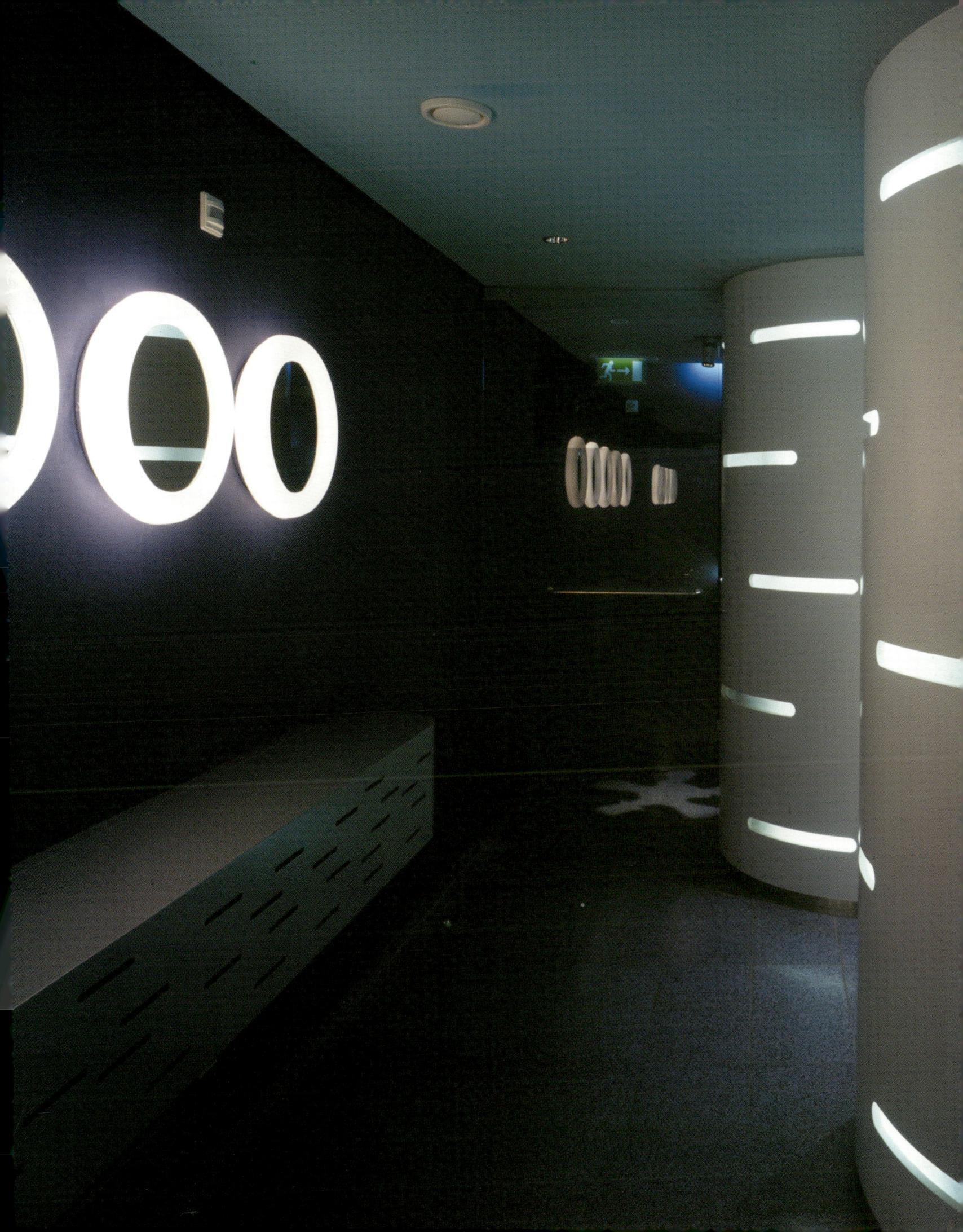

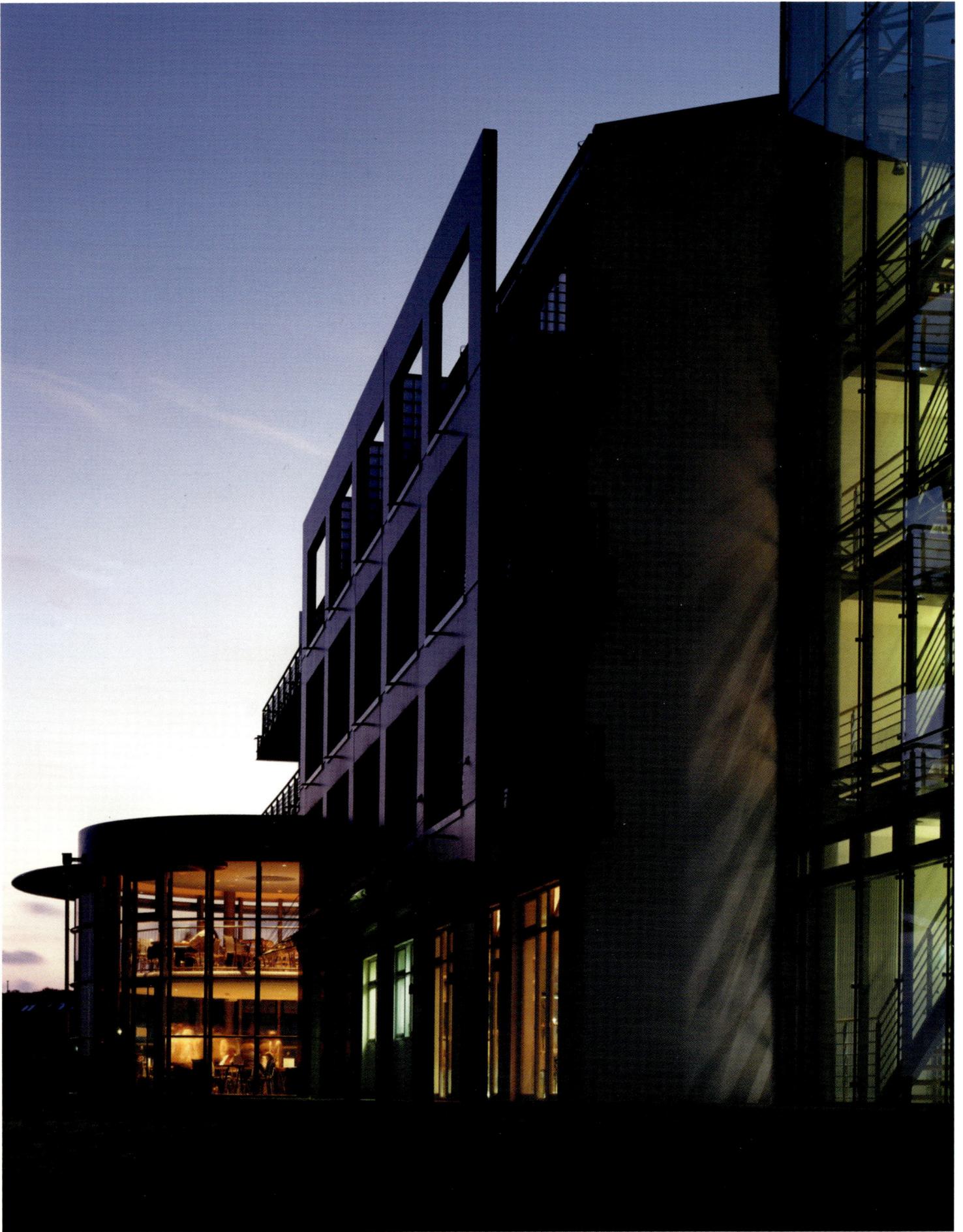

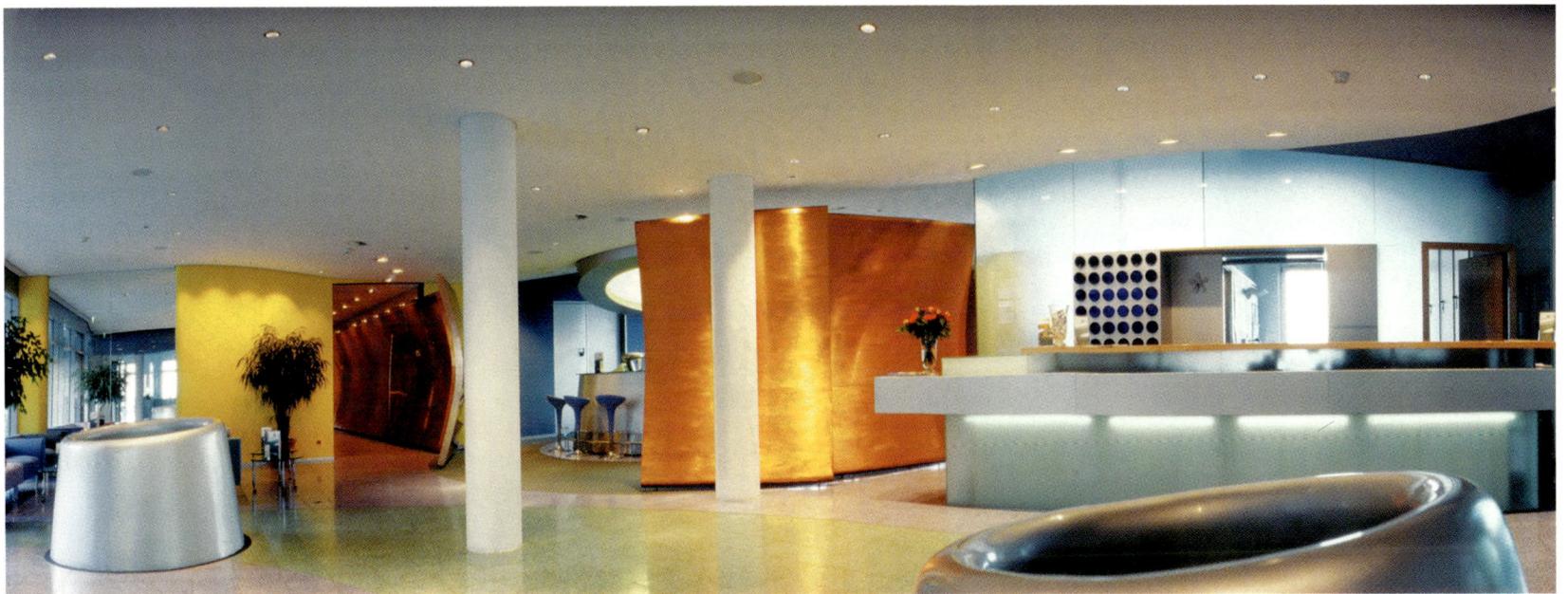

The breakdown of the building into different small-scale bodies helps integrate it into its surroundings. The materials used for the façades, where metal and glass prevail, lighten the structure.

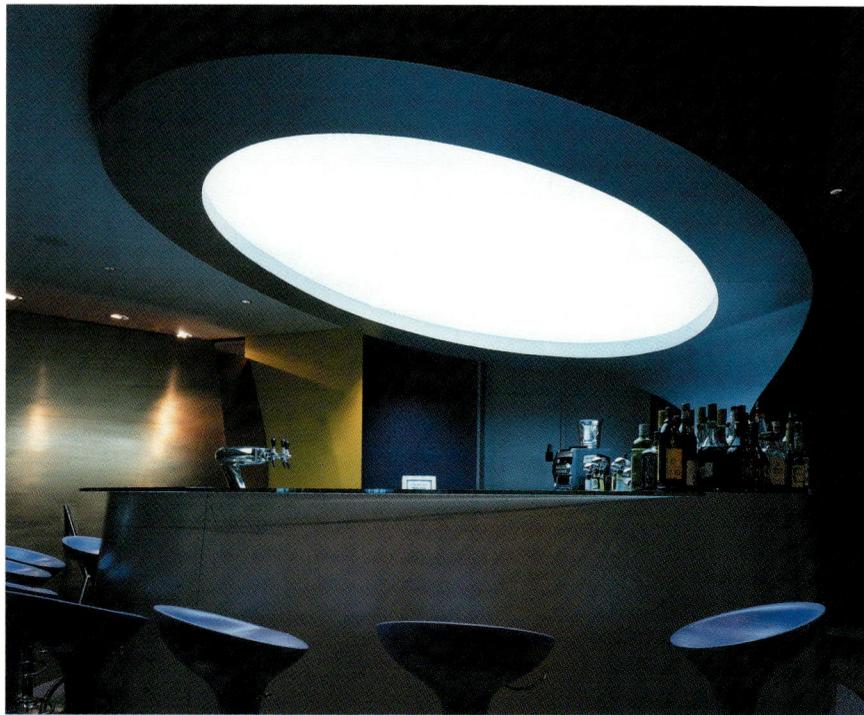

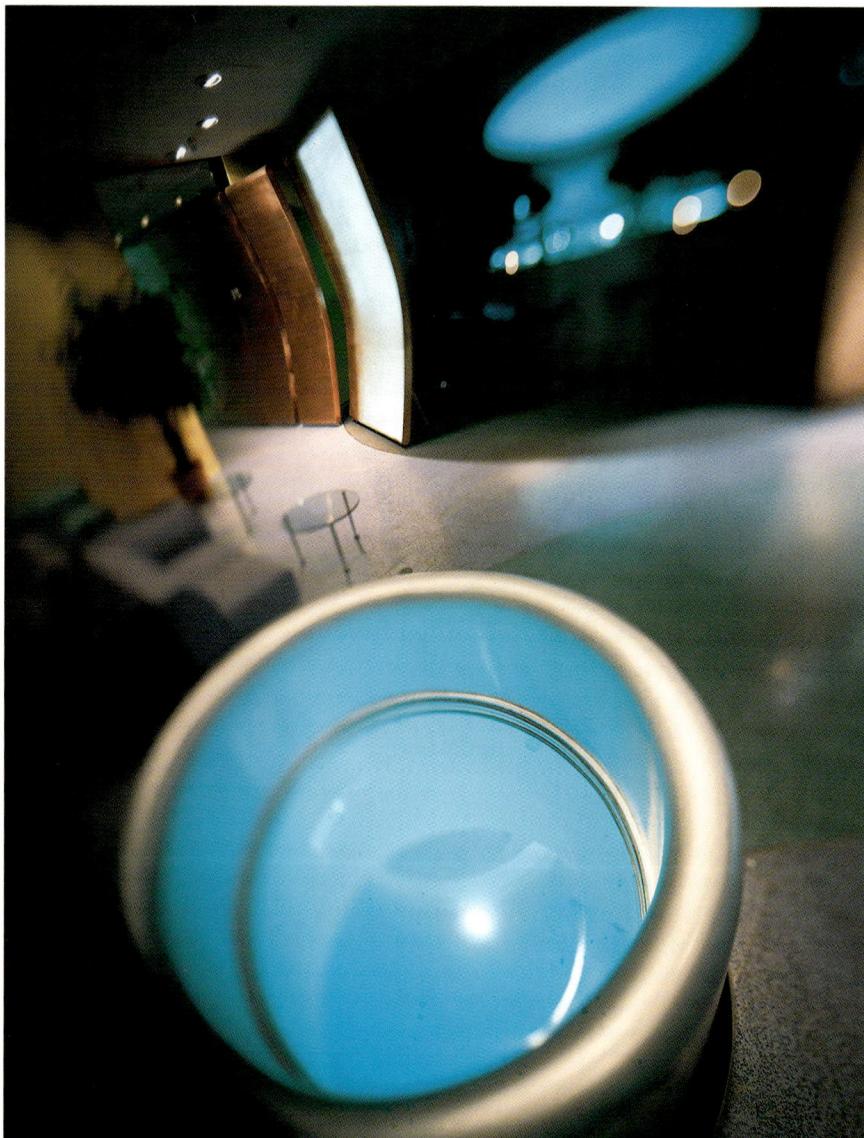

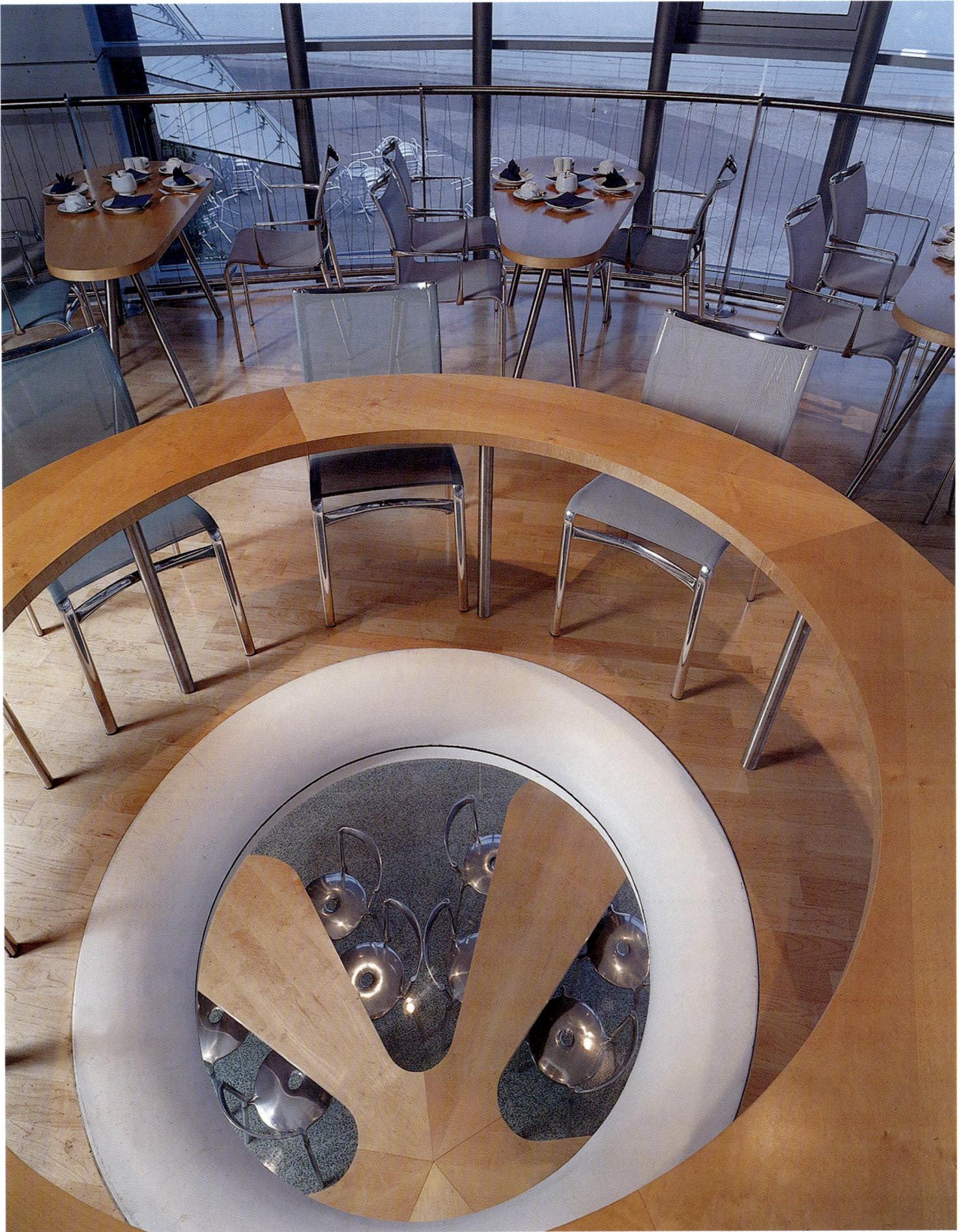

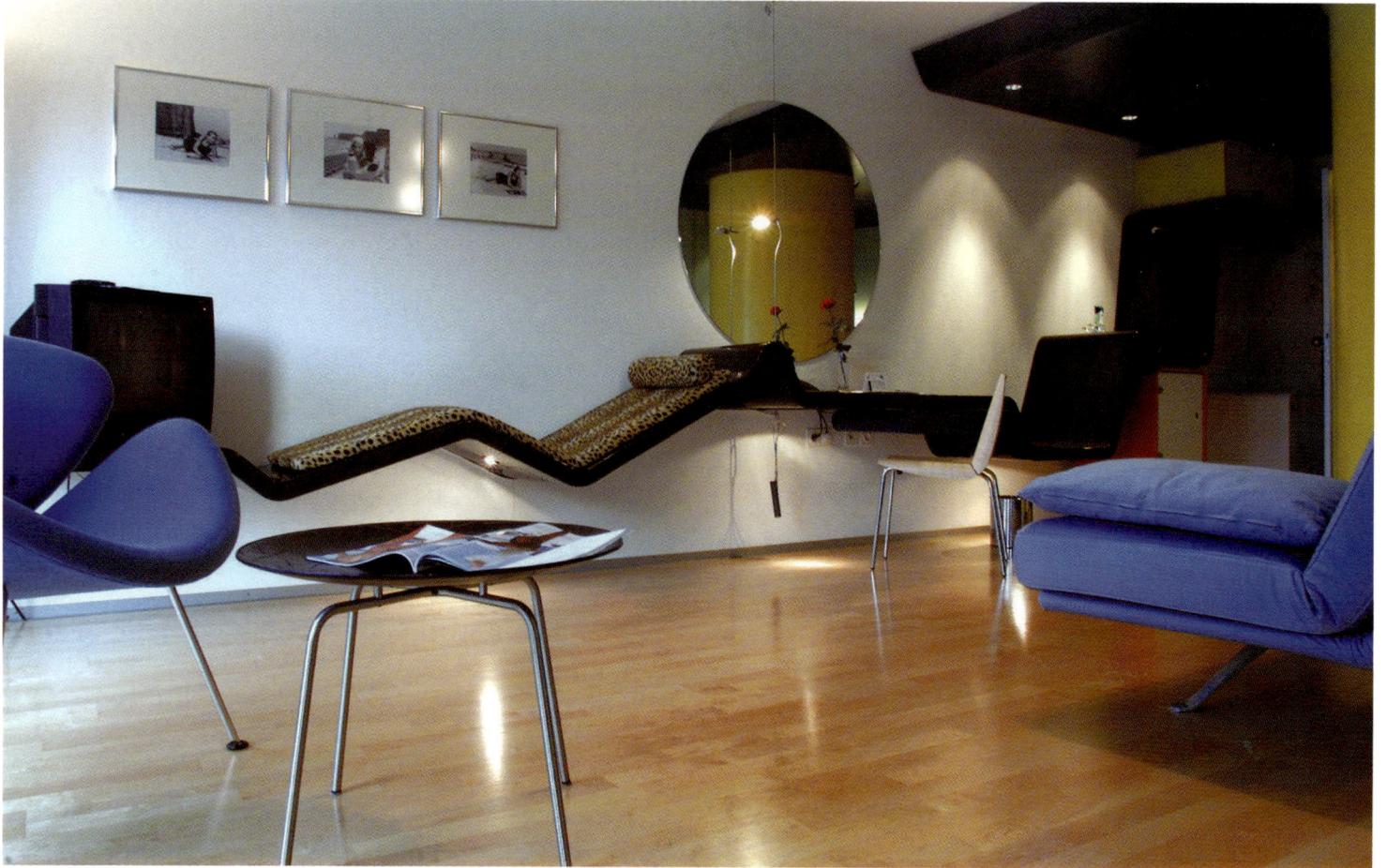

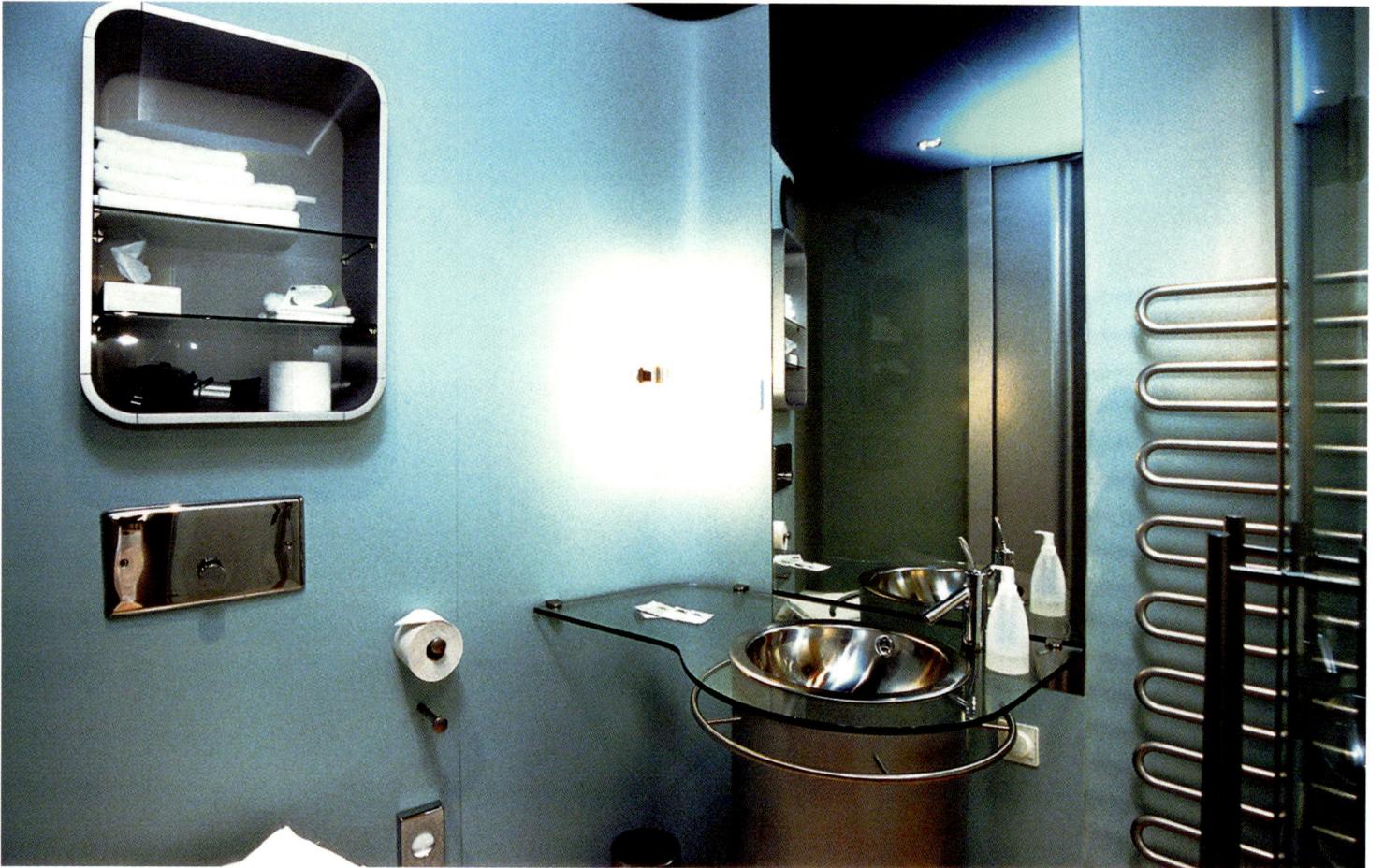

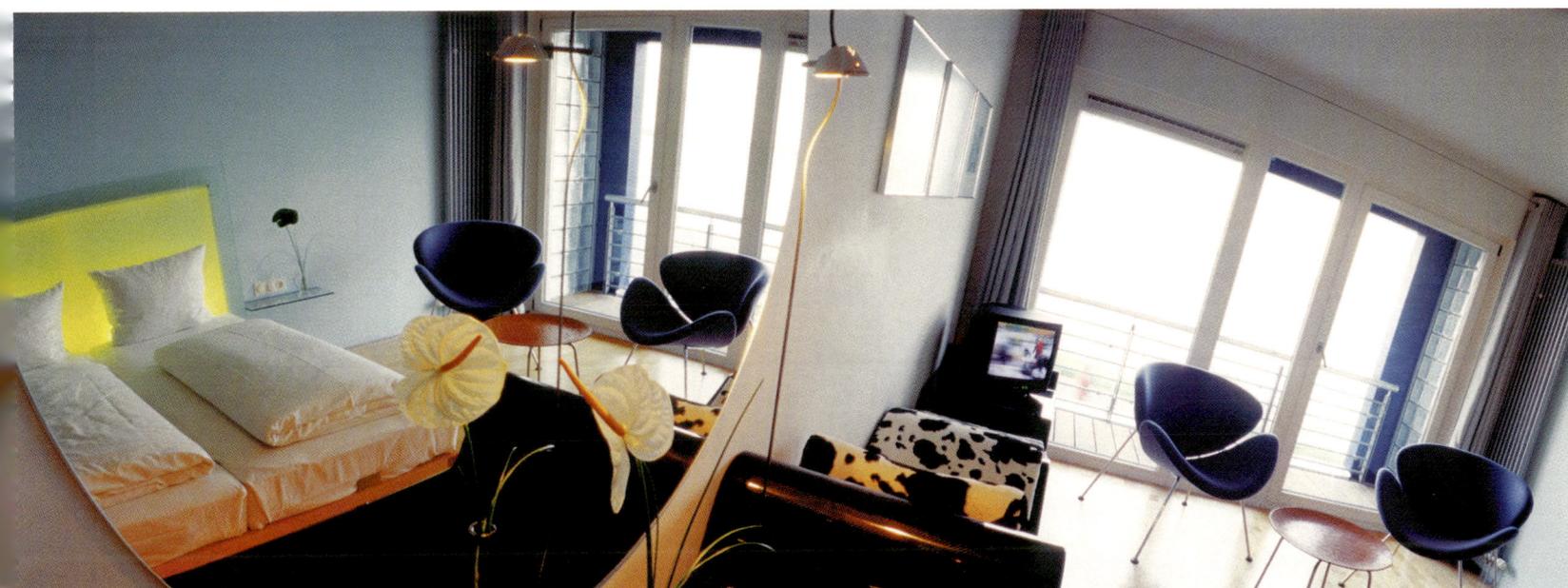

atoll helgoland

Clear nautical references are evident in the shape of the furniture and the look of the finishes. Modern, almost futuristic elements take form in materials such as wood or metal. Color, rounded edges, and elemental geometric shapes are used reinforce the effect.

Emiliano

R. Oscar Freire 384, Jardim America, Sao Paulo, Brazil Tel: +55 11 3068 4399 www.emiliano.com.br

The task of designing the first designer hotel in Sao Paulo brought with it several challenges concerning its location as well as its size. A 23-story building situated on a narrow lot, the hotel was originally designed to be permanent housing before being adapted to its new use. A clean, refined style with Eastern references was chosen for the public areas, which include a conference room, lobby, lounges, and a spa. The magnificent location, in the heart of Sao Paolo's commercial and financial district, was taken advantage of by attempting to integrate the interior and exterior spaces. The lobby embraces the urban life in the street, while the guest rooms take advantage of the splendid view they have from the upper floors, and the spa area on the top floor is glassed-in with spectacular views of the sky and the city.

The absence of superfluous elements and the formal, austere language that characterizes the interior are noteworthy. On the first floor, where the reception area, a sushi bar, and a large restaurant are found, a generous proportion of the space has been set aside for foot traffic. The furnishings bring together pieces designed by the architect himself as well as by famous designers, creating an interesting mix of familiar and new objects. In the guest rooms, light wood was chosen for the doors, most of the furniture, and the decorative pieces in order to continue the Eastern references while also creating a warm, cozy environment.

Architect: Arthur de Mattos Casas Photographer: Tuca Reinés Location: Sao Paulo, Brazil Opening date: 2001

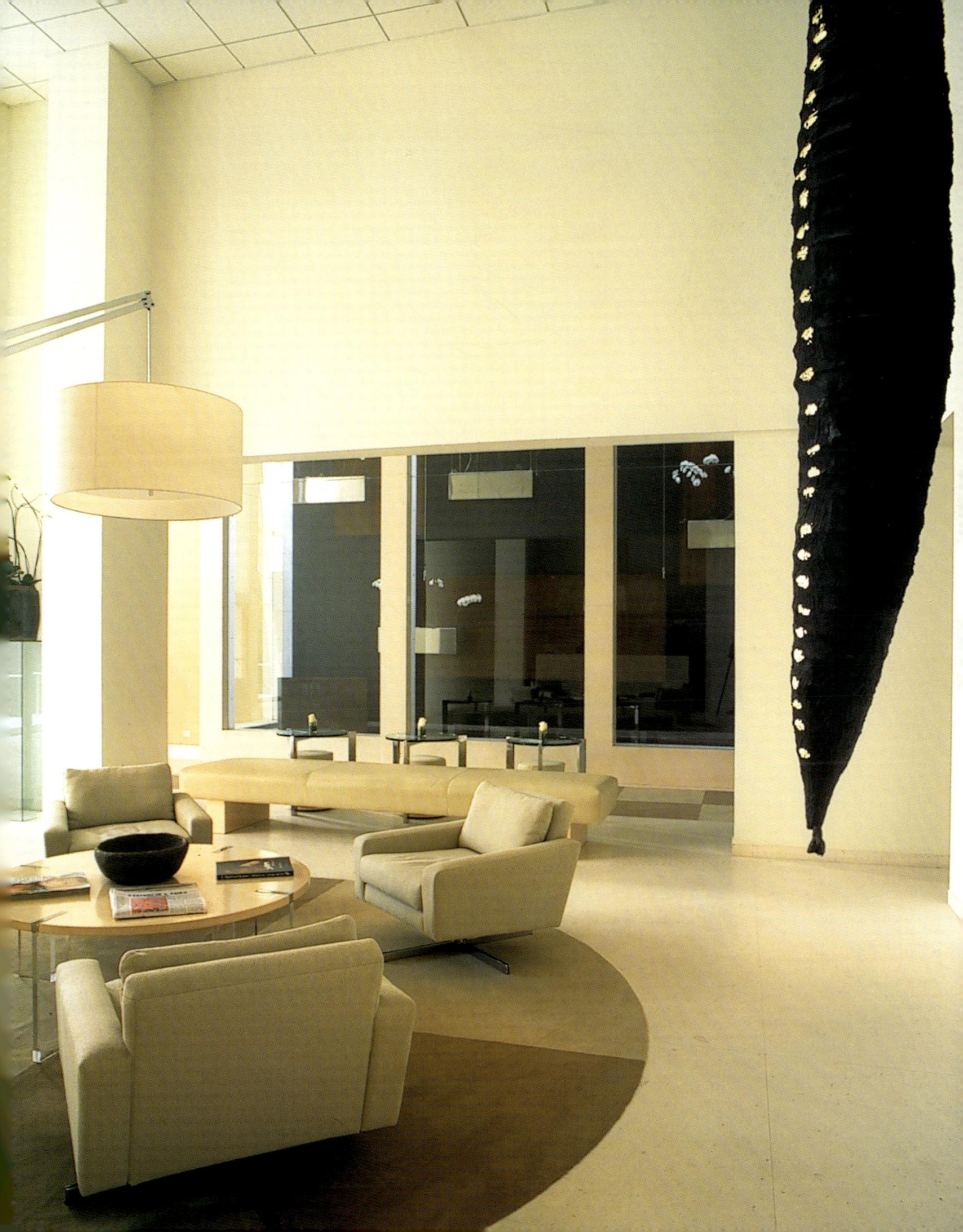

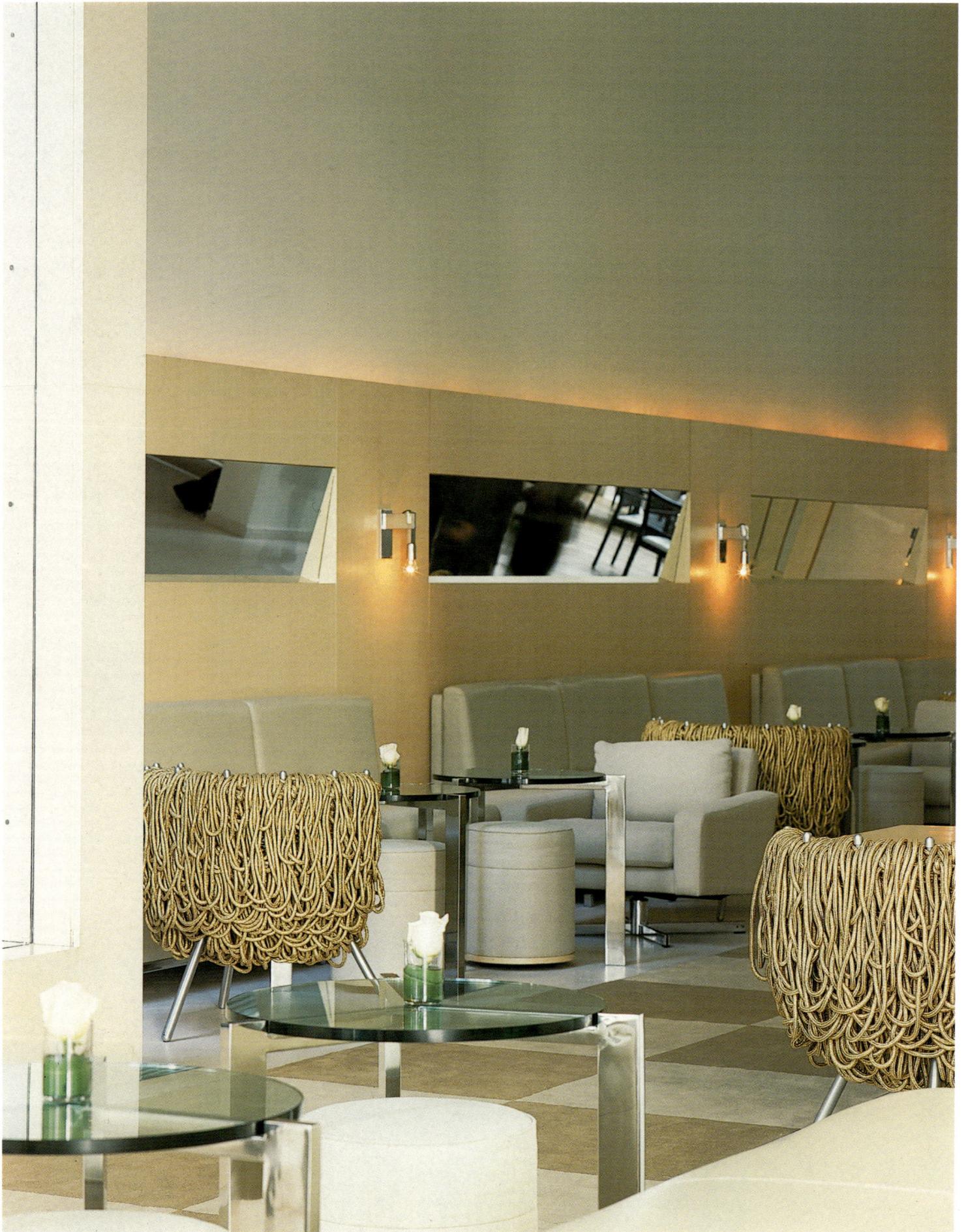

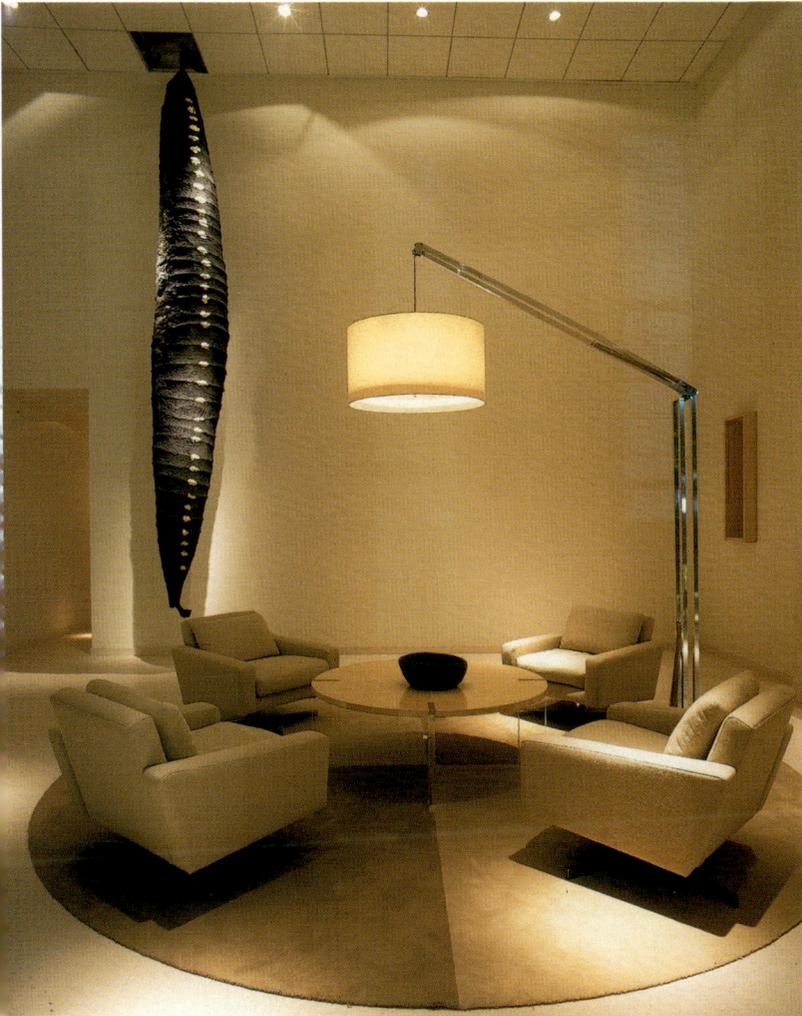

To counterbalance the narrow proportions of the lot, light colors were used for the furnishings and decorative objects in the public areas. The repetition of elements and the use of mirrors accentuate the widening effect.

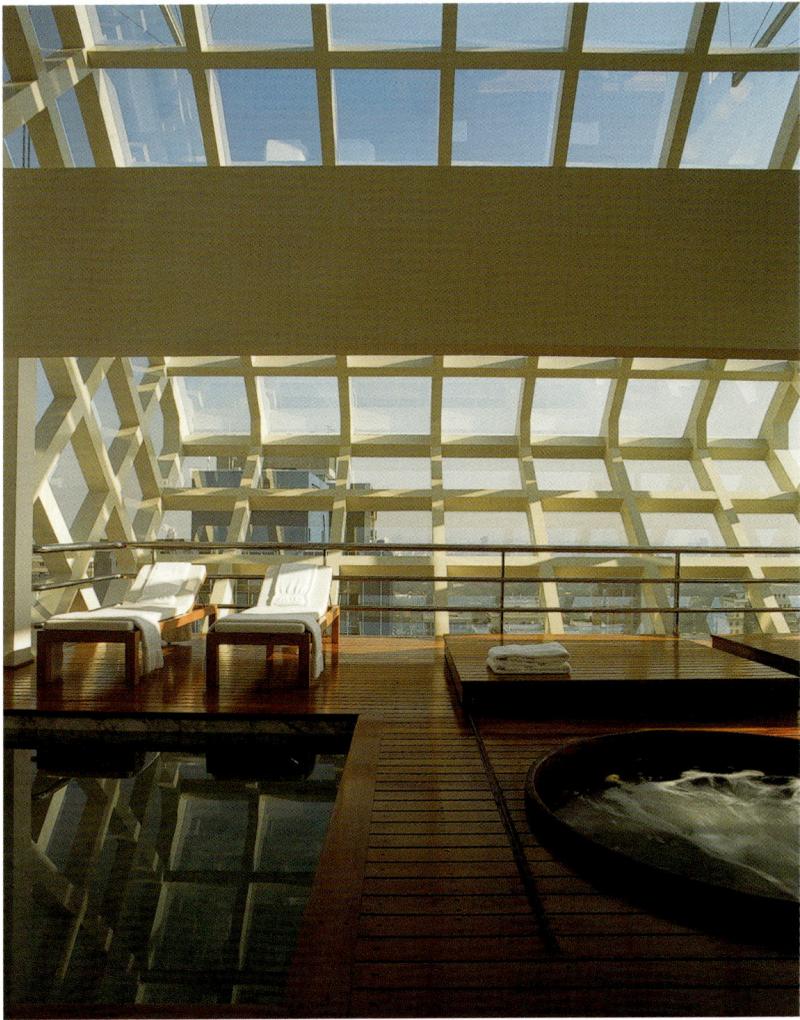
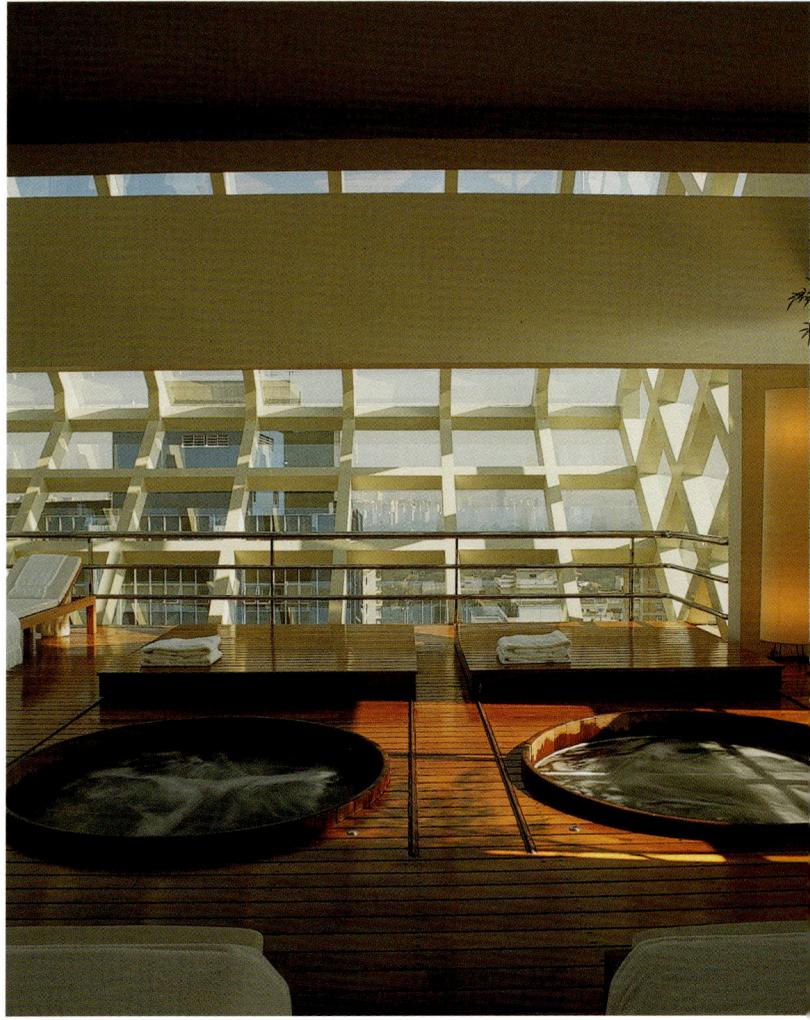
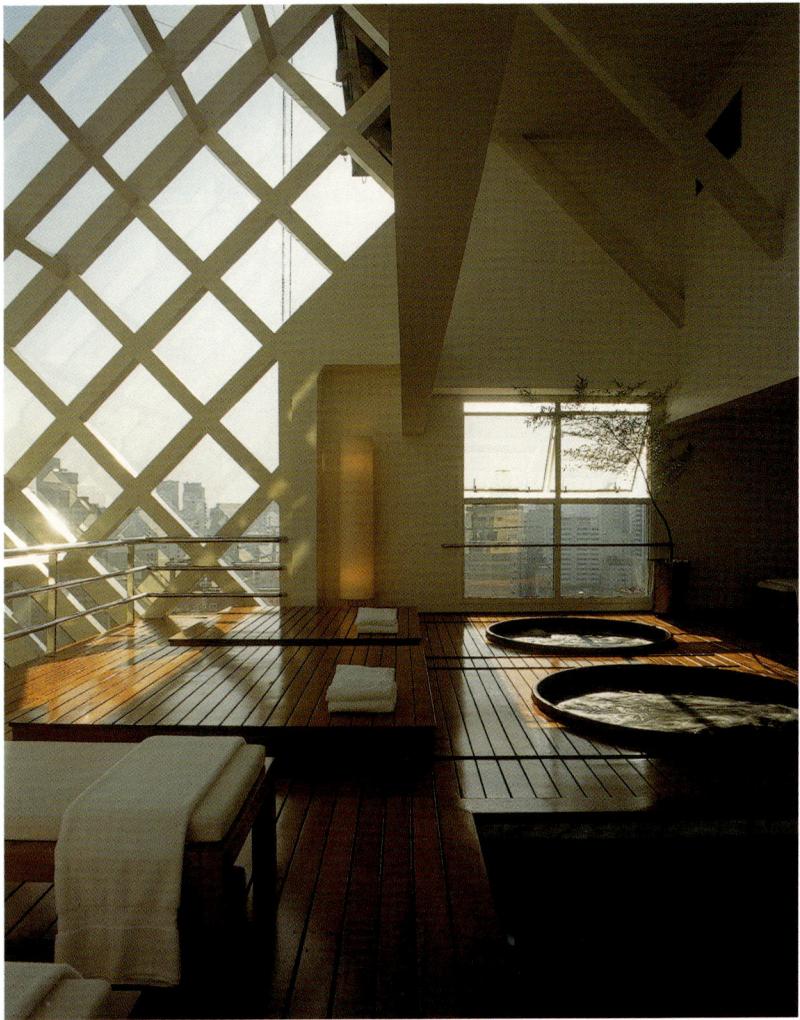
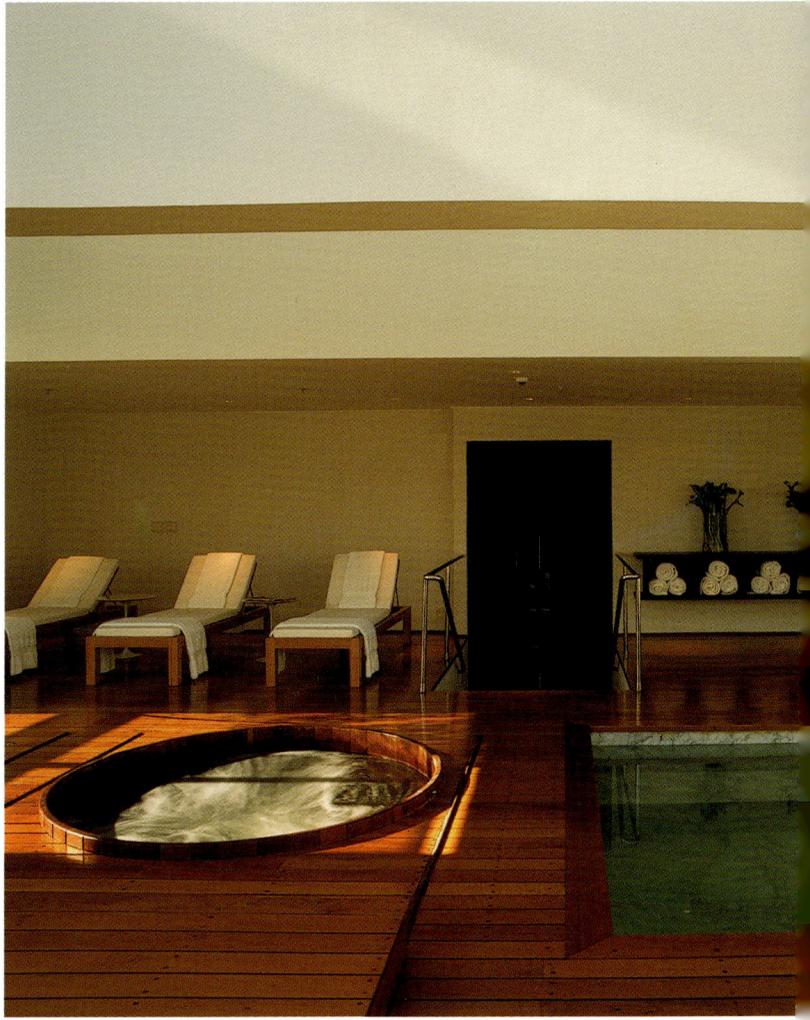

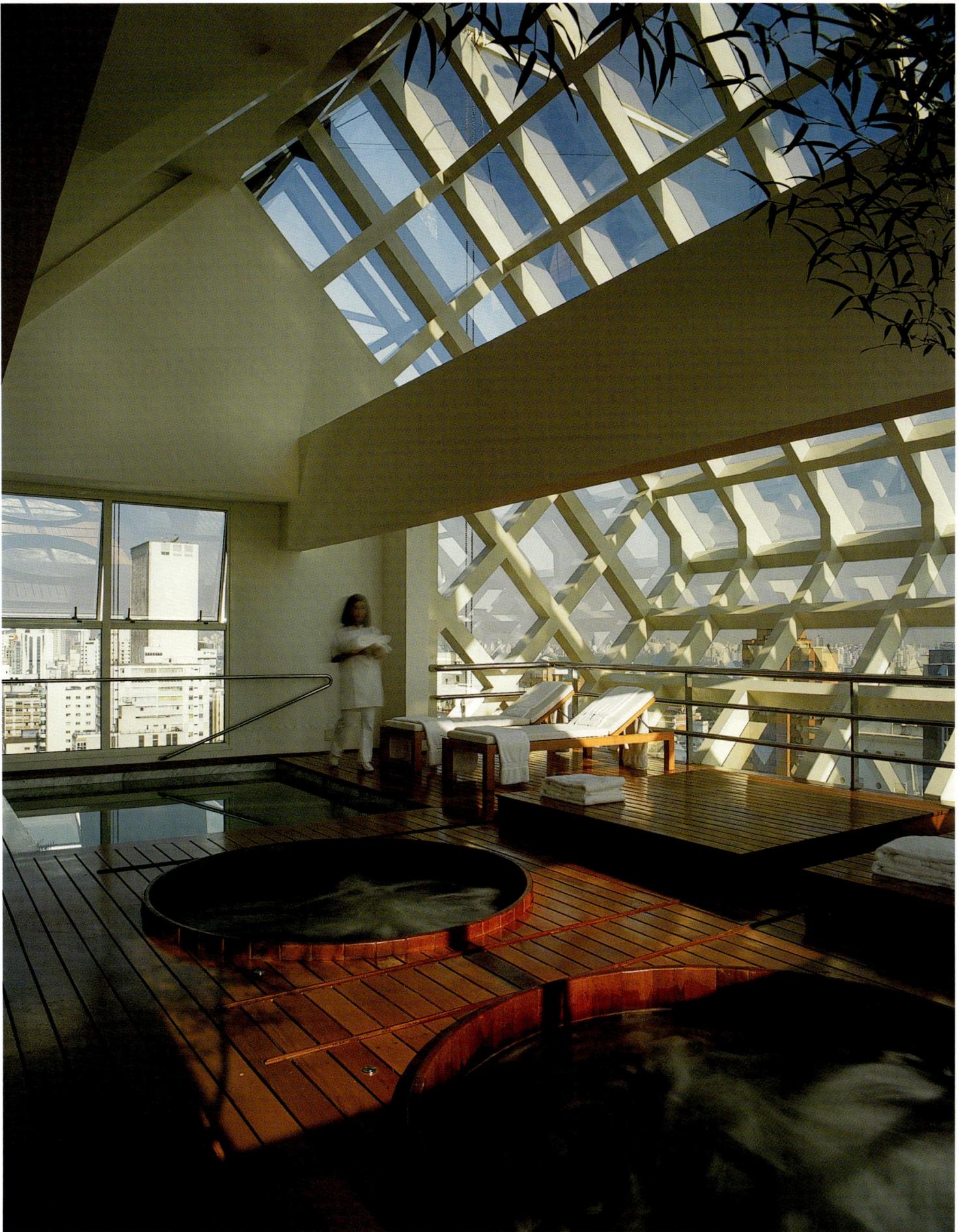

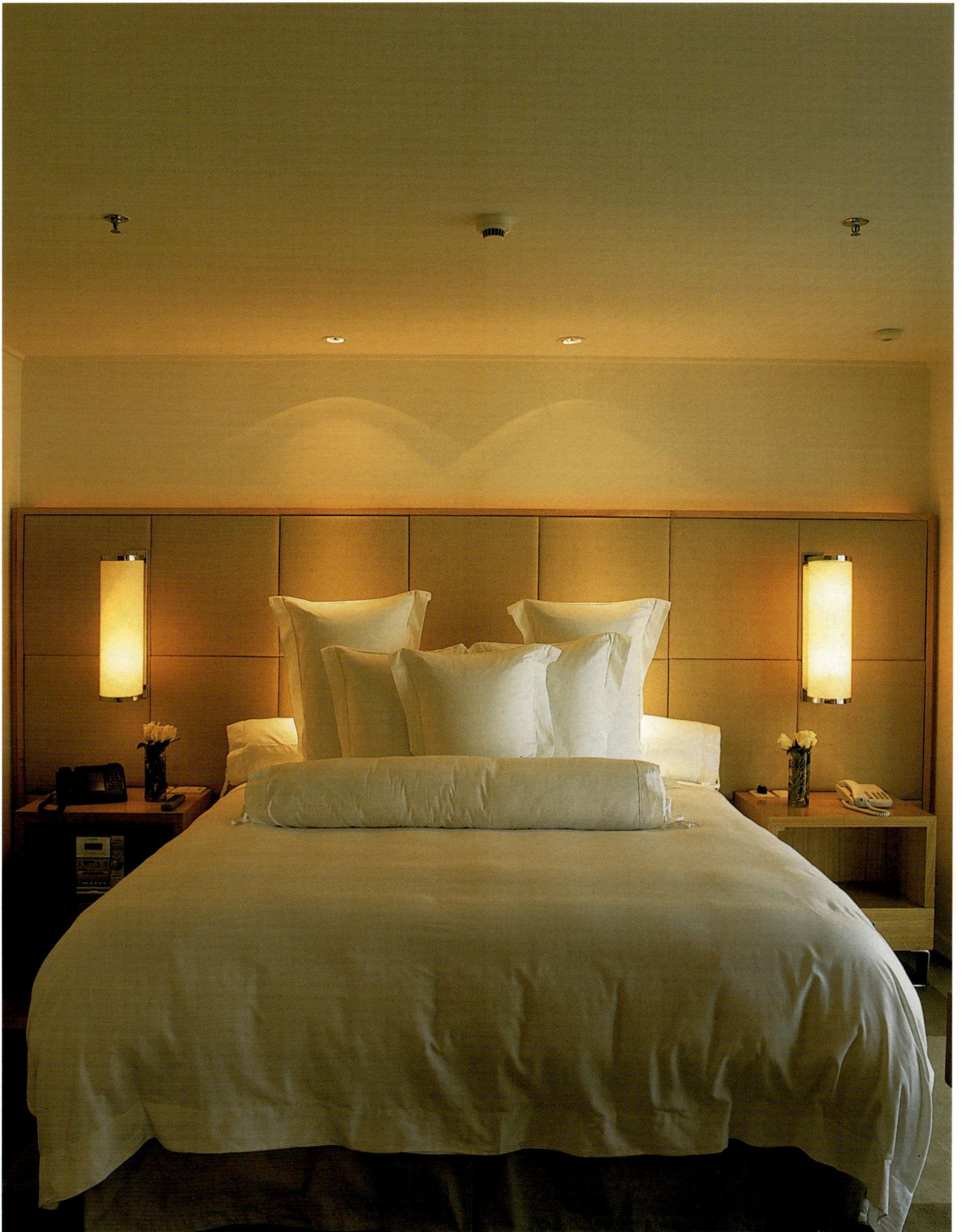

EMILIANO

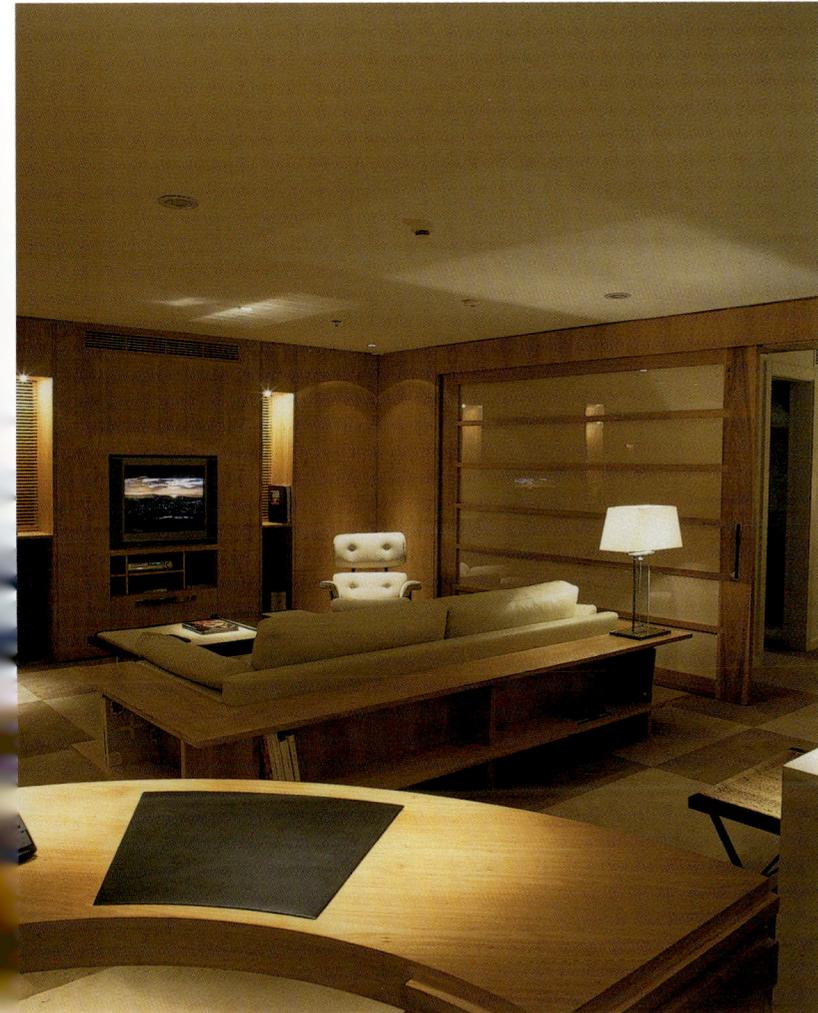

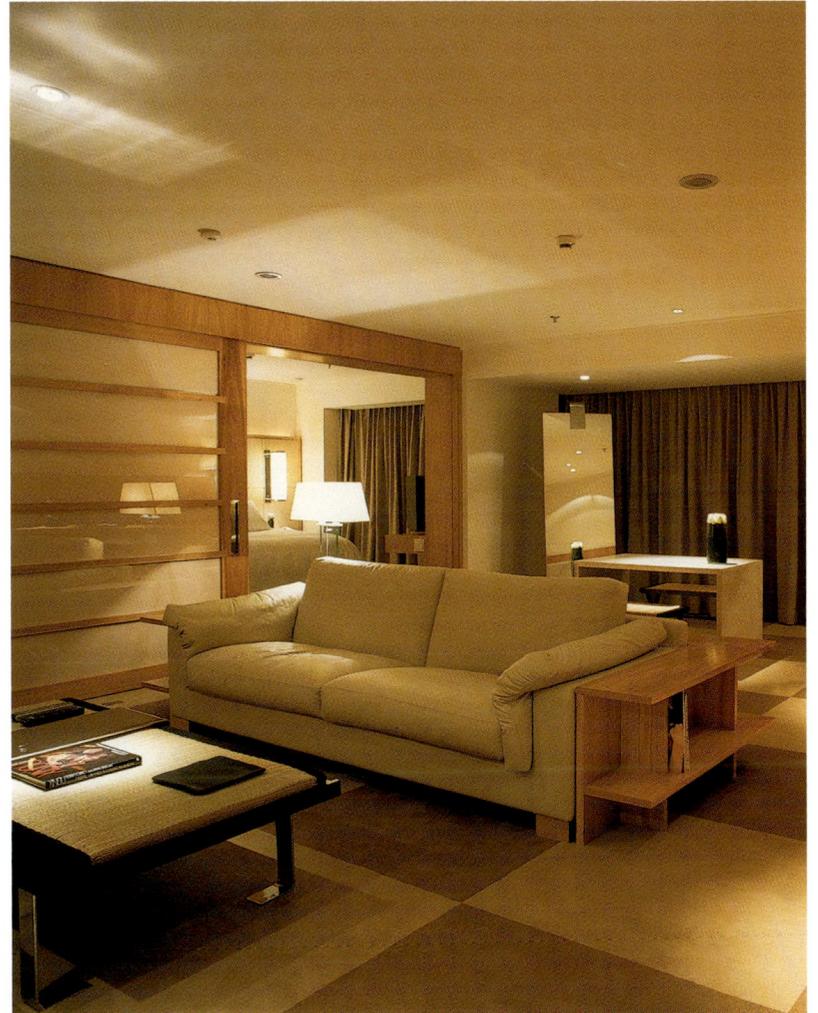

There are only two rooms on each floor of the building, so they all have large, separate living and sleeping areas and varied perspectives of the magnificent view of the city. The indirect lighting and the furnishings in natural fibers complement the natural wood used in the rest of the space.

Design
Suites & Towers

Marcelo T. de Alvear 1683 C1060AAE Buenos Aires, Argentina Tel + Fax: +54 11 4814 8700 marketing@designsuites.com www.designsuites.com

This modern hotel, located in a central area of Buenos Aires, was designed to meet all the needs of the business traveler, including putting the latest technology at his fingertips. This premise is reflected throughout the project, from the exterior image down to the tiniest details and finishes which reflect an innovative, cutting-edge spirit. The extreme verticality of the building's volume harmonizes pleasantly with the green areas in the neighborhood as well as the surrounding architecture of earlier decades. Despite its great height, the hotel's outward appearance is not overwhelming due to the materials used for the building, such as glass, aluminum, and light-colored polished concrete. In contrast, inside the hotel a less vertiginous feeling is achieved through an open and transparent floor plan. The boundaries between outside and inside blur amongst the subtle play of transparencies, emphasizing the continuity of the space.

The interior design and decoration of the hotel's various spaces follow the same contemporary, cutting-edge idea. The practicality and comfort of every room translates into a near-futurist language free of excess. The palette of colors, containing grays, whites, and soft greens, creates monochromatic atmospheres that imbue the rooms with a calm, relaxed feel. Again the glass and aluminum, used in different pieces of furniture and wall coverings, play an important role in reinforcing this feeling.

Architect: **Ernesto Goransky** Photographer: **Virginia Del Guidice** Location: **Buenos Aires, Argentina** Opening date: **1999**

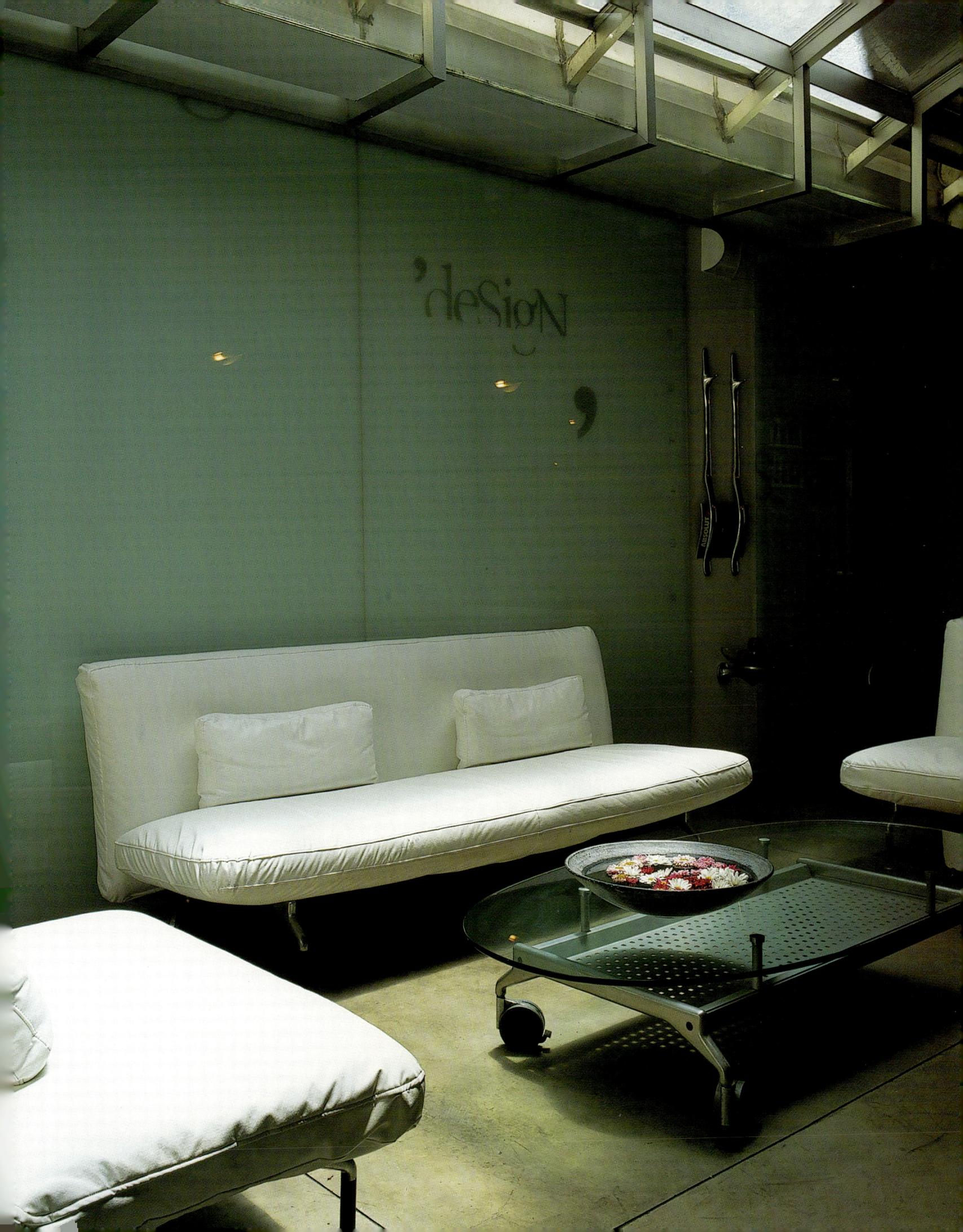

'deSioN'

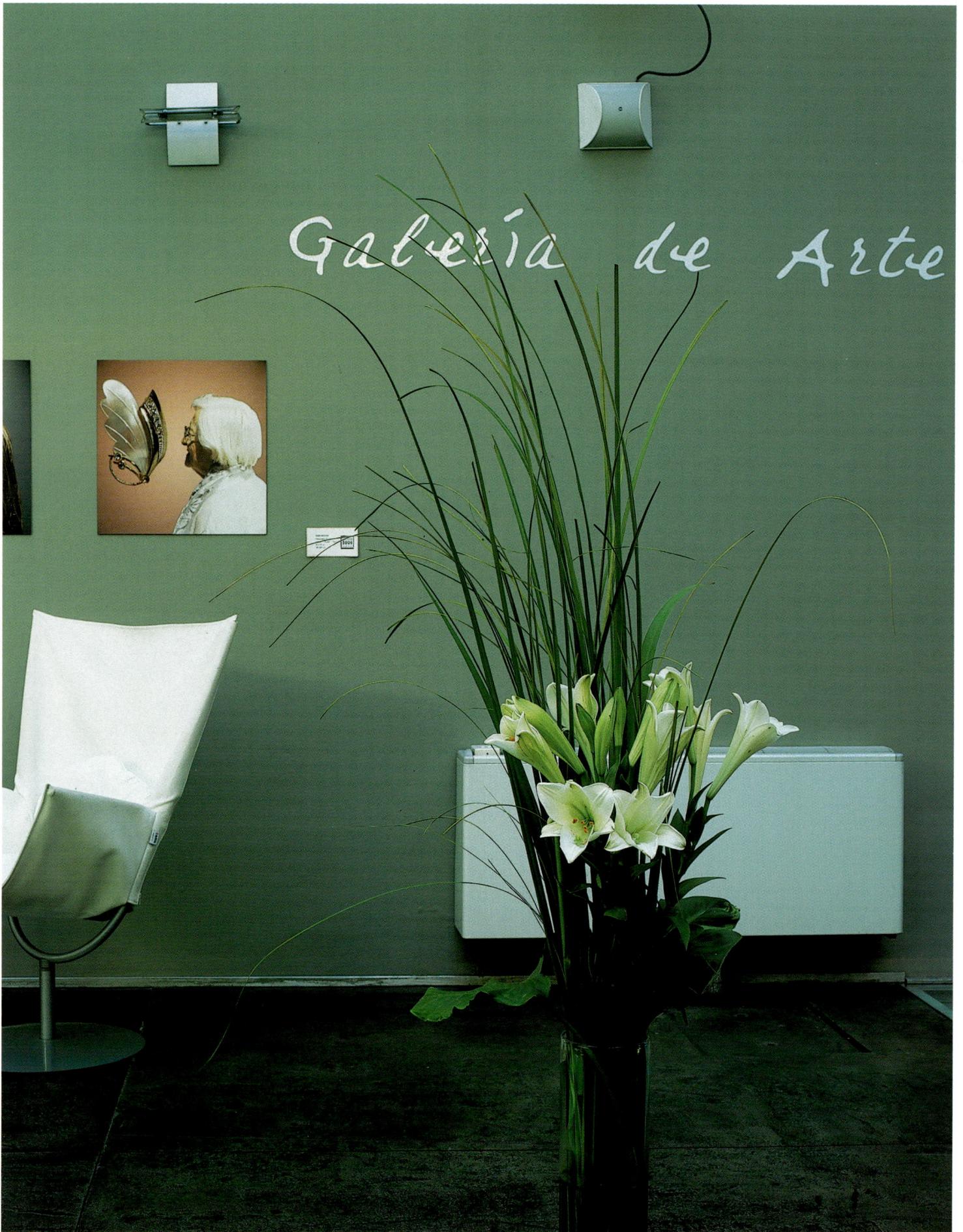

Galería de Arte

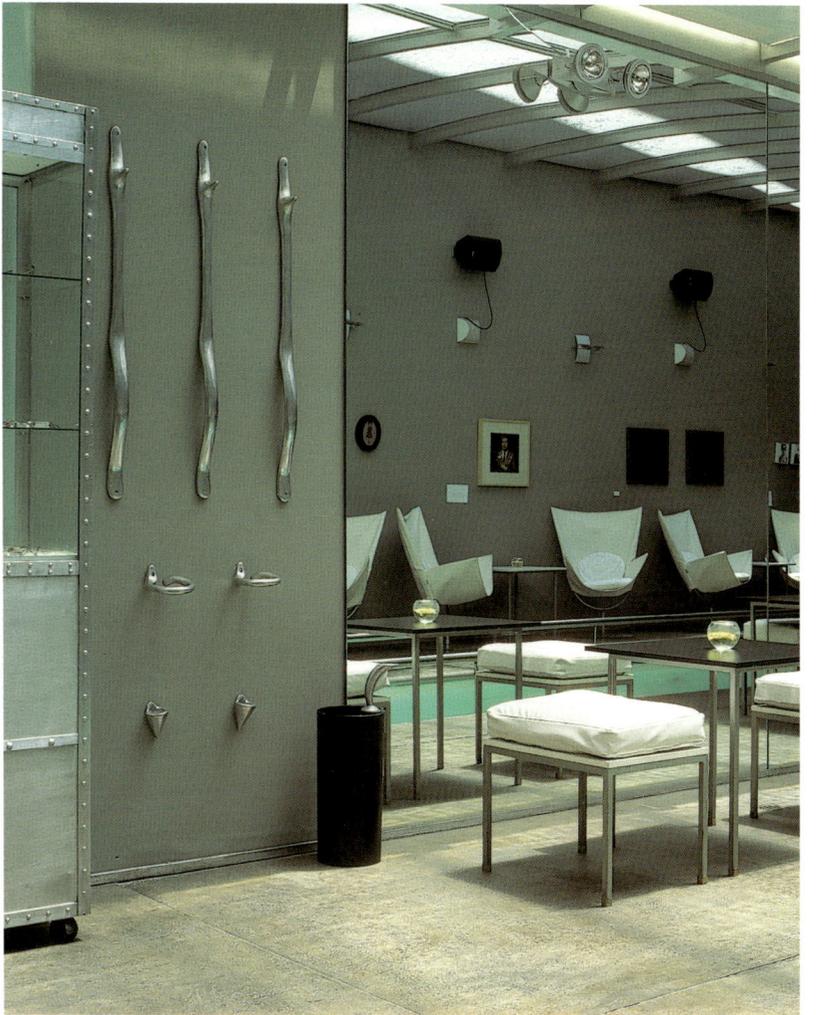
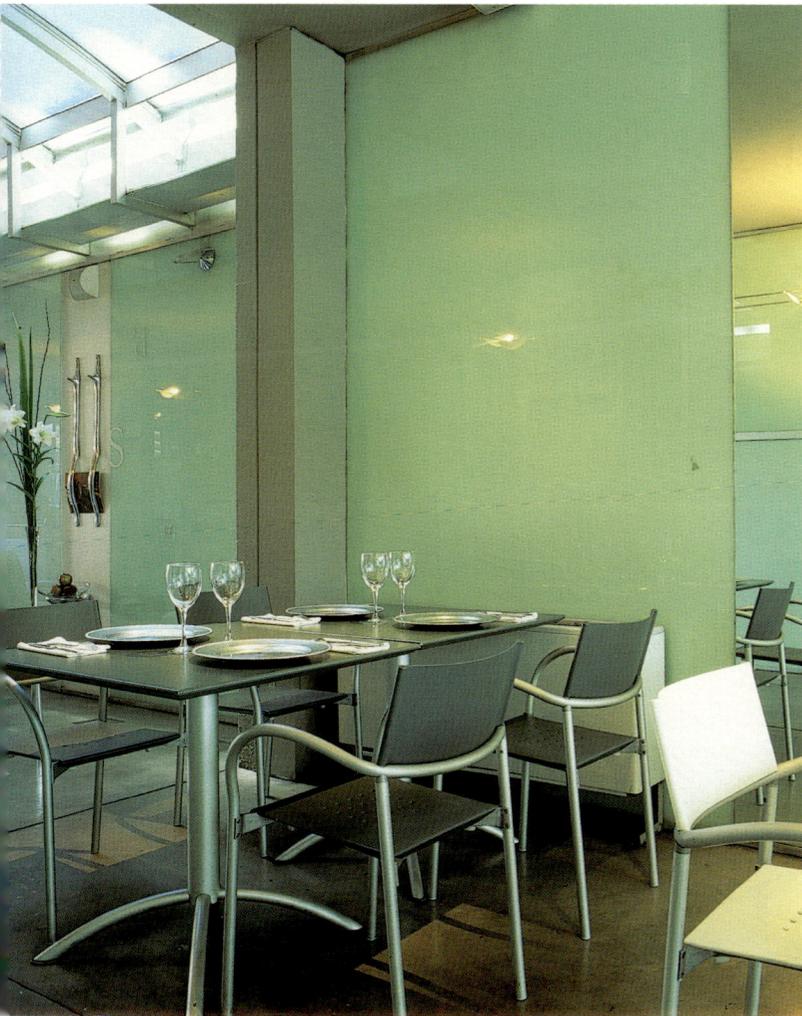

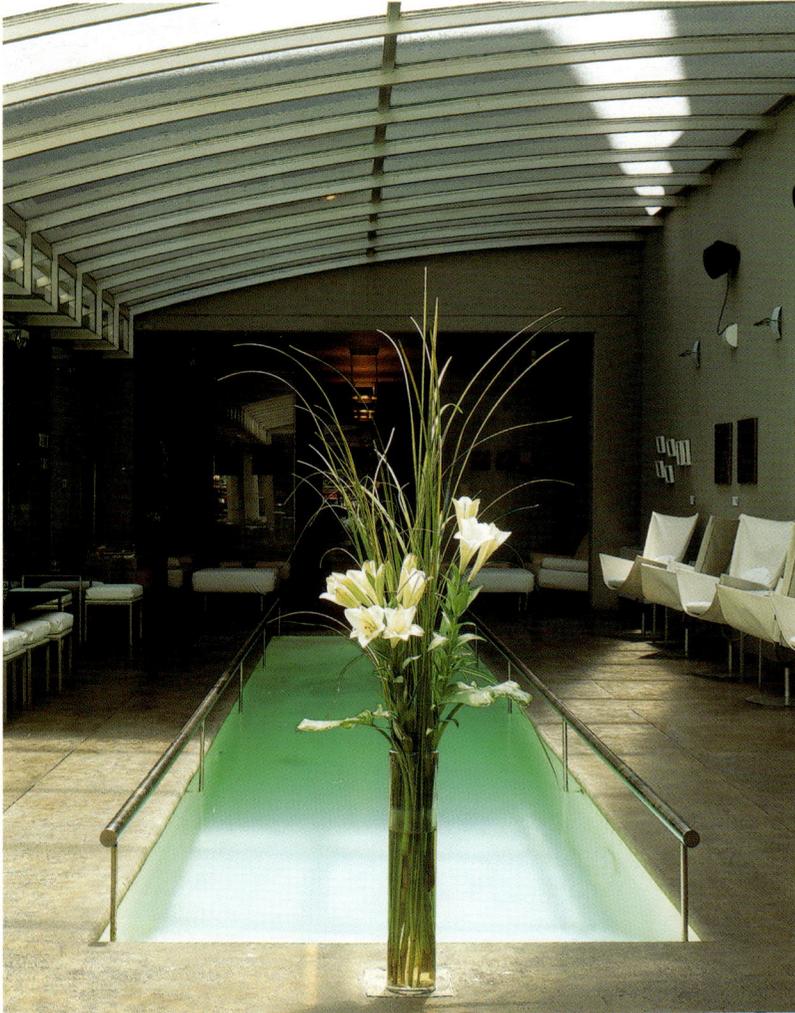

The designers of the hotel paid special attention to the integration of natural light into all the areas. In the indoor pool an ambience similar to that of a living room is achieved due to the color of the walls and the furnishings.

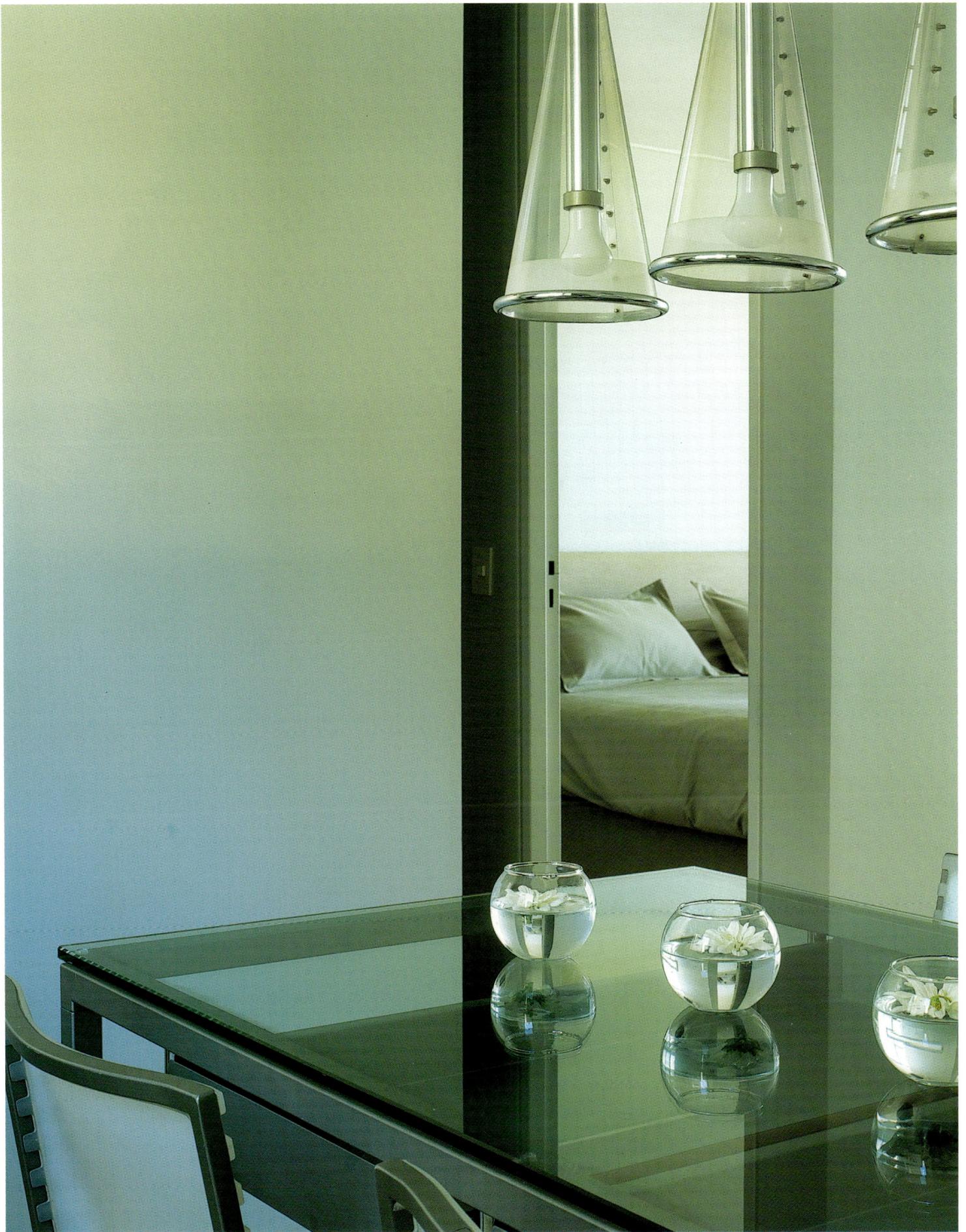

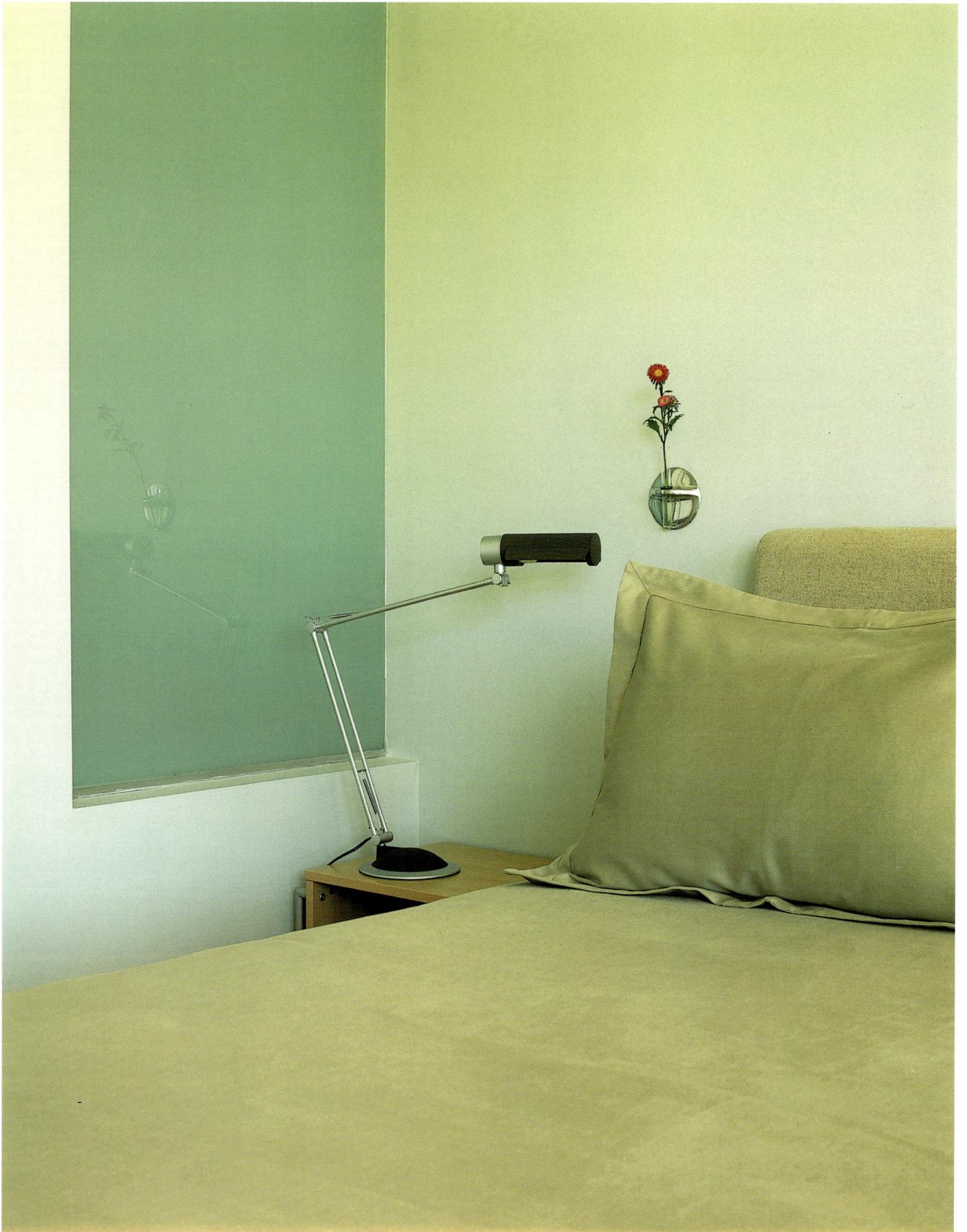

'deSigN
Suites & Towers

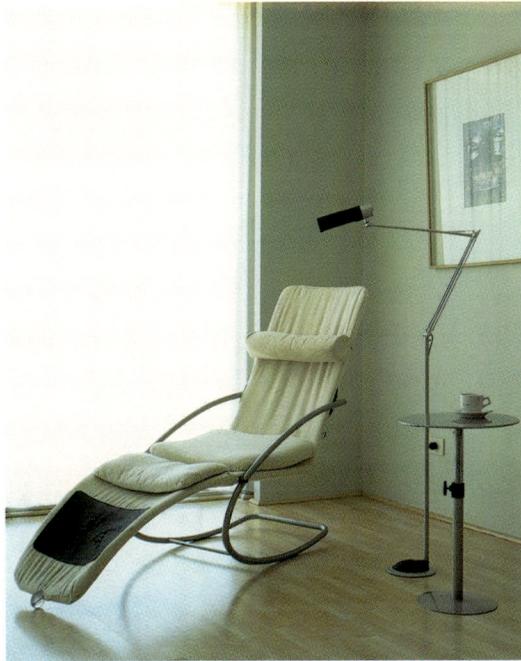

In the rooms guests find that the hotel has maintained the same restrained and functional feeling while adding a few warmer touches such as wood floors and lighter tones.

Mandarin Oriental Miami

500 Brickell Key Drive, Miami, FL 33131, USA Tel: +1 305 913 8288 Fax: +1 305 913 8300 momia-reservations@mohg.com www.mandarinoriental.com

The corporate symbol of this worldwide hotel chain, in the shape of a fan, inspired the design of this building. The resulting curved shape of the building presented several opportunities; not only is the fan-like shape now part of the skyline, but the interior offers countless places from which to enjoy views of Miami. From most of the rooms hotel guests can enjoy views of the bay and the skyline, which vary depending on the room's position in the huge fan spread out against the cityscape. The curved shape also creates an interesting connection between the atmospheres of the different common areas where, despite sharing the same overall space, each one seems different from the other.

The influence of contemporary design in South Florida, combined with more classic touches and luxurious Asian art, generates an energetic image which takes form in colors, shapes, lights, and well-defined shadows. With this combination the architects tried to create an ambience like Miami itself, which brims with cultural diversity. The mirrors, exuberant tropical flowers, and vegetation are contrasted with the contemporary furnishings. The patterns, an important part of the design, complement objects of art, crafts, and sculptures, with special attention paid to the details and the finishes. This way a relaxed yet sophisticated space with the air of a luxurious Art Deco Miami home is achieved.

Architect: **RTKL Associates** Designer: **Hirsch Bedner & Associates** Photographer: **Pep Escoda** Location: **Miami, USA** Opening date: **2001**

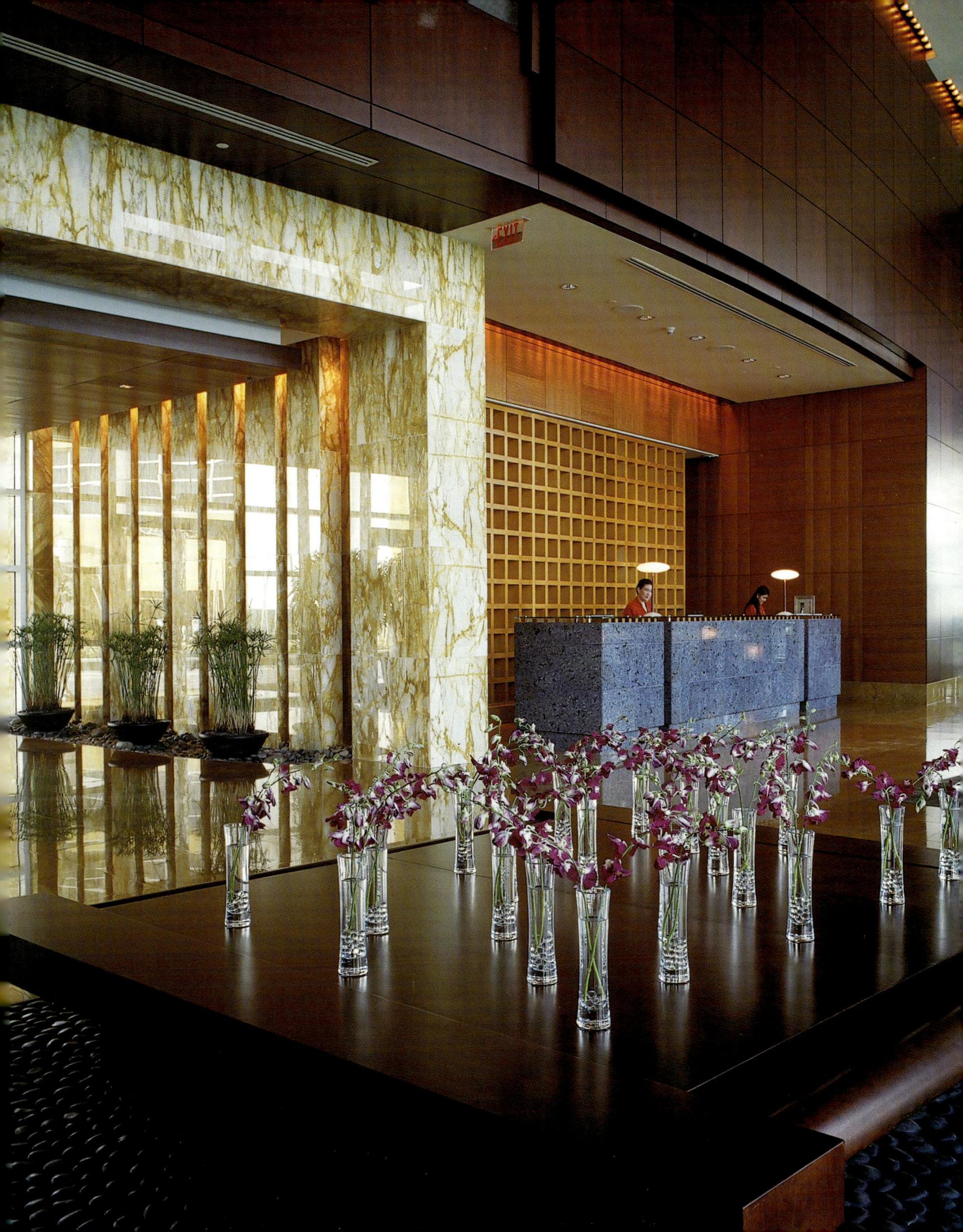

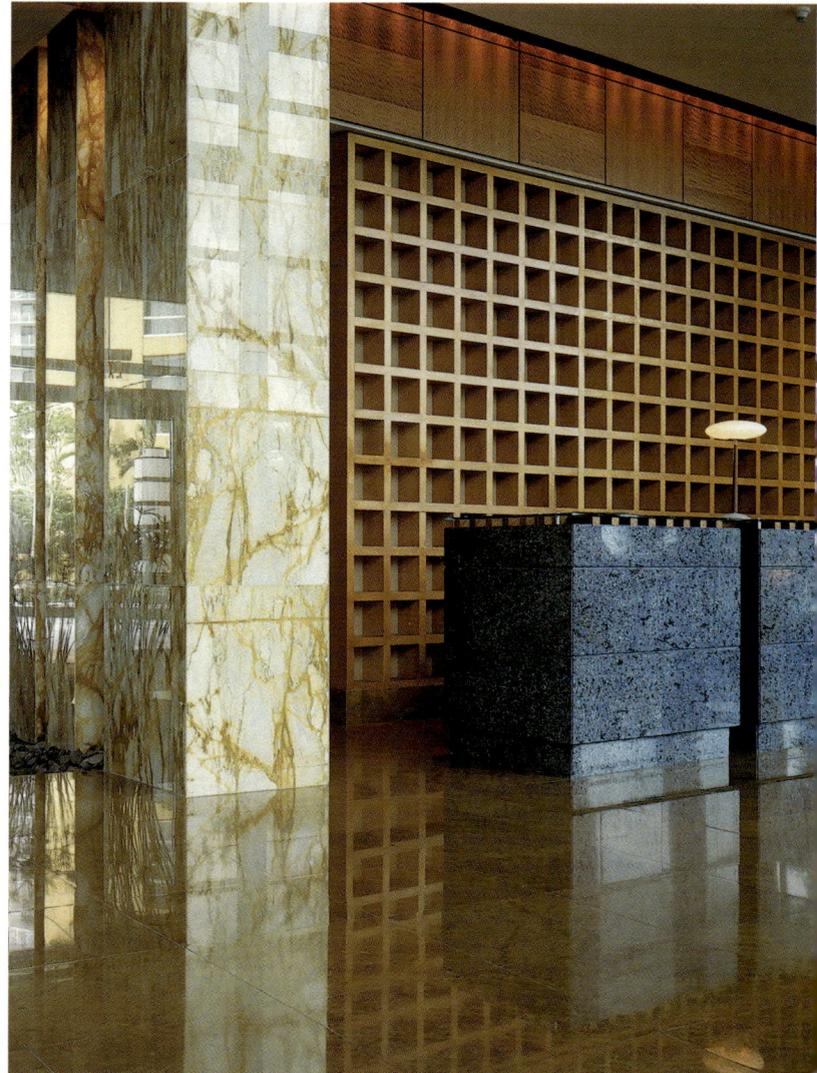

Due to the shape of the building, the vestibule area has large, wide windows that flood the interior with natural light. The exuberant vegetation and colorful furnishings enhance the tropical feeling of the hotel.

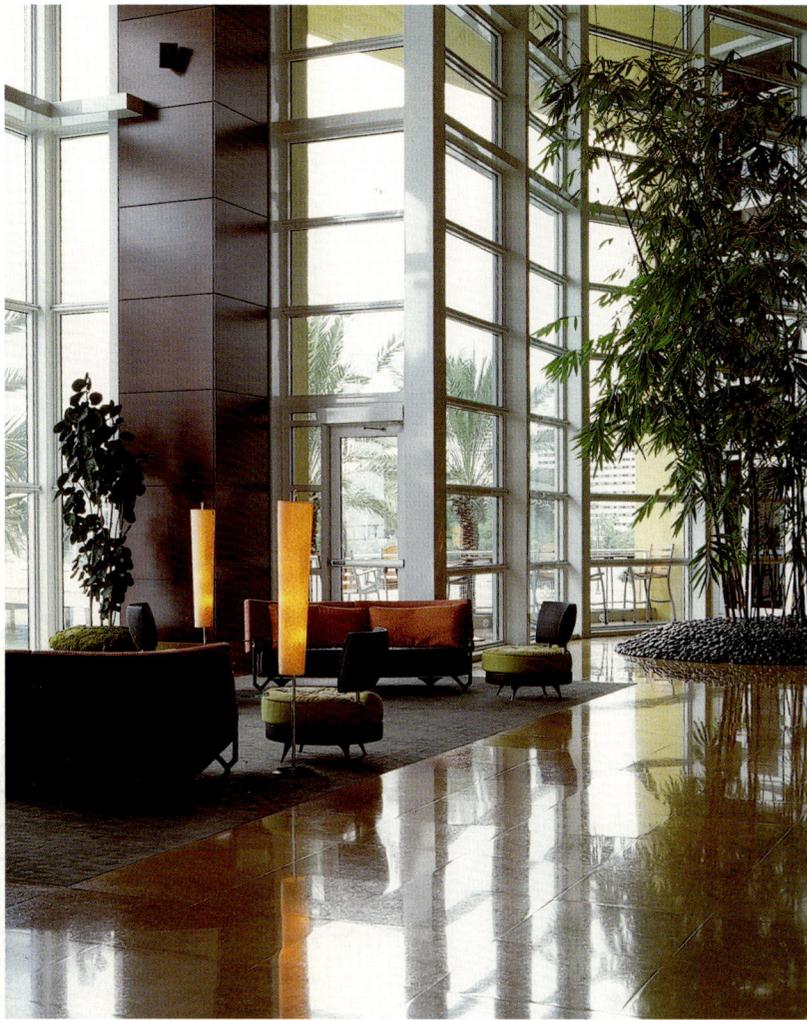
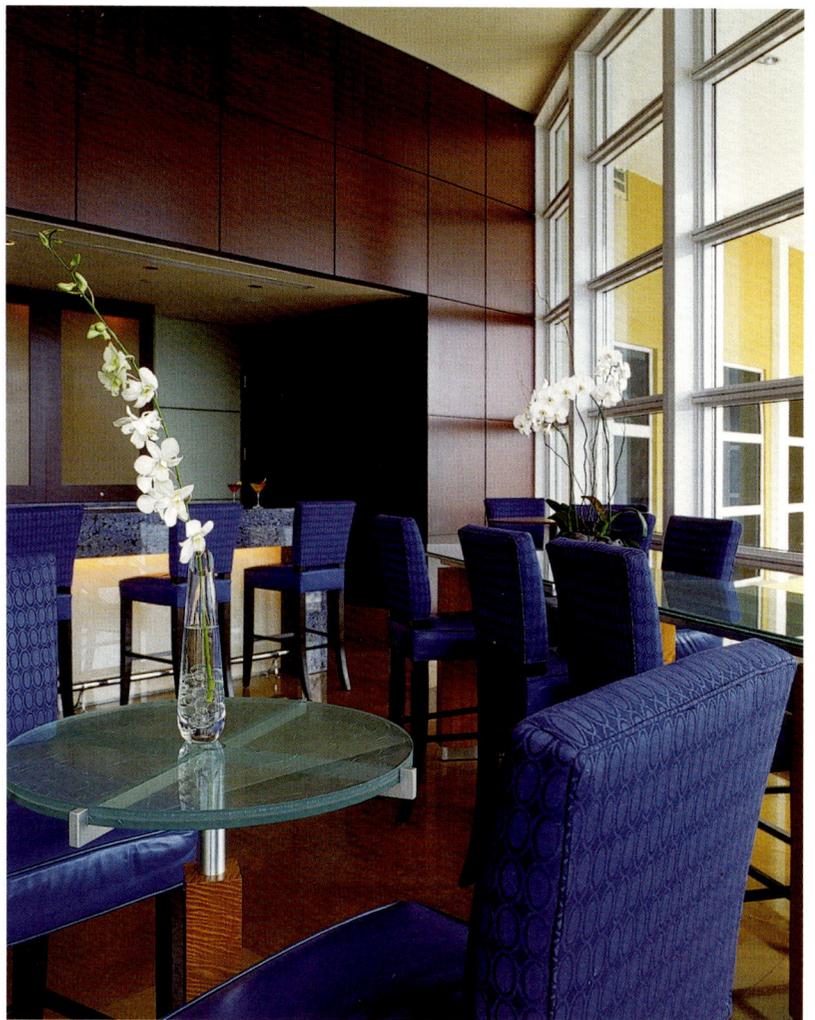
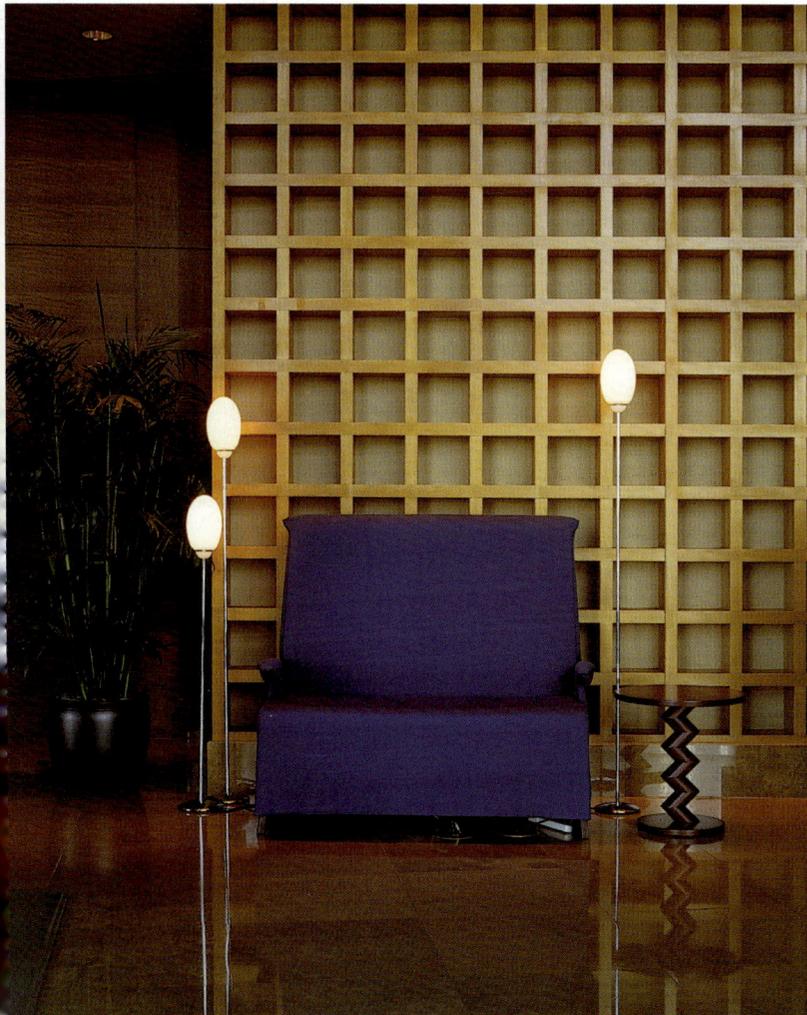
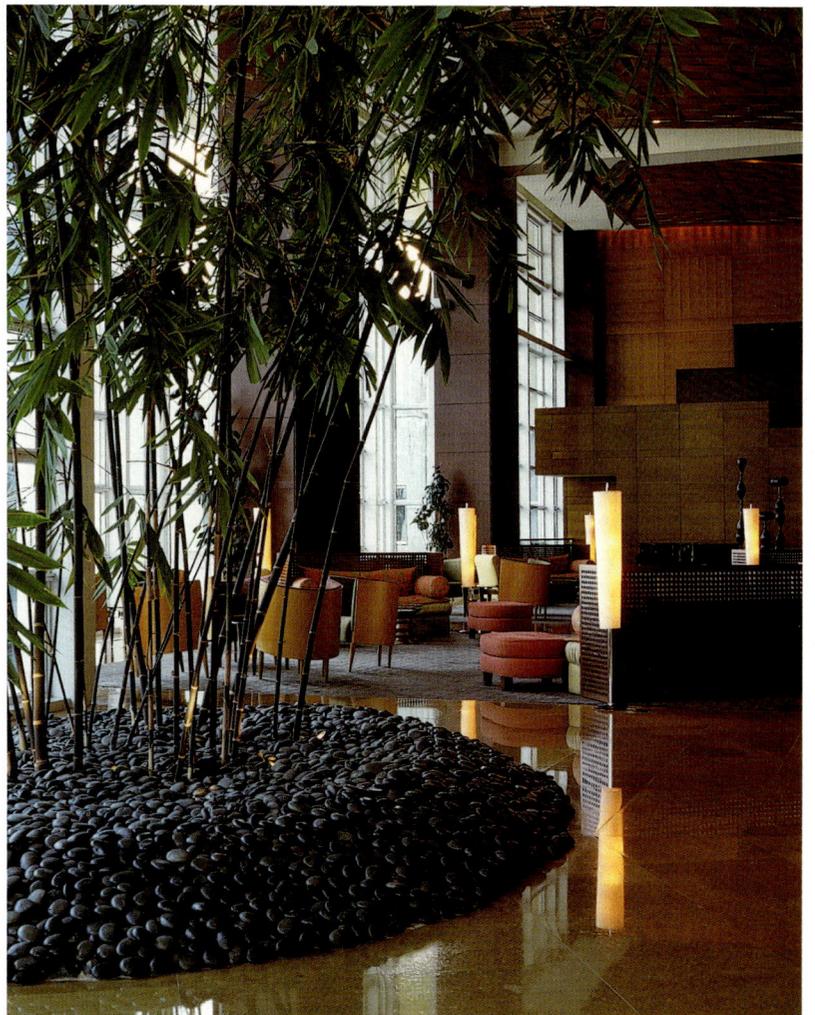

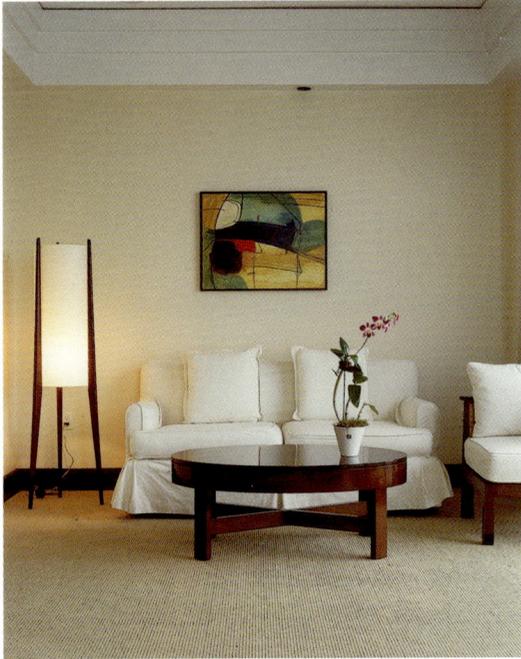

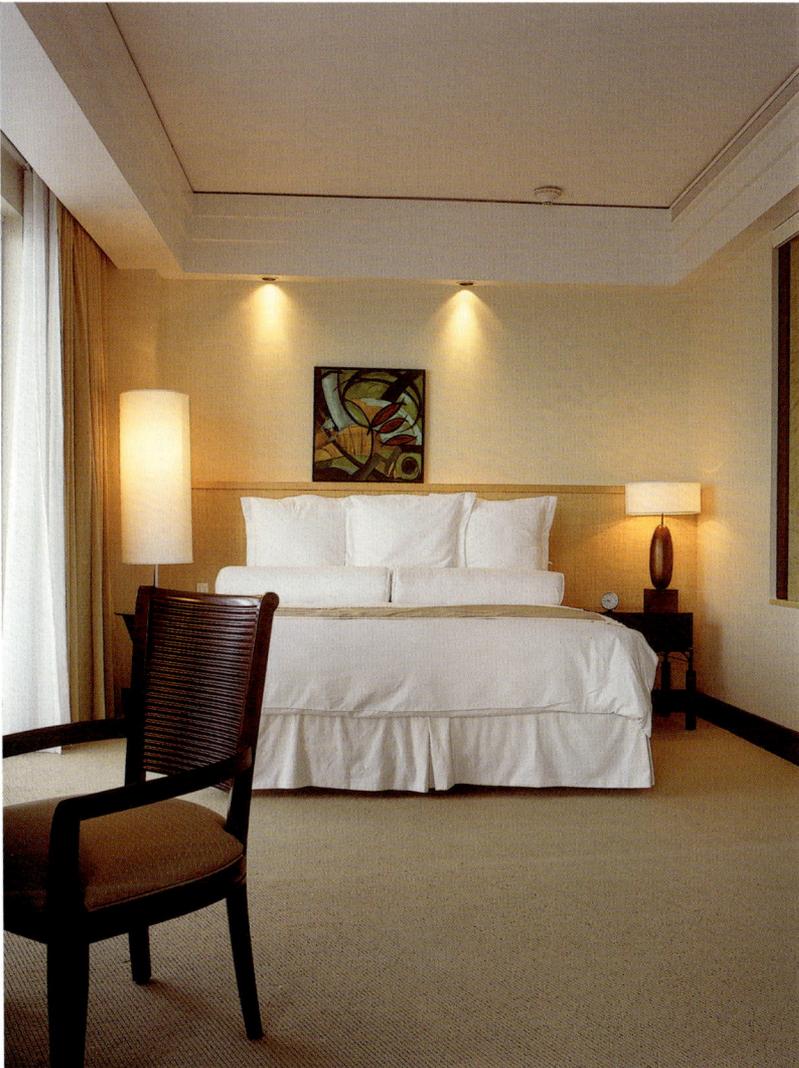

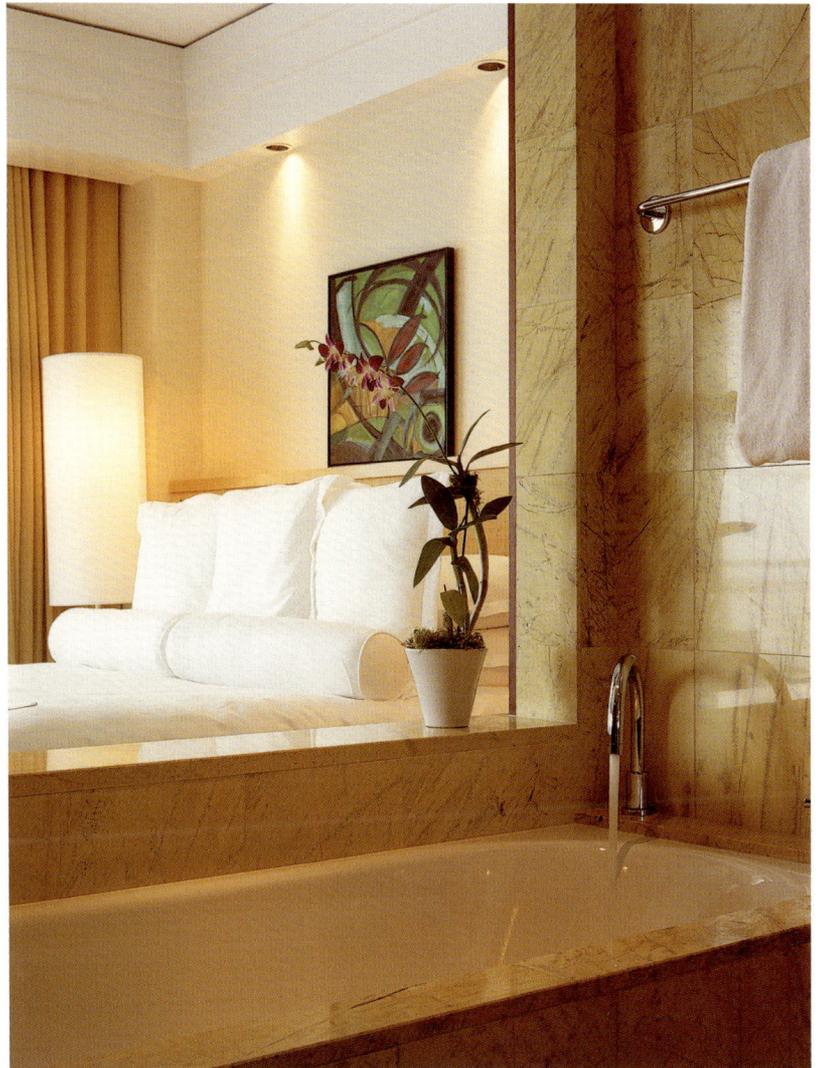

The rooms offer a calm, relaxed atmosphere. The dark wood finishes and pieces of furniture accentuate the cream color scheme.

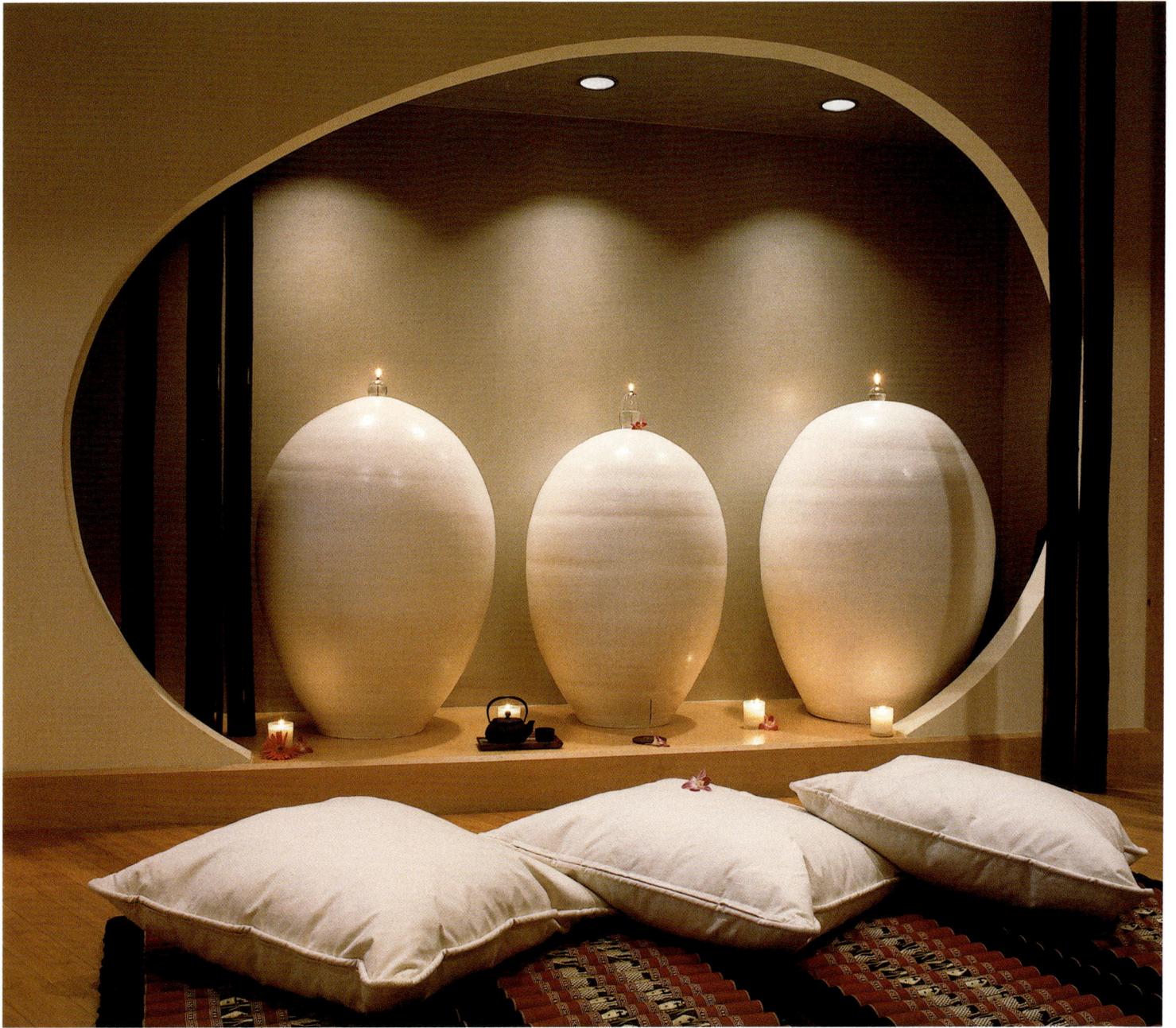

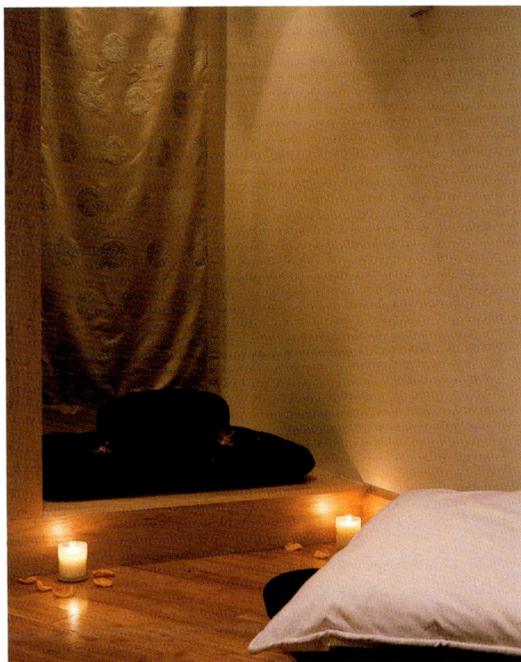

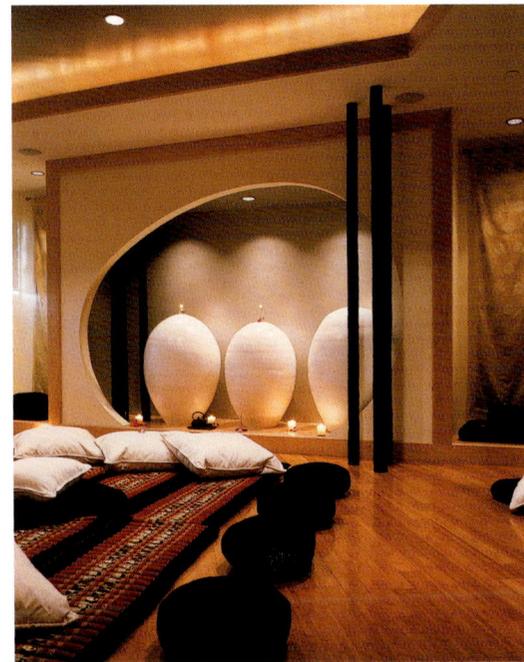

This lounging area, in contrast to the open, luminous parts of the hotel, offers guests a more intimate and secluded atmosphere. The space, whose ambience is defined by Eastern references, is also used as a conference room and for private parties.

Side

Hotel

Drehbahn 49, 20354 Hamburg, Germany Tel: +49 40 30 99 90 Fax: +49 40 30 99 93 info@side-hamburg.de www.side-hamburg.com

The first thing guests notice about this hotel is its impressive and expressive exterior, a mass of stone which took three years to design and erect. The glass façade of the building, which is located in the heart of Hamburg, stands out from the urban skyline surrounding it, especially when lit up at night. Its lightweight and luminous visage is the main theme of the interior design. Materials such as glass, shiny finishes, bright colors, and natural elements like water come together to create a series of spaces that are open and filled with light. Two different concepts coexist in the interior; one in the com-

mon areas that is colorful and cutting-edge, and the other in the calmer and cozier rooms.

The heart of the hotel, located in the center of cosmopolitan Hamburg, is a large glass interior, more than 78-feet-tall. In this plaza-like space the absence of parallel lines stands out because the floor is trapezoidal, and the glass façade leans at a three-degree angle creating an attractive spatial tension. In the upper part of this translucent, light space, on the eighth floor, an enormous lobby offers two attractive views. Through the glass façade, splendid views of the city can be enjoyed, while towards the interior a striking view of the courtyard can be contemplated.

Architect: **Störmer Architekten** Designer: **Matteo Thun** Photographer: **Gunnar Knechtel** Location: **Hamburg, Germany** Opening date: **2001**

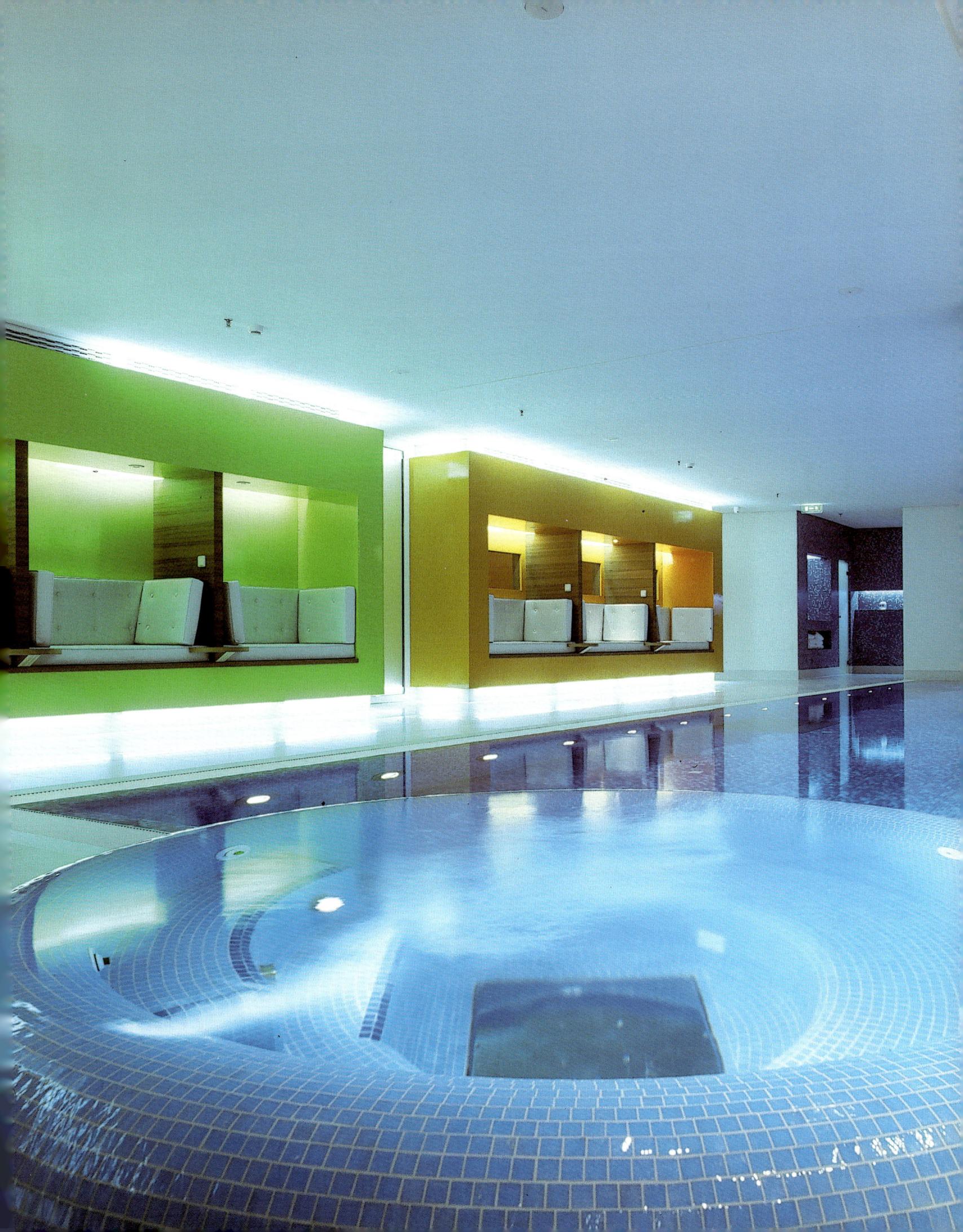

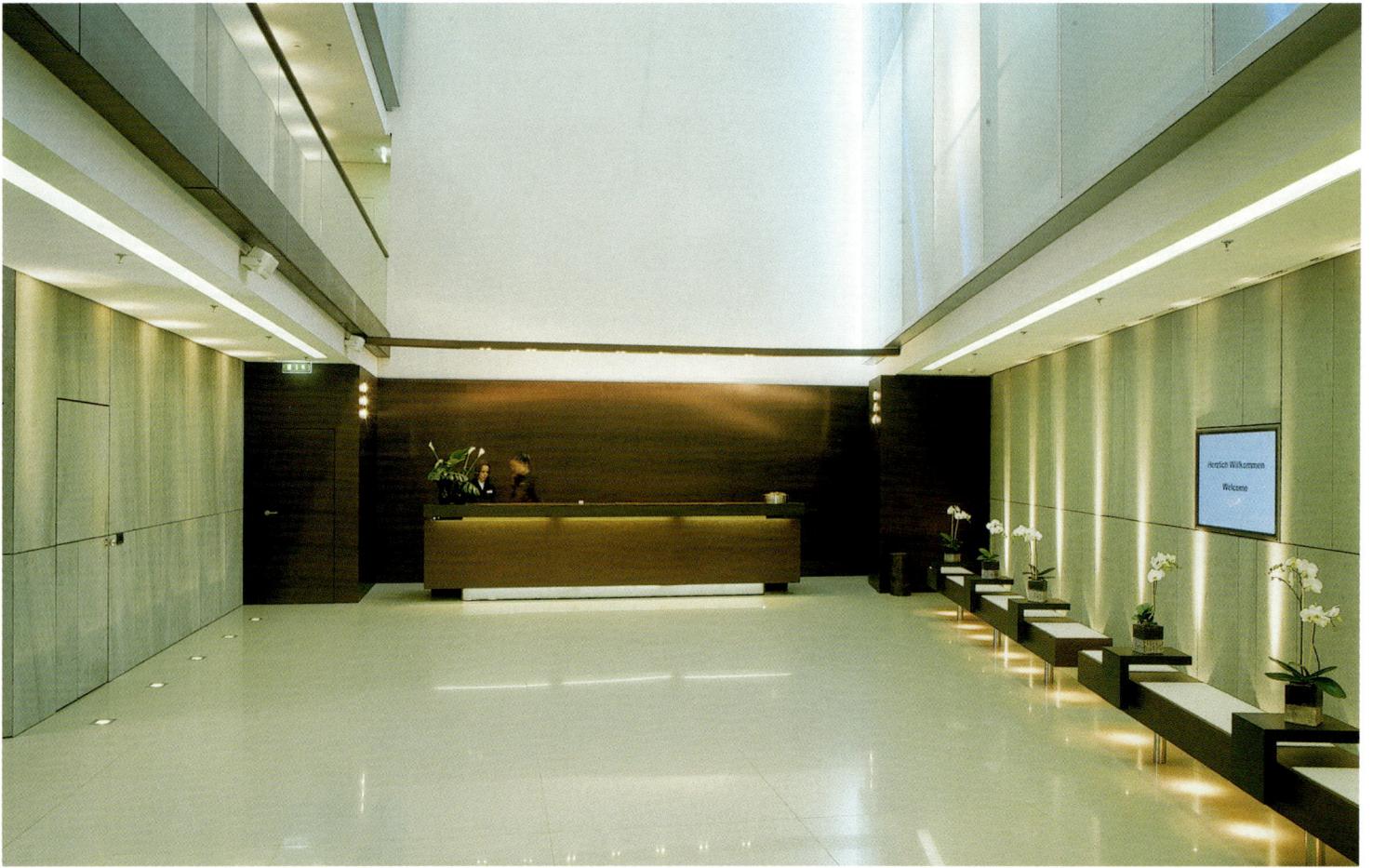

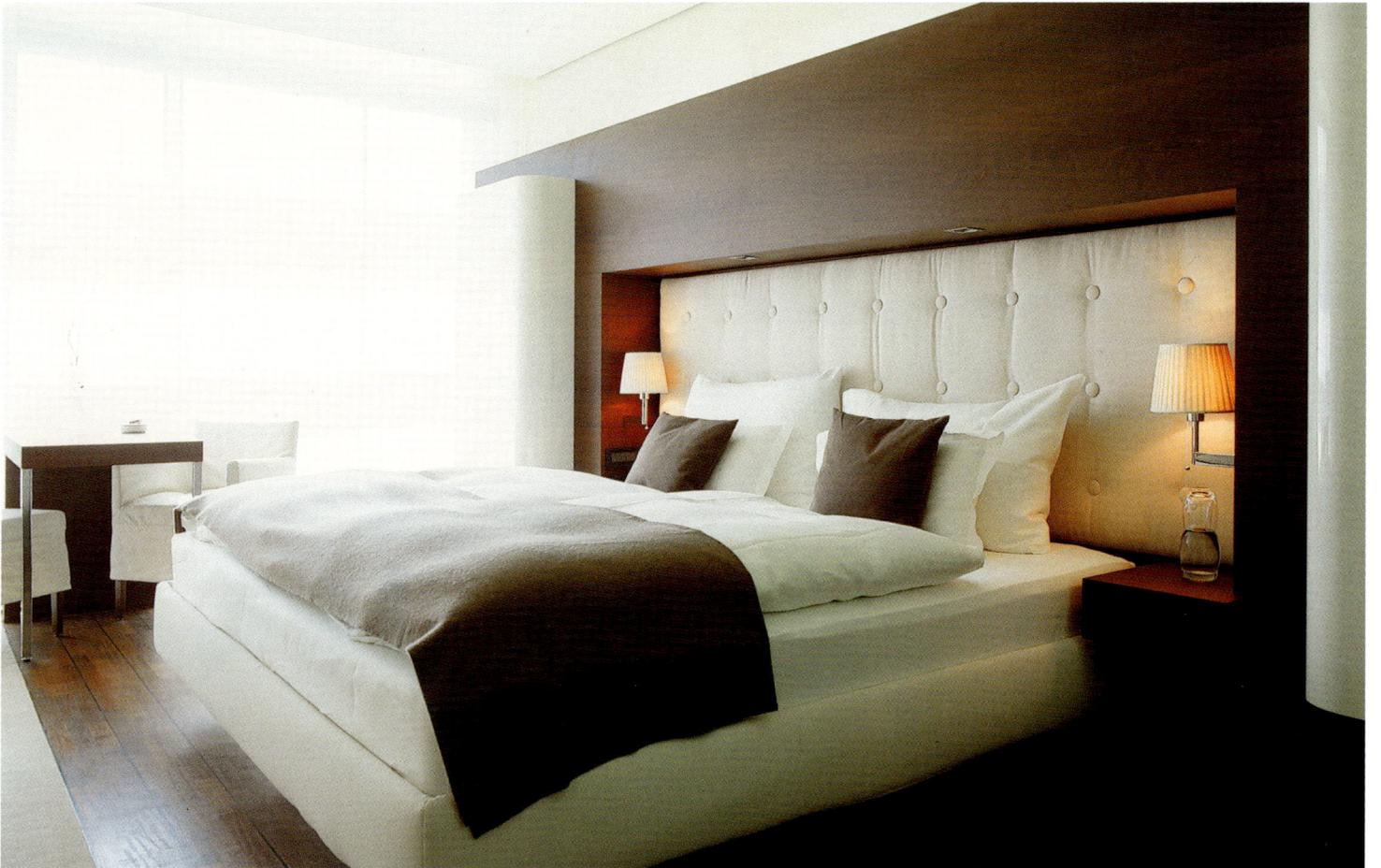

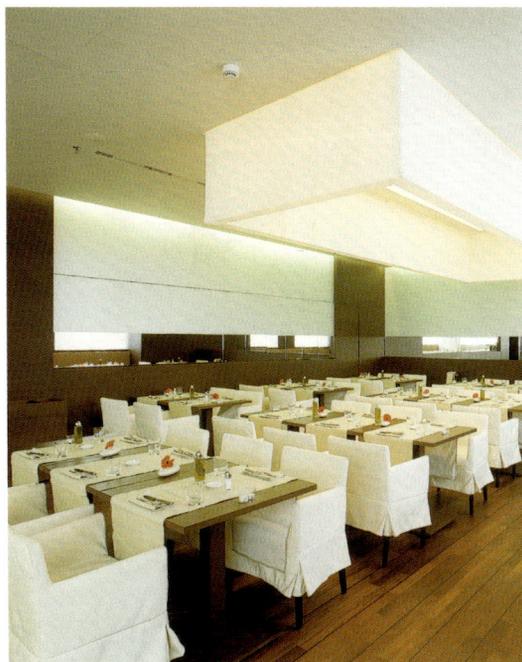

The effect of spatial tension in the main lobby is emphasized even more by the lighting design, achieved with computer-controlled light impulses that modify the color and intensity of the light according to the time of day, weather conditions, and season. The premise of comfort, simplicity, and functionality rules the design of the guest rooms. In the interior the pure lines, minimalist styles, and personal touches in special pieces—such as the headboard—create extremely warm and cozy environments.